THE PUBLISHER GRATEFULLY ACKNOWLEDGES

THE GENEROUS CONTRIBUTION PROVIDED

BY THE DIRECTOR'S CIRCLE OF THE

ASSOCIATES OF THE UNIVERSITY OF CALIFORNIA PRESS

WHOSE MEMBERS ARE

Edmund Corvelli, Jr., New England Book Components

Susan and August Frugé

Florence and Leo Helzel

Ruth and David Mellinkoff

Joan Palevsky

PAST - PRESENT

Una's Lectures

Una's Lectures, delivered annually on the Berkeley campus, memorialize Una Smith, who received her B.S. in History from Berkeley in 1911 and her M.A. in 1913. They express her esteem for the humanities in enlarging the scope of the individual mind.

1. *The Resources of Kind: Genre-Theory in the Renaissance,*
 by Rosalie L. Colie. 1974

2. *From the Poetry of Sumer: Creation, Glorification, Adoration,*
 by Samuel Noah Kramer. 1979

3. *The Making of Elizabethan Foreign Policy, 1558–1603,*
 by R. B. Wernham. 1980

4. *Three Christian Capitals: Topography and Politics,*
 by Richard Krautheimer. 1983

5. *Ideal Forms in the Age of Ronsard,*
 by Margaret M. McGowan. 1985

6. *Past-Present: Essays on Historicism in Art from Donatello to Picasso,*
 by Irving Lavin. 1993

PAST-PRESENT

Essays on Historicism in Art from Donatello to Picasso

Irving Lavin

UNIVERSITY OF CALIFORNIA PRESS

BERKELEY • LOS ANGELES • OXFORD

The publisher gratefully acknowledges the generous support
of the Institute for Advanced Study, Princeton, and the Una
Endowment Fund of the University of California, Berkeley.

University of California Press
Berkeley and Los Angeles, California

University of California Press, Ltd.
Oxford, England

© 1993 by Irving Lavin

Library of Congress Cataloging-in-Publication Data
Lavin, Irving, 1927–
Past-present : essays on historicism in art from Donatello to
Picasso / Irving Lavin.
p. cm. — (Una's lectures ; 6)
Includes bibliographical references and index.
ISBN 0-520-06816-5 (cloth)
I. Art and history. 2. Historicism. I. Title. II. Series.
N72.H58L38 1992
709—dc20 91-28489

Printed in the United States of America
9 8 7 6 5 4 3 2 I

73949

"Only connect . . ."

E. M. FORSTER, *Howard's End*

CONTENTS

Plates

Figures

When I was asked to deliver the Una's lectures at Berkeley in 1987, my response was conditioned by two considerations. The first was that the character of this extraordinary woman, typically Berkeleian in her combination of high intellect and free independent spirit, seemed to encourage an experimental departure from the conventional norms of scholarship to which my work hitherto has more or less conformed.

The second consideration, complementary to the first, emerged from self-reflexive ruminations in which I had been engaged for some time and which the invitation brought to the fore. Much to my chagrin, I have not produced great works of compilation and synthesis. I have written relatively little, mostly in the form of essays (they deserve no other name, even when published as books), on an incorrigibly disparate variety of topics in the history of art from late antiquity to Jackson Pollock. Yet I do perceive in what I have done a consistent mode of operation, and I thought that to search out and expose this common vein of method, rather than to deal systematically with a single subject, might be an appropriately unconventional homage to Una and the lectures that bear her name.

I am an inveterate source-monger. My work, the actual labor I expend in archives, libraries, museums, and churches, is mainly that of a prospector digging and sifting to find a rare and shiny nugget—a work of art, a significant text, an idea—sufficiently analogous and available to suggest it might actually have been pertinent to the matter at hand. To find such a treasure is to outwit the artist, to unmask the perpetrator of what Degas called the perfect crime. My purpose in this sometimes fiendish hunt for precedents is nothing less than to understand history, to grasp (whatever that means) the prime mover in the history of art: the artist's original contribution. Only by reducing the creator's contribution to a minimum can we increase to a maximum our understanding of his particular originality, and hence of the art-historical process generally.

Unusually insightful illustrations of the interest and, I hope, usefulness of this procedure, are offered by cases in which precedent—history, the past—itself plays an explicit role. Here, the artist confesses and indeed flaunts his dissimulation, challenging the viewer to make specific associations, perceive the differences, and hence comprehend the true meaning and novelty of his own message. The essays published

here (the second, third, and fourth were added to the original lectures) all deal with works that define the present expressly in terms of the past. I hope to show that one can only, or at least most efficiently, decipher the message of such creations, for contemporaries and for ourselves, by catching the thief *in flagrante* and hearing his confession with sympathy and appreciation. I like to think that Una might approve of the method, whether or not the effort is successful.

The foregoing methodological proclamation notwithstanding, the pieces here assembled do fit together easily, and not just in the sense that they all deal with art-historically self-referential works of art, that is, works that explicitly refer to earlier works. In each case, they also refer to people, whether the artist himself or the patron or mankind generally. And in each case they define human individuality in some larger conceptual environment, whether philosophical, artistic, political, religious, ideological, cultural, or combinations thereof. The historical evocations serve this anthropological purpose by providing the vocabulary—visual figures of speech (figures of visual speech?)—in which the different definitions of human nature are expressed and through which the conceptual differences from the past are, in turn, made clear. I must further admit that in this context the parts may even constitute a whole of sorts, substantively as well as chronologically. For the visual definitions also contributed significantly—this is my substantive point—to the broad history of human self-consciousness in a sequence that led from what Jakob Burckhardt called the awakening of personality in the Renaissance, when an ancient tradition was invented to which the contemporary ideal aspired, to a "scientific" approach to human creativity in our own time, when precisely the absence of historical reference became the ideal. A final element of continuity is that all the works discussed were, in one way or another, public monuments—from a commemoration in the most conspicuous part of a major Florentine church to a serial image in a reproductive medium disseminated in multiple copies. The larger context in which the definitions of individuality must be understood thus includes the public at large. In this sense, too, I suspect, there may be an inner connection between the meaning of the works of art and their form.

My first debt of gratitude is to Loren Partridge, loyal friend and cordial host for the lectures in Berkeley. In preparing this book I have been ably assisted by the fine apprentice scholars James Clifton, Lisa Farber, Linda Koch, and Kristen Van Ausdall. Several good friends and colleagues, Doris Carl, Jack Freiberg, Jean-Baptiste Giard, Norberto Gramaccini, Edith Kirsch, Sarah Blake McHam, Maurizio Marini, Giovanna Perini, Massimiliano Rossi, Stephen Rustow, Gert Schiff, Christine Smith, Webster Smith, and Lucy Turnbull, were unflinching in their efforts to obtain photographs and information on my behalf. Susanne Philippson Ćurčić was very helpful in preparing the drawings reproduced in Figures 9, 12, and 263. Deborah Kirshman, art editor of the University of California Press, has been a kind and thoughtful shepherdess. I am also greatly indebted to the copy editor, Stephanie Fay, whose unusually careful and perspicacious reading of the manuscript made many valuable contributions; any remaining errors, infelicities or misjudgments are surely my own. I was fortunate also to have had the exemplary secretarial help of Bonnie Tillery and Kathleen Gallo. Ms. Gallo has been a veritable saving grace through the final stages of the work.

Finally, I am pleased to acknowledge a particular debt of gratitude to Brigitte Baer, the *doyenne* of Picasso graphics scholarship, for sharing her vast knowledge of the material with me, for imparting much wise counsel, and for taking great pains to help me obtain original photographs of many of the works illustrated in the last study.

This publication has been assisted by grants from the Una's Lectures series and from the Institute for Advanced Study, for which I am most grateful.

Institute for Advanced Study
Princeton, N.J.
June 1992

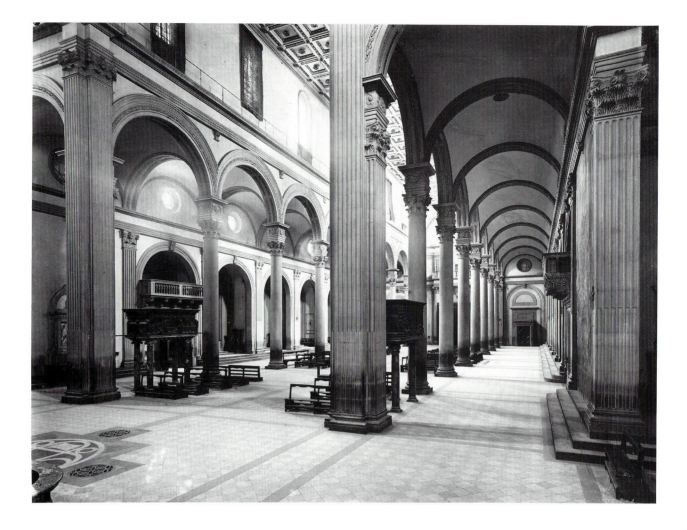

Fig. 1. View in the crossing. San Lorenzo, Florence (photo:
Soprintendenza per i Beni Artistici e Storici, Florence 27).

Fig. 2. Donatello, left pulpit. San Lorenzo, Florence (photo:
Brogi 8635).

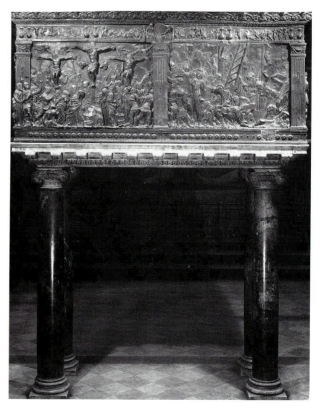

CHAPTER ONE ◆ DONATELLO'S BRONZE PULPITS IN SAN LORENZO AND THE EARLY CHRISTIAN REVIVAL

The pair of bronze pulpits by Donatello in San Lorenzo in Florence, together one of the seminal works of early Renaissance narrative sculpture, have suffered a tragic fate, historically as well as historiographically (Figs. 1–3). There is no contemporary documentation about them. We know only from Vespasiano da Bisticci and Vasari that Cosimo de' Medici commissioned them for San Lorenzo, which Brunelleschi had rebuilt for him into the first new basilica of the Renaissance. The pulpits were Donatello's last work, left unfinished at his death in 1466 and completed by assistants. They were assembled by the early sixteenth century and later attached to the piers at the meeting of nave and transept, very likely the location for which they were originally intended. Early in the seventeenth century they were moved to their present positions in the adjoining nave arches.[1]

The pulpits had been (as they continue to be) the subject of a good deal of discussion about attribution and dating—who did what when—until, in an article published nearly thirty years ago, I argued that they are, after all, a coherent work of art. Focusing primarily on the pulpits' sources, my study "revealed, underlying their apparent diversities, a remarkable unity of function, meaning, and style." Functionally, the unity involved a return to the long obsolete custom of reading the Epistle and Gospel of the Mass from a pair of ambos, except that these were normally placed toward the middle of the nave; the tradition is best exemplified in the early basilicas of Rome such as the Florentine church's own namesake, San Lorenzo fuori le mura (Fig. 4). Thematically, the unity lies in a Christological narrative in which the events of the Passion—except the Last Supper—are portrayed on the left (facing the altar), while the post-Passion miracles appear on the right. In this passing from death to resurrection through the operation of the Eucharist at the altar, Donatello's cycle is unique.[2] In its bilateral confrontation of promise and fulfillment, however, the program recalls the decorations of Early Christian basilicas, in which Old Testament and New Testament narratives flank the nave, or the mosaics of Sant'Apollinare Nuovo at Ravenna, where pre-Passion miracles confront the Passion. Formally, the unity consists in the systematic adoption and adaptation of more or less antiquated features in the overall design of the pulpits as well as in the individual scenes. Donatello rejected the polygonal

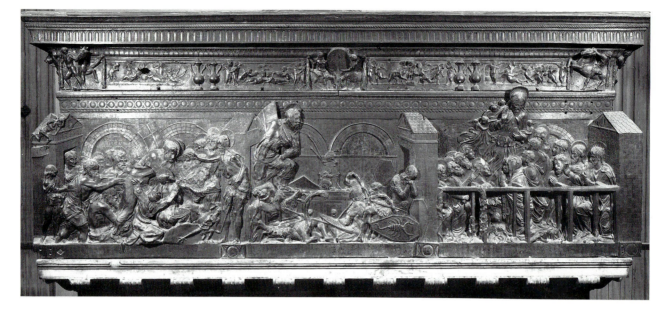

Fig. 3. Donatello, right pulpit. San Lorenzo, Florence (photo: Brogi 8630).

Fig. 4 (*opposite, top*). View in the nave toward the high altar. San Lorenzo fuori le mura, Rome (photo: Istituto Centrale per il Catalogo e la Documentazione, Rome D1781).

Fig. 5. Pulpit. San Leonardo in Arcetri, Florence (photo: Alinari 3341).

shape currently in vogue for pulpits in favor of the oblong format that had been neglected for at least a century (Fig. 5); and the design of the right pulpit, for example, clearly evokes early fourteenth-century sarcophagi like one by Tino di Camaino in Santa Croce (Fig. 6), where the Resurrection also occupies the center panel and is flanked by post-Passion miracles. A striking case among the individual scenes is the Three Marys at the Tomb (Fig. 7); for the portrayal of the event as taking place within an architectural setting, the nearest antecedents in Italy are found on the Tuscan Romanesque painted crosses (Fig. 8).

I concluded that

the unity is essentially one of intent, which may be defined as a concerted effort to resurrect the past and relate it to the present in a new and meaningful way. The past is therefore both an end in itself and the means to convey a more effective spiritual message. The message may have been entirely Donatello's invention; or it may have been a joint product of the humanist group surrounding Cosimo de' Medici, especially during his later years, of which a leading goal was to reconcile antiquity with Christianity by returning to the "early" phases of the Church. One is even tempted to

imagine San Lorenzo as the embodiment of a collective ideal to recreate, in architecture, furnishings, as well as liturgy, a pristine Christianity.[3]

Since that article was published, it has become clear to me that while my eyesight was sharper in those days, my mindsight was more myopic. In this egregiously belated postscript I shall try to fit together what I now see as the pieces of a large and complex, indeed a cosmic, jigsaw puzzle.

The largest piece in the puzzle appeared in an illuminating talk entitled, significantly in our context, "Early Christian Topography in Florentine Chronicles," given at the annual meeting of the College Art Association in 1985 by the historian Charles Davis of Tulane University.[4] Davis greatly expanded our view of the late medieval history and self-image of what he called the "pushy" Tuscan metropolis of Florence. Italian city-states commonly magnified their own images by emphasizing real or imagined claims to the glories of ancient Rome. Studying the early chronicles, Davis found that in Florence this history rhetoric acquired a special dimension, topographical as well as figurative. Florence was assimilated to the early Christian notion—

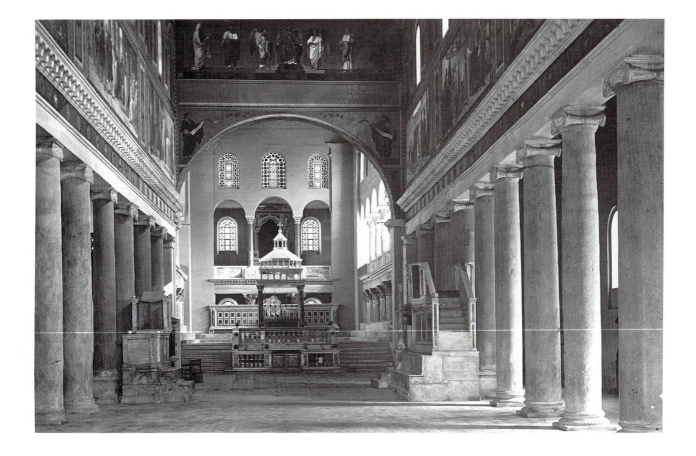

it was invented by the early Church Fathers—of a New Rome under Christ superseding the old Rome of paganism. This grand religio-historical idea emerges first in the anonymous *Chronica de origine civitatis*, written about 1200. Here Florence is said to have been founded originally as a miniature Rome with capitol, amphitheater, aqueducts, and the rest, only to be destroyed five hundred years later by Totila, King of the Ostrogoths. The city was then rebuilt by Charlemagne in the image of the New Rome, and this relationship was specifically defined in the dedications and locations of the main churches. "Just as the church of St. Peter's is on one side of the city of Rome, so it is in the city of Florence. And just as the church of St. Paul is on the other side of the city of Rome, so it is in the city of Florence. And just as the church of St. Lawrence the Martyr is on one side of the city of Rome and on the opposite side the church of St. Stephen, so it is in the city of Florence. And just as on one side of the city of Rome is the church of St. John Lateran, so is the main church of the city of Florence" (Fig. 9).[5] Davis observed that this parallelism with Early Christian Rome was brought into even clearer focus toward the middle of the fourteenth century by

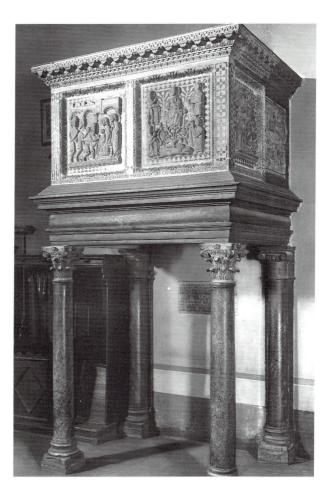

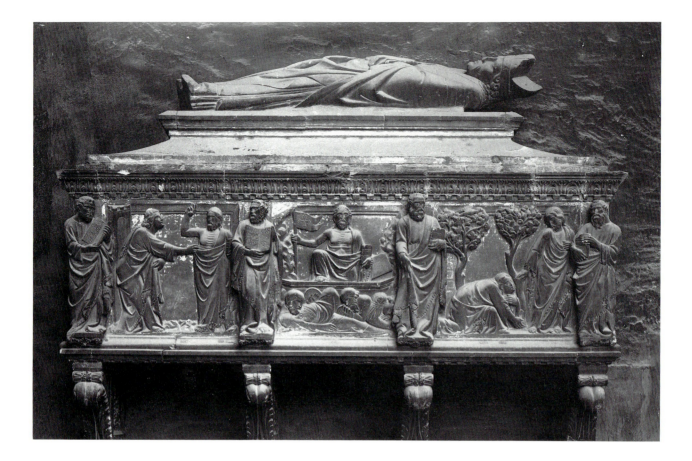

Fig. 6. Tino di Camaino, tomb of Gastone della Torre. Santa Croce, Florence (photo: Brogi 3142).

Fig. 7. Donatello, *Marys at the Tomb,* right pulpit. San Lorenzo, Florence (photo: Alinari 2216a).

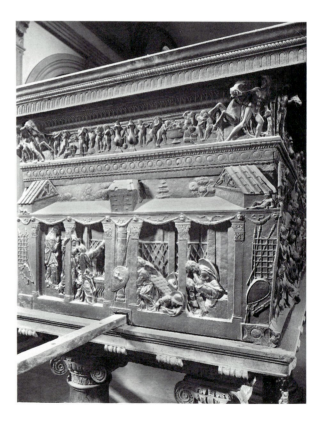

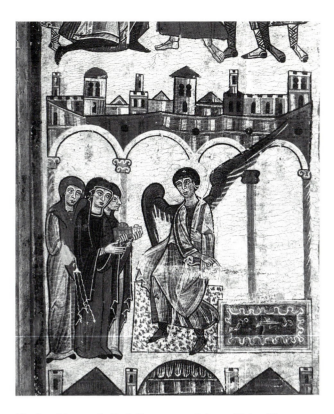

Fig. 8. *Marys at the Tomb*, Cross no. 15. Museo Civico, Pisa
(photo: Brogi 21350).

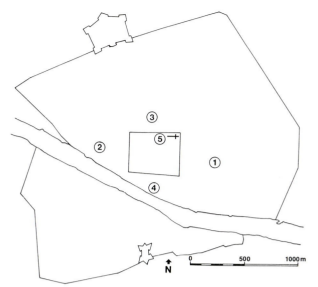

Fig. 9. Map of Florence showing, at center, the Roman walls
and locations of the churches: (1) San Pier Maggiore, (2) San
Paolo (now San Paolino), (3) San Lorenzo, (4) Santo Stefano,
(5) San Giovanni (after Braunfels, 1976, fig. 21 opp. p. 49;
redrawn by Susanne Philippson Ćurčić).

Giovanni Villani, whose *Historia nova* of Florence was
the historiographical herald of the Renaissance.
Villani gives an elaborate account of the layout of
the city as modeled on that of Rome, and once
again the churches are the chief points of reference,
including again the analogy between the two San
Lorenzos *fuori le mura*.[6] The theme recurs in Goro
Dati's *Istoria di Firenze* of about 1410,[7] and the strength
and persistence of the tradition may be gauged by a
passage in Del Migliore's mid-seventeenth-century
guide to Florence. The whole theme of Florentine
emulation of the succession of paganism by Chris-
tianity at Rome is focused on San Lorenzo. Accord-
ing to Del Migliore, "it would not be amiss to say
that the Florentines, as imitators of the actions of
the Romans, especially in matters of religious rites,
permitted the construction of San Lorenzo corre-
sponding to the church built by Constantine out-
side the walls of Rome; nor is the opinion vain of
those who give as a second motive its construction
on the ruins of one of those three-naved buildings
called basilicas."[8]

A second piece of the puzzle may be discerned in
two peculiar and complementary features of Brunel-
leschi's conception of the building. San Lorenzo is

"wested," that is, the high altar is at the west end of
the building rather than at the east, as is usual for
Christian churches. San Lorenzo shares this abnor-
mality above all with the prototypical basilicas of
Rome, including St. Peter's and San Lorenzo fuori
le mura itself in its original form, attributed to
Constantine the Great. Closely related to this direc-
tional peculiarity is an equally distinctive liturgical
orientation that Brunelleschi introduced in his plan
for San Lorenzo. It is well known that in designing
Santo Spirito, Brunelleschi had the radical notion of
separating the altars from the chapel walls so that
the officiating priest would face, rather than turn his
back to, the congregation.[9] This orientation *versus
populum*, a radical departure from custom, was an
early practice that had been retained in a variety of
contexts, notably in churches of the Ambrosian rite
in Milan—a precedent relevant to San Lorenzo, as
we shall see—and most conspicuously in Rome,[10]
in the Lateran and St. Peter's, where the pope offici-
ates, but in other churches as well, including San
Lorenzo fuori le mura. In all these cases the altar
was associated with a martyr's tomb (confessio)
visible below or immediately in front. The arrange-
ment was never put into effect at Santo Spirito, but

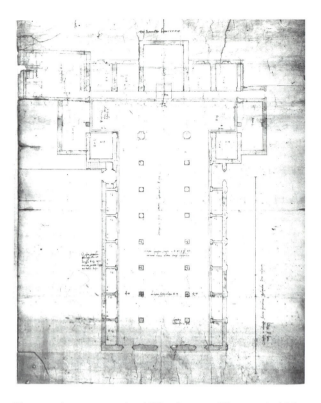

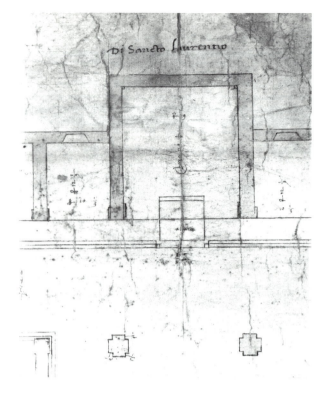

Fig. 10. Anonymous, plan of San Lorenzo, Florence. Archivio di Stato, Venice.

Fig. 11. Detail of Fig. 10.

we now know that at San Lorenzo it was. Some years ago Loredana Olivato and Howard Burns independently discovered a plan of San Lorenzo, dating from around 1500, that shows what must have been the original layout (Figs. 10, 11).[11] The high altar is at the edge of the raised presbytery on a platform reached from behind, so that the celebrant must have faced the congregation in the nave. This remained the orientation of San Lorenzo's high altar until it was reversed in the early seventeenth century.[12] The plan confirms, and helps partly to explain, one of the most novel features of Brunelleschi's rebuilding of the church. It had been the custom to install the choir in the crossing or nave before the high altar, especially in monastic churches where the liturgical devotions were the building's *raison d'être*. At Cosimo's behest, Brunelleschi shifted the choir to the apse behind the altar—precisely as in the Roman basilicas, where pilgrims were thus given unobstructed access to the tomb of the martyr.[13] In the Roman basilicas, such as San Lorenzo fuori le mura (see Fig. 4), the confessio might be flanked by stairs leading up from the nave to the presbytery. However, Burns's reconstruction of the arrangement at San Lorenzo with flanking transverse stairs before

the altar (Fig. 12) points insistently toward Old St. Peter's. There, in the sixth century, Pope Gregory I had given the Constantinian presbytery essentially the same disposition, including the high altar *versus populum* (Fig. 13).[14] It was Gregory's installation that occupied the chancel of St. Peter's in the Renaissance. The purpose of this particular design at St. Peter's is evident: the stairways framed the confessio and focused on the tomb of the apostles in the crypt below. The function was surely analogous at San Lorenzo, where Cosimo de' Medici was given the rare privilege of being buried immediately in front of the high altar. The three salient features of San Lorenzo—the choir in the apse, the high altar *versus populum*, and the tomb at the foot of the altar —were thus interdependent innovations, all of which, like the paired pulpits, reflected Early Christian usage.

Cosimo's tomb, which has also been the subject of some controversy, is the third piece in the puzzle. The burial is marked in the pavement before the high altar by a square geometric design of inlaid marble with red and green porphyry; at the sides bronze gratings, which recall the grille of the early confessio, transmit light to the tomb contained in

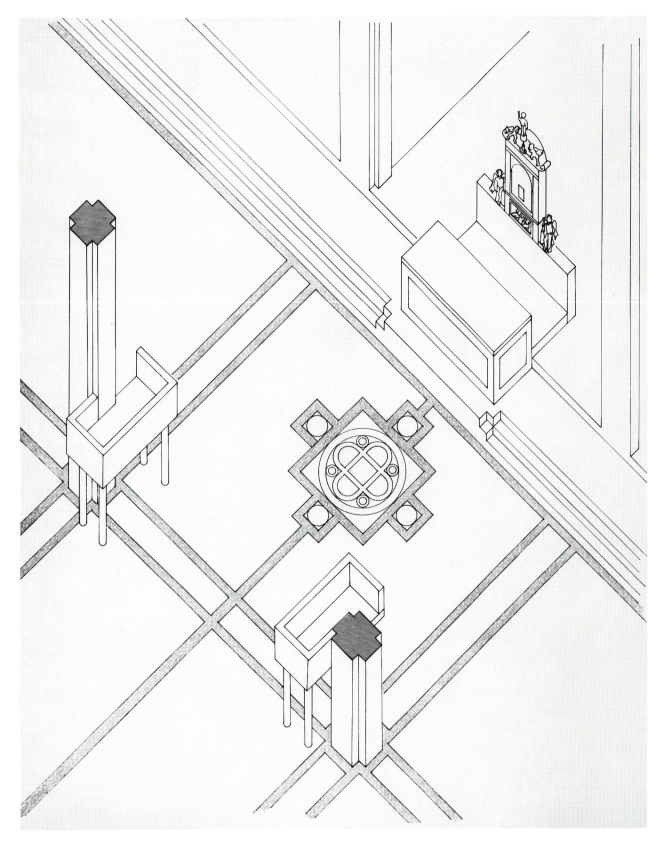

Fig. 12. Reconstruction of the crossing of San Lorenzo with
Donatello's pulpits, Verrocchio's tomb marker of Cosimo,
Desiderio's tabernacle, and the high altar arrangement shown
in Fig. 11 (drawing by Susanne Philippson Ćurčić).

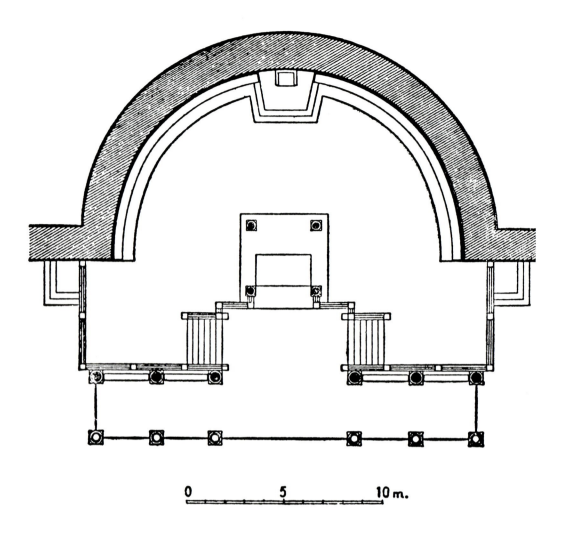

Fig. 13. Plan of medieval presbytery, Old St. Peter's, Rome (from Apollonj Ghetti *et al.*, 1951, fig. 136c).

the supporting pier in the crypt below (Figs. 14–15; Plate I). This curious arrangement was completed by Piero de' Medici in 1467 after his father's death in 1464. The basic explanation, often overlooked, was provided by Del Migliore, who referred to a conciliar proscription against burials in basilicas of the martyrs;[15] San Lorenzo, in fact, has the sobriquet Basilica Ambrosiana, owing to its venerable antiquity and its having been originally dedicated by St. Ambrose himself on a visit to Florence from his episcopal see in Milan. In a fine essay published in the *Rutgers Art Review* in 1981, Janis Clearfield showed that the boldly conceived burial in front of the high altar, as well as the pavement marker—modestly conceived in comparison with the elaborately sculptured monuments erected for other important and

wealthy men—conformed to Cosimo's own wishes as they were reported by Piero at the time of Cosimo's funeral.[16] The duality corresponds to the subtle balance of Cosimo's own character and to the nature of his hegemony in Florence, based not on military power, as with other rulers of Italian city states, but on financial and political acumen, which included careful deference to the republican traditions of the commune.[17]

Clearfield's argument supports an earlier theory of Howard Saalman's that Cosimo and Brunelleschi may have been led to install the choir in the apse to make room for the patron's tomb before the high altar, under the dome.[18] The resulting disposition was surely meant to echo the privileged but discrete burial of Cosimo's own parents in Brunelleschi's Old

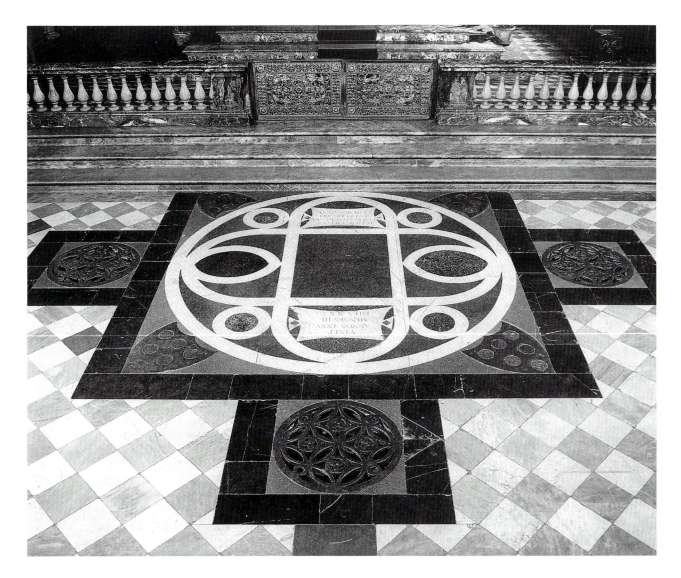

Fig. 14. Andrea del Verrocchio, tomb marker of Cosimo de'
Medici. San Lorenzo, Florence (photo: Silvestri, Florence).

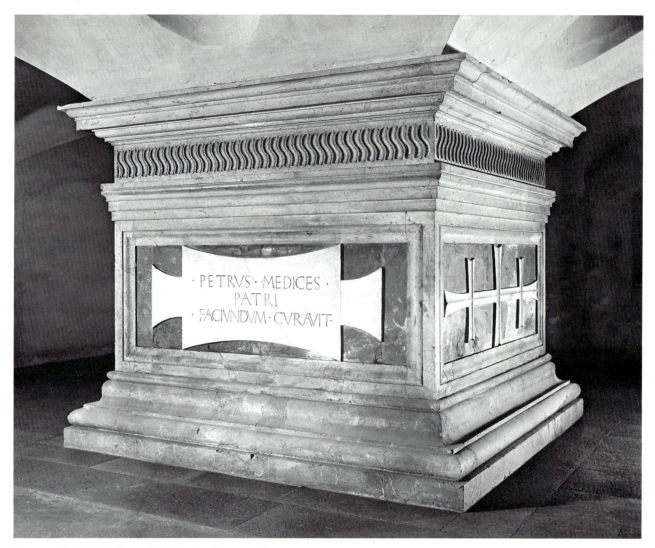

Fig. 15. Tomb of Cosimo de' Medici. San Lorenzo, Florence
(photo: Brogi 20408).

Sacristy at San Lorenzo (Figs. 16–17); the tomb, often attributed to Donatello, is also placed in front of the altar and directly under the cupola.[19] The inlaid marble design of Cosimo's slab—the first documented work executed by Verrocchio—has no parallel as a tomb marker, but the location in front of the high altar of a major basilica has one obvious precedent: the bronze relief effigy of Pope Martin V, another work often attributed to Donatello, situated before the high altar in San Giovanni in Laterano. It was this project, according to Vasari, that occasioned Donatello's trip to Rome in the 1430s, and hence he would already have participated in a modern re-enactment of the early Christian practice of burial near the grave of a martyr.[20] The situation at the Lateran also anticipated the innovative arrange-

ment at San Lorenzo in that the earlier canon's choir in the nave had been removed by Martin V, making way for his own tomb, "as he himself ordered while alive."[21] Reference to the Lateran, the cathedral of Rome, would have been appropriate at San Lorenzo, which had been the original cathedral of Florence.[22]

Another piece of the puzzle was supplied by James Beck in an article dealing in part with the Sacrament tabernacle by Desiderio da Settignano, now in the north aisle but formerly in the Medici chapel of Saints Cosmas and Damian in the south transept of San Lorenzo (Fig. 18).[23] Parronchi had suspected that the tabernacle was not intended for the Medici chapel, and he noted that the wings of the two standing angels have been clipped, indicating that they were once wholly in the round.[24] Beck

Fig. 16 (*left*). Filippo Brunelleschi, Old Sacristy. San Lorenzo, Florence (photo: Alinari 44361).

Fig. 17 (*above*). Tomb of Giovanni and Piccarda de' Medici, Old Sacristy. San Lorenzo, Florence (photo: Brogi 8664).

Fig. 18. Desiderio da Settignano (presumably following a design by Donatello), Sacrament tabernacle. San Lorenzo, Florence (photo: Soprintendenza per i Beni Artistici e Storici, Florence 119478).

looked again at the original records concerning the tabernacle and the new high altar at San Lorenzo. The notices had long since been published separately, but Beck put them back together and realized that they succeeded each other in a single document, referring to successive steps in a single enterprise.

In July 1461 the altar was built, on August 1 the Sacrament tabernacle was completely installed, and on August 9 the altar was consecrated.[25] The tabernacle and the high altar must have been conceived and executed together. The decision to install the choir in the apse, rather than the crossing, thus also made it possible to relate the Sacrament directly to the high altar and to the congregation as a whole — an early instance on a monumental scale in Italy of the disposition that became a hallmark of Counter-Reformation church architecture in the sixteenth century. The tabernacle may have been placed directly on the altar, as Beck imagined, although it would have been awkward for a celebrant to say the Mass facing the congregation; indeed, this may explain why it was moved to the side chapel only a few decades later.[26] It is much more likely that the tabernacle was placed behind the altar, allowing space for the celebrant between. Indeed, a disposition of this kind seems indicated by a series of drawings that incorporate tabernacles inspired by Desiderio in freestanding altars (Fig. 19), and by a particular detail of the altar installation shown in the early plan of San Lorenzo: the narrow rectangle behind the raised platform for the officiating priest, which must represent the parapet that supported the tabernacle (cf. Figs. 11, 12).[27] The situation must have been precisely the same at Old St. Peter's, where the Stefaneschi triptych attributed to Giotto is reported to have stood on (super) the high altar, which was also oriented versus populum. Comparable arrangements involving monumental altarpieces placed behind the altar were created elsewhere around the middle of the fourteenth century, doubtless also following the example of St. Peter's: the Pala d'Oro in San Marco at Venice, and the reliquary altar tabernacle of the Holy Corporal in the cathedral of Orvieto. Each was a particularly precious and important work, devoted, like both the St. Peter's altarpiece and the San Lorenzo Sacrament tabernacle, to Christ and hence charged with eucharistic content.[28]

The last piece in the puzzle is the coincidence of two facts concerning Donatello himself with the dedication of the altar and tabernacle in the summer of 1461. Having returned from Padua in 1454, Donatello left Florence for Siena in October 1457. He petitioned the Balìa to let him live and die there in order to embellish the cathedral, and he is subsequently recorded as working on a set of bronze doors. He remained in Siena until March 1461, when at the urging of a compatriot, he abruptly abandoned the project and went back to Florence. This volte face is puzzling — one of the most intriguing mysteries of his entire career, according to Janson[29] — unless one assumes that Donatello was enticed home by some urgent task. The task is unlikely to have been the San Lorenzo pulpits alone: they were not essential to the liturgy; they were unfinished when Donatello died five years later; and a century passed before they were installed.

I would relate Donatello's return to Florence to a long-neglected passage in Vasari's Ragionamenti, in which he attributes to Donatello "the model of the high altar and the tomb of Cosimo at its foot."[30] The completion of the high altar was essential, and the whole episode would make perfect sense if Donatello went home to supervise the installation, participate in the dedication, and oversee the remaining work on a project he had designed for his friend and patron.[31] Luisa Becherucci took a first bold step in the right direction by reviving an eighteenth-century attribution of the design of Cosimo's tomb to Donatello.[32] I would further suggest that the high altar which formed part of Donatello's model may also have included the tabernacle executed by Desiderio and installed at the same time, six months after Donatello's return to the city. Here too, it is possible that one of the early writers knew the truth, for Del Migliore in the mid-seventeenth century already ascribed parts of the work to Donatello.[33] Besides explaining the importance and urgency of Donatello's return, the hypothesis gives special meaning to the many similarities that have been noted between the tabernacle and works by Donatello, especially the Padua altar. Most important, the extraordinary addition to the high altar of the tabernacle containing the Sacrament is consonant with the extraordinary omission of the Last Supper from the passion cycle of the pulpits, indicating that this event was conceived as taking place at the altar itself.[34]

This mutual, inner reciprocity between the pulpits and the altar completes our picture of what

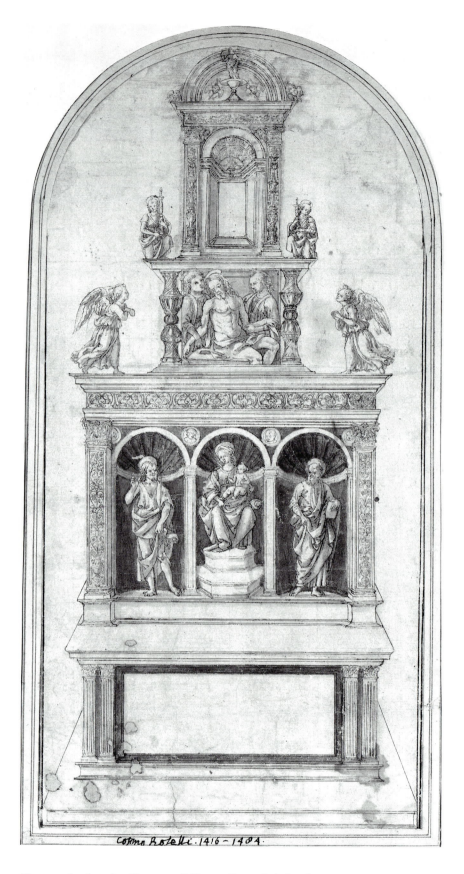

Cosimo Rotelli . 1416 – 1404 .

Fig. 19. Attributed to Francesco di Simone Ferrucci, design for
a freestanding altar with Sacrament tabernacle, drawing. Victoria
and Albert Museum, London.

Fig. 20. View of dome. San Lorenzo, Florence (photo: Silvestri, Florence).

might best be called the Early Christian Renaissance at San Lorenzo. The picture shows the whole — of which Charles Seymour, Luisa Becherucci, James Beck and others (including myself) have glimpsed parts — a coherent and unified conception that included the choir, the high altar, the tomb of Cosimo, and the pair of bronze pulpits.[35] The arrangement would have been a powerful evocation of the early basilicas of Rome, St. Peter's itself, and San Lorenzo's own symbolic prototype outside the walls, where all the same features occur. The picture has another dimension, as well. One must add to it the dome over the crossing (Fig. 20), with the pulpits placed at the corners, Donatello's four gigantic stucco sculptures of the evangelists, now lost, that stood in niches at the transept ends (Fig. 21), and the coffered ceilings.[36] The emphasis on plastic decoration and the powerfully centralized focus would have been downright Pantheon-like. The conception would also have reflected, especially in view of the

plan at Santo Spirito to orient all the altars *versus populum,* the centralizing tendency often observed in the development of Brunelleschi and of Renaissance architecture generally.

The implications of this point at San Lorenzo begin to emerge when one considers that the circular design of the tomb slab mirrors the dome above. I noted earlier the analogy with the unusual disposition of the tomb of Cosimo's parents in the Old Sacristy (Figs. 16–17). The installation there is also noteworthy in that the sarcophagus is placed under the sacristy table, which is not made of wood, as usual, but of marble; the table thus acts as a monumental tomb slab, inlaid with a porphyry disk in the center. Covered with priestly vestments and liturgical utensils used in the Mass, the table provided a sacramental blanket for those buried beneath. The porphyry disk, whose diameter precisely equals that of the lantern opening in the dome above, is a conspicuous emblem of universal dominion; it may also

Fig. 21. View of north transept. San Lorenzo, Florence (photo: Brogi 26240).

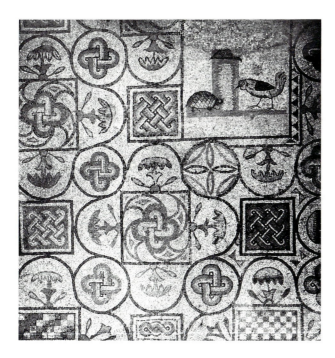

Fig. 22. Mosaic pavement, detail. South Basilica, Aquileia (photo: Istituto Centrale per il Catalogo e la Documentazione, Rome C10251).

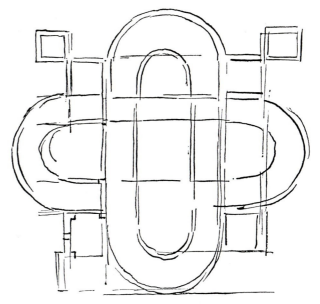

Fig. 23. Leonardo, ground plan of a centralized church, drawing. MS B, fol. 57v, Bibliothèque de l'Institut de France, Paris (from Richter, 1939, II, 39).

have carried sacramental, indeed liturgical, meaning, as was the case with a similar disk that had a ceremonial function in the pavement of St. Peter's at Rome.[37]

I also noted that Cosimo's slab of marble has no precedent as a tomb marker, but it is imbued with pointed references to antiquity. The austere simplicity of the design; the use of inlay rather than the usual medieval techniques of incrustation, inscribed marble or mosaic;[38] and the use of porphyry, a prerogative of the emperor in ancient times — all evoke the mystique of imperial Rome and intimate Cosimo's sense of his own and his family's destiny. Similarly, I have not found an exact parallel for the design, whose centrality is reinforced by the inscriptions that face each other. Various elements are suggestive. The innermost pattern, which might be described as a right-angled intersection of two rectangles with rounded ends, seems like a flattened version of Solomon's knot, a common motif in Early Christian mosaic pavements, where it often serves as a sign of the Cross.[39] A similar scheme with circles in the corners, including Solomon's knots as filler motifs, occurs in the early fourth-century south basilica at Aquileia (Fig. 22).[40] Equally striking is the analogy

with certain projects for centralized churches designed later in the century by Leonardo (Fig. 23), who was Verrocchio's pupil and certainly well aware of Cosimo's tomb and its meaning.[41] The comparison indicates that Leonardo both recalled Cosimo's tomb marker and evidently associated it with one of the noblest Early Christian churches in Italy, San Lorenzo in Milan (Fig. 24), whose layout the sketch plans clearly resemble.[42] Quite possibly, Cosimo's tomb itself alludes to the famous Milanese shrine; the invocation would have been doubly appropriate, apart from the dedication to St. Lawrence, since the church was also closely associated with Ambrose, whose special devotion to the martyr was well known.[43] The basic configuration of a circle containing a cruciform design of intersecting curves recalls a particular class of medieval geometric diagrams whose significance is relevant here (Fig. 25). The diagrams, based on the Christian cosmology of Isidore of Seville, relate the human microcosm to the macrocosm of the universe through tetradic divisions of Man, Time, and the World.[44] A complementary sense is conveyed by diagrams remarkably like that on Cosimo's tomb marker illustrating in geometrical form the numerical relationships

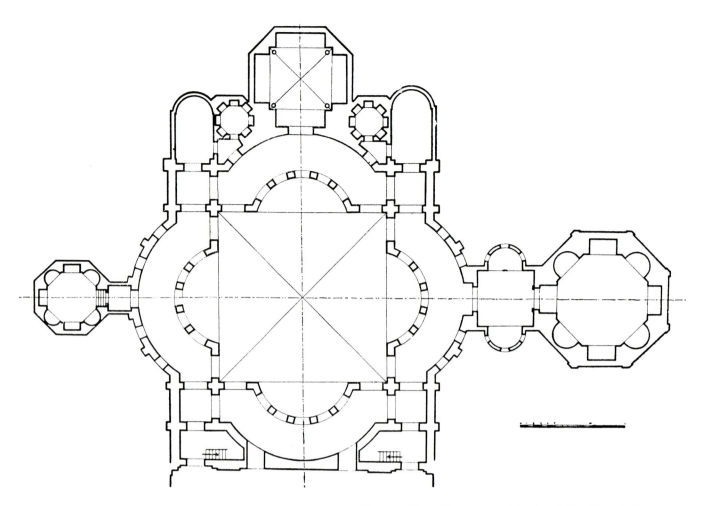

Fig. 24. Plan of San Lorenzo Maggiore, Milan (from Calderini *et al.*, 1951, fig. 2).

defined in Boethius's *De institutione arithmetica* (Fig. 26).[45] Through this work and his treatise on music Boethius was a key figure in the development of Platonic theories of proportion, the music of the spheres, and mathematical cosmology. Musical harmonies have actually been discerned in the proportions of the marker's geometric scheme.[46] In this way, the marker seems to fulfill Alberti's requirements in the *De re aedificatoria:* that in churches there be nothing on the wall and pavement that is not informed by philosophy alone and that the pavement refer to musical and geometrical subjects, so we may be incited from every direction to the cult of the spirit.[47]

Eloquent testimony to the meaning such a diagram might embody in a tomb occurs in a pavement laid by King Henry III in the thirteenth century at the entrance to the choir and before the high altar of Westminster Abbey in London (Fig. 27).[48] Here

a geometric design of intersecting circles is actually accompanied by surrounding inscriptions that explain it as a portrayal of the *primum mobile* through the convergence of the archetypal sphere and the globe of the macrocosm. There is good reason to suppose that the mosaic was made to cover the tomb of Henry, who had himself buried in the sepulcher of his venerated predecessor, St. Edward the Confessor, having earlier moved the saint's body to its present location behind the high altar. The pavement was made in the manner of the Italian Cosmati floors by an artist who actually came from Rome, where the design is fairly common—occurring, for example, in the choir and nave of San Lorenzo fuori le mura.[49] Although not a tomb marker, a striking precedent is offered by the pavement of the chapel in the Vatican Palace decorated toward the middle of the fifteenth century by Fra Angelico—whose frescos included "remodeled"

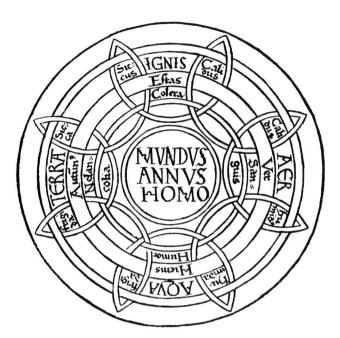

Fig. 25. Isidore of Seville, microcosm-macrocosm (from Heninger, 1977, fig. 66).

Fig. 26. Boethius, diagram illustrating the nature of odd and even numbers. MS H. J. IV. 12, fol. 28r, Staatsliche Bibliothek, Bamberg.

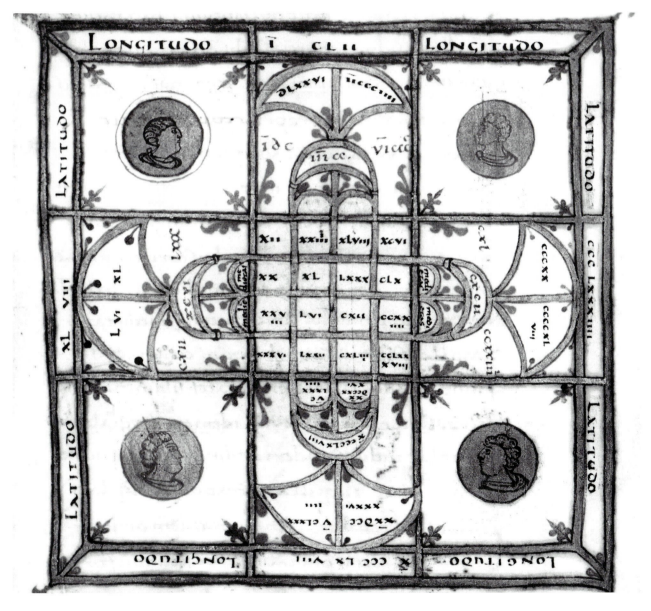

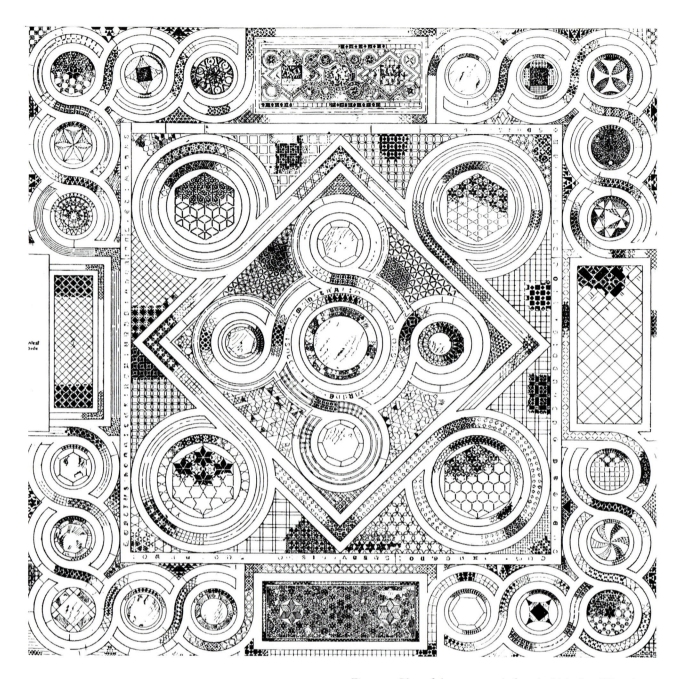

Fig. 27. Plan of the pavement before the high altar. Westminster Abbey, London (from *Royal*, 1924, 26).

views of Old St. Peter's—for Cosimo de' Medici's good friend Pope Nicholas V (Fig. 28).[50] The pope's name is inscribed in the four corner medallions, and a large emblem of the sun, its rays alternating with the initial letters of the months, appears in the center. A tomb marker with associations of this kind would be consonant with Cosimo's well-known philosophical and astrological interests, especially considering the resonant and frequently invoked cosmic pun on his name, Cosimo = cosmos.[51] The depth of these interests is evident from the astro-

logical fresco Cosimo commissioned for the cupola over the altar niche of the Old Sacristy at San Lorenzo (Fig. 29). The arrangement of the constellations corresponds to July 4–5, 1442, only a month before Cosimo and the canons of the church formally agreed that he would underwrite the construction of the choir and crossing, including the high altar, in exchange for the exclusive right to be buried and display his arms there. The precise significance of the date, if any, is not clear, but extremely significant in our context is the recent hypothesis

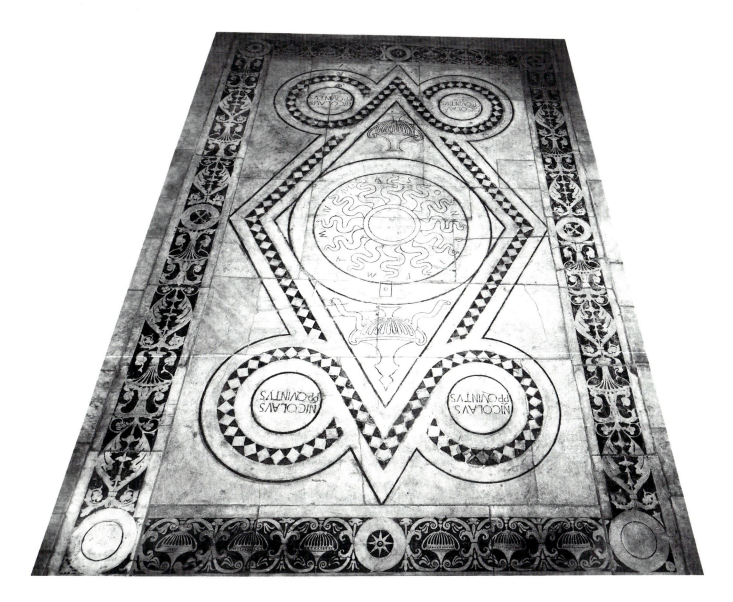

Fig. 28. Pavement of the Chapel of Nicholas V. Vatican Palace, Rome (photo: Musei Vaticani V-1-22).

that the constellations also conform to the auspicious horoscope cast at the re-foundation of Florence in 802. Cosimo identifies himself and his family with the Christian fortune of the city ordained in the heavens from the outset.[52]

The sources give no hint of what Cosimo and Brunelleschi might have planned for the dome of San Lorenzo, except that Cosimo complained that what had been built after Brunelleschi's death was too heavy and dark. Doubtless the original project would have anticipated Brunelleschi's great innova-

tion at Santo Spirito, a drum with windows above to provide truly celestial illumination (Fig. 30).[53] The full scope and import of the enterprise become apparent from the fact that the circle-in-square scheme of the marker mirrors that of the crossing with the dome inscribed directly above, and from Brunelleschi's use of the crossing square as the modular unit from which he derived the elevation of the crossing itself and the plan of the entire building.[54] Cosimo's burial in the center of the crossing thus linked him, through the tomb marker,

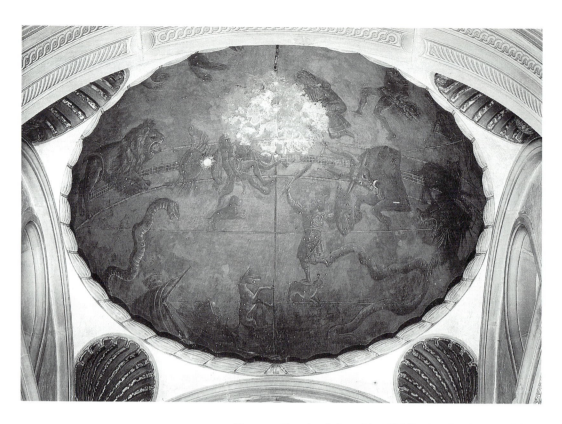

Fig. 29. Cupola of altar niche, Old Sacristy. San Lorenzo, Florence (photo: Silvestri, Florence).

to the widest reaches of the Christian cosmos.

Cosimo's interest in philosophy began in the period when he assumed responsibility for San Lorenzo and became a veritable passion toward the end of his life. The Council of Florence, which Cosimo fervently supported, in 1439 formally proclaimed the reunification of the Eastern and Western churches—a conscious effort to retrieve the ideal, premedieval unity of Christianity. Marsilio Ficino reported that Cosimo met the Greek philosopher Gemistos Plethon during the council and was inspired to establish a Platonic "academy" at his villa at Careggi, with the goal of reconciling Platonic philosophy with Christianity.[55] That Cosimo's tomb marker may itself refer to this Neoplatonic-academic ideal is suggested, retrospectively at least, by the emblem Leonardo devised for his own idea of an academy: he inscribed the name "Academia Leonardi Vinci" on a number of complex interlacing geometric designs in which one may detect traces of the microcosm-macrocosm tradition (Fig. 31).[56] Leonardo's designs also pun on the resemblance between his own name and the Latin *vincire*, "to bind, fetter, tie." The pun combines two of the salient concepts associated with Platonic and Neoplatonic thought,

reason and eros. The former, the principle of order in the universe, was expressed by the motto reputedly inscribed over the entrance to Plato's Academy in Athens, "Let no one enter who is not a geometer";[57] the latter, the principle of union in the universe, was expressed by Marsilio Ficino as the perpetual knot (*nodus perpetuus*), the world embrace (*copula mundi*), by which all things are bound (*vincuntur*) together.[58] Although the purpose of Leonardo's designs is unknown, they have been related to the pavement decorations in some of his studies of churches with a central plan (Fig. 32).[59] On one occasion he used such a pattern, transformed into an arboreal trellis, to decorate a vault, the Sala delle Asse in the Sforza palace in Milan, where it served to express the union of conjugal love.[60]

The underlying meaning of the whole complex at San Lorenzo is perhaps best conveyed in Ficino's letter to Lorenzo the Magnificent, Cosimo's grandson, referring to Cosimo's death. Ficino reports that Cosimo died shortly after they had read together Plato's dialogues "On the One Principle of Things" and "On the Highest Good."[61] These were the titles Ficino gave to the *Parmenides* and the *Philebus*, which he had translated at Cosimo's behest. The two men's

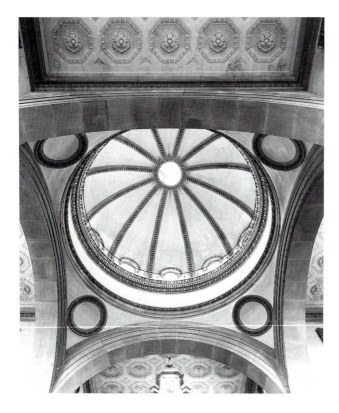

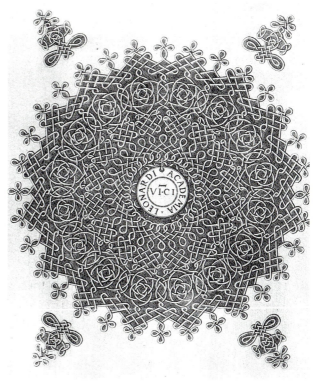

Fig. 30. View of the dome. Santo Spirito, Florence (photo: Alinari 62653).

Fig. 31. "Academia Leonardi Vinci," engraving. British Museum, London.

understanding of these works must have been influenced by the critical discussion in the *Republic*, Books VI–VII, of the idea of the good and the world soul, the universal principle of harmony, expressed in the theory of numbers, geometry, and astronomy; at one point Plato even remarks that "we must use the blazonry of the heavens as patterns to aid in the study of those realities, just as one would do who chanced upon diagrams drawn with special care and elaboration by Daedalus or some other craftsman or painter."[62] Ficino's very next, closing, sentence urges Lorenzo to model himself on the idea of Cosimo, "just as God formed Cosimo on the idea of the world."

The pulpits may have expressed the idea of harmony literally, since we know that they might be used for singing.[63] The singers' tribunes, or cantorie, of Donatello and Luca della Robbia had similarly formed a pair in the crossing of Florence cathedral, above the sacristy doors flanking the choir.[64] At San Lorenzo, however, it is well to recall the traditional link to St. Ambrose, mentioned earlier. In the *Confessions,* St. Augustine attributes to Ambrose the introduction into the service of responsorial singing, which became the model—the Ambrosian chant—

for the subsequent development of antiphonal music in the liturgy.[65] Could it be that the pulpits were intended from the beginning both for the reading of the lessons and for giving voice, as it were, to the venerable Ambrosian antiphons?

It is clear that Cosimo, Brunelleschi, and Donatello developed a collective vision of the crossing of San Lorenzo that was remarkably retrospective. While it entailed a sophisticated knowledge and choice of sources, it was not purely antiquarian. Rather, it facilitated a radically new and self-consciously holistic view of the building, its furnishings, and its functions. Cosimo was interred in a setting that related him to a rediscovered heritage and an auspicious future in the Christian universe.

The new vision was also remarkably prophetic, however. The porphyry in the memorials of Cosimo and his parents established a tradition for Medici funerary art at San Lorenzo that continued a decade later in Verrocchio's second tomb, for Cosimo's sons Piero and Giovanni, in which Piero's sons Lorenzo the Magnificent and Giuliano were later also interred. After the white marble hiatus of Michelangelo's Medici chapel the tradition culminated in the 1560's with Vasari's grandiose *riposte* to Michelangelo, the

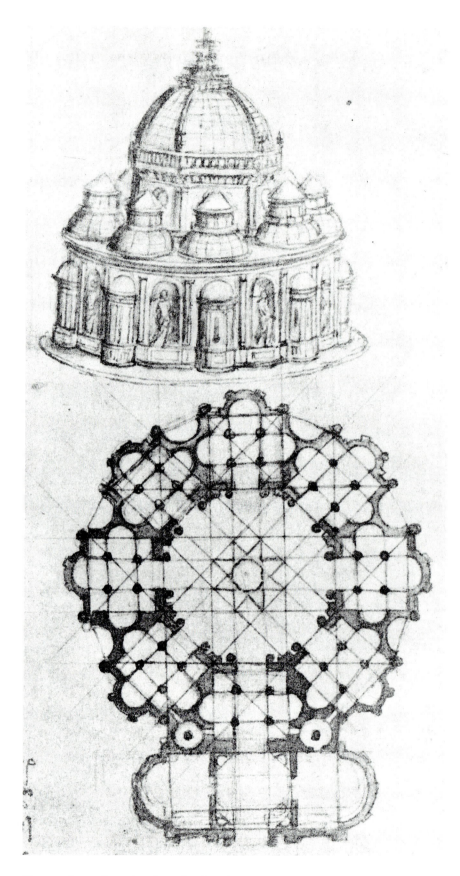

Fig. 32. Leonardo, project for a church with a central plan, drawing, detail. MS Ashburnham I, fol. 5v, Bibliothèque de l'Institut de France, Paris.

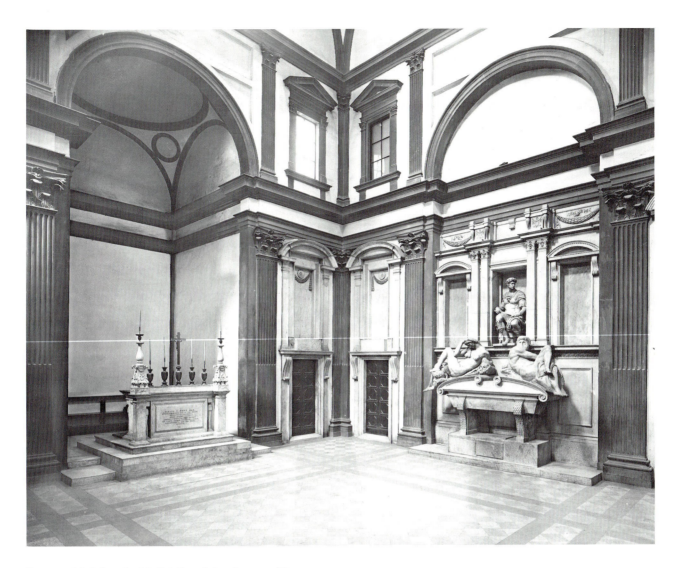

Fig. 33. Michelangelo, Medici Chapel. San Lorenzo, Florence
(photo: Alinari 2235).

Cappella de' Principi memorial for Grand Duke Cosimo I and his family, completely encrusted with colored stones.[66] The imperial associations of such lavish polychromy reflected a tendency in the political ambitions of the family that became explicit in the 1530's with the establishment of dynastic rule over Florence under Cosimo I, who invoked the memory of his revered ancestor in more than name only. Paired pulpits had a notable history well into the next century, including projects by Michelangelo, perhaps, as well as Baccio Bandinelli and Benvenuto Cellini for the Florence cathedral.[67] Christoph Frommel has defined Cosimo's burial near the high altar as inaugurating a tradition in Italy that culminated in Michelangelo's project for the tomb of Julius II at St. Peter's; the analogy would be espe-

cially close if Julius also intended to be buried under the main cupola.[68] Howard Burns observed that the disposition of the stairs and the orientation of the high altar *versus populum* were echoed in Michelangelo's design of the altar precinct of the Medici chapel in the New Sacristy of San Lorenzo (Fig. 33).[69] (Indeed, in the wake of Vatican II all church altars have been given this orientation.) Placing the choir in the apse to provide an unobstructed view of the high altar became the norm in the sixteenth century, as did the custom of placing the Sacrament on the high altar.[70] Essentially the same spirit prevailed in the 1520's with a project by Michelangelo that would have replaced the Sacrament tabernacle by a reliquary ciborium with four columns over the high altar, retaining the orienta-

tion *versus populum* and recalling the fourteenth-century arrangement at San Giovanni in Laterano in Rome (Fig. 34).[71] The whole system, complete with paired ambos, confessio, flanking lateral stairs and altar *ad populum*, was revived again with quasi-archaeological exactitude at the end of the sixteenth century in the "restorations" of the early Roman basilicas San Cesareo and Santi Nereo e Achilleo (Fig. 35), sponsored by the great Counter-Reformation historian Cardinal Baronio.[72]

Above all, however, the vision was prophetic in its very unity and in its innovative recollection of a long, increasingly self-conscious, tradition of Florentine historicism — the tradition that defined the city's religious, political, and cultural nature through what can only be described as a mystical transfer of identity from the past to the present.

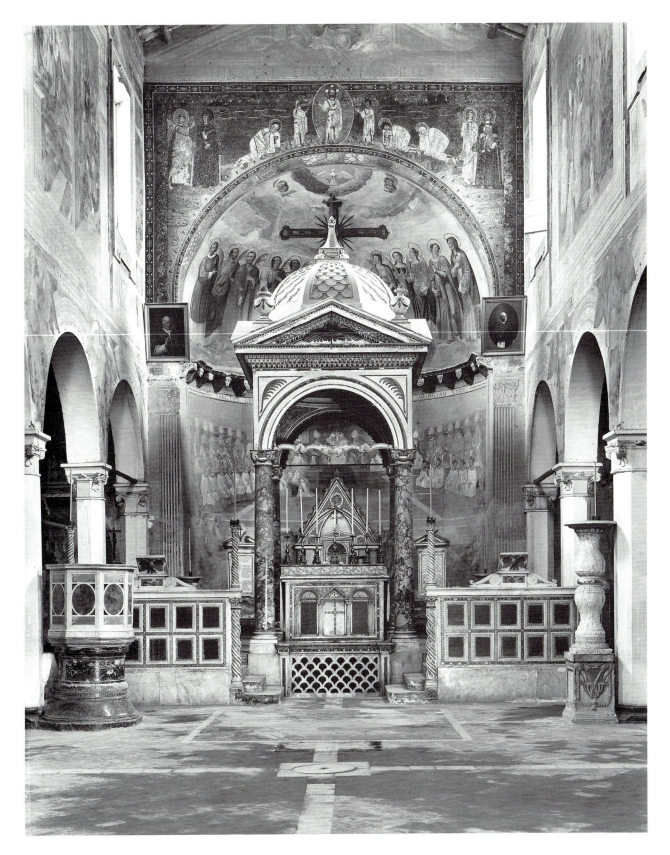

Fig. 34 (*opposite*). Michelangelo, project for the high altar of San Lorenzo, drawing. Casa Buonarroti, Florence (photo: Soprintendenza per i Beni Artistici e Storici, Florence 117145).

Fig. 35. View in the nave. Santi Nereo e Achilleo, Rome (photo: Anderson 5202).

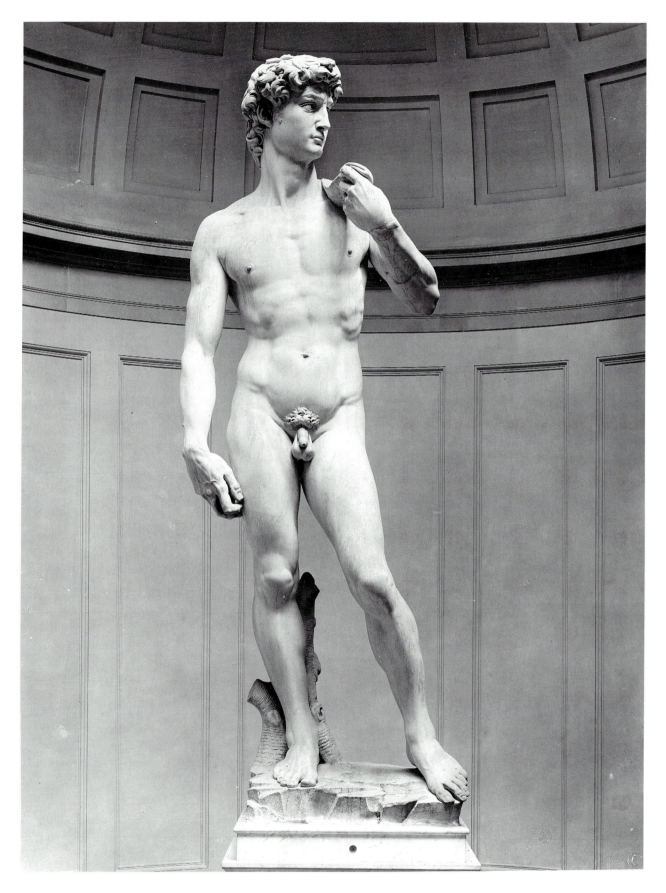

Fig. 36. Michelangelo, *David.* Accademia, Florence (photo: Alinari 1689).

CHAPTER TWO • DAVID'S SLING AND

MICHELANGELO'S BOW:

A Sign of Freedom

Michelangelo's *David* has attained a unique status as a symbol of the defiant spirit of human freedom and independence in the face of extreme adversity (Fig. 36). This emblematic preeminence of the *David* is due largely to Michelangelo's having incorporated in a single revolutionary image two quintessential constituents of the idea of liberty, one creative, and therefore personal, the other political, and therefore communal. We can grasp this dual significance of the *David* because Michelangelo virtually identifies it himself in a famous but still inadequately understood drawing preserved in the Louvre (Fig. 37; Plate II). To my knowledge, the drawing is the first instance in which an artist articulates in words on a preliminary study the sense of the work he is preparing. My purpose is to define and explore the two, complementary aspects of the *David*'s meaning by offering some observations and suggestions concerning the Louvre sheet and its implications.

There is nothing new in suggesting either that the *David* had personal meaning for its creator—Vasari records that Michelangelo returned from Rome to Florence expressly to compete for the commission—or that the work had a political motivation in contemporary Florence: according to

Vasari, the overseers (*operai*) of the cathedral and Piero Soderini, the city's anti-Medicean governor (*gonfaloniere della giustizia*) elected by the parliament (*signoria*), awarded the commission to Michelangelo, who executed it as an "insegna del Palazzo [della Signoria]."[1] The use of a term like *insegna*, meaning "sign" or "advertisement," to describe a work of art as a *genius loci* in this topo-political sense is unprecedented as far as I know. The vast literature on Michelangelo is filled with ideas on the *David*'s private and public personas.[2] I think it possible to establish some of these ideas more firmly and define them more precisely than heretofore and, above all, to perceive in a new way the relationship between the two realms of meaning. I shall discuss the personal and political implications separately, partly because Michelangelo himself made the same distinction. In the final analysis, however, the fundamental unity of the *David* as a work of art lies in the relationship between them.

The sheet in the Louvre, which dates from around 1501–2, includes two figural elements, a sketch for the lost bronze *David* that was sent to France and the right arm of the marble *David*—shown upside down with respect to the figure

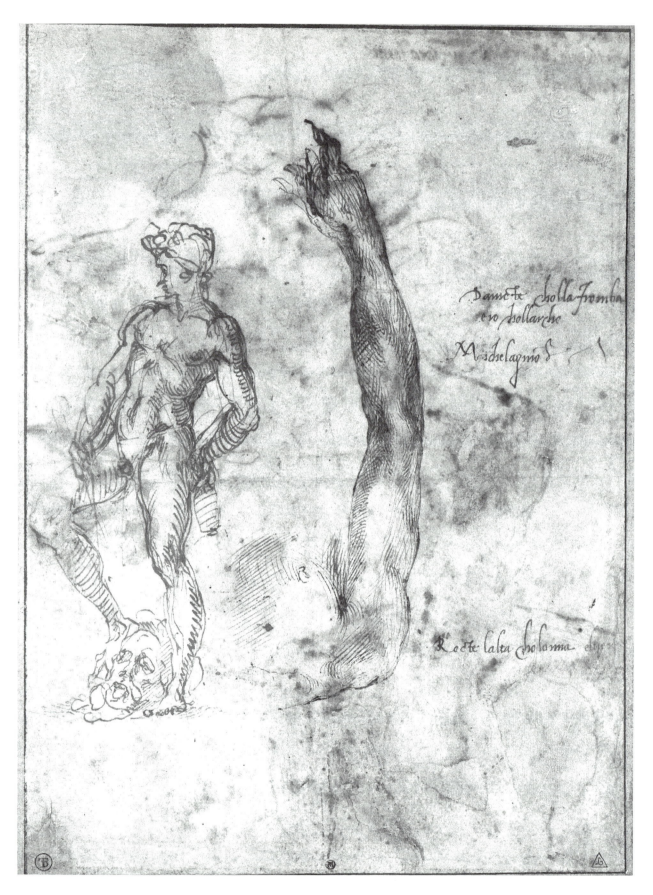

Fig. 37. Michelangelo, studies for the bronze and marble
Davids. Louvre, Paris (photo: Documentation photographique
de la Réunion des musées nationaux 714 R).

Fig. 38. Sculptor's drill (from Seymour, 1974, fig. 4).

study.[3] Two inscriptions appear at the right of David's arm, toward the margin (the page has not been cut at the right):

Davicte cholla Fromba
e io chollarcho
Michelagniolo

and below:

Rocte lalta cholonna elverd

(David with the sling and I with the bow. Michelangelo. Broken the tall column and the green.) The basic sense of the upper inscription seems clear enough. Michelangelo identifies himself with David, equating the instruments with which he and the biblical giant killer dispatch their common adversary. The second inscription has a parallel binary construction. The phrase is a quotation, omitting the last word, from the opening line of a sonnet of Petrarch, "Rotta è l'alta colonna e 'l verde lauro," in which the poet laments the almost simultaneous deaths in the spring of 1348 of his friend Giovanni Colonna and his beloved Laura.[4] Although apparently unrelated, the inscriptions in fact have several layers of meaning that connect them to the figural drawings on the sheet.

Many explanations of Michelangelo's *arco* had been given through the centuries until an ingenious interpretation, first suggested by Marcel Brion in 1940 and then elaborated by Charles Seymour, seemed to resolve the problem.[5] The *arco* must be the bowed drill, called a *trapano*, used by sculptors since antiquity to facilitate the carving of marble (Fig. 38). In that case, the *alta colonna* of the second inscription could refer to the great pillar (or column) of marble, originally intended for a *gigante* to be mounted on a buttress of Florence cathedral, that had defeated sculptors for at least a century before Michelangelo succeeded in carving it into his marble *David*.[6] In turn, the traditional association of the column, either whole or broken, with the virtue of fortitude would reinforce the power of the imagery. The whole column appears as a commemorative trophy in a major Byzantine tradition of David as psalmist, and the broken column appears in the closely related subjects of Hercules and Samson

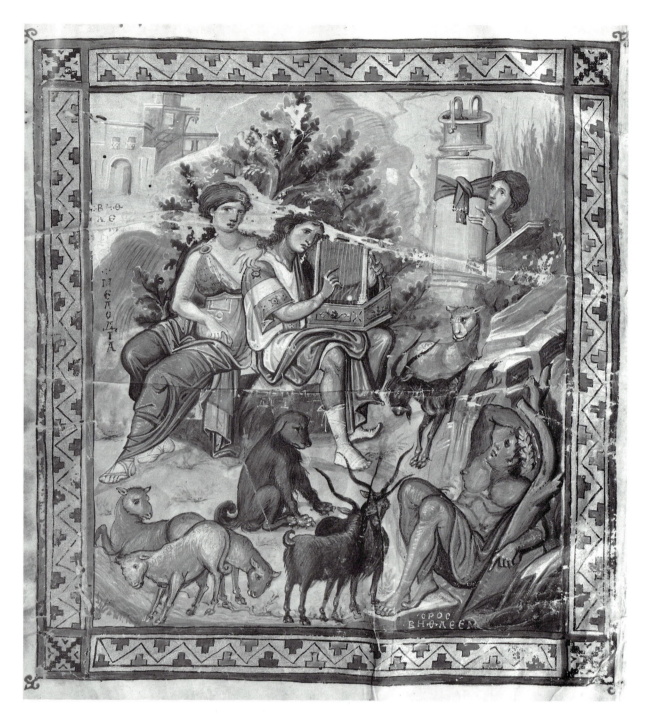

Fig. 39. *David the Psalmist.* MS Gr. 139, fol. 1, Bibliothèque Nationale, Paris.

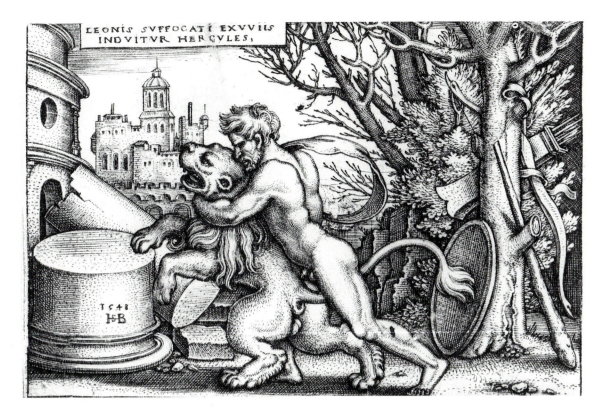

LEONIS SVFFOCATI EXVVIIS
INDVITVR HERCVLES,

Fig. 40. Hans Sebald Beham, *Hercules Killing the Nemean Lion*, engraving.

slaying the lion (Figs. 39, 40).[7] The elements of the Louvre sheet thus interrelate on a strictly mechanical level: David the giant killer is a metaphor for Michelangelo's feat in executing the colossal sculpture.

This "professional" implication of the sheet can be taken several steps further if one modifies slightly and expands the meaning of the term *arco* in the first inscription. There is, to begin with, another kind of *arco* that is essential to the work of the sculptor, whether in modeling, as for bronze, or in carving marble. I refer to the bowed caliper, or compass—the *seste ad arco* (Fig. 41)—used in enlarging from a small-scale model or transferring dimensions from the full-scale model to the final work in stone. In fact, the bowed compass, for use on three-dimensional, rather than flat, surfaces, is the sculptor's primary instrument of measure and proportion.[8] And, enshrined in his metaphorical dictum concerning the importance of artistic good judgment —*avere le seste negli occhi*, "to have one's compasses in one's eyes"—the device played a critical role in Michelangelo's conception of the creative process itself.[9]

We know that to execute such a grandiose work as the marble *David* from a small model—labor in which the artist's accurate use of the compass corresponded to David's use of the sling—was considered a feat of both intellectual and physical prowess.[10] The original commission had been assigned in 1464 to Agostino di Duccio, who was to construct the work from four separately carved pieces of marble. Two years later, the contract was renewed, Agostino in the meantime having undertaken to execute the sculpture from a single monolith, and at a substantially higher fee. The agreement specifically linked the increased compensation not only to the greater cost and expense (*spendio et expensa*) and value and price (*valute et pretii*), but also to the greater mastery (*magisterii*) the new project entailed. The gigantic block thereafter remained as Agostino left it, badly begun—*male abozatum*, in the phrase used nearly forty years later in the contract signed by Michelangelo, who finally succeeded where Agostino had failed. The analogy with David is thus twofold: both heroes overcame great differences in size and strength by sheer force of intellectual and physical virtuosity.

When *arco* is thus understood as a tool of both manual and mental labor, two further, metaphorical, uses of the word with which Michelangelo was cer-

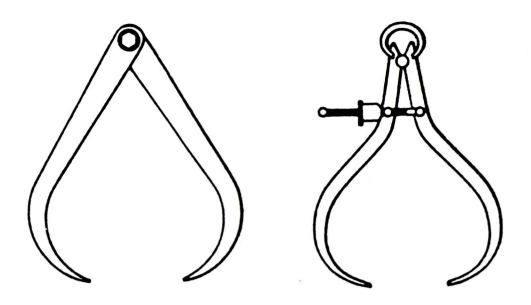

Fig. 41. Bowed calipers (from *The New Encyclopaedia*, 1984, II, 459).

tainly familiar come into play. Both metaphors focus on the tension suggested by the term, and express the complementary intellectual and physical constituents of extreme effort—much as one might speak in English of a mind- or a back-bending task. Boccaccio, for example, speaks of the *arco dell'intelletto,* the mental effort required for a work deserving of eternal fame.[11] But the term was also applied to various parts of the body; the phrase *con l'arco della schiena* is a common adage meaning "to strain with all one's might."[12] Both these senses of *arco* seem to coalesce in Albrecht Dürer's only mythological painting, in which the artist portrays himself as Hercules killing the Stymphalian birds (Fig. 42).[13] Here the prowess of the painter in manipulating the brush is compared to that of Hercules, the classical archer-hero *par excellence,* in using his bow. The theme of Dürer's allegory is the artist's victory over his envious critics, conveyed in the painting through the common equivalence of the Stymphalian birds to the Harpies; these creatures were invulnerable, so that to ward them off required great ingenuity as well as strength.[14] Michelangelo's nude giant has often been related to the tradition of Hercules as a symbol of virtue and fortitude, but the allusion to Hercules the archer

singles out the hero's skill and ingenuity—in a word, his virtuosity. Based on this Herculean tradition, the bow actually became the primary attribute of Cesare Ripa's *Ingegno* (Fig. 43).[15]

Striking, if unexpected, evidence of Michelangelo's meaning is to be found later in the century in the Lombard painter Lelio Orsi's adaptation of the theme of Hercules the archer as a metaphor for the artist. Orsi (ca. 1511–1587), who studied Michelangelo's art carefully, planned a decoration for the facade of his own house, identifiable by the bears (*orsi*) that appear in the coat of arms shown in the upper story (Fig. 44).[16] The composition centers on a man shooting an "arrow" (the tip is actually blunt and rounded, like a painter's mahlstick) directly out and down toward the spectator on the street below; flanking the bowsman are groups of figures holding a broken column on one side, a whole column on the other. The two columns of fortitude, which together here allude to the pillars (often treated as columns) of Hercules, clearly identify the archer as the ancient hero in modern guise. The key to the conceit lies in a story told by the ancient historians about Lelio's namesake, the emperor Lucius Aelius Aurelius Commodus (Lelio = Aelius), notorious for

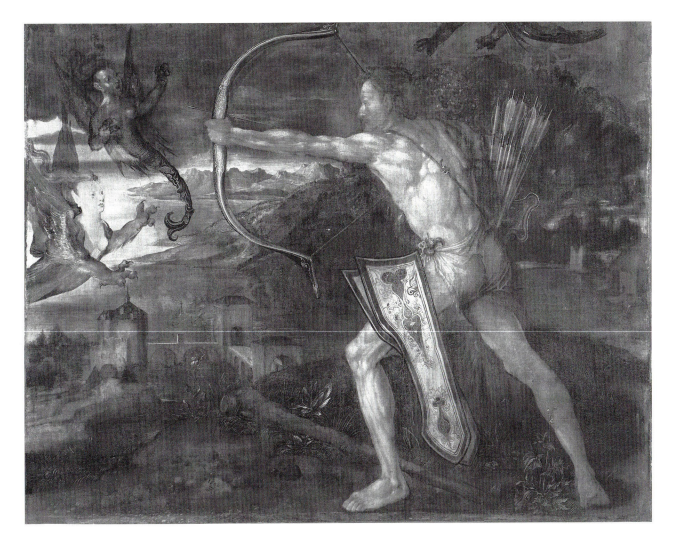

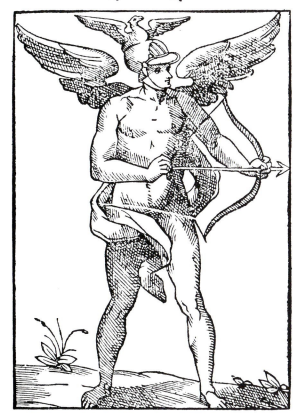

DI CESARE RIPA.
INGEGNO.

Fig. 42. Albrecht Dürer, *Hercules Killing the Stymphalian Birds.*
Germanisches Nationalmuseum, Nuremberg.

Fig. 43. Personification of *Ingegno* (from Ripa, 1603, 221).

Fig. 44. Lelio Orsi, project for the facade decoration of the artist's house, drawing. Devonshire Collection, Chatsworth (photo: Courtauld Institute of Art, London).

identifying himself with Hercules, whom he imitated in every possible way. As an example, Herodian recounts that Aelius set up in front of the senate house a statue of himself "as an archer poised to shoot, for he wished even his statues to inspire fear."[17] The *arco del ingegno* of the painter Lelio consists in challenging the physical reality of his arch-enemy, sculpture, by creating an illusion (presumably in grisaille, to feign sculpture) that penetrates the picture plane and threatens to pierce the spectator's eye and heart—like Michelangelo's *David.*[18] We shall consider presently Michelangelo's own position in the development of this bitterly fought battle of the arts.

The intellectual and physical senses of *arco* recur a decade after the *David* in another work by Michelangelo, which also includes an almost exact equivalent of Dürer's image, ironically inverted. The archer metaphor is the turning point of a poem Michelangelo composed about the labor of mind and body he expended on another of his great achievements, the Sistine ceiling (1508–12) (Fig. 45).[19] He inscribed the sonnet on a sheet, again accompanied by an illuminating sketch that shows the artist's body bent back awkwardly as he transfers his idea to the vault

above. The poem complains of the strain on mind and body:

And I am bending like a Syrian bow.

And judgment, borne in mind,
Hence must grow peculiar and untrue;
You cannot shoot straight when the gun's askew.[20]

Here *arco* conveys the intense labor, physical and intellectual, required by the heroic task the artist has set for himself.

We can trace several additional threads of meaning in what seems an improbable source of ideas for Michelangelo: the traditional Hebrew midrashim, or commentaries on the Old Testament, and the mystical Zohar. These works offered a rich body of legendary and interpretative material on the story of David and Goliath, and may also provide important clues to visual features of the *David.* In one text, for example, Moses is said to have prayed for his seed, and especially for David, as follows: "'Hear, Lord, his voice, and Thou shalt be an help against his adversaries, bring him then back to his people in peace; and when alone he shall set out into battle against Goliath, let his hands be sufficient for him,

I o gia facto ūgozo īqueşto · ştēto
chome fa lacuq agacti ī lonbardia
ouer da lvo paese ch essi chesisia
cha forza luētre apicha soctolmēto
La barba · alcielo · ellamemoria sēto
īsullo scrignio elpecto fo darpia
elpennel sopraluiso tuctauia
melfa gocciando ū richo pauimēto
E' lōbi entrati misō nella peccia
e fo delcul p chotrapeso groppa
epaşsi sēza gliochi muouo īuano
D inātzi misalluga lachorteccia
ep piegarsi adietro siragroppa
e tēdomi comarcho soriano
 Po fallace e straņo
surgie il iuditio ch lamēte porta
ch mal sipra p cerboctana tortr
 lamia pictura morta
di fedi orma giouanni elmio onore
nō sēdo floco bō ne io pictore

Fig. 45. Michelangelo, sonnet and satirical sketch on the Sistine
ceiling. Vol. XIII, fol. 111, Casa Buonarroti, Florence (photo:
Soprintendenza per i Beni Artistici e Storici, Florence 42049).

Fig. 46. Michelangelo, *David Killing Goliath*. Sistine Chapel, Vatican Palace, Rome (photo: Anderson 991).

and Thou shalt be an help against his adversaries.' Moses at the same time prayed God to stand by the tribe of Judah, whose favorite weapon in war was the bow, that their 'hands might be sufficient,' that they might vigorously and with good aim speed the arrow."[21] It has frequently been noted in connection with the conspicuously displayed and enlarged hands of Michelangelo's figure that at least from the time of St. Jerome, David was referred to as *manu fortis*.[22] The midrash is particularly suggestive, however, because of the invocation to the Lord to render David's hands "sufficient" and the linking of his sufficient hands to the Hebrews' divinely inspired use of their favorite weapon, the bow. Similarly, the Zohar speaks of the "evil" eye David cast upon his opponent that rooted him to the ground, an apt description of the effect of the glance of Michelangelo's hero. Michelangelo might well have been aware of these ancient texts, which were avidly studied by such learned men of his generation as Marsilio Ficino, Giovanni Pico della Mirandola, and especially Egidio da Viterbo, who has been credited with an important influence on the conceptual design of the Sistine ceiling.[23]

The personal and artistic associations of the

David, in turn, help to clarify the role of David's victory over Goliath in the further development of Michelangelo's ideas on art and the creative process. The victory itself is portrayed on the spandrel in the southeast corner of the Sistine chapel, where David is shown astride his fallen adversary, winding up to decapitate him with the giant's own gigantic sword (Fig. 46). This composition is unprecedented, with the two figures interlocked like Greco-Roman wrestlers.[24] Michelangelo must have been alluding to the type of David slaying the lion as it appears in Byzantine tradition (Fig. 47).[25] The composition is also based in part, however, as has recently been observed, on what must have been the prototype of the Byzantine formulation, the story of Mithras killing the bull, shown in a relief now in the Louvre that was one of the most familiar antiques in Rome (Fig. 48).[26] In Michelangelo's time the work was identified as Hercules killing the bull, so that here, as in the marble figure, David is identified with the ancient hero.[27] Michelangelo's Sistine group differs from these precedents, as well as from earlier depictions of David killing Goliath, in three ways: the figures are shown in depth, rather than parallel to the picture plane; they are conjoined so as to create

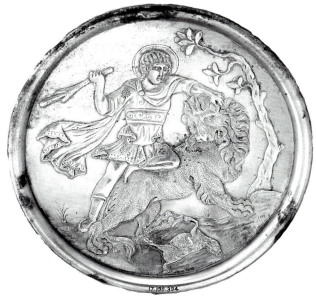

Fig. 47 (*left*). *David Killing the Lion,* silver plate. Metropolitan Museum, New York, Gift of J. Pierpont Morgan, 1917.

Fig. 48 (*above*). *Mithras Killing the Bull,* drawing. Codex Coburgensis, Kunstsammlungen der Veste, Coburg.

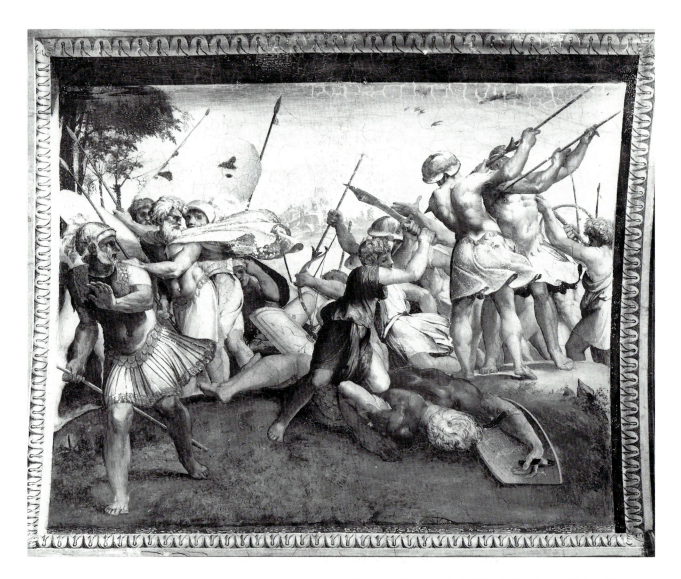

Fig. 49. Raphael, *David Killing Goliath.* Logge, Vatican Palace, Rome (photo: Alinari 7812).

a coherent pyramidal group; and they are arranged so that the composition is dominated by David's action, his raised right arm and sword culminating the movement of his powerful *arco della schiena.* David hacks at Goliath with superhuman fury, and his triumph is supernaturally overwhelming.

Almost immediately after the completion of the Sistine ceiling Raphael paraphrased Michelangelo's composition in his Old Testament cycle in the Vatican Logge (Fig. 49), and soon thereafter the image of David killing the giant was converted to Christianity, as it were, by Raphael's pupil, Giulio Romano, in the Sala di Costantino.[28] The decoration of this great hall, commissioned by the Medici pope Clement VII (1523–34) as a historical sequel to the Old Testament narratives, illustrates the establishment of

Christianity as the state religion. The end of idolatry is an important part of the subject, and in one of the scenes Giulio adopted Michelangelo's composition to portray the sculptor converted to Christianity destroying the giants he had created in his pagan past (Fig. 50).[29]

These considerations help somewhat to alleviate our astonishment that the same group was adapted to portray the sculptor himself at work on the figure of Dawn from the tomb of Lorenzo de' Medici (Fig. 51). The illustration occurs in a book of astrological games published in Venice in 1527 by Sigismondo Fanti, an otherwise little-known itinerant humanist, who may actually have seen Michelangelo at work on the figure.[30] Fanti was perspicacious enough to include the image under

Fig. 50. Giulio Romano, the Christian sculptor destroying the idols. Sala di Costantino, Vatican Palace, Rome (photo: Musei Vaticani XXXII-143-28).

Fig. 51 (*above*). The sign of Jupiter with Michelangelo the sculptor (from Fanti, 1527, carte XXXVIII).

Fig. 52 (*opposite, left*). Maarten van Heemskerck, *St. Luke Painting the Virgin.* Musée des Beaux-Arts, Rennes.

Fig. 53 (*opposite, right*). Detail of Fig. 52.

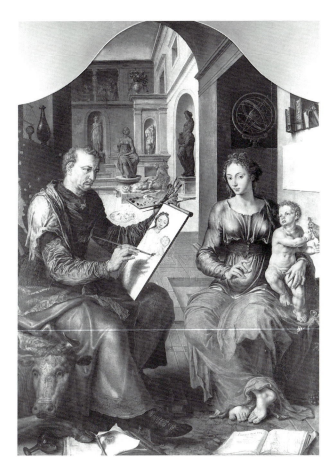

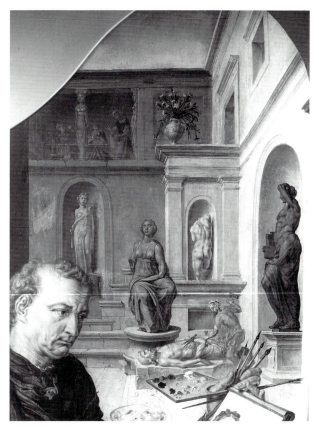

the sphere of Jupiter, which in fact corresponded to Michelangelo's constellation. The vehement action of Fanti's sculptor gives form to the French traveler Blaise de Vigenère's vivid description of the frenzy with which Michelangelo attacked the marble to free his idea from the block.

> I have seen Michelangelo, although more than sixty years old and no longer among the most robust, knock off more chips of a very hard marble in a quarter of an hour than three young stone carvers could have done in three or four, an almost incredible thing to one who has not seen it; and I thought the whole work would fall to pieces because he moved with such impetuosity and fury, knocking to the floor large chunks three or four fingers thick with a single blow so precisely aimed that if he had gone even minimally further than necessary, he risked losing it all, because it could not then be repaired or re-formed, as with images of clay or stucco.[31]

Although in a different mode and with implications different from those of the marble *David,* Fanti must have grasped Michelangelo's interpretation of David's

victory over Goliath as the prototype for the artist's overcoming the difficulties of his art. Indeed, Fanti's whole conception shows such intimate knowledge of Michelangelo and his working method that I suspect the artist himself supplied the information, perhaps suggesting the appropriateness of the formula or even providing the design.

Both the David and Goliath motif and Fanti's paraphrase of it had repercussions roughly twenty-five years later in specifically art-theoretical contexts. The works to be discussed hereafter all date, on independent grounds, to around 1550 and seem to reflect more or less directly the preeminent art-theoretical issue of the period, the *Paragone,* or comparison of the arts. The subject was given wide currency by the opinion poll conducted among the leading artists of the day by Benedetto Varchi in 1548.[32]

Fanti's image reappears in the background of Maarten van Heemskerck's great panel of St. Luke painting the Virgin, now in the museum at Rennes (Figs. 52, 53). Although the meaning of this complex allegory has been much discussed, its underly-

Fig. 54. Maarten van Heemskerck, courtyard of the Palazzo Sassi in Rome, drawing. Kupferstichkabinett, Staatliche Museen, Berlin.

ing theme, an *interpretatio christiana* of the *Paragone,* has remained obscure.[33] Luke is not presented as the simple recorder of appearances but as the knowing re-creator of the visible form of divine nature. He is a painter but is shown giving color to the underlying prototype, or *disegno.* This seminal concept of mid-sixteenth-century aesthetics derived its potency from its dual, punning, significance as both physical drawing and immaterial scheme.[34] With subtle deliberation Vasari described *disegno* as Father (alluding to God the Father) of the arts. Heemskerck realized

that only in the context of Saint Luke depicting the Virgin and Child could he illustrate the pivotal function of *disegno* as the interface (literal as well as figurative, since Luke is painting a portrait) between the artist's creativity and that of God. Luke is surrounded by the paraphernalia of wisdom and learning the humanist artist needed to fulfill his divine mission. *Exempla* of the arts of architecture and sculpture are portrayed in the background, where Heemskerck transposed the drawings of the courtyard of the Palazzo Sassi (Fig. 54) he had made

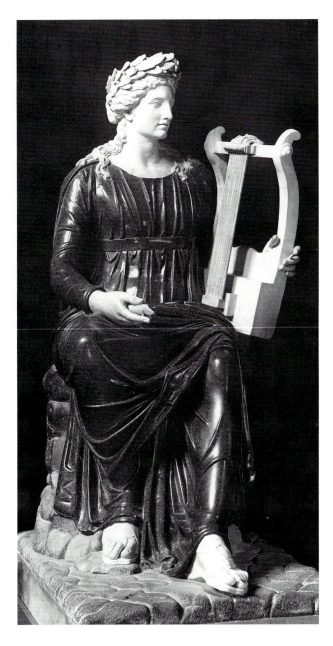

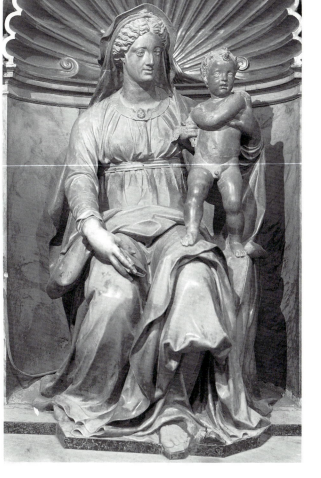

Fig. 55. Apollo Citharoedus. Museo Archeologico Nazionale, Naples (photo: Alinari 19004).

Fig. 56. Jacopo Sansovino, *Madonna and Child.* Sant'Agostino, Rome (photo: Istituto Centrale per il Catalogo e la Documentazione, Rome C8871).

during his visit to Rome a decade earlier. The courtyard must have seemed to him a paradise, reincarnating the classical world with its renowned collection of antiquities. The two works most prominently displayed in the painting are especially important. The seated figure shown on the pedestal was restored in the eighteenth century as Apollo Citharoedus, now preserved in the Naples museum (Fig. 55). In Heemskerck's time it was understood as representing *Roma Trionfante,* no doubt because of its effeminate form and the imperial stone, porphyry, of

which it was made.[35] Jacopo Sansovino had already transformed the figure into a Madonna and Child (Fig. 56), which must have inspired Heemskerck to do the same in his painting.[36] Heemskerck introduces a decisive change, however, by crossing the Virgin's ankles. This motif, probably inspired by Michelangelo's figure of the prophet Isaiah in the Sistine ceiling,[37] alludes to the Crucifixion, of which the Mother of God has foreknowledge. The progression from the fragmentary classical to the perfect modern deity thus illustrates the creative process

whereby Christianity incorporated the good while rejecting the bad in pagan antiquity. Rome triumphant is succeeded by the Church triumphant.

The other image that concerns us, the sculptor at work on his statue (Fig. 53), was conspicuously added by Heemskerck to the actual furnishings of the Sassi courtyard. The reference to Fanti's portrayal of Michelangelo at work—the paradigm of creative fervor—is striking; one scholar has even seen a physiognomical resemblance to Michelangelo.[38] Heemskerck again makes a significant change, however, replacing Aurora with another antique then in the garden of the Villa Madama in Rome and now to be seen, radically transformed into a herm, in the Louvre (Fig. 57).[39] Heemskerck drew the figure in a reclining position (Fig. 58), just as it appears in the painting. In fact, he had already adapted Fanti's Michelangelo as a symbol of sculpture generally, and of the attainments of ancient sculpture in particular, by replacing the Aurora with the same ancient figure in his engraved composition of the children of Mercury, that is, the arts as products of human ingenuity (Fig. 59). The motive for the substitution in the Rennes picture becomes evident when one realizes that the sculpture was recognized as Jupiter Capitolinus (Jupiter was Michelangelo's own planet, we recall), the father of the pagan gods and the chief deity of Rome; contemporaries singled it out as one of the largest and most beautiful statues ever to have been found in Rome.[40] The sculptor is thus shown creating a gigantic idol of the most exalted imperial divinity, whose power would be broken and replaced by that of the divinity portrayed by St. Luke. Taken together, the two pairs of figures, Rome and Jupiter in the background, Mary and Christ in the foreground, mark the succession from antiquity to the present—in time, in belief, and in the self-conception of the artist.

In all likelihood Heemskerck's painting was made for a confraternity of St. Luke and was thus intended to carry north of the Alps the transformation of the craftsmen's guild into the artist's academy then taking place in Italy.[41] The exalted purpose of this transformation, and the ultimate point of Heemskerck's allegory, is embodied in the parrot, a standard symbol of rhetoric, that the Christchild holds up to the viewer. In effect it defines the painting as the visual equivalent of the ideal sermon envisioned by Erasmus and the humanist advocates of a

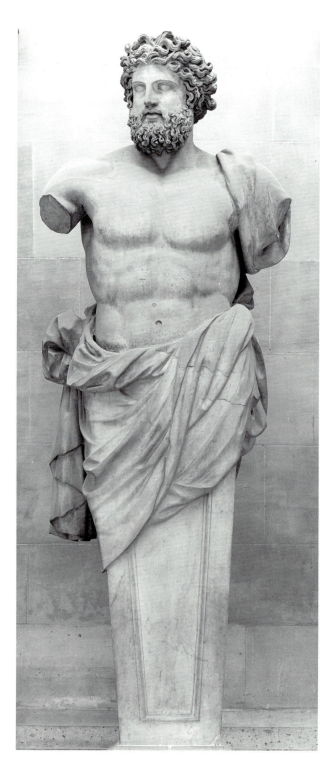

Fig. 57 (*above*). Jupiter herm. Musée du Louvre, Paris (photo: Documentation photographique de la Réunion des musées nationaux 71 EN 2671).

Fig. 58 (*opposite, top*). Maarten van Heemskerck, garden of the Villa Madama in Rome, drawing. Kupferstichkabinett, Staatliche Museen, Berlin.

Fig. 59 (*opposite*). Maarten van Heemskerck, *Mercury and His Children*, engraving (photo: Rijksmuseum-Stichting, Amsterdam 21856).

Fig. 60. Daniele da Volterra, *David Killing Goliath.* Château de Fontainebleau (photo: Documentation photographique de la Réunion des musées nationaux 65 DN 5998 bis).

"Christian rhetoric" that would combine the learning of antiquity with the divinely inspired expressive simplicity of the Bible.[42]

Heemskerck's elaborate compilation of learned but clearly recognizable sources might be described as a modern structured version of the traditional medieval *exemplum* in didactic literature and sermons.[43] In this respect, the painting sheds light on the historical method implicit in Michelangelo's marble *David.* The inscriptions on the Louvre drawing are, after all, a tissue of references—to the biblical hero as the prototype of the artist and, as we shall see, to the verse of Petrarch as a metaphor for a political statement. In this methodological sense, too, the inscriptions are paralleled visually in the statue itself, which refers to the earlier Florentine depictions of the Old Testament David; to Hercules, the pagan paragon of fortitude and virtue;

and, as we shall also see, to the Early Christian warrior saints.

The second legacy of the David-beheading-Goliath tradition is a work by Daniele da Volterra, now at Fontainebleau (Figs. 60, 61), showing on either side (one cannot properly say front and back) of the same panel opposite views of the climax of the action, in a composition clearly derived from the scene on the Sistine ceiling. Vasari records that the picture was made for the poet Giovanni della Casa, who wanted professional help in clarifying certain points for a treatise he was preparing on the art of painting.[44] The panel is one of a number of works by artists of the period that refer to the debate concerning the relationship of the arts, specifically the respective merits of painting and sculpture.[45] The painter answered the sculptor's claim to three-dimensionality by inventing devices that

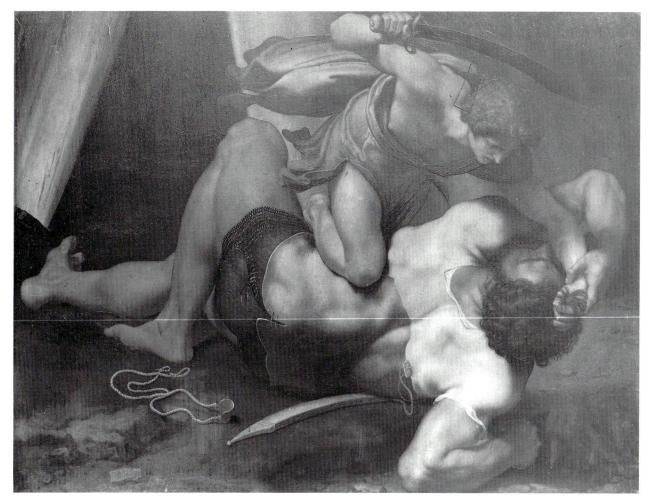

Fig. 61. Daniele da Volterra, *David Killing Goliath.* Château de Fontainebleau (photo: Documentation photographique de la Réunion des musées nationaux 65 DN 5998).

responded in kind, as it were: by introducing a mirror or other reflective materials in the scene, for example, or, as here, by exploiting both sides of the surface. Some critics, beginning with Michelangelo himself, came to regard these disputes about the arts as exercises in futility. Yet the debate entailed a serious challenge to the artist—and on this score Michelangelo did participate—to demonstrate conceptual ingenuity and technical virtuosity and thereby establish a claim to the ambivalent title *Deus artifex.* Vasari's account of the commission (see n. 44) includes a detail, usually neglected, that is of the utmost importance in our context:

> . . . having begun to write a treatise on painting, and wishing clarification of certain details and particulars from men of the profession, [Giovanni della Casa] had

Daniele make, with all possible diligence, a finished clay model of a David; and he then had him paint, or rather portray in a picture the same David, which is most beautiful, on both sides, that is the front and the back, which was a capricious thing.

Daniele therefore made a terra-cotta model first, and then the two-sided painting. It has long been known that the Fontainebleau panel is one of a number of works Daniele based on designs supplied by Michelangelo. A series of sketches by Michelangelo in the Morgan Library representing basically the same composition must have served for the terra-cotta that Daniele then translated into paint (Fig. 62).[46] Surely the real purpose of the lesson in sculpture and painting was to illustrate for Giovanni della Casa the view of the *Paragone* that Daniele had learned from Michelangelo—who, in a statement

Fig. 62. Michelangelo, four sketches for *David Killing Goliath*, drawing. Pierpont Morgan Library, New York.

we shall quote presently, invoked three main principles: the primacy of sculpture, the reflectivity of painting, and the derivation of both ultimately from the same "intelligence."

This understanding helps to elucidate the awesome confluence of form and meaning in Michelangelo's interpretation of David killing Goliath. The key to the unprecedented conception, in the Sistine ceiling and in the composition recorded by Daniele, lies in Michelangelo's invention of an interlocking double contrapposto: both figures show opposite sides, front and back, at the same time, but in opposite directions; both sides of both figures, which together form a single, indissoluble knot, are always visible. David's victory over Goliath is indeed the prototype for the ingenuity and power of the artist to overcome the difficulty and labor of his art—the *arco dell'intelletto* and the *arco della schiena*. There could be no better illustration of the one explicit statement by Michelangelo that has come down to us *verbatim* expressing his conception of his art, and

therefore of himself. At the same time that he painted the figural group, and in response to Varchi's inquiry concerning the *Paragone*, Michelangelo composed an ironic, lapidary verbal conundrum no less interlocking and contrapuntal than the David and Goliath composition itself. The statement both describes and draws upon the same *arco*—*dell'intelletto* and *della schiena*—with which, for the early *David*, the *alta colonna* was broken to the artist's will.

I say that if greater judgment and difficulty, impediment and labor do not make for greater nobility, then painting and sculpture is [*sic*] the same thing. And if this be held so, no painter should make less of sculpture than of painting, and no sculptor less of painting than of sculpture. By sculpture I mean that which one does by taking away; that which one does by adding is similar to painting. Enough, for the one and the other deriving from the same intelligence, that is, sculpture and painting, one can make a good peace between them and abandon so many disputes, because they take more time than making figures.[47]

The parallel Michelangelo draws between David and himself in the first text of the Louvre sheet inevitably does more than simply equate two improbable victories over physically superior adversaries. David had long since become an emblem of Florentine republicanism,[48] and it is clear that Michelangelo imputed to his own colossus an apotropaic efficacy against Florence's contemporary enemies, equivalent to and infused with the same divine power the biblical hero had against the Philistine enemies of Israel. The first inscription itself therefore suggests that Michelangelo's personal power served a larger, communal, purpose through the image of David.

The nature of this public mission, in turn, is manifested in the text written below the artist's signature, for the Petrarchan verse suggests that the defeat of the giant conveys more than the superiority of purely intellectual and technical prowess. To begin with, David and the column had a particularly close, quasi-idolatrous, relationship in Florence.[49] Donatello's bronze *David*, the first freestanding nude statue since antiquity, had been displayed on a column in the classical manner, first in the courtyard of the Palazzo Medici and again, after the expulsion of the Medici in 1494, in the courtyard of the Palazzo Vecchio. Similarly, in the fictive monument painted by Ghirlandaio beside the entrance to the Sassetti chapel in Santa Trìnita (Francesco Sassetti was a close ally of the Medici), David stands on a pedestal supported by a tall pilaster. The inscription on the pedestal proclaims the civic, no less than the religious, import of the monument: *Salvti Patriae et Christianae Gloriae* (Fig. 63). In view of this prior association with the Medici the renewed interest in the colossus under Soderini can only be understood as an attempt by the republican government to reclaim David as its own hero.

A contemporary Florentine would immediately have recognized Michelangelo's allusion to the Petrarchan broken laurel as a patent reference to the Medici, in particular to Lorenzo the Magnificent.[50] Punning on the Latin form of his name, Lorenzo had adopted the laurel as a personal emblem and that evergreen thereupon became one of the most prominent motifs of Medicean heraldic imagery. It has been suggested that Michelangelo was here applying Petrarch's lament to the premature death of Lorenzo in 1492, which deprived the artist of a great friend and early patron.[51] The poet Poliziano

Fig. 63. Ghirlandaio, *David with Head of Goliath*. Santa Trìnita, Florence (photo: Kunsthistorisches Institut, Florence 4526).

had already associated the laurel with Lorenzo's death, reversing with sad irony the plant's legendary immunity to lightning:

> Lightning has struck
> our laurel tree,
> our laurel so dear
> to all the muses,
> to the dances of the nymphs.

Michelangelo's omission of the word *laurel* from the Petrarchan text might thus have been motivated by

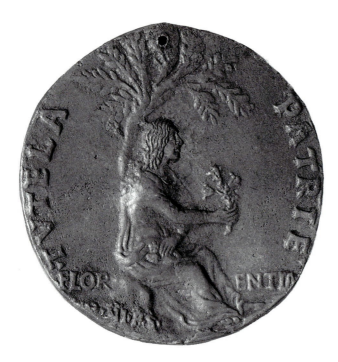

Fig. 64. Medal of Lorenzo de' Medici. Bargello, Florence (photo: Soprintendenza per i Beni Artistici e Storici, Florence 163028).

in the face of this threat that the marble David was revived. Moreover, the re-evaluation of Lorenzo the Magnificent was itself part of a movement that ultimately led to the restoration of the Medici and the demise of the republic. Considering this reactionary tendency, Michelangelo must have felt as much apprehension about a future Medicean tyranny as nostalgia for the lost virtues of Lorenzo. Hence the passage from Petrarch may also be understood as alluding to the defeated but still formidable adversary of the republican spirit championed by David. This anti-Medicean point becomes clear when one realizes that Michelangelo was actually referring to a specific motif of Lorenzo's political propaganda intended to identify his family with the city of Florence; associate himself with Augustus, the founder of the Roman empire; and proclaim his own rule as an Augustan Golden Age. The key factor here is the reference, through Petrarch, to the *broken* laurel. To be sure, the laurel was an ancient and multivalent symbol of virtue, but Lorenzo transformed it into a distinct political message. In a medal of about 1480 (Fig. 64), a figure labeled *Florentia* is seated under a laurel tree holding three fleurs-de-lys to symbolize the City of Flowers that flourishes under Lorenzo's tutelage (*Tvtela Patrie*). Lorenzo adopted a form and meaning for the device that extended its reach across time, so that it both referred to the past and was rife with implications for the future.[53] In antiquity each of the Giulio-Claudian emperors (the dynasty inaugurated by Augustus) customarily planted in a grove the branch of laurel he had carried in triumph; the trees that grew from the branches came to symbolize the continuity of the imperial line. The custom began with Augustus who planted the first branch from which all the others were taken, and who adopted the laurel branch conspicuously on his coinage.[54] Because of these associations and the evergreen's capacity to renew itself from a slip, Lorenzo took as his emblem a branch, or stump— *broncone* in Italian—of laurel and combined it with a chivalric version of a conceit involving temporal renewal that derived from a celebrated passage in Virgil's fourth Eclogue.[55] The *broncone* of laurel with the motto *Le Temps Revient* (Fig. 65) became a striking evocation of the return, under the benign auspices of Lorenzo de' Medici, of the Golden Age under Augustus celebrated by Virgil. The ever-flourishing laurel served as the image of the Medici's

a fear of reprisal from the anti-Medicean republican party then in power.

Apart from the fact that this interpretation makes Michelangelo, the ardent republican, into something of a hypocrite with respect to his current patrons, several factors suggest an alternative meaning of the inscription. The commission for the *David* came during a crucial period in the history of the Florentine republic that had been installed after the Medici were ousted.[52] The longed-for benefits of this democratic form of government failed to materialize, and internal conditions worsened while external dangers became more acute. There were even hints of a change in attitude toward the Medici, including a revival of sympathetic interest in Lorenzo, especially among the intellectuals he had patronized. Eventually, having been denounced after his death as a pernicious tyrant, he came to be idealized as a benevolent and popular leader. There may indeed be an echo of this nascent political nostalgia as well as an expression of personal loss in Michelangelo's quotation from Petrarch.

The successors to Lorenzo, however, enjoyed no such sympathy. They and their supporters were a constant threat to the republic, and it was certainly

Fig. 65. Impresa of Lorenzo de' Medici. MS Plut. 82.10, fol. 3r, detail. Biblioteca Laurenziana, Florence.

tutelage of the city.[56] Imperialist associations had already been evoked by the Medici tombs in San Lorenzo (see pp. 17, 25 above), and the potential threat to republican tradition implicit in such imagery must have aroused suspicions as to Lorenzo's ultimate ambitions.[57] Michelangelo's invocation of the Petrarchan broken tall column and laurel thus uniquely and conspicuously refers to the death of Lorenzo. But also, co-opting the *broncone*, the reference celebrates the rupture of the Medici dominion in Florence and the triumph of republican government—whose future stability Michelangelo would help to assure by the ever-vigilant defiance of his gigantic giant killer. Michelangelo might very well have omitted "lauro" for fear of reprisal, not by the republicans but by supporters of the Medici whose subsequent efforts to take revenge on the statue will be adduced below.

This reading of Michelangelo's written message on the Louvre sheet elicits in the first instance the coherent meaning of the drawing itself.[58] The republican sentiment applies to both figures in the study. The French, for whom Piero Soderini commissioned the bronze *David* expressly in emulation of Donatello's figure, were the chief allies of the

Florentine republic against the political aspirations of the Medici. The anti-Medicean implication of the inscription also clarifies a number of puzzles in the marble sculpture's history and imagery. Apart from its physical character—its extraordinary size and physique and its complete nudity—Michelangelo's *David* is above all distinguished by its unprecedented isolation of the moment *before* the epic battle with the Philistine. Normally, and quite rightly, this abrogation of the traditional rule of showing David triumphant over the decapitated giant is taken as heightening the dramatic intensity of the event. The inscription on the drawing, however, records an underlying change of meaning, as well: emphasis has shifted from victory to vigilance against the potential future menace that was implicit in the retrospective Medicean emblem of verdant laurel and *Le Temps Revient*. Michelangelo's narrative innovation thus imbues the figure with a vital contemporary meaning analogous to that of the physical power and psychological immediacy of the sculpture itself. The prototypical victor over brute physical strength devoid of moral support has become the modern image of the spiritual force with which moral right is endowed. In this sense, especially, the *David* shows its debt to the great tradition of warrior saints, propugnators of the faith, that includes Donatello's St. George and Michelangelo's own earlier portrayal of St. Proculus.

This radical new interpretation of the subject may even have been one of the reasons Michelangelo was given the commission in the first place. At least, good sense can thus be made of Vasari's account of how the earlier work on the marble had been botched: Agostino di Duccio had cut a large hole between the legs, rendering the block useless for the intended figure.[59] Agostino's error is usually assumed to have created a purely technical problem, which Michelangelo succeeded in overcoming. I suspect, however, that the situation entailed another, more substantive, difficulty that profoundly affected the idea the work was to convey. Agostino's gaping hole would have precluded the one indispensable element of the subject as traditionally conceived: the decapitated head of the defeated Goliath. It may have been this very problem that later prompted Andrea Sansovino to propose adding certain pieces of marble to create a figure.[60] We have seen that Michelangelo's achievement lay, in part, in the purely artistic feat of extracting the giant from the immense disfigured block. It also lay in the political feat of

David's Sling and Michelangelo's Bow 53

ICONOLOGIA
FVROR POETICO.

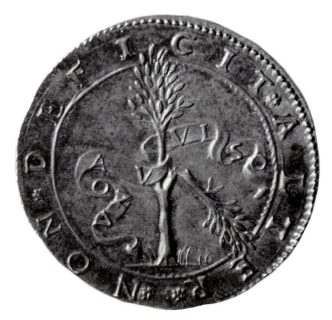

Fig. 66 (*above*). Personification of *Furor poetico* (from Ripa, 1603, 178).

Fig. 67 (*right*). Medal of Cosimo I de' Medici. Bargello, Florence (photo: Soprintendenza per i Beni Artistici e Storici, Florence 277070).

devising a conception of David that would obviate the need for the giant's head while retaining—indeed augmenting, as it turned out—the affective power inherent in the very notion of the basic theme of David as the youthful protector of his people.

Instead of Goliath's head between or beneath David's feet, Michelangelo placed behind his leg the stump of a tree, a conventional support commonly used by ancient sculptors. In the case of Michelangelo's *David*, however, the device may also serve as David's attribute, the equivalent of Goliath's head, though different in form as well as meaning.[61] The stump was in fact called *broncone*, the same word used for Lorenzo's *impresa*, in an often overlooked document describing certain embellishments, now lost, that were added to Michelangelo's statue shortly after it was installed in front of the Palazzo Vecchio.[62] The *broncone* was gilded, as was the strap of David's sling; a gilt bronze laurel wreath was added (recalling, as does the nudity of the figure, Donatello's bronze *David*); and a leafy vine of copper (presumably ivy) was placed about the groin (cf. Fig. 69). A letter written later by Pietro Aretino complaining about the statue's nudity suggests that the vine may have been added in an act of public prudery. Perhaps not without reference to the *David* thus adorned, Cesare Ripa later applied the laurel crown and the ivy cinch to his *Poetic Fury*, as symbols of eternal fame (Fig. 66).[63] In any case, Michelangelo's statue did acquire the laurel as an attribute—the Medicean *broncone* was pruned, as it were, to serve as David's trophy.

To my mind, however, there are still more compelling, and historically more significant, witnesses to the anti-Medicean reference in Michelangelo's inscription and, by implication, in the statue itself. The witnesses testify, as well, that the message was heard and understood by his contemporaries. The evidence is to be found in what happened to the Medici *impresa* after the republic was defeated and the Medici returned to even greater power than before. Under Duke Cosimo I, the pun on Lorenzo's name was replaced by a new, explicitly retrospective pun relating the duke's name to that of the founder of the family's power, Cosimo il Vecchio (itself the subject of a cosmic pun; see p. 20 above). At the same time, the theme of recurrence that had given political overtones to Lorenzo's laurel now resounded in a new Medicean proclamation of dynastic hegemony. In this version of the *impresa*, as on the reverse of an early medal portraying the young duke (Fig. 67), the *broncone* remained but the motto was changed from the chivalric *Le Temps Revient* to *Uno Avulso non Deficit Alter* ("when one [laurel-Cosimo] is torn away, another fails not"), quoting all but the first word of a phrase Virgil had used in reference to the Golden Bough. The substitution of *uno* for Virgil's *primo* transformed a limited sequence into a generic notion of perennial regeneration from the broken laurel of Petrarch. Significantly, the prime image of this principle of "augural historicism," including the laurel branch and revised motto, is Pontormo's portrait of Cosimo Pater Patriae, which pointedly revives the profile format characteristic of the earlier period (Fig. 68). As far as I can discover, however—and this is the essential point—Michelangelo on his drawing for the *David* was the first to apply the Petrarchan phrase to the Medici in specific reference to the eclipse of the family's power following the death of Lorenzo. It is well known that Michelangelo's statue, which he executed secretively behind a specially constructed enclosure, immediately became a matter of civic pride: after a public consultation with no less than thirty citizens of Florence, including the leading artists of the day, the statue was brought to the Piazza della Signoria—following Michelangelo's own advice, according to a contemporary report—and given the most conspicuous civic location, at the entrance to the Palazzo Vecchio.[64] I have no doubt that Michelangelo's subtle and ironic subversion of the Medici laurel device also entered, subversively, into the public domain. The later version of the *impresa* was promulgated as a triumphant rejoinder and can only have been intended to parry Michelangelo's ingenious thrust at the heart of tyranny.

The "battle of the *imprese*" was not the only reply to the *David*. When the huge monument was transported to its destination in the middle of the night, it was attacked and stoned by vandals, who must have been supporters of the Medici faction.[65] The statue appears in depictions of two important political events that took place in the Piazza della Signoria following the Medici restoration: an oration by Giovan Battista Ridolfi, the Medici-supported *gonfaloniere della giustizia* who replaced Piero Soderini, shown in the border of one of the tapestries for the Sistine Chapel designed by Raphael for the Medici Pope Leo X (Fig. 69); and the reception of the insignia of command in defense of the Church given to Florence by the same pope, in a fresco by Vasari

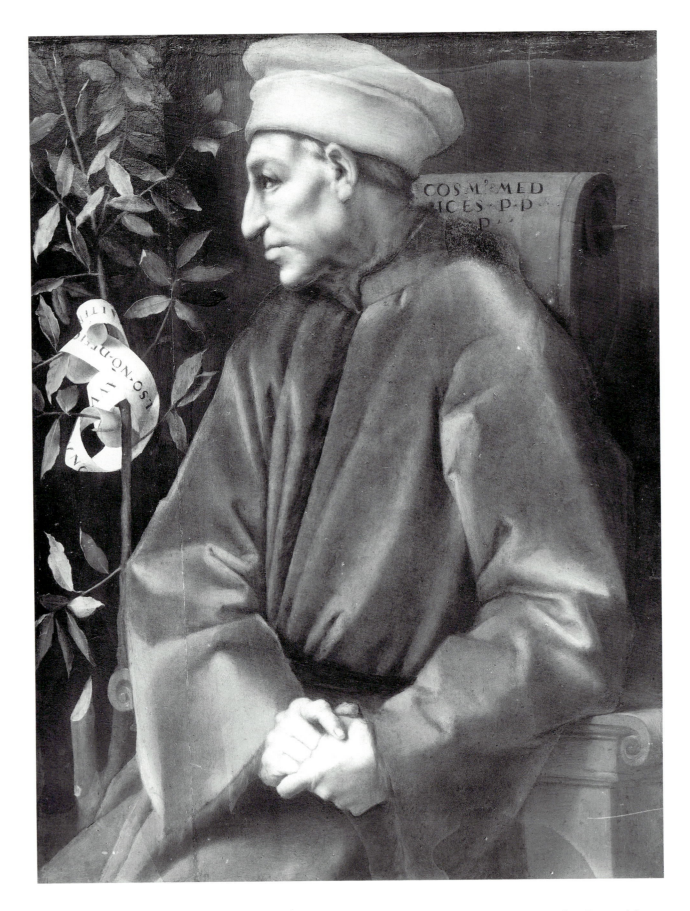

Fig. 68. Pontormo, *Cosimo Pater Patriae*. Uffizi, Florence (photo: Soprintendenza per i Beni Artistici e Storici, Florence 10407).

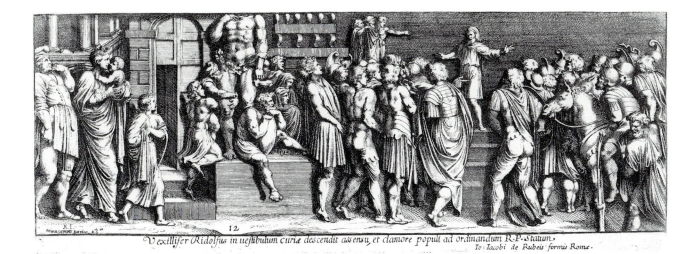

Fig. 69. *Oration of Giovan Battista Ridolfi in Florence,* engraving after the border of a tapestry designed by Raphael, detail (from Bartoli, [ca. 1690], pl. 2).

in the Palazzo Vecchio itself (Fig. 70).[66] It has been suggested—and it can scarcely be coincidental—that in both cases the *David* is deliberately shown "decapitated," as if in ironic response to the threatened beheading of the Medici-Goliath. An amusing, if somewhat vulgar, detail in the fresco confirms the politically charged atmosphere that surrounded Michelangelo's figure. The crowd of spectators in the piazza divides directly beneath the *David,* and in the opening thus conveniently provided a dog is shown conspicuously relieving itself. The vignette underscores the humiliating irony of the scene, in which the defeated republic is conceded the honor of defending its enemy's leader. The reference would have been even more specific if it had been placed where originally planned: an inscribed preparatory sketch for the same defecating animal may be discerned directly in front of the pedestal of the statue itself (Fig. 71).

The episodes of antirepublican symbolic vandalism anticipate the actual decapitation of the portrait reliefs on that great symbol of ancient imperialism, the Arch of Constantine in Rome, perpetrated in 1536 by one of the leading partisans of Florentine republicanism, Lorenzino de' Medici. Lorenzino's purpose was manifestly to propagate the republican cause against his hated and potentially tyrannical cousin Alessandro de' Medici.[67] The specific act of physical violence, however, unmistakably recalled the

dramatic end of the Augustan dynasty with Nero, when the temple of the Caesars was struck by lightning and the heads of all the statues were knocked off.[68] The same mania for decapitating images was also evident in Giulio Romano's depiction of the inspired Christian sculptor surrounded by headless idols (see Fig. 50).

The *David* was not the only work by Michelangelo whose political associations, whether intended or acquired, the Medici rulers of Florence considered intolerable and in need of "neutralization"—or rather reconversion, since the Medici considered themselves the embodiment of Florentine traditions and tactfully maintained the fiction of republican government. The mutilations of the Arch of Constantine were a prelude to the assassination of Alessandro, which Lorenzino perpetrated a year later, in 1537. Michelangelo's over-life-size, apparently unfinished marble sculpture of Brutus (Fig. 72)— the first independent heroic commemorative bust *all'antica* carved in the Renaissance—must have been made to celebrate this act of politically justified homicide. Confirmation of our argument comes from the wonderfully fatuous inscription, added when the *Brutus* was acquired later in the century by Grand Duke Francesco; it explains that while working on the marble, Michelangelo had a change of heart![69]

Under the grand dukes of Tuscany works of art

Fig. 70. Giorgio Vasari, *The Signoria Receiving the Cap and Sword Given by Leo X*, detail. Palazzo Vecchio, Florence (photo: Kunsthistorisches Institut, Florence).

Fig. 71. Detail of Fig. 70, (photo: Kunsthistorisches Institut, Florence).

became weapons of statecraft as never before, and the Medici court transmitted this form of political art-propaganda, for better or worse, into the bloodstream of European culture. I hope it is clear from the spectacle of art-political vicissitudes we have witnessed that this new awareness of the rhetorical value of affective imagery was deeply indebted to the power of Michelangelo's interpretation, both verbal and visual, of David. If this view of its meaning and effect is correct, then the sculpture played a role in Florentine, indeed in European, political history no less significant than its role in the history of art — the first colossal freestanding nude figure carved in marble since antiquity was also the first colossal freestanding public monument conceived in the name of liberty.

Michelangelo's Louvre drawing should also be appreciated as an innovation in itself, since the relationships we have discerned between the figural elements and the inscriptions lend the work a programmatic character that marks a new departure

in the development of the graphic medium. This coherence of visual and verbal content is matched by the structure and balance with which the page itself is organized, the central arm of the marble *David* being flanked on one side by the sketch for the bronze figure and on the other by the "explanatory" inscriptions. Even the comparative scale of the figures is considered, the life-size bronze *David* having been a third the size of the marble giant. In this structural and substantive unity the Louvre drawing foreshadows the beautifully designed conflation of text and image Michelangelo achieved a decade later on the Casa Buonarroti sheet, where he apostrophizes and mocks his own work on the Sistine ceiling (see Fig. 45). The sketch and its verbal equivalent together approach the coherence and deliberateness of an autonomous work of art. In this informal, didactic domain the development parallels that of the elaborate and self-sufficient drawings Michelangelo presented to his friends and patrons, in which the traditionally preliminary medium was raised to a noble art form (see Fig. 274).[70]

Fig. 72. Michelangelo, *Brutus.* Bargello, Florence (photo: Alinari 2718).

Appendix

VASARI ON THE *David* OF MICHELANGELO

"Gli fu scritto di Fiorenza d'alcuni amici suoi che venisse, perché non era fuor di proposito che di quel marmo che era nell'Opera guasto egli, come già n'ebbe volontà, ne cavasse una figura; il quale Pier Soderini, fatto gonfaloniere a vita allora di quella città, aveva avuto ragionamento molte volte di farlo condurre a Lionardo da Vinci et era allora in pratica di darlo a Maestro Andrea Contucci dal Monte San Savino, eccellente scultore, che cercava di averlo; e Michelagnolo, quantunque fussi dificile a cavarne una figura intera senza pezzi—al che fare non bastava a quegli altri l'animo di non finirlo senza pezzi, salvo che a lui, e ne aveva avuto desiderio molti anni innanzi—, venuto in Fiorenza tentò di averlo. Era questo marmo di braccia nove, nel quale per mala sorte un Maestro Simone da Fiesole aveva cominciato un gigante, e sì mal concia era quella opera, che lo aveva bucato fra le gambe e tutto mal condotto e storpiato: di modo che gli Operai di Santa Maria del Fiore, che sopra tal cosa

erano, senza curar di finirlo l'avevano posto in abandono, e già molti anni era così stato e era tuttavia per istare. Squadrollo Michelagnolo di nuovo, et esaminando potersi una ragionevole figura di quel sasso cavare, et accomodandosi con l'attitudine al sasso ch'era rimasto storpiato da Maestro Simone, si risolse di chiederlo agli Operai et al Soderini, dai quali per cosa inutile gli fu conceduto, pensando che ogni cosa che se ne facesse fusse migliore che lo essere nel quale allora si ritrovava, perché né spezzato, né in quel modo concio, utile alcuno alla Fabrica non faceva. Laonde Michelagnolo, fatto un modello di cera, finse in quello, per la insegna del Palazzo, un Davit giovane con una frombola in mano, acciò che, sì come egli aveva difeso il suo popolo e governatolo con giustizia, così chi governava quella città dovesse animosamente difenderla e giustamente governarla. E lo cominciò nell'Opera di Santa Maria del Fiore, nella quale fece una turata fra muro e tavole et il marmo circondato; e quello di continuo lavorando senza che nessuno il vedesse, a ultima perfezzione lo condusse. Era il marmo già da Maestro Simone storpiato e guasto, e

non era in alcuni luoghi tanto che alla volontà di Michelagnolo bastasse per quel che averebbe voluto fare; egli fece che rimasero in esso delle prime scarpellate di Maestro Simone nella estremità del marmo, delle quali ancora se ne vede alcuna. E certo fu miracolo quello di Michelagnolo, far risuscitare uno che era morto.

Era questa statua, quando finita fu, ridotta in tal termine che varie furono le dispute che si fecero per condurla in Piazza de'Signori. Per che Giuliano da San Gallo et Antonio suo fratello fecero un castello di legname fortissimo e quella figura con i canapi sospesero a quello, acciò che scotendosi non si troncasse, anzi venisse crollandosi sempre; e con le travi per terra piane con argani la tirorono e la missero in opera. Fece un cappio al canapo che teneva sospesa la figura, facilissimo a scorrere, e stringeva quanto il peso l'agravava, che è cosa bellissima et ingegnosa, che l'ho nel nostro libro disegnato di man sua, che è mirabile, sicuro e forte per legar pesi.

Nacque in questo mentre che, vistolo su Pier Soderini, il quale, piaciutogli assai et in quel mentre che lo ritoccava in certi luoghi, disse a Michelagnolo che gli pareva che il naso di quella figura fussi grosso. Michelagnolo, accortosi che era sotto al gigante il Gonfalonieri e che la vista non lo lasciava scorgere il vero, per satisfarlo salì in sul ponte che era accanto alle spalle, e preso Michelagnolo con prestezza uno scarpello nella man manca con un poco di polvere di marmo che era sopra le tavole del ponte e cominciato a gettare leggieri con gli scarpegli, lasciava cadere a poco a poco la polvere, né toccò il naso da quel che era. Poi guardato a basso al Gonfalonieri, che stava a vedere, disse: "Guardatelo ora." "A me mi piace più," disse il Gonfalonieri; "gli avete dato la vita." Così scese Michelagnolo, e lo avere contento quel signore che se ne rise da sé Michelagnolo, avendo compassione a coloro che, per parere d'intendersi, non sanno quel che si dicano; et egli, quando ella fu murata e finita, la discoperse. E veramente che questa opera ha tolto il grido a tutte le statue moderne et antiche, o greche o latine che elle si fussero; e si può dire che né 'l Marforio di Roma, né il Tevere o il Nilo di Belvedere o i giganti di Monte Cavallo le sian simili in conto alcuno, con tanta misura e bellezze e con tanta bontà la finì Michelagnolo. Perché in essa sono contorni di gambe bellissime et appiccature e sveltezza di fianchi divine, né ma' più s'è veduto un posamento sì dolce, né grazia che tal cosa pareggi, né piedi né mani né testa che a ogni suo membro di bontà, d'artificio e di parità né di disegno s'accordi tanto. E certo chi vede questa non dee curarsi di vedere altra opera di scultura fatta nei nostri tempi o negli altri da qual si voglia artefice.

N'ebbe Michelagnolo da Pier Soderini per sua mercede scudi 400, e fu rizzata l'anno 1504. E per la fama che per questo acquistò nella scultura fece al sopradetto gonfalonieri un Davit di bronzo bellissimo, il quale egli mandò in Francia." (Barocchi, ed., 1962–72, I, 19–23).

"Some of Michelagnolo's friends wrote from Florence urging him to return, as they did not want that block of marble on the opera to be spoiled which Piero Soderini, then gonfaloniere for life in the city, had frequently proposed to give to Lionardo da Vinci, and then to Andrea Contucci, an excellent sculptor, who wanted it. Michelagnolo on returning tried to obtain it, although it was difficult to get an entire figure without pieces, and no other man except himself would have had the courage to make the attempt, but he had wanted it for many years, and on reaching Florence he made efforts to get it. It was nine braccia high, and unluckily one Simone da Fiesole had begun a giant, cutting between the legs and mauling it so badly that the wardens of S. Maria del Fiore had abandoned it without wishing to have it finished, and it had rested so for many years. Michelagnolo examined it afresh, and decided that it could be hewn into something new while following the attitude sketched by Simone, and he decided to ask the wardens and Soderini for it. They gave it to him as worthless, thinking that anything he might do would be better than its present useless condition. Accordingly Michelagnolo made a wax model of a youthful David holding the sling to show that the city should be boldly defended and righteously governed, following David's example. He began it in the opera, making a screen between the wall and the tables, and finished it without anyone having seen him at work. The marble had been hacked and spoiled by Simone so that he could not do all that he wished with it, though he left some of Simone's work at the end of the marble, which may still be

seen. This revival of a dead thing was a veritable miracle. When it was finished various disputes arose as to who should take it to the piazza of the signori, so Giuliano da Sangallo and his brother Antonio made a strong wooden frame and hoisted the figure on to it with ropes; they then moved it forward by beams and windlasses and placed it in position. The knot of the rope which held the statue was made to slip so that it tightened as the weight increased, an ingenious device, the design for which is in our book, showing a very strong and safe method of suspending heavy weights. Piero Soderini came to see it, and expressed great pleasure to Michelagnolo who was retouching it, though he said he thought the nose large. Michelagnolo seeing the gonfaloniere below and knowing that he could not see properly, mounted the scaffolding and taking his chisel dexterously let a little marble dust fall on to the gonfaloniere, without, however, actually altering his work. Looking down he said, "Look now." "I like it better," said the gonfaloniere, "you have given it life." Michelagnolo therefore came down with feelings of pity for those who wish to seem to understand matters of which they know nothing. When the statue was finished and set up Michelagnolo uncovered it. It certainly bears the palm among all modern and ancient works, whether Greek or Roman, and the Marforio of Rome, the Tiber and Nile of Belvedere, and the colossal statues of Montecavallo do not compare with it in proportion and beauty. The legs are finely turned, the slender flanks divine, and the graceful pose unequalled, while such feet, hands and head have never been excelled. After seeing this no one need wish to look at any other sculpture or the work of any other artist. Michelagnolo received four hundred crowns from Piero Soderini, and it was set upon in 1504. Owing to his reputation thus acquired, Michelagnolo did a beautiful bronze David for the gonfaloniere, which he sent to France . . . " (Hinds and Gaunt, 1963, IV, 115–17).

Fig. 73. Mario Ceroli, "Casa di Nettuno." Palazzo Comunale, Bologna (photo: Guerra, Bologna).

The restoration of a public work of art, often considered a matter of common decency or communal pride, is also much more. In spending time, money, and energy on something old, we enter into a new relationship with the past, signing a new contract with our predecessors who, we recognize, implicitly or explicitly, now speak to us with greater cogency and insistence than before. Historicism repeats itself in a special way when this communication between past and present concerns a work already replete with historical resonances. Such is the case with the restoration of Giambologna's Neptune fountain in Bologna (see Figs. 87–90; Plate III), which was recently celebrated at the inauguration of an international art history colloquium devoted to Bologna as a cultural crossroads.

In restoring the Neptune fountain, Bologna also created a new work of art, for the renovation of this public monument became a public monument in its own right. The grandiose wooden structure, full of poetic allegory and wit, built to house the operation on Giambologna's bronze hero (Fig. 73) and the spectacle of popular pedagogy enacted in the building to demonstrate the technical procedure itself (Fig. 74) were a Postmodern reprise of the famous wooden anatomical theater erected in the Archiginnasio not long after the Neptune fountain was created.[1] The art of restoration as a work of art is an astonishing and revolutionary idea, reminiscent of such Bolognese inventions as Galvani's electrochemical action or Marconi's telegraph. *Bononia Docet* (Bologna teaches)!

This motto of the medieval city expresses the millennial role Bologna has played in the exchange of ideas, as a matter of course and as a matter of principle: as a matter of course because of Bologna's position as a major commercial center at the intersection of the Via Flaminia and the Via Emilia, two ancient roads linking Italy to Northern Europe, and as a matter of principle through Bologna's great university, the oldest in Europe (the name, Archiginnasio, distinguished it from all other schools except the university of Rome). Bologna was unique in adopting as its own two mottos pertaining to the university, *Bononia Docet* and *Bononia Mater Studiorum* (Bologna, mother of studies), which were carried around the world inscribed on the new coinage issued after the city became an autonomous republic in the late fourteenth century (Figs. 75, 76). The legends were on the obverse with the emblem of the

Fig. 74. Restoration demonstration, "Casa di Nettuno." Palazzo Comunale, Bologna (photo: Magic-Vision, Bologna).

commune, a rampant lion holding the vexillum of the cross. The reverses associated the university and the commune with the church of Rome, represented by St. Peter, shown standing, the keys to the Kingdom of Heaven in his right hand, a book in his left; and with the church of the city, represented by its patron St. Petronius, shown enthroned holding a model of Bologna in his right hand, a bishop's crozier in his left.[2] No other city identified itself in this way, through a cultural institution, with the life of the mind and the transmission of thought. In view of this singular tradition of intellectual communication, greatly magnified by Bologna's activity in international trade, it is not surprising that from the early sixteenth century the city was rife with notions of religious reform. Alarmed by the situation, the newly appointed inquisitor sent by the Holy Office reported in 1549 that he found Bologna "a great tissue of heresies" ("una grande intrecciatura di heresie").[3]

Less than twenty years later the city was transformed, physically, administratively, and spiritually, partly by the actions of the Inquisition itself and partly through a major program of public works and the reorganization of public services. These changes were brought about under the aegis of Pope Pius IV, who had studied law in Bologna and had served as papal vice-legate to the city the year before the inquisitor made his observation and whose greatest achievement as pope was to have brought the Council of Trent to a successful conclusion in 1563.[4] The transformation was such that by 1565 in a projected honorific statue of the pope the claim could be made that the heresies had been crushed.

Giambologna's Neptune fountain reflects the city's tradition as a cultural crossroads at this crucial moment in its history, for reasons that go beyond the fact that the artist was an immigrant to Italy from his native Flanders. It is remarkable that a relatively unknown and inexperienced foreign sculptor who had been living in Florence was awarded a major public commission for the most important city in the Papal States after Rome. Historians have been content with the explanation in early sources: that Giambologna had participated in the competition for the great Neptune fountain in the Piazza della Signoria in Florence, awarded to Bartolommeo Ammanati even though it was generally agreed that Giambologna's was the best project.[5] His reputation established by this *succès manqué*, Giambologna came

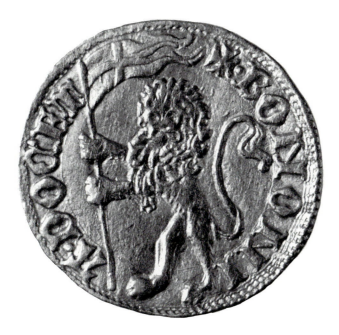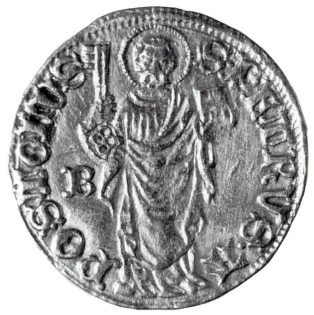

Fig. 75. Bolognino d'oro, *Bononia Docet* with rampant lion holding vexillum, St. Peter, standing, holding keys and book. Museo Civico, Bologna.

to the attention of the vice-legate to Bologna, who hired him for the task. These accounts, however plausible, tell only part of the story; the rest can be discerned in the larger context of politics and ideology to which the projects sponsored by Pius IV owed their origin.

Important inferences can be drawn from the particular circumstances in which the fountain was conceived, and its relation, only recently rediscovered, to two other works by Giambologna that were commissioned but never completed; the sculptures would have formed a monumental civic triumvirate. We owe this work of scholarly restoration, fundamental to our understanding of Bolognese art of the late Renaissance, to Richard Tuttle, who found a manuscript describing these and other projects. It was written by Pier Donato Cesi (1522–1586), bishop of Narni and vice-legate in Bologna of Pius IV's cardinal legate, Carlo Borromeo, who resided in Rome; Cesi governed Bologna between 1560 and 1565.[6] An enterprising and learned man who had studied in Bologna under Andrea Alciati, the renowned scholar of pagan mythology, Cesi commissioned many works of public utility at the pope's behest or with his approval. The projects included

rechanneling a flood-prone river near Bologna; reorganizing the grain supply to ensure against famine; renovating the residence of the apostolic legate (Palazzo Comunale); decorating the chapel of the apostolic residence; creating a poorhouse for Bologna; constructing the university building, the Palazzo dell'Archiginnasio, which included a statue of Mercury on a tall column to be placed in the courtyard; reorganizing and consolidating the city's meat markets; constructing a new aqueduct to augment the water supply at the center of the city, where two fountains were erected—Fontana Vecchia and the Neptune fountain—one an architectural work attached to the palace of the vice-legate, the other standing free in a newly created piazza adjoining the Piazza Maggiore in front of the church of San Petronio; and, finally, creating a portrait statue of the enthroned pope to be placed before the university building in another newly created piazza on the east flank of San Petronio (Fig. 77).

Work on these various enterprises continued for years. Some projects were never finished, and they can scarcely have been conceived all at once. Yet Cesi certainly saw them as a coherent achievement, and as his stay in Bologna came to an end he com-

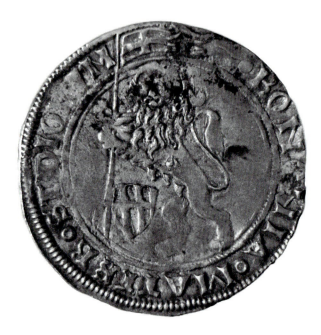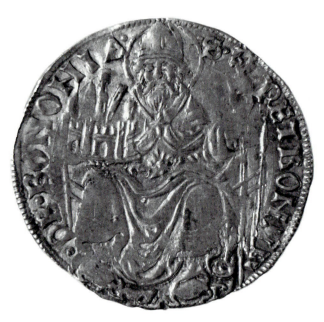

Fig. 76. Grossone, *Bononia Mater Studiorum* with rampant lion holding vexillum; St. Petronius, enthroned, holding model of Bologna and bishop's crozier. Museo Civico, Bologna.

posed his memorial, addressed to the pope, which must be among the first such documents devoted to an extensive civic building program. A series of commemorative medals illustrated each project, an idea derived from the Roman imperial tradition, revived by the Renaissance popes, of celebrating public works by issuing medals. Cesi himself cites the classical precedent, but whereas the ancient medals were issued occasionally or *seriatim*, Cesi's form a closely related group intended to complement his text, which is itself accompanied by drawings of the medallic representations.[7] Altogether Cesi's enterprises are a milestone in the history of what might be called self-conscious urban renewal, social as well as monumental.

Of the three sculptural projects in the program (the statue of the pope, the figure of Mercury, and the fountain of Neptune) only the Neptune fountain, the first to be begun, was carried out; the others were virtually forgotten until the discovery of Cesi's manuscript made it possible to restore all of them to their proper collective place in history.[8] The relationship between the papal statue and the *Neptune* is evident from the record of payments for expenses, which indicates that Giambologna himself

brought the models to Rome for the pope's inspection and approval.[9] All three monuments, grouped around the city's major public square, were conceived to complement one another; together they express not only the pope's relationship to his second city but also the city's relationship to the world at large. To convey these meanings, each sculpture incorporates specific traditions, from which it also departs radically in ways that reflect the common bond between them. The papal portrait states the spiritual and political theme that underlies the whole program. The statue of Mercury provides a key to much of the classical imagery, including that of the Neptune fountain, intended to reassert the ancient Christian message in modern allegorical form. The fountain is the most spectacular of the monuments. It stands literally at the ancient crossroads of the city, facing San Petronio and flanked by the palaces of the vice-legate and the commune, the seats of ecclesiastical and secular power.[10]

Traditional honorific portraits of the enthroned pope might show him holding the (modest-size) keys of St. Peter or a book in his left hand, but the right hand was invariably raised in a gesture of

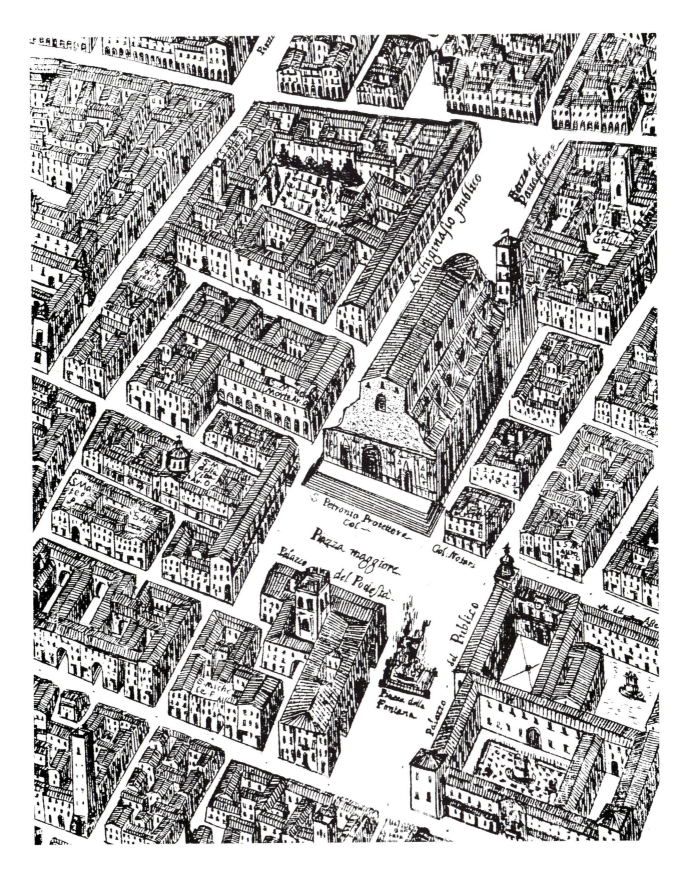

Fig. 77. Filippo Gnudi, "Ichnoscenografia" of Bologna, 1702,
detail showing the fountain of Neptune, palaces of the vice-legate
(del Publico) and the commune (del Podestà), Piazza Maggiore,
S. Petronio, and the Archiginnasio. Piante di Bologna, cart. 2, n.
21/E, Biblioteca Comunale del Archiginnasio, Bologna.

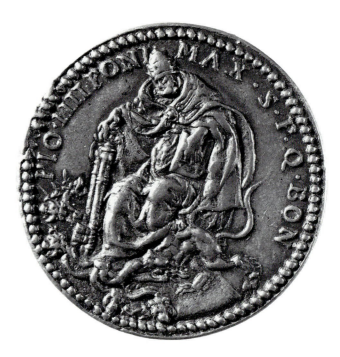

Fig. 78.　Attributed to Girolamo Faccioli, medal of Pius IV. Private collection, Vienna.

blessing. Giambologna showed him holding a book in his left hand but a gigantic pair of keys in his right hand, with which he crushes underfoot the many-headed monster of heresy (Figs. 78, 79).[11] Normally a ruler holds his scepter in his right hand, or a commander his sword or baton. Cesi explains that the two keys signify the pope's unique power both to decide what is sinful and to absolve those who are guilty. The book indicates that judgment is passed on the authority of doctrine. The senate and people of Bologna dedicated the monument to Pius for crushing heresy by the Council of Trent and for the adornments by which he conferred dignity on the city.[12]

We are thus confronted not with the usual beneficent and benign Holy Father but with the vengeful ruler and judge who silences the voices of heresy and rebellion. The pope's aggressive presence was magnified by a voluminous and billowing robe, and a powerful sideward twist of the body. The implications of such an awesome image at the entrance to an institution where scandalous ideas circulated actively would not have been lost on any contemporary viewer. The dangers inherent in the cosmopolitan intellectual ambience of the university

must have been one of the chief motives for building the new building in the first place. Previously dispersed around the city, the various components of the university were brought together so they could be more easily surveyed and controlled.[13] The process of consolidation, organization, and dominance was thus equally evident in the intellectual, social, and commercial spheres.

Although Cesi identifies the many-headed monster at the pope's feet as the Beast of the Apocalypse, it recalls the Hydra, and the pope wielding the massive keys to crush the enemy recalls Hercules's victory over that multifarious enemy with his heroic club. Given this association, Tuttle convincingly suggested that Giambologna's project referred explicitly to the great terracotta sculpture by Alfonso Lombardi in the Palazzo Comunale of Bologna that shows Hercules seated in triumph over the Hydra, holding the club at his side (Figs. 80, 81).[14] (Originally the defeated animal was a lion, no doubt the lion rampant that symbolized Bologna as a free commune. To avoid the potentially awkward pun on Leo X's name [*leo* = lion in Latin], the victim was changed to the Hydra.) We know from an early source that Lombardi's figure, executed in 1513,

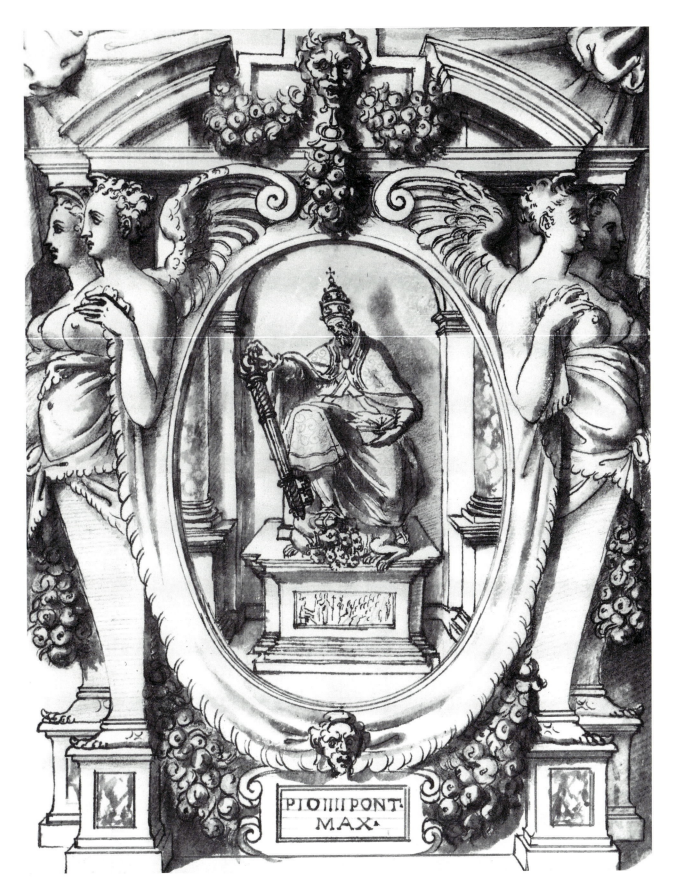

Fig. 79. Statue of Pius IV, drawing. MS A III inf., fol. 54.,
Biblioteca Ambrosiana, Milan.

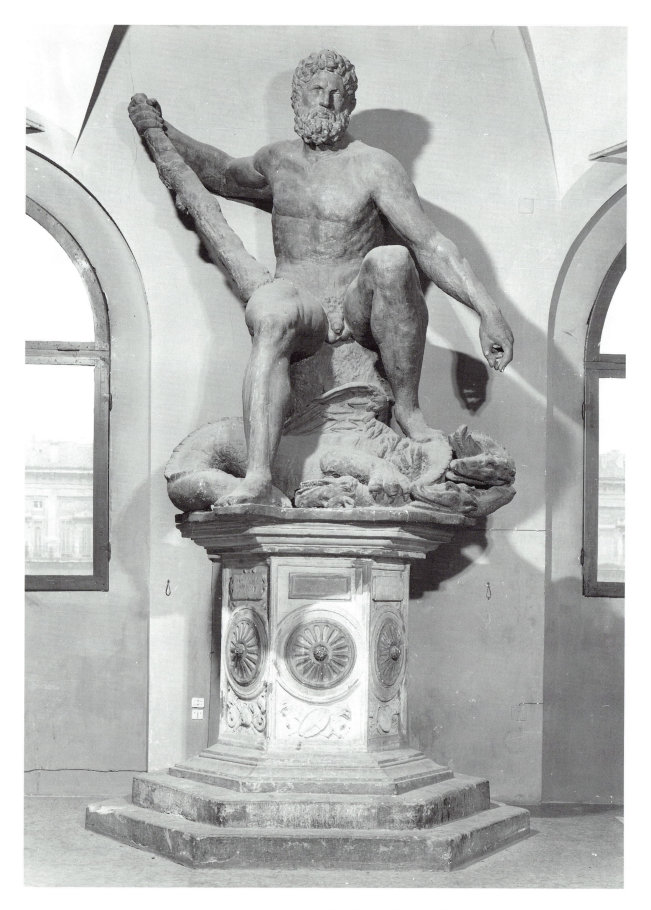

Fig. 80. Alfonso Lombardi, seated Hercules, terracotta. Palazzo Comunale, Bologna (photo courtesy Norberto Gramaccini).

Fig. 81. Detail of Fig. 80 (photo courtesy Norberto Gramaccini).

embodied a highly charged political allegory: the Hydra was the Bentivoglio family, whose repeated attempts to recapture Bologna were finally ended in 1513, when under the Medici pope Leo X Bologna was returned definitively to papal rule.[15] Alfonso's statue, which parallels the Medici adoption of Hercules as the emblem of their dominion over Florence, was always prominently visible in the Palazzo Comunale, the residence of the papal legate; it served as a civic allegory of papal dominion in a city whose tradition of learning made its significance inescapable. Pius IV's family name was Medici, and although not related to the Medici of Florence, he was their protégé and had adopted their coat of arms at the invitation of Cosimo I; so the political implication of Giambologna's reference to Leo X had a personal aspect as well.

Another important model for Giambologna may be discerned through his reference to Lombardi's sculpture. Lombardi's desire to make the analogy between Leo X and Hercules must have motivated him to show the figure seated and triumphant: the pose associated the ancient hero with the familiar tradition of papal portraits in which the pontiff is enthroned. Lombardi's allusion to Michelangelo's

bronze statue of the enthroned Julius II, destroyed in 1511 when the Bentivoglio had last occupied the city, was surely intentional. Michelangelo's figure was notorious because its vigorous action (*atto gagliardo*) served, as the artist himself proclaimed, "to threaten the people, lest they be foolish" ("Minaccia, Padre Santo, questo popolo, se non è savio").[16] The bronze statue of Pius IV also evokes Michelangelo's lost image, which Giambologna seems to have reconstructed, appropriately enough, on the basis of the *Moses* on Julius's tomb, especially for the turn of the body and the action of the legs. In combining Lombardi's mythic hero with Michelangelo's wrathful pontiff, Giambologna related both exemplars to the contemporary religious and political threats to the church (particularly at an intellectual center such as Bologna), which the Council of Trent was intended to crush. Even the reference to Hercules had an intellectual and moral meaning, based on an ancient tradition in which the Hydra was equated with the Sophists, and the victory was won not by physical force but by virtuous philosophy over false reason.[17] Pius's keys and book replace the power of pagan ethical thought with that of Christian doctrine.

◆ ◆ ◆

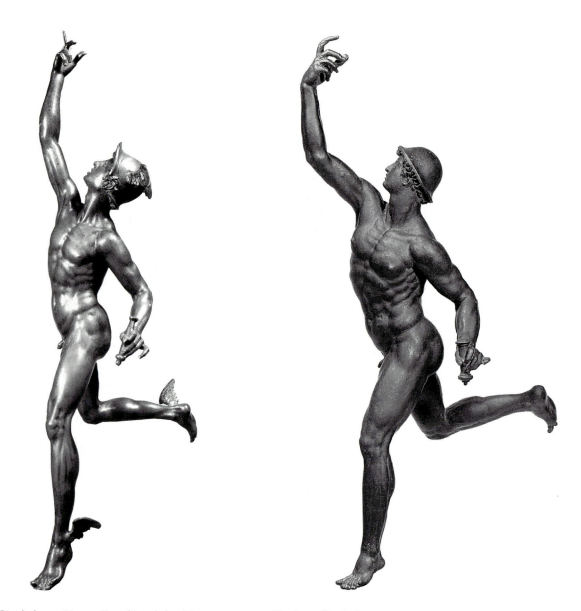

Fig. 82. Giambologna, *Mercury.* Kunsthistorisches Museum, Vienna (photo: Institut Royal du Patrimoine Artistique, Brussels, B106586).

Fig. 83. Giambologna, *Mercury.* Museo Civico, Bologna.

A major revelation of Cesi's memorial is that he intended for the courtyard of the new university building a tall marble column surmounted by a figure of Mercury, messenger of the gods and teacher of the arts and science to men.[18] Apart from resolving the question of the origin of Giambologna's renowned figure of Mercury, the information provided by Cesi solves another problem concerning the sculpture that has always puzzled scholars. As it is most commonly known, the *Mercury* is a lithe, zephyr-borne figure spiraling upward, his face lifted toward the culminating gesture of his upward-pointing index finger (Fig. 82).[19] The figure defies the laws of gravity, a weightless aerial bronze. This

work, commissioned as a gift from Duke Cosimo de' Medici to the emperor Maximilian II, portrayed Mercury as messenger of the gods carrying Cosimo's homage to the emperor as the Olympian Jupiter.

Mystery has surrounded the magnificent version in the Museo Civico in Bologna which, although obviously related, does not at all conform to this type of Mercury rising (Fig. 83). The body is much heavier, more athletic; the glance is lower; and the index finger points back rather than up. The Bologna bronze evidently is not a study for the later Medici commission, as has been assumed, but rather the model for the figure intended for the university, which Cesi describes as *descending*, rather than ascend-

Fig. 84. Logo of the publisher Giovanni Rossi, Mercury with the motto *Coelo Demissus ab Alto* (from Regoli, 1563).

ing to heaven. Cesi explains that Mercury was an ancient symbol of reason and truth, and the statue would remind students that wisdom flowed from heaven as a gift of God. Giambologna's muscle-bound Mercury in Bologna is thus earthbound, like an annunciating angel, and he indicates not the addressee but the source of his "academic" lesson, complementing the religio-political message expressed by the papal monument itself.

Cesi's description of the figure as descending confirms another of Tuttle's proposals, that Giambologna's invention must have been related to an analogous depiction of the flying Mercury as the logo of one of the leading printers of Bologna,

Giovanni Rossi (Fig. 84).[20] The motto that accompanies the image in many of Rossi's editions, *Coelo Demissus ab Alto*, "sent down from high heaven," expresses the idea of a heaven-sent message that Giambologna's figure was also meant to convey.[21] The inscription on Rossi's logo identifies the concept as a conflation of two familiar texts of Virgil, essential to the Christian interpretation of ancient history. The Virgilian scheme, in fact, underlies the grand conception of all three of Giambologna's sculptures for Bologna.[22]

In the first book of the *Aeneid*, when Aeneas and his companions set sail from burning Troy to establish his race and religion at Rome, Juno, angry and

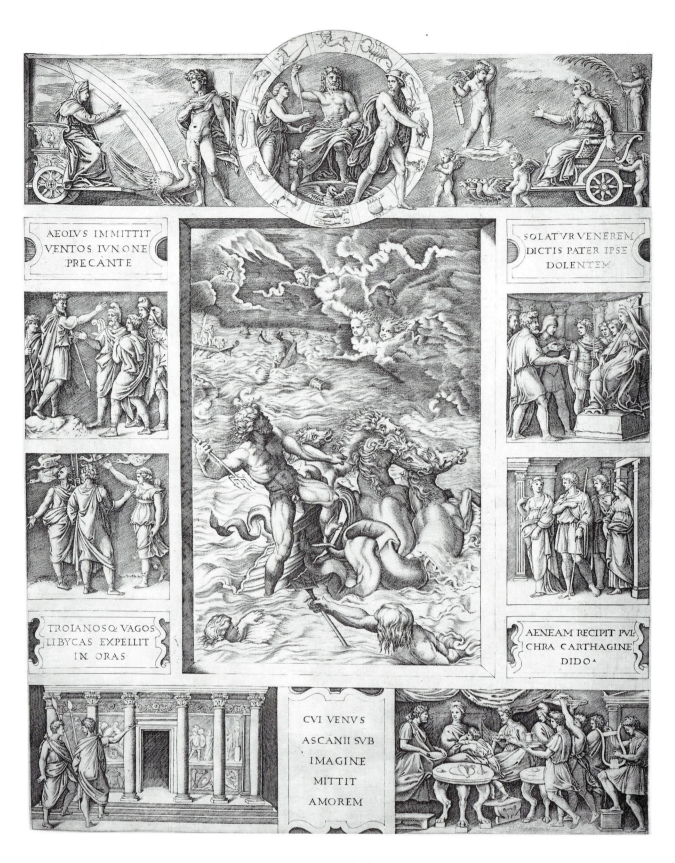

Fig. 85. Marcantonio Raimondi, Neptune calming the waters ("*Quos ego——!*") and other episodes from the *Aeneid*, Book I, engraving.

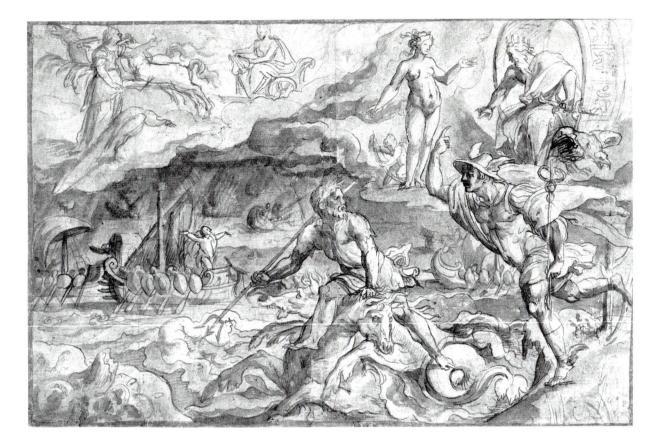

Fig. 86. Genoese, sixteenth century, *Neptune calming the waters* ("*Quos ego——!*"), drawing. National Gallery of Scotland, Edinburgh.

jealous, persuades Aeolus to raise the winds and destroy Aeneas's fleet. Angered at the usurpation of his power over the seas, Neptune quells the storm, uttering the imperious expletive "*Quos ego——!*" with which he confronts his adversaries.[23] Here Virgil, in an obvious political allusion to Caesar Augustus, likens Neptune's act to that of a ruler who calms an unruly populace.[24] After Aeneas takes refuge on the shore of Africa, Venus, his mother, intercedes with Jupiter on behalf of her son. Jupiter renews his promise to establish Rome, and as his first step sends Mercury down (*demittit ab alto*) to urge the Carthaginians and Queen Dido to relinquish all thoughts of hostility and accept Aeneas with good will.[25]

From earliest Christian times the *Aeneid* had been understood as an allegory of the universal dominion of the Church, and the three episodes—Neptune calming the seas, Jupiter yielding to Juno's pleas, and Mercury converting the Carthaginians—were critical moments of divine intervention, ensuring the realization of God's plan to save mankind. Neptune's pacification, Jupiter's command, and Mercury's persuasion assured the establishment of the Roman empire and religion, which prepared for the dominion of Christianity. These acts of providence had been singled out before in an engraving by Marcantonio Raimondi after a composite design by Raphael (Fig. 85) and, merged as a coherent narrative scene, in a fresco by Raphael's pupil Pierino del Vaga that once decorated the villa in Genoa of Andrea Doria, the great naval hero in the struggle against the Turks (Fig. 86).[26] The latter instance is particularly significant since Mercury's pose, including the finger pointing up and back toward Jupiter, anticipates and explains that of Rossi's bookplate. This Virgilian theme must have seemed relevant to the program of public statuary at Bologna, the city of learning *par excellence*, where Pope Pius would readily be identified through Virgil's familiar and prophetic epithet for his hero, "pious" Aeneas.

Rossi's motto contains the word "*coelo*," which

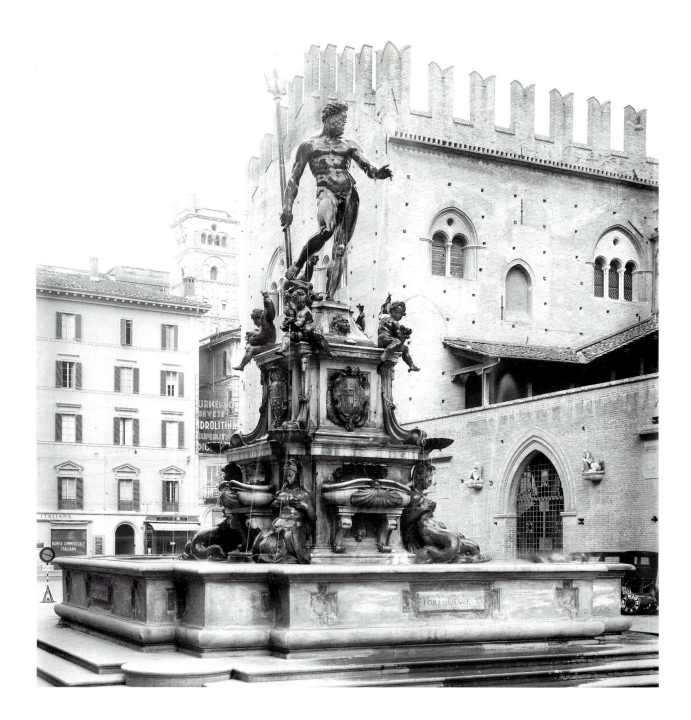

does not occur in the *Aeneid* passage; the full meaning of the image depends on the striking coincidence of phrasing in the passage recording Jupiter's charge to Mercury in the *Aeneid* and another, perhaps even more significant, Virgilian text. In the fourth Eclogue the poet speaks of the birth of a new age, the return of a virgin, and the descent of a new generation from on high. The passage was seen as the one text of pagan antiquity that clearly foretold the birth of Christ and the coming of Christianity. In the last verse of the prophecy the words used in the *Aeneid* when Jupiter dispatches Mercury

to Dido are preceded by a direct reference to heaven, *caelo demittitur alto*.[27] The coincidence of phrasing must have seemed to confirm the divine inspiration of the Virgilian texts, which Rossi applied to the knowledge borne by the messenger of the ancient gods and incorporated in his books. Giambologna's *Mercury* was intended to bear the same message of divinely inspired knowledge.

The Neptune fountain broke with tradition in almost every aspect of both form and content (Figs. 87–90; Plate III). The basic design established a

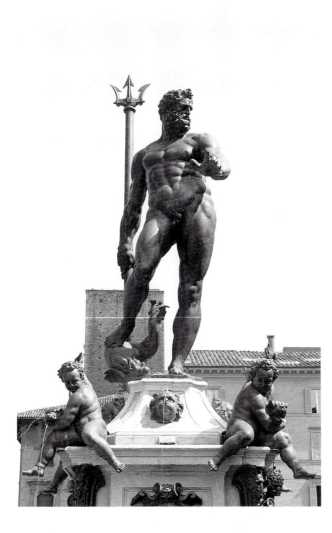

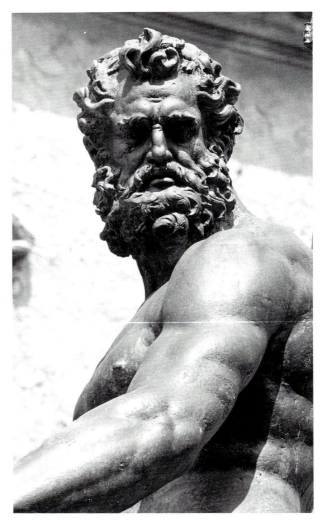

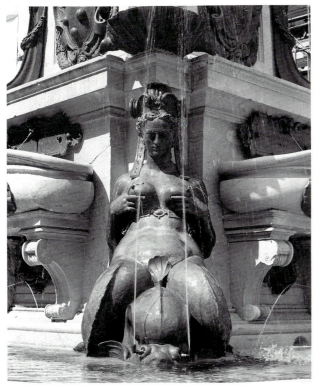

Fig. 87 (*opposite*). Giambologna, Fountain of Neptune. Piazza del Nettuno, Bologna (photo: Anderson 40510).

Fig. 88 (*above, left*). Detail of Fig. 87 (photo: Fanti, Bologna).

Fig. 89 (*above, right*). Detail of Fig. 87 (photo: Fanti, Bologna).

Fig. 90 (*left*). Detail of Fig. 87 (photo: Fanti, Bologna).

Fig. 91 (*above*). Pharos of Alexandria, hemidrachm of Domitian. American Numismatic Society, New York.

Fig. 92 (*right*). *Neptune and Amphitrite* (from Cartari, 1647, 135).

Fig. 93 (*opposite*). Bartolommeo Ammanati, Fountain of Neptune. Piazza della Signoria, Florence (photo: Brogi 3056).

new fountain type, with the figure raised on a high, two-storied architectural base.[28] The traditional architectural base for statuary employed either a tall column or a relatively low pedestal; the latter formula had generally been followed for fountains with a raised central figure (cf. Figs. 93, 97).[29] In the so-called kylix fountain the predominant figure or group might be mounted on a tall support, but this support was a nonarchitectural, sculptured shaft with an elevated basin that resembled an ancient wine goblet. A striking precedent for a high, rectangular, two-storied architectural pedestal for a statue of Neptune is the fabled Pharos, or lighthouse, of Alexandria, one of the wonders of the ancient world.[30] Apart from many classical and medieval textual sources, the monument was recorded on a number of Alexandrian coins, which show the corners of the upper story decorated with figure sculptures and, on top, a statue of a standing deity, often taken for Neptune (Fig. 91). The Pharos of Alexandria was one of the great engineering feats of antiquity, renowned not only for its size but also for the complex mechanisms by which it functioned. (With some ninety water jets the Neptune fountain is itself a notable feat of hydraulic engineering.) This recondite recollection of the primary symbol of the intellectual capital of the ancient world would not have been lost in the city whose university, Cesi claimed, was the foremost in Europe.[31]

In his pioneering manual on the images of the ancient gods, first published in 1556, Vincenzo Cartari includes a depiction of the triumph of Neptune and his consort, Amphitrite (Fig. 92).[32] The pair is accompanied by two vignettes, copied from ancient gems, illustrating the dual nature of the god of the seas. Another great art theoretician of the next generation, Gian Paolo Lomazzo, describes Neptune as "now tranquil, quiet and pacific, now all turbulent."[33] In representations of the first of these ancient types the god stands calmly with his trident at his side, one leg, bent forward at the knee, resting on a support that might take the form of a dolphin; in the other he drives his wave-crashing steeds, angrily brandishing his weapon to stir up the waters. Neptune became a popular subject for fountain sculptures in the second quarter of the sixteenth century, and Giambologna's predecessors reflected the alternative interpretations noted by Cartari:

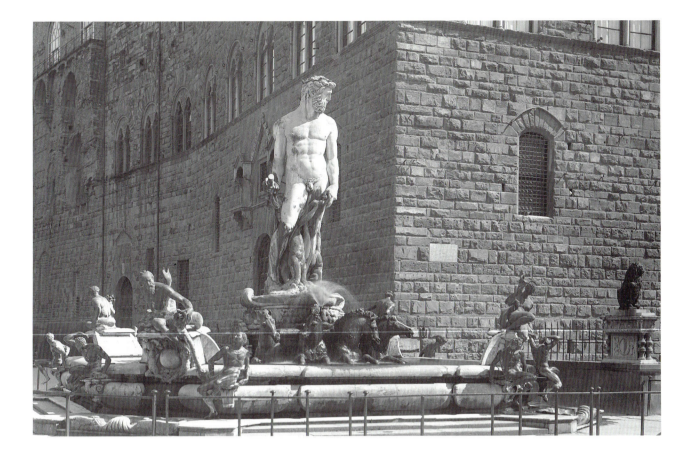

they showed the god either in relatively stiff, firmly grounded, and frontally oriented poses (see Figs. 93, 97) or else actively wielding his trident in a dramatic tableau.[34] Both versions had been adapted to the Virgilian "*Quos ego——!*" theme, by showing the figure raising a hand in an imperious gesture of suppression (Fig. 97) or fiercely subduing the sea by spearing it with his trident.[35]

Giambologna, in effect, combined these two seemingly incompatible types in a single figure. It is important to observe how and why this merger of opposite states of being is brought about.[36] Neptune bends his right leg back and out to the side rather than straight forward, and throws his left hip forward and out to the opposite side. The right arm extends down and back, the left up and forward. These complex interactions and projections impart to the standing figure a continuous spiraling movement that penetrates the surrounding space in all directions.[37] In this way, the stasis proper to statuary is combined with the motion proper to dramatic action and the *Neptune* becomes both a *statua* and a *historia,* merging the two categories that for Renaissance theoreticians of art were distinct.[38]

Underlying these formal innovations is a fundamental reinterpretation of the theme. Neptune's pose indicates that he is stepping down to the side, toward the city's great central square, the Piazza Maggiore. Having ridden into the center of Bologna on his undulating steed, he *descends* majestically to his pedestal to receive the adulation of the populace. The motion here parallels that of the water itself, carried through the aqueduct and the fountain to the city square. The descent is divine, and as such it corresponds to the action of the *Mercury* intended for the courtyard of the university. In both works the idea of descent from on high alluded to papal patronage as well as to the divine origin of all true knowledge.

The gestures of Giambologna's figure also involve a meaningful revision of predecessors. In the colossal marble Neptune carved by Ammanati, who won the commission for the fountain in Florence (Fig. 93), the giant figure rides his chariot as if in imperial triumph, and he holds in his right fist not a trident but the handle of a leather-thonged whip, in a distinctly menacing way. This theme sheds light on the significance of the small bronze preliminary model

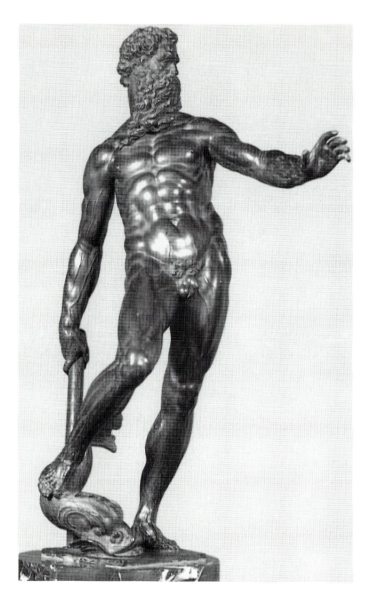

Fig. 94 (*right*). Giambologna, *Neptune*. Museo Civico, Bologna.

Fig. 95 (*opposite, left*). Emperor Commodus as Hercules. Vatican Museum, Rome (photo: Musei Vaticani XXXIV-14-51).

Fig. 96 (*opposite, right*). Giambologna, medal of Pius IV. Museo Civico, Bologna.

by Giambologna in the Museo Civico of Bologna (Fig. 94). Here Neptune holds a huge commander's baton in his right hand, as if it were a weapon he is about to wield. In fact, the motif recalls a famous colossal statue of the emperor Commodus as Hercules (Fig. 95), just as Hercules imagery permeated the monument to Pope Pius.[39] A religious import is also evident here in the patent similarity of the face and flowing beard to those of Michelangelo's Moses, consonant with the reference to Moses in the seated figure of Pius IV. Neptune, of course, governed all waters, not just the sea, and, like Moses with his "rod of God," Neptune with his trident could strike water from a rock. Seen in this guise, the Neptune-Moses figure might well have been understood as bidding the waters to gush forth. In the final version the trident was substituted for the baton and,

as if in compensation, the resemblance to Moses was suppressed in favor of a physiognomy like that of Hercules (cf. Figs. 81, 89, 95). Neptune holds the trident as if he were about to hurl the weapon, according to Cesi, who, echoing Virgil's political implication, compares the action to that of the ruler who would liberate his subjects from all fear of disturbances and agitation.[40] If we recall that the trident is a pun on the Tridentine Council, we can hear the religious undertone, especially through the further pun, inscribed on the medal commemorating the fountain, relating the pope's name to the waters of baptism: *Aqua Pia* (Fig. 96).[41]

Giambologna owed a further debt to Giovanni Montorsoli, who in his Neptune fountain in Messina evoked the theme of Neptune stilling the waters through the gesture of the right arm and

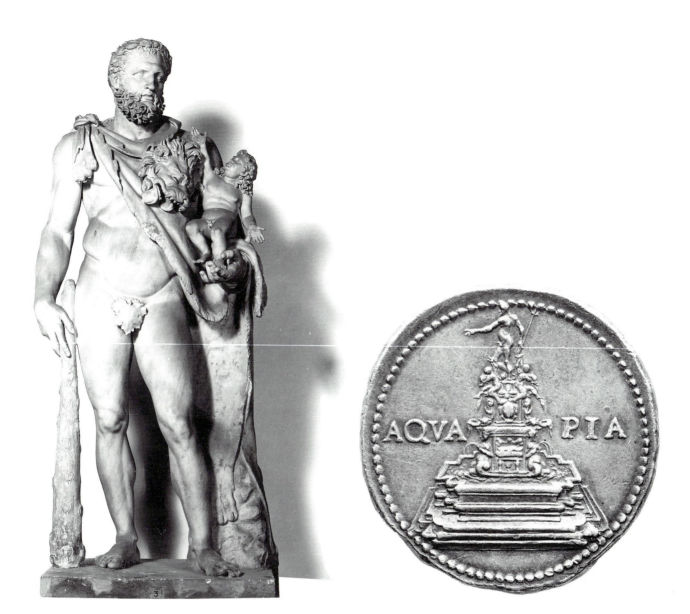

hand (Fig. 97).[42] The stiff salute seems appropriate to the fountain's purpose: to commemorate the emperor Charles V's naval victories over the Moslems. The gesture of Giambologna's Neptune is entirely different, however: the arm is more relaxed, and the fingers uncurl in a gentle, insinuating sequence. The action evokes, above all, the equestrian statue of Marcus Aurelius in Rome (Fig. 98), which, more than any other ancient work, had strong positive associations from the Middle Ages, when it was identified as Constantine the Great. It retained these associations when it was reidentified in the Renaissance as the noble-minded philosopher-emperor considered to be the pagan embodiment of Christian virtue. The gesture, in particular, was much appreciated and discussed and was explained almost universally as expressive of pacification.[43]

Indeed, there could hardly be a better definition of the effect of benign nobility, at once firm and reassuring. The outstretched arm is, in fact, a grand rhetorical gesture of persuasion, whose applicability to Neptune was inspired, or at least reinforced, by the Christian tradition of moralizing interpretations of the pagan deities. In this tradition Neptune was understood to personify intelligence and reason, precisely because he calmed the seas in the first book of the *Aeneid*.[44] The interpretation is analogous to that of Hercules and the Hydra which underlay Giambologna's treatment of the statue of Pius IV. In contrast to all his predecessors Neptune here does not achieve his end by command or violence. Emulating the passage in which Virgil likens the "*Quos ego——!*" episode to the ruler swaying the angry rabble with his speech, Giambologna's sea god

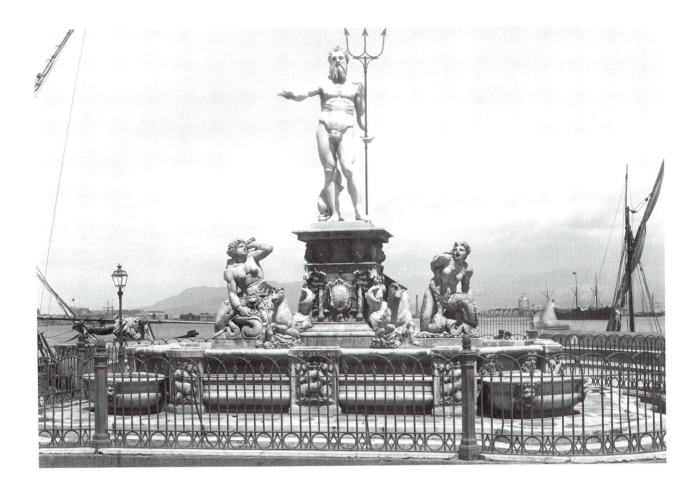

Fig. 97. Giovanni Montorsoli, Fountain of Neptune. Messina (photo: Alinari 19742).

Fig. 98. *Marcus Aurelius*. Piazza del Campidoglio, Rome (photo: Deutsches Archäologisches Institut, Rome).

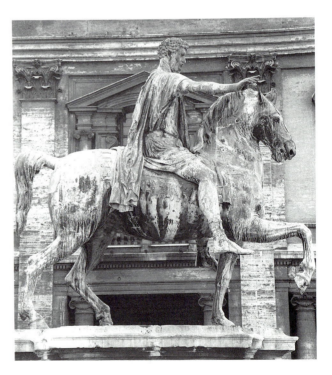

soothes the forces of sedition by the subtle power of persuasion.[45]

Cesi considered the study of eloquence and wisdom primary to human society, a point of view that brings into sharp focus other major elements of the Neptune fountain's decoration.[46] Putti embracing dolphins are a common expression of love, partly derived from the ancient stories, cited by Cesi, of affection between these animals and young boys (see Fig. 88).[47] The water spouting from the animals' mouths recalls the dolphin as an emblem of persuasion (dolphins had induced Amphitrite to leave her island refuge and become Neptune's consort).[48] Cesi observes that the sirens, too, were embodiments of persuasion, owing to their magical song; and here, discharging water from their ample breasts, they also offer more solid fare, becoming metaphors for the fructifying *Aqua Pia* (see Fig. 90). The ultimate meaning of the fountain is itself rhetorical since, as Cesi says, it proclaims the benefits of the ruler's concern for his domain.[49] If in connection with these points one recalls the conformity of the overall design to that of the Pharos of Alexandria, the fountain may be seen as a veritable beacon of civic and spiritual salvation.

In his complementary gestures—the right arm held back to wield the trident, the left put forward to pacify—Giambologna's Neptune embodied the Renaissance mythographers' definition of the dual nature of the divinity. Like the Christian deity, alternatively angry and benign, the Neptune speaks to the people of Bologna as the *Mercury* spoke to the students and the statue of Pius spoke to both. All three images in concert invite peaceful and reasoned acceptance of the articles of faith, love, and papal rule while also implying that a just retribution awaits those who are heedless.

In view of the central role played by the Counter-Reformatory zeal of Pius IV and his vice-legate in the sculptural program and the design of the individual figures, one may wonder whether enthusiasm for Giambologna's entry in the Florence competition was the only reason he was chosen for the Bologna *Neptune*, his first major work. In addition to being a promising sculptor he was a Northerner who succeeded in fusing the classical tradition he adopted in Italy with the dynamism of his own Germanic heritage. In the *Neptune* Giambologna transformed the balanced mechanism of antiquity

into a fluid spatial movement of great pathetic power; and solid muscles have been replaced by bulging, tight-skinned forms that have a positively pneumatic quality, so the figure seems to burst with vitality, inflated by some inner spirit. This transformation, in turn, is inconceivable without the continuous weightless motion with which the classical contrapposto had already been imbued by Northern artists of the late Middle Ages—the so-called Gothic S-curve that epitomized the International Style of about 1400. Giambologna's "restoration" of this distant late-medieval past, which enabled him to carry the contemporary Mannerist *figura serpentinata* to new heights of expressivity, was surely no less deliberate than his classicism, and perfectly in accord with the reaffirmation of traditional faith that was one of the driving forces of the Counter-Reformatory movement.[50] One wonders whether Cesi might have intuited this profound harmony between Giambologna's art and the efforts of Catholicism to constrain transalpine religious zeal within the ancient traditions of the Roman church.

In reviving the Northern tradition of continuous dynamics and melding it anew with the classical legacy of equilibrated mass, Giambologna created a revolution of his own, a new International Style that from Bologna would sweep the emergent absolute monarchies of Europe and dominate developments for the next two centuries.[51] Neptune's pose, the action of the arms, and the turn of the head not only appear commanding from every point of view but also impart a sweeping and turning motion that suggests the boundless reaches of the god's domain. The figure is endowed with nobility, autonomy, universality, and grace, and the Lord of the Seas views the world with what has aptly been described as "a sovereign regard."[52] *Bononia Docet,* indeed!

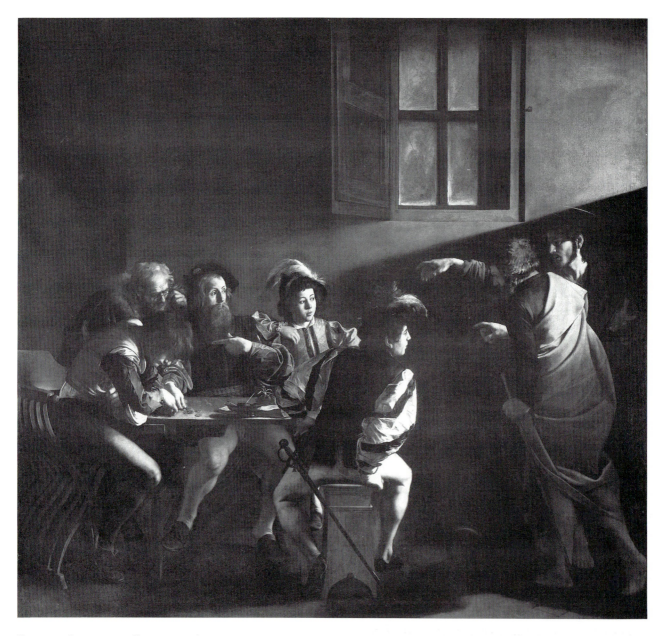

Fig. 99. Caravaggio, *Calling of St. Matthew.* San Luigi
dei Francesi, Rome (photo: Istituto Centrale del Restauro,
Rome 9779).

Fig. 100. Detail of Fig. 99.

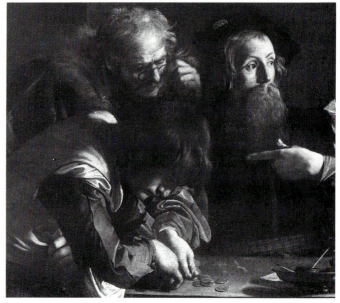

CHAPTER FOUR ✦ CARAVAGGIO'S

Calling of Saint Matthew: THE IDENTITY

OF THE PROTAGONIST

A powerful current runs through the entire history of Western art—a complex, imponderable, paradoxical metaphor that defines in visual terms the relationship between the world and Christian belief. The metaphor occurs in 1 Corinthians 13:12, where St. Paul explains the understanding that will come in the fullness of faith: "For now we see through a glass, darkly, but then face to face" (*Videmus nunc per speculum in aenigmate, tunc autem facie ad faciem*). One of the principal interpretations of the passage was that it alluded to the presence of God in everyday, ordinary, even unworthy things. Paul's dictum was thus related both to the ancient rhetorical tradition of rhyparography, the art of portraying lowly and insignificant things, and to the Christian devotional tradition of the *sermo humilis*, or humble style, both of which have important corollaries in the visual arts. These traditions enjoyed a great florescence in the Northern European Renaissance, becoming a veritable mode of thought, as well as of persuasion, among the major thinkers of the age, including Nicholas of Cusa, Erasmus, and Rabelais.[1]

My subject here is really an episode in this millennial story, although a significant one, as I hope will become clear. Paul's formulation in Latin involves a conundrum that is obscured in the King James translation. The glass is a mirror (*speculum*) *through* which we see, and what we perceive "darkly" is an enigma. The point I want to focus on particularly, however—because I believe Caravaggio did so, in an unprecedented and utterly devastating way—is the second part of the metaphor. "Face to face" is also a conundrum: the phrase may be taken both metaphorically and literally—and this is exactly how Caravaggio took it. Appropriating the Renaissance understanding of physiognomy as the outward manifestation of psychological and moral character (see pp. 109, 212 below), Caravaggio used the face in the second part of Paul's metaphor to portray (the pun is deliberate) the enigma of the first. Justification for Caravaggio's interpretation was provided by Paul's use of the same metaphor in 2 Corinthians 3:18, where he relates the image in the mirror to the *change of face* wrought by the spirit of the Lord in those who believe: "But we all, with open face beholding as in a glass the glory of the Lord, are changed into the same image from glory to glory, even as by the Spirit of the Lord" (*Nos vero omnes revelata facie gloriam Domini speculates in eandem imaginem transformamur a claritate in claritatem, tanquam a Domini Spiritu*).

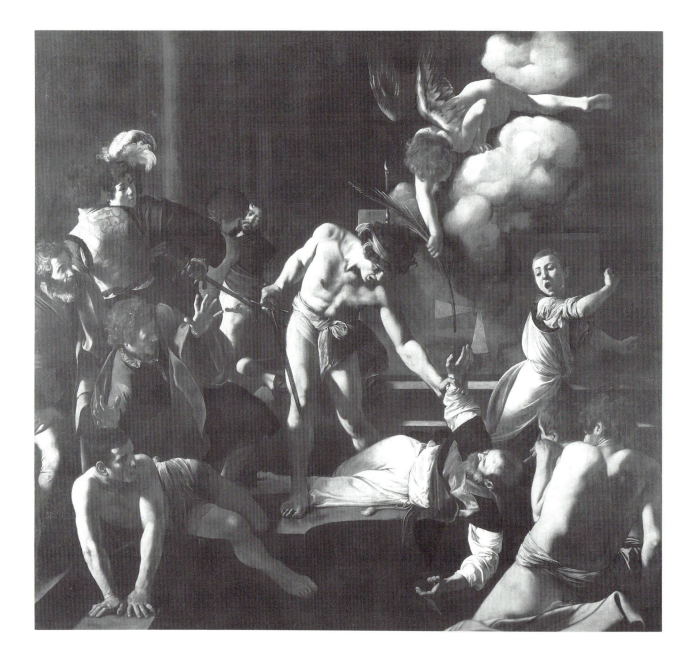

My immediate purpose is to offer a counterproof to arguments recently made to re-identify the figure of the Jewish tax collector Levi, whom Jesus calls to the apostolate in Caravaggio's painting of that subject executed for the left wall of the Contarelli chapel in San Luigi dei Francesi, the French national church in Rome (Figs. 99, 100; Plate IV). Besides the *Calling of St. Matthew,* Caravaggio painted three other canvases for the chapel between 1599 and 1603 at the behest of the executors of Cardinal Matthieu Cointrel, who had died in 1585: the *Martyrdom of St. Matthew* for the right wall (Figs. 101, 102) and two versions of the altarpiece showing Matthew composing his Gospel under the inspiration of his symbolic angel (Figs. 103, 104).[2] A

tradition universally accepted since the early seventeenth century had identified as the publican the elegantly dressed bearded man who, bathed in Christ's light, looks toward the approaching figure of the Lord and points to himself, assenting to the divine command "Follow me."[3] Caravaggio's paintings created an astonishing three-act religious drama in which — to judge by appearances — the chief protagonist played three completely different and incompatible roles.

An alternative suggestion has been made that Levi-who-became-Matthew should be identified with the youth seated at the left of the counting table, unaware of Christ's approach, engulfed in

Fig. 101 (*opposite*). Caravaggio, *Martrydom of St. Matthew*. San Luigi dei Francesi, Rome (photo: Istituto Centrale del Restauro, Rome 9773).

Fig. 102 (*above*). Detail of Fig. 101 (photo: Istituto Centrale per il Catalogo e la Documentazione, Rome E24570).

darkness, his head down, grasping a money bag close to his chest.[4] The main arguments presented to support this interpretation, though reasonable, do not in themselves seem persuasive to me: that the pointing gesture of the seated figure could refer to his companions at the end of the table—in fact, the gesture seems clearly self-referential and not at all ambiguous; that the physiognomy of the youth is more readily reconcilable with the Socratic features Caravaggio gave the evangelist Matthew composing his Gospel in the original version of the altarpiece for the chapel—in fact, notwithstanding the difference in age, the evangelist's features seem much coarser; and that the design of the chairs on which

the two figures sit, the so-called Savonarola chair, is identical—in fact, Caravaggio also reused the bench under the youth with the sword (at right) for the evangelist in the second version of the altarpiece (Fig. 104), and he had already used both props in the London *Supper at Emmaus* (Fig. 105). The simple, unadorned pieces of furniture were just that, props, like the Capuchin's frock and the pair of wings Caravaggio borrowed from the painter Orazio Gentileschi during the very period he was working on the Contarelli chapel.[5] In any case, accepting this partial cure for the consistently split personality of Caravaggio's hero would be worse than the disease, for we would then have to confront, without help from

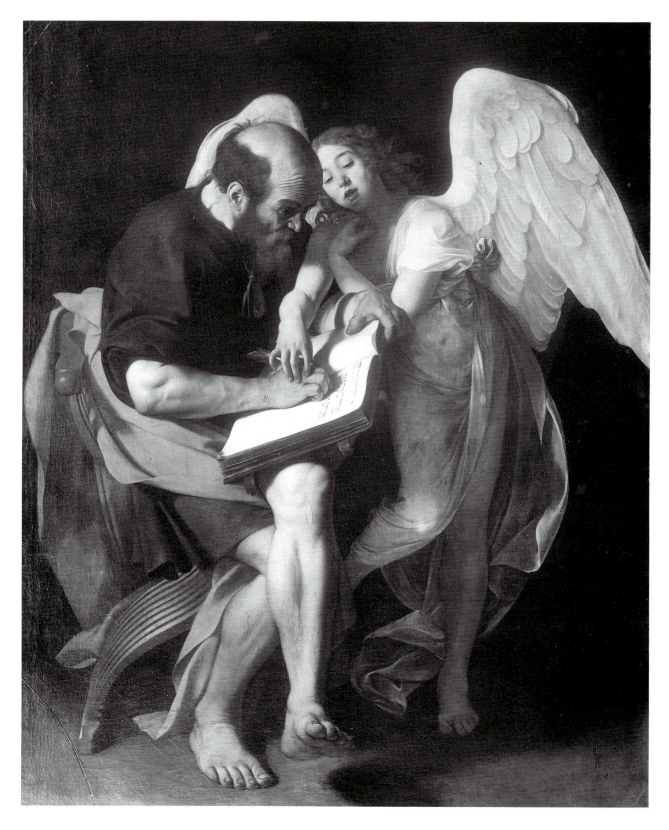

Fig. 103 (*above*). Caravaggio, *St. Matthew Composing His Gospel.*
Destroyed in 1945; formerly Kaiser-Friedrich-Museum, Berlin
(photo: Zentralinstitut für Kunstgeschichte, Munich 120854).

Fig. 104 (*following plates*). Caravaggio, *St. Matthew Composing His
Gospel.* San Luigi dei Francesi, Rome (photo: Istituto Centrale
del Restauro, Rome 9783).

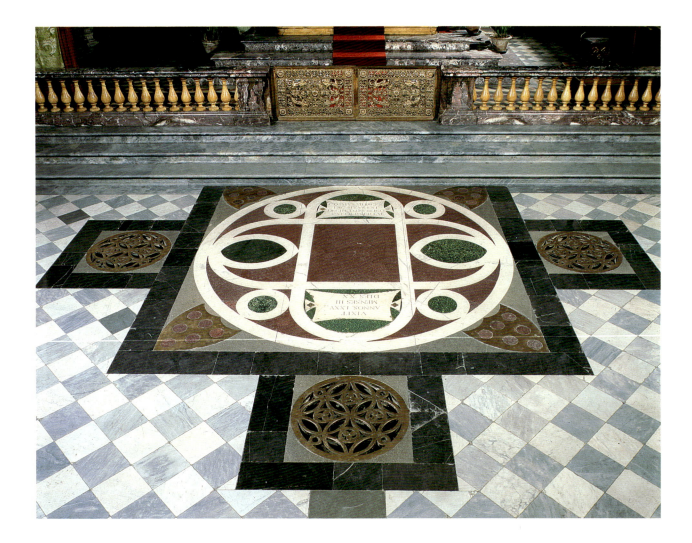

Plate I.　Andrea del Verrocchio, tomb marker of Cosimo de'
Medici. San Lorenzo, Florence (photo: Silvestri, Florence).

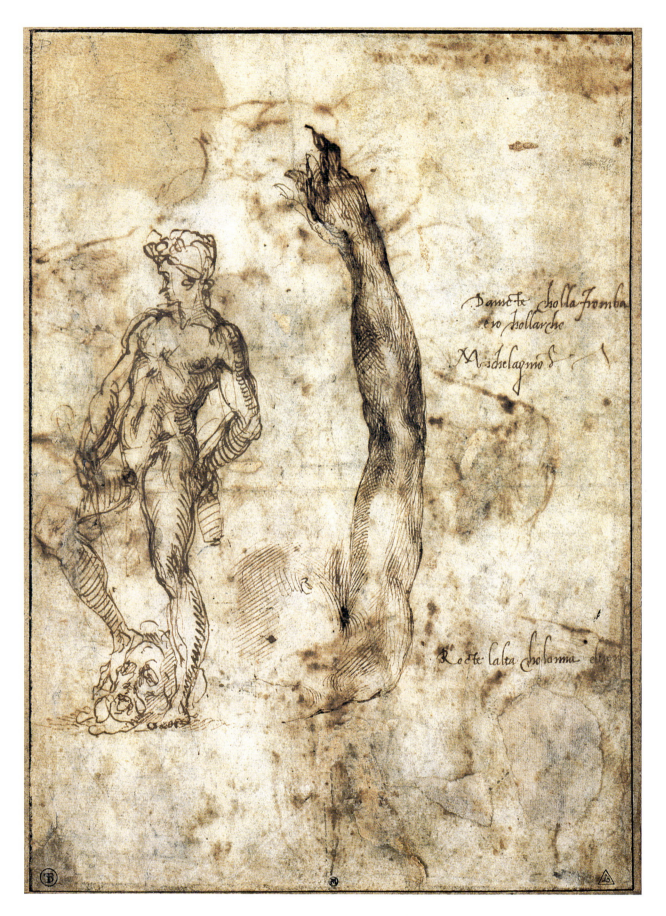

Plate II. Michelangelo, studies for the bronze and marble
Davids. Louvre, Paris (photo: Documentation photographique de
la Réunion des musées nationaux).

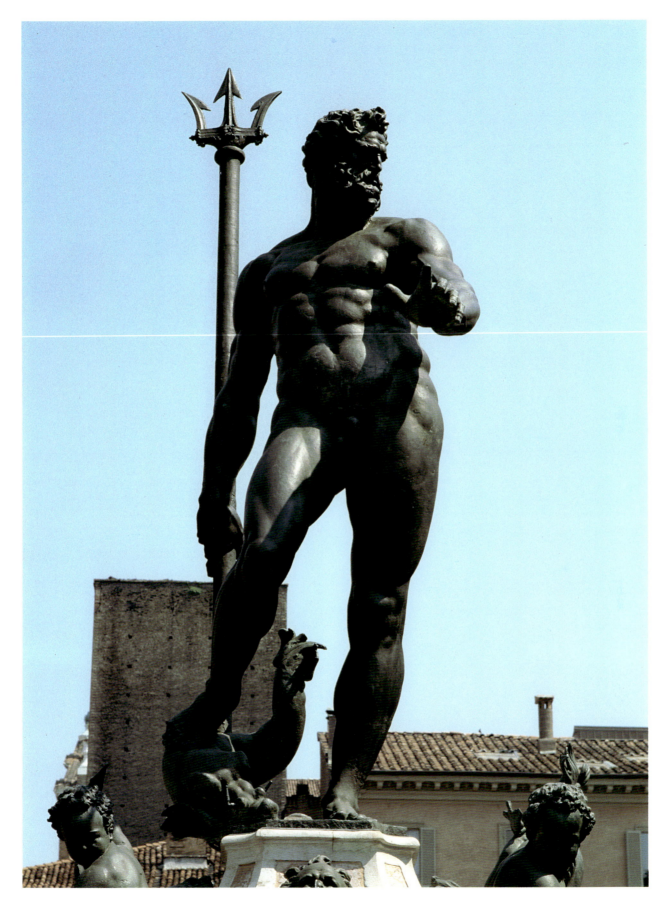

Plate III. Giambologna, Fountain of Neptune, detail. Piazza
del Nettuno, Bologna (photo: Fanti, Bologna).

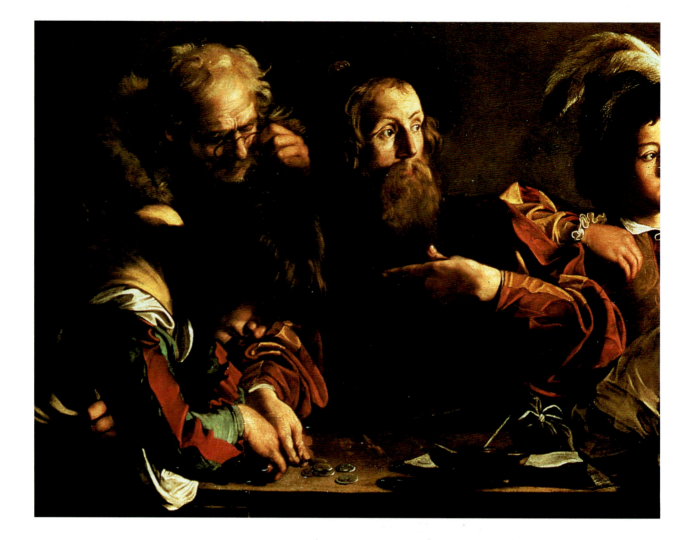

Plate IV (*above*). Caravaggio, *Calling of St. Matthew*, detail. San Luigi dei Francesi, Rome (photo: courtesy Maurizio Marino).

Plate V (*right*). Pieter Coecke, *Last Supper*, detail. Musées Royaux des Beaux-Arts, Brussels.

Plate VI (*opposite, above*). Jan van Hemessen, *Calling of St. Matthew*. Metropolitan Museum of Art, New York.

Plate VII (*opposite, below*). Hendrick Terbrugghen, *Calling of St. Matthew*. Centraal Museum, Utrecht.

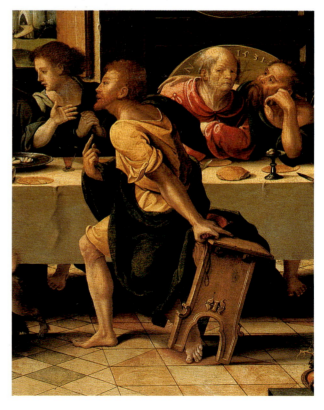

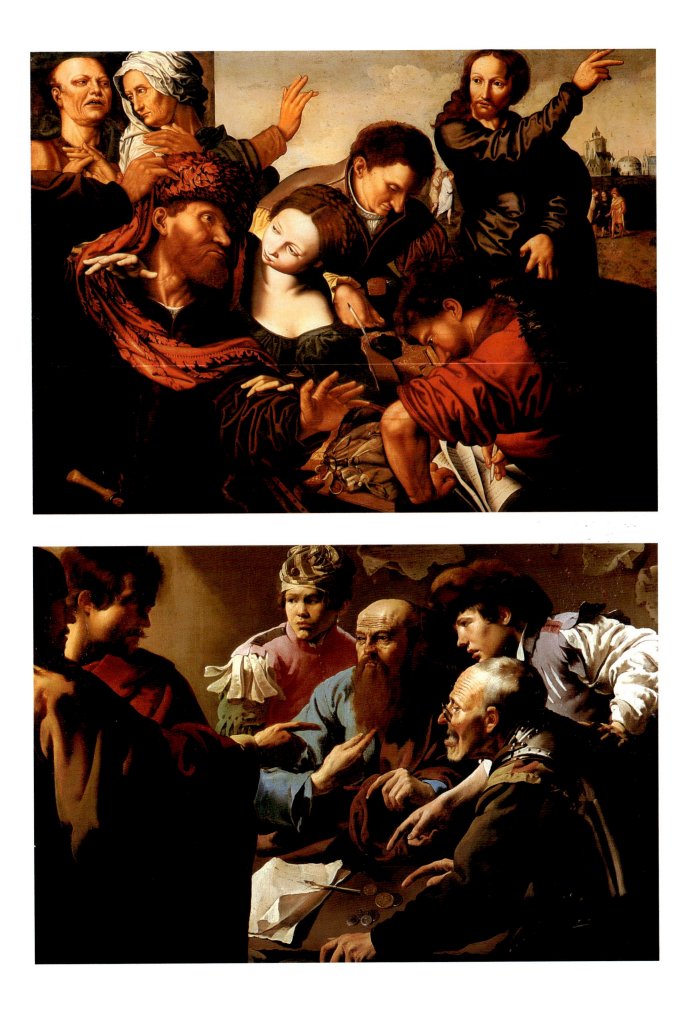

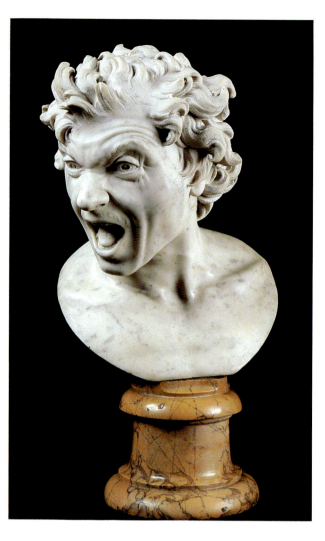

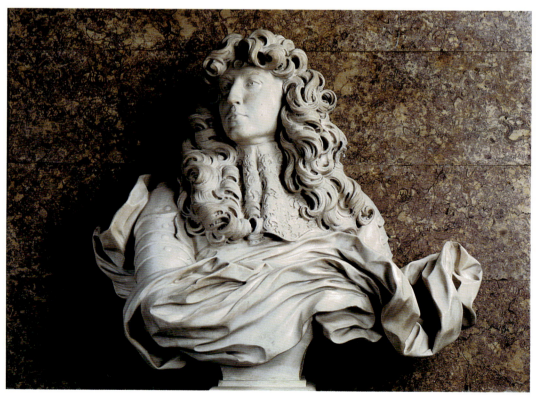

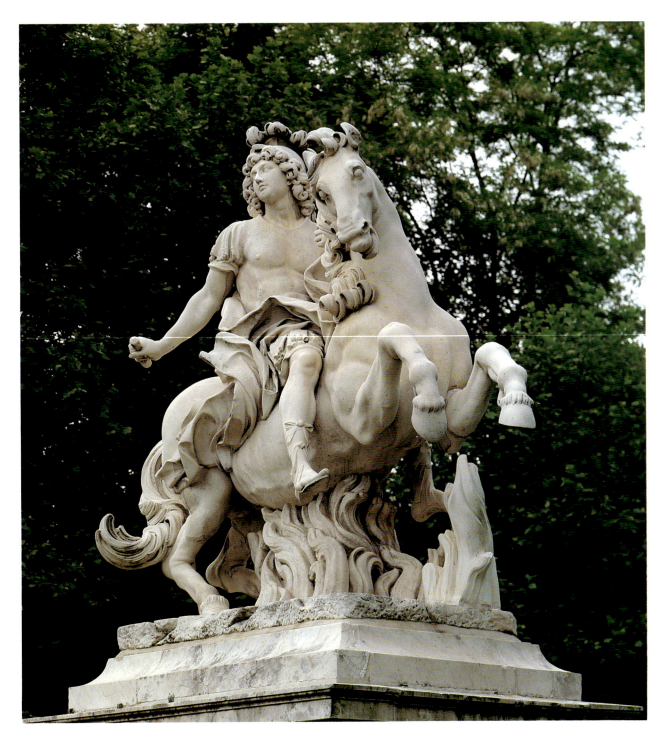

Plate VIII (*opposite, top left*). Bernini, *Anima Beata*. Palazzo di Spagna, Rome (photo: Arte fotografica, Rome).

Plate IX (*opposite, top right*). Bernini, *Anima Dannata*. Palazzo di Spagna, Rome (photo: Arte fotografica, Rome).

Plate X (*opposite, below*). Bernini, bust of Louis XIV. Musée National du Château de Versailles (photo: Documentation photographique de la Réunion des musées nationaux).

Plate XI (*above*). Bernini, equestrian monument of Louis XIV, altered by Giraudon to portray Marcus Curtius. Versailles (photo: Documentation photographique de la Réunion des musées nationaux).

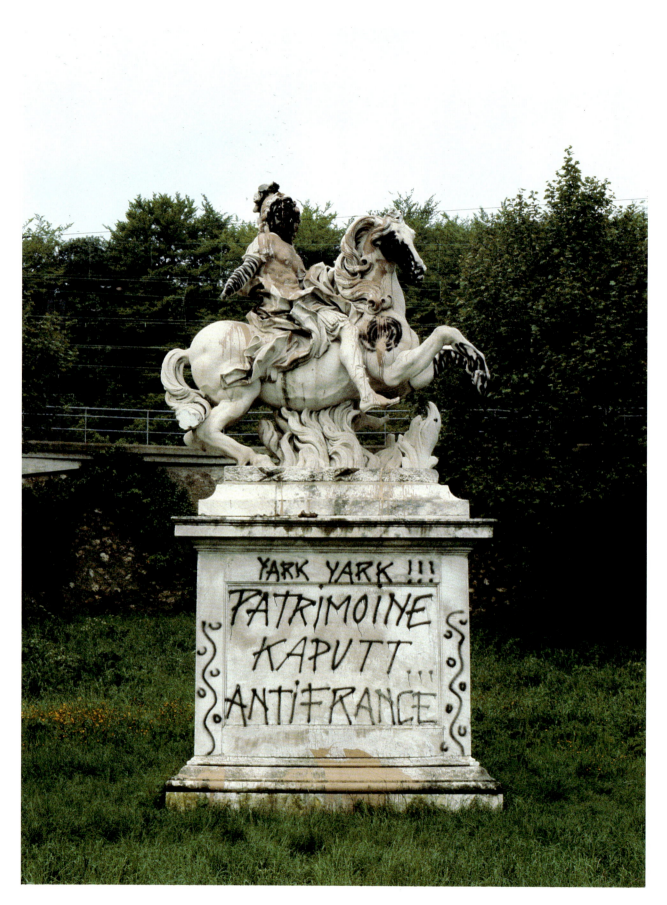

Plate XII. Bernini, equestrian monument of Louis XIV, defaced
by vandals on June 6, 1980. Versailles (photo: Simone Hoog).

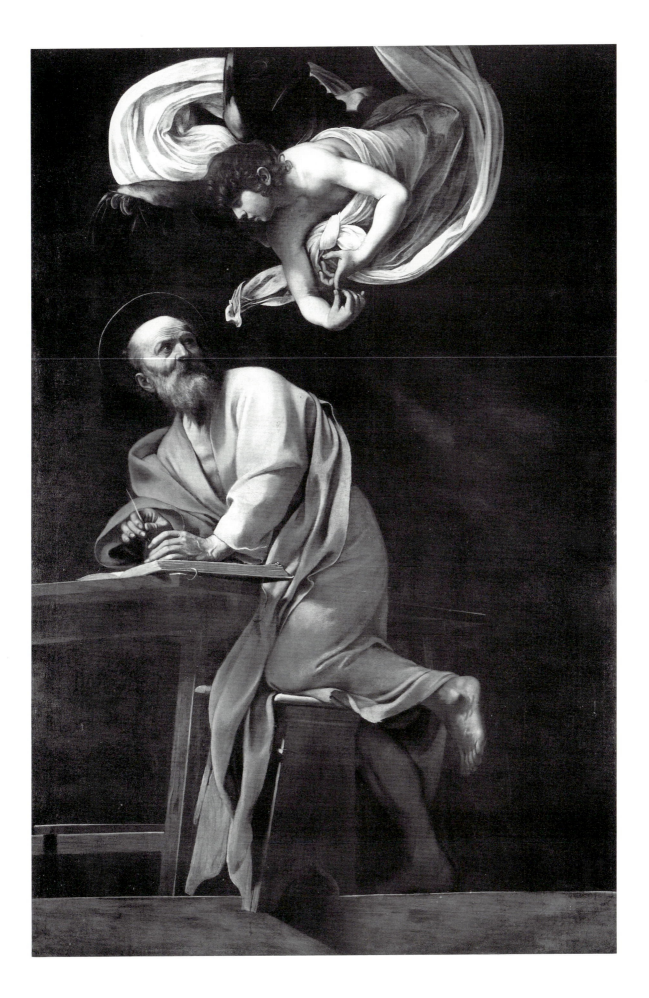

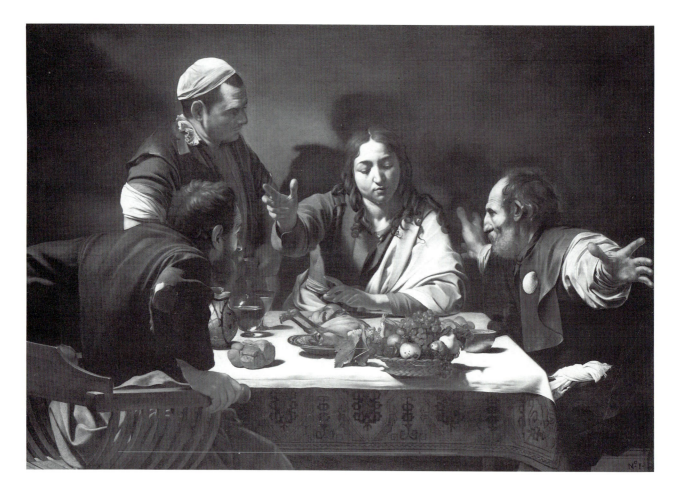

Fig. 105 (*above*). Caravaggio, *Supper at Emmaus.* National Gallery, London.

Fig. 106 (*opposite*). Pieter Coecke, *Last Supper.* Musées Royaux des Beaux-Arts, Brussels.

the theory's proponents, the inconsistency of the same individual as Matthew in the first two scenes, but another in the third.

To my mind, however, the alternative identification is excluded *a priori* by other, more fundamental, considerations. A youthful beardless and hatless publican would contradict the worldly maturity universally attributed to this government official, however corrupt. The relative obscurity of the youth at the side as Levi would contradict the high drama of the composition as a whole, which focuses on the man in the center who looks toward Christ and points. A Levi oblivious to Christ's appearance would contradict the essential point of the episode, the publican's *response*—not lack of response—to the Call. A benighted Levi would contradict one of the most profound and innovative principles of Caravaggio's art, the use of light as a visual metaphor for divine illumination. Indeed, the metaphor has particular relevance in the *Calling of St. Matthew*, as a visual analogue to a passage connecting Matthew's conversion to his vision of Christ's radiance, in the liturgy for the saint celebrated in the chapel on his feast day. The breviary quotes St. Jerome's luminous response, in his commentary on this episode in the first Gospel, to the shadow of doubt cast on the authenticity of the conversion by the pagan philosopher Porphyry and the apostate emperor Julian. They claimed that either the story was false or it bespoke the folly of anyone who would follow without hesitation at a call. Jerome replied that "certainly the radiance and the majesty of the hidden divinity which shone out from the human face of Christ could draw to Him at first sight those who saw Him."[6]

These points are obvious enough, perhaps even

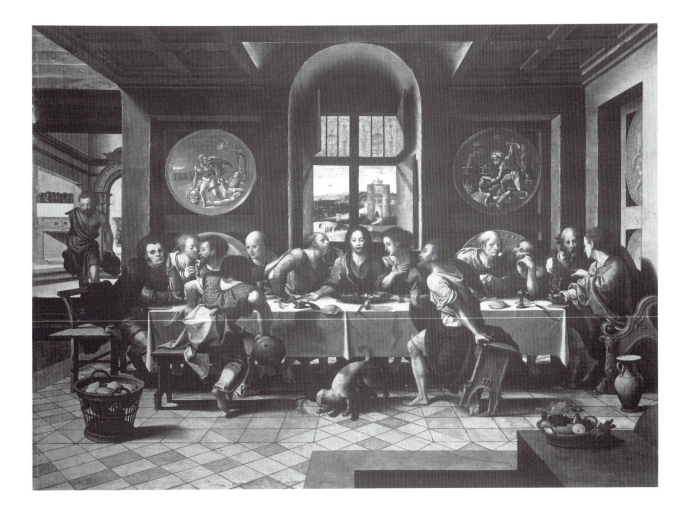

self-evident. So too is the simple observation that the tax collector literally wears the sign of his profession, the gold coin attached to his hat as a brooch.[7] Another of Levi's salient features, however, requires special comment because, although it seems not to have been discussed heretofore, it is fraught with implications for the ultimate meaning of Caravaggio's painting (Plate IV). I refer to the central figure's auburn hair and beard. Red hair — *ruddiness* is the English term often used for the Latin *rufus* — is one of the physical characteristics most commonly, and opprobriously, associated with Jews, in works of art as in every other domain.[8] The association is particularly significant since ruddiness, far from being a Jewish genetic trait, is relatively rare among Semitic peoples. Surely one factor above all contributed to the development of the idea: in the Old Testament, David is twice referred to as *rufus et pulcher*, so that

what distinguished him in a positive way among the Jews came to characterize the Jews themselves in a negative way among Christians, who attributed David's ruddiness to his lust.[9] The extreme case of this ironic inversion, in which an unusual and attractive individual feature becomes an exemplary but repulsive genetic trait, is illustrated in the many works of art in which Judas, the archenemy of Christ and nefarious Jew *par excellence*, is shown with red hair and beard, often with a money bag. It is tempting to think that Caravaggio was particularly interested in a *Last Supper* by Pieter Coecke that has been described as one of the most popular Flemish paintings of the sixteenth century, known in more than forty versions and an engraving made in 1585 (Fig. 106; Plate V).[10] Here the ruddy Judas points in accusation to himself with the index finger of his right hand while grasping the money bag in his left

hand; he seems stupified by Christ's revelation of the truth, overturning his bench in a striking anticipation of the action of Caravaggio's second St. Matthew the Evangelist.

In turn, the Jewishness of Levi the tax collector had special, twofold, significance. By virtue of his profession—Jews often served as tax collectors in the Middle Ages and after—he was egregiously associated with the main negative moral characteristic of his race, avariciousness and devotion to usury; this is the case in the Golden Legend, for example, the most popular of all hagiographies.[11] (Usury did not mean lending at exorbitant rates of interest, but lending at any interest at all. Medieval Jews became moneylenders because they were excluded from other trades but exempted from the laws against usury because they were not Christian.) Levi was also quintessentially Jewish because his name coincided with that of one of the tribes of Israel. Thus, paradoxically, portraying Levi in all the depravity of his Jewishness illustrated the totality of his metamorphosis into Matthew. By heeding the call, even the lowest can attain the highest. The point is made explicit in the episode of the feast in the house of Levi, which follows the Calling in the Gospel narratives (Mark 2:14, Luke 5:27). Asked by the scribes and Pharisees why he ate and drank with publicans and sinners, Jesus answered, "I came not to call the righteous, but sinners to repentance." In the well-known compilation of the lives of the saints by Domenico Cavalca, Matthew is taken as the model for the conversion of that most depraved of females, Mary Magdalene, the prostitute.[12]

Caravaggio was by no means the first to express this paradoxical meaning of the subject. He derived his basic interpretation from Netherlandish artists of the sixteenth century. Reacting to the phenomenal growth of trade that made Antwerp the leading commercial center of Europe, the painters of that city in particular had made a specialty of scenes depicting banking and money exchange, including the Calling of St. Matthew.[13] In almost claustrophobic images of covetous self-interest, these works gave powerful form to the strictures against the unrestrained pursuit of material gain that characterized the ascetic morality of the *Devotio moderna*, whose leading protagonist was that archironist Erasmus. Erasmus was actually rather tolerant of usury as such, but he fully grasped the import of Levi's conversion to Matthew; he declared that "suddenly to

turn into another" (*repente vertere in alium*) a man devoted to infamous profit and involved in inexplicable affairs (*inexplicabilibus negotiis*) was a more signal miracle than to restore the nerves of a paralytic.[14]

Caravaggio's indebtedness to Northern depictions of the Calling has often been emphasized, and he must surely have been aware of a portrayal like Jan van Hemessen's of the dandified red-headed and red-bearded moneymonger responding to Christ's sudden command (Fig. 107; Plate VI).[15] Caravaggio's figure, however, is much more sympathetic and, apart from his ruddiness, far less crudely "ethnic" than such predecessors; in this respect he conforms to Italian tradition and expresses his underlying (or nascent) nobility. Two other differences, quite unprecedented, are especially noteworthy because they reflect Caravaggio's subtle but fundamental reinterpretation of the story. The changes reflect the two salient moral features, both supremely ironic, attributed to Matthew in popular tradition, as in the Golden Legend.[16] Matthew was credited with humility, because in his own Gospel (10:3) he says he is a publican, an unsavory fact that the other evangelists who mention him omit. Matthew's self-referential humility is expressed in the painting by the self-referential gesture of his left hand. Matthew places his hand on his breast in certain versions of the subject that Caravaggio may have known (Fig. 108);[17] but these are traditional gestures of devotion rather than of reference. Normally interpreted as a bewildered "Who, me?" the accusatory action of Caravaggio's protagonist is better understood as a self-deprecating, "Me, a publican?" Matthew's humble confession—for that is what it was—also had another, deeper, implication important for Caravaggio's understanding of the evangelist's role in the history of salvation. The idea was formulated as follows by St. Jerome, whose text was incorporated in the liturgy for St. Matthew: "Out of respect and honor for Matthew, the other Evangelists did not wish to give him his usual name. They called him Levi: for he had two names. But Matthew (according to the saying of Solomon, 'The just man is the first to accuse himself' and again, 'Confess your sins that you may be justified') calls himself Matthew and a publican, to show his readers that no one need despair of salvation if he is converted to better things, since he himself was suddenly changed from a publican into an Apostle."[18] Matthew's reference to his sinful past was therefore not simply an act of

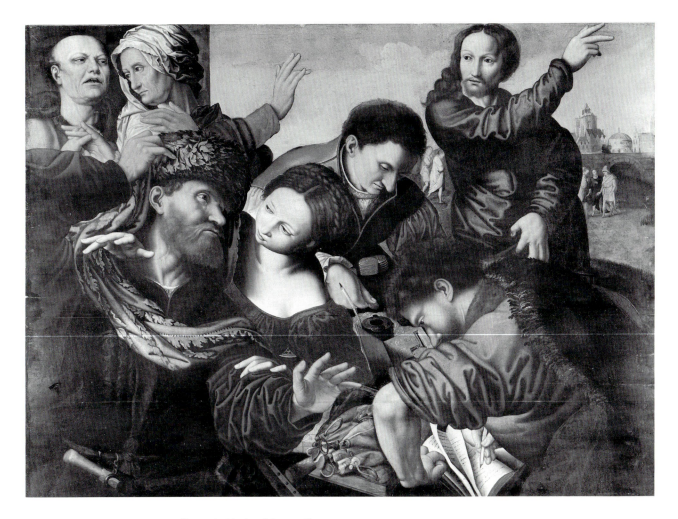

Fig. 107. Jan van Hemessen, *Calling of St. Matthew.* Metropolitan Museum of Art, New York.

humility; it was also an exhortation—himself being the example—to those who had converted to remain firm in their faith. This was the very same motivation which, according to St. Jerome, inspired Matthew's equally extraordinary act of writing his gospel in his native Hebrew, the inspiration that Caravaggio explicitly illustrated in the first version of the altarpiece for the chapel. It is indicative of the depth of Caravaggio's response to and transformation of the Netherlandish tradition that his own ruddy Levi-Matthew, centrally placed and self-incriminating, was soon understood and adopted by Hendrick Terbrugghen (1621; Fig. 109; Plate VII).[19]

Matthew was also especially noteworthy for the virtue of generosity, because after his conversion he offered a great feast in his own house for the Lord and his followers. This event is recorded in the Gospels (and the breviary) directly after the Calling; hence

it was the newly converted disciple's first Christian act. Matthew's immediate renunciation of his wealth—an emphatic counterpoint to his previous greed as Levi—had been alluded to by van Hemessen, whose Matthew doffs his elaborate red hat with his right hand and rejects with his open left hand the money bags on the table before him.[20] Caravaggio's Matthew demonstrates his generosity specifically by the gesture of his right hand, which is clearly not taking in the money but counting it out. This motif also occurs frequently in the Northern works, as in van Hemessen's, where accounts are being settled, but never in the hand of the apostle himself. It is as though Matthew, having put down his last coin, were meting out in saving grace the thirty pieces of silver gained by the other often red-headed apostle, whose faith was infirm. In fact, Matthew's gesture is pointedly juxtaposed and contrasted to the closed,

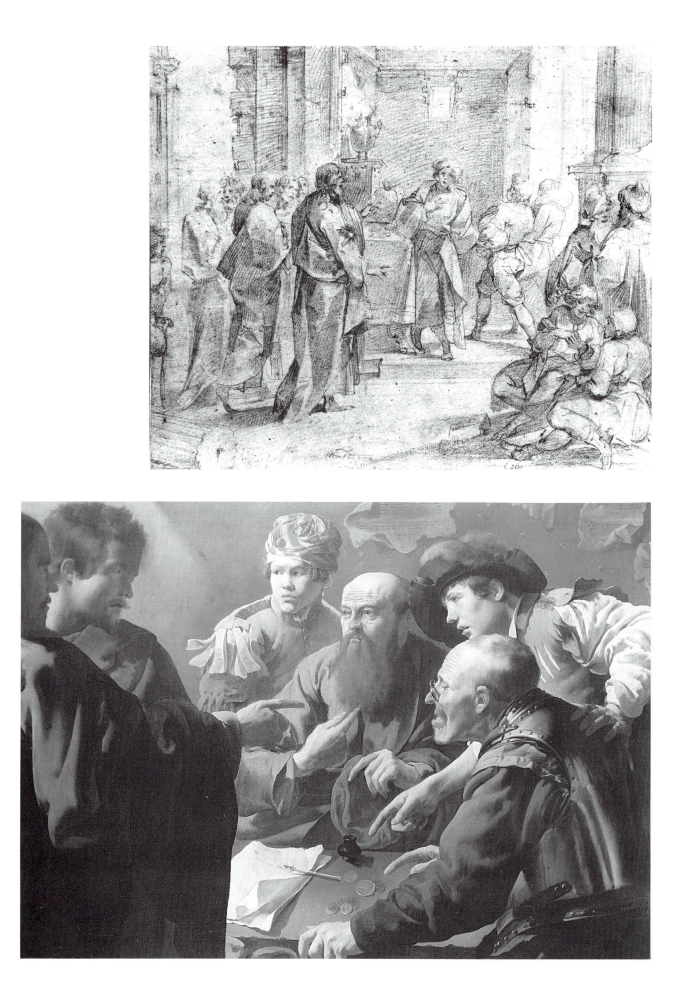

Caravaggio's Calling of St. Matthew

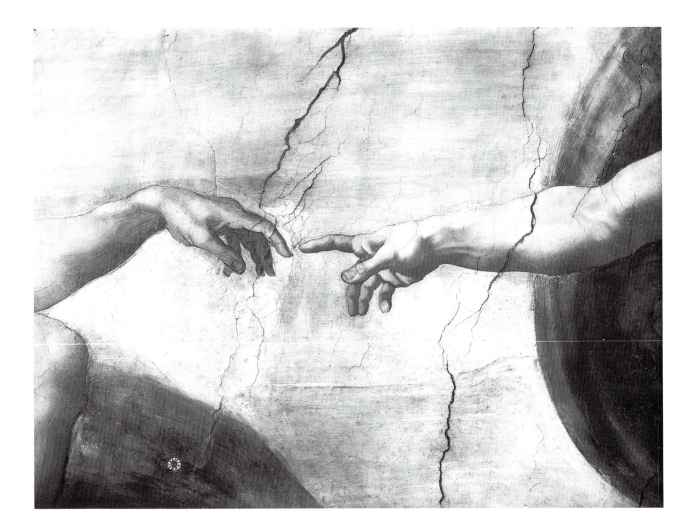

coin-hoarding hand of the youth at the left, who also conceals the money bag, as does Judas in scenes of the Last Supper.

This interpretation of Matthew's action in turn helps to clarify what is perhaps the most obvious visual citation in Caravaggio's picture. Christ's right hand conspicuously reverses the left hand of Adam in Michelangelo's Creation scene in the Sistine ceiling, where Adam receives the gift of life from God the Father (Fig. 110).[21] It is clear, therefore, that Caravaggio's Christ, the New Adam, not only beckons to Levi, signaling his new life as Matthew, but also *receives* the penance that Matthew pays for his sins with symbolic coins. In this sense, the reciprocal relationship seems explicitly to illustrate the lesson in the breviary on the feast in the house of Levi. The former publican is again taken as a model of conversion, now also of penance, and Christ repeats his call, now to all sinners and for mercy: the assembled publicans and sinners "saw that the publican converted from his sins to better things had found

Fig. 108 (*opposite, top*). Attributed to Giuseppe Cesari, *Calling of St. Matthew*, drawing. Graphische Sammlung Albertina, Vienna.

Fig. 109 (*opposite, below*). Hendrick Terbrugghen, *Calling of St. Matthew*. Centraal Museum, Utrecht.

Fig. 110 (*above*). Michelangelo, *Creation of Adam*, detail. Sistine Chapel, Vatican Palace, Rome (photo: Anderson 3789).

Quid prodeſt homini, ſi vniuerſum Mun-
dum lucretur, animæ autem ſuæ detri-
mentum patiatur?

MATT. XVI.

Che gioua al' huom, che tutto'l mondo ac-
 quiſti,
 Se l'alma ſua poi ne riceue danno?
 Onde ne i luoghi tenebroſi, & triſti
 Pianga dannata à ſempiterno affanno.

Fig. III. Hans Holbein, *The Gambler* (from *Simolacri*, 1549).

an opportunity for penance; and so they themselves did not despair of salvation. Nor did they come to Jesus as remaining in their former vices, as the Pharisees and Scribes complained, but as doing penance. The Lord's words which follow indicate this: 'I desire mercy, and not sacrifice. For I have come to call sinners, not the just.'"[22]

With the two gestures of Levi-Matthew, Caravaggio gave unprecedented expression to that process of enlightenment whereby the selfish, money-grubbing Jew, the most execrable of the damned, becomes the charitable, poverty-loving Christian, the most exalted among the saved. This understanding of the picture as calling the iniquitous to faith makes particular sense of the one visual reference to an earlier work of art that has always been recognized as a factor in the genesis of the composition. Already in the seventeenth century Joachim von Sandrart observed that Caravaggio based his young man with the money bag at the left on the figure seated at the right of the gaming table in Holbein's woodcut portraying gamblers in the *Dance of Death* series (Fig. 111).[23] It is clear from what has been said here, however, that there is much more to the relationship than a simple borrowing of a motif; Caravaggio's whole conception of his subject is indebted to, and is in turn illuminated by, Holbein's portrayal of the "calling" by Death and the Devil of a greedy sinner who, in his lust for money, "gambles" with his life. The figure at the left in Holbein's composition sees, understands, and is alarmed by what is happening while the huddled and benighted man at the right, intent upon raking in the pot, remains oblivious. The relevance to Caravaggio's interpretation of the story of St. Matthew is evident also from the caption to the illustration that appears in many editions of the work, including one of 1549 with the Italian translation below. The caption quotes the familiar passage in the Gospel of Matthew (16:26) in which Christ denounces worldliness ironically in terms of an exchange of values: "For what is a man profited, if he shall gain the whole world, and lose his own soul?" (*Quid prodest homini . . .*) Caravaggio grasped Holbein's meaning as well as his design, and this relationship also makes clear who is Caravaggio's protagonist. Holbein's protagonist, the bearded figure at the center of the composition, shows what happens when the avaricious moneygrubber does not heed the call;[24] Caravaggio's shows what happens when he does. No less significant is the context

established in the preceding, even more familiar, passage of the Gospel, where Matthew, in effect, recounts his own metamorphosis. Addressing His disciples, Christ exhorts a total transformation of the self (16:24–5): "Then Jesus said unto his disciples, If any man will come after me, let him deny himself, and take up his cross, and follow me. For whosoever will save his life shall lose it: and whosoever shall lose his life for my sake shall find it." In the Gospel, therefore, worldly renunciation and self-sacrifice follow directly from personal mutation; this was the basic spiritual idea that the physical permutations through which Levi-Matthew passes in the Contarelli chapel paintings made visible.

It might be said that in the *Calling* Caravaggio's characterization of the protagonist illuminated and transformed by Christ's appeal gave metaphysical form to two opposite states of moral existence: the avaricious Jewish publican Levi and the generous Christian apostle Matthew. Both personas have leading and heretofore unappreciated roles in the context of the commission for this great narrative cycle in which Caravaggio's art was itself transformed into maturity. Among the critical issues of the early church that were revived in the period of the Counter-Reformation was the conversion of the Jews. Although the number of people involved was small, the matter acquired new symbolic importance during the church's struggle to combat heresy, and the effort was greatly intensified in the course of the sixteenth century. Adrienne von Lates has noted in connection with Caravaggio's work that the parish priest of San Luigi dei Francesi was a zealous participant in this effort.[25] I need not emphasize the relevance of this fact, which I had overlooked, to my argument some years ago in a paper on the Hebrew text Matthew the Evangelist composes in Caravaggio's first altarpiece for the chapel.[26] Apart from reaffirming the tradition of the church concerning the divine inspiration "in the pen" of the first Gospel, the text echoes the report of St. Jerome that Matthew had composed his Gospel in the language of his fellow Semites so that those of them who had converted might remain firm in their faith. The metaphorical relevance of the message in the much more formidable struggle with the Protestants also needs no emphasis. Gregory XIII, Matthieu Cointrel's patron, was particularly solicitous of converts, founding the Collegio dei Neofiti for former Jews and Muslims who wished to further their

Christian education.[27] Precisely in this context, it becomes significant that the idea of conversion may already have been uppermost in Matthieu Cointrel's mind in 1565 when he made his original, testamentary, prescription for the chapel: he provided that Matthew baptizing the Egyptians, a scene emphasized in the Golden Legend, be the subject represented in the center of the vault (subsequently changed to a miracle scene). These facts, in turn, reinforce the suggestion that the seminude figures shown at the edge of a sunken basin in the lower part of Caravaggio's depiction of the martyrdom of St. Matthew are neophytes. The reference to baptism makes the *Martyrdom* a testimony to the transforming power of faith comparable to the *Calling*.[28]

Caravaggio's interpretation of the Calling of St. Matthew also reflects what must have been a much more personal concern of Matthieu Cointrel's executors, who actually commissioned the work from Caravaggio in fullfillment of the cardinal's legacy. In their view Matthieu Cointrel must have had far more in common with the apostle than a name. Cointrel, who died in 1585, had been one of the most powerful figures in the church hierarchy. The son of a blacksmith, he met as a young man Ugo Buoncompagni, later Pope Gregory XIII, who became a close lifelong friend. Pope Gregory made Cointrel, his protégé, a cardinal and appointed him to the key post of papal datary, which gave him control over all church benefices—the often richly endowed offices whose revenues it was his responsibility to confer, in good faith and *gratis*, upon worthy recipients. The position, which lent itself easily to corruption, was extremely sensitive, and when the great fortune Cointrel had amassed came to light at his death, he was accused by Gregory's reforming successor, Sixtus V, of simony, the selling of church benefices.[29] This was the most execrable of ecclesiastical crimes, in direct contravention of Christ's charge to his disciples—recorded in a key passage in the Gospel of St. Matthew itself—that they give freely the spiritual benefits they had received freely (*gratis accepistis, gratis date;* 10:8).[30] The papal datary was, in effect, the ecclesiastical equivalent of the ancient publican; he had the moral obligation, sometimes honored in the breach, to collect and transmit revenues fairly and honestly. The simoniac datary was thus the equivalent of the double-sinning Levi, who embodied both the avarice of his race and the guilt of the administrator who breaches the

trust—a sacred trust in Cointrel's case—of his public office for personal gain.

Pope Sixtus appointed a commission; after diligent investigation it found so many simonies that one of the datary's assistants, called to testify, fled and thereby incriminated himself as well as his former patron. The inquest continued and uncovered "very aromatic material" (*materia molto aromatica*) in which many officials of the datary were implicated, even Pope Gregory himself, who, it was suspected, had known of the malfeasance of this foreigner and his ministers. There was a threat to confiscate the entire legacy.[31] The heirs evidently offered, in vain, a settlement of 30,000 scudi. It was discovered that a certain Domenico Atton had usurped the income from seventy French monasteries; the pope had destined the money for the construction of the church of San Luigi dei Francesi, which received, instead, only 3,000 scudi. It also emerged that Cointrel had assigned pensions from Spanish benefices to nonexistent persons, which he then canceled, retaining the income for himself. The investigation discovered so much aromatic material, in fact, that it risked jeopardizing the Holy See's relations with France. Pope Sixtus finally thought best to suppress the whole issue, though not without a stern warning of prosecution to the officials of the datary, whom he expected to provide a model for others.[32]

Matthieu Cointrel's numerous charities were legendary. He built the Jesuit church at Tivoli, and at San Luigi dei Francesi, besides commissioning his own chapel, he contributed to the construction of the facade, as well as paying for the decoration of high altar. His munificence, which must have helped to arouse suspicion in the first place, was the main theme of the eulogy delivered at his funeral, and no doubt it figured largely in the efforts of his heirs to defend him and their patrimony.[33] Caravaggio's reinterpretation of the Calling of St. Matthew can be understood in this context. Focusing on Matthew's humility in confessing his evil past and his charity in expending his earthly wealth, Caravaggio portrays the model for redemption for the patron of the chapel.[34] The model is also universal, however, and the same call is made to the spectator, toward whom Christ gestures from the darkness with his left hand.

The full import of Caravaggio's meaning, and perhaps his most important innovation, would have been grasped only in the context of the chapel as a whole, where the three *different* personas of this

divine drama would have been patently juxtaposed. The spectator would have been dumbfounded by the physiognomical manifestations of the spiritual progression he beheld taking place in the chapel, from the arrogant Jew-becoming-Christian at the left, through the humble philosopher-becoming-evangelist at the altar, to the venerable priest-becoming-martyr on the right.[35] Caravaggio had made a comparable break with tradition in the *Supper at Emmaus,* where he portrayed the altered—that is, rejuvenated and beardless—face of the resurrected Christ, whom the astonished apostles recognize "in another form," *in alia effigie,* according to the Gospel, at the sacramental blessing and breaking of bread (see Fig. 105).[36] The paintings of the Contarelli chapel offer, in an almost cinematographic sequence (see Figs. 99, 103, 101), the same opportunity: to behold and recognize the mysterious power of faith to illuminate and transform those able to see. The lateral scenes, with the conversion of the Jew by Christ and the conversion of the pagans by Matthew, complement each other as visual expressions of the salvific action of God's word. They embrace in narrative terms the same portentous message embodied in the emblematic icon of Levi-Socrates-Matthew that Caravaggio originally intended as the chapel's altarpiece: the great promise of the early church to triumph *ex circumcisione* and *ex gentibus.*[37]

Recalling the metaphor of St. Paul—"For now we see through a glass, darkly, but then face to face"; "with open face beholding as in a glass the glory of the Lord, [we] are changed into the same image"— we can see clearly that a key to understanding the Contarelli chapel lies in another text in the liturgy for St. Matthew, a passage from Gregory the Great quoted in conjunction with that from St. Jerome mentioned earlier. Gregory comments on Ezekiel's momentous vision of four creatures with faces, one with the face of a man, on which the tradition of the symbols of the evangelists was based. Matthew enjoys the pride of place among the evangelists not only because he was the first called and the first to write his Gospel but also because he recounts the genealogy and birth of Christ, that is, the incarnation in human form of God's only Son. Jerome therefore assigned to Matthew the man-creature, which ultimately became the evangelist's angel. What Gregory says, reflecting the conundrum of St. Paul's image, is this: "Now surely the face is the symbol of recognition ... You recognize a man by his face ... and by the same token the face is concerned with faith ... and it is by our faith that we are recognized by almighty God. As he said of his sheep, 'I am the good shepherd, as I know my sheep, and mine know me.' And again he said, 'I know whom I have chosen.'"[38]

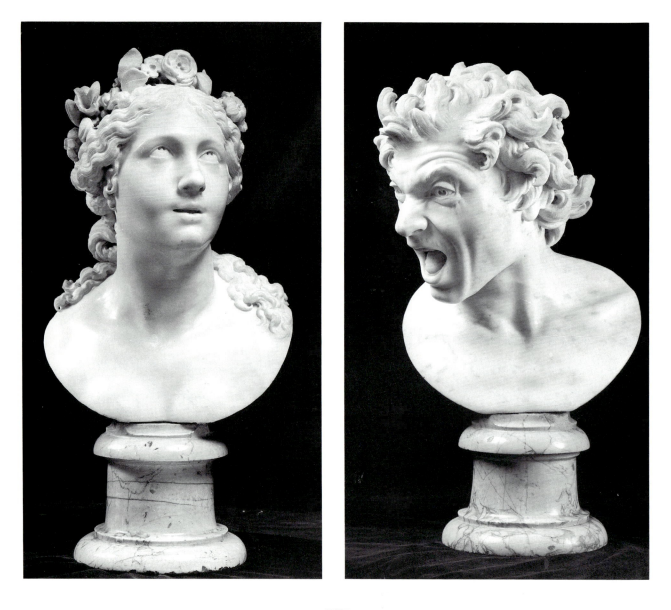

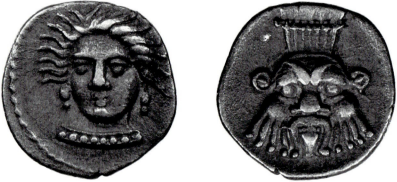

Fig. 112 (*top, left*). Bernini, *Anima Beata*. Palazzo di Spagna, Rome (photo: Vasari 18618).

Fig. 113 (*top, right*). Bernini, *Anima Dannata*. Palazzo di Spagna, Rome (photo: Vasari 18617).

Fig. 114 (*above*). Female head and head of Bes, obverse and reverse of obolos from Judea. Bibliothèque Nationale, Paris (Deleperre 3068–69).

Some of Bernini's most innovative works owe their novelty in part to their revival of much earlier traditions. A notable case is the pair of busts portraying blessed and damned souls (*Anima Beata* and *Anima Dannata*) in which Bernini explored what might be described as the two extreme reactions to the prospect of death (Figs. 112, 113; Plates VIII, IX).[1] Bernini presumably made the sculptures in 1619 (when he was twenty-two), at the behest of a Spanish prelate, Monsignor Pedro de Foix Montoya, for whose tomb in the Spanish national church in Rome, San Giacomo degli Spagnoli, Bernini carved the portrait in 1622.[2] Montoya died in 1630, and two years later the busts were bequeathed by a certain Fernando Botinete to the Confraternity of the Resurrection at San Giacomo, of which Montoya had also been a member. The purpose of the sculptures is unknown, but their subject is appropriate for a confraternity devoted to the Resurrection, for which Montoya may have intended them from the outset; a further possibility is that Montoya intended them eventually to decorate his tomb. The souls of the dead are portrayed life-size, *al vivo* in contemporary terminology, an irony that was surely deliberate.

Such powerful physiognomical and expressive contrasts have an ancient history, occurring, like Beauty and the Beast, on opposite sides of certain Greek coins of the fourth century B.C. (Fig. 114), and, juxtaposed, in the familiar masks of Comedy and Tragedy from the classical theater (Fig. 115).[3] In both cases the focus is on the face alone, and one, male, is distorted in a wild and grimacing shout while the other, female, is beautiful and portrayed as if transmitting some lofty, portentous truth. The masks are particularly relevant because, like Bernini's busts, they have generic as well as specific meaning: they symbolize their respective theatrical genres, but they also represent the actual roles or characters the actors performed—the ancients called them *personas*. The masks stand for heroic types, however, not real people, as do Bernini's sculptures. This reference to ordinary people relates the busts to the participants in those great medieval visualizations of the Last Judgment in which the souls of the resurrected dead are weighed by St. Michael and go, joyously or pathetically, to their fates (Fig. 116).

Three points above all distinguish Bernini's sculptures not only from these precedents, but from all precedents, as far as I know. The souls are portrayed not as masks or full-length figures but as busts, they

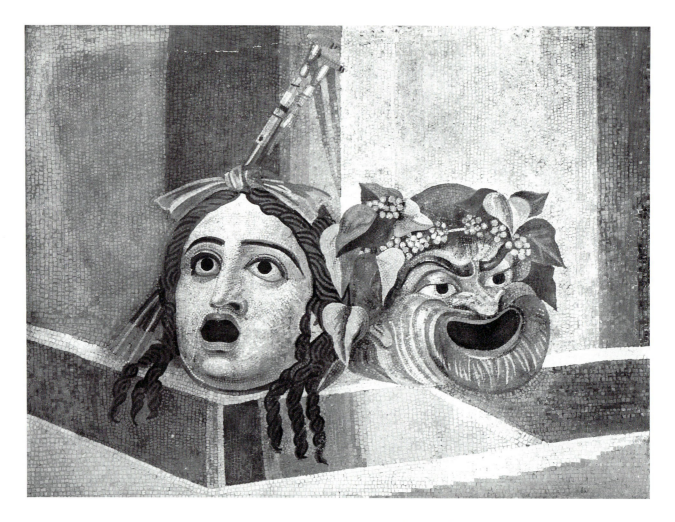

Fig. 115. Theater masks, mosaic. Capitoline Museum, Rome
(photo: Anderson 1745).

are isolated from any narrative context, and they are independent, freestanding sculptures. The images are thus blatantly self-contradictory. They constitute a deliberate art-historical solecism, in which Bernini adopted a classical, pagan form invented expressly to portray the external features of a specific individual, to represent a Christian abstract idea referring to the inner nature of every individual. My purpose in this chapter is to shed some light on the background of these astonishing works and their significance in the history of our human confrontation with our own end.

Among the intense mystical exercises enjoined upon the pious in the late Middle Ages was to contemplate death. Often regarded as a morbid symptom of decadence at the end of the Age of Faith, this preoccupation in fact reflected a positive, indeed optimistic, view that people could provide for their

well-being in the afterlife by looking death in the face. They could prepare for a good death, as it was termed, by putting their affairs in order and examining their conscience, and they could consider the effect of their attitude and behavior upon God's just and ineluctable judgment. These two complementary exhortations, to prepare for death and consider the afterlife, were converted into veritable techniques for achieving salvation in two of the most widely distributed books of the fifteenth century, which had remarkably similar histories. The *Ars moriendi* (The art of dying) prescribed the measures to be taken as life drew to a close, and the *Quattuor novissima* (The four last things) described the ultimate events in the curriculum of human existence: death, judgment, damnation, and salvation.[4] Although not directly related, the first work ends where the second begins. After their original success *The Art of*

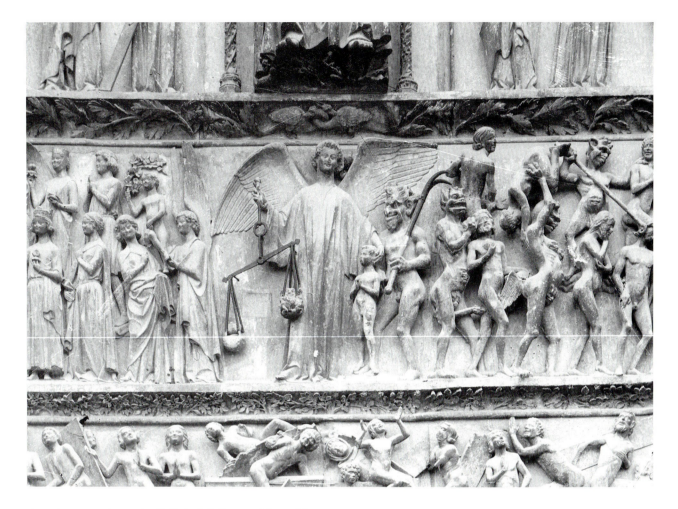

Fig. 116. *Last Judgment,* detail. Cathedral, Bourges (photo: Monuments historiques AH 18902).

Dying and *The Four Last Things* (Figs. 117–120), to which most of our attention will be devoted, were largely eclipsed during the humanistic florescence of the early sixteenth century. Thereafter, however, these popular eschatologies were retrieved and vigorously cultivated by the militant church activists of the Counter-Reformation,[5] especially the Jesuits, who incorporated the Four Last Things into their catechisms. Among the most powerful offensive weapons in the Jesuits' spiritual arsenal, the catechisms were not theological tracts but served a primarily edificatory purpose, and from the beginning they were frequently accompanied by illustrations (Figs. 121–124).

There were even instances when the illustrations predominated over the text, the latter being reduced to brief captions (Figs. 125–128).[6] Characteristic of the entire tradition of the Four Last Things illustra-

tions is that whereas death, following the *Ars moriendi,* might be confined to a single individual, the events of the afterlife—judgment, damnation, and salvation—were conceived as universal occurrences and shown as panoramic scenes with many participants.[7]

Bernini's sculptures break with this tradition by eliminating the first two events and focusing instead upon their ethical implications. Moreover, Bernini conceived of damnation and salvation themselves in a novel way, describing neither the tortures of hell nor the pleasures of paradise but instead concentrating on the single soul and its "state of mind." Treated as independent busts, Bernini's sculptures are "soul portraits": portraits of Everyman and Everywoman, but of No-body.

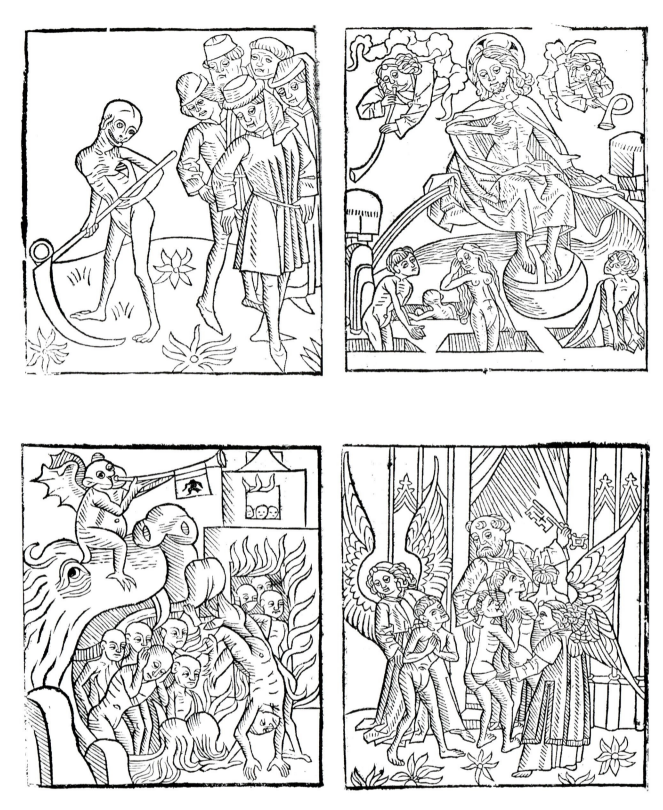

Figs. 117–120. Death, Last Judgment, Hell, Heaven (from Dionysius, 1482).

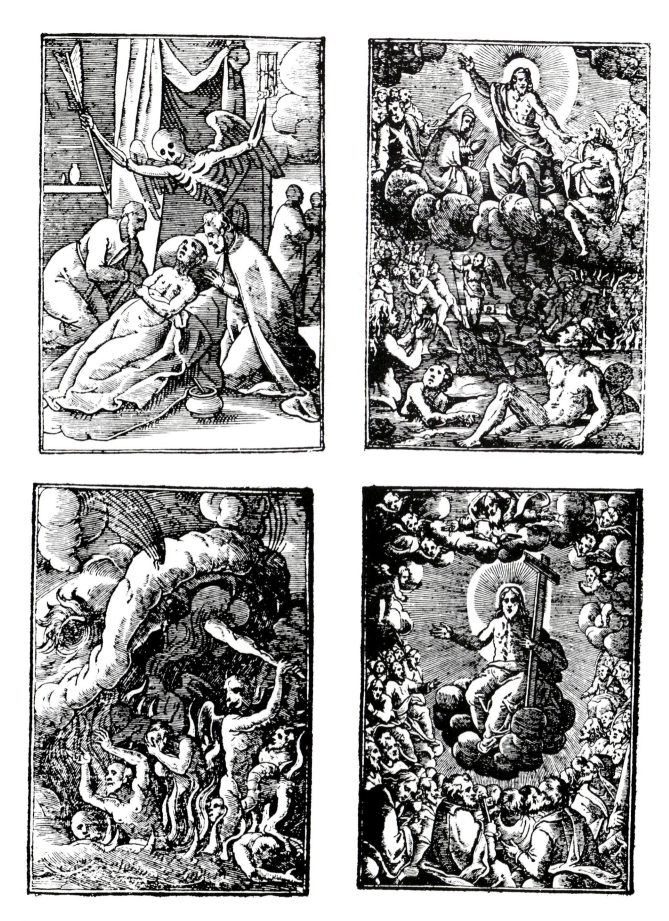

Figs. 121–124. Death, Last Judgment, Hell, Heaven (from
Bellarmine, 1614, 112–15).

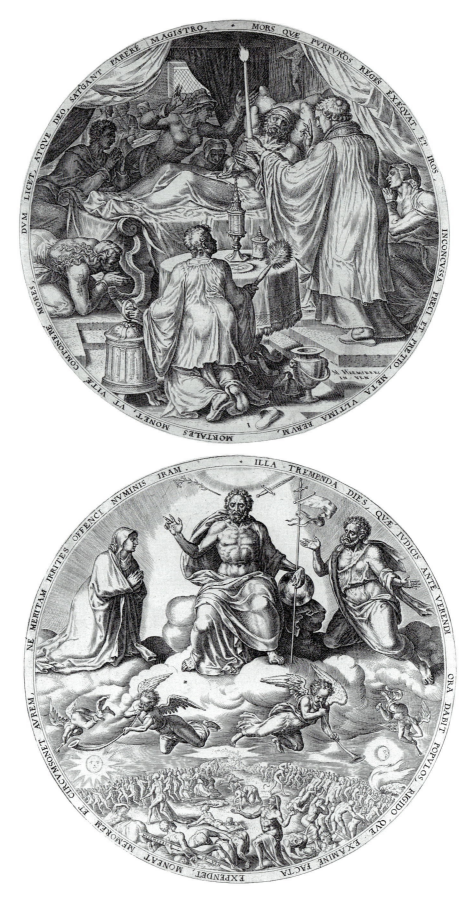

Figs. 125–128. Maarten van Heemskerck, Death, Last Judgment, Hell, Heaven, engravings. Metropolitan Museum, New York, The Elisha Whittelsey Collection, The Elisha Whittelsey Fund, 1949.

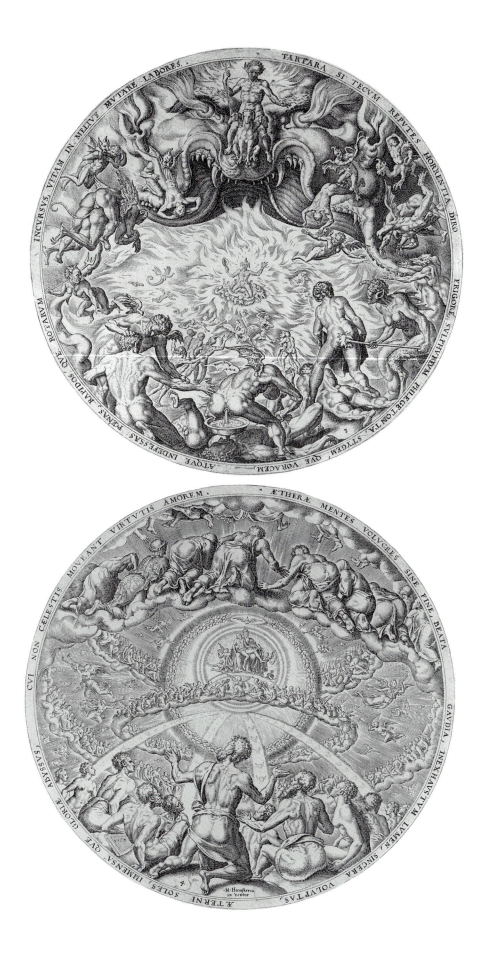

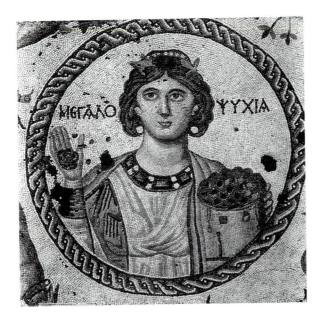

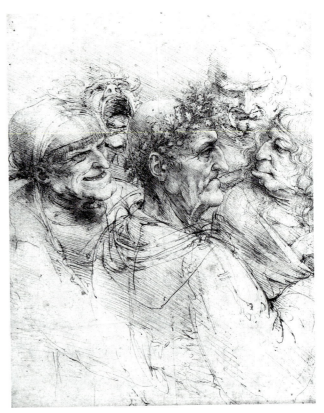

Fig. 129 (*top, left*). *Megalopsychia*, mosaic. Antioch (photo: Dept. of Art and Archaeology, Princeton University).

Fig. 130 (*top, right*). Leonardo, grotesque heads, drawing. Royal Library, Windsor Castle.

Fig. 131 (*right*). Michelangelo, so-called Anima Dannata, drawing. Galleria degli Uffizi, Florence.

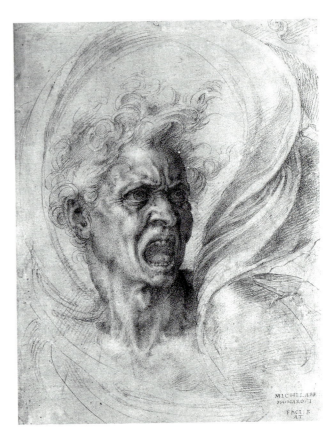

Hæc fele natæ galli nafus incauus, cum conuexa circulari frontis fuperꞏ
fcie exprimitur, cum humano ad eiufmodi formam effigiato, infra
defcribendo.

*Incauus nafus ante frontem, rotundus, & fupereminens
rotundum.*

Vt fe habet antiqua tranflatio Ariftotelis in Phyfiognoꞏ
monicis; Qui nafum concauum habent, ante frontem rotun‐
dum, & fupereminentem rotundum, luxuriofi funt, & ad
gallos referuntur. Nos, cum eiufmodi nafum ignoraremus,
tum Ariftotelici textus corruptione, tum interpretis tranfla‐
tione, gallos confuluimus, atque diligenti eorum infpectio‐
ne, ita textū & fenfum verbis accommodauimus, habet enim
gallinaceus gallus ante frontem in confinio valleculam quan‐
dam, vel incauum quoddam, & pars ea nafi ante frontem ro‐
tunda, & inde frons à nafo ad capillorum radicem, velut cir‐
culi circumferentia eft.Vt verba textus tranflata dicant:Qui
ante nafum habet incauum, & partes, quæ ante frontem ro‐
tundas, circumferentiam vero fupra affurgentem, &c. hos
ego etiam puerarios iudicarem:abutuntur enim Venere galli

gallinacei, perdices, & coturnices; quæ fere fimilem nafum
habent.Cum enim feminæ ouis incubant,mares dimicant pu‐
gnamque inter fe conferunt,quos cœlibes vocant; qui victus
in pugna fuerit, victoris Venerem patitur, nec nifi à fuo vi‐
ctore fubigitur,ex Ariftotele:& multos amicos cognoui eiuf‐
modi nafo præditos, huic enormi luxuriæ generi obnoxios.
Fingunt Poëtæ Iouem aquilæ forma Ganymedem rapuiffe,
fubtali figmento id fortaffe innuentes.Ælianus etiam ichneu‐
monem huic turpitudini obnoxium dixit. Tali nafo Satyri
& Sileni ab antiquis effigiati funt, & tali nafo etiam Socra‐
tes ipfe præditus fuit:nam Xenophon Socratem Silenis fimi‐
lem fuiffe, & preffis naribus, fcribit.

Latus in medio nafus.

Nafus in medio latus, declinans ad fummitatem, demon‐
ftrat mendacem & verbofum. Ariftoteles ad Alexandrum.

*Si bouis nafum infpexerimus, & hominem fimilem effigiauerimus, non
ab hac quæ hic cernitur figura, longe aberit, ita affabre in imo craf‐
fius deducitur.*

Fig. 132. Physiognomical types (from Della Porta, 1586).

As such, the sculptures seem unprecedented on
two accounts. Antiquity might deify certain per‐
sonal qualities such as piety or magnanimity (Fig.
129), and the Middle Ages might personify certain
moral qualities such as virtues and vices (cf. Fig. 154).
The pagan concepts were the subject of religious
cults, and the Christian notions were part of an
abstract scheme; but neither personal nor moral
qualities were represented as individual, isolated
sculptured busts. As far as I can determine, the
Anima Beata and *Anima Dannata* are the first indepen‐
dent images of the soul, and they are the first inde‐
pendent portrayals of pure psychological states.
Most scholars have been preoccupied with these
psychological states. The sculptures are indeed
prime documents in the history of physiognomical
expression in art, key links in a chain that leads
from Leonardo's studies of grotesque facial types

(Fig. 130—note especially the juxtaposition of the
smiling and howling heads at the left) and Michel‐
angelo's explorations of extreme expressions (Fig.
131), through the quasi-scientific classical tradition
represented in the late sixteenth century by Giam‐
battista della Porta's book relating animal and human
characterological traits (Fig. 132), to Charles Le
Brun's systematic treatment of physiognomics and
emotional expression in the mid-seventeenth century
(Figs. 133, 134). The tradition culminated in the
eighteenth century with the series of bronze busts
by Franz Xavier Messerschmidt (Figs. 135, 136), in
which Bernini's contrasting pair of object lessons in
affective morality is transformed into an extensive
catalogue of grimacing character masks, including
the artist's own.[8]

However important Bernini's sculptures may be
to these scientific and rhetorical explorations of

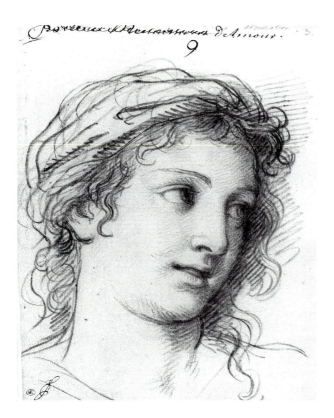
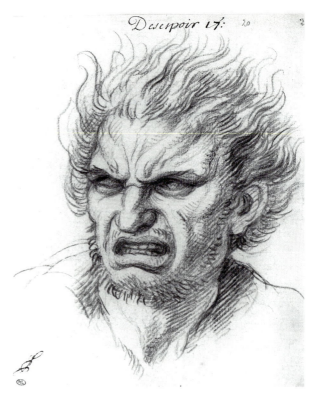

Figs. 133–134. Charles Le Brun, *Amour* and *Désespoir*, drawings.
Musée du Louvre, Paris (photo: Documentation photographique
de la Réunion des musées nationaux).

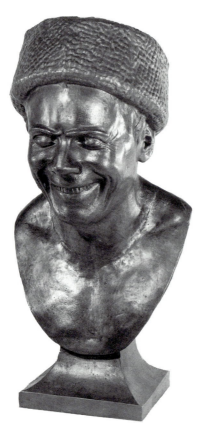
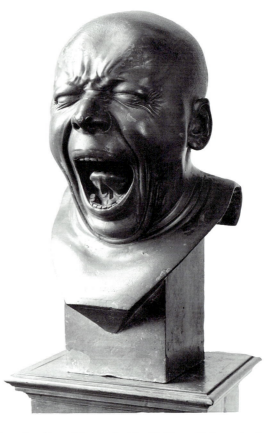

Fig. 135. Franz Messerschmidt, self-portrait, smiling. Galéria
hlavného mesta SSR Bratislavy, Bratislava.

Fig. 136. Franz Messerschmidt, *The Yawner*. Szépmüvészti
Múzeum, Budapest.

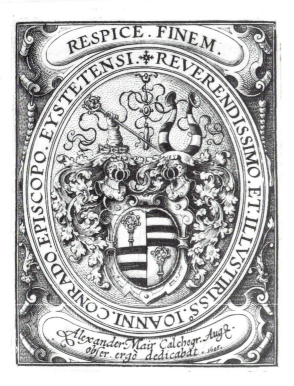

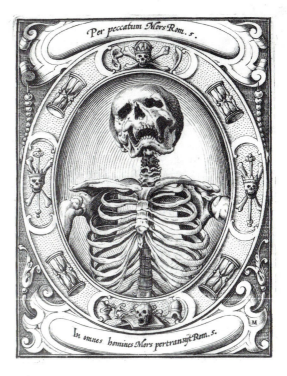

Figs. 137–138. Alexander Mair, arms of Johann Conrad and
Memento mori, engravings. Staatliche Graphische Sammlung,
Munich.

psycho-physiognomics, his chief interest surely lay in the "interface" between moral and psychological states, as is apparent from what must have been one of his direct inspirations for the *anime* busts. In 1605 the visual tradition of the Four Last Things had been radically reinterpreted by the Augsburg printmaker Alexander Mair, who issued a suite of six engravings on the theme (including the intermediate state of purgatory), dedicated to the Archbishop of Eichstätt in Bavaria, Johann Conrad (Figs. 137–142).[9]

The playing-card-size format of this suite reflects its individualized, *ad hominem* function; and Mair in fact distilled the universal scope of the catechistic tradition into a personal, not to say private, *memento mori* in which events are reduced to a few peripheral symbolic details and the subject of the action is one individual. The framed niche, the close-up view, and the bust-length format are all features that suggest the familiar type of the portrait medallion, especially on tombs (Fig. 143). Indeed, it might be said, con-

versely, that Mair here transformed the traditional portrait medallion into a moral emblem. The emblem is given a liturgical and sacerdotal cast by the inscriptions, drawn mainly from the Office for the Dead, and by the image of the Blessed Soul, shown wearing the surplice of a deacon and a brooch inscribed with the IHS device of the Jesuit order.

The expressive force of Mair's images would have been of particular interest to Bernini. The souls' highly charged emotional responses to what they see, from the howling scream of the damned to the blissful moan of the saved, were also probably transferred from a domain other than the engraved *Novissima* suites. The intensity of the contrast recalls the great painted altarpieces of Frans Floris, in which the reactions of the participants are brought to the fore (Fig. 144).

If Bernini knew Mair's suite of engravings, as I think he did, he transformed them in three ways. He treated them as independent sculptured busts,

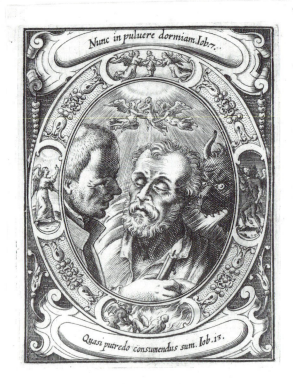

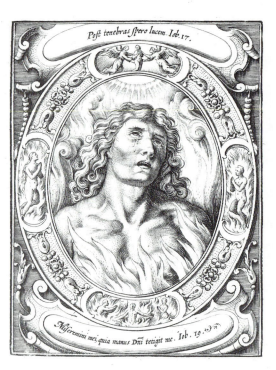

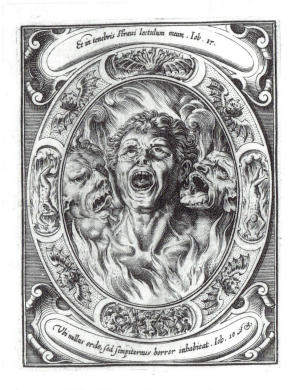

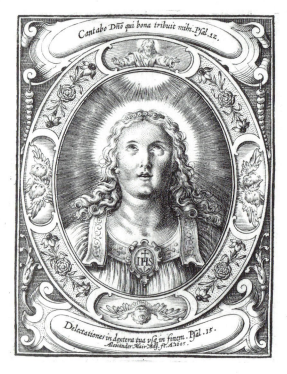

Figs. 139–142. Alexander Mair, Death, Purgatory, Hell, Heaven,
engravings. Staatliche Graphische Sammlung, Munich.

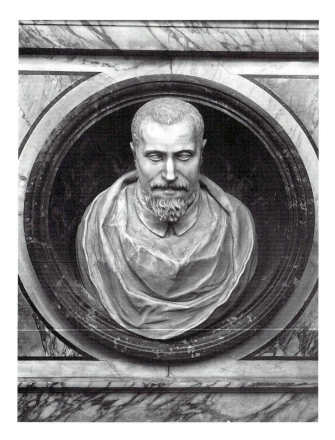

Fig. 143 (*left*). Tomb portrait of Ippolito Buzio. Santa Maria sopra Minerva, Rome (photo: Istituto Centrale per il Catalogo e la Documentazione, Rome E54398).

Fig. 144 (*below*). Frans Floris, *Last Judgment*. Kunsthistorisches Museum, Vienna.

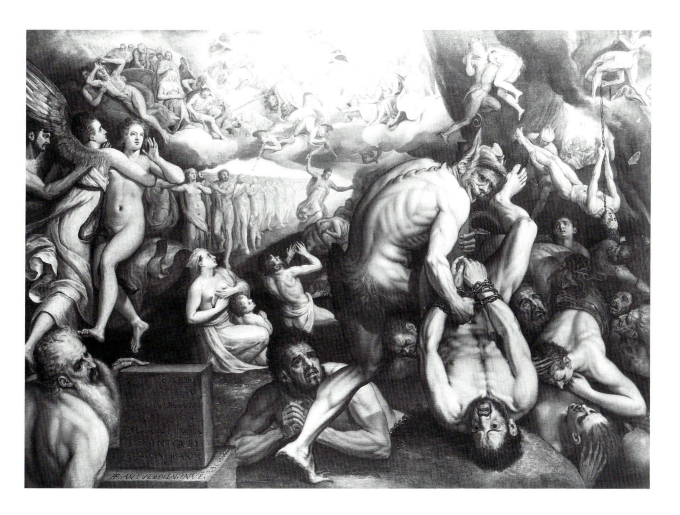

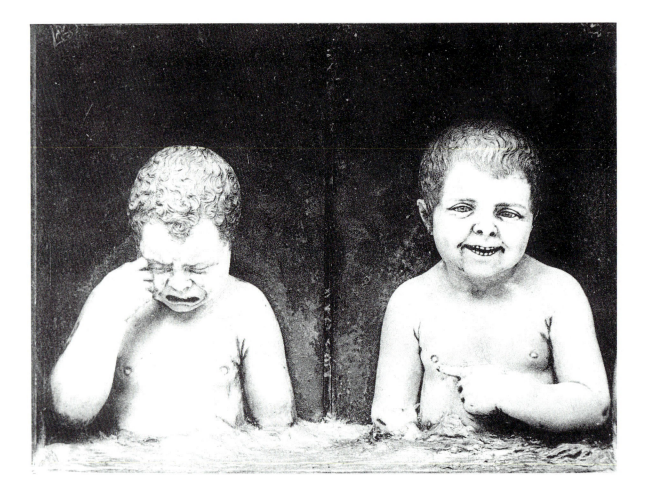

Fig. 145. Crying and laughing babies, wax. Formerly Lanna collection, Prague (from *Sammlung*, 1911, pl. 20).

Fig. 146 (*opposite*). Willem van Haecht the Younger, *Studio of Cornelis van der Geest*, detail. Rubenshuis, Antwerp.

he eliminated the narrative elements entirely, and he reduced the number to a pair, the damned and the saved, male and female, alter egos of our common humanity. For each innovation there was at least partial precedent. Mair's powerful images had been made even more vivid in three-dimensional translations—or rather, retranslations, since they themselves allude to sculptured medallions—by a once acclaimed but now little known painter and sculptor, Giovanni Bernardino Azzolini. Azzolini was a native of Sicily who worked mainly in Naples. He visited Genoa in 1610, where he modeled in colored wax depictions of the Four Last Things as half figures, in whose faces transpired "the affects of a blessed soul, of another condemned to suffer but with hope for eternal peace [that is, a soul in purgatory], of a third portraying a skeleton, and of a fourth expressing in a horrid abyss the idea of rabid desperation" (cf. Figs. 157–176).[10] Azzolini's dramatic portrayals were very successful and many versions are known, none of which can be ascribed to him with certainty. What is clear, both from the descriptions and from the known copies, is that the

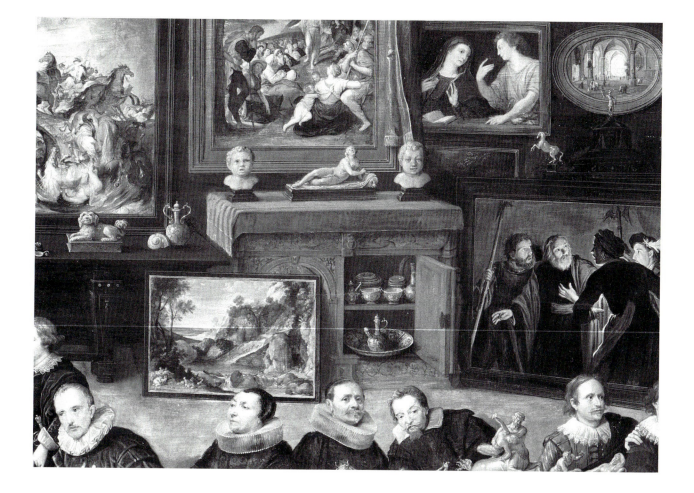

reliefs were based on Mair's prints, and it is possible that Azzolini, who registered with the painter's guild in Rome in 1618, may in turn have inspired Bernini to make his own sculptural versions.[11]

Azzolini was known for another work that may have been relevant to Bernini's sculptures. This was a pair of colored waxes, now lost, described as heads of infants, one crying, the other laughing.[12] Here, human emotions were brought to expressive peaks and directly contrasted. The pertinence of these sculptures is enhanced by an almost inevitable association with the old tradition of representing the human soul in the form of an infant. Many versions of the pair are known (Fig. 145), including the marble busts in the ideal collection shown in a "gallery" picture of the seventeenth century by the Flemish master Willem van Haecht the Younger (Fig. 146).[13]

This version, in turn, brings into focus another aspect of the prehistory of Bernini's soul portraits: his adoption of the bust form. The ancient Romans developed the sculptured bust as the portrait form *par excellence*.[14] The full-length statue might portray an allegory, a god, or a human being, whereas the

bust was reserved almost exclusively for people—or rather, the spirits of people, for it originated and remained intimately associated with the ancestor cult (Fig. 147). The bust was thus antiquity's most conspicuous form of personal commemoration, and its role in the imperial cult made it for early Christians the very symbol of idolatry. Certain Early Christian depictions of the story of the three youths who refuse to worship the image of Nebuchadnezzar show not a statue but a bust on a pedestal standing on the ground (Fig. 148). The bust signified far more than met the eye, and this quasi-demonic potency led to its virtually complete suppression in the Middle Ages. When it was revived in the Renaissance, some of its super-charged meaning was transmitted to the modern cult of the individual, so that the renewed form acquired an emblematic significance of its own. In the seventeenth century, by a characteristic process that might be called paradoxical inversion, sculptured busts were often given prominent roles in the flourishing genre of moralized still life, or *vanitas*, painting.[15] These pictured busts were never actual portraits but represented

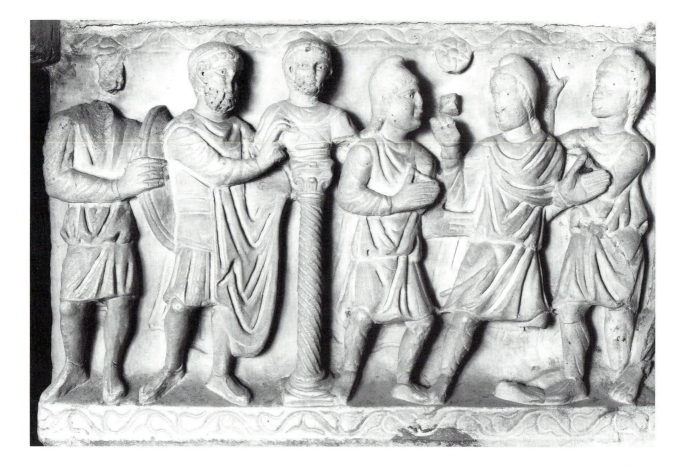

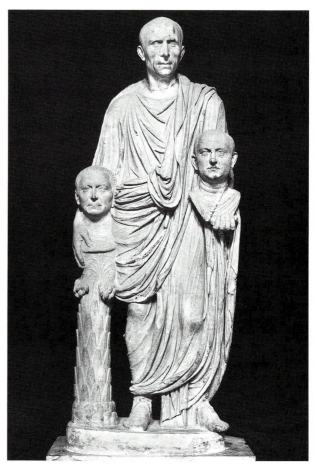

Fig. 147 (*right*). Roman patrician with ancestor portraits. Palazzo Barberini, Rome (photo: Anderson 6371).

Fig. 148 (*above*). Nebuchadnezzar and the Three Youths, sarcophagus of St. Ambrose, detail. Sant'Ambrogio, Milan (photo: Electa).

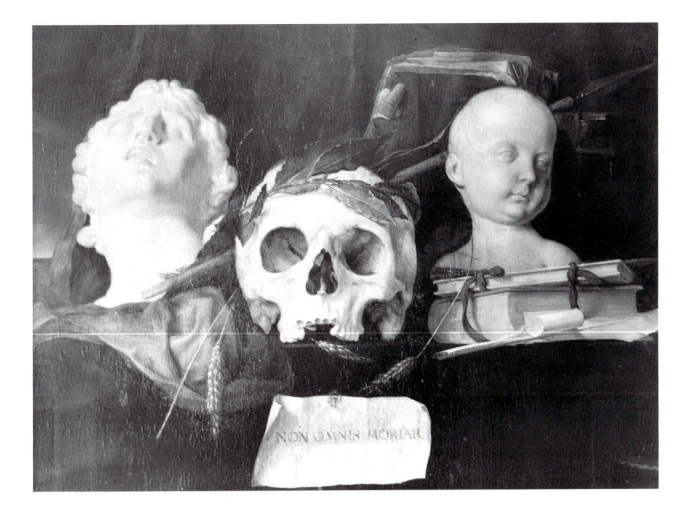

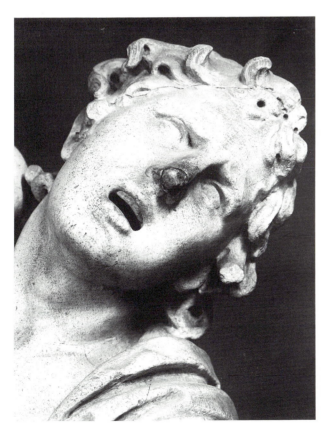

Fig. 149. Jan Davidsz de Heem, *Vanitas* still life. Schloss Pommersfelden (photo: Marburg 63877).

Fig. 150. Laocoön, detail. Vatican Museum, Rome.

ideal types, such as were kept in artists' studios as models of classical beauty and expression. In this context they might have dual significance, alluding not only to the transitoriness of life but also to the futility of the arts themselves, even that of carving stone. A *memento mori* composition by Jan Davidsz de Heem (Fig. 149) evidently alludes to the three ages of man, with a skull in the center flanked by sculptured heads of a serene child and a suffering man, perhaps that of the son of Laocoön in the ancient *exemplum doloris* group in the Vatican (Fig. 150).[16] By adopting the bust form for his soul portraits, Bernini transformed a visual device that evoked generically the life of this world into one that evoked individual life in the next.

Fig. 151. *Laughing Faun.* Rijksmuseum, Amsterdam.

Bernini's busts form a complementary and contrasting pair in composition, sex, and expression. The action of the heads and direction of the glances create a spatial environment that includes the spectator and extends upward to heaven and downward to hell. The portrayal of the souls followed a tendency evident in some depictions of the Last Judgment to focus on a representative male to convey the rabid fury of the damned and on a female to convey the ecstasy of the saved (see Fig. 144).[17] In the *Anima Beata* Bernini omitted the deacon's surplice Mair had provided (see Fig. 142) and gave greater prominence to the wreath of flowers, an attribute of purity often worn by angels. The effect is to replace the liturgical and ritual emphasis of Mair's interpretation with an embodiment of moral innocence. Looking up and slightly to the side, with nostrils distended and lips parted in a gentle sigh, the blessed soul responds to the beatific vision that all the blessed in heaven enjoy. The expression of blissful suffering recalls, in positive terms, the physical torment and anguished groan of Laocoön's son.

The blunt features and unruly hair of the damned soul are derived from the common identification of devils with satyrs, the ancient embodiments of unrestrained passion. In certain instances the satyr-devil's ghoulish grin is quite deliberately matched by the howling grimace of the damned (see Fig. 144). Specifically, the *Anima Dannata* seems to convert into negative terms the features of an ancient dancing satyr, a type for which Bernini later expressed great admiration, and which was also given bust form in this period (Fig. 151).[18] In both of Bernini's busts, therefore, the expressive qualities seem to have resulted in part from subtle and ironic inversions of ancient expressive conventions.

Taken together, the sculptures convey a sense of the Last Things very different from that of earlier portrayals of the theme; Bernini emphasized not the physical but the psychological consequences of good and evil. In this respect the *Anima Beata* and *Anima Dannata* seem to embody medieval theological definitions of the *summum bonum* and the *summum malum* as the judged soul aware of its destiny either to behold

or to be banished from the face of God, forever.[19] These are the prospects Bernini's images contemplate, and they react to what they "see."

Finally, there can be little doubt that Bernini's soul portraits reflect a Roman theatrical event of the Jubilee year 1600, in which personifications of damned and blessed souls appeared together outside their usual narrative context. This was the *Rappresentatione di anima et di corpo*, a musical drama sponsored by the Fathers of the Oratory, founded in the late sixteenth century in Rome by St. Philip Neri, and performed in the order's oratory at Santa Maria in Vallicella.[20] The music was written by Emilio de' Cavalieri (1550?–1602), a leading figure in the development of the early opera, and the text by Agostino Manni (1548–1618), an Oratorian who had previously published several volumes of spiritual poems called *laude*. The *Rappresentatione* was important from many points of view. It marked the introduction from Florence to Rome of the new technique of melodic recitation, or the use of song in a dramatic enactment—melodrama, as it was called—intended to recapture what was thought to be the essential principle of ancient theatrical art. All this was stated explicitly in the preface to the original edition of the text and score of the *Rappresentatione*, as was the intention to move the audience by expressing through the melodic dialogue the strongly contrasting emotions of the characters, like pity and joy, weeping and laughter. "Passing from one affection to its contrary, as from mournful to happy, from ferocious to gentle and the like, is greatly moving."[21]

The text of the play, which must certainly have been conceived with musical enactment in mind, was no less innovative, in part because of precisely the return to much earlier traditions that would animate Bernini's sculptures. Essentially, the text combined two late-medieval modes, both revived in the latter part of the sixteenth century: the *lauda*, or song of praise, with narrative and dialogue between voices or characters, real or imaginary, but no proper enactment; and the *sacra rappresentazione*, or religious play in verse, usually based on a biblical story, with parts often sung to musical accompaniment.[22] The three-act work, something between a recitation and a play, included, besides Body and Soul, allegorical characters such as Time, Understanding, Good Counsel, Mammon, and Worldly Life. The plot consists entirely in the exchange of arguments for good and evil, presented in counterpoint until Virtue triumphs. The only events, properly speaking, occur in the third act when hell and heaven alternately open and close, their denizens intoning laments and exhaltations (cf. Figs. 152, 153).

So far as we know, the *Rappresentatione di anima et di corpo* was not performed again after the Jubilee of 1600, but its impact was immediate and profound. A contemporary biographer of Manni described the performances, attended by the whole College of Cardinals, as "the first in Rome in the new recitative style, which then became frequent and universally applauded."[23] The response may be judged from the vivid, moving recollections of an eyewitness, recorded after the death of Emilio de' Cavalieri in 1602. The report illustrates not only the thematic but also the expressive context from which Bernini's sculptures emerged.

I, Giovanni Vittorio Rossi, found myself one day in the home of Signor Cavaliere Giulio Cesare Bottifango, not only a fine gentleman but also one of rare qualities—excellent secretary, most knowledgeable poet and musician. Having begun to discuss music that moves the emotions [*musica che move gli affetti*], he told me resolutely that he had never heard anything more affecting [*più affettuosa*], or that had moved him more than the Representation of the Soul put to music by the late Mr. Emilio del Cavaliere, and performed the Holy Year 1600 in the oratory of the Assumption, in the house of the Reverend Fathers of the Oratorio at the Chiesa Nova. He was present that day when it was performed three times without satisfying the demand, and he said in particular that hearing the part of Time, he felt come over him a great fear and terror; and at the part when the Body, performed by the same person as Time, in doubt whether to follow God or the World, resolved to follow God, his eyes poured forth a great abundance of tears and he felt arise in his heart a great repentance and pain for his sins. Nor did this happen only then, but thereafter whenever he sang it he was so excited to devotion that he wanted to take communion, and he erupted in a river of tears. He also gave extreme praise to the part of the Soul, divinely performed by that castrato; he said the music was also an

Ite à trouar gli sciocchi,
C'hanno abbagliati gli occhi:
O quanta nebbia, & ombra
Gli occhi mortali ingombra!

Scena Ottaua.

Angelo Custode. Anima, e Corpo; &
Angeli nel Cielo, che s'apre.

52. *Ang. cust.* AL forte vincitore
E' debito l'honore,
L'honor, ch'è apparecchiato
Nel Ciel, che fa beato:
Si c'hormai da la terra,
C'hauete vinta in guerra,
Volgete il cor, e'l viso,
E i passi al Paradiso.
53. Venite al Ciel diletti,
Ange. li. Venite benedetti,
Che queste sedi belle
Furon fatte per voi sopra le stelle:
Lasciate pur la terra,
Dou'è perpetua guerra;
Salite al Ciel con volo glorioso,
Dou'è pace, e riposo,
Doue senz'alcun velo
Si vede il Rè del Cielo.

Scena Nona.

Choro.

54. DOpo breui sudori
Poter dal caldo, e'l gielo
Salir beato al Cielo
A i sempiterni honori
Dal mondo pien di mali,
E'sorte auenturosa de' mortali.
Poter dopò le proue
L'huomo frale, e mendico,
Ma di virtute amico,
Salir'in alto, doue
Son richezze immortali,
E'sorte auenturosa de' mortali.
Da gli abissi terreni,
Doue regna la Morte,
Poter salir per sorte
A i sommi eterni beni,
Che non hanno altri eguali,
E'sorte auenturosa de' mortali.
Amar'il bene eterno,
Salir'al Ciel superno,
Fuggir del Mondo i mali,
E'sorte auenturosa de' mortali.

ATTO TERZO.

Scena Prima.

Intelletto. Consiglio. Anima, e
Corpo. & Choro.

55. In. SAlite pur al Cielo,
Che nel Ciel Dio si vede,
56. Del cor ricca mercede.
Cons. Fuggite pur l'Inferno,
Dou'alberga ogni male,
Dou'è il verme immortale.
57. In. Salite pur al Cielo,
Doue s'odon i canti
58. De gli Angeli, e de i Santi.
Cons. Fuggite pur l'Inferno,
Doue s'odon le voci
59. De gli Angeli feroci.
Choro. Fugge il nocchier l'infesta
Del mar fiera tempesta,
Ma più s'han da fuggire
Del Ciel gli sdegni, e l'ire.

60. In. Nel Ciel sempre è allegrezza,
Nel Ciel sempre è la Luce,
61. Ch'eternamente luce.
Cons. Ne l'Inferno è spauento,
Ne l'Inferno è dolore,
Le tenebre, e l'horrore.
62. In. Nel Ciel son le richezze,
Nel Ciel sono i tesori,
63. E i sempiterni honori.
Cons. Ne l'Inferno ogni tempo
Miseria, e infamia stà,
Vergogna, e pouertà.
64. In. Nel Ciel sono i palazzi
Fatti di pietre d'oro,
65. Di mirabil lauoro.
Choro. Cerca altri à tutte l'hore
Le gemme di valore:
Ma più s'han da cercare
Del Ciel le gemme rare.
66. *Cons.* Ne l'Inferno vi stanno
Le spelonche, e le grotte,
Doue alberga la notte.
67. In. Nel Cielo è Primauera,
Che'l Paradiso infiora,
68. E in sempiterno odora.
Cons. Nel profondo è l'Inuerno,
L'immonditia, e'l fetore
D'abominoso odore.

Scena Seconda.

Consiglio. Anime dannate, & appress' vna
Bocca d'Inferno.
Intelletto. Anima, & Corpo.

Cons.
segue. VOi che sete la giù,
Che vi tormenta più?
69. *Ani.* Il foco, il foco eterno?
dan. Il foco, il foco eterno,
Crudel, crudel Peccato,
Per cui ci hà condennato
Il Giudice superno,
Al foco, al foco eterno.

Scena Terza.

Intelletto. Anime beate in Cielo, che s'apre, &
chiude l'Infer. Consiglio. Anima, & Corpo.

70. In. ALme ch'in Ciel godete,
Qual premio in Cielo hauete
71. Più nobile, e più degno?
Ani. Eterno, eterno Regno:
Bea. O' Regno, ò Regno eterno:
O' Ben sommo, e superno,
Che mai non giunse al segno
Eterno, eterno Regno.
Intelletto. Consiglio. Anima, e Corpo
Dicono insieme: Cielo aperto.
72. O' gran stupore!
O graue errore!
C'huomo mortale
D'vn tanto male,
Ch'eterno dura,
Si poco cura!
O' gran stupore!
O' graue errore!
C'huomo mortale
Regno immortale,
Ch'eterno dura,
Stolto non cura!

Scena Quarta.

Consiglio. Anime dannate, et si riapre l'Infer.
Intelletto. Anima. Corpo, e Cielo aperto.

73. *Cons.* ANime sfortunate
L'altiere voci alzate,

74. Che v'è toccato in sorte?
Ani. Eterna, eterna Morte,
dan. Ahi! ci è toccata in sorte:
Morte, che mai non More
Sepolta nel dolore,
Aspra penosa, e forte,
Eterna, eterna morte.

Scena Quinta.

Intelletto. Ani. beate, nel Cielo aperto: Choro.
Cons. Anima, e Corpo: si rinchiude l'Inf.

75. In. ALme beate, e belle,
La sù sopra le stelle
76. Qual cosa è più gradita?
Ani. Eterna, eterna Vita,
Bea. Vita, che viue, e regna,
Dolce, celeste, e degna,
Sempre, sempre gradita,
77. Eterna, eterna Vita.
Chor. O gran stupore!
O graue errore!
C'huomo mortale
D'vn tanto male,
Ch'eterno dura,
Si poco cura!
O gran stupore!
O graue errore!
C'huomo mortale
Regno immortale,
Ch'eterno dura,
Stolto non cura!

Scena Sesta.

Consiglio. Anime dannate, e s'apre l'Inferno.
Intelletto. Anima. Corpo, e'l Cielo aperto.

78. *Cons.* ALme la pena, e'l danno,
Che vi dà tanto affanno,
79. Finir si deue mai?
Ani. Non mai, non mai, non mai.
dan. O sempiterni guai,
Che non finiscon mai!
Non mai, non mai, non mai.

Scena settima.

Intelletto. Anime beate, si rinchiude l'Inf.
Consiglio Ani. & Corpo.

80. In. ALme la vostra Gloria,
Ne l'eterna memoria
81. E' per durar mai sempre?
Ani. Sì, sempre, sempre, sempre.
Bea. Sempre, sempre sarà,
E mai non finirà:
E con perpetue tempre,
Durerà sempre, sempre.

Intelletto, Cons. Ani. Corp. dicono insieme.

82. Ogn'un faccia sempre bene,
Che la Morte in fretta viene:
Ami Dio ch'è suo Signore,
Fugga il Mondo ingannatore;
E perche hà errato,
Del suo peccato
Con pura fede
Chiegga mercede:
Facci opre bone, e la sua vita emende,
Che da vn momèto sol l'Eterno pède.

Anima, e Corpo dicono insieme.

83. Come Ceruo assetato
Corre al fonte bramato,

Figs. 152–153. Last act of *Rappresentatione di anima e di corpo* (from De' Cavalieri, 1600).

Cosi da noi si brama, e si desia
Salir al Ciel con voi per erta via.
Ma prima insiem cantiamo,
E'l gran Signor lodiamo.

Scena ottaua.

Angeli, et Ani. beate in Cielo: Anima, Corpo,
Intelletto, & Consiglio tutti insieme.

84. Gloria sia à Dio supremo,
Che viue in sempiterno:
A l'alto, e gran Signore
Sia sempiterno honore.
Anime beate, & Angeli.
85. Chiamiamo tutto il Mondo,
E con canto giocondo
Cantiam, cantiam gioiosi
Di Dio le lodi, e i fatti gloriosi.

Scena nona.

Anime beate Angeli, Anima, Corpo, Intelletto,
Consiglio, Choro, & tutta la moltitudine insieme.
86. O Signor santo, e vero,
Che del mondo hai l'impero:
O Signor santo, e forte,
Domator de la morte,
Donator de la vita;
Somma bontà infinita:
A te Signor', à te
Gloria, e laude si dè;
A te sómo Signor supremo, e degno
Sia gloria eterna, e sépiterno Regno.

87. I. Voi ch'ascoltando state,
Perche non giubilate?
Non più, non più pensosi:
Tutti lieti, e gioiosi
Con festa giubiliamo,
Con giubilo cantiamo,
Fugga lontano il lutto:
Festa, festa per tutto.
Tutta la moltitudine insieme.
88. Gratie, Hinni, laudi, e giubili d'amore
Canti la lingua, e le risponda il core.
89. A. Ogni lingua, ogni core
Dia laude al mio Signore,
Che l'alme pouerelle
Da terra alz'à le stelle.
Vi prego alme dilette,
Al ben oprar' elette,
Come da serpe irato
Fuggite dal peccato:
E liete à i vostri alberghi ritornate,
E con voi riportate
Questo ricordo mio: (Dio.
Ch'eterno Regno haurà chi serue à
90. Tenga ogn'vn, tenga nel core,
Choro. Ch'al fuggir son prette l'hore;
Et è forza, ch'ogn'vn lassi
Tutto il ben, ch'in terra stassi.
Ne c'inganni il mondo rio,
Ch'ogni ben nasce da Dio:
E à l'opre sante, e bone
Rispódono nel Ciel scettri, e corone.
FESTA.
Tutta la moltitudine insieme.
91. C Hiostri altissimi, e stellari,
Doue albergano i Beati,

Luna, Sol, Stelle lucenti
Fate in Ciel dolci concenti;
Tutto il mondo pieno sia
D'allegrezza, e d'armonia.
Rè del Mondo, e gran signori
Giubilate dentro à i cori,
D'ogni sesso, d'ogni etate
Donne, & huomini cantate
Con fanciulli, e verginelle,
Canzonette allegre, e belle.
D'arpe, lire, organi, e trombe,
L'aria, e terra, e mar rimbombe,
L'aure vaghe, il suon giocondo
Portin via per tutt'il Mondo,
E roccando il suono il core,
Senta giubili d'amore.
Voi di Dio fedeli amanti,
Genti giuste, huomini santi,
Gratie eterne à Dio rendete,
Gigli, e rose insiem spargete,
E co' i gigli, e con le rose
Lodi eterne, e gloriose.
Voi celesti Gierarchie
Fate noue melodie:
Ecco vn'altra noua stella
Tutta chiara, tutta bella
Verso il Ciel vola splendente,
Perche luca eternamente.
Congiungete Angeli buoni,
Congiungete i canti, e i suoni:
E qua giù la Terra ancora,
Mentre lieta il seno infiora,
Con il canto, e con il riso
Corrisponda al Paradiso.
LAVS DEO.

Aria Cantata, & Sonata; al modo Antico.

Io piango Fil li il tuo spieta to inte ri to, E'l Modo del mio mal tutto rinuer desi: Deh pensa prego al bel vi uer pre te ri tos

Se nel pastar di Le the A mor non per de si.

In ROMA, appresso Nicolò Mutij 1600. Con Licenza de' Superiori.

Fig. 154. *Largitas* and *Avaricia*. Nôtre-Dame-du-Port, Clermont-Ferrand (photo: Monuments historiques J.F. 639/73).

Fig. 155. Hildegard of Bingen, "Beati" and "Maledicti." MS lat. 935. fol. 38v, Bayerische Staatsbibliothek, Munich.

inestimable artifice that expressed the emotions of pain and tenderness with certain false sixths tending toward sevenths, which ravished the spirit. In sum, he concluded, one could not do anything more beautiful or more perfect in that genre, and, so I might see for myself the truth of what he said, he took me to the harpsicord and sang several pieces from the representation, in particular that part of the Body which had so moved him. It pleased me so much that I asked him to share it with me, and he most courteously copied it himself. I learned it by heart, and often went to his house to hear him sing it himself.[24]

The legacy of Manni's and Cavalieri's *Rappresentatione* was twofold. Its drama and spectacle were absorbed into the operas on religious themes produced in Rome in the second quarter of the century; the work also influenced the development by Neri's order of the oratorio form itself, in which recitative predominated over staging. Common to both forms was melodic dialogue, and its use in the *Rappresentatione* may have been directly inspired by a medieval work. The interchange between Anima and Corpo that provided the main theme as well as the title of the *Rappresentatione* seems to recall explicitly one of the *laude*, a *contrasto* between Body and Soul by the fourteenth-century Franciscan poet Jacopone da Todi, whose writings were incorporated into the daily devotions of the Oratorians by Philip Neri himself.[25] The *contrasto* was a distinct literary genre in which two characters, who may personify abstract ideas, debate a moral issue. Related both to scholastic dialectic and the *Psychomachia*, or *Battle of the Virtues and Vices*,[26] the struggle could take forms that strikingly anticipate Bernini's contrast of moral, physical, and emotional types. In a capital of the cathedral of Clermont-Ferrand (Fig. 154), for example, a noble female Liberality (*Largitas*) confronts a disheveled male Avarice (*Avaricia*). In an illumination of the prayer book of the great twelfth-century mystic Hildegard of Bingen a similar pairing of opposites illustrates the concord and discord of "Beati" and "Maledicti" (Fig. 155). Hildegard's vision is a rare precedent for the isolation of good and bad spirits in the last act of *Rappresentatione di anima et di corpo,*

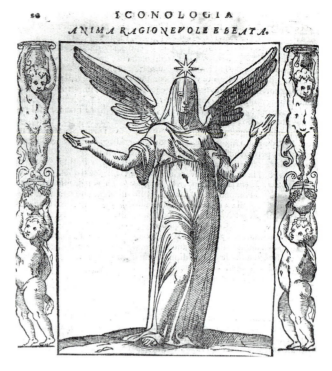

Fig. 156. *Anima ragionevole e beata* (from Ripa, 1603, 22).

where, apparently for the first time, damned and blessed souls acting in chorus become characters in a dramatic confrontation. In this respect, as well, the *Rappresentatione* prepared the way for Bernini's sculptures.

So far as I can discover, *Anima Dannata* and *Anima Beata* were also first treated as isolated images precisely in this context. Cesare Ripa included them in the third edition (1603) of his pictorial handbook of personified concepts, the *Iconologia.* He explains that when the soul of a person is introduced onstage in dramatic presentations, it should be given human form. No doubt Ripa, who lived and worked in Rome under the patronage of Cardinal Antonio Salviati and his family, was referring to and motivated by the Oratorian production; his description of the images, one of which he illustrates (Fig. 156), may well reflect the costumes used in 1600. The figures are identified by various attributes—Beata is a gracious maiden, Dannata is disheveled—and by "accidents" indicating their "condition": wounded, in glory, tormented.[27]

Bernini, too, isolated the participants from their contexts, creating a powerful duet of independent and contrasting, yet also complementary, actors performing on the infinite stage of human existence. Souls in the form of portrait busts, the sculptures seem to restore to the masks of Tragedy and Comedy

the deeper meaning of the term *persona* by which they were known in antiquity. In the *Anima Dannata* and *Anima Beata,* innermost human nature emerges at last from collective anonymity to assume, for better or for worse, a personality of its own.

Agostino Manni's subsequent publications bring our themes down to Bernini's sculptures and even suggest a reciprocal relationship between them. In 1609 and 1613 Manni published *Spiritual Exercises,* "an easy way to fruitful prayer to God and to think upon the things principally relevant to salvation, to acquire the true pain of sins, and to make a good death." Following a series of daily devotions, the things principally relevant to salvation are treated in exercises—which often include what Manni calls "imaginations"—on heaven and hell, the Four Last Things, and a good life and death.[28] Manni's exercises thus actually combine the two great late medieval eschatologies, *The Four Last Things* and *The Art of Dying,* with which we began. The last edition, greatly abbreviated, appeared posthumously in 1620, shortly after Bernini's sculptures were presumably made.[29] There followed in 1625 a new publication excerpted from Manni's works, this time in just two parts. The first consists only of the meditations on the joys of heaven and the torments of hell; the second is none other than a reprint of the text of the *Rappresentatione di anima et di corpo.*[30] In effect, the Four

Last Things have been reduced to two, and the dramatic debate between virtue and vice has become the model of preparation for a good death. Significantly, however, the drama itself is given a new name. It is no longer conceived in terms of body and soul, but rather—and I quote the new title—as a "representation in which by diverse images the individual is shown the calamitous end of the sinner and the honored and glorious end of the just man." I can think of no better description of Bernini's sculptures. In fact, when one recalls that they had only recently been made for a member of the Spanish church not far from that of the Oratorians, one cannot help wondering whether they might in turn have played a role in the distillation, intensification, and visualization of the very dramatic work from which they themselves seem to have derived.

Appendix A

NEW DOCUMENTS CONCERNING THE *Anime* BUSTS AND
THE TOMB OF PEDRO DE FOIX MONTOYA

The sculptures, mentioned by Bernini's biographers Filippo Baldinucci and Domenico Bernini as in San Giacomo degli Spagnoli, were moved in the late nineteenth century to the Palazzo di Spagna, residence of the Spanish ambassador to the Vatican (replacement copies were made which are now in Santa Maria di Monserrato). Having discovered that they came to the church with the legacy of Botinete, I once questioned the traditional association of these busts with Monsignor Pedro de Foix Montoya, for whose tomb, also originally in San Giacomo and now in Santa Maria in Monserrato, Bernini executed the famous portrait toward the end of 1622 (Lavin, "Five Youthful Sculptures," 1968, 240 n. 114). I subsequently found in the archive of the confraternity additional documents concerning Montoya and his tomb; these established that Montoya was indeed the patron of the *Anime*, which were in his possession by December 1619, and suggest that he may have intended them to decorate his tomb.

An inventory of Montoya's household possessions taken in December 1619 includes "dos estatuas" (see Document 1 below), the only such objects listed; these must have been the *Anime*, which appear again in the inventory taken after Montoya's death (below, and Document 2). On March 8, 1623, Montoya signed an agreement with the stonecutter Santi Ghetti for his

tomb (Document 8), to be made according to a design provided by the architect Orazio Turriani, who received payment on March 11 (Document 9). The monument was to include "two angels" that are specifically excluded from Ghetti's responsibility, indicating that they, like the portrait, were to be (or already had been) executed by someone else. Perhaps Fernandez Alonso (1968, 106) was alluding to this document in suggesting that the busts formed part of the tomb. The tomb was not finished at Montoya's death on May 31, 1630, and the executors paid for the remaining work over the next few months (Documents 3–7).

The *Anime* are listed in an inventory of Montoya's possessions, undated but taken shortly after his death (Document 2), after which they evidently became the property of Ferdinando Botinete, one of Montoya's confreres; they next appear in a 1637 inventory of San Giacomo, as a legacy of Botinete (Document 10).

All the documents listed below are in the Archive of the Instituto Español de Estudios Eclesiasticos, Rome.

Busta 1746, *Papeles de la memoria de Mons. Montoya:*
Fols. 20ff.: Memoria de toda la Ropa que hasta oy Jueves de dicembre de 1619 Años Quai en caza de Mons.ᵒʳ De Foix Montoya, Misenor Para el servisio de su casa y persona.
 1. fol. 27: dos estatuas

Fols. 29ff.: Inventory of Montoya's household possessions ordered by the executors of his will.
 2. fol. 31r.: Item dos medios cuerpos de piedra de statuas

Fols. 35ff.: Nota de como se una cumpliendo los legados y ultima voluntad de Monseñor Pedro de Foix Montoia por sus executores testamentarios desde el dia de su muerte, que fué alos 31 de Maio de 1630.
 3. fol. 42b: Io Giovanne Mariscalco ho receu.ᵗᵒ dalli ss.ʳⁱ Essecutori testamentarij di mons.ʳᵉ Montoia in 2 partite sc.ᵗᵃ quarentacinco sonno per il deposito et lapida et à bon conto. Et in fede q.ᵗᵒ di 16 Xbre 1630 sc.ᵗᵃ 45 [in margin: scarpellino].
 4. fol. 43b: Io francesco Pozi muratore ho riceu.ᵗᵒ dalli ss.ʳⁱ Essecutori testam.ʳⁱ del q. Mon.ʳᵉ Montoia scudi sedici m.ᵗᵃ sonno per saldo et intiero pagam.ᵗᵒ di tutti li lauori di muratore fatti da me nel deposito di d.ᵒ Mons.ʳᵉ con-

forme alla lista tassata dal sig.^{to} della Chiesa.
Et in fede etc. sc 16 q.º di 6 di Genaro 1631.
Io fran.^{co} Pozo a fermo come sopra mano
propria.

5. fol. 43b: Io infrascritto ho riceuto dalli Ill.^{ri}
sig.^{ri} essecutori testamentarii del q. Monsig.^{re}
Montoya scudi tre m^{ta} p̲ hauere indorato le
Arme e le lettere del suo sepolcro e in fede ho
fatto la p^{te} di mia pp^a mano questo di 23
Aprile 1631 et dico _____ sc 3
Io Giovanni Contini Mano pp^a

6. fol. 44: Adi 23 Marzo 1632
Io Santi Ghetti ho riccuuto dalli ss.^{ri}
Essecutori testamentarii del q. Mons.^{re} Mon-
toya scudi Trenta m.^{ta} & sonno li scudi ven-
ticinq. per la lapida che ho fatto per la sepol-
tura di esso Monsig.^{re} et li scudi Cinque per
saldo, et intiero pagamento del deposito.
Et in fede di q.º di
sc.^{ta} 30
Io santi Ghetti afermo come sopre sua mano
pp.^a

Fols. 46ff. Memoria de lo que se ha sacado de
Mons.^{re} foix de Montoya conforme al Inuentario, y
al moneda que se hizo

7. fol. 48: al pintor por las armas que
hizo _____ sc. 5.60
al murador por abrir la sepoltura y
cerrarla _____ sc. 4

fol. 48 verso: al scarpelino abuena quenta de
la sepoltura _____ sc. 45
de dorar las armas de la sepoltura _____
sc. 3
al murador por los labores hechos en poner el
deposito de Monseñor _____ sc. 16
al scarpelino por intero pagamento de la la-
pida y sepoltura _____ sc. 30.
al murador por abrir y poner la lapide
_____ sc. 3.

Fols. 55–56b. Contract with Santi Ghetti for
Montoya's tomb:

8. Douendosi dal Molto Ill.^{mo} et R.^{mo} Monsig.^{re}
de Foix Montoija far fare un deposito nella
Chiesa di s. Giacomo delli spagnioli vecino
alla porta che va in sagrestia à mano manca
nel entrare, sotto al organo, qual deposito n'é

stato fatto il disegnio da Horatio Torriani
Architetto in Roma per altezza di pⁱ 17 et nel
modo, e forma che si uede detto disegnio, si
douera eseguire conforme alli patti capitoli,
conuentioni infrascritti. Pertanto il detto
Monsig.^{re} da a fare il sudetto deposito à tutta
robba di m.º santi Ghetti scarpellino rencon-
tro la pista piccola di santa Adriano alli pat-
tani, et campo vaccino a tutte sue spese nel
modo, e forma che si dechiara in questo
foglio. _____

Item che detto scarpellino sia obligato di fare
il frontespitio sopra l'arme di marmo bianco
di Carrara.

Il timpano sotto il frontespitio di bianco e
nero antico orientale _____

La cornicia sopra l'arme di marmo bianco di
Carrara, atorno al arme il simile _____

L'arme con il cappello, et fiocchi sia tutto di
un pezzo di marmo bianco di Carrara, et il
repiano del arme di bianco e nero antiquo
orientale, et le cartelle accanto l'arme di
marmo bianco, et incastrato di marmo, e
bianco e nero antiquo orientale _____

Il frontespitio sopra alle colonne di marmo
bianco di Carrara, con il timpano di bianco
e nero antiquo orientale _____

La cornice sotto l'arme, et che ricorre sopra
alle colonne, et membretti si fara di marmo
bianco di Carrara _____

Il campo sotto la cornice, et intorno al
retratto, et cassa si fara di bianco e nero
antiquo orientale _____

Cartelle dalle bande del ouato che fa
modello si farano di marmo bianco
d'Carrara con campanella di marmo
simile _____

L'ouato cioe la fascia si fara di brocatello de
Spagnia _____

Lo sfondato del retratto dentro la nicchia si fara p dentro piano, et di nero assoluto _____

Il fregio sopra alle colonne si fara di bianco e nero antiquo orientale _____

La prima iscritione si faccia di paragone senza macchia tutto negro _____

Il tellaro atorno addetta iscritione sia di gialdo orientale _____

fol. 55b

Le caretelle sotto la prima iscrittione siano di marmo bianco di Carrara et repieni di bianco e nero antiquo orientale _____

La cassa sia di gialdo, et nero di portovenere del più bello che uenghi conforme à quella della cappella del Cardinal Gaetano in santa Potentiana, et sia della medesima fattura ne piu nemeno _____

Il zoccholo sotto alla cassa sia di alabastro rigato antiquo, et il simile sotto alle base delle colonne, et membretto _____

Le colonne si farano di nero, et gialdo de portovenere come di sop.ª conforme alla cassa de S.ª Potentiana, et della medesima bonta di pietra _____

Li contrapilastri delle colonne si farano di marmo bianco di Carrara _____

Li membretti delle colonne cioe dalle bande di brocatello di Spagnia _____

Le base, et capitelli come si uedono in disegnio siano de marmo bianco di Carrara _____

La cimasa la colonna di marmo bianco di Carrara _____

La seconda iscritione che fa piedestallo sia di marmo bianco di Carrara _____
con suo membretti _____

Sopra della 2.ª iscrittione si fara un poco di fregio di bianco e nero antiquo orientale dove e il collarino del pedestallo di tutta lunghezza _____

Il basamento che andera sotto a d.º iscritione, et alli pedestalli delle colonne et membretti si faranno di marmo bianco di Carrara _____

L'ultimo zoccholo sotto il fine del opera al piano di terra si fara di africano bello, et antiquo _____

Ite. che tutta la detta opera sia fatto nel modo e forma detto di sopra con le pietre dechiarate in questo foglio, et non altrimenti, quale tutte doverano essere poste in opera, con ogni diligenza, et ataccate con mistura, et stuccate a foco e doveranno alustrare il tutto ad ogni bellezza, et paragone tutto a spese del detto m.ro santi scarpellino _____

Ite. che detto m.º santi sia obligato di dar fornito tutta l'opera di detto deposito a tutta perfettione intermine di quattro mesi prossimi da cominciarsi da hoggi _____

fol. 56

Ite. che il detto mons.re sia obligato a tutta sue spese di far mettere in opera il detto deposito p quello che spettera al muratore con patto che vi debbia intervenire, et assistere continuamente il d.º m. santi mentre si mettera in opera, et con interuento alle cose principali del Architetto _____

Ite. che detto m.º santi debbia fare a sue spese una croce di gialdo al detto deposito atutte sue spese ancorche non vi sia nel disegnio, et gli Angeli che sono in d.º disegnio non si comprendino nel patto, et conventione che si obliga d.º scarpellino _____

Ite. che detto scarpellino sia obligato di fare intagliare à tutte sue spese tutte le lettere che si daranno da s. R.ma tanto nella prima iscritione di paragone negro come in quella seconda di marmo bianco di Carrara _____

Che l'horo che andera sopra alle lettere della pietro di paragone si debbia mettere a spese di ss. R.ᵐᵃ et doue anderanno di tenta negre sul bianco a spese del d° scarp.ⁿᵒ _____

Ite. che detto scarpellino debbia mostrare primo a s. R.ᵐᵃ et al Architetto tutte le pietro dette di sop.ᵃ avanti li lavori p̄ mettere in opera, et che non debbia lauorare il detto deposito se prima non habbia hauto li modeni in carta di tutta la detta opera dal Architetto, et a quelli modeni non sminuisca, et no preterisca di cosa alguna, et d.ⁱ modeni siano dati p̄ primo che cominci et cole picture siano uiste prima _____

Che volendo disegniare il detto deposito lo scarpellino in prima grande debbia il d° Monsig.ʳᵉ fare che l'Architetto debbia intervenire p̄ d° disegnio in quel modo che piu piacera, et sara comodo allo scarpellino, et questo si faccia senza spese dallo scarpellino

Ite. che il detto deposito s'intenda all'allezza, et larghezza che seconda la scala delli p.ᵐⁱ che stanno disegniati sotto d° deposito et non altrimenti _____

fol. 56b

Ite. che p̄ tutto quello che si possa pretendere tanto per la fattura come del valore della robba del detto deposito il detto mons.ʳᵉ et santi Ghetti scarpellino si convengono di accordo de farlo p̄ prezzo et valore di sc.ᵈⁱ cento sessanta di moneta li quali s. R.ᵐᵃ promette di pagarli liberamente in questo modo, scudi sessanta al p̄ᵗᵉ p̄ un ordine al banco, et altri sc.ᵈⁱ cinquanta nella meta del opera, et li altri scudi cinquanta fornito che haueua detto deposito subbito _____

Ite. che mancando di fare detto scarpellino alcuna delle cose sud.ᵉ che non fussero a contentimento del s. R.ᵐᵃ possa d° Monsig.ʳᵉ a tutte spese danni, et interessi di d° scarpellino farli rifare conforme alli patti, et conventione, et di quello che importera

defalcarlo dal prezzo che douera hauere d° scarpellino _____

Et p̄ osservanza delle cose sud.ᵉ tanto p̄ il denaro che douera pagare d° Mons.ʳᵉ R.ᵐᵒ come p̄ l'opera che deue fare il detto m.ᵒ santi Ghetti scarpellino, conforme alli patti conuentioni d.ᵉ di sopra, l'una parte el l'altra si obligano nella piu ampla della forma della Camera Apostolica, con ogni sorte di clausole, et consuete che si aspettano ad° obligo Camerale et p̄ ciò ad ogni beneplacito del una et l'altra parte da adesso p̄ allora danno faculta, a qualseuoglia Notaro di potere stendere d.ⁱ capitoli come Istrumento publico, che p̄ segnio della uerita hanno sottoscritto la presente de loro propria mano alla presentia delli infrascritti Testimonij questo di, et anno sud.ᵒ 8 de Marzo 1623

Licen.d° p̄ᵒ de Foix Montoya
Io santi ghetti afermo quanto di sop̄ mano pp̄ᵃ _____
Io Ju.ᵒ yvaniz fui p̄'sente quanto di sop.ᵃ
Io Jacomo Turriani fui presente quanto di sop.ᵃ mp̄.

Io soprado m° santi Ghetti scarpellino mi obligo in forma Camera di fornire fra tutto ottobre di questo anno 1623 tutti li lauori che sto obligato a fare à Mons.ʳᵉ de Foix Montoia in questo Instrumento di sop.ᵃ et come non lo fornisca fra questo tempo me contentero che d° Mons.ʳᵉ de foix Montoijia lo possa mandare à fornire allo scarpellino che verra a tutte spese mie fatta in Roma alli 19 di Agosto 1623

Io santi Ghetti mi obligo et prometto come di sop.ᵃ mano pp̄ᵃ
Yo Ju.ᵒ ybanez fui presente a quanto di s.ᵃ
Io Jacomo Turriani fui presente quanto di sop.ʳᵃ

Fol. 57: Receipt of Orazio Turriani

9. Io Horatio Turriani Architetto ho riceuto dal Molto Ill.ᵒ et R.ᵐᵒ Mons.ʳᵉ Montoya scudi sei di moneta quali sono p̄ ultimo resto et intiero

pagamento di quanto posso pretendere in tutti
li disegni et ogni altra cosa che hauessi fatto,
et che douero fare p̄ tutto l'opera del deposito
che andera posto nella chiesa di S. Giacomo
delli Spagnioli in Roma, et mi contento di
essere sodisfatto con detti scudi sei p̄ qual-
sivolia cosa che di nouo facessi p̄ d° deposito
p̄ sino che sia del tutto posto in opera in dᵃ
chiesa et cosi prometto et me ne chiamo con-
tento questo 11 di Marzo 1623

 Io Horatio Turriani mppᵃ

Busta 1335, Inventario de los muebles de Santiago
hecho en el mes de heno 1637:

> 10. fol. 169b. Mas dos estatuas de marmol blanco
> del Bernino con sus pedestales de jaspe. Son
> dos testes que representan una el anima in
> gloria & la otra anima en peña & las quales
> vinieron con la que dejò el D.ʳ Botinete ala
> Egl.ᵃ

Appendix B

CHECKLIST OF PRESERVED AND RECORDED EXAMPLES OF
THE FOUR LAST THINGS IN THE WAX VERSION BY
GIOVANNI BERNARDINO AZZOLINI*

1. Convento de las Carmelitas Descalzas, Peñaranda de
Bracamante, Spain. Five wax panels forming a cross,
Death in the center, Purgatory on the left, Limbo (a
naked child) on the right, Hell below, Heaven above.
Gómez-Moreno, 1967, I, 453; Gonzáles-Palacios
(1984, 227) gives evidence for a Neapolitan prove-
nance. (Fig. 157)

2. Victoria and Albert Museum, London. Purgatory
and Hell. Pope-Hennessy, 1964, II, 633f. (Purgatory
mistakenly identified as Paradise); Lightbown, 1964,
495 n. 20; Cagnetta, 1977, 497; *idem*, 1976, 219;
Curiosità, 1979, 41; Gonzáles-Palacios, 1984, 227.
(Figs. 158, 159)

3. Museo degli Argenti, Palazzo Pitti, Florence. Purga-
tory and Hell. Lightbown, 1964, 495; Aschengreen,

1968, 176; Cagnetta, 1977, 497; *idem*, 1976, 218;
Malke, 1976, 57; *Curiosità*, 1979, 41; Gonzáles-Palacios,
1984, 227. (Figs. 160, 161)

4. Galleria Nazionale d'Arte Moderna, Rome. Limbo,
Purgatory, Hell, Heaven. Ex coll. Mario Praz, prov.
Sestieri, Rome, 1961, from Black, London. Attributed
to Azzolini ca. 1560 by Praz, who also noted the rela-
tion to the Ex coll. Schevitch group. Cagnetta, 1977,
498; *idem*, 1976, 219; *Curiosità*, 1979, 41. (Figs. 162–165)

5. Ex Coll. Schevitch, Paris. Purgatory, Hell, Heaven.
Catalogue, 1906, 213f., no. 313, ill.; Pyke, 1973, 8; Cag-
netta, 1977, 498; *idem*, 1976, 219; Malke, 1976, 57 n.
18; Gonzáles-Palacios, 1984, 227. (Figs. 166–168)

6. Ex Coll. Gonzáles-Palacios, Rome. Heaven. Attrib-
uted to Azzolino. Cagnetta, 1977, 498; *idem*, 1976,
219; Gonzáles-Palacios, 1984, 227; *Finarte*, 1986, 81.
(Fig. 169)

7. Schloss Nymphenburg, Munich. Death, Judgment,
Hell, Heaven. Gonzáles-Palacios, 1984, 236 n. 97;
Metken, ed., 1984, 26–28, no. 14. (Figs. 170–173)

8. Rhode Island School of Design Museum, Provi-
dence. Hell. Attributed to Zumbo. *Rhode Island*, 1985,
30f. (Fig. 174)

9. Museo del Prado, Madrid. Paintings of Purgatory
and Heaven. Attributed to Francisco Ribalta (d.
1628), Gómez-Moreno, 1967, 1:453; *Ribalta*, 1987, 144.
(Figs. 175, 176)

10. Coll. Duke of Alcalá, Seville. Five wax images
framed in ebony, showing the four souls and one
dying, by Giovanni Bernardino [Azzolini]. Recorded
in an early inventory. Brown and Kagan, 1987, 254,
no. 131.

11. Coll. Alcázar, Madrid. Three wax heads, Purgatory,
Hell, Heaven, with frames of ebony and glass.
Recorded in an early inventory. Bottineau, 1956, 450,
no. 47.

 *For information concerning several of the Spanish examples I
am indebted to Professor Vincente Lleo Cañal.

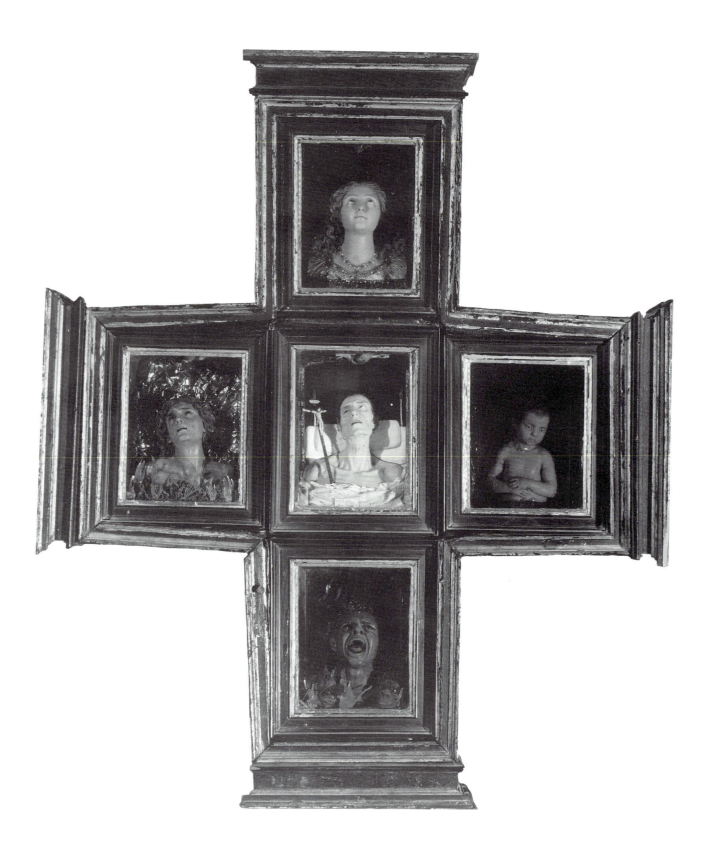

Fig. 157. Death (*center*), Purgatory (*left*), Limbo (*right*), Hell (*bottom*), Heaven (*top*), wax reliefs. Convento de las Carmelitas Descalzas, Peñaranda de Bracamante, Spain (photo: Antonio Casaseca, Salamanca).

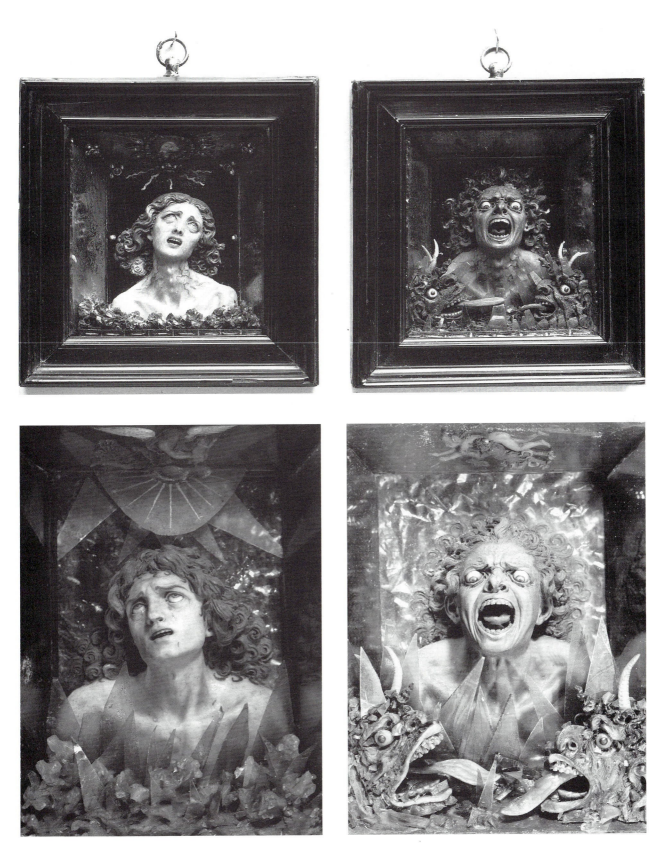

Figs. 158–159 (*top*). Purgatory, Hell, wax reliefs. Victoria and Albert Museum, London.

Figs. 160–161 (*above*). Purgatory, Hell, wax reliefs. Palazzo Pitti, Florence (photos: Soprintendenza per i Beni Artistici e Storici, Florence 122743–44).

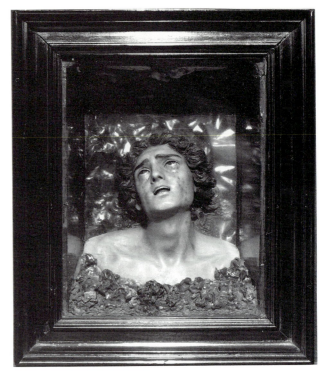
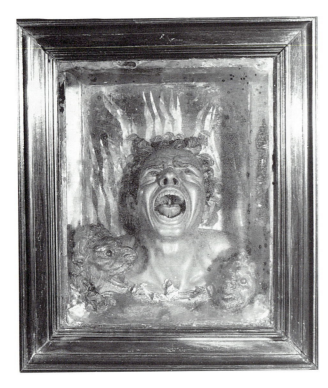
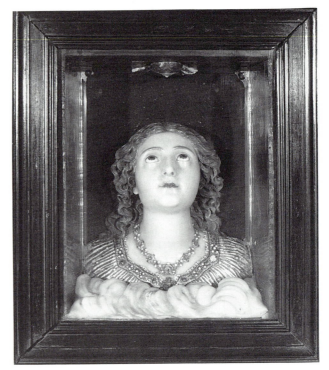

Figs. 162–165. Limbo, Purgatory, Hell, Heaven, wax reliefs.
Galleria Nazionale d'Arte Moderna, Rome.

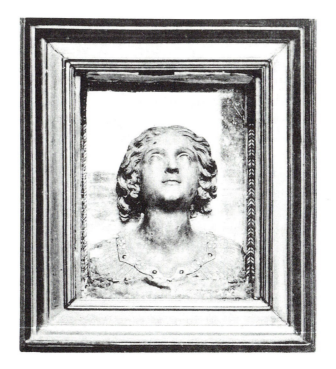

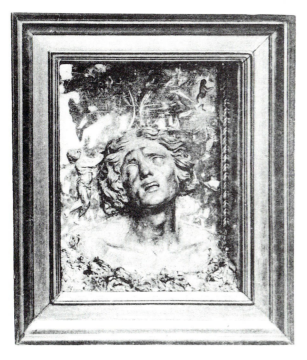

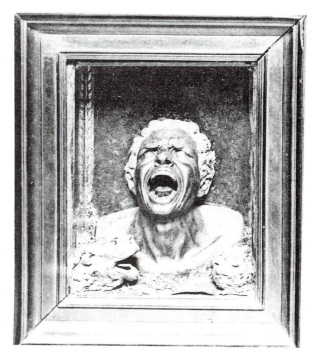

Figs. 166–168. Purgatory, Heaven, Hell, wax reliefs. Formerly
Coll. Schevitch, Paris (from *Catalogue*, 1906, fig. 313).

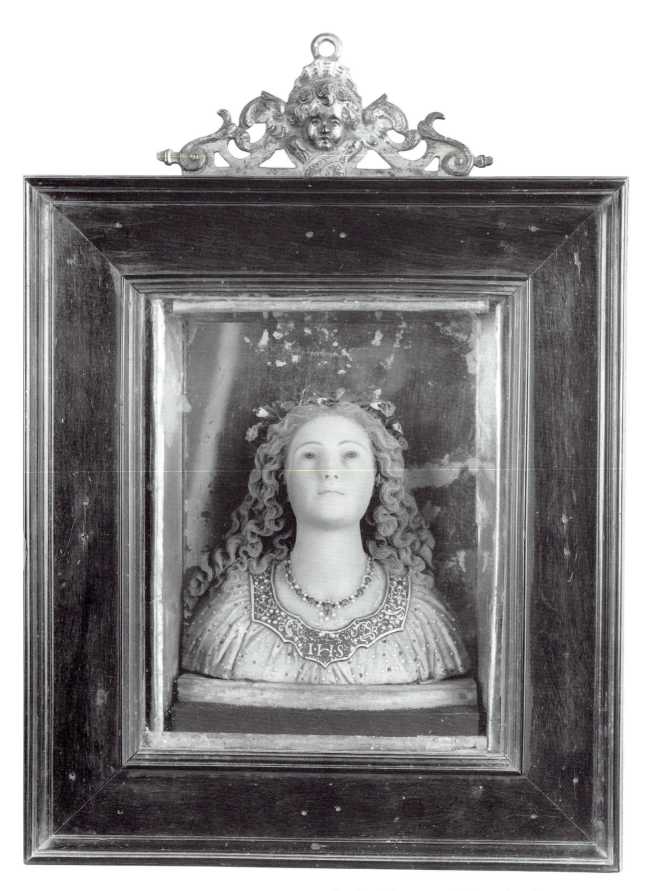

Fig. 169. Heaven, wax relief. Formerly Coll. Gonzáles-Palacios, Rome (photo: Arte fotografica 99962).

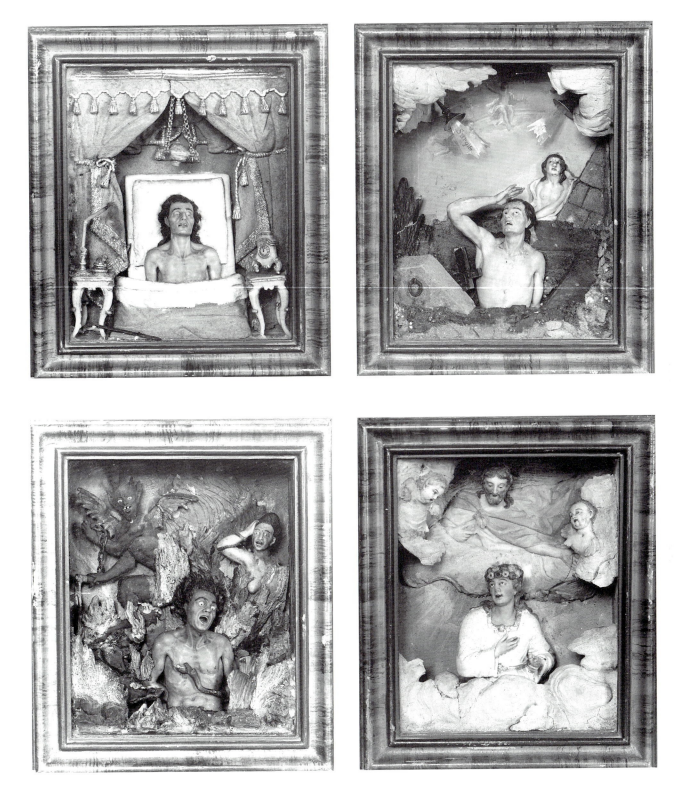

Figs. 170–173. Death, Judgment, Hell, Heaven, wax reliefs.
Schloss Nymphenburg, Munich.

Fig. 174 (*right*). Attributed to Gaetano Zumbo, Hell, wax relief.
Rhode Island School of Design Museum, Providence.

Figs. 175–176 (*above*). Attibuted to Francisco Ribalta, Purgatory,
Heaven. Museo del Prado, Madrid.

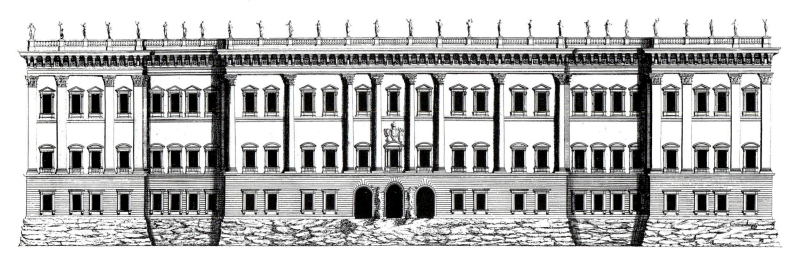

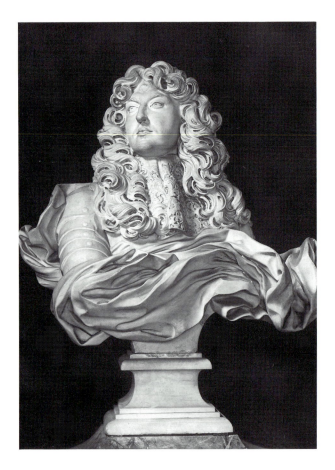

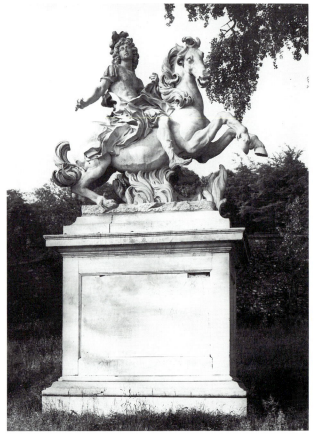

Fig. 177 (*top*). Bernini, third project for the Louvre, east facade (from Blondel, 1752–56, vol. 4, pl. 8).

Fig. 178 (*left*). Bernini, bust of Louis XIV. Musée National du Château de Versailles (photo: Alinari 25588).

Fig. 179 (*right*). Bernini, equestrian monument of Louis XIV, altered by Girardon to portray Marcus Curtius. Versailles (photo: Documentation photographique de la Réunion des musées nationaux 58 EN 1681).

Puis, se tournant vers ceux qui faisaient cercle autour du Roi, il a ajouté:

"Qu'on ne me parle de rien que soit petit."

É ben vero, a-t-il dit, *che le fabriche sono i ritratti dell'animo dei principi.*

Paul Fréart de Chantelou, *Journal du voyage du Cavalier Bernin en France,*

June 4 and October 8, 1665

It is well known that Bernini made three major works for Louis XIV: the design for rebuilding the Louvre, which brought him to Paris in the summer of 1665 (Figs. 177, 180); the life-size portrait bust of the king executed while he was in Paris (Figs. 178, 181; Plate X); and the monumental equestrian statue executed after his return to Rome (Figs. 179, 182; Plate XI). Each of these works has been studied separately, but they have hardly been considered together or appreciated for what they really are, equivalent expressions in different media of the concept held by one man of genius who was an artist of another who was a monarch.[1] I want to emphasize at the outset that although I shall focus mainly on the visual ideas through which this basic concept was expressed, it was not purely abstract or theoretical. On the contrary, the detailed diary of Bernini's stay in Paris kept by his escort, Paul Fréart de Chantelou, bears witness to the warm personal relationship established between the artist and the king, based on mutual respect and admiration.[2]

The reasons for the lack of a unitarian vision of the three works are complex. Each project had its own dramatic and ultimately abortive history. The design for the Louvre became a scapegoat in

the rising tide of French cultural nationalism, and the building never rose above the foundations. The bust, which never received the pedestal Bernini intended for it, was installed at Versailles rather than the Louvre. The equestrian monument met with violent disapproval—including the king's—when it reached Paris long after Bernini's death; it too was sent to Versailles, where it was finally installed in the garden, having been converted from a portrait into an illustration of a recondite episode from Roman history. Above all, I suspect that the different media have obscured the common ground of the three works. Within the traditional conventions of art it is practically inconceivable that architectural and figural works might convey the same ideas in the same way—not just indirectly through abstract symbolism but directly through mimetic representation. I believe that this was precisely what Bernini had in mind. This intention explains the paradoxical metaphor he expressed during his visit to Paris: "buildings are the portraits of the soul of kings;"[3] and it permits us to see his works for Louis XIV as reflections of a single, coherent image that was among his most original creations.

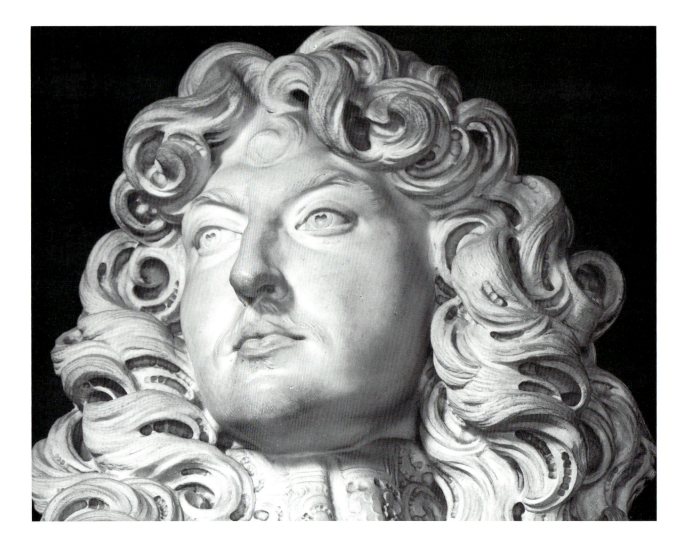

Fig. 180 (*right*). Detail of Fig. 177.

Fig. 181 (*above*). Detail of Fig. 178.

Fig. 182 (*opposite, left*). Detail of Fig. 179 (photo: Documentation photographique de la Réunion des musées nationaux 79 EN 7468).

Fig. 183 (*opposite, right*). Sun emblems of Louis XIV before 1651, engraving (from Menestrier, 1693, 4).

The King, the Sun, and the Earth

The primary component of Bernini's image of the king was the preeminent metaphor of Louis's reign, the sun—in conformity with the millennial tradition of the *oriens augusti,* "the rising of the august one," identifying the ruler with the sun.[4] The richness, frequency, and programmatic nature of the theme are illustrated in an engraving published in Claude François Menestrier's *History of the King* of 1689 (Fig. 183); the emblems linking Louis with the sun in the period from his birth to his majority in 1651 are gathered in a design that itself forms a composite solar emblem.[5] In 1662 Louis adopted as his official device the sun as a face seen high above a spherical earth, with the famous motto *Nec Pluribus Impar*—"not unequal to several (worlds)," that is, capable of illuminating several others (Fig. 184).[6]

Bernini had had ample experience with such solar imagery long before his visit to Paris. The sun had also been an emblem of the Barberini pope, Urban VIII, one of Bernini's greatest patrons, and Bernini was intimately familiar with an important document of this association, a frescoed vault in the Barberini palace in Rome, executed by Andrea Sacchi around 1630 (Fig. 185).[7] Divine Wisdom, with an emblem of the sun at her breast, appears enthroned in the heavens above the sphere of the earth. Bernini himself had exploited the image in the allegorical sculpture of Time discovering Truth, which he began toward the end of the 1640's in response to slanderous attacks then being made on his reputation (Fig. 186).[8] Truth is a splendid nude whom a figure of Father Time, flying above, was to discover, literally as well as figuratively, by lifting a swath of drapery. The figure of Time was never executed, but the whole conceit drew on the traditional theme of Time rescuing his daughter, who had been secreted by her great enemy Envy in a dark cavern. Time was shown raising up Truth from the earth, represented as a craggy peak below (Fig. 187). This tradition is alluded to by the rocky base on which Bernini's Truth sits, with one foot resting on the globe and an emblem of the sun in her hand. The joy of the occasion is illustrated by the radiant smile on Truth's face, the physiognomical equivalent of the sun's own beneficent splendor.

Fig. 184 (*right*). Medal of Louis XIV, 1663. American Numis-
matic Society, New York.

Fig. 185 (*above*). Andrea Sacchi, allegory of Divine Wisdom.
Palazzo Barberini, Rome (photo: Istituto Centrale per il Catalogo
e la Documentazione E72392).

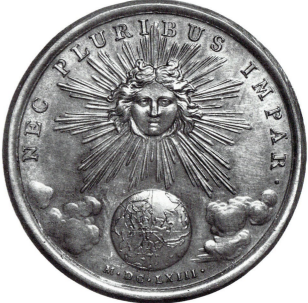

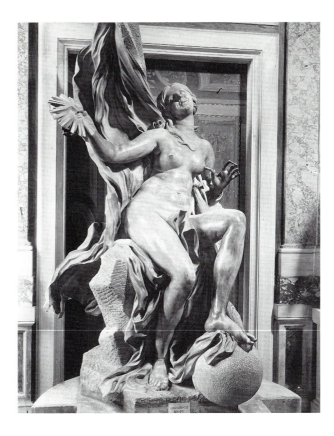

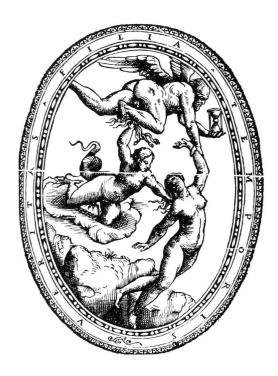

The Palace Portrait

Roman antiquity offered three notable instances of solar imagery in palaces. The imperial palace *par excellence*, built initially by Augustus on the Palatine hill, included a Temple of Apollo crowned by a resplendent gilded sculpture of the Chariot of the Sun (cf. Figs. 208, 209). Solar imagery was associated with the building itself in the revolving circular dining hall of Nero's Domus Aurea and in the heavenly, high-columned dwelling of Apollo described in Ovid's *Metamorphoses*. Following these sources, Louis Le Vau and Charles Le Brun had introduced the metaphor at Vaux-le-Vicomte, the great residence of Louis's finance minister Fouquet, in the oval salon and in the design for its vault decoration (Fig. 188). Bernini admired Le Brun's composition when it was shown to him in Paris except that, the design being oval, "if the palace of the sun represented in it had the same form, or indeed were round, it might have been better suited to the palace and to the sun itself."[9]

The allusion had, in turn, been introduced into designs for the new Louvre proposed by Louis Le Vau and his brother François shortly before Bernini came to Paris. Louis included an oval salon as the

Fig. 186 (*left*). Bernini, Truth. Galleria Borghese, Rome (photo: Alinari 27070).

Fig. 187 (*right*). Time rescuing Truth (Willaert, 1536, from Saxl, 1936, fig. 2).

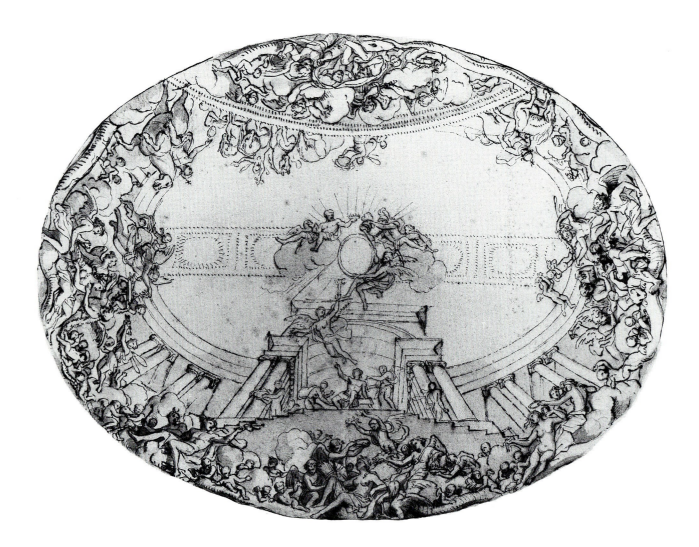

Fig. 188. Charles Le Brun, The Palace of the Sun, drawing. Louvre, Paris (photo: Documentation photographique de la Réunion des musées nationaux 68 DN 3160).

centerpiece of the east wing (Fig. 189), and François included a relief showing Apollo in his chariot, as well as the *Nec Pluribus Impar* motto, in the decorations of the central pavilion (Fig. 190). Bernini must have been aware of Louis Le Vau's Louvre project, which was sent to Rome as an example for several Italian architects who were to comment and submit designs of their own. The two projects Bernini sent to Paris before his visit develop the oval motif into powerful curves that dominate the designs (Figs. 191, 192); significantly, he emphasized the Sun-Apollo allusion in the architectural form of the projects, while evidently excluding any such imagery from the decorations of the facades.[10]

Bernini's distinctive approach to the problem began to emerge in a series of dramatic developments at the outset of his visit. From his first inspection of the Louvre, on June 3, 1665, the day following his arrival in Paris, he concluded that what had already been built—a considerable portion of the palace—was inadequate.[11] At their first

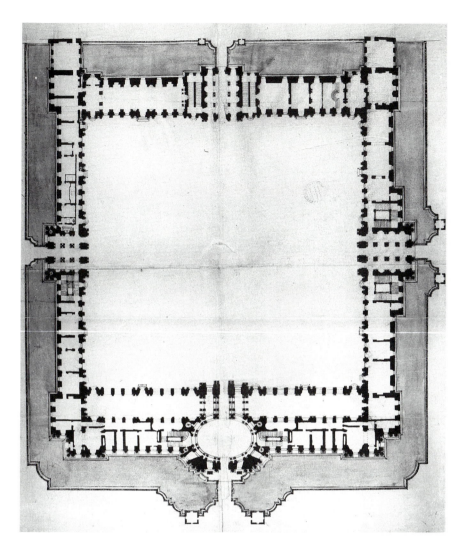

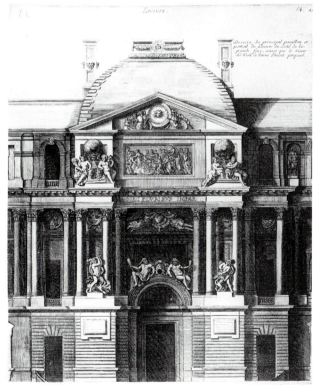

Fig. 189 (*above*). Louis Le Vau, project for the Louvre, drawing. Musée du Louvre, Paris (photo: Documentation photographique de la Réunion des musées nationaux, Receuil du Louvre I, fol. 5).

Fig. 190 (*left*). François Le Vau, project for the Louvre, engraving. Bibliothèque Nationale, Paris.

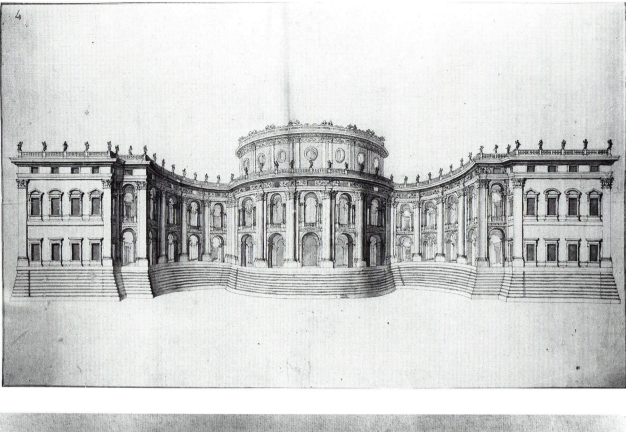

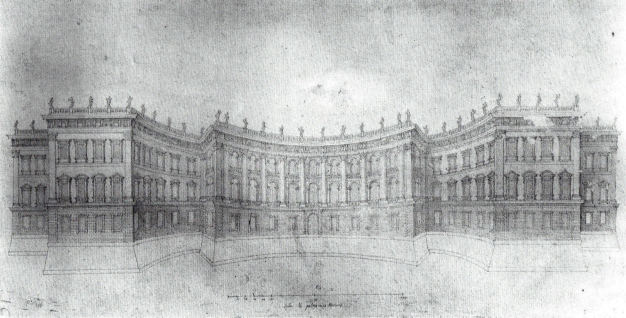

Fig. 191. Bernini, first project for the Louvre, drawing. Musée du Louvre, Paris (photo: Documentation photographique de la Réunion des musées nationaux, Receuil du Louvre, I, fol. 4).

Fig. 192 (*bottom*). Bernini, second project for the Louvre, drawing. Nationalmuseum, Stockholm.

interview, on June 4, Bernini anticipated some of the allusions he would incorporate in his own designs, telling Louis that he had "seen the palaces of the emperors and popes and those of sovereign princes located on the route from Rome to Paris, but the king of France, today, needed something greater and more magnificent than all that."[12] He proposed to demolish the whole building and start over, a drastic solution to which the king acceded only reluctantly. During the next five days, however, Bernini changed his mind. On June 9 he proposed to keep the existing structure and employ the ground floor as the base for the colossal order he envisaged for his own project. In part, this change of heart was a concession to practical necessity and fiscal responsibility;[13] but surely it was also motivated by a new solution, one that would assimilate the flat facade of the traditional French château, resting on the foundation in a moat, to the image portrayed by Louis's solar emblem.[14]

The project Bernini offered the king on June 20 (see Figs. 177, 180) represented the royal device in a profound and utterly novel way—not in geometrical design or decorative sculptures but in the very fabric of the structure. The elevation has three main levels: the colossal order that comprises the two upper stories, the ground story with fine horizontal courses of drafted stone masonry, and a massive, irregular foundation level that would have been visible in an open moat. The frequent references to it in Chantelou's diary show how important this foundation was to Bernini.[15] He first presented his project to Louis in drawings that showed two alternative ways of treating the lowest level, one with ordinary rustication, the other with a rock-like formation that he described as an entirely new idea. When the king chose the latter, even though it would be more difficult to execute, Bernini was delighted and remarked that few people, even among professionals, had such good judgment.[16] He insisted on providing detailed designs himself, on executing a model so that the workmen might see what he meant, and on supervising the work on the foundations to make sure that the workmen would do it properly. The reason for his care was that in carrying out the rustication Bernini intended for the Louvre, the workmen would be functioning more as sculptors than as ordinary stonemasons.

Rustication, which had a long history, was discussed and its varieties illustrated in the mid-sixteenth century by Serlio, in his treatise on architecture (Fig. 193).[17] Traditionally, although the stones were given a more or less rough surface, they were treated equally, and each stone or course of stones was clearly separated from the next so that a more or less regular pattern resulted. This kind of rustication could become very rough indeed, especially when it was used to evoke primitive or decaying structures, as in Wendel Dietterlin's book of architectural fantasies (1598); but the individual units remained separate and distinct (Fig. 194). Bernini's "natural" rustication (this term seems most effectively to distinguish it from the traditional "artificial" rustication) had its roots in artificially created natural settings—garden fountains (Fig. 195) and grottoes, for example, which were often conceived as artful accidents in an artificial world[18]—and in such temporary decorations as festival floats (Fig. 196) or theatrical stage sets, especially those depicting the underworld (Fig. 197). Steps were even taken in the sixteenth century to introduce irregular rustication into the permanent urban environment, as in the house of the artist Federico Zuccari in Florence (1579) where rough-cut stones, carefully arranged, decorate the facade (Fig. 198).[19] The stones remain separate and distinguishable, however, fragments from another world introduced not as structural elements but as precious fragments, like those from antique sculptures that were displayed symmetrically on the walls of contemporary villas and palaces (Fig. 199).

By and large rustication since the Renaissance had been understood in three ways. From the fourteenth century social value had been attached to the technique because it involved more labor, and therefore expense, than dressed stone.[20] It had also acquired an expressive meaning when Alberti spoke of its capacity to inspire awe and fear—when used in city walls, for example.[21] Finally, rustication had metaphorical significance as an allusion to the work of nature, and this was its meaning in sixteenth-century gardens and other nonarchitectural contexts.[22]

DE L'ORNAMENTO RVSTICO

Le prime opere Rustiche furon fatte in questo modo, cioè pezzi di pietre abbozzate così grossamente; ma le sue commissure sono fatte con somma diligentia,

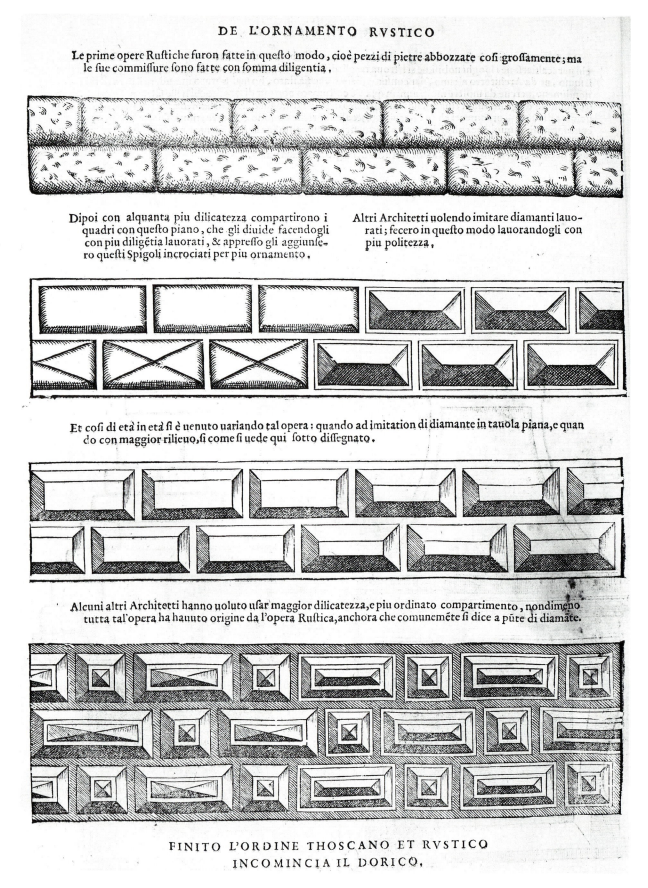

Dipoi con alquanta piu dilicatezza compartirono i quadri con questo piano, che gli diuide facendogli con piu diligetia lauorati, & appresso gli aggiunsero questi Spigoli incrociati per piu ornamento,

Altri Architetti uolendo imitare diamanti lauorati; fecero in questo modo lauorandogli con piu politezza,

Et così di età in età sì è uenuto uariando tal opera: quando ad imitation di diamante in tauola piana, e quando con maggior rilieuo, sì come si uede qui sotto dissegnato.

Alcuni altri Architetti hanno uoluto usar maggior dilicatezza, e piu ordinato compartimento, nondimeno tutta tal'opera ha hauuto origine da l'opera Rustica, anchora che comunemete si dice a pute di diamate.

FINITO L'ORDINE THOSCANO ET RVSTICO
INCOMINCIA IL DORICO.

Fig. 193. Sebastiano Serlio, varieties of rusticated masonry (from Serlio, 1562, opp. p. 17).

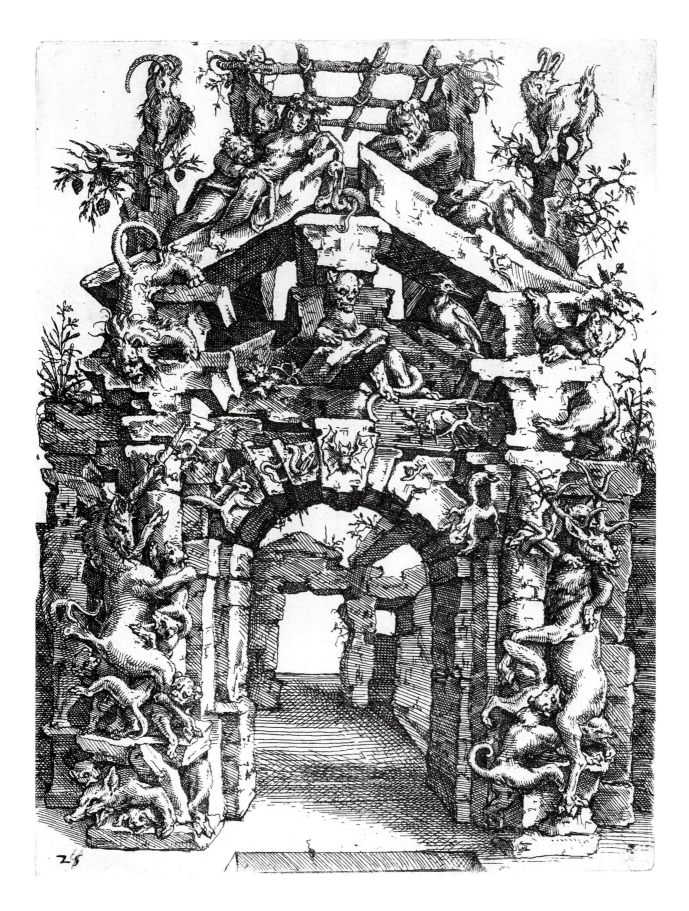

Fig. 194. Wendel Dietterlin, fantastic portal (from Dietterlin, 1598, pl. 24).

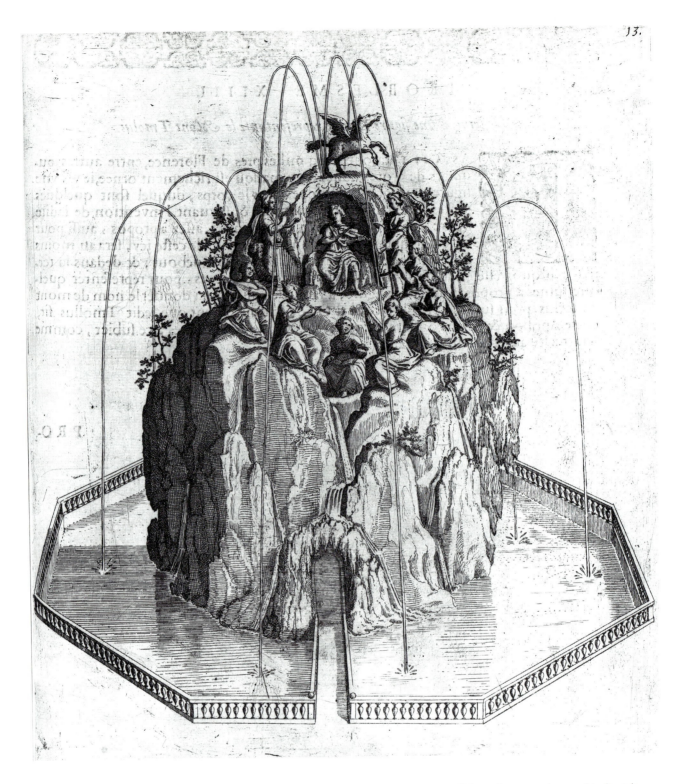

Fig. 195. Fountain of Mount Parnassus, destroyed in the eighteenth century. Formerly Villa Pratolino, Florence (from Caus, 1616).

Fig. 196 (*opposite, top*). Giulio Parigi, *Mount Parnassus*, etching (from Salvadori, 1616).

Fig. 197 (*opposite, bottom*). Scene of the underworld, engraving (from [G. Rospigliosi], 1634, pl. 2).

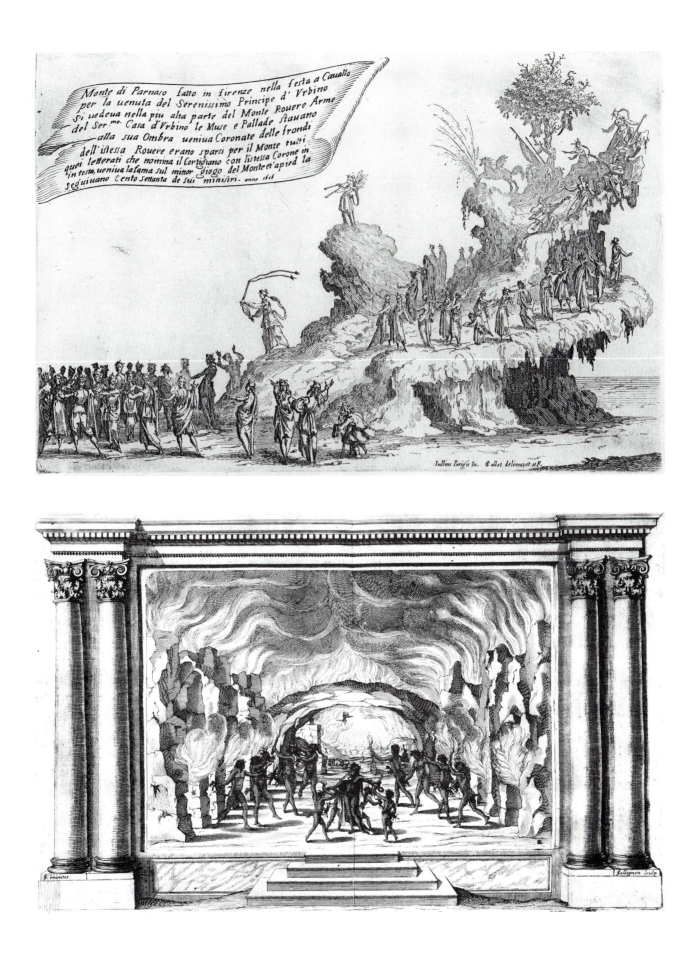

Monte di Parnaso fatto in firenze nella festa a Cauallo
per la uenuta del Serenissimo Principe d' Vrbino
Si uedeua nella piu alta parte del Monte Rouere Arme
del Ser.mo Casa d'Vrbino le Muse e Pallade stauano
alla sua Ombra ueniua Coronate delle frondi
dell'istessa Rouere erano sparsi per il Monte tutti
quei letterati che nomina il Cortigiano con listessa Corone in
in testa, ueniua la fama sul minor giogo del Monte et'apied la
seguiuano Cento settanta de sui ministri. anno 1616

Iullius Parigis In. Callot delineauit et F.

B inuentor. Sellignon sculp.

Bernini, in effect, merged this "representational" tradition with that of rustication as a proper architectural mode. In doing so he brought to a mutually dependent fruition the three associative aspects of rustication—the nobility of a magnificently carved, rather than merely constructed, foundation; the expression of awesome unassailability to all but the most persevering and virtuous; and the actual depiction of a "natural" form, the Mountain of Virtue, that served a structural as well as a metaphorical purpose. Significantly, Bernini did not refer to his brainchild by the technical term *rustication,* but instead called it a *scogliera,* or rocky mass.

Bernini had long since taken the giant step of creating coherent irregular rock formations and using such wild, natural art works as major monuments in the heart of the city. In the Four Rivers fountain, the centerpiece of the refurbished Piazza Navona, where Innocent X (1644–55) built his family palace, an artificial mountain island supports an obelisk (Fig. 200). Here, too, drawings show how carefully Bernini planned the "accidental" forms, and the sources emphasize his own participation in the actual carving (Fig. 201).[23] Because the obelisk was

Fig. 198 (*opposite, bottom*). Federico Zuccari, the artist's house. Florence (photo: Alinari 29281).

Fig. 199 (*opposite, top*). Johannes Baur, view of the Villa Borghese. Galleria Borghese, Rome (photo: Anderson 20880).

Fig. 200 (*top*). Bernini, Fountain of the Four Rivers. Rome (photo: Anderson 300).

Fig. 201 (*above*). Bernini, studies for the Fountain of the Four Rivers, drawing. Museum der bildenden Künste, Leipzig.

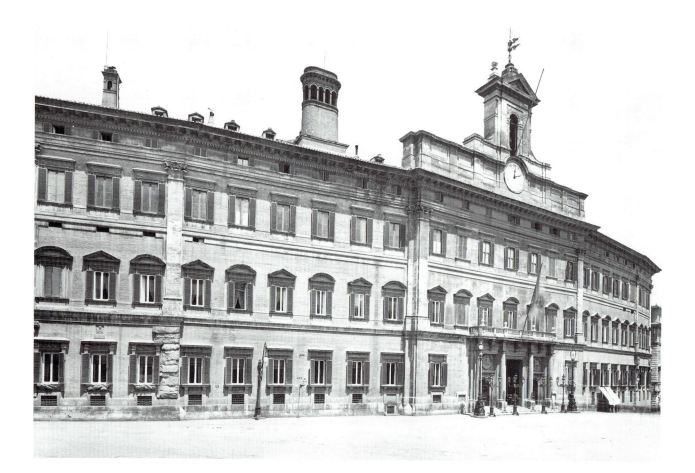

Fig. 202 (*above*). Bernini, Palazzo di Montecitorio. Rome
(photo: Anderson 447).

Fig. 203 (*right*). Detail of Fig. 202 (photo: Jack Freiberg).

Fig. 204 (*opposite*). Anonymous, Bernini's project for the
Palazzo di Montecitorio. Camera dei Deputati, Rome (photo:
Istituto Centrale per il Catalogo e la Documentazione E41848).

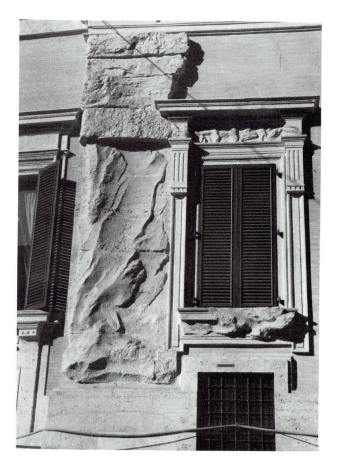

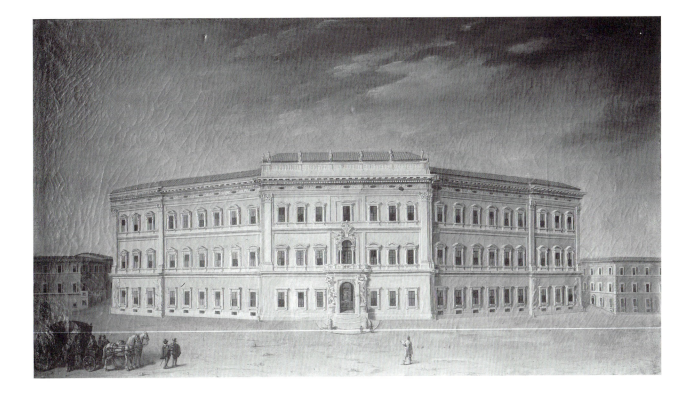

regarded as one of antiquity's foremost solar symbols, the fountain itself has the same emblematic sense that concerns us here.

A few years later Bernini introduced this idea of a rock-like foundation into a properly architectural context in the facade of the palace, known from its location as the Palazzo di Montecitorio, which he designed for the same pope's niece and her husband; here he used natural rustication on the basement story, beneath a colossal order of pilasters (Figs. 202–204).[24] Bernini may have adopted the natural form in the rustication of the new palace for the pope's niece to echo the motif of the Piazza Navona fountain. There may have been other reasons as well. The base of the Piazza Navona fountain portrayed a mountain, after all, and the new palace was situated on a prominence, the Mons Citatorius, that had been an important center of urban life in antiquity.[25] The idea of the Louvre as a palace metaphorically on a mountain top may have germinated here. In the Roman palace the rustication is confined to the strips beneath the outermost pairs of the order of pilasters. These powerful animated bases thus appear as equivalents in "living" rock of the atlantean figures that support the central balcony from which the pope would have greeted the populace (Fig. 205).

Although there is no documentary evidence that Bernini planned a piazza before the new Montecitorio palace, the monumental entrance and balcony would scarcely have made sense without one. Perhaps because of such a plan he first had the idea, to which we shall return, of moving the column of Trajan to form a pair with that of Marcus Aurelius.[26] The place in front of the Montecitorio palace would have been the obvious choice for the new location, especially because nearby portions of a third column were preserved, that of Antoninus Pius. In fact, the name of the area was thought to have derived from the *colonna citatoria*, so called because it was supposedly used to disseminate public decrees.[27] In studying the ancient columns, Bernini would have become aware not only of their Christianization—to be discussed presently—but also of the unrestored condition of the Aurelian column, which had long been confused with the column of Antoninus. The original facing of the base had been hacked away, leaving only the rough-hewn substructure, the condition recorded in many early depictions. Bernini's pilasters on rusticated strips were perhaps intended to evoke the destroyed column of Montecitorio by echoing the Aurelian column in its ruinous state, the memory of which was still very much alive. Indeed, the relationship was evidently appreciated by one

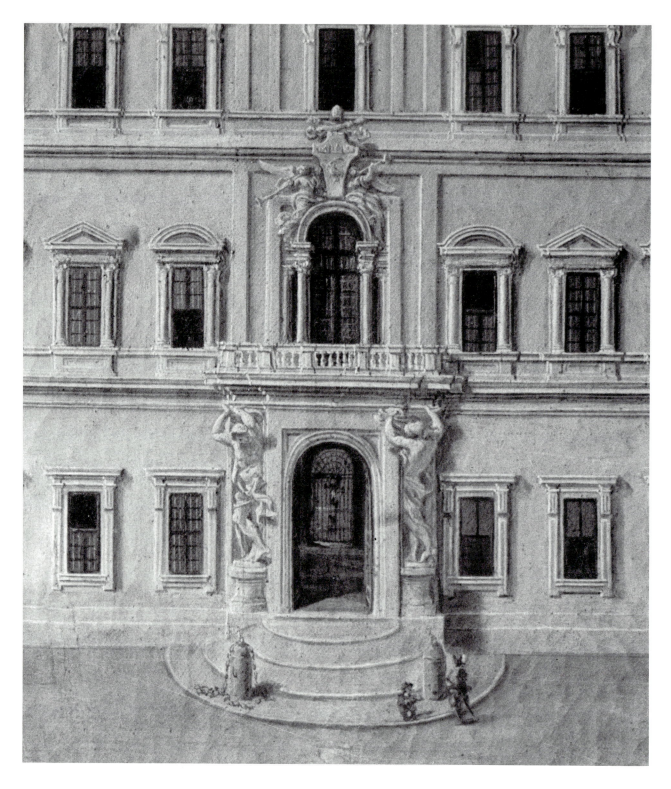

Fig. 205. Detail of Fig. 204.

Fig. 206 (*opposite*). Johann Meyer the Younger, view of Piazza
Colonna (from Sandrart, vol. 2, 1665–79, pl. XXII).

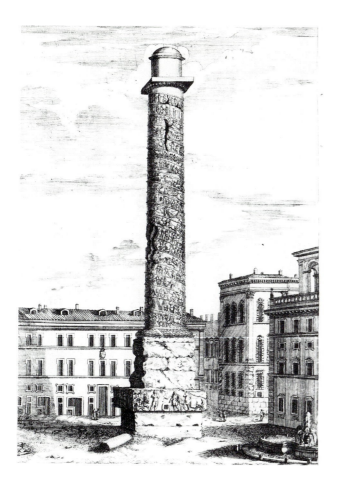

artist who pointedly juxtaposed the unrestored column with the corner of Bernini's unfinished palace in an engraved view of the Piazza Colonna published in 1679 (Fig. 206).[28] If a reference to the decrepit triumphal column is thus incorporated into the facade of the building, it may serve, along with the supporting atlantes, to suggest the subservience of the power of antiquity to the New Dispensation represented by the pope.

The pair of colossal figures flanking the doorway was another motif that Bernini transferred from the Palazzo di Montecitorio to the Louvre. In Rome they were "subjugated" to an ecclesiastical context, whereas in the secular domain at Paris they have become great guardian figures of Hercules carrying clubs (cf. Fig. 180). Hercules had long been a favorite antetype of the French kings, and sculptured depictions of Hercules and his Labors accompany the Apollo imagery that decorates the east facade of the Louvre in the project of François Le Vau (see Fig. 190). Early in the century, in the antiquarian Giacomo Lauro's fanciful recreation of the facade of the Golden House of Nero, situated on the Mons

Esquilinus, a pair of freestanding statues of Hercules with clubs had been placed before the central section (Fig. 207).[29] In Bernini's Louvre, the figures flank the portal, and they stand on rocky bases (on these supports, see p. 177 below); like the dressed masonry behind them, the figures mediate between the rusticated foundation below and the actual dwelling of the king above. In a letter written from Paris, Bernini's assistant describes the figures as guardians of the palace, signifying fortitude and labor. He quotes Bernini as explaining that Hercules "by means of his fortitude and labor is a portrait of virtue, which resides on the mountain of labor, that is, the rocky mass; and he says that whoever wishes to reside in this palace must pass through virtue and labor. This thought and allegory greatly pleased His Majesty, to whom it seemed to have grandeur and sententiousness."[30]

Bernini's statement provides the key to the unity of form and meaning in the project, which incorporated two essential elements of the architectural heritage of antiquity, one affecting the design, the other the significance of the building. The Louvre proposals echo such features as the multistoried facade of open arcades, the curved atrium, and the rusticated base that appear in certain ideal reconstructions of the palace of the Roman emperors on the Palatine, notably those by Onofrio Panvinio and Giacomo Lauro (Figs. 208, 209).[31] Bernini must also have been struck by the images that showed the palace in its contemporary ruinous state atop the rocky promontory (Fig. 210).[32] This association, in turn, may have encouraged Bernini to extend his rocky base to the whole building, so as to underscore the Louvre's role as a modern reincarnation of the ancient imperial palace, the embodiment of the very name for a royal dwelling, derived from the Mons Palatinus.

Furthermore, Bernini's explanation of his project as expressing a moral-architectural progression articulated a concept implicit in another illustrious Roman structure, the double temple of Honor and Virtue—so arranged that one had to pass through the one to reach the other. Bernini was certainly familiar with the reconstruction by Giacomo Lauro (see p. 280 and Fig. 240 below), whose comments on the monument he seems to have drawn on for the underlying ethical tone as well as several themes echoed in his own ideas for the Louvre. Lauro quotes St. Augustine to the effect that in the ingenious disposition of the temple the ancient Romans

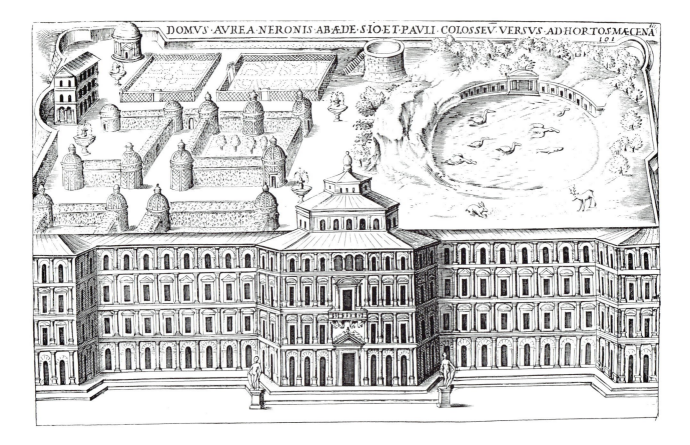

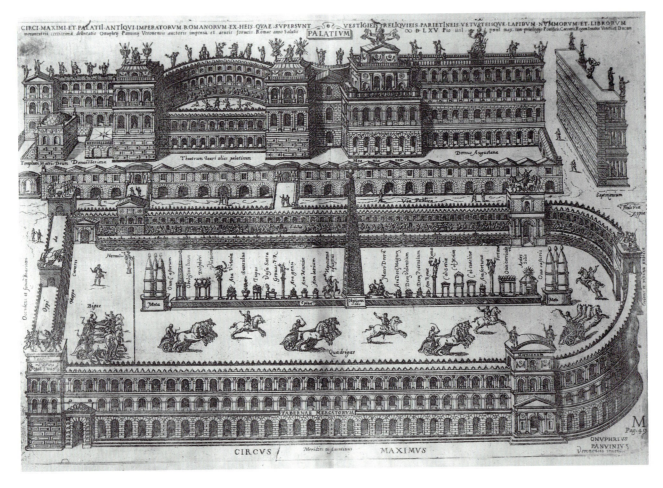

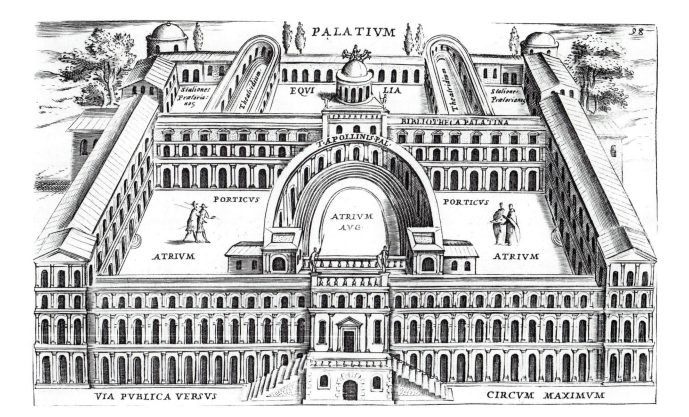

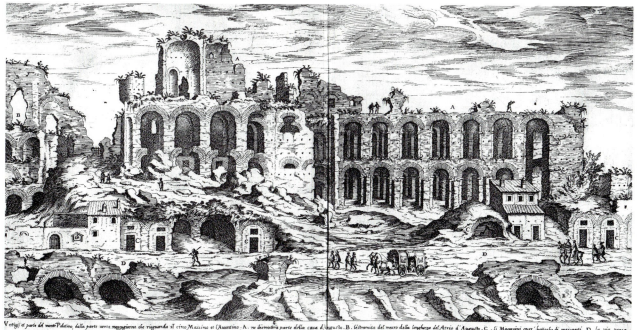

Fig. 207 (*opposite, top*). Giacomo Lauro, Nero's Domus Aurea
(from Lauro, 1612–41, pl. 101).

Fig. 208 (*opposite, bottom*). Onofrio Panvinio, Palatine palace and
Circus Maximus (from Panvinio, 1642, 49).

Fig. 209 (*top*). Giacomo Lauro, Palatine palace and Circus
Maximus (from Lauro, 1612–42, pl. 98).

Fig. 210 (*above*). Etienne Dupérac, Palatine palace and Circus
Maximus (from Dupérac, 1621, pl. 9).

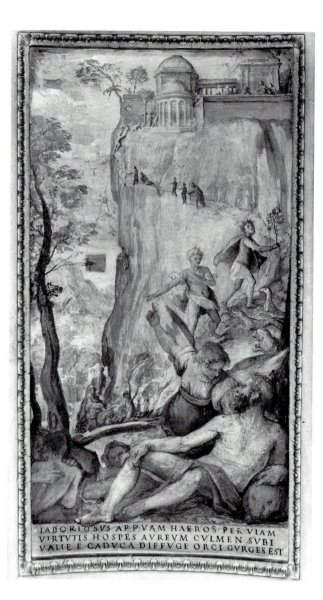

Fig. 211 (*right*). Federico Zuccari, The Mountain of Virtue, Honor, and Fame. Palazzo Zuccari, Rome (photo: Bibliotheca Hertziana D12019).

Fig. 212 (*opposite*). Bernini, bust of Francesco I d'Este. Galleria Estense, Modena (photo: Alinari 15669).

"taught that no one should be honored, or desire honors, who has not entered and long dwelt with profit in the virtues. . . . Princes should take this occasion to construct in their spirits similar temples of honor and virtue . . . exactly as did a number of ancient emperors . . . who never would accept the title of Maximus if they had not first earned it through virtue," as did Trajan and Marcus Aurelius, whose virtuous actions have been "preserved unharmed against the violence of time, war, and public calamities, as one may understand from the most beautiful columns constructed in their honor" (on the columns see pp. 176–82).[33] Bernini must also have drawn on the one important precedent for relating this idea of a moral progression in architecture to that of a physical progression to the top of a rocky peak: a fresco made about 1600 by Federico Zuccari to decorate his own home

in Rome (Fig. 211) in which the two temples, linked in turn to the temple of Fame, are perched on a high promontory reached by a tortuous path.[34]

In sum, Bernini developed a whole new mode of architectural expression at the Louvre to convey Louis XIV's adaptation of the traditional *oriens augusti* theme to himself as the Sun King. Bernini's project created a summa of the major ancient Roman "solar" palaces, merging them with a quasi-religious notion of ethical achievement expressed through architecture. These traditions, in turn, he associated with the equally venerable metaphor of the ruler as Hercules reaching the summit of the Mountain of Virtue. The visual, structural, and metaphorical basis for these relationships was Bernini's beloved *scogliera*, the invention of which, I am convinced, was the underlying motivation for his sudden willingness

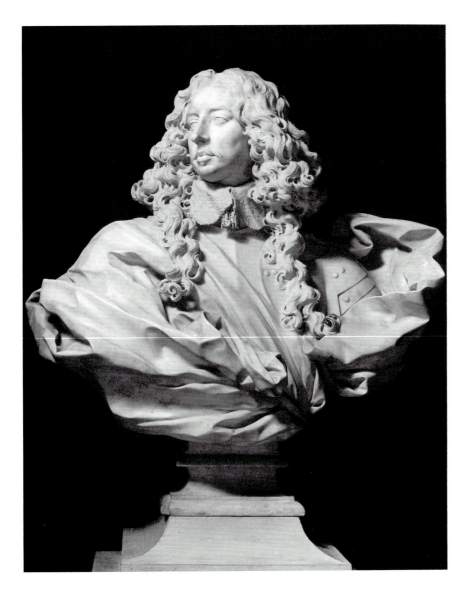

to abandon his earlier plans. This revolutionary form enabled him to envisage in his design for the Louvre the power of virtue and order to triumph over brute chaos.

The Bust Portrait

The bust of the king (see Figs. 178, 181; Plate X) is a "living" metaphor embodying two major themes, the royal medallic device and the imagery of Alexander the Great. In a sense, the merger simply vested in Louis XIV the ancient conflation of Helios and Alexander that had been the mainspring of the Sun King tradition itself.[35] These references help to explain some of the work's conspicuous differences from its nearest ancestor, Bernini's portrait of Fran-

cesco I d'Este, duke of Modena, of the early 1650's (Fig. 212). Louis's great wig engulfs his head with twisting lambent curls that are deeply undercut by corruscating drillwork; they recall Alexander's "leonine mane," and, in an uncanny way, they suggest the flaming locks of the sun god, Helios (Fig. 213). The king's forehead rises from heavily padded brows, and the vigorous sideward turn of the head and glance has a distinct upward cast suggestive not of arrogance but of a farsighted, ardent, and noble *hauteur* that is reminiscent of the ancient portrait type of the divinely inspired ruler. Bernini commented on both these details, observing that "the head of the king has something of that of Alexander, particularly the forehead and the air of the face."[36] In other words, Bernini saw the features of Alexander in those of the king, and he reported more than

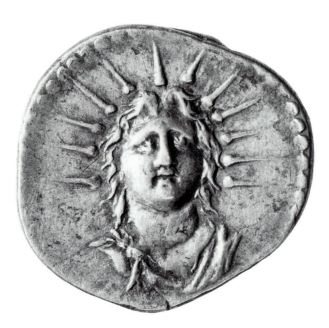

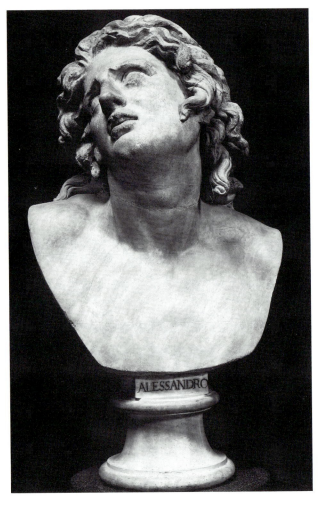

once that people saw this resemblance in the bust itself: visitors, he said, were reminded of the medals and the "beautiful heads" of Alexander.[37] An antiquarian and collector of medals, Pierre Seguin, also noted the strong Alexandrine "air" of the bust, which "turned to the side as one sees in the medals."[38] Since the numismatic portraits of Alexander that can be identified with certainty are all in profile, the latter reference was probably to Greek coins of Helios with a three-quarter face or to a rare Roman type in which the head is turned up and to the side, and the neck and part of the chest are included to convey the torsion (Fig. 213).[39] The beautiful heads must be the famous sculptures in Florence (Fig. 214) and Rome (Fig. 215), then universally identified as Alexander.[40] The Roman version was associated with the group popularly known as the Pasquino; Bernini admired this pathetically mutilated work, which was thought to portray the death of Alexander, more than any other ancient sculpture.[41] Both the head and the movement of the figure—one

shoulder forward in the direction of the glance, the arm wrapped round the body in a powerful contrapposto—recall Alexander as he had been portrayed in a painting by Giulio Romano (Fig. 216). Giulio himself had adopted the pose of the Greek hero from that of Julius Caesar in Titian's series of the Twelve Roman Emperors (Fig. 217).[42] In Bernini's sculpture the implied reversal of the lower right arm checks the forward thrust suggested by the movement of the upper torso and the drapery, a notable difference from the d'Este bust whose significance will emerge when we consider the equestrian portrait of Louis.

The extraordinary drapery and Bernini's special concern that it seem to be flowing freely in the wind may also be understood in the same context of exultation and exaltation *all'antica*.[43] The use of drapery to "carry" a portrait bust was derived from an ancient funereal tradition in which a portrait of the deceased was placed against a cloth of honor. Bernini adapted this device for certain memorials of

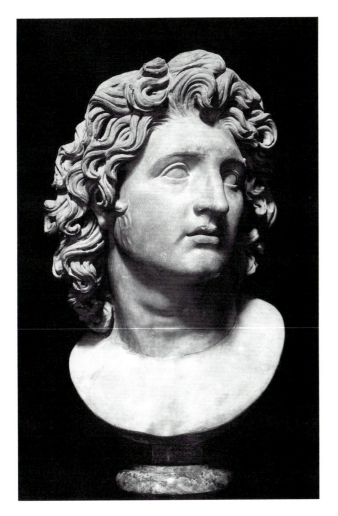

Fig. 213 (*opposite, left*). Helios, denarius of Vespasian. British Museum, London.

Fig. 214 (*opposite, right*). "The Dying Alexander." Galleria degli Uffizi, Florence (photo: Brogi 3223).

Fig. 215 (*left*). Colossal head of Alexander-Helios. Museo Capitolino, Rome (photo: Alinari 5972).

the 1630's and 1640's, transforming the hanging cloth into a billowing swath of drapery (Fig. 218).[44] The drapery of Francesco d'Este actually flutters upward and wraps around the torso, Christo-like, so as to suggest the lower silhouette of a portrait bust wafted into the empyrean. Bernini surely devised this mixture of objectivity and metaphor to give form to a train of political thought, particularly strong among the Jesuits, in which the ideal ruler was conceived as a hero, both human and divine. The concept of the monarch as a demigod-like prince-hero had been formulated with respect to Francesco I himself, shortly after his death in 1658, in a commemorative volume by a leading Jesuit of Modena, Domenico Gamberti, that actually celebrates Bernini's portrait of the duke (Fig. 219).[45] The sculpture thus represents what it is, an honorific monument of heroic apotheosis. In the bust of Louis, Bernini carried this conundrum a significant step further. Louis's drapery gives no hint of the lower edge of the torso, so that the figure appears to

be what the sculpture represents, a living human being. Moreover, the cloth blows freely to the side, and Louis's cloak becomes a magic carpet, the sartorial equivalent of the cloud formations above which the emblematic sun appears to float.

The king's device and the imagery of Alexander also coincided in the treatment of the pedestal, a final point of difference from the d'Este portrait. Chantelou records that Bernini intended to place the bust of the king on a terrestrial globe of gilded and enameled copper bearing the ingenious inscription *Picciola Basa*, "small base"; the globe rested on a copper drapery emblazoned with trophies and virtues (these last were essential attributes in Bernini's conception of the ideal ruler, as we shall see); and the whole was set on a platform. It was a common device to portray a monarch perched on an earthly sphere; a specifically French typology had been established by images in which Henry IV was shown thus, both as a standing figure and as an equestrian mounted on a rearing Pegasus.[46] There was also an ancient

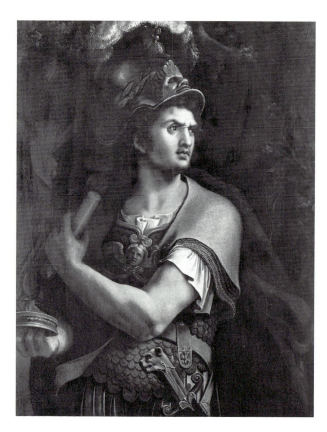

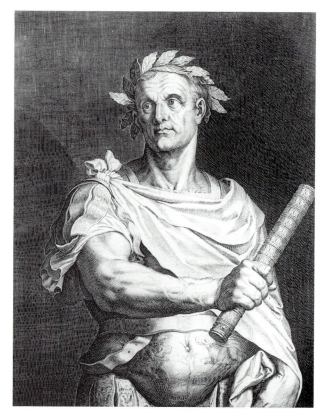

Fig. 216 (*above, left*). Giulio Romano, *Alexander the Great.* Musée d'Art et d'Histoire, Geneva.

Fig. 217 (*above, right*). Aegidius Sadeler, Titian's *Julius Caesar,* engraving.

Fig. 218 (*right*). Bernini, Cenotaph of Suor Maria Raggi. Santa Maria sopra Minerva, Rome (photo: Istituto Centrale per il Catalogo et la Documentazione, Rome E54086).

Fig. 219 (*opposite*). Bernini's bust of Francesco I d'Este (from Gamberti, 1659, frontispiece).

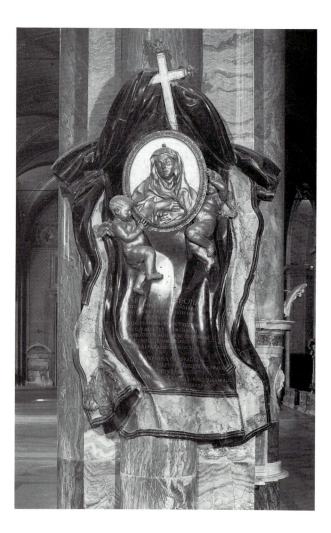

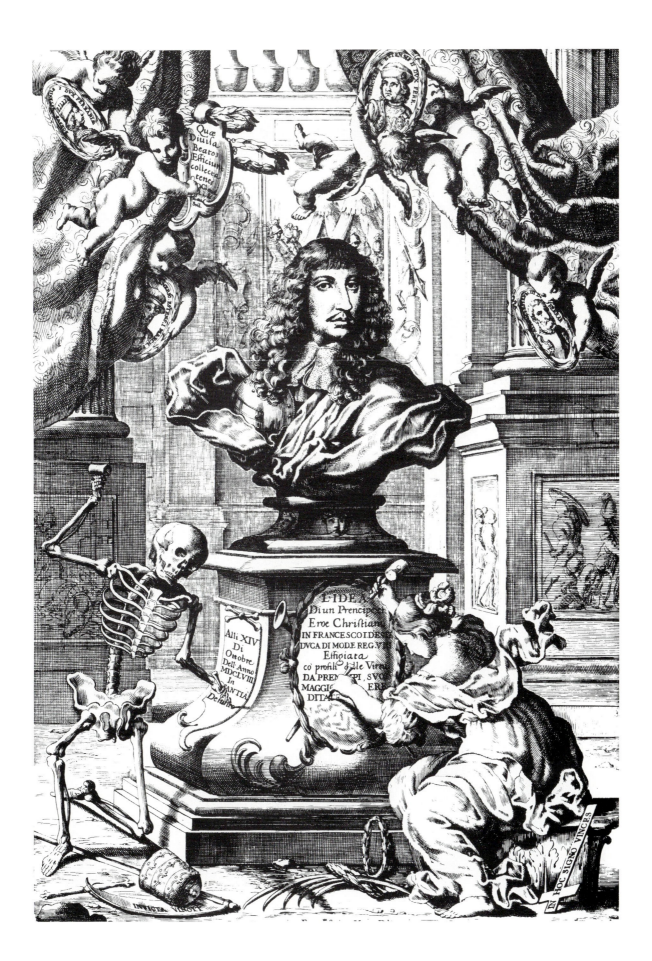

tradition of portrait busts mounted on a (celestial) globe to suggest apotheosis (Fig. 220). A bust-monument of the emperor Claudius included a pedestal with a globe and military spoils that in the mid-seventeenth century had been placed on a sculptured platform (Fig. 221). Bernini may have been inspired to apply these ideas to Louis by another invention of Le Brun's, perhaps again for Fouquet. I refer to a tapestry door covering, or por-tière, in which the crowned face of the sun shines above the arms of France and Navarre; below, a ter-restrial globe rests on a panoply of military spoils (Fig. 222).[47] It is indeed as though Le Brun's mag-nificent and emblematic armorial display had sud-denly come to life.[48] The motivating force was evidently Plutarch's familiar description of Lysippus's portrait of Alexander, which combined the upward and sideward glance with a reference to the earth below: "When Lysippus first modelled a portrait of Alexander with his face turned upward toward the sky, just as Alexander himself was accustomed to gaze, turning his neck gently to one side, someone inscribed, not inappropriately, the following epi-gram: 'The bronze statue seems to proclaim, looking at Zeus: I place the earth under my sway; you O Zeus keep Olympos.'"[49] These references were quite evident to contemporaries. When Bernini described his idea for the base, Chantelou drew the analogy with the king's device.[50] Another witness, no doubt aware of the passage in Plutarch, perceived the link between the royal emblem and the ancient monarch, remarking, as Bernini himself reported, that the ad-dition of the world as a base enhanced the resem-blance to Alexander.[51]

The multiple allusions to the royal device and to the Helios-Alexander tradition fill the bust with meaning; they contribute as well to its expressive intensity and to the sense of supernatural aloofness it conveys.

The Equestrian Portrait

The bust of Louis is itself without any allegorical paraphernalia: the king is shown wearing his own—not classical—armor, and his own Venetian lace collar, in a vivid likeness with lips poised at the moment Bernini described as just before or after speaking; one observer thought Louis looked as if

Fig. 220 (*opposite*). Roman portrait bust. Colchester and Essex
Museum, Colchester.

Fig. 221. The Colonna Claudius (from Montfaucon, 1719,
vol. 5, pl. XXIX).

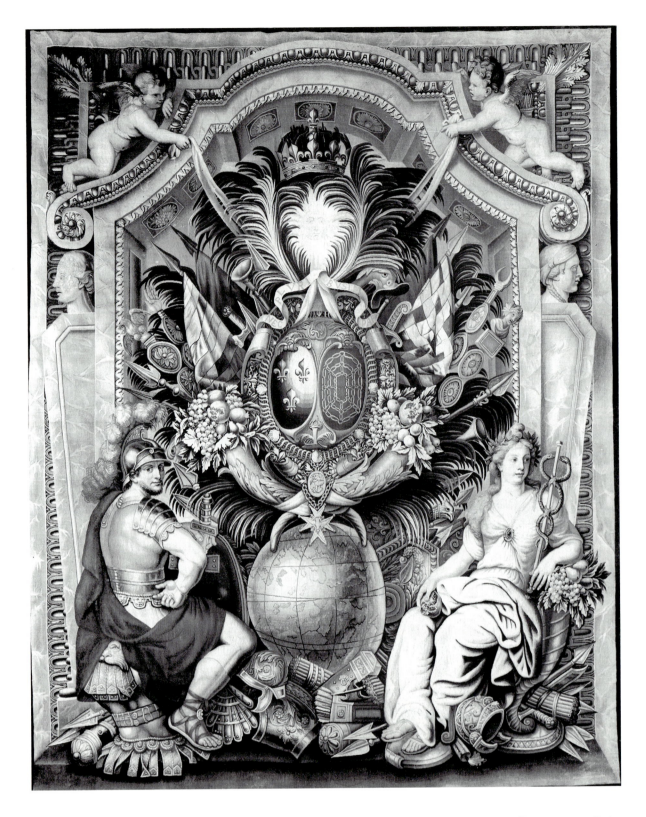

Fig. 222. Charles Le Brun, portière of Mars, tapestry. Paris, Musée du Louvre (photo: Documentation photographique de la Réunion des musées nationaux 83 EN 5233).

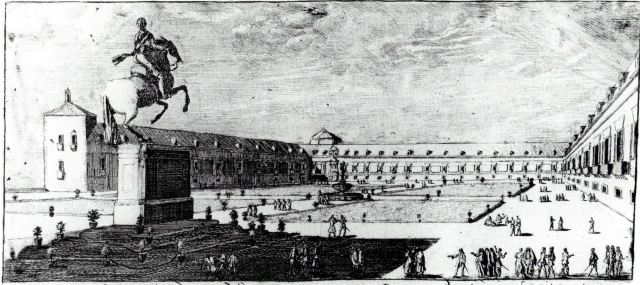

entre du Retiro de madrid La Entrada del buen Retiro en Madrid

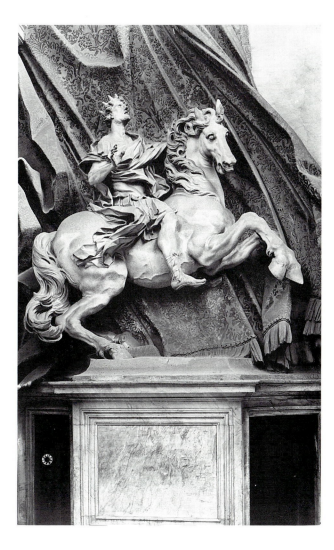

Fig. 223 (*top*). L. Meunier, entrance to Buen Retiro, Madrid, engraving. British Museum, London.

Fig. 224. Bernini, equestrian monument of Constantine. St. Peter's–Vatican Palace, Rome (photo: Anderson 191).

he were about to issue a command.[52] All this was changed in the equestrian monument, where the king was shown in antique guise, his features, as we know from the sources, utterly transfigured into those of a radiant, smiling youth (Figs. 179, 182; Plate XI). Functionally, Bernini's project took up an old tradition—which had been followed by François Mansart, Pierre Cottard, and Charles Perrault in their projects for the Louvre—of equestrian statues of French kings in their residences;[53] Bernini's was evidently the first such monument in France with a rearing horseman, and freestanding rather than attached to the building. The precedent in both these respects was Pietro Tacca's sculpture of Philip IV in the garden of the Buen Retiro at Madrid (1642), the first monumental rearing equestrian in bronze since antiquity (Fig. 223);[54] the apparent emulation reflects the notorious French rivalry with Spain, further repercussions of which will emerge presently.

In form, Bernini's work was intentionally related to but also, as he himself reported, completely different from his earlier equestrian monument of the emperor Constantine in Rome (Fig. 224). Both horses rear in strikingly similar poses, and the riders mount, miraculously, without reins or stirrups. But whereas the glance and gestures of Constantine are raised to convey his spiritual bedazzlement at the vision of the Holy Cross above, those of Louis are earthbound and convey his mundane power in what Bernini called an "act of majesty and command."[55] The phrase should not be taken as referring to a military directive, as in Donatello's *Gattamelata*—an interpretation Bernini abjured (see below). Instead,

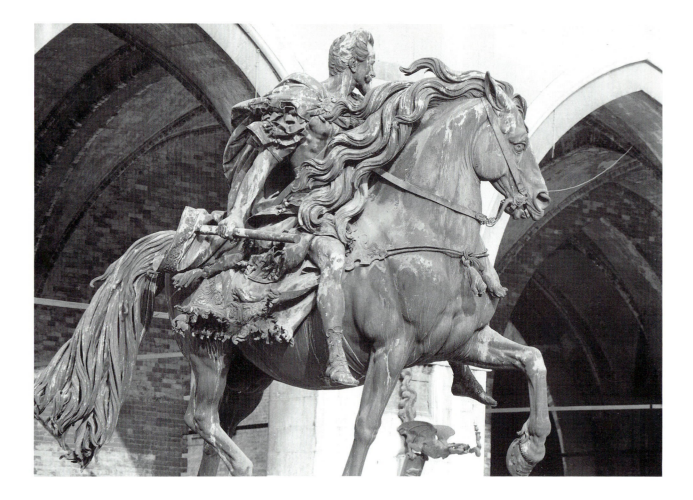

he adapted the gesture of Verrocchio's *Colleoni* or Francesco Mochi's *Alessandro Farnese* in Piacenza (Fig. 225) to suggest that this ruler leads by sheer force of being.[56] And whereas Constantine springs from an abstract architectural base, Bernini gave Louis a new form of support reminiscent of the substructure of the Piazza Navona fountain and echoing that of the Louvre itself (Fig. 226). The base portrayed a craggy peak and the image as a whole recalled that of Pegasus atop Mount Parnassus (see Fig. 195).[57] In the final version a swirl of windblown flags symbolized the conquest of the summit; like the drapery of Louis's bust, the unfurling banners seemed to bear the portrait aloft (see Figs. 232, 233).[58]

When the work was recut to represent Marcus Curtius hurling himself into the fiery abyss, two major changes were made. The flowing hair at the back of the head became the casque of a crested helmet, and the flags were transformed into a mass of flames. I do not believe the expression was radically altered, since one of its most distinctive features, its benign smile, must have seemed appropriate to

the new subject; the theme of heroic self-sacrifice preserved, as we shall see, an essential element of the meaning Bernini intended for the work.[59] The smile echoed the resplendent visage of Bernini's own image of Truth. The smiling sun was a traditional metaphor, of course, and Bernini was not the first to portray Louis this way; the image of radiant youthful benignity had appeared a few years earlier, for example, in a portrait of the king as Jupiter, victorious after the rebellions of the Fronde (Fig. 227).[60] Also relevant, perhaps, was the description of an equestrian figure of the emperor Domitian by the poet Statius, who expresses the joy of contemplating a face in which are mixed the signs of war and peace.[61] To convey Bernini's thought, however, I can do no better than to quote his own words:

I have not represented King Louis in the act of commanding his armies. This, after all, would be appropriate for any prince. But I wanted to represent him in the state he alone has been able to attain through his glorious enterprises. And since the poets imagine that Glory resides on the top of a very high and steep

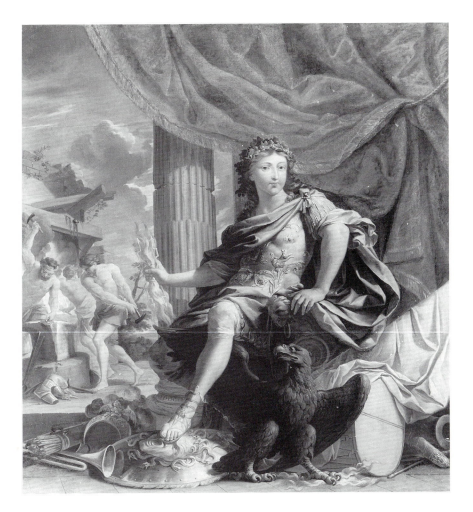

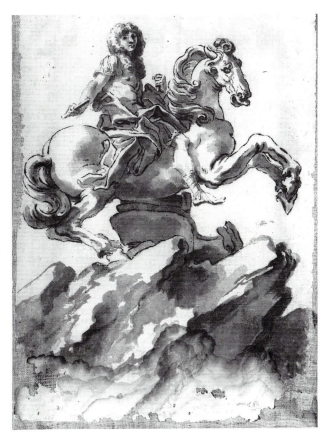

Fig. 225 (*opposite*). Francesco Mochi, equestrian monument of Alessandro Farnese. Piazza dei Cavalli, Piacenza (photo: Manzotti, Piacenza).

Fig. 226 (*left*). Bernini, study for the equestrian monument of Louis XIV, drawing. Museo Civico, Bassano.

Fig. 227 (*above*). Anonymous, Louis XIV as Jupiter. Musée National du Château de Versailles (photo: Documentation photographique de la Réunion des musées nationaux MV 8073).

mountain whose summit only a few climb,[62] reason demands that those who nevertheless happily arrive there after enduring privations [*superati disaggi*], joyfully breathe the air of sweetest Glory, which, having cost terrible labors [*disastrosi travagli*], is the more dear, the more lamentable the strain [*rincrescevole . . . stento*] of the ascent has been. And as King Louis with the long course of his many famous victories has already conquered the steep rise of the mountain, I have shown him as a rider on its summit, in full possession of that Glory, which, at the cost of blood [*costo di sangue*], his name has acquired. Since a jovial face and a gracious smile are proper to him who is contented, I have represented the monarch in this way.[63]

The equestrian *Louis XIV* went through several stages of development and incorporated many ideas and traditions, of which I want to consider only a few. An important, though heretofore unnoticed, idea is reflected in an emblem book published by a learned Bolognese antiquarian and historian, Achille Bocchi, in 1555 (Fig. 228). One of Bocchi's devices shows a horseman, Diligence, striving up a high peak to receive from Felicity a crown ornamented with fleurs-de-lys. The caption reads, "Happiness is the ultimate reward of prudence and diligence."[64] Once again Bernini merges the image of the rustic mountain of glory scaled by the assiduous labors of virtue with that of the radiant and beneficent sun shining brightly above the earth.

What might be called the physical character of the monument—its size and technique—is an essential part of its meaning. As far as I can determine Bernini's *Louis XIV* is the first monumental, free-standing, rearing equestrian statue executed in stone since antiquity. It was, moreover, carved from a single block, "larger than the Constantine," "the largest ever seen in Rome," "the largest ever struck by chisel," according to the early biographers.[65] The whole enterprise, especially considering the mountainous base, reminded one contemporary of the architect Dinocrates who, in the guise of Hercules, proposed to carve a statue of Alexander the Great from Mount Athos.[66] The operative factor here was the ancient mystique, emulated by sculptors since the Renaissance, of large-scale monolithic sculpture as testimony to the prowess of both the artist and the subject.[67]

Bernini's concept for the marble group had several notable precedents in purely secular contexts, in Rome and in Florence and Turin, where the artist

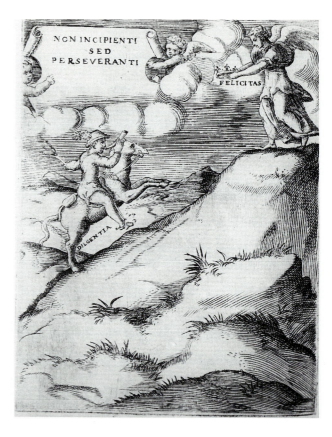

was received at court in grand style as he traveled to Paris.[68] First and foremost was the so-called Farnese Bull, representing the Fable of Dirce, now in the Archeological Museum in Naples (Fig. 229).[69] In Bernini's time it was to be seen in Michelangelo's Palazzo Farnese in Rome, having been discovered in the Baths of Caracalla in 1545 and identified as a Labor of Hercules, the heroic ancestor of the Farnese family. It was one of the most prominent of all ancient sculptures known, and in the few months before Bernini's visit to Paris Louis had sought more than once to acquire the piece for himself. The significance of the sculpture was partly a matter of scale and technique—a huge "mountain of marble," as it was called, with multiple figures said to have been carved from a single block; the work was mentioned for precisely these reasons in a discussion of important antiquities during Bernini's stay at the French court. Furthermore, from Bernini's point of view, at least, the epithet "mountain of marble" could be taken literally, offering classical precedent for the unorthodox pedestal he envisioned for his own group. Finally, the great work had been the motivation for an ambitious project of Michelangelo, described by Vasari, for the Farnese palace then under construction. Michelangelo would have made the sculpture

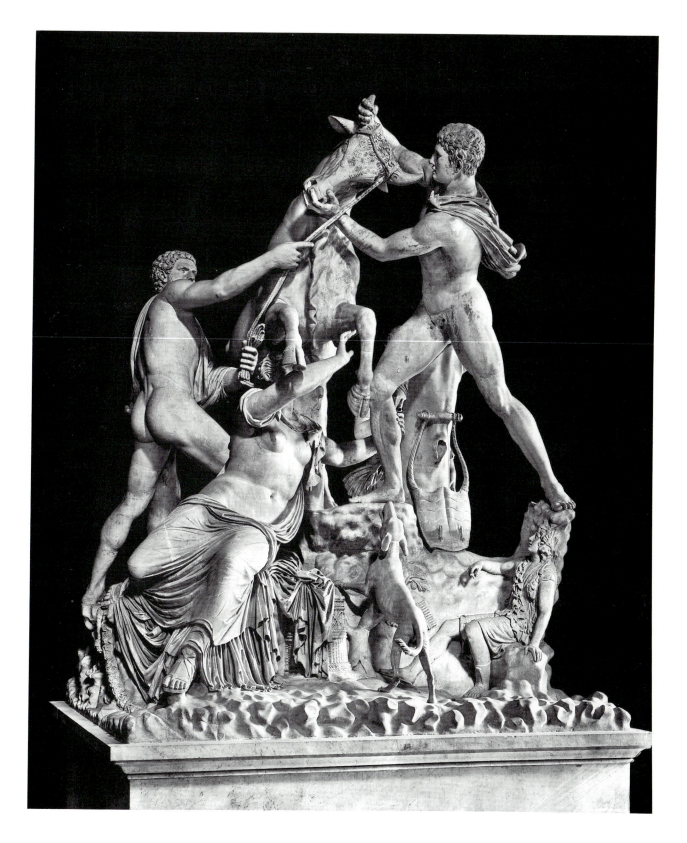

Fig. 228 (*opposite*). Achille Bocchi, "Felicitas prudentiae et diligentiae est" (from Bocchi, 1555, p. CLXXVIII).

Fig. 229. Farnese Bull. Museo Archeologico Nazionale, Naples (photo: Anderson 23202).

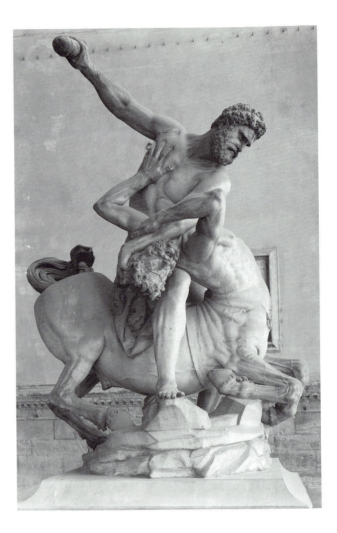

Fig. 230. Giovanni Bologna, Hercules overcoming Nessus. Loggia dei Lanzi, Florence (photo: Soprintendenza per i Beni Artistici e Storici, Florence 117231).

the focal point of a vista extending from the square in front of the Farnese palace through the building itself to the courtyard in the rear, where the group would have been installed as a fountain, and beyond along a new bridge across the Tiber to a Farnese garden and casino on the other side of the river. The challenge of the heroic sculptural feat of the ancients, the bold idea of a naturalistically carved base that served to raise the figure to the summit of the earth, and the prospect of integrating the sculpture along a grandiose urban, architectural, and landscape axis—all these features associated with the Farnese Bull were emulated in Bernini's plan to locate his monolithic, multifigured mountain-top monument in the space between the rear facade of the Louvre and the Tuileries palace.

No less essential to Bernini's thought was an equestrian monument of sorts that had also been carved from a single, if considerably smaller, block: Giovanni Bologna's *Hercules Overcoming Nessus*, dated

1600, in the Loggia dei Lanzi in Florence (Fig. 230).[70] The group was intended to glorify Ferdinando I and the Medici dynasty of Tuscany, which more than any other set the direction for the European monarchic style that Louis XIV would follow. The relevance of the work lay partly in its form and material and partly in the way the Herculean theme was interpreted—not simply as a victory but as a labor, an obstacle overcome on the road to glory. This message was spelled out on a commemorative medal, inscribed *Sic Itur ad Astra*, "thus one reaches the stars."[71] Giambologna's sculpture itself, the medal, and the inscription were all to be reflected in Bernini's work.

In certain respects the nearest antecedent for Bernini's idea was the equestrian statue of Vittorio Amadeo I of Savoy, which had been installed just a year before Bernini's visit in a niche in the grand staircase of the Palazzo Reale in Turin (Fig. 231).[72] This mixed-media work by Andrea Rivalta—the

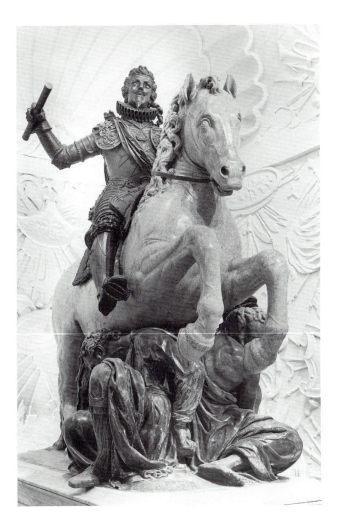

Fig. 231. Andrea Rivalta, equestrian monument of Vittorio Amadeo I of Savoy. Palazzo Reale, Turin (photo: Aschieri, Turin).

horse is of marble, the rider and supporting figures of bronze — must have raised the prospect of a rearing equestrian portrait in stone as a royal monument, perhaps to reinforce visually Louis's political hegemony over the north Italian duchy. Taken together, the Giambologna and Rivalta sculptures foreshadowed Bernini's conception of a monolithic freestanding rearing equestrian portrait and the idea of a royal equestrian monument with a Herculean theme.

In the religious, or quasi-religious, sphere the monument responded to a specific request from Colbert that it be similar but not identical to Bernini's own portrayal of the first Christian emperor, situated at the junction between the narthex of St. Peter's and the Scala Regia, the Royal Stairway to the Vatican palace. The allusion was doubly significant in view of the association the French must have made between the statue in Rome and the many equestrian figures, often identified with Constantine and his

Frankish reincarnation Charlemagne, that decorate the entrance portals to French medieval churches. The reference served to assimilate Louis to the venerable tradition identifying the French monarchs as the defenders of the faith and true successors to the Holy Roman Empire.[73]

The secular and Christian themes conveyed by Bernini's sculpture were epitomized in two medals struck in Rome about 1680, doubtless under the aegis of the pope, reproducing the final design.[74] One medal (Fig. 232), which is monoface, bears the inscription *Hac Iter ad Superos*, "this way to the gods."[75] This was a preeminently Herculean sentiment, associated especially with the theme of Hercules at the Crossroads; the hero chooses the difficult path of righteousness over the easy road to pleasure, thereby expressing the supreme Stoic virtue, conquest of the self.[76] The other medal (Fig. 233) shows the sculpture on the obverse, with two inscriptions. The legend *Lud(ovicus) Magn(us) Rex Christianissimus* describes

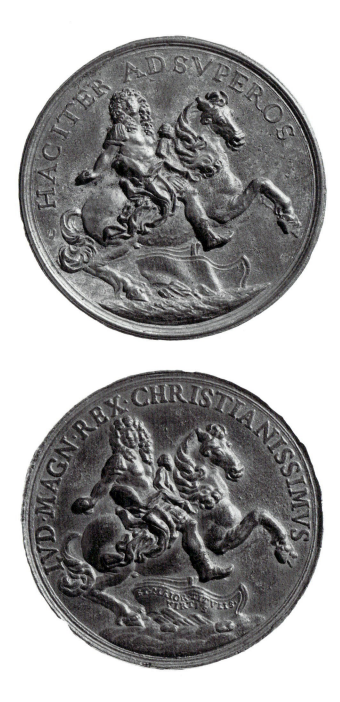

Fig. 232. Antonio Travani, medal of Louis XIV. Vatican Library, Rome.

Fig. 233. Antonio Travani, medal of Louis XIV. Vatican Library, Rome.

Louis as "the Great" and as "Most Christian King" —both early epithets adopted by Louis in reference to the secular and religious titles by which the French kings traced their authority back through Charlemagne to Constantine the Great.[77] The motto on the flags, *Et Major Titulis Virtus,* "virtue is greater than titles," emphasizes the moral, as distinct from the feudal, basis of Louis's claims to the titles, a crucial point to which we shall return presently. The reverse of the medal (Fig. 234) has an allegorical composition in which Victory and Religion triumph over Heresy—an obvious reference to the Huguenots—with the motto *Victore Rege Victrix Religio,* "victorious the king, victorious religion."

The pedestal of Bernini's sculpture was to have borne the inscription *Non Plus Ultra,* and the sculpture itself would have been flanked with two great columns alluding both to the columns of Trajan and Marcus Aurelius in Rome and to the Pillars of Hercules (cf. Fig. 235).[78] To my knowledge, these potent symbols, real and mythical, of ancient imperial and Herculean triumph were here linked for the

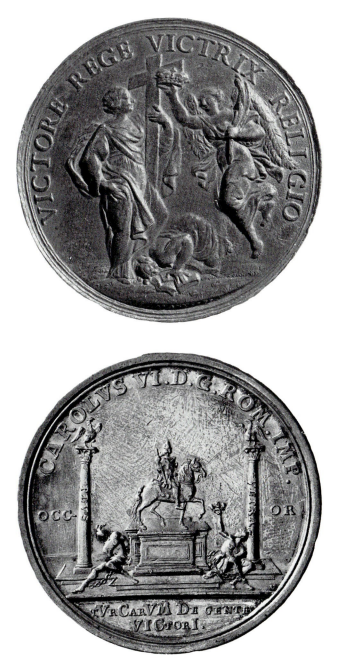

Fig. 234. Antonio Travani, medal of Louis XIV, reverse of Fig. 233. Vatican Library, Rome.

Fig. 235. Georg Wilhelm Vestner, medal of Charles VI, 1717. American Numismatic Society, New York.

first time.[79] The idea of a portrait of the Sun King placed between the Pillars of Hercules may have derived from an ancient devotional relief much discussed by contemporary antiquarians as an epitome of classical mythological symbolism (Fig. 236). A radiate bust of Apollo appears between a pair of Herculean clubs resting on rocky bases that anticipate the supports of the Hercules figures flanking the entrance in Bernini's third Louvre project (see Fig. 180). The relief, which was in the Mattei collection in Rome, had been illustrated and interpreted by the great Jesuit polymath Athanasius Kircher, who had worked closely with Bernini on the Piazza Navona fountain, in a learned book on the fountain's obelisk.[80] Rearing equestrian portraits and twisted columns had appeared together on the catafalque of Francesco I d'Este (Fig. 237); Bernini had once engaged to provide the model of a commemorative equestrian monument of the duke for the Piazza Ducale at Modena.[81] Paired columns representing the pillars of Hercules and associated with the motto *Non Plus Ultra* were a common

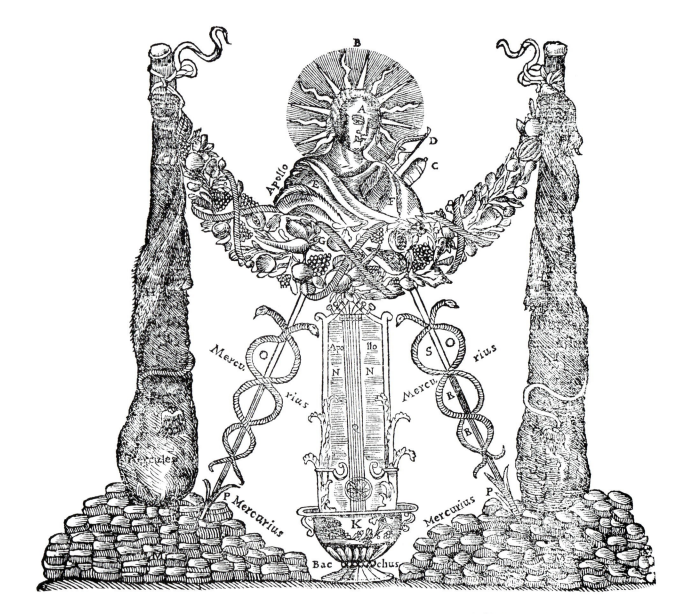

Fig. 236. Ancient (?) relief linking Apollo and Hercules. Formerly Villa Mattei, Rome (from Kircher, 1650, 236).

Fig. 237 (*opposite*). Catafalque of Francesco I d'Este (from Gamberti, 1659, opp. p. 190).

emblem that might refer either to an unsurpassable achievement, physical or spiritual, or a limitation imposed by prudence. Associated especially with the Hapsburgs, the device also connoted the geographical extent of the empire.[82]

All these associations converged in Bernini's mind with a stunning proposal he had evidently made to Pope Alexander VII in Rome before his trip to Paris. The family of the pope in 1659 had acquired a palace on the Piazza Colonna, immediately adjacent to the still unfinished Palazzo di Montecitorio,

which Bernini had designed for Alexander's predecessor.[83] Bernini suggested moving the column of Trajan from the Forum, presumably to the Piazza di Montecitorio, to make a pair with the column of Marcus Aurelius. This arrangement would have created an explicit reciprocity between the columns in the Montecitorio-Colonna area, and the two papal palaces would have been linked by the city's most grandiose public square after that of St. Peter's itself.[84] Thus paired, the columns would have suggested the columns and metas marking the spina of

Fig. 238. Piazza Navona, the ancient circus of Domitian, Rome (photo: Fototeca Unione 6469 FG).

Fig. 239 (*opposite, bottom*). Domenico Fontana, catafalque of Pope Sixtus V (from Catani, 1591, pl. 24).

Fig. 240 (*opposite, top*). Giacomo Lauro, Temple of Honor and Virtue (from Lauro, 1612–41, pl. 30).

an ancient circus, and the whole arrangement would have recalled that at Piazza Navona (Fig. 238)—the ancient stadium of Domitian—as well as the disposition of the Vatican Palace beside the circus of Nero. The connection of palace and circus evoked an ancient tradition of imperial, Herculean triumph, based on the juxtaposition of the palace of the emperors on the Palatine and the Circus Maximus (see Figs. 208, 209).[85] The ancient columns had been paired spiritually, as it were, ever since Sixtus V had crowned them with statues of Peter and Paul, patrons of the Holy See. Sixtus also restored the badly damaged column of Marcus Aurelius, and the inscription on the new base refers to the triumph of Christianity over paganism.[86] The ancient spiral columns had also been brought together physically as trophies on the catafalque erected for Sixtus's funeral in 1591 (Fig. 239) and as background for Giacomo Lauro's ideal reconstruction of the Temple of Honor and Virtue in Rome (Fig. 240).[87] Bernini's project for the Piazza Colonna would have referred these themes specifically to the Chigi

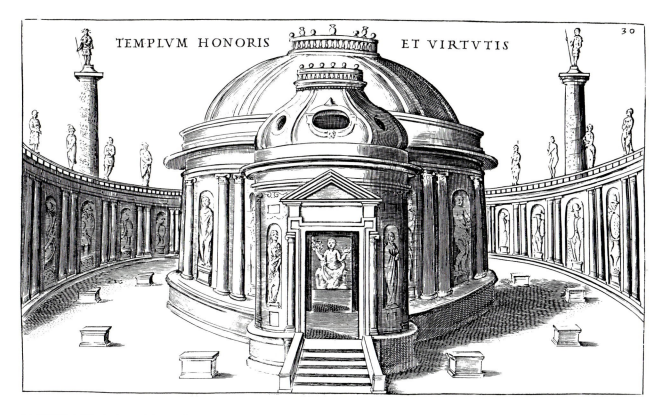

TEMPLVM HONORIS ET VIRTVTIS

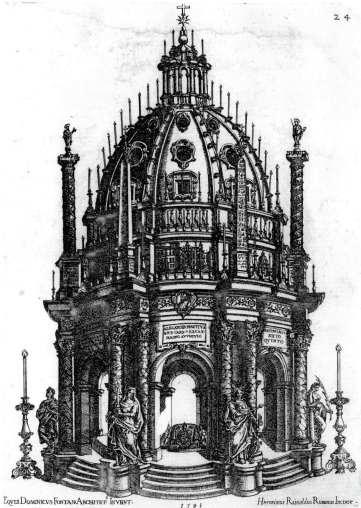

EQVES DOMINICVS FONTANA ARCHITET INVENT. 1591 Hieronimus Rainaldus Romanus Incisor.

papacy.[88] By shifting the ideas of religious and moral victory to the Louvre and associating the Roman triumphal columns with the Pillars of Hercules, Bernini would have endowed Louis with the same claim to superiority over the ancients in the secular sphere. In the Louvre project, however, this notion acquires a different and unexpected aspect, owing to the repercussions of a great historical event that must have played a considerable role in Bernini's thinking.

In 1659 the Treaty of the Pyrenees was signed by France and Spain, whose power was broken. The treaty established the boundary between the two countries, with the victorious Louis agreeing not to pursue his expansionist designs beyond the Pyrenees. Louis's marriage the following year to Maria Theresa of Austria, daughter of Philip IV and queen of León and Castile, forged a new link between the two countries. The spirit of peace and reconciliation heralded by these events was invoked in a tract published in 1660 by Bernini's own nephew, Father Francesco Marchesi, a devout and learned member of the Oratorio of San Filippo Neri. This massive work, dedicated to the respective protagonists, Cardinal Mazarin and the count-duke of Olivares, extolls the treaty and marriage as the culmination of the entire millennial history of the relations between the two countries. Bernini was extremely attached to his nephew, and recent research has shown that Marchesi was an important influence on the artist in his later years.[89] No doubt in this case Marchesi's views prepared the way for Bernini's subsequent adaptation for his equestrian project of another work in which essentially the same attitude was expressed emblematically.

The political implications of the pact were illustrated in a great tableau used in the celebration at Lyon in 1660 of Louis's marriage to Maria Theresa (Fig. 241).[90] A personification of war stood on a pile of military spoils that bore the inscription *Non Ultra*, between two columns to which her arms are bound by chains. One column was decorated with the emblem of France, the other with those of León and Castile, and the whole was placed atop a craggy two-peaked mass referring to the Pyrenees. Menestrier included the device in another publication with a commentary that explains Bernini's conceit, which radically reinterpreted the traditional notion of an equestrian monument.

It is often desirable for the glory of heros that they themselves voluntarily put limits on their designs before Time or Death does so of necessity. . . . The grand example [of Hercules who raised the columns, then stopped to rest after his victories] makes all the world admire the moderation of our monarch, who, having more ardor and courage than any of the heros of ancient Greece and Rome, knew how to restrain his generous movements in the midst of success and victories and place voluntary limits to his fortune . . . The trophy that will render him glorious in the history of all time will be the knowledge that this young conqueror preferred the repose of his people over the advantages of his glory and sacrificed his interests to the tranquility of his subjects.[91]

Precisely the same sentiment introduced the commemorative inscription on a copper tablet that was immured by the king with the foundation stone of the Louvre itself, in a ceremony shortly before Bernini left Paris:

> Louis XIIII
> King of France and Navarre,
> Having conquered his enemies and given
> peace to Europe
> Eased the burdens of his people.[92]

The themes of virtue and self-mastery as the true basis for rule were also the leitmotif of Le Brun's great series of paintings from the life of Alexander, executed for the king beginning in 1661. Bernini, who saw and greatly admired two of the compositions during his stay in Paris,[93] took up this idea, combining the image from the Lyon festival with the centerpiece of another project celebrating the Peace of the Pyrenees to which he himself had contributed. To commemorate the event and further humiliate Spain in Rome, the French minister proposed to create an elaborate stairway up the Pincian hill from the Piazza di Spagna to the French enclave at Trinità dei Monti. Bernini made a model for the project, and his idea may be reflected in several drawings that include an equestrian monument in which the king is shown charging forward with drapery flying (Figs. 242, 243).[94] The conception seems to anticipate the work Bernini made for the Louvre, but it is far more aggressive. Indeed, Bernini may well have been referring to this project when he

Fig. 241. Allegory of the Peace of the Pyrenees (from Menestrier, 1660, opp. p. 54).

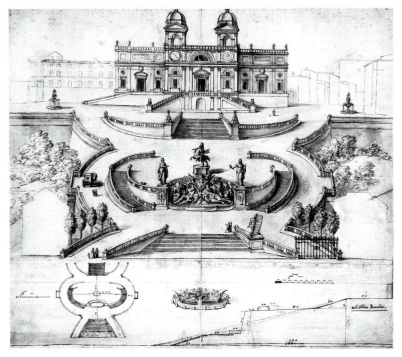

Fig. 242 (*above*). Workshop of Bernini (?), project for the stair-
way to Trinità dei Monti, drawing. MS Chigi P. VIII. 10, fols.
30v–31, Biblioteca Vaticana, Rome.

Fig. 243 (*top*). Detail of Fig. 242.

Fig. 244. Mattia de' Rossi, project for a monument containing Bernini's equestrian Louis XIV, drawing. Bibliothèque Nationale, Paris.

pointedly remarked that he would *not* show Louis commanding his troops (see p. 170 above).

Menestrier's comment on the image from Lyon explains Bernini's emphasis on the "privations," the "terrible labors," the "lamentable strain," and the "cost of blood" Louis suffered for his greatness. Bernini universalized the idea; the Pyrenees became the mountain of virtue, and territorial containment became victory over the self. He thus managed to embody both meanings of the *Non Plus Ultra*/Pillars of Hercules tradition, expressing Louis's attainment of the extreme limit of glory through victories achieved at great self-sacrifice. The essence of Bernini's conceit lies in the profound irony of the great hero reaching the heights of spiritual triumph by limiting earthly ambition.[95] The equestrian monument becomes thereby an emblem not only of military but of moral force, a vehicle not only of political but also of ethical precept. Bernini's image, above all, is that of potentially overwhelming power held in firm and benign restraint.

The King, Rome, and the Pope

All three works by Bernini for Louis XIV were composed of essentially the same three elements, which serve in each context to create a form of visual apotheosis: a lower realm of the natural earth; an intermediate, man-made, Herculean domain of dressed stone or providentially arranged drapery; and an upper level inhabited by the king. The community of Bernini's projects was clearly understood by his astute assistant Mattia de' Rossi, whose report from Paris, quoted on p. 157 above, gave Bernini's own interpretation of the equestrian monument. A design signed by de' Rossi (Fig. 244), presumably dating from shortly after Bernini's death, incorporates the same three elements and allusions to all three projects.[96] An isolated "tempietto" containing the equestrian group on its rocky base stands on a *scogliera* platform; the entrance is flanked by statues of Hercules with his club, while above the portal a figure of Atlas, surrounded by military trophies, supports a globe displaying fleurs-de-lys.

I trust it is also clear that all three works convey essentially the same message: noble ideals are embodied in a man whose merit derives not from his noble birth but from his virtue and labors. Bernini himself expressed as much shortly before he left Paris, when he said to Louis that "he would have been happy to spend the rest of his life in his service, not because he was a king of France and a great king, but because he had realized that his spirit was even more exalted than his position."[97] It

Fig. 245. Jean Warin, foundation medal for the Louvre. Bibliothèque Nationale, Paris.

Fig. 246 (*opposite*). Etienne Dupérac, Michelangelo's project for the Campidoglio, engraving.

is striking and symptomatic that Bernini's design for the palace is inordinately sparing of ornament and almost devoid of regal or dynastic references—an austerity that Colbert had already complained of in the second project.[98] Moreover, the visual and conceptual hierarchy from crude mass to ideal form reflects Bernini's understanding of the creative process itself: "He cited the example of the orator, who first invents, then orders, dresses, and adorns."[99] The processes of achieving moral and expressive perfection are essentially the same. In its context each portrayal of the king embodied on a monumental scale a single existential hierarchy in which form and meaning were permeated with ethical content.[100] It seems only logical that Bernini should have regarded the medium through which the hierarchy is unified, stone, not as a rigid but as a protean material subject to his will. It seems appropriate that he formulated this unorthodox notion precisely in response to a criticism of the crinkled and perforated drapery and mane of the equestrian *Louis XIV:* "the imputed defect, he replied, was the

greatest praise of his chisel, with which he had conquered the difficulty of rendering marble malleable as wax"; not even the ancients were "given the heart to render stones obedient to the hand as if they were of dough."[101]

The simplicity, grandeur, and unity of Bernini's thought can be fully grasped, however, only if one reconstructs in the mind's eye how he imagined the works would be seen. Following the path of the sun, as it were, the visitor entered the mountain-top palace through the Hercules portals of the east facade to have his audience with the king. While waiting in the antechamber to be admitted to the august presence, he would gaze upon the king's portrait bust hovering above its mundane pedestal.[102] Bernini envisaged the equestrian monument in front of the opposite, western, facade, between the Louvre and the Palace of the Tuileries. There, the image of Louis, smiling as his mount leaps to the summit of the Mountain of Glory and flanked by the imperial triumphal columns as the Pillars of Hercules, would have been the focus of the vista at the western limit

of the sun's trajectory.

The thinking displayed here had its only real precedent in Rome. To be sure, despite Bernini's notorious distaste for much of what he saw in France, his projects for Louis were deeply and deliberately imbued with allusions to French tradition: the visualization of the royal emblem, the retention of the palace-in-a-moat, the portrait mounted on a globe, the palace equestrian, all bear witness to this acknowledgment.[103] Yet, Bernini's whole conception of the Louvre seems intended to meld into one surpassing synthesis at Paris the two quintessential monuments of Roman world dominion, secular and religious.[104] This dual significance was defined explicitly in the medals issued to commemorate the enterprise, of which those recording the equestrian portrait have already been discussed (p. 175f. above). The same idea was inscribed on the foundation medal of the Louvre itself, by Jean Warin, showing Bernini's facade with the legend *Maiestati ac Aeternit(ati) Gall(orum) Imperii Sacrum*, "sacred to the majesty and eternity of the Gallic empire" (Fig. 245).[105]

Seen in this light the complementary monumental allusions—secular and sacral—of Bernini's conception become all but inevitable. The colossal order crowned by a continuous balustrade with statues emulates Michelangelo's palaces on the Campidoglio (Fig. 246); these, too, like the residence on the Palatine, rise from a summit redolent of imperial glory, that of the Capitoline hill, and include the equestrian statue portraying the most benign of emperors, Marcus Aurelius. The analogy actually gave rise to a dialogue between the Capitol and Bernini, in which the artist was reported to have said, "Dove è il gran Luigi, è il Campidoglio!"[106] (Where the great Louis is, there is the Capitol!—a Roman version of Louis's notorious dictum "L'état c'est moi"). No less meaningful and deliberate were the many transferrals to Paris we have noted of ideas and projects Bernini had devised in the service of the popes. The imperial palace tradition had long since been assimilated to papal ideology, and important aspects of Bernini's conceit for the Louvre had been suggested in a volume of emblems devoted to

CCIIII.

Con ampij giri la superba Mole,
Che'l Regno importa ben fondato, e retto
Cinge DRAGO immortal, Signor perfetto,
Che i Soggetti vgualmente intender vuole.
E quale in meẓo à i celesti Orbi il Sole
Alluma, e scalda con sereno aspetto
Come à Saturno, à la Sorella il petto,
Tal QVESTI à ogn'Alma, che l'honora, e cole.
Del Mondo Italia è vn piccol Mondo, e Roma
E d'ambi il Capo, oue riluce, e splende
Con noua Sfera il Pastor santo, e giusto.
Tal che non men può venerar sua Chioma,
Che del foco diuin gli Animi accende,
Il Gelato German, che l'Indo adusto.

Fig. 247. Emblem of Gregory XIII's Palazzo Quirinale (from Fabricii, 1588, p. 308).

Gregory XIII in which that pope's actions and his armorial device, the dragon, had been graphically intertwined.[107] The image illustrating the summer palace built by Gregory (Fig. 247) shows the building perched conspicuously atop the Quirinal hill (Monte Cavallo, from the ancient sculptures of the horse tamers that adorn the square); the accompanying epigram identifies the pope as the sun and Rome and the pontiff as head of the microcosm, radiating beneficence on Italy and the world; Italy is described as a *piccol Mondo,* anticipating the inscription Bernini intended for the globular base of his bust of Louis XIV. I believe that Bernini, in turn, was consciously seeking to create at the Louvre for the world's greatest terrestrial monarch the equivalent of what he had created at St. Peter's for the world's greatest spiritual monarch. The invention of the *scogliera* even made it possible to link the allusions to the imperial mountain-top palaces with the *Mons Vaticanus* of St.

Peter and the popes and with the biblical metaphor of the rock on which Christ had built his church: *Tu es Petrus et super hanc petram aedificabo Ecclesiam meam* (Matthew 16:18). These associations had been given a French cast in a medal that showed the basilica of St. Peter's perched on a rocky base (Fig. 248). The medal celebrated the constant support given to the Holy See by one of the great French cardinals of the period, François de la Rochefoucauld (1558–1645), the image and the inscription *Rupe Firmatur in Ista,* "secure on that rock," punning on his name.[108]

The visitor to the Louvre would have been ravished by a secular version of the awesome spectacle he experienced in Rome proceeding through the embracing portico into the basilica to the high altar, surmounted by the baldachin, and beyond to the throne of the Prince of the Apostles in the apse. When Bernini's unitarian vision of the Sun King

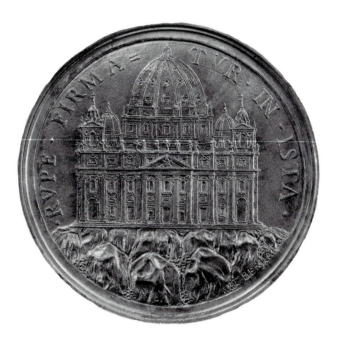

Fig. 248. Thomas Bernard, medal of Cardinal François de la Rochefoucauld. Bibliothèque Nationale, Paris.

is viewed in this way, one can readily understand Bernini's view of his own contribution as an artist: he was, he said, the first to make of the arts a marvelous whole, occasionally breaching without violence the boundaries that separate them.[109]

Afterimages at Versailles

The failure of Bernini's visit to Paris is normally taken as a turning point in French attitudes toward Italian culture since the Renaissance; the demise of his various projects for the Louvre signaled the triumph of a new national self-consciousness and self-confidence north of the Alps. Stylistically these new attitudes are linked to the rejection of the fulsome rhetoric of the Italian baroque and the development of the tempered logic of French classicism. Although

correct in general terms, this analysis needs to be qualified, especially on the evidence of what took place in the immediately succeeding years when the king determined to move both his residence and the seat of government from the Louvre to Versailles. Le Brun adapted Bernini's equestrian project in designing a monument of Louis, intended initially for the Louvre but then evidently to be placed before the facade of Versailles (Fig. 249).[110] Le Brun also presumably designed the stucco relief executed by Coysevox in the Salle de la Guerre that serves as the antechamber to the ceremonial reception hall known as the Galerie des Glaces (Fig. 250). Depicting Louis crowned by a personification of princely glory, the composition translates Bernini's moral conceit into the grandiloquent language of high allegory.[111]

Both of Bernini's own sculptures were also brought to Versailles, after all. The equestrian group was

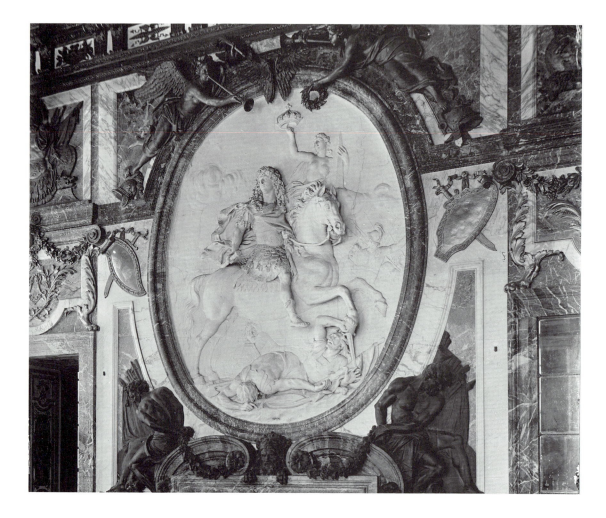

Fig. 249 (*right*). Copy after Charles Le Brun, project for a monument of Louis XIV, drawing. Nationalmuseum, Stockholm.

Fig. 250 (*above*). Antoine Coysevox, Louis XIV crowned by Princely Glory. Salon de la Guerre, Versailles (photo: Giraudon 16915).

Fig. 251 (*opposite*). Jean Warin, bust of Louis XIV. Musée National du Château de Versailles (photo: Documentation photographique de la Réunion des musées nationaux 74 DN 2415).

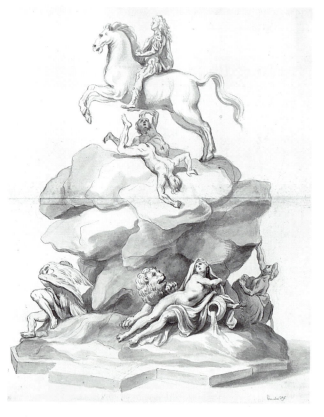

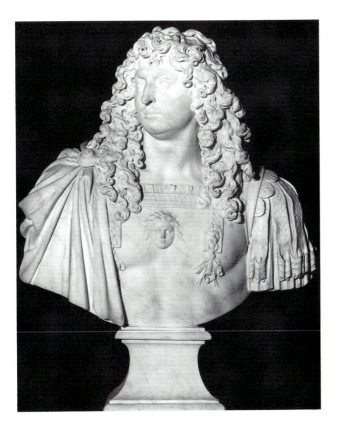

placed in the garden and moved several times, but the common notion that it was sent into exile must be reconsidered. In fact, it was conspicuously located as the focal point of the view along the major transverse axis in front of and parallel to the facade of the palace, first at the north side of the Bassin de Neptune and finally, in the early eighteenth century, at the end of the Pièce d'Eau des Suisses. It was replaced at the Bassin de Neptune by Domenico Guidi's highly esteemed group of Time and History holding a portrait medallion of the king, so that the two works faced each other at opposite sides of the horizon. Bernini's sculpture was thus displayed far more prominently than many other works dispersed among the minor recesses of the garden.[112] Furthermore, the transformation of the group was, in a way, singularly appropriate. Marcus Curtius was one of the great legendary heroes of antiquity who sacrificed himself to save his country. In this sense the revision showed a remarkably subtle understanding of the meaning Bernini emphasized in explaining his conception. I suspect, indeed, that Girardon's alterations were not intended to obliterate the reference to the king but to transform the work into a moralized depiction of Louis XIV in the guise of Marcus

Curtius.[113] The modification accommodated the sculpture to the principle, followed consistently in the garden decorations, of avoiding any direct portrayal of the king. Louis was present everywhere, of course, but in the sublimated domain of the garden his spirit was invoked only through allegory.[114]

We know that Bernini's bust of Louis also had a rather active life before it finally alighted in the Salon de Diane in 1684. At each stage along the way, it was accompanied by the bust made by Jean Warin in 1666 to rival Bernini's (Fig. 251). First at the Louvre and then at the Tuileries and finally again at Versailles, Warin's sculpture accompanied Bernini's as a demonstration of French ability to compete with the acknowledged master, whose work was thus regarded and prominently displayed as the touchstone of supreme achievement in the art.[115]

As to the château of Versailles (Fig. 252), the very clarion of French architectural identity, the analogy was long ago noted between the upper silhouette of Bernini's Louvre project—the continuous horizontal cornice and balustrade crowned with sculptures—and that of Louis Le Vau's building.[116] This relationship, indeed, is symptomatic of the synthetic creative procedure that is perhaps the chief legacy at Versailles of Bernini's work for the Louvre. In certain respects the garden facade, as originally planned by Le Vau, belongs in a series of works that link elements of the two traditional types of noble residential architecture, the urban palace (Fig. 253) and the informal extramural villa (Fig. 254). The earmark of the former was the flat street facade with a monumental order or orders placed on a high rusticated base; the earmark of the latter was a ⊔-shaped plan embracing a garden or courtyard between projecting wings. Various steps had been taken earlier in the century to relate the two types. In the Villa Borghese at Rome a coherent facade was achieved by including a terrace between the two wings (Fig. 199).[117] In the Palazzo Barberini, where Bernini himself had worked, the orders and rusticated base of the palace type were introduced in a ⊔-shaped facade (Fig. 255). It can hardly be coincidence that both these buildings are near, but not in, the city center; hence they are topographically as well as typologically intermediate between the two alternatives. Le Vau in effect combined these intermediate suburban arrangements, partly by applying the unifying lesson of Bernini's Louvre: a rusticated base surmounted by a single order and crowned by

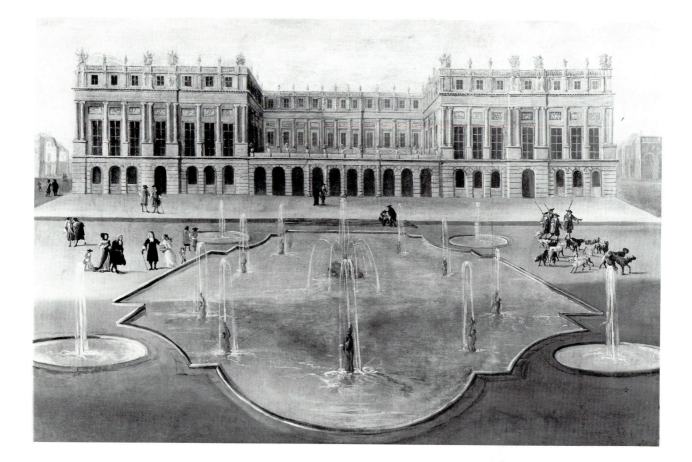

Fig. 252 (*above*). Anonymous, Louis Le Vau's original project for the west facade of Versailles. Musée National du Château de Versailles (photo: Documentation photographique de la Réunion des musées nationaux 84 EN 3116).

Fig. 253 (*right*). Attributed to Raphael, Palazzo Caffarelli-Vidoni, Rome (photo: Fototeca Unione 1385).

Fig. 254 (*opposite, top*). Baldassare Peruzzi, Villa Farnesina, Rome (photo: Anderson 27850).

Fig. 255 (*opposite, bottom*). Carlo Maderno and Bernini, Palazzo Barberini. Rome (photo: Fototeca Unione 10954 FG).

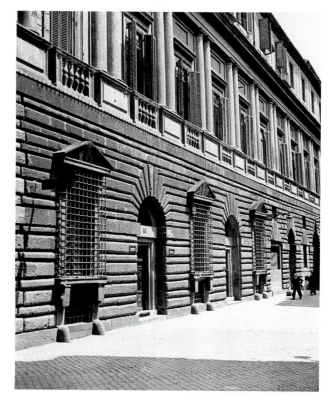

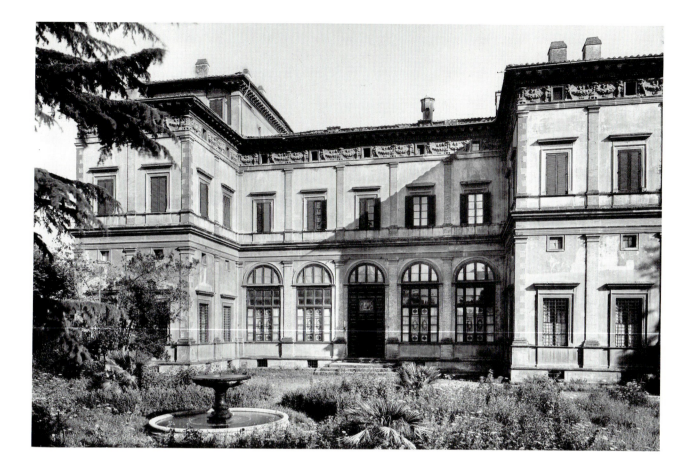

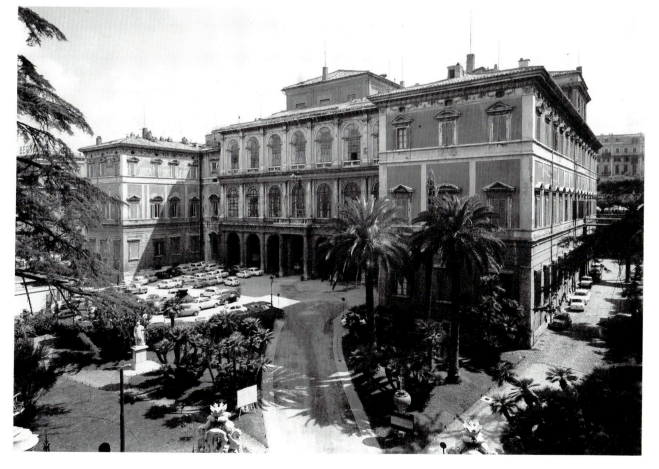

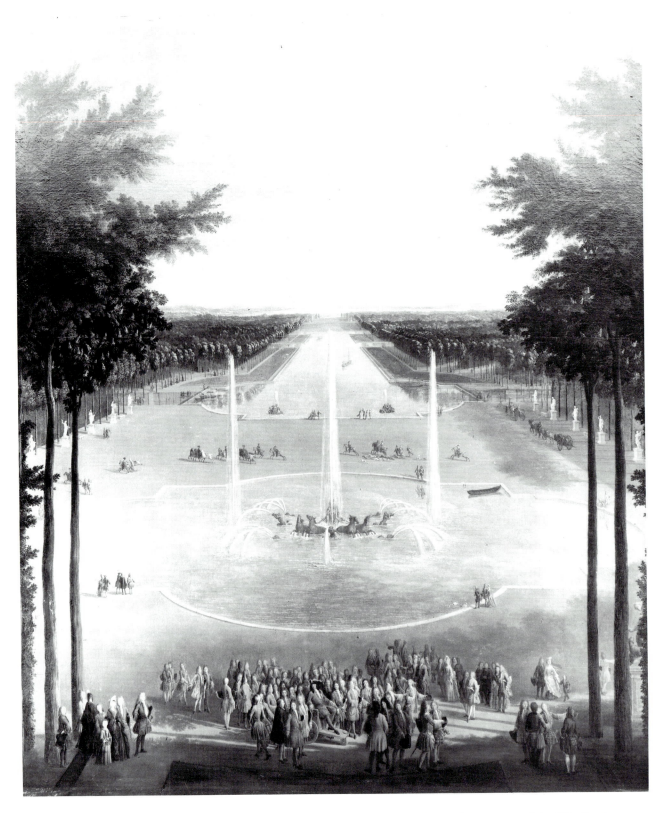

Fig. 256. Jean-Baptiste Martin, view of the Allée Royale,
Versailles. Grand Trianon, Versailles (photo: Documentation
photographique de la Réunion des musées nationaux 64 EN 147).

a horizontal roofline with sculptured balustrade. Le Vau thus for the first time fused the palace and villa types into a unified and consistent architectural system that incorporates the entire facade. The fusion perfectly expresses the unique status of Versailles as a royal château in the venerable tradition stemming from Charlemagne—Constantine's "great" successor and Louis's model in other respects as well—a permanent extra-urban seat of the monarchy.

In another context a bold observation has recently been made concerning a painting of Versailles by Jean-Baptiste Martin (Fig. 256). The view toward the west of the Bassin d'Apollon and the Grand Canal is framed by poplar trees, sacred to Hercules. The arrangement seems to reflect Bernini's project for the Louvre, where the Pillars of Hercules would have framed the view from the palace to the west, in reference to the *Non Plus Ultra* device used by the Hapsburgs.[118]

Most intriguing of all is the evidence recently discovered that Bernini actually made a design for Versailles and that, for a time at least, his design may have been adopted for execution.[119] This information is supplied by a source that cannot be dismissed out of hand—a detailed diary of a visit to Versailles by the future Grand Duke Cosimo III of Tuscany in 1669. Under the date August 11 of that year, it is reported that work at Versailles was proceeding on a majestic facade designed by Bernini. Except for Bernini's own expressed admiration for Versailles during his stay in Paris in 1665,[120] this statement provides the first direct link between Bernini and the château. No trace of Bernini's project has come down to us, and the claim may well be exaggerated. It is certainly fortuitous, however, that the notice comes at just the right moment to help explain a heretofore puzzling episode in the history of the planning of Versailles. Early in the summer of 1669 work was proceeding according to a plan by Le Vau that, following the king's wish, retained the old Petit Château built by his father. Yet in June Louis suddenly changed his mind and issued a public declaration that he intended to demolish the earlier structure. Colbert, who opposed the idea, held an emergency competition among half-a-dozen French architects, including Le Vau, for new proposals for a new Versailles. The suggestion is inescapable that the competition was held in reaction to the receipt—perhaps unsolicited—of a project of this kind from Bernini. His submission may even

have been adopted until the final decision was taken later that year to retain the old building after all and return to Le Vau's first plan.

◆　◆　◆

Absolutely nothing of Bernini's projects for France remains as he intended, either at the Louvre or at Versailles. There can be no doubt, however, that his conception of the nobility and grandeur suitable for a great monarch left an indelible trace on the French imagination. A tragi-comical testimony to this fact was the defacement and mutilation of the equestrian portrait with paint and hammer, perpetrated in 1980, the tricentennial of Bernini's death (Fig. 257; Plate XII). Evidently, the vandals considered the monument a symbol of *French* culture, and instead of the inscription Bernini intended, they left an eloquent graffito of their own:

<div style="text-align:center">

YARK YARK!!!

PATRIMOINE

KAPUTT

ANTIFRANCE [121]

</div>

The Idea of the Prince-Hero

There was a certain ironic justice in the vandals' gesture of desecration, for Bernini's conception itself was profoundly subversive, both in its form—the suppression of royal and dynastic imagery, the portrayal of the king in a momentary action, the smile that seemed inappropriate, the treatment of marble as if it were dough, the elevation of raw nature to the domain of high art—and in its content. Bernini's image of Louis XIV must be seen against a major current of thought concerning political hegemony and the qualities required of the ideal ruler that had been developing for the better part of a century. The main proponents were the Jesuits, who were intent upon responding and providing an alternative to Machiavelli's model of cynical unscrupulousness in the worldly practice of statecraft. In the late sixteenth and seventeenth centuries a veritable stream of anti-Machiavellian literature defended the relevance of Christian moral principles not only to utopistic ideals of domestic rule and foreign diplomacy but also to realistic and successful statesmanship. The key argument in this "reason of state" was that the best form of government, monarchy, while

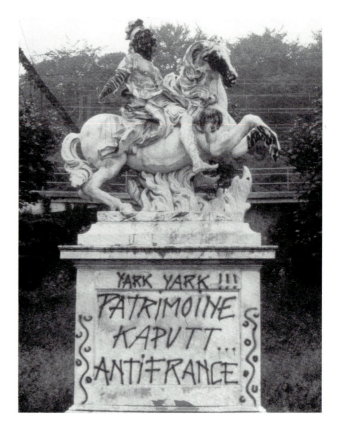

Fig. 257. Bernini, equestrian monument of Louis XIV, defaced by vandals on June 6, 1980. Versailles (photo: Simone Hoog).

responsible ultimately to God, was based on the consent of the people, that the power of the ruler derived practically from his reputation, and that his reputation in turn depended on his exercise of virtue. Bernini's profound indebtedness to this vital tradition of moral statesmanship is evident in his explanation of his own work and the philosophy of kingship it embodied, as well as in his appropriation of the Jesuit Claude Menestrier's emblem and interpretation of the Peace of the Pyrenees. The tradition culminated in the idea of the prince-hero, but Bernini carried the argument a decisive step further. The restraint evident in the equestrian portrait and in the bust of Louis expressed the radical political idea that the true basis of just rule lay in individual virtue and self-control rather than in inherited rank and unbridled power. His view challenged the very foundations of traditional monarchist ideology.[122]

This fundamental conflict of interest is dramatically illustrated by what was perhaps the major bone of contention in the debates between the artist and Colbert and the other French critics of his design for the Louvre: the location of the royal apartment. Bernini insisted to what proved to be the bitter end that the king must be quartered in the east wing, the most prominent part of the palace; he rejected the argument that the rooms would be relatively cramped and

exposed to the turmoil and dangers of the public square in front (the Fronde and the Gunpowder Plot of 1605 against James I of England had not been forgotten).[123] Ceremony and symbolism, as such, were not the primary point; it was rather that the concerns of safety and convenience were secondary to the duties imposed by the office of ruler. Bernini measured the stature of a ruler by the moral restraints and obligations of personal leadership he undertook, despite the discomforts and risks they entailed.

This was precisely the point Bernini explained to the obtuse Frenchman who could not understand a happy, benevolent expression on the face of an armed warrior on a martial horse—that he had portrayed Louis enjoying the glory of victory attained through virtue and self-sacrifice. The passage (quoted in n. 63) is of further interest because it reveals the full import of Bernini's formal subversion of hallowed ideology, his nonviolent break with artistic convention and decorum. Having given his explanation, Bernini added that his meaning was evident throughout the work, but would become much clearer still when the sculpture was seen on its intended rocky promontory. By raising to lofty moral and aesthetic standards a lowly and depreciated form, he created a new means of visual expression to convey a new social ideal.[124]

Fig. 258. Projects for the Louvre, 1624–1829, engraving. Biblio-
thèque National, Paris.

POSTSCRIPT

LOUIS XIV : BERNINI = MITTERAND : PEI

The power of Bernini's image of the Sun King has been reflected anew in the no less revolutionary developments that have taken place at the Louvre under President Mitterand and the architect I. M. Pei. This rapprochement across the centuries is evident in an anecdote recounted to me by Pei, who recalled that on one occasion Mitterand said to him, "You can be sure of one thing, Mr. Pei: I will not abandon you as Louis XIV abandoned Bernini!"—a promise the president has maintained, despite a storm of protest against the project for a new entrance to the new Grand Louvre. Owing in part, perhaps, to the sheer logic of the situation but also in part, surely, by design, Pei has brought into being several important elements of Bernini's dream of giving form to the glory of France.

From the time of Louis XIV and Bernini onward, the space between the west facade of the Louvre and the Tuileries was not meant to stand empty. Many projects were proposed (Fig. 258 includes those dating 1624–1829), until the series finally came to an end in the glass pyramid designed by another architect imported from abroad, who succeeded in illustrating the breadth of French vision and the grandeur of

French culture.[125] Bernini himself proposed for the area now occupied by Pei's pyramid two theaters, modeled on the Colosseum and the Theater of Marcellus in Rome, one facing the Louvre, the other the Tuileries.[126] Placed back to back, with room for ten thousand spectators on either side, the theaters would have realized on a monumental scale the effect of one of Bernini's fabled comedies, in which he created the illusion of two theaters and two audiences in plain view of one another.[127] The two theaters at the Louvre would have reflected the spectacle of French civic and ceremonial life at its very heart.

This is exactly what Pei has created—a great spectacle at the veritable center of French cultural life. And he has achieved this result, which might be described as maximum, with means that can be described as minimum (Figs. 259, 260). Apart from its symbolic associations (Pei denies that he intended any—cf. Fig. 261),[128] the pyramid is the simplest and least obtrusive of structural forms, and glass, whether opaque or transparent, is the most self-effacing structural material. When the glass is opaque, it mirrors the scene of people from all over the world who have come to enjoy, participate in, and pay homage to French culture, with the sacrosanct facades of the Louvre as their backdrop. When the glass is transparent, what does one see? People from all over the world who have come to

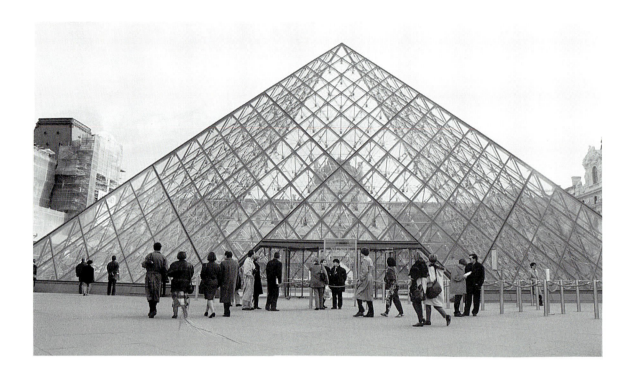

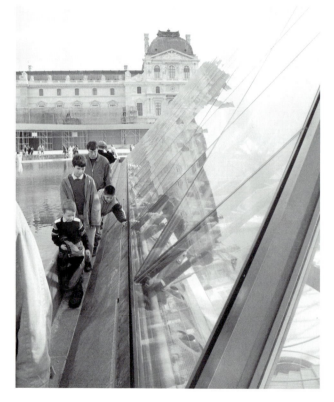

Fig. 259. I. M. Pei, entrance to the Louvre. Paris (photo: Stephen Rustow).

Fig. 260. I. M. Pei, entrance to the Louvre. Paris (photo: Stephen Rustow).

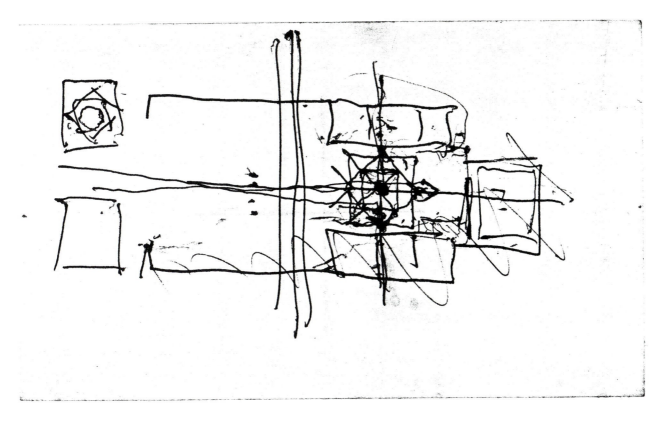

Fig. 261. I. M. Pei, illustration of derivation of the Louvre
pyramid from the geometric configuration of Le Nôtre's garden
parterre of the Tuileries (diagram at upper left) and axial
displacement, December 29, 1989, drawing. Collection of
the author.

enjoy, participate in, and pay homage to French culture, with the sacrosanct facades of the Louvre as their
backdrop. Either way, the pyramid itself disappears,
becoming a clear and limpid representation of its environment.[129] Pei solved the terrifying problem of making a monumental entrance to the Louvre by creating
an almost invisible theater where the people of the
world are the actors and the Louvre is the stage set.

Almost exactly ten years after its desecration at
Versailles, Bernini's equestrian image of the Sun King
was "restored" (cast in lead) to the space between the
Louvre and the Tuileries for which it had originally
been destined (Fig. 262).[130] The restitution of the
image to its proper position of leadership provoked
almost the same furor as its original appearance in
Paris three centuries before — appropriately enough,
since Bernini's sculpture, far from adhering comfortably to the conventions of its genre, was meant to
convey the artist's new, provocative, even subversive,
conception of the ideal head of state. In replacing
the work, Pei used neither the same material nor the

location Bernini had envisaged. Instead, Pei used the
image of the Sun King to resolve one of the historic
problems of ceremonial urbanism in Paris — the nonalignment of the Louvre with the axis formed by the
Tuileries, the Napoleonic arches of triumph and the
Champs-Elysées. Pei oriented the horseman and his
pedestal on that axis, but aligned the platform beneath
the monument with the Louvre (Fig. 263).[131] In this
way, the Pei-Bernini image of the Sun King functions
visibly as well as symbolically as the intermediary link
between the old France and the new.

The whole conception, which is truly in the spirit
of Bernini, also fulfills Bernini's definition of the architect's task, which "consists not in making beautiful and
comfortable buildings, but in knowing how to invent
ways of using the insufficient, the bad, and the ill-
suited to make beautiful things in which what had
been a defect becomes useful, so that if it did not
exist one would have to create it."[132]

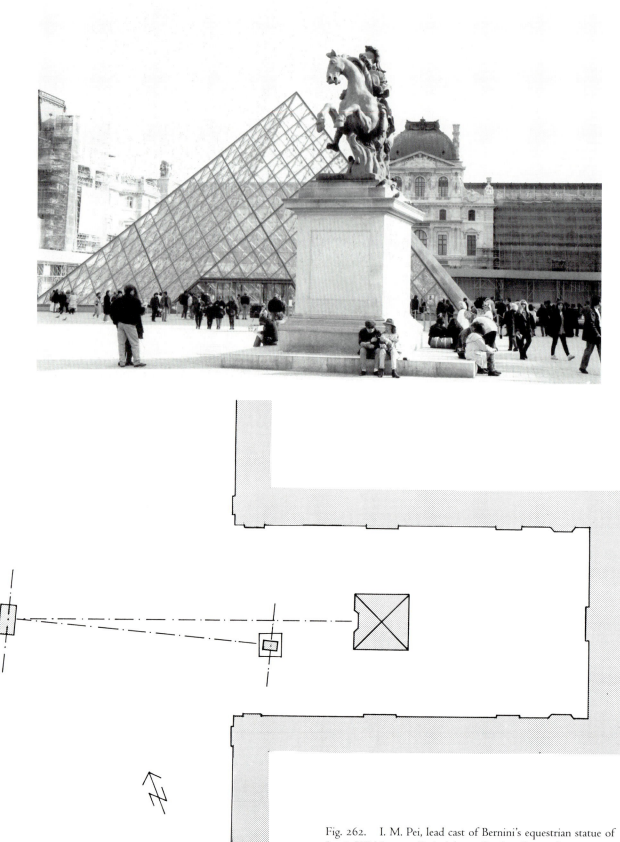

Fig. 262. I. M. Pei, lead cast of Bernini's equestrian statue of Louis XIV. Louvre, Paris (photo: Stephen Rustow).

Fig. 263. I. M. Pei, plan of the entrance to the Louvre, indicating the citing of the equestrian *Louis XIV* (photo: office of I. M. Pei; redrawn by Susanne Philippson Ćurčić).

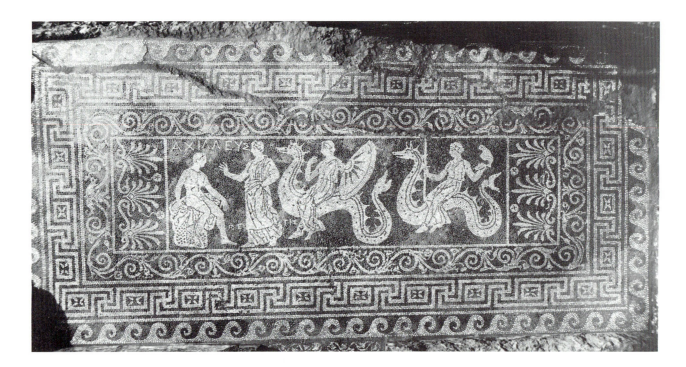

Fig. 264. Pebble mosaic with representation of Achilles, Thetis, and Nereids. Villa of Good Fortune, Olynthus (photo: David M. Robinson Collection, University of Mississippi Department of Special Collections).

CHAPTER SEVEN ◆ PICASSO'S LITHOGRAPH(S) "THE BULL(S)" AND THE HISTORY OF ART IN REVERSE

Modernism is now so closely identified with formalism that a fundamental constituent of the Modernist movement since the late nineteenth century, its new social awareness, is often forgotten. This new social concern engendered an appreciation of popular—more generally of unsophisticated—culture in all its manifestations. The thoroughness with which Modernism rejected traditional cultural values and the intimacy of the association it established between that rejection and social reform were unprecedented since the coming of Christianity. The association had a long prehistory, however, to which the Modern movement was deeply indebted but which we tend to overlook. We think of the development of culture instead in Darwinian terms, as an evolutionary progress toward, if not necessarily improvement, then at least increased sophistication and facility. The exceptions to the Darwinian principle are just that, exceptions: cases in which, owing to special circumstances, supposedly primitive or subnormal cultural forms are preserved accidentally, as in certain "remote" corners of the globe; or persevere incidentally within the domain of high culture in certain extra-, preter-, or non-cultural contexts, as in the art of the untutored (popular and folk art,

including graffiti), of children, of the insane—what I have elsewhere called "art without history."[1] Without presuming to challenge the biological theory of evolution as such, I view the matter in art historical terms quite differently. I would argue that an "unartistic" heritage persists, whether recognized or not, alongside and notwithstanding all developments to the contrary. The sophisticated and the naive are always present as alternatives—in every society, even primitive ones—exerting opposing and, I venture to say, equal force in the development of culture. They may appear to exist and function independently, but in fact they are perennial alter egos, which at times interact directly. Like Beauty and the Beast, they go hand in hand.

A striking and surprising instance is offered by a series of mosaic pavements found in large and lavishly decorated houses at Olynthus in Greece dating from the early fourth century B.C.[2] Here the figural compositions with concentric borders display all the order and discipline we normally associate with Greek thought (Fig. 264). Traces of this rationality are discernible in certain of the floors where large geometric motifs are placed in the center, above finely lettered augural inscriptions, such as "Good

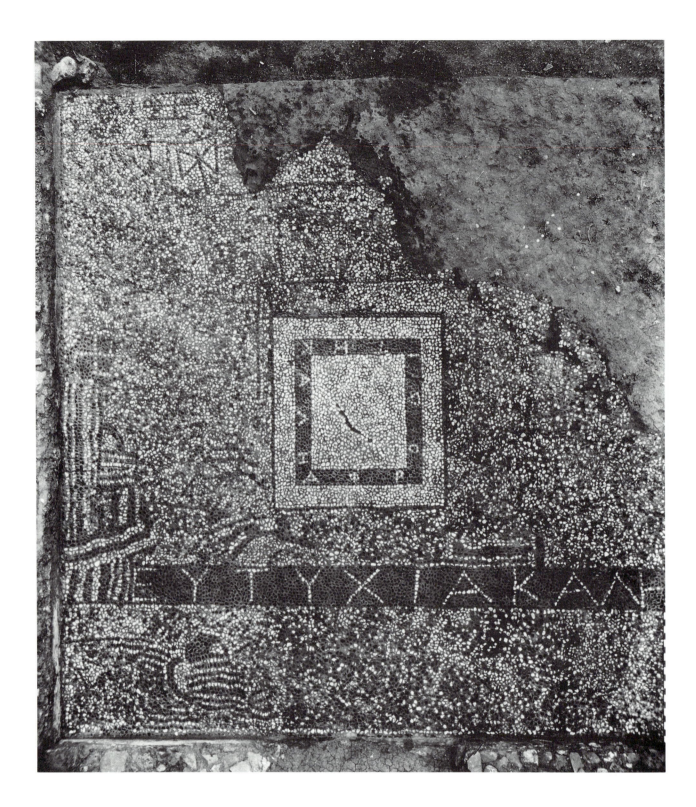

Fortune" or "Lady Luck," while various crudely drawn apotropaic symbols—circles, spirals, swastikas, zigzags—appear here and there in the background (Fig. 265). Finally, the entire composition may be dissolved in an amorphous chaos from which the magical signs shine forth mysteriously helter-skelter, like stars in the firmament—the random arrangement is as deliberate and significant as the signs themselves (Fig. 266). The entire gamut of expressive form and meaningful thought seems here encapsulated, at the very apogee of the classical period in Greece, when the great tradition of European High Art was inaugurated. The Olynthus mosaics reveal the common ground—the sense of the supernatural—that lies between the extremes of sophistication and naïveté to which we give terms like mythology

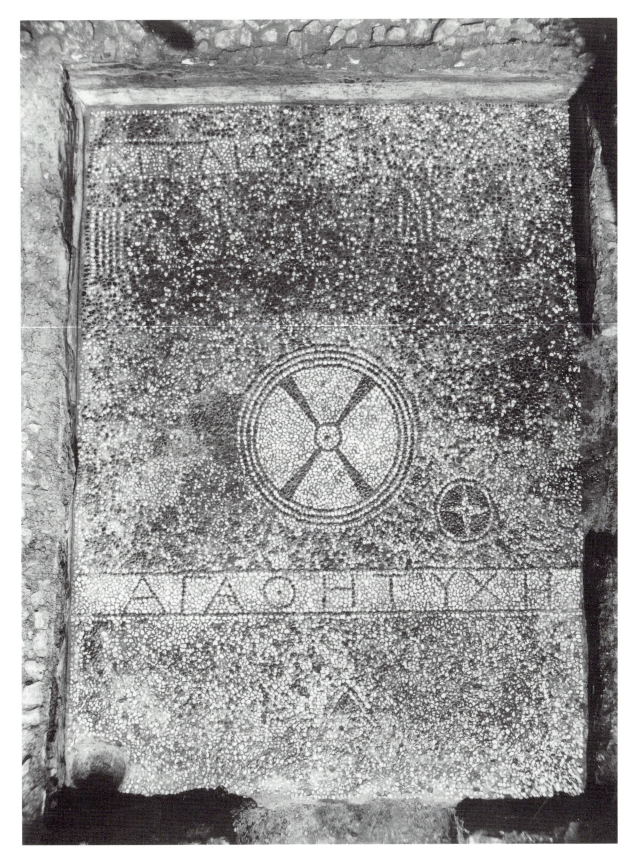

Fig. 265 (*opposite and above*). Pebble mosaics with inscriptions and symbols (double axe, swastika, wheel of fortune). Villa of Good Fortune, Olynthus (photo: David M. Robinson Collection, University of Mississippi Department of Special Collections).

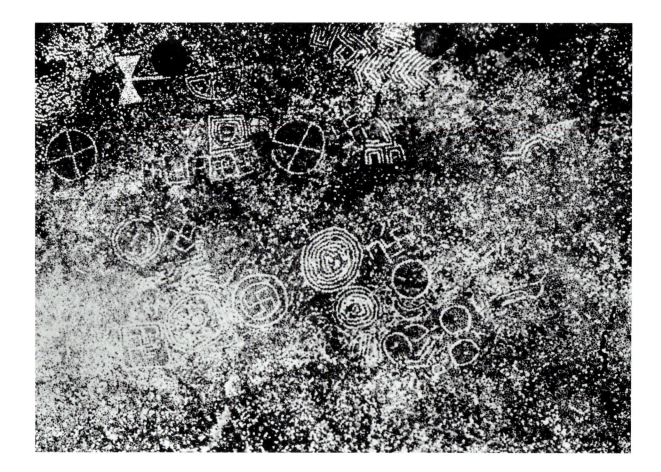

Fig. 266. Pebble mosaic with many symbols, including swastika and double axe. House A xi 9, Olynthus (photo: David M. Robinson Collection, University of Mississippi Department of Special Collections).

and superstition. The subsequent development of Greco-Roman art also abounds in various kinds and phases of radical retrospectivity—Neo-Attic, Archaistic, Egyptianizing—in which the naturalistic ideals of classical style were thoroughly expunged. Virtuoso performances by artists of exquisite taste and refined technique recaptured the awkward grace and innocent charm of a distant and venerable past. The retrospective mode might even be adopted in direct apposition to the classical style, as in the reliefs of a late-fourth-century altar from Epidaurus, where the archaistic design of the figure on the side contrasts with the contemporary forms of those on the front (Figs. 267, 268).[3]

A conspicuous and historically crucial instance of such a coincidence of artistic opposites occurred at the end of classical antiquity, in the arch built by the emperor Constantine in Rome to celebrate his victory over Maxentius in A.D. 312. Parts of earlier monuments celebrating the emperors Trajan, Hadrian, and Marcus Aurelius were incorporated in the sculptural decorations of the arch, along with contemporary reliefs portraying the actions of Constantine himself (Fig. 269; compare the rondels with the narrative frieze below them). The former display all the nobility and grace of the classical tradition; the latter seem rigid, rough, and ungainly, culturally impoverished. It used to be thought that the arch was a monument of decadence, a mere pastiche in which Constantine's craftsmen salvaged what they could of the high style art of their predecessors, using their own inadequate handiwork only when

Fig. 267 (*above*). Front of an altar from Epidaurus. National
Archeological Museum, Athens.

Fig. 268 (*left*). Side of an altar from Epidaurus. National
Archeological Museum, Athens.

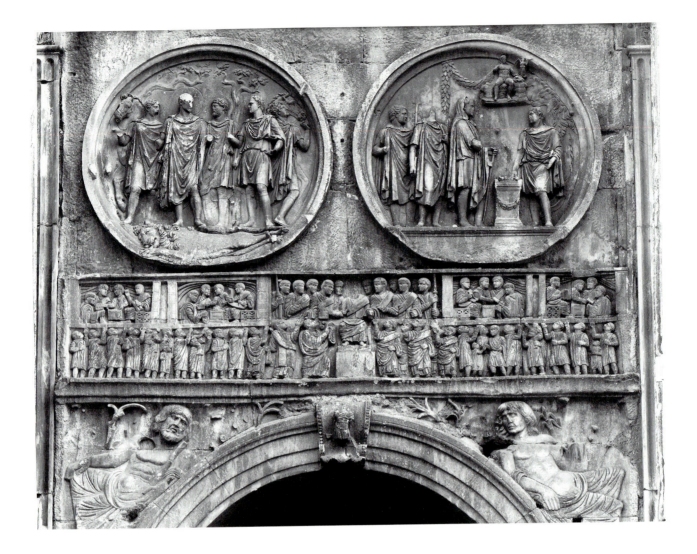

necessary. In fact, there is ample evidence that the juxtaposition was deliberate, intended to illustrate Constantine's wish to associate the grandeur of the empire at the height of its power with the humble spirituality of the new Christian ideal of dominion. The latter mode may be understood partly as an elevation to the highest level of imperial patronage of vulgar forms, whether Roman or provincial. It has been suggested, however, that the vulgar style, which was destined to play a seminal role in the development of medieval art, was also a conscious evocation of Rome's archaic past, when simplicity, austerity, and self-sacrifice had first laid the foundation of a new world order.[4]

An analogous phenomenon has been observed in medieval art itself, at the height of the Romanesque period. Many churches of the eleventh and twelfth centuries, including some of the most illustrious, display more or less isolated reliefs executed in a crude, "infantile," manner and illustrating grotesque or uncouth subjects (Fig. 270).[5] Formerly dismissed as reused "debris" from a much earlier period, such works have recently been shown to be contemporary with, often part of the very fabric of, the buildings they adorn. They might even proudly display the inscribed signature of the sculptor, and the bold suggestion has been made that the same artist may have been responsible for the more familiar and sophisticated parts of the decoration. Such stylistic and thematic interjections must be meaningful, especially since they inevitably recall the real spolia, bits and pieces of ancient monuments, with which many medieval churches are replete. These deliberately retrieved fragments incorporated, often discordantly, into the new masonry, bore physical witness to the supersession of paganism by Christianity. Perhaps the substandard Romanesque reliefs express a similar idea.

Despite many such antecedents, something new happened in the Renaissance. The classical ideals of

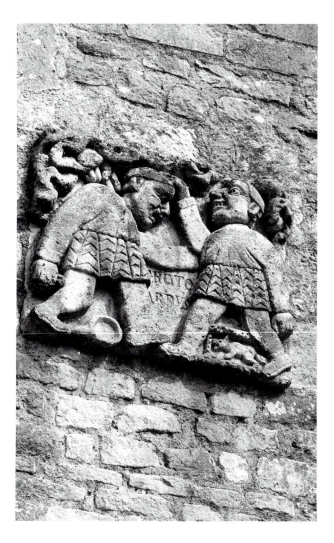

Fig. 269 (*opposite*). Arch of Constantine, medallions and frieze on north side. Rome (photo: Alinari 17325).

Fig. 270. Two fighting figures, relief signed by Frotoardus. South portal, La Celle–Bruère (photo: Zodiaque).

naturalism and high culture were not only retrieved but also revived, refined, regularized, and embedded in a theoretical framework. This philosophical, mathematical, even theological structure, which culminated toward the end of the sixteenth century in a treatise by Gian Paolo Lomazzo with the significant title *L'idea del tempio della pittura* (1590), explained and justified the classical values themselves and raised their practitioners to the level of liberal, and therefore noble, artists. The classical ideals were thus enshrined in a code of visual behavior that had the force of—and indeed was often linked to—a code of personal behavior. One alternative to this unprecedented idea of a pure high art associated with a corresponding level of social values was the caricature, a "low" art form that we still today think of as peculiarly modern. The subject of this chapter may thus be viewed as an episode, a particularly significant one, in the history of cultural extremes that sometimes touch.

My purpose is to illuminate, if not actually to map, the common ground as well as the great gulf that lies between the two disparate and deceptively simple drawings reproduced in Figures 271 and 318. One is a caricature of Pope Innocent XI made by Bernini in the 1670's, the other a caricature of a bull made by Picasso in 1946. Both are revolutionary works, breaking radically with reigning conventions and establishing in turn precedents that other artists would be quick to follow. The common ground I want to illuminate is not their novelty, however, but the achievement of novelty in both cases through deliberate and explicit references to earlier traditions —exactly the process we normally see in the history of art, except that in this case the references were to the flip side of what we normally think of as art and ultimately challenged the hallowed notion of tradition itself. We normally admire the accomplished performance of the graceful and sophisticated Dr. Jekyll; here the crude and unruly Mr.

Hyde steps out of the wings and onto center stage.

Bernini was seventy-eight and had only four years to live when Benedetto Odescalchi was elected pope at age sixty-five in 1676; the caricature of Innocent is one of the few remaining traces of Bernini's handiwork from the artist's last years. As a work of art it is slight enough—a few tremulous, if devastating, pen lines sketched in a moment of diversion on a wisp of torn paper measuring barely 4½×7 inches.[6] Despite its modest pretensions—in part because of them, as we shall see—it represents a major turning point in the history of art because it is the first satirical drawing of its kind that has come down to us of so exalted a personage as a pope. Innocent XI is reduced to an insectlike creature that seems to embody all the astringent crankiness for which he was famous, or rather, infamous. Signifying as it does that *no one* is beyond ridicule, the drawing marks a critical step in the development of a new form of visual expression in which the noblest traditions of European art and society are called into question.

By and large, before Bernini there were two methods of ridiculing people in a work of art. The artist might poke fun at a particular individual without indicating any setting or ideological context; in these cases the victim occupied a relatively modest station in life. Such evidently were the informal comic sketches of friends and relatives by Agostino and Annibale Carracci, which they called *ritrattini carichi,* "little charged portraits." Described in the sources but now lost, these were certainly among the primary inspirations for Bernini's caricatures (Fig. 272). If the victim was important, he would be represented in a context that reflected his position in society. The artists of the Reformation had made almost a specialty of satirizing the popes as representatives of a hated institution and its vices (Fig. 273). In the first mode the individuality of the victim was important, but *he* was not; in the second, the opposite was true.[7]

The differences between Bernini's drawing and these antecedents have to do, on the one hand, with the form of the work—a particular kind of drawing that we immediately recognize and refer to as a caricature—and, on the other hand, with its content: the peculiar appearance and character of a specific individual who might even be the supreme pontiff of the Roman Catholic church.[8]

Much of what I shall say on both these counts was already said by Bernini's early biographers, who were fully aware of his achievement. Filippo Baldinucci observes that Bernini's

Antichriſti.

Fig. 271 (*opposite*). Bernini, caricature of Pope Innocent XI, drawing. Museum der bildenden Künste, Leipzig.

Fig. 272 (*above*). Attributed to Annibale Carracci, drawing. Royal Library, Windsor Castle.

Fig. 273 (*left*). Lucas Cranach, Leo X as Antichrist (from *Passional*, 1521).

boldness of touch [*franchezza di tocco*] in drawing was truly miraculous, and I could not say who in his time was his equal in this ability. An effect of this boldness was his singular work in the kind of drawing we call caricature, or exaggerated sketches, wittily malicious deformations of people's appearance, which do not destroy their resemblance or dignity, though often they were great princes who enjoyed the joke with him, even regarding their own faces, and showed the drawings to others of equal rank.[9]

Domenico Bernini, the artist's son, gives the following formulation:

at that time [under Urban VIII] and afterwards he worked singularly in the kind of drawing commonly referred to as caricature. This was a singular effect of his spirit, in which as a joke he deformed some natural defect in people's appearance, without destroying the resemblance, recording them on paper as they were in substance, although in part obviously altered. The invention was rarely practiced by other artists, it being no easy matter to derive beauty from the deformed, symmetry from the ill-proportioned. He made many such drawings, and he mostly took pleasure in exaggerating the features of princes and important personages, since they in turn enjoyed recognizing themselves and others, admiring the great inventiveness of the artist and enjoying the game.[10]

These passages focus on the peculiar mimetic nature of caricature, defining it as a comic exaggeration of the natural defects of the sitter's features. The element of deformation reflects the origin of the word in the verb *caricare:* to load, as with a gun, or a brush, or a cart. It is essential, however, that an individual be represented, preferably one of high rank, and that the distortion not obscure that individual's identity. The formal qualities are expressed implicitly: the drawings were independent works of art, conceived as ends in themselves and appreciated as such; they were also true or pure portraits in that they depicted a single individual, isolated from any setting or narrative context; and they were graphically distinctive, in that they were drawn in a singular manner (reflecting Bernini's *franchezza di tocco*), specifically adapted to their purpose.[11]

On all these counts Bernini's drawings are sharply distinguished from the one tradition to which they are most often referred: I mean the Renaissance scientific, or pseudo-scientific, investigation of ideal physical types as they relate to moral and psycho-logical categories. The chief cases in point are Leonardo's studies of grotesque heads as expressions of the aesthetic notion of perfect or beautiful ugliness (see Fig. 130), and Giambattista della Porta's 1586 physiognomical treatise assimilating human facial traits to those of various animal species to bring out the supposed characterological similarities (see Fig. 132). But such illustrations, though Bernini certainly learned from them the association between exaggeration and character analysis, never portrayed specific individuals, were never drawn in any special style of their own, and were never sufficient unto themselves as works of art.

It is well known that in the course of the sixteenth century drawing did achieve the status of an independent art—that is, serving neither as an exercise, nor a documentary record, nor a preparatory study—in a limited variety of forms. One was

what may be called the presentation drawing, which
the artist prepared expressly for a given person or
occasion. Michelangelo's drawings for his friend
Tommaso Cavalieri are among the earliest such
works that have come down to us (Fig. 274).[12]
Another category was the portrait drawing, which
by Bernini's time had also become a genre unto
itself. In the early seventeenth century Ottavio
Leoni, a specialist in this field in Rome, recorded
many notables, including the young Bernini (Fig.
275). Bernini also made portrait drawings of this
type.[13] Commonly such works were highly finished,
and the draftsman adopted special devices—the
distinctive stippling and rubbing of Michelangelo, a
mixture of colored chalks by Leoni and Bernini—
that distinguished them from other kinds of draw-
ings.[14] They are carefully executed, rich in detail,
and complex in technique. The artist, in one way or

Fig. 274 (*opposite*). Michelangelo, Fall of Phaeton, drawing.
Royal Library, Windsor Castle.

Fig. 275. Ottavio Leoni, portrait of Gianlorenzo Bernini,
drawing. Vol. H. I., fol. 15, Biblioteca Marucelliana, Florence.

Fig. 276 (*above*). Albrecht Dürer, letter to Willibald Pirck-heimer, detail. Pirckh. 394.7, Stadtsbibliothek, Nuremberg.

Fig. 277 (*opposite*). Erasmus of Rotterdam, manuscript page. MS C.VI. A.68, p. 146. Universitäts-Bibliothek, Basel.

another, created a separate formal domain midway between a sketch and a painting or sculpture.

Bernini's caricatures incorporate two interrelated innovations from this prior history of drawing-as-an-end-in-itself. They are the first such independent drawings in which the technique is purely graphic — that is, the medium is exclusively pen and ink, the forms being outlined without internal modeling; and in them the rapidity, freshness, and spontaneity usually associated with the informal sketch become an essential feature of the final work of art.[15]

The distinctive graphic style of Bernini's carica-tures marks them as caricatures quite apart from what they represent. They consist entirely of out-

lines, from which hatching, shading, and modeling have been eliminated in favor of an extreme, even exaggerated, simplicity. The lines are also often patently inept, suggesting either bold muscle-bound attacks on the paper or a tremulous hesitancy. In other words, Bernini adopted (or rather created) a lowbrow or everyman's graphic mode in which tradi-tional methods of sophisticated draftsmanship are travestied along with the sitters themselves.[16]

If one speculates on possible antecedents of Bernini's caricature technique, two art forms — if they can be called that — immediately spring to mind, in which the inept and untutored form part of the timeless and anonymous heritage of human

creativity: children's drawings and graffiti. It is not altogether farfetched to imagine that Bernini might have taken such things seriously in making his comic drawings, for he would certainly not have been the first to do so. Albrecht Dürer drew a deliberately crude and childish sketch of a woman with scraggly hair and a prominent nose in a letter he wrote from Venice in 1506 to his friend Willibald Pirkheimer (Fig. 276). The drawing illustrates an incisive passage in which Dürer describes the Italians' favorable reaction to his Rosenkranz Madonna. He reports that the new picture had silenced all the painters who admired his graphic work but said he could not handle colors.[17] The clumsy-looking sketch is thus an ironic response to his critics, as if to say, "Here is my Madonna, reduced to the form these fools can appreciate."

Something similar appears in certain manuscripts of Dürer's friend and admirer, Erasmus of Rotterdam. Here and there he introduced sketches—one might almost call them doodles, except they are much too self-conscious—that include repeated portrayals of himself with exaggerated features in what Panofsky described as the sharply observant, humorous spirit that animated the *Praise of Folly* (Fig. 277).[18] The crude style of the drawings visually parallels Erasmus's ironic exaltation of ignorance in that work. Although Erasmus was an amateur, it

should not be assumed that his sketches are simply inept. He did know better, for he had practiced painting in his youth, and he had an art-historical eye discriminating enough to appreciate the "rustic" style he associated with early medieval art.[19] On the back of a Leonardesque drawing from this same period, in a deliberate graphic antithesis, a wildly expressive profile head is redrawn as a witty schoolboyish persiflage (Fig. 278).[20] Around the middle of the sixteenth century a child's drawing plays a leading role in a portrait by the Veronese painter Caroto (Fig. 279).[21] Perhaps the drawing, which includes a full figure, a fragmentary head-nose, and a profile eye, is the work of the young man who shows it to the spectator. He seems rather too old, however, and the eye (the eye of the painter?) seems much more correctly drawn than the other elements on the sheet.[22] The knowing smile and glance with which the youth confronts the viewer certainly suggest an awareness of the ironic contrast between the drawing and the painting itself.[23]

Graffiti have a particular relevance to our context because while their stylistic naïveté may be constant, the things they represent are not. Historically speaking, portrait graffiti are far rarer than one might

suppose. The Roman passion for portraiture has a comic aspect in the many graffiti depicting individuals, often identified by inscriptions, that decorate the walls of buildings in the capital, at Pompeii, and elsewhere (Fig. 280).[24] I feel sure Bernini was aware of such drawings, if only because we know he was acutely aware of the wall as a graphic field. It was his habit, he said, to stroll about his house while excogitating a project, tracing his first ideas upon the wall with charcoal.[25]

The term *graffito*, of course, refers etymologically to the technique of incised drawing. The beginning of its modern association with popular satirical representations can be traced to the Renaissance, notably to Vasari's time when it described a kind of mural decoration practiced, it was thought, in antiquity; these designs often included grotesque and chimaeric forms with amusing distortions and transformations of nature.[26] It is also in the Renaissance that we begin to find allusions to popular mural art by sophisticated artists. Michelangelo, who often made reference, serious as well as ironic, to the relations among various kinds of art, was a key figure in the development. By way of illustrating the master's prodigious visual memory, Vasari

Fig. 278 (*opposite*). Leonardo da Vinci (?), sketches of heads.
Royal Library, Windsor Castle.

Fig. 279. Giovanni Francesco Caroto, boy with drawing. Museo
del Castelvecchio, Verona.

Fig. 280. Ancient graffiti from Rome and Pompeii (from
Väänänen, ed., vol. 2, 121, 213; Cèbe, 1966, pl. XIX, 3, 6).

describes an occasion when young Michelangelo was
dining with some of his colleagues. They held an
informal contest to see who could "best" draw a
figure without design, awkward, Vasari says, as the
doll-like creatures (*fantocci*) made by the ignorant
who deface the walls of buildings. Michelangelo
won the game by reproducing as if it were still
before him such a scrawl (*gofferia*) he had seen long
before. Vasari's comment, that this was a difficult
achievement for one of discriminating taste and
steeped in design, shows that he was well aware of
the significance of such an interplay between high
and low styles.[27] Juxtapositions of this kind may
actually be seen among the spectacular series of
charcoal sketches attributed to Michelangelo and his
assistants that were discovered a few years ago on
the walls of the chancel behind the altar and cham-
bers beneath the Medici chapel in Florence. In one
particularly mordent transformation, an elaborate
and pompous plumed helmet is rescribbled and
deflated into a cockscomb (Fig. 281, center top and
bottom).[28]

Fig. 281. Michelangelo and assistants, wall drawings. Medici
Chapel, San Lorenzo, Florence (photo: Kunsthistorisches Institut,
Florence).

An even more pointed instance, and as it happens almost exactly contemporary with the Dürer letter, involves the ironical poem by Michelangelo discussed earlier (see Fig. 45 and pp. 36, 58 above). In the sonnet Michelangelo parodies his own work on the Sistine ceiling, the gist being that the agonizing physical conditions of the work impair his judgment (*giudizio*), that is, the noblest part of art, so that he is not a true painter and begs indulgence:

. .
My belly's pushed by force beneath my chin.
. .
My brush, above my face continually,
Makes it a splendid floor by dripping down.
. .
And I am bending like a Syrian bow.

And judgment, borne in mind,
Hence must grow peculiar and untrue;
You cannot shoot straight when the gun's askew.

John, come to the rescue
Of my dead painting now, and of my honor;
I'm not in a good place, and I'm no painter.

In the margin of the manuscript page Michelangelo drew a sketch depicting his twisted body as the bow, his right arm holding the brush as the arrow, and a figure on the ceiling as the target. (The text and illustration give the lie, incidentally, to the popular notion that Michelangelo painted the vault while lying comfortably on his back.) Of particular interest in our context is the striking contrast in style between the two parts of the sketch: the figure of the artist is contorted but elegantly drawn; that on the ceiling is grotesquely deformed and drawn with amateurish, even child-like, crudity.[29] Michelangelo transforms the Sistine ceiling itself into a graffito to satirize high art—in this case his own. I suspect that the grotesque figure on the vault alludes to God the Father in the Creation of the Sun and Moon, more precisely to the rough black underdrawing of that figure in its "primitive" state. If so, Michelangelo's thought may reach further still: the graffito style would express the artist's sense of both inadequacy in portraying the Supreme Creator and unworthiness in the traditional analogy between the artist's creation and God's.

A final example from Rome brings us to Bernini's own time. This is a drawing by Pieter van Laar, nicknamed Il Bamboccio, the leader of a notorious group of Flemish painters in Rome in the seventeenth century called I Bamboccianti, "the painters of dolls," a contemporary term that refers derisively to their awkward figures and lowlife subject matter. The members of the group formed a loose-knit organization, the Bentvogel, and were notorious for living unruly lives that made a mockery of the noble Renaissance ideal of the gentleman artist. The drawing (Fig. 282) shows the interior of a tavern filled with carousing patrons; the back wall is covered with all manner of crude and grotesque designs, including a caricatural head shown in profile.[30] Many works by the Bamboccianti are reflections on the theory and practice of art, and van Laar's drawing is also surely an ironic exaltation of the satirical and popular art held in contempt by the grand and often grandiloquent humanist tradition. We are invited to contemplate this irony by the figures who draw attention to the word *Bamboccio* scrawled beneath a doll-like figure seen from behind and the profile head.

One point emerges clearly from the prehistory of Bernini's deliberate and explicit exploitation of aesthetic vulgarity. The artists who displayed this unexpected sensibility to the visually underprivileged did so to make some statement about art or their profession. The statements were, in the end, deeply personal and had to do with the relation between ordinary or common creativity and what is usually called art. No doubt there is an art-theoretical, or even art-philosophical element in Bernini's attitude as well, but with him the emphasis shifts. His everyman's style is not a vehicle for comment about art or being an artist, but about people, or rather being a person. His visual lampoons are strictly *ad hominem*, and for this reason, I think, in the case of Bernini one can speak for the first time of caricature drawing not only as art but as an art of social satire.

Bernini's invention was a great success, and he himself introduced the concept and the example to Louis XIV, who was greatly amused, during his visit to the French court in 1665.[31] To be sure, there is no evidence that Bernini ever intended to publish his persiflages in the form of prints; we owe the caricature as a public instrument of social reform to eighteenth-century England. Yet, the modest little drawings sprang from a deep well within, and they were far from mere trifles to him. Both points emerge,

Fig. 282. Pieter van Laar, artists' tavern in Rome. Kupferstich-kabinett, Staatliche Museen, Berlin.

along with Bernini's clear awareness of what he was about, from a charming letter he wrote to a friend named Bona Ventura (meaning "good fortune" in Italian) accompanying two such sketches, now lost:

As a cavaliere, I swear I'll never send you any more drawings because having these two portraits you can say you have all that bumbler Bernini can do. But since I doubt your dim wit can recognize them I'll tell you the longer one is Don Giberti and the shorter one is Bona Ventura. Believe me, you've had Good Fortune, because I've never had greater satisfaction than in these two caricatures, and I've made them with my heart. When I visit you I'll see if you appreciate them.

Your True Friend
G. L. Bern.
Rome 15 Mar. 1652[32]

This is, incidentally, the first time the word *caricature* is used as we use it today, as the name for a class of drawings. The ignoble here achieves the status of an independent visual and intellectual concept.

It might be said that with the invention of caricature, visual illiteracy for the first time reached a state of self-conscious articulateness. An alternative art form was established that helped pave a permanent and ever-widening inroad into the classical tradition as it had been defined by the theoreticians of the Renaissance. Beauty had begun to accept the Beast and the future of their relationship was assured. Almost by definition, however, caricature, like the parallel efflorescence of quotations of children's art and graffiti in more sophisticated works, is strictly *ad hoc,* bound irrevocably to a particular person, situation, or context, and therefore also to a moment

in time—bound, that is, in history. And however important these developments were in transforming cultural values, something radically new happened with the Modern movement. There took place what amounted to a repetition in reverse of the historical revolution of the Renaissance, which had given justification and elaboration to the classical tradition, thereby arousing the sleeping Beast in the first place. The simple and unsophisticated came to be exalted *in principle* as the norm to which truly modern man, in his communal spirit, must return or aspire in order to achieve a *summum bonum* both timeless and universal. The various forms of art-without-history came to be appreciated not simply as aberrations from, alternatives to, or primitive stages of sophisticated culture, but as ends in themselves, worthy of emulation even to the point of supplanting sophisticated culture altogether. What was perceived, ultimately, was the protean substance of which all these seemingly unselfconscious forms of expression are made, precisely their ahistoricity, the glimpse they provided of a distant but attainable ideal of innocence and authenticity. Historicism self-destructs.

◆ ◆ ◆

On November 2, 1945, when Picasso entered the lithographic workshop of Fernand Mourlot in the Rue de Chabrol in Paris, he took up a medium he had practiced before only rarely, and never assiduously. On that day, however—as if to celebrate the liberation of Paris and the end of the war—Picasso began a veritable orgy of lithographic creativity that lasted four months.[33] He worked at least twelve-hour days, almost without interruption; the hectic activity was described by one of the craftsmen who participated:

We gave him a stone and two minutes later he was at work with crayon and brush. And there was no stopping him. As lithographers we were astonished by him . . . When you make a lithograph, the stone has been prepared, and if you have to make a correction the stone has to be retouched . . . Right. We run off twelve to fifteen proofs for him and return the stone to him in good order. Then he makes his second state. On a stone like that, normally when it has been retouched twice, the original preparation becomes somewhat spoiled . . . And he would scrape and add ink and crayon and change everything! After this sort of treatment the design generally becomes indecipherable and

is destroyed. But, with him! Each time it would turn out very well. Why? That's a mystery . . . Picasso is a real hard worker. We used to leave at 8:00 at night and he would be there at 8:30 in the morning. Sometimes I would suggest that we should call it a day . . . He would look at the stone, light up a Gauloise and give me one, and then we were off again . . . and in the morning we would start again.[34]

We know everything he did during that period and we can follow his progress day by day. The chief results of this frenzied activity were four series of images, two female heads, a pair of nudes, and a bull (Fig. 283 [see foldout] and Figs. 290–295, 308–318). Picasso took up the themes in that order, producing respectively six, ten, eighteen, and eleven versions; of every variant a number of prints—I hesitate to say proofs—were pulled, reserved for the artist. In each case the suite was made not from separate lithographic stones but from successive reworkings of the same stone.[35]

The description confirms the evidence of the actual prints, that what possessed Picasso was the process itself, the sequence of states and their cumulative effect as a series. Indeed, Picasso seems to have put into practice here an idea he had expressed a few months earlier when speaking of one of his paintings: "If it were possible, I would leave it as it is, while I began over and carried it to a more advanced state on another canvas. Then I would do the same thing with that one. There would never be a 'finished' canvas, but just the different 'states' of a single painting, which normally disappear in the course of work."[36]

As far as I can discover, nothing quite like it had ever been seen before. There was certainly nothing new about works in series on a single theme—Monet's church facades and haystacks spring to mind; and there was certainly nothing new about multiple states of a single print—Impressionist print makers achieved varied effects comparable to Monet's through multiple modifications of the same plate (Figs. 284–286).[37] Picasso had subjected some of his own etched plates to thirty or more reworkings (Figs. 287–289).[38] Three main points, taken together, distinguish the lithographic series. First, the states acquire a new self-sufficiency, with the separate reworkings treated quite differently. Instead of pulling a small number of trial proofs before a much larger run from the final version, Picasso ordered a fixed and usually large number of prints—eighteen or nineteen—to

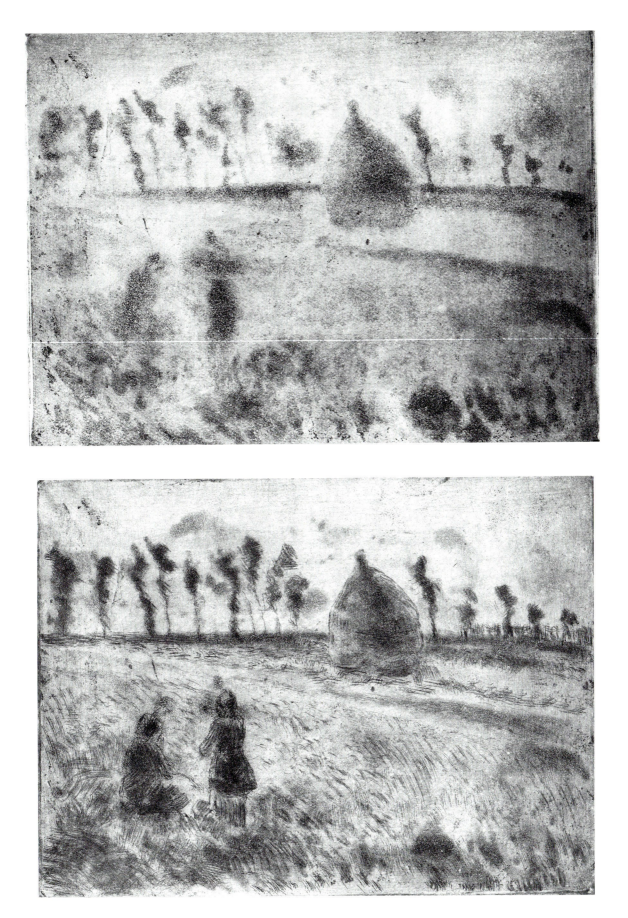

Figs. 284–285. Camille Pissarro, *Rain Effects,* states II and IV of
six, aquatint and drypoint.

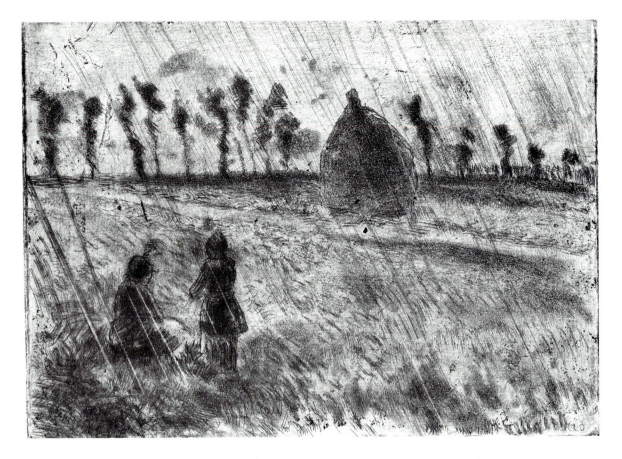

Fig. 286. Camille Pissarro, *Rain Effects*, state VI of six, aquatint and drypoint.

be made from each state, including the last, which was then given an additional, final, run of its own. In the case of the bull, several sketches and a water-color; a number of intermediate states, of which evidently only single proofs were taken; and inde-pendent lithographs made concurrently indicate that Picasso actually studied the solutions he would then commit to the tortured stone (see Figs. 319–327).[39] Clearly neither the states nor the multiple prints made from them were trials in the ordinary sense; they were conceived as a unified, if not wholly pre-determined, series and were meant to be compared with one another. Second, the designs were not sim-ply variations but consistently progressive transfor-mations of a basic theme; it is as if Picasso had set out to tell a story, an epic narrative that recounted the life history of a work of art. Third, the formal and conceptual sequence moved in the opposite direction from that of earlier suites. Normally, the successive states of prints, including Picasso's own (see Figs. 287–289), become richer and more complex. The bull started out that way, with the second state darker and weightier than the first.

Thereafter, however, the compositions became ever more simple and schematic—more "abstract," if that word has any sense in this context (Figs. 290–291, 292–293, 294–295, 308–318).

While they might seem coincidental, I believe these innovations were interdependent and com-plementary; if so, the lithographs could even be con-scious, programmatic illustrations of the trenchant self-revelations Picasso made in an interview with Christian Zervos in 1935.

"In the old days," he said, "pictures went forward toward completion by stages. Every day brought some-thing new. A picture used to be a sum of additions. In my case a picture is a sum of destructions. I do a picture—then I destroy it. In the end, though, nothing is lost . . . It would be very interesting to preserve pho-tographically, not the stages, but the metamorphoses of a picture. Possibly one might then discover the path followed by the brain in materializing a dream. But there is one very odd thing—to notice that basically a picture doesn't change, that the first 'version' remains almost intact, in spite of appearances."[40]

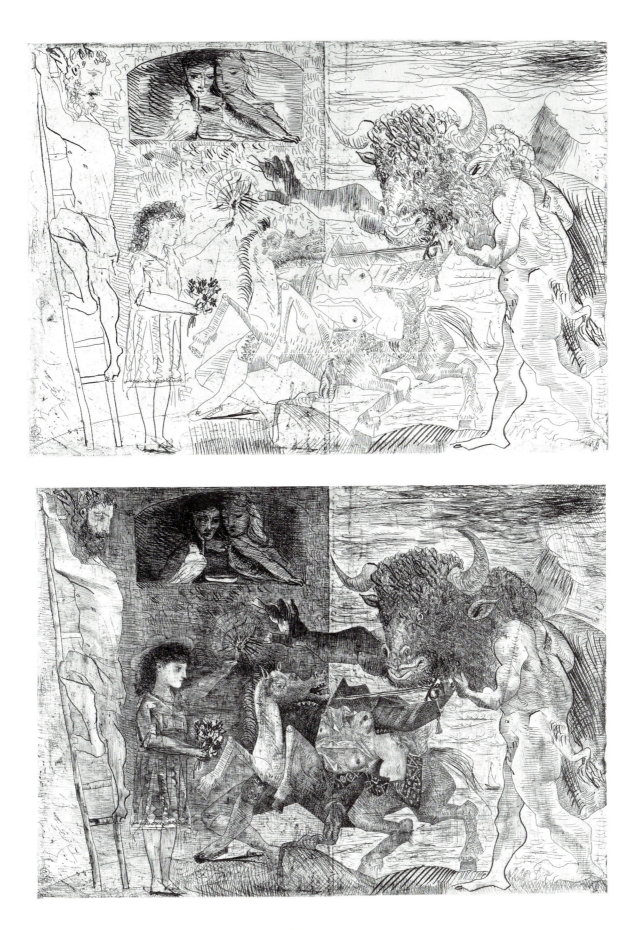

Figs. 287–288. Picasso, *Minotauromachy,* states I and III of seven, etching, 1935.

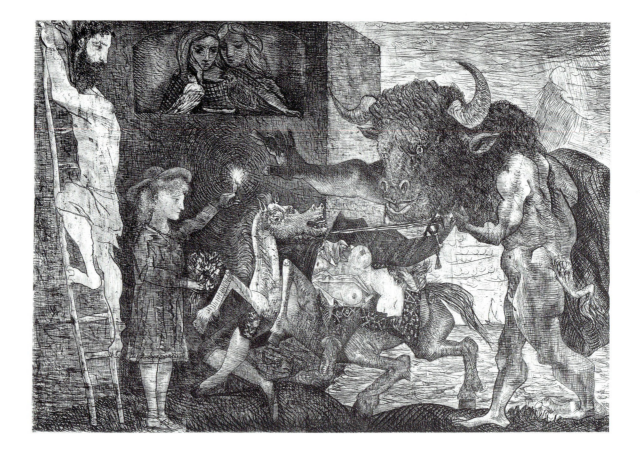

Fig. 289. Picasso, *Minotauromachy*, state VII of seven, etching, 1935.

Figs. 290–291 (*opposite, top*). Picasso, female head, states I and VI of six, lithographs, November 6 and 24, 1945. Mourlot no. 12.

Figs. 292–293 (*opposite, bottom*). Picasso, female head, states I and X of ten, lithographs, November 7, 1945, and February 19, 1946. Mourlot no. 9.

Matisse, who used photographs to record the evolution of his paintings, often toward greater abstraction (Figs. 296–299), offers a striking parallel and contrast. His purpose was not to document the process as such, however, but to enable him to judge the progress of the work: "The photos taken in the course of execution of the work permit me to know if the last conception conforms more [to his mental conception] than the preceding ones; whether I have advanced or regressed."[41] Matisse referred to the succeeding conceptions as stages (*étapes*), a notion which, as we have just seen, Picasso specifically rejected.[42] Similarly, Matisse described the multiple permutations portrayed in his *Themes and Variations* suite of drawings (Figs. 300–302) as "a motion-picture film of the feelings of an artist."[43] The cinema metaphor expressed the variation, however, not a consistent formal progression of the different motifs; in fact, while some of the themes start with a shaded drawing, all the other sketches are purely linear and betray no tendency toward abstraction.

In engraving and etching, the normal sequence of states, from relative simplicity to relative complexity, is consonant with the technique because expunging the marks in a metal plate is extremely difficult.

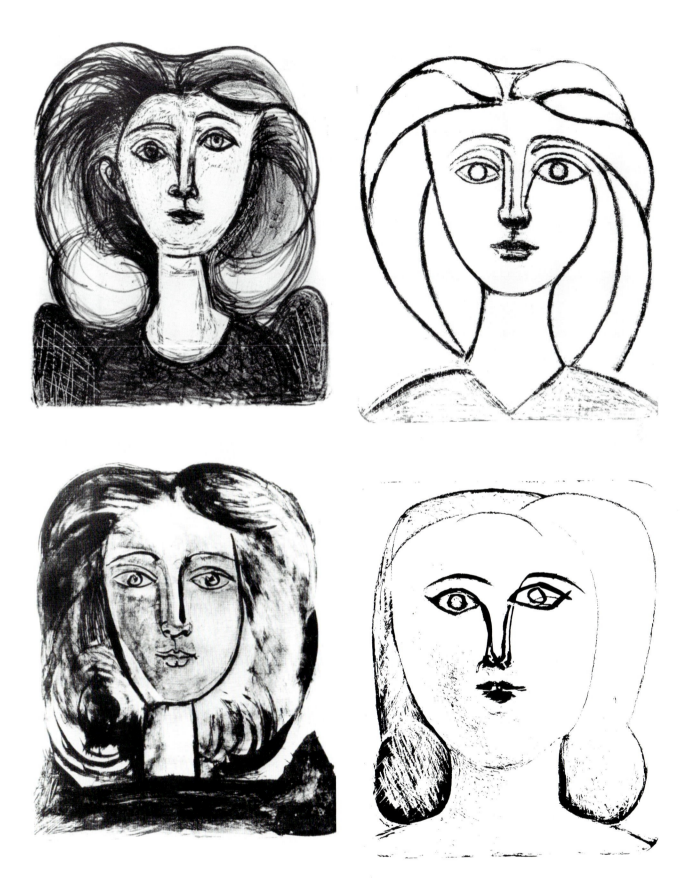

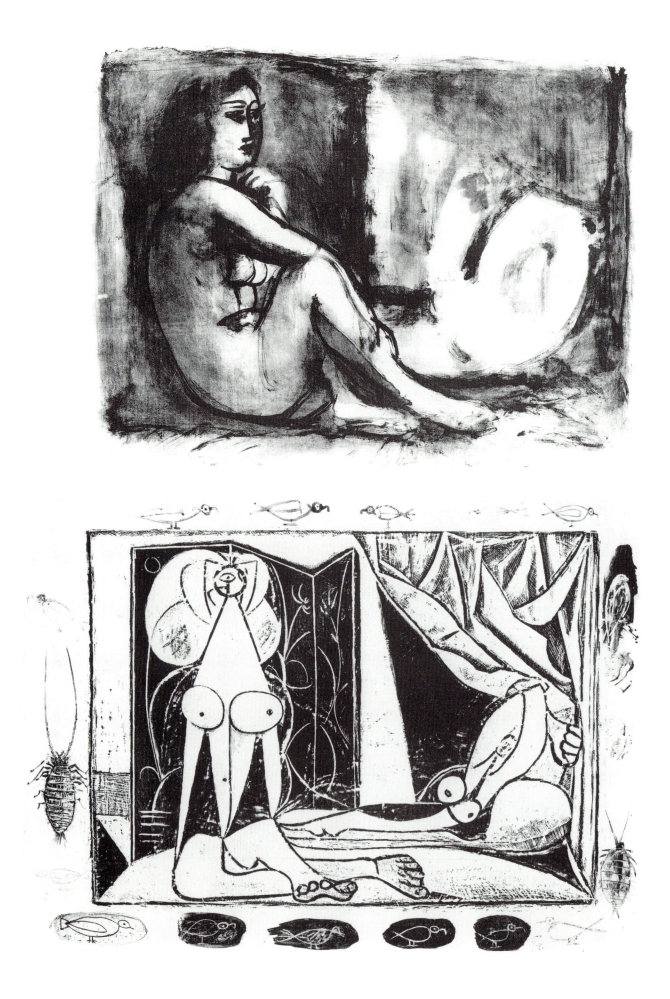

228 *Picasso's Lithograph(s) "The Bull(s)"*

NOVEMBER 8, 1937

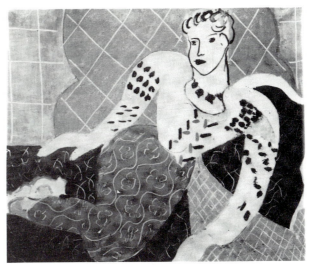

NOVEMBER 9, 1937

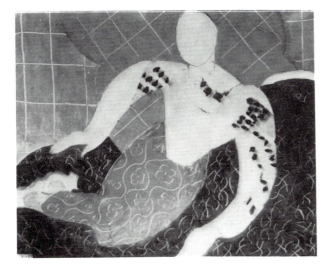

NOVEMBER 11, 1937

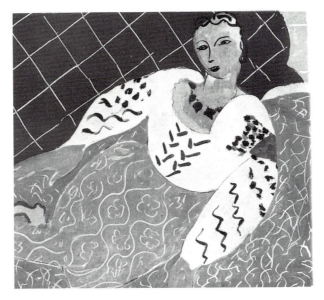

NOVEMBER 12, 1937

Figs. 294–295 (*opposite*). Picasso, two nudes, states II and XVIII of eighteen, lithographs, November 13, 1945, and February 12, 1946. Mourlot no. 16.

Figs. 296–299 (*above*). Matisse, "étapes" of *The Rumanian Blouse,* photographs during work (November 8, November 9, and November 11, 1937) and final version (November 12, 1937) (from Delectorskaya, 1986, 244–45).

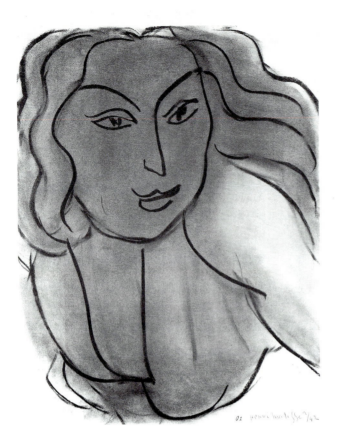
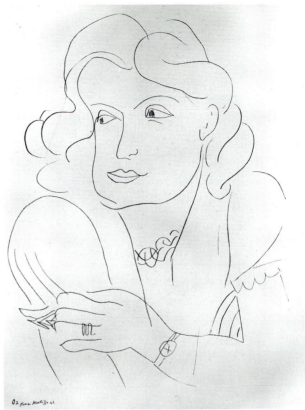
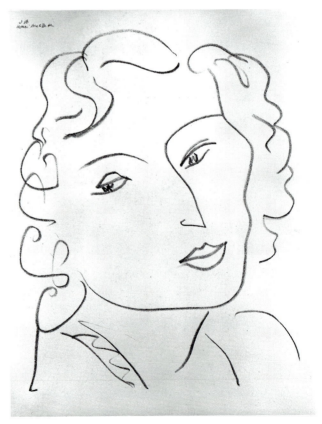

Figs. 300–302. Matisse, drawings 1, 2, and 18 of eighteen in the "O" series (from Matisse, 1943).

Erasures are much easier in lithography, though Picasso evidently now also pushed this medium much farther than the experts thought possible,[44] whence the plot of the creation drama enacted in Mourlot's workshop begins to emerge. Only on the lithographic stone was it possible to tell the particular story Picasso had in mind—the retrogressive destruction of a single work of art back to its original state, or, what amounts to the same thing, the progressive evolution of a single work to its ideal state.

The process of simplification and abstraction had been inherent in the Cubist enterprise and on occasion had approached quasi-seriality. A case in point, which Picasso certainly knew, is Matisse's successive variations of the same sculpture (Figs. 303–306). It is doubtful that Matisse conceived these sculptures as a series, however, since he made them only intermittently, sometimes at intervals of many years, and almost never exhibited them together.[45] Moreover, the progression consists in reorganizing, rather than eliminating, modeled form. Modeled form is progressively eliminated in another case, which I suspect Picasso also knew, a sequence of cows by the Dutch De Stijl painter Theo van Doesburg, who published a selection in a treatise on aesthetics in 1925 (Fig. 307);[46] they are not variations of the same work, however, but begin with a photograph and pass through a number of preparatory drawings to a final, completely nonobjective, painting. In Picasso's lithographs, the process becomes coherent, unified, objectified, and the subject of an object lesson, not in art theory but in art history. The lesson, moreover, is conceived in a special way, which can best be learned from the history of the bull.

Several factors suggest that the bull was, in fact, the main offspring of Picasso's lithographic orgy (Figs. 308–318). The four series were conceived in relation to one another and form a coherent group, personally and psychologically no less than formally. The women evidently refer to Dora Maar and Françoise Gilot, with whom Picasso was then deeply involved, and the bull served, here as elsewhere in his work, as a self-image and a symbol of bestiality in general.[47] Moreover, Picasso started the bull series after the other three but then worked on it with particular intensity; for a time, he even dropped everything else to pursue the bull to its end—or should one say its beginning? The bull thus forms the centerpiece, both thematically and chronologically, in this complex group of interlocking sequences

of quasi-autobiographical images. The bull also has a special place in the participants' recollections of the time at Mourlot's:

One day . . . he started work on the famous bull. It was a superb, well rounded bull. I thought myself that that was that. But not at all. A second state and a third, still well rounded, followed. And so it went on. But the bull was no longer the same. It began to diminish, to lose weight . . . Picasso was taking away rather than adding to his composition . . . He was carving away slices of his bull at the same time. And after each change we pulled a proof. He could see that we were puzzled. He made a joke, he went on working, and then he produced another bull. And each time less and less of the bull remained. He used to look at me and laugh. "Look," he would say, "we ought to give this bit to the butcher. The housewife could say: I want that piece, or this one . . . " In the end, the bull's head was like that of an ant. At the last proof there remained only a few lines. I had watched him at work, reducing, always reducing. I still remembered the first bull and I said to myself: What I don't understand is that he has ended up where really he should have started! But he, Picasso, was seeking his own bull. And to achieve his one-line bull he had gone in successive stages through all the other bulls. And when you look at that line you cannot imagine how much work it involved . . . [48]

Picasso's joke about the butcher and the housewife reveals part of what he had in mind: to retrieve the bull's constituent parts, to recover and reduce the *disjecta membra* of his dream bull—bred of pure lines —to an elemental, disembodied, quintessential bullishness.

Another insight is suggested by one of the most striking aspects of the animal's metamorphosis— duly observed, at least in part, by the perspicacious craftsman—the progressive diminution in the relative size of the head and the genitalia, surely metaphors for rationality and brutishness. Picasso's bull was headed toward a preternatural state of illuminated absent-mindedness and incorporeality—before it had acquired the bulky accretions of sophisticated European culture.

References to sophisticated European culture are both numerous and essential to the import of Picasso's image. The animal's mythological and sporting associations, the Minotaur and the *corrida*, had long been part of the fauna of Picasso's visionary landscape, and in this tradition the suite is certainly related to

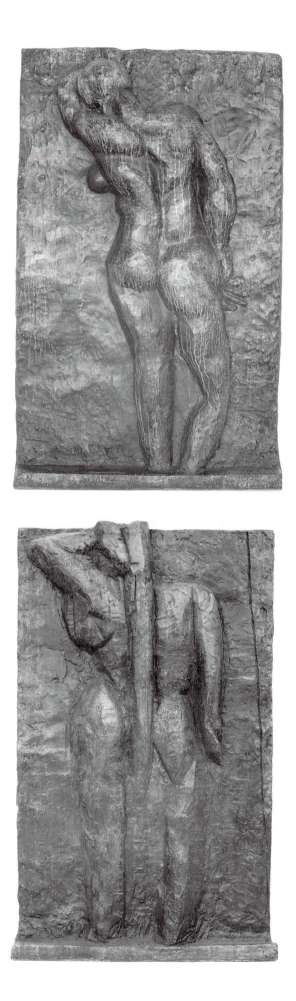

Picasso's Lithograph(s) "The Bull(s)"

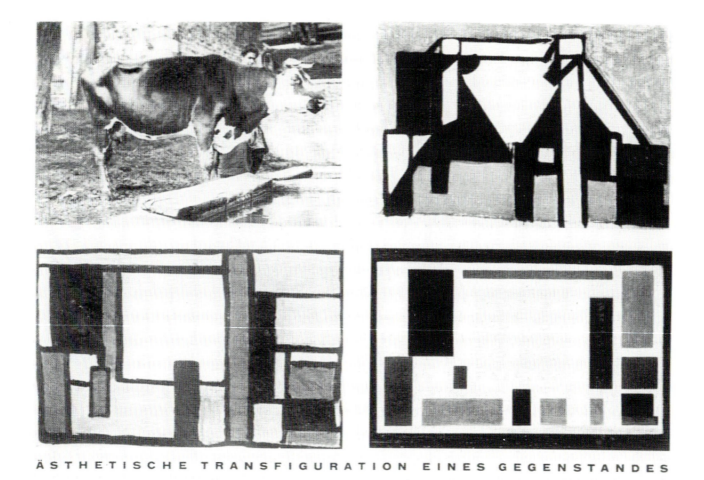

ÄSTHETISCHE TRANSFIGURATION EINES GEGENSTANDES

Figs. 303–306 (*preceding foldout*). Matisse, *The Back*, I (1909), II (1913), III (1916), IV (1931). Museum of Modern Art, New York.

Fig. 307 (*above*). Theo van Doesburg, *Aesthetic Transfiguration of an Object* (The Cow) (from Van Doesburg, 1925, figs. 5–8).

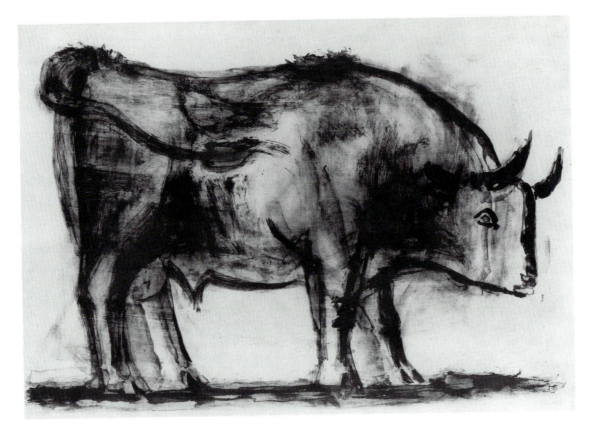

I. December 5, 1945

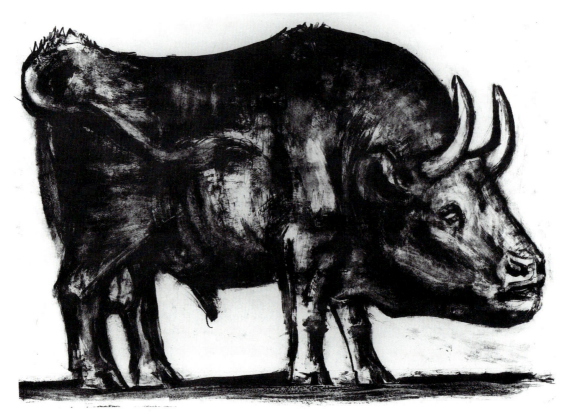

II. December 12, 1945

Figs. 308–318. Picasso, *The Bull*, states I–XI, lithographs.

Picasso's Lithograph(s) "The Bull(s)"

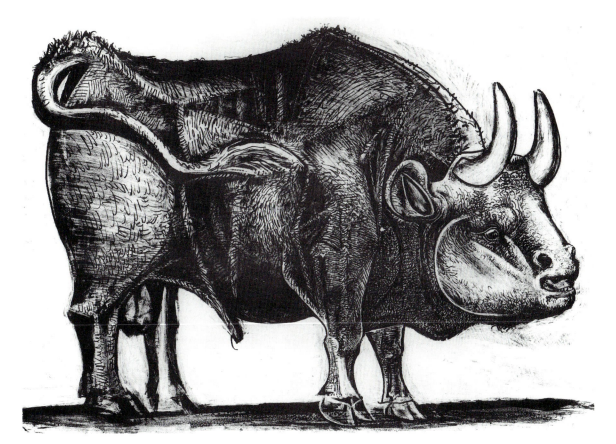

III. December 18, 1945

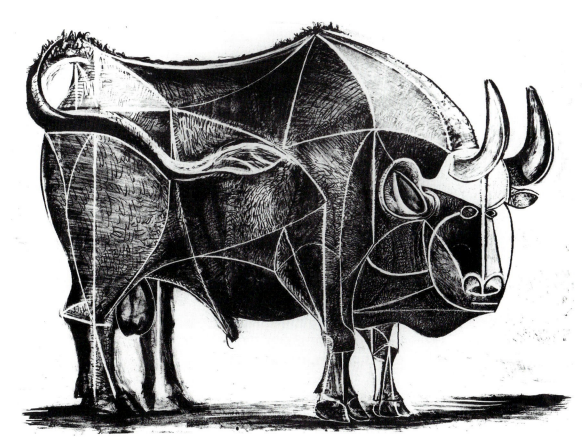

IV. December 22, 1945

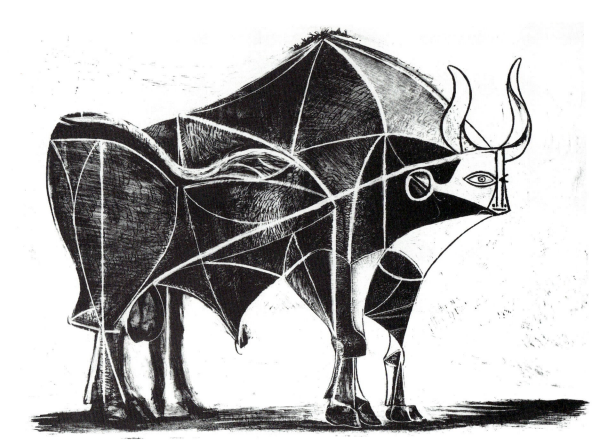

V. December 24, 1945

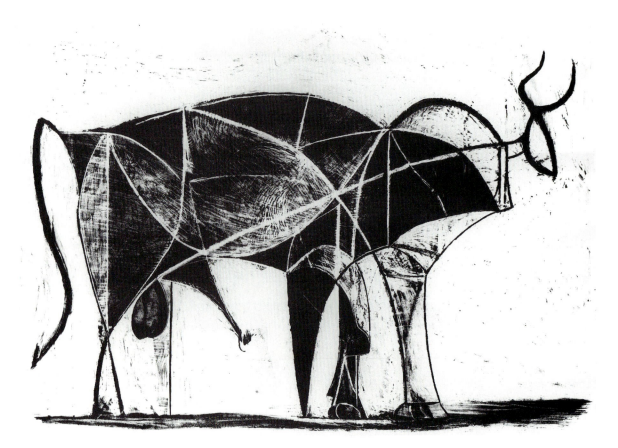

VI. December 26, 1945

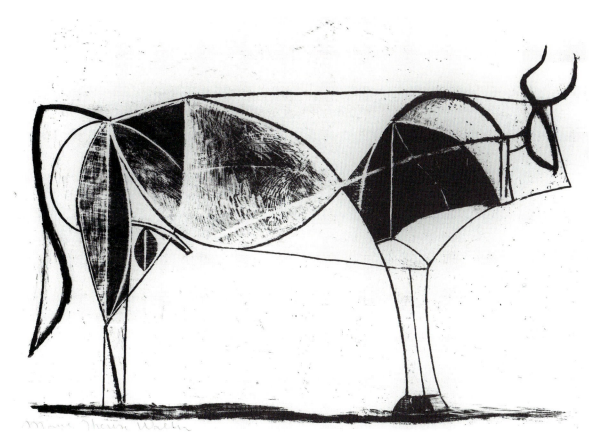

VII. December 28, 1945

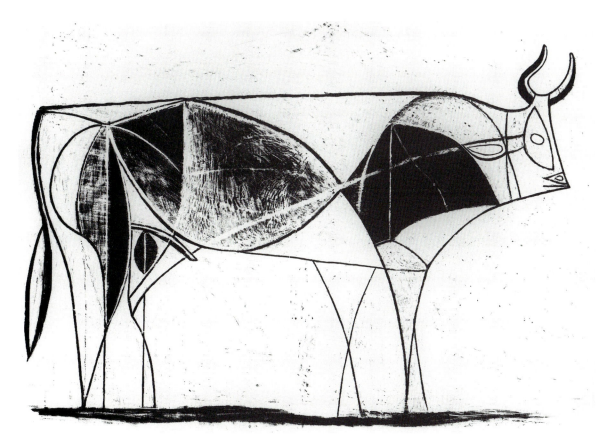

VIII. January 2, 1946

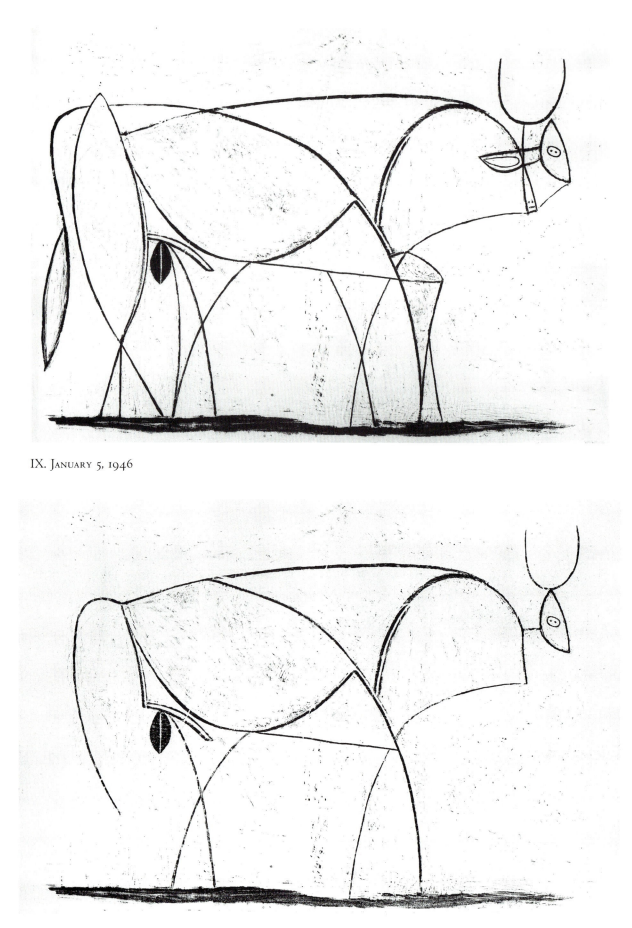

IX. January 5, 1946

X. January 10, 1946

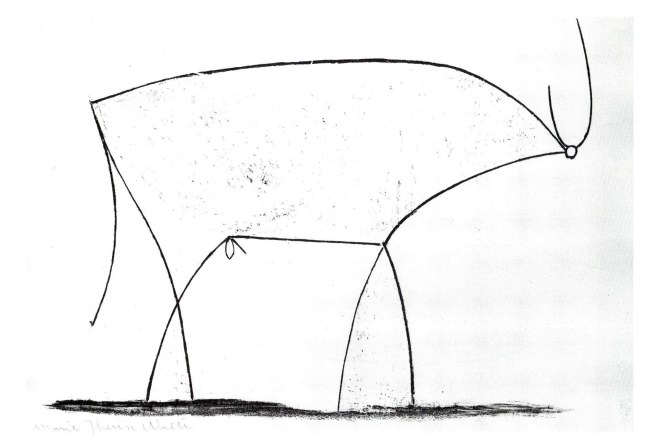

XI. JANUARY 17, 1946

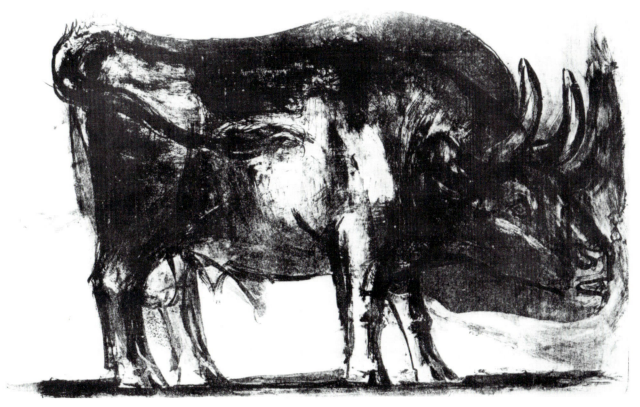

Fig. 319. Picasso, bull, proof of state intermediate between I
and II, December 5–12, 1945, lithograph (from Deuchler, 1974,
fig. 50).

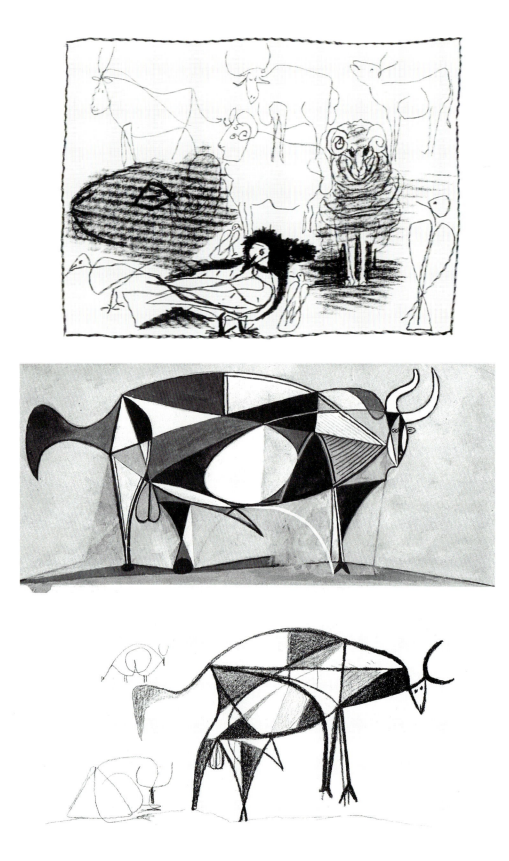

Fig. 320 (*top*). Picasso, bulls, rams, and birds, December 22, 1945, lithograph. Mourlot no. 21.

Fig. 322 (*bottom*). Picasso, bull, December 25, 1945, lithograph. Mourlot no. 27.

Fig. 321 (*middle*). Picasso, bull, December 24, 1945, watercolor. Musée Picasso, Paris (photo: Documentation photographique de la Réunion des musées nationaux MP 1339).

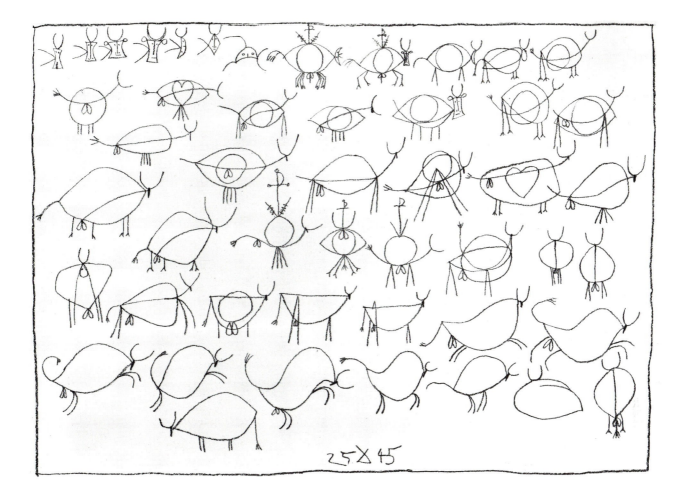

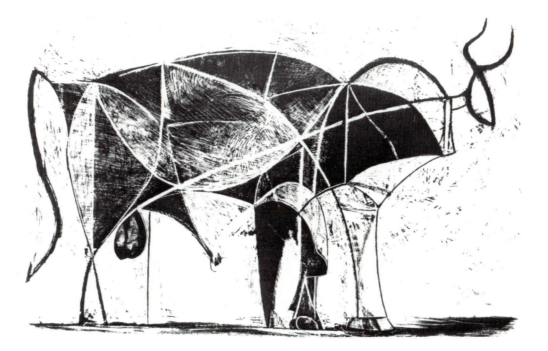

Fig. 323 (*top*). Picasso, bulls, December 25, 1945, lithograph.
Mourlot no. 28.

Fig. 324 (*above*). Picasso, bull, proof of state intermediate
between V and VI, December 24–26, 1945, lithograph (from
Deuchler, 1974, fig. 55).

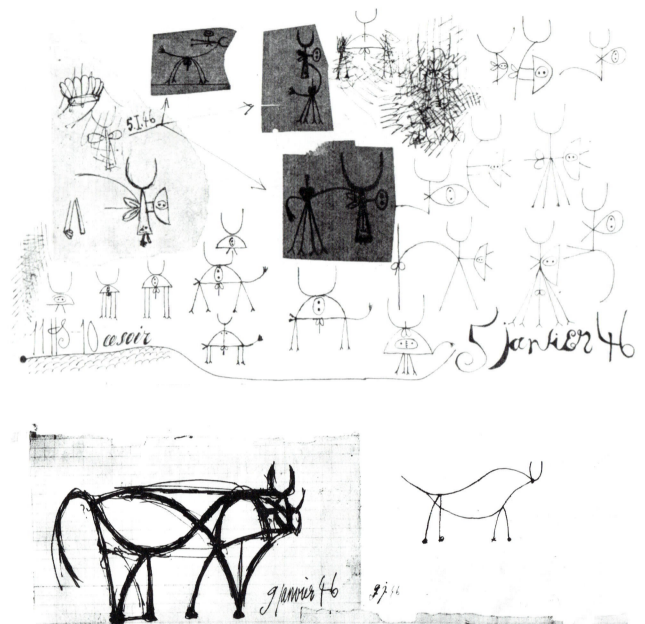

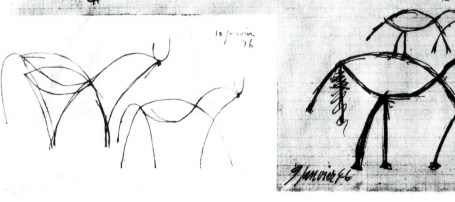

Fig. 325 (*top*). Picasso, studies of bulls, January 5, 1946, drawings (from Deuchler, 1973, fig. 94).

Fig. 326 (*above*). Picasso, studies of bulls, January 9 and 10, 1946, drawings (from Zervos, 1932–38, vol. 14, no. 133).

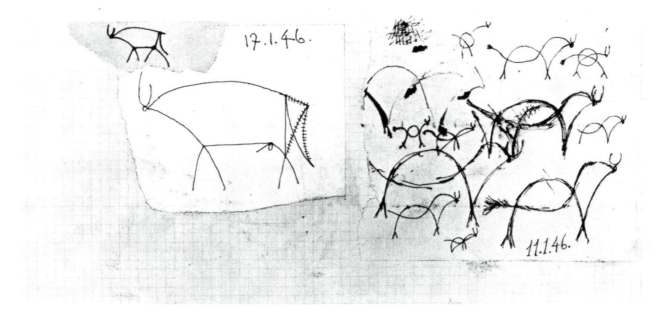

Fig. 327. Picasso, studies of bulls, January 11 and 17, 1946, drawings (from Deuchler, 1973, fig. 96).

Goya's etched cycle of floating dream bulls, provocatively titled *Folly of Fools* (Fig. 328). Since the Middle Ages, when St. Luke, who painted the first portrait of Christ and the Virgin, became the patron of the artists' guilds and the early academies of art, the evangelist's ox had been the very emblem of the art of painting. As such, it often served to introduce books of instruction on academic drawing (Fig. 329), a genre of publication that held special significance for Picasso, as we shall see presently.[49] Even Picasso's joke about the butcher is relevant here, since his remark, and the intermediate stages of the design itself, insistently recall those sectioned images of bovine anatomy that adorn the walls of butcher shops and the chapters on meat in elementary cookbooks (Fig. 330).[50]

Apart from such serio-comic references to traditional and familiar themes, Picasso's process of thought might be defined as a genetic historicism in which, to borrow a pair of biological concepts, ontogeny repeats phylogeny—that is, the history of the individual recapitulates the history of the species. Picasso's bull really does have a binary genealogy. The grandiose, primordial beasts of Paleolithic art must also have figured vividly in Picasso's imagination. The final state of the lithographic bull has been aptly likened to such Ice Age depictions.[51] Indeed, the whole series seems to echo the great thundering procession of weightless animals at Lascaux, the noblest of all prehistoric bull pens; or, more specifically perhaps, the Black and White Chamber at Niaux (Fig. 331), where the monochrome figures are shown in varying degrees of articulation, from modeled form to outlined shape.

Picasso defined his attitude to this art in two remarkable statements, one made quite spontaneously to his secretary, Jaime Sabartés, who reported it as follows:

I cannot recall why nor on what occasion [Picasso] decided to pass on to me, as if he were tired of thinking, this idea which he seems to have been meditating for the longest time: "Primitive sculpture has never been surpassed. Have you noticed the precision of the lines engraved in the caverns? . . . You have seen reproductions . . . The Assyrian bas-reliefs still keep a similar purity of expression." "How do you explain to yourself," I asked, "the disappearance of this marvelous simplicity?" "This is due to the fact that man ceased to be simple. He wanted to see farther and so he lost the faculty of understanding that which he had within reach of his vision . . . The same happens with a watch: it will go more or less well; but if it goes at all it is not so bad. The worst begins the moment it falls into the hands of a watchmaker . . . His manipulations will rob it of its purity, and this will never return. It may preserve the same external appearance, just as the idea of

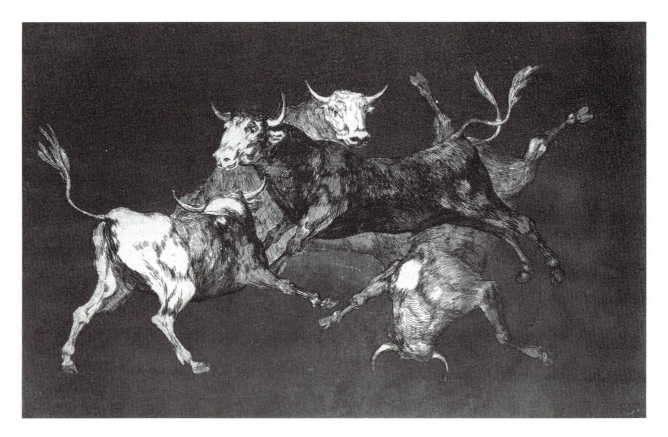

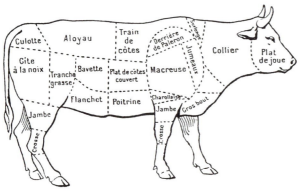

Fig. 328 (*top*). Goya, *Disparate de Tontos* (Folly of fools), aquatint.

Fig. 329 (*above*). Abraham Bloemaert, the ox of St. Luke as the symbol of painting (from Bloemaert, ca. 1650, pl. 21).

Fig. 330 (*above, left*). Butcher's diagram (from *Larousse*, 1926, 201).

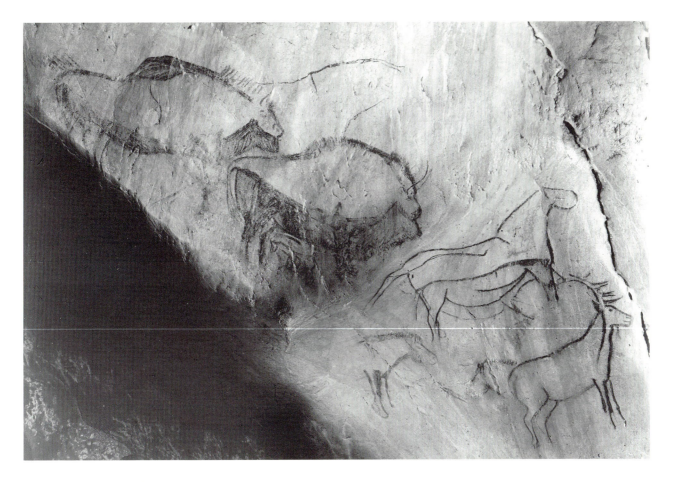

Fig. 331. Paleolithic bulls. Niaux (photo: Jean Vertut, Paris).

art subsists; but we already know what has been done to it by the schools . . . Its essence has evaporated, and I make you a present of what remains."[52]

The pristine purity of expression emphasized here had so deep a meaning for Picasso that it motivated the explanation he gave André Malraux of the underlying difference between his own early interest and that of Matisse and Braque in African sculpture—*les Nègres,* "the Blacks," to use his term. The Blacks, he said, were not primitive, like Egyptian and Chaldean sculpture, and his interest, unlike Matisse's and Braque's, was not merely formal, as if these works were no different from any other good sculpture. He realized instead that the Blacks were magic things, intercessors, mediators, fetishes, weapons; and he described *Les demoiselles d'Avignon* as his first exorcism painting. In this link between what he called "the spirits," "the unconscious," "emotion," and the exorcism of the accumulated legacy of Western tradition, Picasso's enterprise is phylogenetic.[53]

One might say with equal aptness that as Picasso's lithographic bulls become increasingly simple and simpleminded, they also seem to become increasingly childish. This is the ontogenetic aspect of the enterprise. It is best understood from another of Picasso's notorious pronouncements, that in his youth he drew like Raphael, and it took him many years to learn to draw like a child. This dictum itself has a revealing history. The first part alone was printed in an anonymous article in the *London Times* of October 25, 1956, on the occasion of Picasso's seventy-fifth birthday. It was reported that on visiting an exhibition of children's art, Picasso had remarked that at their age he drew like Raphael. The writer comments that such personal arrogance would be worthy only of a man of Picasso's greatness.[54] Two days later Herbert Read, the great English art critic, wrote a corrective letter to the editor of the *Times* explaining that the remark, which he now quoted in full, was made to him during a visit he and the artist made to the exhibition. Taking the

Fig. 332 (*right*). Picasso, *Hercules*, 1890, drawing. Museu Picasso, Barcelona.

Fig. 333 (*opposite*). Picasso, bullfight and six doves, 1892, drawing. Museu Picasso, Barcelona.

comment metaphorically, Read thought it showed "the humility that is a characteristic of all true genius."[55] In my view, the observation was neither arrogant (he did not claim that he drew *as well as* Raphael!) nor humble nor metaphorical but a simple — and perhaps somewhat rueful — statement of fact.

In another context, discussing a young boy's drawings, which he greatly admired, Picasso spoke of "the genius of childhood":

Contrary to what sometimes happens in music, miracle children do not exist in painting. What might be taken for a precocious genius is the *genius of childhood.* When the child grows up, it disappears without a trace . . . As for me, I didn't have this genius. My first drawings could never be exhibited in an exposition of children's drawings. The awkwardness and naïveté of childhood were almost absent from them. I outgrew that period of marvelous vision very rapidly. At that boy's age I was making drawings that were completely academic. Their minuteness, their exactitude, frightens me. My father was a professor of drawing, and it was probably he who pushed me prematurely in that direction.[56]

For Picasso the fragile genius of childhood could be subverted in the name of freedom. On another occasion he said,

They tell you that you have to give children freedom. In reality they make them do children's drawings. They teach them to do it. They have even taught them to do children's drawings which are abstract . . .

In reality, as usual, on the pretext of giving them complete freedom and above all not tying them down, they shut them up in their own special style, with all their chains.

An odd thing is that I have never done children's drawings. Never. Even when I was very small. I remember one of my first drawings. I was perhaps six, or even less. In my father's house there was a statue of Hercules with his club in the corridor, and I drew Hercules. But it wasn't a child's drawing. It was a real drawing representing Hercules with his club.[57]

This drawing of Hercules is actually preserved (Fig. 332), inscribed with Picasso's signature and the date November 1890, when he was nine; it confirms his

youthful academic ability. In fact, we have many drawings by Picasso from this early period. They are often playful and deliberately crude, but they are never really childish (Fig. 333).[58] In complete contrast to the childhood works are the astonishing counterfeits of children's drawings and cutouts made by Picasso for his daughter Maia about 1937–40 (Figs. 334, 335); some of these seem uncannily like childish versions of Picasso's own early (ca. 1890) "art-toys" (Figs. 336, 337).[59] In any case, it may not be coincidental that the children's exhibition mentioned in the *Times,* which had been arranged by Herbert Read himself, was shown in Paris in 1945, shortly before the lithographic series began (Fig. 338).[60]

The lithographic process enabled Picasso to merge, in the evolution of a single work, two conceptions of history — one cultural and rooted in a prerationalistic spiritual state of society, the other psychological and rooted in the presophisticated mental state of the child. In a way, Picasso was taking up an old theme that had been illustrated a century before — for example, by the American painter Thomas Cole in the second of a set of five historical paintings representing the Course of Empire from the Savage State through the Consummation of Empire to the final Desolation.[61] The Arcadian or Pastoral State includes the invention of the practical and the fine arts; Cole shows the invention of painting as a young boy drawing a childish stick figure on a stone that bears Cole's own initials (Figs. 339, 340). The difference is that Picasso was not motivated by a romantic historicism but by the search for a new and universally valid expressive idiom.

In a curious way, however, Cole's image focuses on the *tertium quid* that conjoins phylogeny and ontogeny in the history of Picasso's bull(s), namely, the idea of a timeless graphic naïveté. This concept is most sharply perceived in Picasso's affinity for popular graffiti, which underlay his friendship with the photographer Brassaï. During the very period that concerns us Brassaï was preparing his book on graffiti (published in 1961), and the subject was a leitmotif of his conversations with Picasso (Fig.

Fig. 334 (*opposite*). Picasso, drawing of Maia, colored crayon
(from Deuchler, 1973, fig. 84).

Fig. 335 (*opposite, top*). Picasso, cutout of Maia, back and front,
colored pencil (from Deuchler, 1973, fig. 89).

Fig. 336 (*top*). Picasso, cutout of dove, 1890. Museu Picasso,
Barcelona.

Fig. 337 (*above*). Picasso, cutout of dog, 1890. Museu Picasso,
Barcelona.

Fig. 338 (*opposite*). April Harbour (aged 12), portrait (from *Peintures*, 1945, no. 57).

Fig. 339 (*opposite, top*). Thomas Cole, *The Arcadian or Pastoral State.* New-York Historical Society, New York.

Fig. 340 (*above*). Detail of Fig. 339.

341).[62] From the disparate remarks Brassaï recorded it is clear that Picasso was intensely affected by graffiti: "A wall is a wonderful thing, isn't it? I've always paid close attention to what happens on them. When I was young, I often used to copy the graffiti I saw." And he engaged in the practice himself: "I left lots of them on the walls of Montmartre." He recognized the potentiality as works of art, both of his own graffiti—he told of a banker who had one removed from the wall of a building under renovation and installed on the wall of his apartment— and those of others: "They are really astonishing. What fantastic inventions you sometimes find in

them." Some graffiti are "absolutely splendid . . . They are little masterpieces." He applied the technique to his own work: ". . . now I myself am making graffiti. But they are engraved in cement, instead of on a wall . . . enlarged, and cut out with electric chisels . . . for a building in Barcelona . . . each of them . . . two to three stories high." And he saw the influence of graffiti on other artists: "This is a Rouault!" "That one is a Klee!" Picasso recognized local and regional "styles" of graffiti: ". . . Italian and Spanish graffiti—I know them very well—do not resemble the Parisian graffiti. The phallic symbols you see on the walls of Rome, for instance, are

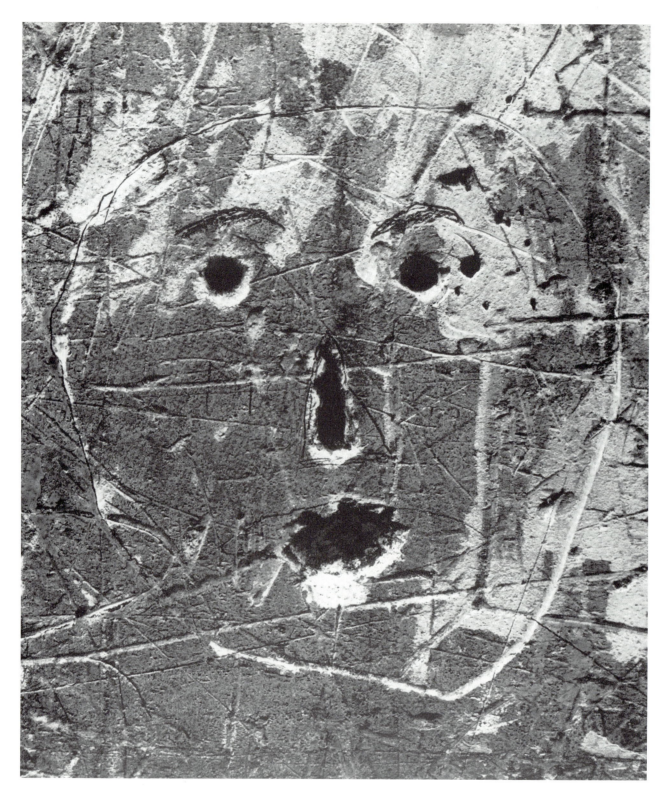

Fig. 341. Brassaï, photograph of a graffito (from Brassaï, 1961, fig. 22).

specifically Italian. Rome is very rich in graffiti, as a matter of fact . . ." At the same time, he grasped their universality, even in the physical sense: "Graffiti belong to everyone and no one . . ." Most important in our context is that Picasso associated graffiti both with the art of children ("I always stop when I see children drawing in the street, or on the sidewalk or on a wall. It's surprising—the things that come from their hands. They often teach me something") and with primitive art: "That [head] is as rich as the facade of a cathedral! . . . Your book links art with the primitive arts." His comments show that he found in graffiti evidence of an ultimate abstract graphic distillation of reality:

> To arrive at abstraction, it is always necessary to begin with a concrete reality . . . I have often done faces like this myself. The people who scratch them out like this naturally gravitate to symbols. Art is a language of symbols . . . Two holes—that's the symbol of the face, enough to evoke it without representing it . . . But isn't it strange that it can be done through such simple means? Two holes; that's enough if you consider the complexity of man . . . Whatever is most abstract may perhaps be the summit of reality . . . abstract art is not far removed from the random brushstrokes or carvings on a wall. No matter what anyone says, we always imitate something, even when we don't know we are doing it.

The history of art thus leads to an art without history that seeks to exorcise the past and discover, or rather rediscover, the magic, the fetish—the will-o-the-wisp, if you will—of our common humanity.

Finally, it must be said that in its deliberateness and coherence the lithographic series seems distinctly pedagogical; the prints have the consequential, demonstrative quality of scholastic exercises. Picasso was not just finding implicit meaning but also, as I suggested earlier, imparting that meaning in an explicit lesson—a lesson not only in genetic history but also in formal as well as graphic method. Indeed, the series strikes me as an ironic but serious shift into reverse of two classic vehicles of European visual sophistication, with which Picasso felt he had been made all too familiar in his youth. One of these preeminently academic systems was theoretical, the other practical, and both involved specific correlations between nature and abstraction. Since the fifteenth century the study of harmonic proportions and geometric figure construction had preoccupied

artists, who sought to retrieve the classical ideal of demonstrably perfect form. Only recently has Picasso's own preoccupation with this subject emerged—a preoccupation crucial for our understanding of the genesis of modern art. At the birth of Cubism, Picasso recalled the theoretical investigations of Albrecht Dürer in creating a new, measured, canon of beauty based on "primitive" sculpture. Picasso studied Dürer in the spring of 1907 while working on *Les demoiselles d'Avignon.* He was evidently inspired by Dürer's Dresden sketchbook, which had been published for the first time in 1905 (Figs. 342, 343).[63] The German artist's effort to reconcile the sometimes crass realism of his native tradition to the norms of antiquity must have seemed singularly appropriate to Picasso in his own search for an unclassical, or rather a proto-classical, ideal.

In the domain of practical pedagogy the drawing manual—the academic course in draftsmanship—was intended, through a series of increasingly complex states, to change the simple and perhaps mystified neophyte into the divine Raphael.[64] Publications illustrating the method begin in 1608 with Odoardo Fialetti's *Il vero modo et ordine per dissegnare tutte le parti et membra del corpo humano* (Fig. 344), and in 1753 William Hogarth anticipated Picasso's reversal of the sequence in one of the plates of his *Analysis of Beauty* (Figs. 345, 346). To be sure, Hogarth's purpose—an irony in itself—was not to undermine the system but to exalt it by starting from an antique head admired by Raphael (no. 97) and showing "the reverse in several degrees, down to the most contemptible meanness that lines can be formed into . . . composed merely of such plain lines as children make" (no. 105).[65] By the mid-nineteenth century in France there was a veritable collision of childishness, caricature, and the academic tradition, with political overtones, in a journalistic cartoon from a mock Exhibition of Fine Arts (Fig. 347).[66] The image portrays the cultural state of the "anonymous Republic" in the "noble genre." An armored Marianne, enthroned on her lion, holds a lance and a schoolchild's tablet displaying the very same elements with which Caroto's young draftsman had confronted the spectator (cf. Fig. 279): a nose, an eye, and a whole figure drawn with evident ineptitude. The lampoon suggests the immense symbolic and practical importance drawing manuals achieved from the mid-nineteenth century on, with the development and dissemination of art education as a

Fig. 342 (*top, left*). Albrecht Dürer, nude figure constructed with annular torso, drawing. MS R-147, fol. 163, Sächsische Landes-bibliothek, Dresden (from Bruck, 1905, pl. 74).

Fig. 343 (*top, right*). Picasso, study of nude with annular torso-arms, drawing. Carnet no. 7, fol. 59, private collection (from Zervos, 1932–78, vol. 26, no. 256).

Fig. 344. Odoardo Fialetti, noses (from Fialetti, 1608, fol. 8).

Fig. 345 (*top*). William Hogarth, *Analysis of Beauty*, 1753, Plate I.

Fig. 346 (*above*). Detail of Fig. 345.

Fig. 347 (*above*). "République anonyme (genre noble)" (from *Le Pamphlet,* 1848, 4).

Fig. 348 (*above, right*). Seated nude, lithograph (from Bargue, 1871, no. 1).

Fig. 349 (*right*). Van Gogh, seated nude after Bargue, drawing. Stedelijk Museum, Amsterdam.

means of elevating popular culture. Van Gogh taught himself to draw by copying no fewer than three times the schematized exemplars in an important series of albums published by Charles Bargue in 1868–71 (Figs. 348, 349).[67] One of Picasso's early art school drawings (1892–93) shows him following precisely the same method, progressing from abstraction to illusion, from simplicity to sophistication (Figs. 350, 351). Indeed, the sheet is also copied from one of Bargue's plates, as is Picasso's contemporaneous drawing of a seated nude (Figs. 352, 353).[68] Here we see Picasso laboriously learning what he later took years to unlearn. Lithography —which demonstrated, especially through the technique of stumping, the transition from line to modeling—was the process of choice for illustrating such publications; perhaps it was this very association that motivated Picasso's disdain for the lithographic medium before the period with Mourlot.[69] The academic system in general comprised three basic elements, all of which have counterparts in Picasso's attitude. The method progressed in stages with respect to form, technique, and subject: (1) from simple geometric shapes to complex curved and undulating surfaces; (2) from linear definition to interior modeling and cross-hatching; (3) from parts or fragments of the anatomy to the complete body.

Fig. 350 (*top*). Studies after a sculpture by Germain Pilon, lithograph (from Bargue, 1869, pl. 35).

Fig. 351 (*above*). Picasso, profile heads after Bargue, drawing. Estate of the artist, Paris.

Fig. 352. Seated nude, lithograph (from Bargue, 1871, pl. 39).

Fig. 353. Picasso, seated nude after Bargue, drawing. Estate of the artist, Paris.

Picasso's bull progresses in exactly the opposite way and arrives at a coherent and unified design of a whole new figure.

Seen in this light, Picasso's graphic method in the lithographs becomes crucial: it is not merely a progressive simplification and abstraction; in each series *contour* tends increasingly to predominate, until ultimately the ferocious bull is subdued by one continuous outline of quite enchanting grace. The modeling of brute form is metamorphosed into the delineation of pure spirit—there is no other way to describe the simultaneous degeneration of the bull and regeneration of this ethereal and apocalyptic beast. By his ironically serious reversal of tradition and evocation of "artlessness," Picasso seems to have given shape at last to that mystical ideal of *disegno interno* (inner design) artists had been dreaming of since the Renaissance.

These considerations, in turn, help to illuminate specific stages in Picasso's lithographic bullfight. I believe he conceived the series as a graphic *corrida*, with the lithographic stone as the arena.[70] The confrontation at first progresses in the traditional way, with the forms becoming denser and more richly

modeled while the bull becomes heavier and more aggressive (see Figs. 308, 309). Then Picasso begins his attack: the forms coagulate and break into gruff, rhinoceroslike sections (Fig. 310). On one momentous day, Picasso made two crucial "passes": in a sort of sketch-lithograph he drew a delicate, purely linear bull, along with a menagerie of much less intimidating animals—rams, a cow, and doves (see Fig. 320); in the main bull itself he introduced lines that delimit its constituent parts and change its dumb, brutish expression into an almost caricatured scowl (see Fig. 311). The dual principle implicit in these parallel works continues thereafter. In the monumental isolated bull the preponderance of dark and modeled areas tends to diminish step by step in a relentless ritual of decimation and dismemberment (see Figs. 312–317). In a number of drawings and collateral lithographic "spin-offs" the bull is already conceived as a purely linear wraith, not in grandiose isolation but in small, multiple guises (see Figs. 322, 323, 325–327). Here the bull's awesome power is "exorcised" in a humorous and playful game of hide-and-seek. The once threatening enemy becomes Picasso's pet, executing a repertory of witty tricks

and permutations like a tame circus animal commanded by its handler. Only in the eleventh and final state are the lessons learned in the practice pen, as it were, applied unflinchingly in the main arena. The coup de grace to the earthly academic bull is elegantly delivered by the reduction of his entire body to a simple continuous outline.

Even in his own working procedure, therefore, Picasso transferred to the realm of "high" art the qualities achieved in a domain of informal, spontaneous creativity. It can hardly be coincidental that during the same period Picasso also produced lithographs of bulls and actual *corrida* scenes (Figs. 354, 355), for which he invented a radical collage technique employing crudely cut out paper figures like those he had made both as a child and, later, for his infant daughter (cf. Figs. 336, 337).[71]

If this view of Picasso's lithographic series is correct, it implies an absolute historicism from whose all-encompassing scrutiny nothing escapes, not even the artist himself. In this context one of the most salient manifestations of Picasso's conception of his own work may be understood. I refer to his practice —obsession, one is tempted to say—from his earli-

Fig. 354 (*above*). Picasso, bulls, December 15, 1945, lithograph. Mourlot no. 10.

Fig. 355 (*top*). Picasso, bullfight, January 7, 1946, lithograph. Mourlot no. 25.

est childhood to sign his works, however slight and ephemeral, and to date them to the very day they were executed; when several versions of the same work were done on the same day, he would often number them in sequence. No other artist has left such a complete record of his production. It might be tempting to attribute this preoccupation to megalomania; no doubt pride played a role, and certainly Picasso in this way fixed his own place in history with unprecedented precision. More to the point, in my view, is the implicit identification, through the historical process, of the individual self with human nature at large. This seems to me the ultimate meaning of Picasso's luminous notion, in the statement quoted earlier, that the record of the metamorphoses of a work of art might help to "discover the path followed by the brain in materializ-

ing a dream." Picasso made this point explicit in explaining why he dated his work, paradoxically linking—through the history of art, particularly his own—human creativity and science, subjectivity and objectivity, personal and collective awareness:

Why do you think I date everything I do? Because it is not sufficient to know an artist's works—it is also necessary to know when he did them, why, how, under what circumstances . . . Some day there will undoubtedly be a science—it may be called the science of man—which will seek to learn more about man in general through the study of the creative man. I often think about such a science, and I want to leave to posterity a documentation that will be as complete as possible . . . That's why I put a date on everything I do . . . [72]

SYNOPTIC TABLE OF PICASSO'S BULLS (DECEMBER 5, 1945 TO JANUARY 18, 1946)

Fig.	States			Drawings	Collateral Lithos	Date	Location	
	M	*Db*	*B*					
308	I	48	I			Dec. 5	NGA	NS
319		49	II			Dec. 12		NS
		50						
		[heavier ink]						
309	II	51	III			Dec. 12	NGA	NS*
310	III	52	IV			Dec. 18	NGA	NS
311	IV	53	V			Dec. 22	NGA	NS
320					Mourlot 21 Db 72	Dec. 22		
312	V	54	VI			Dec. 24	NGA	NS
321				Z XIV 130		Dec. 24	MP	
322					Mourlot 27 Db 64	Dec. 25		
323					Mourlot 28 Db 65	Dec. 25		
324		55	VII			Dec. 24–26	NGA	NS*
313	VI	56	VIII			Dec. 26		
314	VII	57	X			Dec. 28	NGA	NS†
		58						
		[counterproof]						
315	VIII	59	XI			Jan. 2	NGA	NS
325				Z XIV 132 Da 94 Db 66		Jan. 5	Christie's Dec. 2, 1980	
316	IX	60	XII			Jan. 5	NGA	NS
		61						
		[counterproof]						
326				Z XIV 133 Da 95 Db 67		Jan. 9, 10		
317	X	62	XIII			Jan. 10	NGA	NS
327				Z XIV 136 Da 96 Db 68 top		Jan. 11, 17		
318	XI	63	XIV			Jan. 17	NGA	NS†
				Z XIV 135 Da 98 Db 68 bottom		Jan. 18		
				Z XIV 135 Db 69 Da 97		Jan. 18		

Abbreviations

B	Baer (privately)	M	Mourlot, 1947–64	NS	Norton Simon Museum
Da	Deuchler, 1973	MP	Musée Picasso	Z	Zervos, 1932–78
Db	Deuchler, 1974	NGA	National Gallery of Art		

* Signed on back by Marie-Thérèse Walter
† Signed on front by Marie-Thérèse Walter

I. Donatello's Bronze Pulpits in San Lorenzo and the Early Christian Revival

The gist of this paper was first presented at a meeting of the College Art Association of America, February 1986. An earlier version was published in German in Cämmerer, ed., 1989, 155–69. I have profited greatly from the suggestions of kind and knowledgeable friends: Isabelle Hyman, Ernst Kitzinger, Howard Saalman, and Marvin Trachtenberg. Beverly Brown generously allowed me to read and learn from a draft chapter on San Lorenzo and Santo Spirito in the study she is preparing, entitled *Sacred Settings: Choir and Altar Placement in Renaissance Italy.*

1. Lavin, 1959 (my main conclusions were adopted earlier by Janson, 1957, 209ff.). The pulpits have since been the subject of a number of studies, listed here, to which I shall refer individually only as they affect my own argument: Herzner, 1972; Becherucci, 1979; Parronchi, *Donatello,* 1980; Greenhalgh, 1982, 193–99; Bennett and Wilkins, 1984, 11–28.

2. In my original study (Lavin, 1959, 19 n. 4) I argued for the coherence and meaningfulness of the relationship between the two narrative sequences; but I allowed that the striking formal differences between the two pulpits—relatively rational and spacious Passion scenes vs. smaller and more crowded and "expressionistic" post-Passion miracles—may have been due to a chronological gap. I am now inclined to believe that the visual juxtaposition was also a deliberate complementary contrast—a reversal, as it were, of the relationship on the Padua altar between the scenes of St. Anthony's miracles and the Entombment of Christ.

3. Lavin, 1959, 38.

4. I am grateful to Professor Davis for a typescript copy of his paper, since published with a different title (Davis, 1988). The basic work on the early accounts of the Roman origins of Florence is that of Rubinstein, 1942. On Florence as the New (imperial) Rome, see Simons, 1987, 245f., with further references. Davis's observation of the equation of Christian Rome and Florence was adumbrated in Green, 1972, 137f.

5. "Et sicut est ab uno latere urbis Roma ecclesia beati Petri, ita est in civitate Florentiae. Et sicut est ab uno latere urbis Romae ex adverso ecclesia beati Pauli, et ita in civitate Florentiae. Et sicut

est ecclesia beati Laurenzii martiris ex una parte urbis Romae, ex adversa parte ecclesia beati Stephani, et ita in Florentiae. Et sicut est ex una parte urbis Romae ecclesia Sanctae Iohannis in Laterano, ita est major ecclesia civitatis Florentiae" (Hartwig, 1875, 59).

6. "... e di fuori di quella porta fu edificata la chiesa di San Lorenzo, al modo ch'è in Roma San Lorenzo fuori le mura..." (Villani, 1823, I, 138).

7. Cf. Green, 1972, 137.

8. "Il dirsi, che i Fiorentini, come imitatori dell'azzioni de' Romani, e massime de' Riti appartenenti alla Religione, ne permettessero l'edificazione fuori della Città, corrispondente a quella, che il Magno Costantino edificò, ancor egli ad onor di S. Lorenzo, fuori delle Mura di Roma, non è fuor di proposito, si come non è del tutto vano l'openione di quelli, che portano per secondo motivo, esservi seguito ciò, come Fabbrica alzata sopra alle rovine, d'un di questi Edifizi de' Gentili, che spartiti in tre Navate..., chiamati per la lor magnificenza Basiliche..." (Del Migliore, 1684, 157).

9. Frey, *Codice*, 1892, 66; *idem*, *Libro*, 1892, 33.

10. The orientation is discussed by Hager, 1962, 100f., and Nussbaum, 1965. On the Ambrosian rite, see p. 23 below; on Rome, see J. Braun, 1924, I, 411.

11. Burns, 1979; Olivato, 1980, 804 and 806 n. 14. Burns dates the plan 1490–1510; in fact, it must precede a documented reconstruction of the high altar in 1499 (see n. 26 below).

12. Richa, 1754–62, V, 57, reports the change in 1622.

13. The new choir arrangement was emphasized by Brunelleschi's early biographer, Antonio Manetti, and by Vasari; the former attributes the idea to Cosimo, the latter to Brunelleschi (cf. Manetti, 1970, 109, 147f. n. 143; Vasari, 1966–, Testo III, I, 185).

14. Cf. Apollonj Ghetti *et al.*, 1951, 161ff.; Krautheimer *et al.*, 1980, 265f.

15. Del Migliore, 1684, 167f., cited by Young, 1923, I, 132ff.

16. Clearfield, 1981.

17. On this point see Gutkind, 1938, chapter III, "Cosimo, *Primus Inter Pares*."

18. Manetti, 1970, 147 n. 143.

19. As noted by Frommel, 1977, 47 n. 86, and Clearfield, 1981, 21. On the attribution see Paatz and Paatz, 1952–55, II, 498, 565 n. 202; Janson, 1957, 134 n. 1.

After completing this essay I received the typescripts of important papers dealing with Verrocchio's Medici tombs, by S. McKillop, W. S. Sheard, and C. Sperling (all forthcoming; see Bibliography), whose arguments at several points intersect and reinforce my own. Particularly relevant are McKillop's exploration of the liturgical context for the developments at San Lorenzo (see p. 23 below), Sheard's discussion of the symbolic use of porphyry in these monuments (pp. 15–17 below), and Sperling's reference of the installation of the tomb of Cosimo's parents to the early tradition of placing martyrs' relics beneath the mensa, or altar table (p. 15 below; see also Fortuna, 1960, 11).

20. Janson, 1957, 232ff. Janson rejected Vasari's anecdote as well as the attribution to Donatello, but there is no consensus; see Bennett and Wilkins, 1984, 235 n. 16. The recent discovery that the bronze slab was sent to Rome from Florence (Esch and Esch, 1978) seems to me to lend weight to Vasari's story: a trip to Rome would have been necessary for the inspection of the prospective site of the monument.

Clearfield, 1981, 29 n. 74, cites several instances of burials of private citizens near high altars. Cf. Gaston, 1987, 123.

21. Cf. Lauer, 1911, 273f., 436 col. 1; Montini, 1957, 270.

22. Cf. Paatz and Paatz, 1952–55, II, 465, 518 n. 4.

23. Beck, 1984, 213ff.

24. Parronchi, 1965, 131; cf. further *idem*, "Un tabernacolo," 1980.

25. "Per tutto il mese di luglio 1461 si murò l'altare maggiore nostro"; "Per tutto dì primo d'agosto 1461 fu murato interamente il tabernacolo del Corpo di Cristo"; "... 9 d'agosto 1461 fu consecrato detto altare maggiore..." (Beck, 1984, 215).

Unaware of Beck's contribution, Van Os (1988–90, II, 209ff.) assumed that the high altar at San Lorenzo had no altarpiece.

26. Beck (1954, 214f.) documented a complete reorganization of the high altar in 1499, at which time Desiderio's tabernacle must have been moved to the Medici chapel, then dedicated to Cosmas and Damian and thereafter also referred to as the Chapel of the Sacrament.

27. The basic essay on the drawings referred to is by Kurz, 1955; Ames-Lewis, 1985, 216, has also emphasized that the relevant drawings are for freestanding altars and relates them to a work of this kind at Prato commissioned by a son of Cosimo de' Medici. The studies clearly seek to resolve the problem of combining a monumental Sacrament tabernacle with an altarpiece by placing the former atop the latter, an arrangement that had no long-term success (although Carl, 1990, 1991, has shown that it was occasionally carried out); this further suggests that the prototype, Desiderio's tabernacle, stood free, without an altarpiece. In fact, as Van Os observed (1988–90, II, 209ff.), there is no evidence that the high altar at San Lorenzo had a proper altarpiece. In a recent article Dunkelman (1991) stresses the importance of the three-dimensional character of Donatello's Sacrament tabernacle in St. Peter's; might the St. Peter's tabernacle itself once have stood free and hence foreshadowed the San Lorenzo tabernacle in this as in other respects?

The rectangle shown behind the priest's platform in the Venice plan cannot be a step, which would normally have extended along the sides of the platform as well.

28. On the St. Peter's altar see J. Gardner, 1974, 61 n. 23, 78f.; Kempers and Blaauw, 1987, 93ff. With the arrangement I propose, the altarpiece when seen from the nave would indeed have appeared to stand *on* (or above) the altar. (As far as I am aware, no one has considered the solution offered here to the problem of the Stefaneschi altar.) On the Pala d'Oro, cf. Fiocco, in Hahnloser, ed., 1965, 81f. On the chapel at Orvieto, Fumi, 1896; Benois *et al.,* 1877, pl. I,

for a plan. Nicholas of Verdun's enamel altar at Klosterneuberg may have been given a similar disposition at this same period; cf. Fillitz, 1984, esp. 86.

29. Janson, 1957, 207.

30. Speaking of Donatello's works for Cosimo at San Lorenzo, Vasari mentions the stucco decorations and bronze doors of the Old Sacristy, the "quattro figure di stucco, grandi, che sono ne' tabernacoli della crociera della chiesa, e le cere da far gittare di bronzo i pergami di San Lorenzo, ed il modello dell'altar maggiore con la sepultura di Cosimo a' piedi" (Vasari, 1906, VIII, 99). Referring to this passage, Herzner (1972) proposes that the reliefs of the right-hand pulpit were originally intended for the tomb, even though Vasari clearly distinguished between the pulpits and the tomb; elsewhere, Herzner argues that Donatello left Siena for lack of funds, rather than for a Medici commission (1971, 176f.). With regard to the first point, Herzner fails to consider that the tomb in question might be the one actually executed by Verrocchio; with regard to the second, he fails to note the coincidence of Vasari's report with the date of Donatello's return to Florence and the date of the consecration of the high altar.

31. It is worth recalling Vasari's report that at Cosimo's wish Donatello was buried near his own tomb "so that the dead body should be near him in death, as they had always been near in spirit when alive" ("a cagione che così gli fusse vicino il corpo già morto, come vivo sempre gli era stato presso l'animo"; Hinds, 1963, I, 312; Vasari, 1906, VIII, 99). Documentary confirmation of the report was discovered by Lightbown, 1980, II, 327f.

32. Becherucci, 1979, 7; cf. Passavant, 1969, 171, and Garzelli, 1983. This is not to deny that Verrocchio may have influenced the design. Vasari reports Verrocchio's early interest in geometry, and Verrocchio later echoed the materials, technique, and pattern of the Cosimo marker in the platform on which his tomb of Piero and Giovanni de' Medici rests (Passavant, 1969, 9; Seymour, 1971, 51). The pattern of the bronze

gratings recalls those used by Brunelleschi in the cupola of the Old Sacristy (Luporini, 1964, figs. 228–33).

33. Del Migliore, 1684, 164.

34. On this point, see Lavin, 1959, 23; Beck, 1984, 216. A close model for this arrangement may have been provided in the Brancacci chapel in Santa Maria del Carmine; it has been suggested that the altar there may have been decorated with Donatello's early relief of Christ giving the Keys to St. Peter in the Victoria and Albert Museum, London, thus explaining the absence of this crucial subject from Masaccio's fresco cycle (Pope-Hennessy, 1964, I, no. 61, 70–73). It is also interesting to speculate—as Marilyn Aronberg Lavin has pointed out to me—that Donatello's pulpit narratives may help to explain the striking absence of Christological subjects, except for the crowning figure of Christ in Glory, in the fresco cycle including Old Testament and eschatological scenes executed in the choir of San Lorenzo around the middle of the sixteenth century by Pontormo (see Cox-Rearick, 1964, I, 318ff.).

35. Seymour, in particular, saw the relationship between the tomb, the high altar, and the pulpits (1971, 50f.); Becherucci, 1979, 10; Beck, 1984, 217.

36. On the dome, see pp. 21f. below. Vasari also perceived Donatello's work at the crossing as a unified whole, mentioning together the evangelists, the pulpits, the high altar and the tomb; see n. 28 above. On the stucco figures, see the literature cited by Paatz and Paatz, 1952–55, II, 512, 588 n. 287.

37. Ruschi, 1986, 23 n. 28. Cf. Delbrueck, 1932, 27ff., 148ff. and Deér, 1959, 149. On the last point, see the illuminating essay by Tronzo, 1985, 101ff., and that by M. A. Lavin, 1985. Seymour (1971, 55) noted the resurrectional symbolism of the vestment table and related it to Brunelleschi's allusion to the Holy Sepulcher in the design of the Old Sacristy.

38. For a perceptive discussion of the technique, see Passavant, 1969, 10.

39. Cf. Kitzinger, 1970; Zischka, 1977; Leite de

Vasconcellos, 1918, 69–71.

40. Cf. Kier, 1970, fig. 280.

41. The analogy was the subject of a perspicacious observation by M. Kemp, 1981, 110f.

42. Cf. Heydenreich, 1971, 61ff.

43. Cf. Calderini et al., 1951, 46ff.

44. Cf. Heninger, 1977, 109f.; Murdoch, 1984, 356. Our Fig. 25 (Heninger's fig. 66) is from the editio princeps of Isidore's De natura rerum, Augsburg, 1474. The tetradic diagram, which also relates to the theme of the Four Ages of Man, is discussed by Sears, 1986, 16–20, who reproduces many similar schemata.

45. Murdoch, 1984, 102; Masi, 1983, 87–89. Barbara Obrist kindly brought this comparison to my attention. Cosimo owned a Boethius manuscript as early as 1426; see Gutkind, 1938, 228. A strikingly similar design, no doubt of related origin, appears on a late fifteenth-century Ottoman talismanic shirt in the Topkapi Museum, Istanbul, that is covered with magical diagrams containing numbers and Koranic verses (Circa 1492, 1991, 198–200).

46. The geometry of the design has been studied in this sense by Adorno, 1989, 46f.

47. "Sed velim in templis cum pariete tum et pavimentum nihil adsit quod meram philosophiam non sapiat"; "Maximeque pavimentum refertum velim esse lineis et figuris, quae ad res musicas et geometricas pertineant, ut ex omni parte ad animi cultum excitemur" (Alberti, 1966, II, 611).

48. I am greatly indebted to Ernst Kitzinger for reminding me of this precedent, for which see the fine essay by Wander, 1978; also Claussen, 1987, 176–85; and Binski, 1990.

49. Kier, 1970, fig. 348.

50. On the pavement, cf. Biagetti, 1933, 211ff., and Gilbert, 1975, 253; on the portrayal of the Constantinian basilica, Krautheimer, 1977.

51. Cosimo's philosophical readings, especially of Plato, with Marsilio Ficino, are described by Gutkind, 1938, 239ff. On the cosmic pun, see Chastel, 1961, 227ff.; M. A. Lavin, 1974, 364 n. 94 (a strikingly similar pun was made on Sigismondo Malatesta's given name); Cox-Rearick, 1984, index, p. 326, s.v. "Cosmos"; for

the reprise of the name and the pun by Cosimo I in the sixteenth century, see Crum, 1989, 248–50.

After this essay was completed I learned, thanks to Günter Passavant, that precisely the same observation concerning the tomb slab of Cosimo was made by Liebenwein, 1977, 52, 241 n. 186. Recently, Weil-Garris has related Raphael's cupola of the Chigi chapel to the same cosmographical tradition (1986, 138–40).

52. Following the recent cleaning (Lapi Ballerini, 1986), the most likely date for the sacristy cupola has been established by Forti *et al.,* 1987; further observations concerning the date will be found in a study being prepared by Kristen Lippincott. The association with the re-foundation horoscope of Florence is developed in a forthcoming essay by Peter Blume, "Regenten des Himmels. Zur Geschichte astrologischer Bilder in Mittelalter und Renaissance." I am much indebted to Lippincott and Blume, who kindly allowed me to read their work in manuscript. For other recent interpretations of the cupola, see Lapi Ballerini, 1988, Beck, 1989, L. Schneider, 1990, 268ff. For Cosimo's contract with the Canons, August 13, 1442, see Ginori Conti, 1940, 62f., 240ff.

53. On the dome of San Lorenzo, see Manetti, 1970, 108–9, 148 nn. 145, 146; Hyman, 1978, 269f.

54. The first observation was also made by Adorno, 1989, 46. On the second point see the master's thesis by Nyberg, 1953, 15–20; Heydenreich and Lotz, 1974, 8; Scarchilli, 1977, no. 1, 43–47. These relationships give particular meaning to Paolo Giovio's observation (cited by Clearfield, 1981, 22) that the entire church served as Cosimo's sepulcher.

55. Gutkind, 1938, 241; Chastel, 1954, 8. Hankins's recent (1990, 1991) deflation of the institutional character commonly attributed to Ficino's academy and transferal of its locus from Careggi to the Ficino family home in Florence do not affect the argument here.

56. For a helpful discussion, based on Dürer's woodcut copies of the designs, see Talbot, ed., 1971, 173f.; also Pedretti, 1981, 296ff.; Alberici, ed., 1984, 21f.

57. See Saffrey, 1968.

58. ". . . omnes mundi partes, quia unius artificis opera sunt, eiusdem machinae membra inter se in essendo & uiuendo similia, mutua quadam charitate sibi inuicem uinciutur, ut meritò dici possit amor nodus perpetuus & copula mundi, partiumq. & eius immobile sustetaculum, ac firmum totius machinae fundamentum" (Ficino, 1576, 2: 1330, cf. Marcel, 1956, 165). The leading phrase of Ficino's motto for his own Academy had a similar ring: "à bono in bonum omnia diriguntur" (Ficino, 1576, 1: 609). See Kristeller, 1943, 112, 145, 296, and, in relation to Ficino's Platonic Academy, *idem,* 1965, 96ff. Ficino's academy was also imbued with a sense of cosmic irony by a depiction on one of the walls of the philosophers Democritus and Heraclitus flanking a terrestrial globe, the one laughing, the other weeping at the foolishness of worldly concerns (Della Torre, 1902, 639f., recorded in a fresco fragment by Bramante from a house in Milan, *Circa 1492,* 1991, 229).

Three passages in Leonardo's own notebooks are relevant in this context. "Nō mi legga, chi non è matematico, nelli mia prīcipi" (Let no man who is not a mathematician read the elements of my work [Richter, 1939, I, 112, no. 3]) is an obvious allusion to the inscription on Plato's Academy. "Amor ōnj cosa vīce" (Love conquers everything [Pedretti, 1977, II, 250]) may involve a further pun linking Leonardo's name to the idea of Love as the binding force of the universe. "Mvouesi l'amante per la cosa amata come il senso . e lo sensibile, e cō seco s'uniscie e fassi vna cosa medesima; l'opera è la prima cosa che nasce dall'unione . . ." (The lover is moved by the beloved object as the senses are by sensible objects; and they unite and become one and the same thing. The work is the first thing born of this union . . . [Richter, 1939, II, 249, no. 1202]) is clearly of Neoplatonic inspiration and again expresses the uniting force of love.

In an ironic passage in the *Republic* concerning

the education of the young, Plato himself associates geometry and eros through the notion of binding necessity: the students, living in close proximity, will mate "not by the necessities ['ανάγκη, also bonds, constraints] of geometry but by those of love, which are perhaps keener and more potent than the other to persuade and constrain the multitude" (Shorey, 1956, I, 456ff.).

Finally, the interlace pattern enveloping the name Julius II in the altar in Raphael's *Disputa* should be recalled in this connection (Pfeiffer, 1975, 94, 196).

59. Pedretti (1980 and 1981, 298) has revived an eighteenth-century idea that the designs may have been intended for floor decorations in central-plan churches, referring also to Michelangelo's Capitoline pavement, which in turn has been compared to medieval astronomical schemata illustrating Isidore of Seville's *De natura rerum* (Ackerman, 1961, I, 72, pl. 38c).

60. On the Sala delle Asse, see M. Kemp, 1981, 181ff.

61. "Itaque postquam Platonis librum de uno rerum principio, ac de summo bono legimus . . . paulo post decessit . . . Vale, & sicut Deus Cosmum ad ideam mundi formauit, ita te ipse . . . ad ideam Cosmi figura" (Ficino, 1576, I, 649). Ficino repeats the account in the preface to his translation of another, pseudo-Platonic, dialogue on death. See Klibansky, 1943, 314f.; A. M. Brown, 1961, 203f.

62. Shorey, 1956, II, 86ff., 184ff.

63. One of the pulpits, at least, served this purpose in 1515. Kauffmann, 1936, 179, even supposed they were intended as singers' tribunes; but see Janson, 1957, 213f. The existence of a singers' tribune (also often attributed to Donatello) in the left aisle over the portal to the cloister, however, did not preclude the use of the bronze pulpits for singing as well.

64. Cf. Pope-Hennessy, 1971, 253, 273f., and *idem*, 1980, 20; Haines, 1983, 117ff. A valuable contribution emphasizing the liturgical complementarity of the cantorie is that by Tōyama, 1990.

65. I follow here a suggestion by Battisti, 1981, 369 n. 17. As McKillop points out (forthcoming), the Ambrosian rite also normally calls for the altar to be oriented *versus populum.* On the Ambrosian chant, and *Confessions* 9.6–7, see Cattaneo, 1950, esp. 12ff.

66. See Morrogh, 1985.

67. See Morselli, 1981.

68. Frommel (1977, 47) also notes that the idea may have originated in the placement of the tomb of Cosimo's mother and father under the dome of the Old Sacristy.

69. Burns, 1979, 150.

70. Parronchi, "Un tabernacolo," 1980, documents a marble Sacrament tabernacle by Brunelleschi, 1426–27, placed in relation to the high altar of San Jacopo in Campo Corbolini in Florence, but the wording is not clear.

71. Barocchi, 1962, 120f.; Wallace, 1987, 45f. The high altar is shown close to the steps leading to the choir, and therefore oriented *versus populum,* in an anonymous plan of about 1550 and in a sketch plan by Sallustio Peruzzi (Burns, 1979, 149 fig. 4, 153 n. 11).

72. Baronio's projects have been studied most recently in a paper by a former student of mine, Alexandra Herz, 1988. Herz compares these projects to the medieval presbytery of St. Peter's.

2. David's Sling and Michelangelo's Bow

An earlier version of the first part of this essay was presented at a colloquium entitled "Der Künstler über sich in seinem Werk," organized by Matthias Winner at the Bibliotheca Hertziana in Rome in February 1989. In the discussion that followed Horst Bredekamp, Phillip Fehl, Kristina Herrmann Fiore, Christoph Frommel, Justus Müller-Hofstede, and Matthias Winner made especially helpful comments. I have incorporated several of their suggestions here. The present version was published in abbreviated form in the Acts of the Twenty-Seventh International Congress for the History of Art at Strasbourg in September 1989 (Lavin, "David's Sling," 1990).

1. Because the fascinating story of the David as

told by Vasari will be referred to repeatedly, it is quoted in full in the Appendix to this chapter (see pp. 59–61).

2. A handy survey of "Davidiana" will be found in the notes of Barocchi, 1962–72, II, 190ff. More than any other scholar Charles Seymour (1974) perceived Michelangelo's identification of his personal artistic accomplishment in the *David* with the monument's public mission in the republican cause. My own observations partly differ from and partly develop, but do not re-place, those of Seymour. One important differ-ence is that Seymour is at pains to discredit Vasari's account of the *David* as reflecting mid-sixteenth-century anti-libertarian bias. For exam-ple, Seymour dismisses Vasari's report that Piero Soderini was involved in the commission because Soderini is described as *gonfaloniere* for life, a posi-tion he acquired only a year later, in 1502. In fact, Soderini had already been elected *gonfaloniere* for a two-month term, March–April 1501 (Bertelli, 1971, 344), just before the project was officially revived in early July. Interestingly enough, in the first edition of the *Vite*, 1550, Vasari's statement was perfectly accurate since he did not refer to Soderini's lifetime appointment and noted prop-erly that Soderini *had been gonfaloniere*: "già gon-faloniere in quella città" (Barocchi, 1962–72, I, 19). The anachronism introduced in the second, 1568, edition—"fatto gonfaloniere a vita allora in quella città" (*ibid.*)—was clearly inadvertent. We shall see that Vasari did indeed join in the later Medicean effort to disarm the anti-Medicean thrust of the statue, but precisely because he was well aware of its original intent.

My view of the anti-Medicean political im-port of the *David* is essentially in line with that of Levine, 1974, although I would not follow a number of his arguments; the main difference, however, is that my point of departure is the Louvre drawing, which Levine does not consider.

3. For a full discussion of the drawing and further bibliography, see Seymour, 1974, 3ff.; Summers, 1978.

4. The opening stanza is as follows:

Rotta è l'alta colonna e 'l verde lauro,
Che facean ombra al mio stanco pensero;
Perduto ò quel che ritrovar non spero
Dal borrea a l'austro, o dal mar indo al mauro.

Chiòrboli, 1923, no. CCLXIX, 621ff., with com-mentary. Rendered as follows by Armi, 1946, 387:

Broken the column and the green bay tree
That lent a shade to my exhausted thought;
And I have lost what can nowhere be sought
In any distant wind or distant sea.

5. Brion, 1940, 102; Seymour, 1974, 7ff. Surveys of the various interpretations will be found in Clements, 1961, 416f., and Seymour, 1974, 84f.; see also Summers, 1978, 116. Brion's suggestion has been largely overlooked, and Seymour does not cite it, although the title of his chapter on the subject is curiously similar to Brion's.

6. For an interpretation of Michelangelo's technical feat in relation to his novel use of preliminary models, see Lavin, 1967, 98ff.

7. On the symbolism of the column, see Tervarent, 1958, I, 106ff., and, with reference to Michel-angelo's drawing, Summers, 1978, 119f. n. 17. As far as I can discover, no attempt has been made to explain the significance of the column in Byzantine scenes of David as psalmist (for which see Cutler, 1984, index, *s.v.* "David" and "Melo-dia"; Suckale-Redlefsen, 1972, 38).

8. Various uses of the compass are illustrated in Carradori, 1979, and in *La Sculpture*, 1978, 582f., 592; for the *circinus arcuatus* in antiquity see Zimmer, 1982, 168f.

9. On this concept, see the literature cited in Barocchi, ed., 1962–72, IV, 1853ff.; Clements, 1961, 29ff.; Summers, 1981, 332ff.

10. For what follows here, see Lavin, 1967. The rela-tionship between Michelangelo's *David* and that of Agostino di Duccio has recently been dis-cussed by Parronchi, 1989–90.

11. "Così adunque operando si pigliano gli animi

de' suggetti; dàssi altrui materia di bene operare, e le fame eterne s'acquistano. Alla qual cosa oggi pochi o niuno ha l'arco teso dello 'ntelletto" (cf. Battaglia, 1961–, I, 631).

12. Battaglia, 1961–, I, 631; Symonds, 1893, I, 107 n. 2.

13. We owe this important understanding of Dürer's painting as an allegory of the artist's victory over his detractors to Fiore, 1989.

14. The same conflation underlies Dürer's use of this classical subject in the prayer book of Maximilian I to illustrate the opening verses of the Nineteenth Psalm, where heaven is cleansed of falsehood by Maximilian-Hercules's handiwork (*opera manuum eius adnuntiat firmamentum*) and the word of God is ubiquitous (Sieveking, ed., 1987, p. XXIII, fol. 39v.; Strauss, ed., 1974, 78; and especially Vetter and Brockhaus, 1971–72, 81f.). Dürer must have known a text and illustration such as that in the manuscript of Pietro Andrea di Bassi's *Le fatiche d'Ercole* (Bassi, 1971, 77, 81f.).

15. "L'arco, e la frezza in atto di tirare, mostra l'inuestigatione, e l'acutezza.

Et gl'Egittij, & Greci, per Hieroglifico dell'Ingegno, & della forza dell'intelligenza dipingeuano Hercole con l'arco in vna mano, & nell'altra vna frezza con tre punte, per dimostrare, che l'huomo con la forza, & acutezza dell'ingegno, va inuestigando le cose celesti, terrene, & inferne, ouero, le naturali, diuine, & matematiche, come riferisce Pierio Valeriano nell'aggiunta dell'Hieroglifici" (Ripa, 1603, 220; the reference is to Valeriano, 1602, 624).

16. The five preserved drawings for this heretofore unexplained project are reproduced and discussed in Monducci and Pirondini, eds., 1987, 208ff.

17. Echols, 1961, 36.

18. There is still another dimension to this perspicuous invention. In maintaining the superiority of painting over sculpture, Orsi, who was strongly imbued with Northern traditions, is surely also referring to an important and well-known passage concerning the nature of the icon, with which Nicholas of Cusa introduced his treatise on the sight of God (*De visione Dei*). To illustrate the all-seeing eye of God, Cusa describes a painting on the city hall of Nuremberg depicting a bowsman aiming his arrow, which seemed to follow the spectator wherever he moved. The image is reflected in a number of early drawings and prints. Cf. Mende, 1979, no. 573, 429f., with further bibliography.

19. I have commented on the relationship between the text and the drawing on this sheet in Lavin *et al.*, 1981, 34.

20. c'a forza 'l ventre appicca sotto 'l mento.
. .

e 'l pennel sopra 'l viso tuttavia
mel fa, gocciando, un ricco pavimento.
. .

e tendomi come arco soriano.
 Però fallace e strano
surge il iudizio che la mente porta,
chè mal si tra' per cerbottana torta.
 La mia pittura morta
difendi orma', Giovanni, e 'l mio onore,
non sendo in loco bon, nè io pittore.

Girardi, 1960, 4f., translation adapted from C. Gilbert and Linscott, 1963, 5f. The sheet has most recently been dated 1511–12 by Tolnay, 1975–80, I, 126.

21. Ginzberg, 1938, III, 456; IV, 87; VI, 251.

22. For example, Tolnay, 1943–60, I, 153f.

23. On Egidio, with references to the earlier literature on the passion of Christian humanists for Hebrew learning, see O'Malley, 1968. On the relevance of Egidio's thought for the Sistine ceiling, see Dotson, 1979, 250ff. Haitovsky, 1988, 5ff., has cited Hebrew sources in connection with the David and Goliath scene in the Sistine ceiling.

24. Tolnay, 1943–60, 2:94, observed the novelty of the composition, though my analysis differs from his.

25. The relationship of Michelangelo's composition

to the motifs of David killing the lion and Mithras killing the bull was pointed out by Haitovsky, 1988, who overlooked the identification in Michelangelo's time of the subject of the Mithras relief as Hercules.

26. Visible throughout the Middle Ages and widely influential, the relief is reproduced here from a drawing in the mid-sixteenth-century Codex Coburgensis.

27. Cf. Bober and Rubinstein, 1986, 85.

28. The derivation of the Logge composition from that in the Sistine ceiling has often been noted (cf. Dacos, 1977, 195f.). The most recent discussion of the Sala di Costantino decorations is that of Quednau, 1979; see 489f., for the scene discussed here.

29. See the fine study by Buddensieg, 1965, esp. 62ff. Quednau, 1979, 490, refers the figure in the fresco to one on the Column of Trajan of a soldier at work on the construction of a fortress.

30. Fanti, 1527; a facsimile of Fanti's book has been published by Biondi, 1983. The relationship between the Sala di Costantino image and that of Fanti was discussed by Buddensieg, 1965, 63 n. 57, with earlier bibliography. The design of Fanti's frontispiece, for which a drawing is preserved, has been attributed to Baldassare Peruzzi and those of other pages to Dosso Dossi (Frommel, 1967–68, 137f.; Gibbons, 1968, 266, 268; *Firenze*, 1980, 426f.). The figure standing behind the sculptor refers to another work by Michelangelo, as noted by Tolnay (1966, 329 and 332 n. 7; cf. Summers, 1979, 161, 389), who also points out the correspondence to Michelangelo's constellation. The same woodcut is repeated on later pages of the book, with other artists' names substituted.

31. "... je puis dire avoir veu Michell'Ange bien que aagé de plus de 60 ans, et encore non des plus robustes, abattre plus d'escailles d'un très dur marbre en un quart d'heure, que trois jeunes tailleurs de pierre n'eussent peu faire en trois ou quatre, chose presqu'incroyable qui ne le verroit; et y alloit d'une telle impétuosité et furie, que ie pensois que tout l'ouvrage deust aller en pièces,

abattant par terre d'un seul coup de gros morceaux de trois ou quatre doigts d'espoisseur, si ric à ric de sa marque que, s'il eust passé outre tant soit peu plus qu'il ne falloit, il y avoit danger de perdre tout, parce que cela ne se peut plus réparer par après, ny replaster comme les images d'argille ou de stucq" (Vigenère, 1578, here quoted from Barocchi, ed., 1962–72, II, 232).

32. The literature on the Paragone and Varchi's inquiry is vast, but see the monograph by Mendelsohn, 1982.

33. I have adumbrated my understanding of Heemskerck's picture in some brief remarks on an analogous work by Jan Gossaert (Lavin, "Addenda," 1974). Following are some of the more valuable earlier contributions: Winner, 1957, 33f.; M. E. T. Beijer and E. R. M. Taverne, in *Het Schildersatelier*, 1964, 29, 33; J. Foucart, in *Le XVIe siècle*, 1966, 127; F. Bergot, in *Le Dossier*, 1974; Veldman, 1977, 115–21; C. M. Brown, 1979; Grosshans, 1980, 195ff.; G. Luther, in *Stilleben*, 1979, 48ff.; P. Georgel, in *La Peinture*, 1983, 114ff.; P. L. Price, in *Children*, 1984, 49ff.; a full bibliography will be found in Harrison, 1987, 692ff.

34. See in particular, W. Kemp, 1974; Poirer, 1976; Lavin, 1980, 7ff.

35. Cf. Bober and Rubinstein, 1986, 77f.

36. See Garrard (1975), who observed the relevance of the ancient figure to Sansovino's Madonna and Heemskerck's reference to both; Garrard also noted, but failed to grasp the significance of, the identification as *Roma trionfante*.

37. As noted by Foucart, in *Le XVIe siècle*, 1966.

38. Bergot (in *Le Dossier*, 1974, 73), evidently without knowledge of the Fanti print.

39. Heemskerck's use of the Villa Madama Jupiter has been the subject of a special study by C. M. Brown, 1979.

40. See *ibid.*, 57f.

41. There is a good chance that the Rennes picture is identical with a documented work painted by Heemskerck about 1550 for the Guild of St. Luke in Delft; cf. Grosshans, 1980, 196ff.; King,

1985, 253; Schaefer, 1986–90, I, 415 n. 8.

On the change in the social and intellectual status of the artist, see generally Pevsner, 1973. The development in Italy from guild and workshop to academy has been studied by Rossi (1980); for the corresponding change in the North, as reflected in portrayals of St. Luke as painter, cf. Schaefer, 1986–90.

42. See Tervarent, 1958–59, 303f., on the parrot as a symbol of rhetoric. The parrot was also a symbol of the virginity of Mary, and the nut the Christchild offers the bird refers to the Passion (Grosshans, 1980, 200). These allusions help to explain another important liberty Heemskerck took with the antiquities visible in the courtyard of the Palazzo Sassi: he transferred the grotesque, open-mouthed mask in the pavement from the Palazzo della Valle, where he had seen and drawn such a sculpture, presumably an ancient sewer cover. The transposition was surely based on the superstitious oracular power popularly associated with a similar piece preserved at the church of Santa Maria in Cosmedin, the *Bocca della verità*, or "mouth of truth" (cf. Spargo, 1934, 207ff.). Heemskerck thus contrasts the infernal, false voice of the pagan demon exuding foul odors from the earth with the gospel truth repeated by the gorgeous bird of Christian eloquence.

I should emphasize that Heemskerck also incorporates in the image of Luke as artist references to the other two aspects of the disciple's traditional persona: Luke the Evangelist, whose open Gospel the knowing ox points to with its hoof, and Luke the physician, surrounded by his medical texts and specimen flasks. Luke as physician was evoked, *expressis verbis,* by an inscription on the frame based on the passage in Paul's letter to the Colossians 4:14: *Salutat vos Lucas medicus charissimus* (Luke, the beloved physician, hails you). The inscription itself is a device of visual rhetoric, exhorting the spectator to receive the central message that the picture illustrates by merging all three aspects of Luke: the painter "shows" that Christ's sacrifice is the salvific medi-

cine conveyed to mankind through the "word" of God.

On the rhetoric of Erasmus, see the splendid pages of Fumaroli, 1980, 92ff.

43. For which see Welter, 1927.

44. "Avendo monsignor messer Giovanni Della Casa, fiorentino ed uomo dottissimo (come le sue leggiadrissime e dotte opere, così latine come volgari, ne dimostrano) cominciato a scrivere un trattato delle dose di pittura, e volendo chiarirsi d'alcune minuzie e particolari dagli uomini della professione, fece fare a Daniello, con tutta quella diligenza che fu possibile, il modello d'un Davit di terra finito; e dopo gli fece dipignere, o vero ritrarre in un quadro, il medesimo Davit, che è bellissimo, da tutte due le bande, cioè il dinanzi ed il di dietro, che fu cosa capricciosa" (Vasari, 1906, VII, 61).

The work is painted on slate; cf. Levie, 1962, 122–30; G. Barnaud, in *Le XVIᵉ siècle,* 1966, 86f.; Barolsky, 1969, 20ff., 90ff.; Larsson, 1974, 56f.

45. On the illustrated *Paragone,* see Holderbaum, 1956; Larsson, 1974, 54–58; Summers, 1981, 270, 530 n. 5; Mendelsohn, 1982, 124, 151.

46. Tolnay, 1975–80, III, 39–41.

47. ". . . e dico che, se maggiore giudicio et dificultà, impedimento et fatica non fa maggiore nobilità; che la pittura e scultura è una medesima cosa: e perché la fussi tenuta così, non doverrebbe ogni pictore far manco di scultura che di pictura; e 'l simile lo scultore di pictura che di scultura. Io intendo scultura quella che si fa per forza di levare; quella che si fa per via di porre è simile alla pictura. Basta, che, venendo l'una e l'altra da una medesima intelligenza, cioè scultura e pictura, si può far fare loro una buona pace insieme, et lasciar tante dispute; perché vi va più tempo, che a far le figure" (Barocchi and Ristori, 1965–83, IV, 266).

48. On the David theme in Florence, see Schmidt, 1960; Janson, 1978; Herzner, 1978. Pamela Askew is preparing a study of artists' self-portrayals as David.

49. See the observations on this point in Janson, 1978, 34, 37f.; Borsook and Offerhaus, 1981, 48;

M. A. Lavin, 1972, 75ff. Botticelli placed a statue of David with the head of Goliath on a tall column in his *Death of Lucrezia* (in the Gardner Museum, Boston); cf. Walton, 1965, 178f., 185f., where the motif is aptly related to Michelangelo's *David*, the theme of tyrannicide, and Florentine republicanism.

50. On the Medici laurel, see the invaluable study by Cox-Rearick, 1984, esp. 16ff. Further to the political aspect of Medicean laurel symbolism, see Kliemann, 1972; Winner, 1972; Warnke, 1977, 7f.; Bredekamp, 1988, 38ff., 87ff.; Landi, 1986.

51. For what follows here, see Seymour, 1974, 5f.

52. For the political history of Florence during the period that concerns us here, see, besides the classic study by F. Gilbert, 1965, Stephens, 1983; Butters, 1985.

53. My interpretation at this point varies slightly from that of Cox-Rearick.

54. The story of Augustus's laurel grove is told by Pliny, *Natural History*, XV, 136–38 (Rackham, 1945, IV, 381–83), and Suetonius, *Galba*, I, 1 (Rolfe, 1950, II, 190f.). The laurel imagery of Augustus will be discussed in a forthcoming paper on the emperor's villa *Ad Gallinas* by Barbara Kellum, who kindly allowed me to read a preliminary version.

55. Ultima Cumaei venit iam carminis aetas;
 magnus ab integro saeclorum nascitur ordo.
 iam redit et Virgo, redeunt Saturnia regna;
 iam nova progenies caelo demittitur alto.

 (Now is come the last age of the song of Cumae; the great line of the centuries begins anew. Now the Virgin returns, the reign of Saturn returns; now a new generation descends from heaven on high [*Eclogues* IV, 4–7; Fairclough, 1950, I, 28f.]).

56. In particular, Bredekamp's important interpretation of Botticelli's *Primavera* as a political allegory (1988) can be carried further in the syncretistic vein of Christian humanism: the perennial spring illustrates the classical heritage of the Medicean *le temps revient* in the City of Flowers, while the apsidal bower of laurel and the basilica-like grove of flowering fruit suggest a Christian sacral architecture and the patronage of the Virgin, Santa Maria del Fiore.

57. The theme of return and the potential threat of Medicean rule is evident in other devices adopted by Lorenzo, such as "Glovis" (*si volg[e]*, "it turns," spelled backward) with a disk; and "*Suave*" ("gentle") with a yoke (Cox-Rearick, 1984, 29ff.).

58. For an analysis of Michelangelo's political views, see Tolnay, 1964, 3ff. An important earlier formulation was that of Portheim (1889, 150ff.). Verspohl (1981) has interpreted the *David* in relation to the political thought of Machiavelli.

59. For a discussion of some of the technical aspects of the giant's history, see Lavin, 1967, 97ff.

60. "Poichè di tal pezzo di marmo non potevano cavar cosa che buona fosse, parve a un Andrea dal Monte a San Sovino, di poterlo ottener da loro, e gli ricercò che gliene facessero un presente, promettendo che, aggiungendovi certi pezzi, ne caverebbe una figura" (Condivi, 1938, 58). "Since they were unable to get anything out of that block of marble which was likely to be good, one Andrea dal Monte a San Sovino had the idea that he might obtain it from them, and he asked them to make him a present of it, promising that, by adding certain pieces to it, he would carve a figure out of it" (Condivi, 1976, 27).

61. For this type of support in antiquity, see Muthmann, 1951. Verspohl (1981, 213) interprets the tree trunk analogously, but less aptly, I think, as an allusion to the renovation of the Florentine republic.

62. October 31, 1504: ". . . per dorare la cigna, el bronchone e la ghirlanda al Gighante . . . et per fogli 12 di stagno per mectere d'oro el broncone di d(e)cto Gighante . . . ; . . . per havere messo d'oro el broncone del Gigante et la cigna et la ghirlanda . . . ; . . . per un filo d'octone con venctotto foglie di rame e per saldatura di d(e)cte

fogle in su' d(e)cto filo saldato con l'ariento per il Gighante . . ." The document has recently been republished and discussed by Ristori, 1986, 85f.; cf. also the comments by Isermeyer, 1965, 325.

63. ". . . la fama de gl'huomini, che poi si mantiene verde, e bella per molti secoli, come la fronde del lauro, & dell'edera si mantengono" (Ripa, 1603, 178). In a letter of 1545, published in 1550, Aretino mentions the statue's leafy cinch as an expression of "la modestia fiorentina" (cf. Ristori, 1986, 84). On the honorific symbolism of the plants, cf. Trapp, 1958.

64. On the interviews and the issues involved, see especially Levine, 1974; Parks, 1975. The chronicler Pietro Parenti records under the year 1504 that the *David* was brought to the Piazza "per consiglio del maestro," a passage that seems to have been overlooked or neglected by nearly everyone who has considered the matter. Raffaele Borghini later (1584) claimed that the installation did not please Michelangelo, who would have preferred to see the sculpture placed in a niche (Barocchi, ed., 1962–72, II, 207).

65. Cf. Levine, 1974, 39f. and n. 36, and the passages quoted in Barocchi, ed., 1962–72, 2:208.

66. See Levine, 1974, 34 n. 13; Ristori, 1986, 95f. On the identification of the scene on the tapestry, see Langedijk, 1981–87, 1:45 n. 20.

67. I am indebted at this point to Bredekamp's study (1989) of Lorenzino's "Brutian" attack on the arch, and its anti-Medicean political implications.

68. Suetonius, *Galba* I, 1 (Rolfe, 1950, II, 190f.).

69. M. DUM . BRUTI . EFFIGIEM A.
 SCULPTOR . DE . MARMORE . DUCIT
 IN . MENTEM . SCELERIS . VENIT
 B. ET . ABSTINVIT F.

(As he carves the image of Brutus from the marble, the sculptor is reminded of the crime, and desists. Michael Angelus Buonarrotus Fecit.)

The material concerning the bust is assembled in Barocchi, ed., 1962–72, IV, 1792ff., but see Gordon, 1957; Lavin, 1975, 357f. Portheim

(1889, 153) once suggested that the bust commemorates not the murder of Alessandro by Lorenzino, as is commonly assumed, but Lorenzino's own assassination in 1547 at the behest of Duke Cosimo; this view has been revived by Hirst (1977). If this later dating is correct, Michelangelo may have conceived the sculpture in response to the busts of Cosimo I made by Bandinelli and Cellini explicitly in the imperial tradition (see Lavin, 1975, 385ff.).

70. Further to the subject of this paragraph below, p. 213ff.

3. Giambologna's Neptune *at the Crossroads*

First presented in the Aula Magna of the Archiginnasio at Bologna in October 1990. The lecture served to inaugurate the newly restored Fountain of Neptune and a colloquium on the subject of Bologna as a cultural crossroads, "Il luogo e il ruolo della città di Bologna tra Europa continentale e mediterranea," held under the aegis of the International Committee for the History of Art.

1. On the restoration and the "Casa del Nettuno" see *Il Nettuno*, 1989; on the anatomical theater see Fabretti, 1987.

2. See Malaguzzi Valeri, 1901, 31f.; *Corpus*, 1927, 10ff.; Miller, 1977, 25; Bellocchi, 1987, 20f.

3. "Questo nuovo inquisitor [Girolamo Muzzarelli] è un dotto giovane e se mostra molto fervente et dice che qui è una grande intrecciatura di heresie"; cited by Rotondò, 1962, 136, after Buschbell, ed., 1937, 494. On the religious situation in Bologna at this period, see also Battistella, 1905, esp. 118ff., 129ff.

4. See Pastor, 1923–53, XVI, 440f.

5. The primary sources on the fountain are Vasari, 1906, VI, 191f., and Borghini, 1584, 586. For the modern literature see Avery, 1987, 206–9, 256, no. 31, with bibliography. Most important for the present essay are the contributions of Miller,

1977 (whose wide-ranging essay intuited a number of points made clear by the discovery and studies of Tuttle), and Tuttle: 1977; 1984; "*Bononia*," 1987; and "Il palazzo," 1987. (In a subsequent volume that came to my attention only after the present work was completed, Miller, 1989, extended her studies to the city as a whole, though without reference to Donato Cesi's account of his projects, published by Tuttle.)

6. See Tuttle, "*Bononia*," 1987, with the manuscript published *in extenso* as an appendix. Tuttle is preparing a comprehensive monograph on the Neptune fountain.

7. In his dedicatory letter to the pope Cesi notes that he had been inspired by the medals issued, on the example of the ancients, to commemorate Pius's achievements in Rome (see n. 41 below): "His de rebus cum scirem, quae Romae acta sunt, ea veterum exemplo aeternitatis esse numismatum monumentis ad prodendam memoriam commendata . . ." [Tuttle, "*Bononia*," 1987, 235]; "When I learned of the things accomplished in Rome which, by the example of the ancients, had been commended to memory in the eternal monuments of numismatics" Cesi's initiative seems to have been taken up at once in Florence, where a series of commemorative medals was issued for Cosimo I (noted by Tuttle, "*Bononia*," 1987, 231; see C. Johnson, 1976). Although no explanatory text accompanied the Florentine series, it was broader in scope, including notable events as well as public works. These series in turn laid the groundwork for the great medallic history of Louis XIV. On the use of such medallic series as propaganda, see Kantorowicz, 1963, 166ff.

8. The only hint of a Bologna connection for the *Mercury* was that the earliest of the bronze models of the figure is preserved in the Museo Civico (Fig. 83), whence scholars attributed to the period of Giambologna's stay in Bologna the project for the figure later sent to the Hapsburg emperor in Vienna (Fig. 82; Gramberg, 1936, 76; Avery and Radcliffe, 1978, 83f.). The project

for the statue of Pius IV was known from documents and other sources (Tuttle, "*Bononia*," 1987, 288, and "Il palazzo," 1987, 74f.), but its connection with the fountain project was unsuspected.

Although Giambologna may have become involved in the fountain during a visit to Bologna early in 1562, the work is first mentioned in a papal brief of March 1563, a month before the sculptor moved to Bologna; after much delay the *Neptune* was cast in August 1566 and installed in December of that year (Gramberg, 1936, 4, 16–23). The project for the statue of Gregory is first mentioned in February 1564 and the model was taken to Rome the following April (Tuttle, "*Bononia*," 1987, 228; Gramberg, 1936, 71); the first and only reference to the *Mercury* is in Cesi's manuscript, which Tuttle dates between December 1564 and January 1565 ("*Bononia*," 1987, 218). The statue of the pope and the *Mercury* were evidently abandoned after Giambologna and Cesi left Bologna in January 1565.

9. Gramberg, 1936, 97f.

10. The strategic location of the fountain is discussed by Miller, 1977, 29ff.

11. The medal illustrating the sculpture was published by Leithe-Jasper, 1972, with an attribution to Guglielmo della Porta; the medal's relationship to Giambologna's project was established by Tuttle, "Il palazzo," 1987, 73ff.; "*Bononia*," 1987, 228f.

12. ". . . addiditque sub pedibus conculcatam haeresim horrendum in modum expressam, atque ea quidem monstri forma qua a D. Ioanne in Apocalypsi describitur. Statue ipsa laeva librum tenet, quo actum esse doctrina cum haereticis significatur; dextra vero binis clavibus, idest binis potestatis suae symboles monstri capita comminuit. Altera enim indicari volunt Theologi solius Pont. Maximi esse quid sit peccatum statuere, altera vero ad eundem pertinere peccato obnoxios expiare. . . . Addita est praeterea haec inscriptio. PIO IIII PONT. OPT. MAX. / OB CONCVLCATAM TRIDENTINO CONCILIO HAERESIM /

COLLATAQVE AD HVIVS CIVITATIS DIGNITATEM /
ORNAMENTA / S. P. Q. BONONIENSIS PIVS AC
GRATVS" (Tuttle, "*Bononia*," 1987, 244); ". . . and
added trampled beneath his feet is heresy shown
in a horrendous way, in the very form of the
monster described by St. John in the Apoca-
lypse. The statue holds a book in the left hand,
signifying that the heretics are dealt with by
doctrine; in its right hand are two keys, symbols
of his dual power with which he crushes the
heads of the monster. With one of the keys the
theologians wish to indicate that only the pope
determines what sin is; and with the other that
it is for him to expiate those guilty of sin. . . .
There is also added this inscription: To Pope
Pius IV for having trampled heresy with the
Tridentine council and having provided orna-
ments to the dignity of the city, the pius and
grateful Bolognese senate and people of Bologna
[offer this statue]."

13. On this point see Fasoli, 1962, 5f.; Miller, 1977,
 30f.; Tuttle, "*Bononia*," 1987, 78.

14. See Tuttle, "Il palazzo," 1987, 76ff.; on Lom-
 bardi's *Hercules*, see Gramaccini, 1980, 28ff.

15. See Gramaccini, 1980, 28.

16. The menacing aspect of Michelangelo's colossal
 statue of Julius II pervades Condivi's account of
 it: "E dubitando quel ch'egli dovesse fare nella
 mano sinistra, facendo la destra sembiante di dar
 la benedizione, ricercò il papa, che a veder la
 statua venuto era, se gli piaceva che gli facesse
 un libro. *Che libro?* rispose egli allora: *una spada;*
 ch'io non so lettere. E motteggiando sopra la destra,
 che era in atto gagliardo, sorridendo disse a
 Michelagnolo: *Questa tua statua, dà ella la benedizione*
 o maledizione? A cui Michelagnolo: *Minaccia, Padre*
 Santo, questo popolo, se non è savio" (Condivi, 1938,
 75f.); "And, since he was in doubt as to what to
 do with the left hand, having made the right
 hand in an attitude of benediction, he inquired
 of the pope, who had come to see the statue,
 whether he would like it if he made a book in
 that other hand. 'What book,' was the pope's
 response; 'a sword: because I for my part know
 nothing of letters.' And, joking about the force-

ful gesture of the right hand, he said smilingly
to Michelangelo, 'This statue of yours, is it
giving the benediction or a malediction?' To
which Michelangelo rejoined, 'It is threatening
this populace, Holy Father, if they are not pru-
dent'" (Condivi, 1976, 38–39). Miller (1977, 38)
and Gramaccini (1980, 30f.) also perceived
Giambologna's papal monument as a reprise of
Michelangelo's.

17. As noted by Tuttle, "Il palazzo," 1987, 76.

18. "Illud tamen addam, statutum esse in medio
 compluvio supra paratam iam ex vermiculato
 lapide columnam Mercurij e coelo labentis
 simulachrum aereum poni: ut, cum illo sig-
 nificata sit antiquitus ratio et veritas, sapientiam
 e coelo manasse, eamque veluti Dei donum esse
 summo studio ac veneratione suspiciendam
 scholares facile, posito ibi signo in memoriam
 revocarent" (Tuttle, "Il palazzo," 1987, 84; 71ff.
 for discussion); "I will add that it has been
 decided to place in the middle of the courtyard
 on a prepared column of vermiculated stone a
 bronze image of Mercury descending from
 heaven; since in antiquity he symbolized reason
 and truth, the image being placed there as a
 reminder, the students may readily recall that
 wisdom descends from heaven and that it is a
 gift of God to be received with study and
 veneration."

19. The most recent discussion of the Mercury is in
 Avery, 1987, 125–30, 261 nos. 68, 72, 73, with
 previous bibliography.

20. Tuttle, "Il palazzo," 1987, 73. The variants of
 Rossi's logo show the same distinction between
 upward- and backward-pointing gestures of
 Mercury, so that he may also have inspired the
 version Giambologna sent to Vienna; see the
 examples illustrated in Sorbelli, 1923, 39–44;
 Zappella, 1986, 247, figs. 829–38.

21. Sorbelli, 1923, 38–44; Zappella, 1986, 246–47,
 figs. 829–38.

22. Rossi's logo also helps to identify an individual
 who may have had an important share in formu-
 lating the Virgilian program of the sculptures.
 The device appears in a commentary on the first

book of the *Aeneid* published in 1563 by Sebastiano Regoli (1514–1570), who was professor of humane letters at the university (Fig. 84). Regoli's subtle and learned commentary includes many of the interpretations discussed here and in Cesi's memorial. Regoli also delivered one of the inaugural addresses when the new university was dedicated in the same year, and Rossi's publication of the text of the oration also contains the logo. (Regoli, *In primum*, 1563, and *Oratio*, 1563; on Regoli, see Fasoli, 1962, 97, and 1987, 274f.; Fantuzzi, 1781–94, VII, 180–82.)

23. *Aeneid*, I, 135 (Fairclough, 1950, I, 250).

24. ac veluti magno in populo cum saepe coorta est
seditio, saevitque animis ignobile volgus,
iamque faces et saxa volant (furor arma ministrat),
tum pietate gravem ac meritis si forte virum quem
conspexere, silent arrectisque auribus adstant;
ille regit dictis animos et pectora mulcet

"And as, when oft-times in a great nation tumult has risen, the base rabble rage angrily, and now brands and stones fly, madness lending arms; then, if haply they set eyes on a man honoured for noble character and service, they are silent and stand by with attentive ears; he with speech sways their passion and soothes their breasts" (I, 148–53; Fairclough, 1950, I, 250–53).

25. Haec ait et Maia genitum demittit ab alto,
ut terrae utque novae pateant Karthaginis arces
hospitio Teucris, ne fati nescia Dido
finibus arceret. volat ille per aëra magnum
remigio alarum ac Libyae citus adstitit oris.
et iam iussa facit, ponuntque ferocia Poeni
corda volente deo; in primis regina quietum
accipit in Teucros animum mentemque benignam

"So speaking, he sends the son of Maia down from heaven, that the land and towers of new-built Carthage may open to greet the Teucrians, and Dido, ignorant of fate, might not bar them from her lands. Through the wide air he flies on the oarage of wings, and speedily alights on the Lybian coasts. At once he does his bidding, and, God willing it, the Phoenicians lay aside their savage thoughts; above all, the queen receives a gentle mind and gracious purpose towards the Teucrians" (I, 297–304; Fairclough, 1950, I, 262f.).

26. The Marcantonio engraving has been discussed most recently by Lord, 1984. On the drawing in Edinburgh, which is presumed to reflect Pierino's composition, see Boccardo, 1989, 66f.

27. Ultima Cumaei venit iam carminis aetas;
magnus ab integro saeclorum nascitur ordo.
iam redit et Virgo, redeunt Saturnia regna;
iam nova progenies caelo demittitur alto.

"Now is come the last age of the song of Cumae; the great line of the centuries begins anew. Now the Virgin returns, the reign of Saturn returns; now a new generation descends from heaven on high" (IV, 4–7; Fairclough, 1950, I, 28f.).

The same motto was used with reference to Louis XIV; see Kantorowicz, 1963, 169.

28. There are a number of drawings for the fountain by Tommaso Laureti, who had overall responsibility for the project; some were discussed by Tuttle in a paper presented at the colloquium in Bologna; others have been published by H. Widaner in *Italienische*, 1991. Only one of the drawings, in Darmstadt, anticipates the structure as well as aspects of the sculptural decoration of the executed work; I believe the sketch must have been made after Giambologna became involved in the project and reflects his intervention (this also seems to be the view of Widaner, ibid., 32).

29. On the statuary pedestal in the Renaissance see Weil-Garris, 1983; on the fountain types, Wiles, 1933, chapters V and VI.

30. The standard work on the Pharos is Thiersch, 1909; for a more recent summary see Fraser, 1972, I, 18–20, II, 42–54. ffolliott, 1984, 224 n. 36, compared Montorsoli's design for a light-

house at Messina and the decorative sculptures on his Neptune fountain there to the Pharos of Alexandria.

31. "At vero cum hisce temporibus multis in locis constitutae academiae tota Europa sint, Bononiensis quidem vel ob coeli benignitatem, vel ob doctorum excellentiam, vel ob urbis ornatum, vel denique ob civium tum mansuetudinem tum miram erga exteros homines charitatem iamdiu florentissima est" (Tuttle, "*Bononia*," 1987, 240); "Although in these times academies have been established in many places throughout Europe, that of Bologna is the most flourishing whether owing to the goodwill of heaven, the excellence of the teachers, the beauty of the city, or the citizens' warmth and charity toward strangers."

32. For what follows see Gorse, 1985, 28, with respect to the lost fountain of Neptune by Giovanni Montorsoli at the villa of Andrea Doria in Genoa.

33. "Nettuno, Dio del mare, fu formato in diversi modi, ora tranquillo, quieto et pacifico, et ora tutto turbato, come si legge appresso Omero e Vergilio" (Ciardi, ed., II, 1974, 508; cited by Wiles, 1933, 60 n. 2).

34. Neptune fountains are studied by Wiles, 1933; a useful survey of Neptune monuments in the sixteenth century is in Hamilton, 1976.

35. Precedent examples of this latter type are Montorsoli's lost fountain for the garden of the Villa of Andrea Doria at Genoa (see Gorse, 1985, 28) and an unexecuted fountain in the Villa d'Este at Tivoli (Coffin, 1960, 17). Also relevant, perhaps, is a medal cast some years later that may, however, reflect an early project for the Neptune fountain in Florence (Campbell, 1985, 116f.).

36. See the remarkable analysis of Neptune's pose and movement by Gramberg, 1936, 28ff., esp. 32.

37. The spatial quality of the figure is displayed to maximum effect in the side view of the fountain shown on the commemorative medal (Fig. 96), which Tuttle attributes to Giambologna himself ("*Bononia*," 1987, 226, fig. 18, 230).

38. On these concepts see Smith, 1968, and Greenstein, 1990 (see also Greenstein's forthcoming book, *Alberti, Mantegna, and Painting as "Historia"*).

39. On this work see Haskell and Penny, 1981, 188–89. Miller, 1977, 36, also saw in the baton a reference to Hercules.

40. "qui tridentem teneat dextra, quasi ictum inflicturus . . . ut subiectas ditioni suae gentes omni procellarum atque agitationis metu liberet" (Tuttle, "*Bononia*," 1987, 243). On Neptune as the supreme magistrate who suppresses sedition, see Regoli, *In primum*, 1563, 181f., 185.

41. Miller, 1977, 36, noted the trident-Tridentine relationship. The pope was fond of punning on his name, especially with projects such as the "Porta Pia," the "Aqua Pia," the "Via Pia," and the "Civitas Pia" in Rome (see Fagiolo and Madonna, 1972).

42. On Montorsoli's fountain see ffolliott, 1984, 139ff.

43. For an excellent study of the role of the *Marcus Aurelius* in the sixteenth century, including the gesture, see Mezzatesta, 1984, esp. 621f., 628f., 631. Miller, 1977, 26 n. 17, points out that contemporaneously with the Piazza Nettuno in Bologna, Pius IV was also preoccupied with the Campidoglio and the setting for the equestrian monument. On the meaning of the gesture in antiquity, see Bergemann, 1990, 6ff.

44. On this point see Miller, 1977, 28; Kallendorf, 1989, 140. The source is Cicero, *De natura deorum*, III, xxv (Rackham, 1933, 346–49). On Neptune as intelligence and reason, see Regoli, *In primum*, 1563, 171, 174.

45. See the last line in the passage quoted in n. 24 above. Concerning this verse Sebastiano Regoli speaks of the true ruler, who quells sedition by the power of eloquence: "Et principem eum, esse verum regem, qui in Deos pietate, meritisq. in patriam sit clarus, ac eloquentia plurimum valeat. Item hinc discimus, quanta sit vis eloquentiae; & quas ad res sit adhibenda, ad seditiones scilicet tollendas, ac motum populi sedandum; ad iniurias prohibendas, & quod vi, ac armis summi Imperatores saepe non possunt; verbis id assequuntur viri boni oratores" (*In primum*, 1563, 188).

46. Cesi introduces his account of the building of the university with an eloquent praise of human-

istic studies: "Cum dispersa primum ac passim vagans hominum multitudo eloquentiae ac sapientiae viribus intra urbes ad civilem cultum coacta ferinos illos mores exuerit, ac deinde paulatim mansuefactis doctrina animis ad florentissimum vitae statum sit perducta, facile intellectum est literarum studijs nihil ad tuandam aut ornandam mortalium societatem antiquius, nihil aptius, nihil denique praestabilius inveniri posse, beatasque respublicas illas esse, in quibus literarum cultus non postremus habeatur" (Tuttle, "*Bononia,*" 1987, 238); "When first the dispersed multitude of wandering men gathered into cities by the powers of eloquence and wisdom had cast off those savage ways and then, their spirits tamed by education, gradually been led to a flourishing state of life, it was readily understood that to safeguard and adorn human society nothing could be found more ancient, more apt or preferable than the study of letters, and that those nations are blessed in which letters are not held in least regard."

47. "Delphinos autem esse ingenus hominum natura propensiores, ut verosimile sit cum illis pueros iocari, fidem faciunt ubique historiae, dum eorum beneficio Arionem, Palemonem, Phalantum, Tarantem, Telemachum et plaerosque alios servtos commemorant" (Tuttle, "*Bononia,*" 1987, 243); "Many stories attest that dolphins have an innate propensity toward human beings, whence it is natural that young boys play with them, and record that Arion, Palemon, Phalantus, Tarantis, Telemachus and many others were saved by the benevolence of dolphins."

48. On the dolphin see Tervarent, 1959, II, 143f.

49. "Sirenes quamquam apud aliquos illecebrarum loco habentur, non inepte tamen ab aliis ad significandam orationis dulcedinem flectuntur, unde illud Martialis Cato grammaticus latina Siren, ut praeteream aureas sirenum illecebras in Apollonis templo apud Philostratum suspensas legi" (Tuttle, "*Bononia,*" 1987, 243); "Although according to some Sirens are considered beguiling, they are aptly construed by others to signify the sweetness of speech, whence Martial calls Cato the Grammarian the Latin Siren, and I also read

in Philostratus that the golden lures of the Sirens were hung up in the temple of Apollo. Moreover, since our Sirens express their breasts they seem to indicate that they excel not only by the delight of the voice, but also offer something more solid from within themselves. Therefore the artful construction and ornament of the leaping water speaks thus: the highest leisure and pursuit of peace thrive most if the ruler himself assumes the task of administering the realm."

50. Emphasis on Giambologna's absorption of the classical tradition has tended to obscure this fundamental debt to his Northern background. Holderbaum found evidence of a medieval revival in Giambologna's late religious works, which he also sees as Counter-Reformatory in spirit (1983, 207, 213f., 274f., 290).

 There is some evidence that Giambologna himself may have had Protestant leanings during the 1560's (Holderbaum, 1983, 196–98); if so, he must later have returned to the Catholic fold, as his funerary chapel in SS. Annunziata in Florence testifies.

51. The relationship between Giambologna's art and contemporary political development was another enduring contribution of Holderbaum, 1983, 149ff.

52. Emiliani, 1989.

4. Caravaggio's Calling of Saint Matthew: *The Identity of the Protagonist*

First presented in a session on Irony and Paradox in Northern Art at a meeting of the College Art Association in February 1990.

1. For the early history of Paul's metaphor, see Hugedé, 1957. For the exaltation of the lowly, see the pioneering and still fundamental studies of the paradoxical encomium by Colie (1966) and of the *sermo humilis* by Auerbach (1965). This essay is a sequel to an earlier study in which I discussed the Socratic irony embodied in Caravaggio's first altarpiece for the Contarelli chapel (Lavin, "Divine Inspiration," 1974).

2. For recent accounts of the complex and much-debated history of the Contarelli chapel, see Hibbard, 1983, 91ff., 138ff.; the marvelously comprehensive entries in Cinotti, 1983, 412ff., 525ff.; and Marini, 1989, 39ff., 426ff.

3. Bellori identifies the figure in his biography of Caravaggio (1672, 206), but the earliest testimony is Terbrugghen's painted interpretation of the picture, dated 1621 (Fig. 109).

4. This alternative view was suggested first by DeMarco, 1982, then by Prater, 1985, and Hass, 1988. The idea was rejected by Hibbard, 1983, 296; Kretschmer, 1988; Treffers, 1989, 247 n. 44; and Röttgen, 1991. (The study by Treffers, which came to my attention only after the present work was completed, coincides at certain points with my own, but errs in reading the chapel in Franciscan terms.)

5. Cf. Friedlaender, 1955, 278f.

6. "Certe fulgor ipse et maiestas Divinitatis offultae, quae etiam in humana facie relucebat, ex primo ad se videntes trahere poterat aspectu" (*The Hours*, 1964, III, 1570; September 21). Porphyry, here cited in the liturgy for St. Matthew, was the pagan writer whose report that Socrates was illiterate played a crucial role in the formulation of Caravaggio's first image of the evangelist writing his Gospel (see Lavin, "Divine Inspiration," 1974, 74f.). Hess, 1967, 303, showed that the revised breviary of 1568 was the specific source for the scene of Matthew reviving the daughter of the king of Ethiopia, painted earlier by Giuseppe Cesari in the vault of the chapel.

 Jerome in this passage seems to refer to the explanation St. Paul gives of the metaphor of the mirror and the changed face in the succeeding passage (2 Corinthians 4:2–6), which provides an almost complete gloss on Caravaggio's interpretation of the subject: "[we] have renounced the hidden things of dishonesty, not walking in craftiness, nor handling the word of God deceitfully. . . . But if our gospel be hid, it is hid to them that are lost: in whom the god of this world hath blinded the minds of them which believe not, lest the light of the glorious gospel of Christ, who is the image of God, should shine unto them. . . . For God, who commanded the light to shine out of darkness, hath shined in our hearts, to give the light of the knowledge of the glory of God in the face of Jesus Christ" ("abdicamus occulta dedecoris non ambulantes in astutia neque adulterantes verbum Dei. . . . Quod si etiam opertum est evangelium nostrum, in iis qui pereunt est opertum; in quibus deus huius saeculi excaecavit mentes infidelium, ut non fulgeat illis illuminatio evangelii gloriae Christi, qui est imago Dei. . . . quoniam Deus, qui dixit de tenebris lucem splendescere, ipse illuxit in cordibus nostris ad illuminationem scientiae claritatis Dei in facie Christi Iesu").

7. On Renaissance cap-brooches as emblems of their wearers, see Beard, 1939; Schwartz, 1990, 56ff. On the varieties of headgear and other insignia Jews were required to wear in Rome, see the article "Ebrei" in Moroni, 1840–61, XXI, 5–43.

8. See the fine essay on the red-headed Judas by Mellinkoff, 1982. Marilyn Aronberg Lavin reminds me that the critically important precedent in Caravaggio's own work was the red-headed and red-bearded protagonist of the first version of the conversion of Saul into the apostle Paul for the Cerasi chapel (see Hibbard, 1983, 121ff., 298f.; Marini, 1989, 190f., color illustration, 447ff.). For the importance of Saul–St. Paul, see further below, n. 37.

9. "Erat autem rufus et pulcher aspectu decoraque facie" (1 Samuel 16:12); "erat enim adulescens rufus et pulcher aspectu" (*ibid.*, 17:42).

10. Marlier, 1966, 93–108; Snyder, 1985, 430, 435, color plate 69; not mentioned by Mellinkoff; the engraving by Goltzius reproduces the composition in reverse. The analogy between the Calling of St. Matthew and the Last Supper in this context involves more than the simple fact of a group of men gathered at table; in both cases the essence of the episode lies in the distinction between recognition and obtuseness.

11. "Matthew committed the sin of avarice, by his panting greed for filthy lucre; for he was a keeper of the customs." (Voragine, 1969, 565f.)

The context of the passage is particularly interesting because it associates Matthew and his avarice with two other notorious Hebrews converted from their evil ways, Saul, who had his name from the proud King Saul and committed the sin of pride when he persecuted the Church, and David, who committed the sin of lust. The paradoxical moral is always the same, the wonder of the highest grace for the most depraved who convert: "These three men, therefore, were sinners. Yet their repentance was so pleasing to the Lord that not only did He forgive them, but also heaped His gifts upon them in greater abundance. Of the most cruel persecutor He made a most faithful preacher, of the adulterer and murderer He made a prophet and psalmist, of the miser and money-seeker He made an apostle and an evangelist. Therefore the words of these three are read to us most frequently [in the liturgy], so that none that wishes to be converted may despair of pardon, when grace wrought such wonders in such great sinners" (*ibid*).

On Jewish tax collecting, see *Jewish*, XII, 69.

12. "E pensomi che disse: Vedete che essendo così buono questo Maestro e faccendo tanti miracoli, sì lo accagiarono i nostri maggiori, e dicono che mangia co' peccaroti e co' publicani e che egli perdona loro i peccati. E Maddalena, udendo questo, levò la mente per udire e intendere bene queste parole; e l'altro disse: I' te 'l dirò; Matteo, ch'era prestatore e teneva il banco in cotale luogo, ei chiamollo, ed egli lasciò istare ogni cosa, e hallo fatto suo discepolo, e va con lui continuamente" (Cavalca, 1830, VI, 16f.).

13. Many works of this kind are mentioned and/or reproduced in Friedländer, 1967–74, XII, nos. 158–59, 167–70, 185–88; Fokker, 1928–29; Puyvelde, 1951 and 1957; Roethlisberger, 1966; Vlam, 1977; Wallen, 1983, 67ff.; Silver, 1984, 136ff. The last three sources, along with Roover, 1948, and Moxey, 1985, discuss the genre in relation to the commercial development of Antwerp and the criticism of avarice.

14. "Jam hoc erat insignius miraculum, hominem infami quaestui deditum, et negotiis inexplicabi-

libus involutum, repente vertere in alium, quam paralytico suos nervos reddere" (*Paraphrasis in Evangelio Lucae*, in Erasmus, 1703–06, VII, col. 341; cited after Wallen, 1983, 68). The Antwerp tradition is considered in relation to Erasmus also by Vlam, 1977, and Marlier, 1954, 251ff.

15. Listed by Wallen (1983, 308) as a copy or variant. Calvesi, 1990, 301, 400, related van Hemessen's composition in the Metropolitan to Caravaggio's *Calling*, noting in particular the gesture of money counting, mentioned below.

16. Voragine, 1969, 565.

17. On this drawing and a fresco in the Palazzo Mattei-Caetani in Rome, the dating and attribution of which are uncertain, see Röttgen, 1974, 23ff., 102ff.

18. *The Hours*, 1964, III, 1569. On Matthew's self-accusation, see also Treffers, 1989, 247.

19. Nicholson, 1958, 99ff. In fact, Terbrugghen seems to have understood Caravaggio's physiognomical procedure, as well, merging all three facial types.

20. The female at Matthew's left is clearly a prostitute, so that the apostle rejects both Luxuria (David's sin) and Avarice. Vlam (1977, 568) notes the significance of these gestures and also discusses a version of the Calling by van Hemessen in Vienna; here the feast is shown in the background, with an allusion to the transformation of Matthew in Christ's parable of new wine in new bottles.

21. H. Wagner, 1958, 62; Hibbard, 1983, 100.

22. "Videbunt publicanum, a peccatis ad meliora conversum, locum invenisse paenitentiae; et ob id etiam ipsi non desperant salutem. Neque vero in pristinis vitiis permanentes veniunt ad Iesum, ut pharisaei et scribae murmurant, sed paenitentiam agentes, ut sequens Domini sermo significat, dicens: Misericordiam volo, et non sacrificum; non enim veni vocare iustos, sed peccatores." (*The Hours*, 1964, III, 1570–71)

23. Sandrart, 1925, 102. The illustration here is from the Italian edition, *Simolachri*, 1549.

24. Caravaggio may have seen a reference to Judaism in Death's action, since beard pulling was a common way of illustrating the sterile acrimony and

consternation of rabbinical disputations. The last two verses of the Italian subscription seem strikingly to anticipate the meaning of Caravaggio's "tenebroso" lighting: "whence in dark and melancholy places the damned soul wails in eternal affliction."

25. Lates, 1989, 33–38. According to Armailhacq, 1894, 30, the parish registers of San Luigi record many conversions. On October 4, 1604, amid great solemnities, ten Jews who had been instructed by the parish priest were baptized by the bishop of Sidon, and the same ceremony was repeated the following year.

26. Lavin, "Divine Inspiration," 1974; also *idem*, "Addenda," 1974, and 1980. For a perceptive discussion of a painting by Guercino similarly intent upon the conversion of the Jews, see Perlove, 1989.

27. Pastor, 1923–53, XIX, 249.

28. On the vault scene see Acqua and Cinotti, 1971, 186 n. 249. The suggestion that the lower figures in the *Martyrdom* are neophytes (Marini, 1974, 29, and 1989, 42) was confirmed in an article on the painting by Trinchieri Camiz, 1990, that appeared after the present essay was completed. The author argues convincingly that the figures allude to baptism and adduces some of the same evidence cited here concerning the conversion of the Jews. The "crucified" pose of Matthew in the Martyrdom, which recalls the evangelist's report, cited in the text above, of Christ's call to his disciples to take up the cross, follow him, and give up their lives, may also be related to the theme of Baptism; the tradition linking the blood of Christ to the waters of baptism was illustrated in a print by H. Wierix, labeled "Fons Vitae," showing Christ seated on the edge of a baptismal basin into which his blood flows (Mauquoy-Hendrickx, 1978–83, I, 102, fig. 581). Calvesi, 1990, 279–84, linked Caravaggio's *Calling* to Henry IV's conversion to Catholicism in 1595.

29. For a biographical sketch of Cointrel, see Fragnito (in *Dizionario*, 1960–, XXVIII, 68ff.), who, following a clue in Pastor, 1923–53, XXI, 129, recovered and described the reports of Cointrel's

malefactions in the *Avvisi di Roma*, which I quote here *in extenso*.

"Dopo una diligente inquisitione fatta da certi deputati da Palazzo sopra l'amministrazione del Car.le San Stefano nel Datario di Gregorio, si sono trovate tante simonie, che chiamato da loro al sindicato un certo Pietr'Antonio delli sostituti di detto Datario, et a presentare alcune scritture, se n'è fuggito di quà avvisando se stesso, et il già suo P.rone con tal fuga, et il Papa per haverlo ha per più vie spediti Corr.ri, procedendosi in q.ta causa con esquisita curiosità" . . . "Il Frizolio sec.rio della congreg.ne del concilio, et già delli sustituti del Car.le Santo Stefano sta sequestrato in casa d'ordine delli superiori" (July 16, 1586, Biblioteca Vaticana, MS Urb. Lat. 1054, fol. 321v.ff.).

"È così chiara, che 'l fisco pretende il giusto possesso di tutti i beni del Card.le S. Stefano per simonia, et per altre cose scoverte nelli suoi libri secreti, et nelle scritture delli suoi sustituti, per le qual cose, i diputati sono intorno con le male parole à mons.re Rubustiero aderiva à quell'anima negra in dispense, et risegne molte brutte" (August 13, 1586, *ibid.*, fol. 380).

"Si va innanzi tuttavia nella causa del già Car.le San Stefano, con un travaglio di nuova persone, ch'erano interessate seco, et perche si scopre materia molto aromatica, in un libro intitolato Nemini ostendatur, per il q.ale P.ro Ant.o è stato presentato alla corda, si vede che le cose andaranno in lungo, et per q.to gli heredi si lasciano intender' di composit.ne offerendo 30 m scudi. Altri sono d'opinione che per esser'stato scritto in Ispagna che venghino di là scritture, et testimonij per c.a di tanti pensioni ritrovate estinte, et riservate, N. S.re stia in pensiero di deputare una congreg.ne per decidere utro Pontifex potuerit esse simoniacus, dubitandosi in qualche parte Gregorio possi havere havuto inditio delle ribaldarie di q.to Oltramontano, et de suoi ministri" (August 20, 1586, *ibid.*, fol. 393).

"Hanno i deputati sopra la causa del Car.le San Stefano assegnate la casa per carcere à D.nco Atton Agente del Duca di loreno interrogato sopra le sepditioni di 70 Monasteri in Francia

per via segreta passate per man sua con dare ad intendere à Gregorio, che servivano per la fabrica di San Luigi, secondo che S. B.ne haveva destinato, et poi si trova, ch'egli à detta fabrica non ha dati più di 3 m scudi di tanti, che ha riscossi per dette speditioni. Et Pietro Antonio è interrogato sopra le pensioni, che si mettevano sù le Chiese di Spagna, per hu.oi [?], de quali mai sen' ha possuto havere cognitione, et poi si facevano estinguere in utile (per q.nto si trova) di detto Datario, il qual veniva ad esser lui q.el solo delli tanti, c'havevano havute le pensioni" (August 30, 1586, *ibid.,* fol. 424).

"Dicono alcuni, che per altro non si procede adesso nella causa del Car.le San Stefano, che per dubio, che l'Amb.re di Francia non faccia officio caldo co'l Papa in suo favore. et che poi non sia in potere di S. B.ne di negargli ogni gratia per l'amore eccessivo, che mostra portare à q.ti ss.ri Galli" (September 17, 1586, fol. 454).

"Se il Papa trovarà cosa alcuna di mal fatto nelli sustituti del Datario, come ha presentito possono essere sicuri di non andare senza acqua calda, perche vuole S. S.ta che siano, i suoi sempre i primi a dar norma agli altri" (January 24, 1587, MS Urb. Lat. 1055, fol. 28; cf. Pastor, 1923–53, XXI, 129).

30. This text is also cited by Treffers, 1989, 255, in a different context.

31. This claim on the part of the apostolic camera is alluded to in one of the documents concerning the executors' delay in completing the work (Mahon, 1952, 20f.).

32. It may be relevant that the Jesuit Jacobo Laynez, who had been a close associate of Cointrel (*Dizionario,* 1960–, XXVIII, 68), was the author of an important treatise on simony (published in Lainez, 1886, II, 322–82).

33. The eulogy, by the Jesuit François Rémon, is published in Chacon, 1677, IV, cols. 96ff.

34. Although she identifies the man as a taxpayer, Hass (1988, 250) perceives that his gesture may allude to Cointrel's charities and suggests that he may actually represent the cardinal.

35. These physiognomical differences are so conspicuous that they must be deliberate and cannot be explained simply by the sequence in which the pictures were executed. The second version of the altarpiece established a compromise with Caravaggio's original, radical, differentiation: the evangelist and the martyr were now recognizably the same person, and what remained was the visible transformation of the Jew into the Christian.

36. See the essay on this painting by a former student of mine, Scribner (1977). Caravaggio's preoccupation with this idea in the Contarelli chapel is attested by newly discovered documents indicating that the London picture must be virtually contemporary with the first St. Matthew; see Correale, ed., 1990, 41, 77.

37. See Lavin, "Divine Inspiration," 1974, 78. To my mind it cannot be coincidental that the bald and bearded head of Matthew in the *Martyrdom* distinctly recalls the standard image of St. Paul. The reference would be appropriate not only because of Paul's general importance for the imagery of the chapel but also because of the specific traits he had in common with Matthew: Paul was also converted suddenly by Christ's call; his name was also changed along with his character (Caravaggio had given the Jews' red hair and beard to Saul-becoming-Paul in the first version of the *Conversion* for the Cerasi chapel; see n. 18 above); and he also died by the sword. Moreover, Paul invokes the same paradoxical notion of Socratic ignorance that Caravaggio applied to Levi-Matthew in the first version of the Contarelli altarpiece ("And if any man think that he knoweth any thing, he knoweth nothing yet as he ought to know" [1 Cor. 8:2]; see Lavin, "Divine Inspiration," 1974, 66ff.). And whereas Matthew by his Gospel was the apostle of the Jews, Paul by his mission was the apostle of the Gentiles. (In the apse mosaic of Santa Pudenziana, Paul and Matthew had evidently been related in this same context: Paul holds a book inscribed with the opening words of the first Gospel; *ibid.,* 78 n. 66.)

38. Quid per faciem, nisi notitia . . . Per faciem quippe unusquisque conoscitur . . . Facies itaque

ad fidem pertinet . . . Per fidem namque ab omni-
potenti Deo cognoscimur, sicut ipse de suis
ovibus dicit: Ego sum pastor bonus, et cognosco
oves meas, et cognoscunt me meae. Qui rursus
ait: Ego scio quos elegerim" (*The Hours* 1964, III,
1568).

5. Bernini's Portraits of No-Body

First presented in March 1987 in a colloquium at the
University of Maryland honoring my friend George
Levitine, to whom it is now sadly dedicated *in
memoriam*.

1. See Wittkower, 1981, 177, no. 7.
2. See Lavin, "Five Youthful Sculptures," 1968,
 239f., and Appendix A, pp. 125–29. New docu-
 mentary evidence presented here supports the
 1619 date proposed by Wittkower for the *Anime*
 busts on stylistic grounds.
3. On the coins, see Head, 1911, 805; G. F. Hill,
 1914, lxxxviiif., 182f., pl. XX, 1–3. The few
 instances of coins with facing heads on both
 sides (Baldwin, 1908–9, 130) nearly all involve
 male–female confrontations. For the mosaic,
 found on the Aventine in Rome, see Bieber,
 1920, 162, no. 137. Theater masks were some-
 times actually associated with portrait busts, as
 on a Roman sarcophagus in the Camposanto at
 Pisa that shows three masks, a youth, a female,
 and a grizzled Pan, beneath a medallion contain-
 ing busts of a man and his wife (Aries *et al.*,
 1977, 114ff.). Among the classical precedents
 revived and much illustrated, often as bust por-
 traits, from the Renaissance on were the philoso-
 phers Democritus and Heraclitus, who, respec-
 tively, laughed and wept at the foibles of the
 world (see p. 268, n. 58).
4. I have discussed the revived *Ars moriendi* tradition
 and Bernini's profound relationship to it in life
 and death (1972). On the *Ars moriendi*, see
 Delumeau, 1983, 389ff.

 On the *Quattuor novissima*, see Lane, 1985. My
 own remarks on the visual tradition of the Four
 Last Things, including Bernini's busts, offer only

modest supplements to those in the excellent
article by Malke, 1976.

5. See Franza, 1958; Turrini, 1982. The illustrated
 catechisms have been studied by Prosperi, 1985.
6. On the engravings by Theodor Galle after
 Maarten van Heemskerck and a painting of the
 same theme by Heemskerck, see Grosshans,
 1980, 214–43. Other important suites are by
 J. B. Wierix after Martin de Vos (Mauquoy-
 Hendrickx, 1979, II, 271f.), Hendrik Goltzius
 after Johannes Stradanus (Strauss, ed., 1980,
 309f.), Jan Sadeler after Dirck Barendsz (Judson,
 1970, 64f., 74, 140–42).
7. In these instances, it seems the purpose was to
 establish a deliberate link between the universal
 character of the *Quattuor novissima* and the indi-
 vidual focus of the *Ars moriendi*.
8. Although the moral component of Bernini's
 interest in expression was diluted, his position in
 this development is clear. So far as we know,
 Leonardo's drawings do not portray any particu-
 lar emotions or pattern or system of emotions.
 Della Porta's physiognomics are consistent, but
 they are not really devoted to expression; they
 attempt, instead, to link various physiognomi-
 cal types with corresponding character types,
 based on counterparts in the animal kingdom.
 Descartes was the first to study human emotions
 systematically, and it was Le Brun's contribution
 to relate that effort to the visual tradition repre-
 sented by Leonardo, Della Porta, and Bernini,
 producing the first systematic exploration of the
 facial effects of emotion.

 The most recent interpretation of Bernini's
 sculptures in this vein, which entails charac-
 teristically a focus on the *Anima Dannata* as a
 "self-representation," will be found in a fine essay
 by Preimesberger, 1989, with further references.

 On Messerschmidt's character studies, see
 Behr *et al.*, 1983.
9. Mair's engravings are reproduced in Hollstein,
 1954–, XXIII, 146ff., with further bibliography.
 Johann Conrad (1561–1612), who had lived for
 several years in Italy, was a great patron of the
 arts and maintained close ties with the Jesuits;
 Sax, 1884–85, II, 478–93; H. A. Braun, 1983,

168ff. (I am much indebted to Georg Daltrop, professor at the Catholic University of Eichstätt, for bibliography and other help in this connection.) Apart from the images discussed here, Mair's "emotional" and seemingly rising skeleton in a medallion frame (Fig. 138) was an important model for the gesticulating skeletons Bernini later depicted in the pavement of his Cornaro and Chigi chapels (Lavin, *Bernini*, 1980, 134ff.); I hope to explore this relationship in another context.

10. "Giunse in Genova l'Azzolini circa l'anno 1510, ove vedutisi alcuni suoi lavorietti in cera dal Sig. Marc'Antonio Doria, tanto piacquero a questo Cavaliere; che alcuni gliene commise; i quali con indicibile accuratezza, e finezza furono dal Napoletano Artefice eseguiti: onde ne salì in maggior credito presso i nostri Cittadini.

 Ciò, che egli al Doria compose furono quattro mezze figure rappresentative de' novissimi. Ne' volti di quelle rispettivamente spiravano gli affetti d'un'Anima beata: d'un'altra condannata a patire, ma con la speranza dell'eterno contento: della terza finta dentro uno scheletro: e della quarta esprimente nell'orrendo abisso l'idea d'una rabbiosa disperazione. Lavori di spiritosa, ed efficace energia" (Soprani, 1768, I, 417). On Azzolini, see Pyke, 1973, 8, and the important contribution by Gonzáles-Palacios, 1984, I, 226–36. There is considerable confusion with at least one other artist named Giovanni Bernardino (Prota-Giurleo, 1953, 123–51; *Mostra*, 1977, 109–13; Mongitore, 1977, 80–112; Di Dario Guida, 1978, 149–54).

 For a checklist and illustrations of preserved and recorded examples of the Four Last Things in the wax versions by Azzolini, plus a few related works, see Appendix B, p. 129, and Figs. 157–176. The traditional association of these works with the better known wax sculptor Gaetano Giulio Zumbo (1656–1701), who also came from southern Italy and worked for a time in Naples, is unfounded. Fagiolo dell'Arco and Fagiolo dell'Arco, 1967, Scheda no. 12, noted the dependence of the Victoria and Albert waxes, attributed to the circle of Zumbo, on Bernini's

sculptures.

11. Azzolini's presence in Rome was noted by Orlandi (1788, col. 617).

12. "E questo suo medesimo talento nella forza dell'espressione diede pur egli a conoscere allo stesso Signore in due altre modellate, e colorite teste di putti, ridente l'una, e piangente l'altra: ove l'affetto, che in esse appariva, vivamente eccitavasi ne'riguardanti" (Soprani, 1768, I, 417).

13. The theme of the Laughing and Crying Babies is discussed briefly, with great acumen but without reference to Azzolini, by Schlegel (1978, 129–31), who attributes the origin of the type to Duquesnoy. For a recent discussion of the painting by Van Haecht, see Filipczak, 1987, 47ff. Closely related are the crying babies attributed to Hendrik de Keyser (cf. Avery, 1981, 183 figs. 18, 19, 184ff.).

14. For what follows concerning the history and significance of the bust type, see Lavin, 1970, 1975.

15. Works of this kind, including that by De Heem reproduced here, are discussed in Veca, 1981, 85–91; *Stilleben*, 1979, 106–9, 455–7; Heezen-Stoll, 1979, 218–21; Merrill, 1960, 7ff.

16. See Ladendorf, 1953, 37–45; Ettlinger, 1961.

17. Frans Floris repeated the elements of the Vienna composition reproduced in Figure 144 (dated 1566) in a triptych in the Musée des Beaux-Arts, Brussels (cf. Van de Velde, 1975, 314–18, nos. 178–80).

18. For the type, see Haskell and Penny, 1981, 205–8; Bober and Rubinstein, 1986, 97. Bernini's enthusiasm is recorded for a version of the type he saw during his visit to Paris in 1665: "Il a dit, voyant de *Faune qui danse,* qu'il voyait cette statue mal volontiers, lui faisant connaître qu'en comparaison il ne savait rien" (Chantelou, 1885, 116; entry for August 23). The bronze in Amsterdam reproduced in Figure 151 is ascribed to Rome, seventeenth century (Leeuwenberg, 1973, 404).

19. For a survey of the medieval history of this idea, and further bibliography, see Bernstein, 1982.

20. See Smither, 1977–87, I, 80–89. A facsimile of the original edition, De' Cavalieri, 1600, was published in 1967. A useful commentary and

English translation of the text can be found in T. C. Read, 1969. On the architectural history of the oratory, see Connors, 1980.

21. "... singolari, e nuoue sue compositioni di Musica, fatte à somiglianza di quello stile, co'l quale si dice, che gli antichi Greci, e Romani nelle scene, e teatri loro soleano à diuersi affetti muouere gli spettatori"; "suonato, e cātato all'antica, come s'è detto"; "musica affettuosa"; "habbia potuto . . . rauuiuare quell'antica usanza così felicemente"; "questo stile sia atto à muouer'anco à deuotione"; "questa sorte di Musica da lui rinouata commoua à diuersi affetti, come à pietà, & à pianto, & à riso, & ad altri fimili"; "esprima bene le parole, che siano intese, & le accompagni con gesti, & motiui non solamente di mani, ma di passi ancora, che sono aiuti molto efficaci à muouere l'affetto"; "laudarebbe mutare i[s]tromenti conforme all'affetto del recitante"; "il passar da vno affetto all'altro cōtrario, come dal mesto all'allegro, dal feroce al mire, e simili, commuoue grandemente."

"... singular and novel compositions of music, made similar to that style with which, it is said, the ancient Greeks and Romans in their scenes and theaters used to move the spectators to various affections"; "played and sung 'all'antica,' as it is said"; "affective music"; "able to revive that ancient usage so felicitously"; "this style is also suited to move to devotion"; "this kind of music revived by him [Cavalieri] will move to various affections, like pity and joy, weeping and laughter, and others like them"; [the singer should] "express well the words so that they may be understood and accompany them with gestures and movements, not only of the hands but also of steps, which are very effective aids to move the affection"; [Cavalieri] "would praise to change the instruments according to the effect of the singer"; "passing from one affection to its contrary, as from mournful to happy, from ferocious to gentle and the like, is greatly moving."

22. My analysis is based essentially on Smither, 1977–87, I, 6f., 22–28, 57–89; Kirkendale, 1971; J. W. Hill, 1979; and Prizer, 1987, which Professor Prizer kindly allowed me to consult.

23. "... fu rappresentato in scena cogl'habiti nell'Oratorio nostro da due volte, con l'intervento di tutto il sacro collegio di Card.li, e ve ne furono da quindici e venti per ciascuna volta . . . Fu questa rappresentatione la prima che fosse fatta in Roma in stile recitativo, e di indi in poi cominciò con universale applauso a frequentarsi negli oratorii il detto stile" (Alaleona, 1905, 17, 18).

24. "Ritrovandomi io Go: Vittorio Rossi un giorno in casa del Signor Cavaliere Giulio Cesare Bottifango, gentil'uomo oltre la bontà, di rare qualità secretario eccellente, poeta e musico intendentissio, et entrati in ragionamento della musica che move gli affetti, mi disse risolutamente che non haveva sentita cosa più affettuosa, ne che più lo movessi della rappresentatione dell'anima messa in musica dalla buona memoria del Signor Emilio del Cavaliere, e rappresentata l'anno Santo 1600 nell'oratorio dell'Assunta, nella casa delli molto Reverendi Padri dell'Oratorio alla Chiesa Nova, e che egli vi si trovò presente in quel giorno, che si rappresentò tre volte senza potersi mai satiare e mi disse in particolare che sentendo la parte del tempo, si sentì entrare adosso un timore e spavento grande, et alla parte del corpo, rappresentata dal medesimo che faceva il tempo, quando stato alquanto in dubbio, che cosa doveva fare, o seguire Iddio o'l Mondo, si risolveva di seguire Iddio che gli uscirno da gl'occhi in grandissima abbondanza le lacrime e sentì destarsi nel core un pentimento grande e dolore dei suoi peccati, né questo fu per allora solamente, ma di poi sempre che la cantava, talché ogni volta che si voleva comunicare, per eccitare in sé la divotione, quella parte, e prorompeva in un fiume di pianto. Lodava ancora in estremo la parte del'anima, che oltre esser stata rappresentata divinamente da quel putto, diceva nella musica essere un artifitio inestimabile che esprimeva gli affetti di dolore e di dolcezza con certe seste false, che tiravano alla settima, che rapivano l'anima; insomma, concludeva, in quel genere non potersi fare cosa più perfetta, e soggiunse, acciò vediate soi stesso esser vero quanto

vi dico mi condusse al cembalo, e cantò alcuni pezzi di quella rappresentatione et in particolare quel loco del Corpo, che lo moveva tanto, e mi piacque in maniera ch'io lo pregai a farmene parte, il che molto cortesemente fece, e me lo copiò di sua mano, et io lo imparai alla mente, et andavo spesso a saca sua per sentrilo cantare da lui" (Morelli, 1985, 196). Rossi is well known as Ianus Nicius Erythraeus, the author of the three-volume series of biographies of contemporaries, *Pinacotheca* (Cologne, 1643, 1645, 1648), which included accounts of Agostino Manni and Bottifango (for the latter see also *Dizionario*, 1960–, XXIII, 456f.).

Cavalieri himself described the audience's response in a letter written to Florence soon after: "I forgot to say what the priests of the Vallicella told me, and this is great. Many prelates among those who came to Florence saw a *rappresentatione in musica* that I had done this carnival at their Oratorio, for which the expenditure was six scudi at the most. They say that they found it much more to their taste, because the music moved them to tears and laughter and pleased them greatly, unlike this music of Florence, which did not move them at all, unless to boredom and irritation" ("Mi era scordato dire; che questa e grande; che da quei preti della Vallicella mi hanno detto; che molti prelati; di quelli uenuti a Fio.za ueddero una costesta che io feci fare questo Carneuale, di rappresentatione in musica; al loro oratorio; che si spese da D sei al piu; et dicono; che ne receuerno altro gusto; poiche la musica il mosse a pianto et riso; et le diede gran gusto/et che questa musica di Firenze; non li mosse se non a tedio et fastidio"); published in English by Palisca, 1963, 352, to whom I am indebted for supplying the Italian text.

25. The relationship to the medieval *contrasto* and Jacopone da Todi was first suggested by Becherini (1943, 3 n. 3, and 1951, 233f.), followed by Kirkendale (1971, 17), who referred specifically to Jacopone's "Anima e Corpo" *contrasto* (Jacopone da Todi, 1953, 9–11), and Smither (1977–87, I, 57), who also noted Neri's interest in and use of Jacopone.

On the medieval *contrasto* between Body and Soul, see Walther, 1920, 63ff.; Wilmart, 1939; Toschi, 1955, 149–65; *Enciclopedia*, 1975, III, cols. 1357–60.

26. For what follows, see Katzenellenbogen, 1964, 1ff., 8 n. 1, 58f.; Houlet, 1969.

27. "ANIMA RAGIONEVOLE E BEATA . . . Si dipinge donzella gratiosissima, per esser fatta dal Creatore, che è fonte d'ogni bellezza, & perfettione, à sua similitudine . . . *Anima dannata.* Occorrendo spesse volte nelle tragedie, & rappresentationi di casi seguiti, & finti, si spirituali come profani, introdurre nel palco l'anima di alcuna persona, fa mestiero hauer luce, come ella si debba visibilmente introdurre. Per tanto si dourà rappresentare in forma, & figura humana, ritenendo l'effigie del suo corpo. Sarà nuda, o da sottilissimo & trasparente velo coperta, come anco scapigliata, & il colore della carnagione di lionato scuro, & il velo di color negro . . . Dicesi anco meglio conoscerla, se gli habbia à rappresentarla con diuersi accidenti, come per esempio, ferita, ò in gloria, ò tormentata, &c. & in tal caso si qualificherà in quella maniera, che si conuiene allo stato, & conditione sua" (Ripa, 1603, 22f.).

Ripa's image in turn inspired Guido Reni's late visionary portrayals of *Anima Beata*, in the Capitoline Museum, Rome (*The Age of Correggio*, 1986, 522; Bruno, 1978, 61f.).

28. Manni, 1609 and 1613. The full titles are given in the bibliography. The headings of the pertinent sections in the 1613 edition are as follows: pp. 60ff., Essercitio circa l'eternità della felicità del cielo; 79ff., Essercitio circa la consideratione della pene dell'Inferno; 104, Essercitio per haver'in pronto le quattro memorie, della Morte, del Guidicio, dell'Inferno, e del Paradiso; 105ff., Memoria della Morte; 122ff., Memoria secondo, del Giudicio; 132ff., Memoria Terza, dell'Inferno; 142ff., Quarta Memoria, del Paradiso; 177ff., Essercitio per vivere, e morire felicemente.

29. Manni, 1620.

30. Manni, 1625; this edition, which I have not seen, is recorded in Villarosa, 1837, 162. I give the full title from the edition published in 1637 (see Bibliography).

6. Bernini's Image of the Sun King

The main argument of this paper was first presented at a symposium entitled "The Ascendency of French Culture during the Reign of the Sun King," sponsored by the Folger Shakespeare Library in March 1985; an abbreviated version appeared in French (Lavin, 1987). Some of the material is incorporated in an essay devoted to the relationship of Bernini's ruler portraits to the "anti-Machiavellian" tradition of political theory and the idea of the prince-hero (Lavin, 1991). These studies and the preceding chapter relate to a series of attempts I have made to describe the nature, meaning, and development of "illusionism" in the Italian sculptured bust since the Renaissance (Lavin, 1970, 1975; see further Lavin, 1968, 1970; with the collaboration of M. Aronberg Lavin, 1970, 1972).

1. Some of the thoughts and observations offered here were adumbrated in Fagiolo dell'Arco and Fagiolo dell'Arco, 1967, 90f., and in the fine studies by Del Pesco, "Gli 'antichi dèi'" and *Il Louvre*, both 1984. I have also profited greatly from the recent monographs by Berger, *Versailles* and *In the Garden*, both 1985. For a general account of Bernini's visit, see Gould, 1982. An excellent summary on the Louvre will be found in Braham and Smith, 1973, 120–49, 255–64; Daufresne, 1987, provides a useful compendium of the many projects for the palace.

 On the bust of the king and its antecedents, see Wittkower, 1951; I. Lavin, 1972, 177–81, and 1973, 434ff.

 On the equestrian monument, see Wittkower, 1961, 497–531, and, with supplementary material on the statue's reception in France, Berger, *In the Garden*, 1985, 50–63, 69–74; also Weber, 1985, 288ff. The history of the work is summarized in Hoog, 1989. Mai, 1975, considers the bust and the equestrian together in the general context of Louis XIV portraiture.

2. Chantelou, 1885; an English translation by M. Corbett, not always reliable but with excellent annotations by G. Bauer, is now available (Chantelou, 1985).

3. The translation given in Chantelou, 1985, 274—"... buildings are the mirror of princes"

—obscures the very soul of Bernini's metaphor!

4. See Kantorowicz, 1963, esp. 167–76 on Louis XIV.

5. I have used the edition Menestrier, 1693, plate preceding p. 5; Kantorowicz, 1963, 175. A medal issued at Louis's birth in 1638 shows the chariot of the infant Apollo, with the motto *Ortus Solis Gallici* (Menestrier, 1693, opp. p. 4; cf. Kantorowicz, 1963, 168, 170, fig. 45).

6. Cf. Kantorowicz, 1963, 162; Menestrier, 1693, pl. 6, no. XXVI; Jones, 1982–88, II, 222, no. 237.

7. Harris, *Andrea Sacchi*, 1977, 9–13, 57–59; Scott, 1991, esp. 38ff. I have discussed the relevance of Sacchi's fresco to an emblematic conceit, also involving the sun and earth, which Bernini designed as the frontispiece of a book on optics, in I. Lavin, 1985.

 Bernini must have associated the Barberini solar imagery with that of Louis XIV virtually from the king's birth in 1638; at least by 1640, the artist promised to reveal to Mazarin the secret of a new method he had devised of portraying the rising sun on stage. The episode is mentioned by Baldinucci, 1948, 151; Domenico Bernini, 1713, 56f.; and Chantelou, 1885, 116; on the date see Bauer in Chantelou, 1985, 143 n. 170; Brauer and Wittkower, 1931, 33 n. 7.

8. Cf. Lavin, *Bernini*, 1980, 70–74.

9. The importance of this drawing and the solar symbolism in the French projects for the Louvre were emphasized by Berger (1970) and developed by Del Pesco (*Il Louvre*, 1984, 137–72); also Berger, forthcoming.

 Cf. Chantelou, 1885, 224, October 11: "Come c'est une ovale, il a dit que si le palais du soleil, qui y est represénté, avait été de même forme ou bien rond, peut-être aurait-il mieux convenu au lieu et au soleil même."

10. Colbert actually complained about the sparseness of ornament in the second project, especially the absence of any "statua o cifra in memoria del Rè" above the portal (letter to Bernini from the papal nuncio in Paris, March 23, 1665, in Mirot, 1904, 191n.; cited by Del Pesco, *Il Louvre*, 1984, 140); Bernini, in turn, had

criticized the minor ornaments in the facades of Louis Le Vau's project as being "più proprii per un cabinetto, che per le facciate di un gran palazzo" (letter of March 27, Mirot, 1904, 192n.).

11. Bernini's initial reaction is reported in several letters written by Italian members of the court: "Fuì però da lui [i.e. Bernini] mercordì sera doppo che hebbe visto il Louvre, e per quel che mi disse pensa che quel che è fatto possa servire poco" (letter of the papal nuncio, June 5, 1665, in Schiavo, 1956, 32); "Si dice che le prime proposizioni furono di battere tutto a terra, il che messe in confusione questi francesi" (letter of Alberto Caprara to the duke of Modena, June 19, in Fraschetti, 1900, 342 n. 1); ". . . havendo detto dal primo giorno, che bisognava abbattere tutto il Louvre se si havesse voluto fare qualche cosa di buono . . . Hora s'è ridotto a dire, che farà il dissegno per la gran facciata del Louvre in modo, che si attaccarà assai bene con la fabbrica vecchia . . . Mà non si parla più di levare il primo piano, che e quello che havrebbe obligato ad abbattere tutto il Louvre . . ." (letter of Carlo Vigarani to the duke of Modena, June 19, in Fraschetti, 1900, 343 n. 1).

12. "J'ai vu, Sire, a-t-il dit à S.M., les palais des empereurs et des papes, ceux des princes souverains qui se sont trouvés sur la route de Rome à Paris, mais il faut faire pour un roi de France, un roi d'aujourd'hui, de plus grandes et magnifiques choses que tout cela." The passage is followed by that quoted in the first epigraph to this essay (p. 139), to which the King replied, "il avait quelque affectation de conserver ce qu'avaient fait ses prédécesseurs, mais que si pourtant l'on ne pouvait rien faire de grand sans abattre leur ouvrage, qu'il le lui abandonnait; que pour l'argent il ne l'épargnerait pas" (Chantelou, 1885, 15, June 4).

13. Bernini acknowledged the practical and financial considerations in a memo he read to the king, adding, "comme l'étage du plan terrain du Louvre n'a pas assez d'exhaussement, il ne le fait servir dans sa façade que comme si c'était le piédestal de l'ordre corinthien qu'il met au-dessus" (Chantelou, 1885, 27f., June 9).

14. The solution perfectly illustrates Bernini's view that the architect's chief merit lay not in making beautiful or commodious buildings but in adapting to necessity and using defects in such a way that if they did not exist they would have to be made: ". . . diceva non essere il sommo pregio dell'artefice il far bellissimi e comodi edifici, ma il sapere inventar maniere per servirsi del poco, del cattivo e male adattato al bisogno per far cose belle e far sì, che sia utile quel che fu difetto e che, se non fusse, bisognerebbe farlo" (Baldinucci, 1948, 146; cf. Bernini, 1713, 32).

15. References to the rustication occur in Chantelou's diary on June 20; September 22, 25, 26, 29, 30; October 6 (Chantelou, 1885, 36, 176, 179, 182, 189, 192, 203).

16. ". . . un écueil ou espèce de rocher, sur lequel il a fait l'assiette du Louvre, lequel il a couvert d'un papier où était dessiné un rustique, fait pour avoir à choisir, à cause que cet écueil était de difficile exécution, le Roi ayant considéré l'un et l'autre, a dit que cet écueil lui plaisait bien plus, et qu'il voulait qu'il fût exécuté de la sorte. Le Cavalier lui a dit qu'il l'avait changé, s'imaginant que, comme c'est une pensée toute nouvelle, que peut-être elle ne plairait pas, outre qu'il faudrait que cet écueil, pour réussir dans son intention, fût exécuté de sa main. Le Roi a répété que cela lui plaisait extrêmement. Sur quoi le Cavalier lui a dit qu'il a la plus grande joie du monde de voir combien S.M. a le goût fin et délicat, y ayant peu de gens, même de la profession, que eussent pu en juger si bien" (Chantelou, 1885, 36, June 20).

17. On the history of rustication, see most recently Ackerman, 1983, 27ff.; Fagiolo, ed., 1979. Bernini's use of rustication has been treated most extensively by Borsi (1967, 29–43), but the nature and significance of his contribution have not been clearly defined.

 As far as I can see, the first to note the character and intimate the significance of Bernini's rustication was Quatremère de Quincy in his *Encyclopédie* article on "Opposition": "Ainsi, des blocs laissés bruts, des pierres de taille rustiquées, donneront aux soubassemens d'un monument

une apparence de massivité dont l'opposition fera paraître plus élégantes les parties et les ordonnances supérieures. L'emploi de ce genre d'opposition entre les matériaux a quelquefois été porté plus loins. Il y a des exemples de plus d'un édifice, où l'architecture a fait entrer dans son appareil, des pierres tellement taillées et façonnées en forme de rochers, que leur opposition avec le reste de la construction semble avoir eu pour but, de donner l'idée d'un monument pratiqué et comme fondé sur des masses de rocs naturels. Tel est à Rome (peut-être dans un sens allégorique) le palais de justice à Monte-Citorio" (1788–1825, III, 36). The reference was brought to my attention by Sylvia Lavin.

18. See the chapter on these types in Wiles, 1933, 73ff. For the fountain illustrated in Figure 195, see Zangheri, 1979, 157f., and 1985, 38ff.; Vezzosi, ed., 1986, 138ff.

19. See now Salomone, in Fagiolo, ed., 1979.

20. An indicative case in point is the report concerning Filippo Strozzi's feigned modesty in building his palace in Florence: "Oltre a molt'altre spese s'aggiunse anco quella de' bozzi di fuori. Filippo quanto più si vedeva incitare, tanto maggiormente sembianza faceva di iritarsi, e per niente diceva di voler fare i bozzi, per non esser cosa civile e di troppa spesa" (Gaye, 1839–40, 1:355; cited by Roth, 1917, 13, 97 n. 22; Sinding-Larsen, 1975, 195 n. 5).

Many passages concerning rustication are assembled in an article by Morolli, in Fagiolo, ed., 1979.

21. "There are some very ancient castles still to be seen … built of huge unwrought stone; which sort of work pleases me extremely, because it gives the building a rugged air of antique severity, which is a very great ornament to a town. I would have the walls of a city built in such a manner, that the enemy at the bare sight of them may be struck with terror, and be sent away with a distrust of his own forces" (Alberti, 1965, Bk. VII, ch. 2, p. 135); "Visuntur et vetusta oppida … lapide astructa praegrandi incerto et vasto, quod mihi quidem opus vehementer probatur: quandam enim prae se fert rigiditatem severissimae vetustatis, quae urbibus ornamento est. Ac velim quidem eiusmodi esse urbis murum, ut eo spectato horreat hostis et mox diffidens abscedat" (Alberti, 1966, 539).

22. On the first of these points see, for example, Serlio's remarks concerning the mixture of nature and artifice, quoted by Ackerman, 1983, 28: "It would be no error if within one manner one were to make a mixture representing in this way partly the work of nature and partly the work of artifice: thus columns bound down by rustic stones and also the architrave and frieze interrupted by voussoirs reveal the work of nature, while capitals and parts of the columns and also the cornice and pediment represent the work of the hand; and this mixture, according to my judgement, greatly pleases the eye and represents in itself great strength."

On the second point, see Ackerman, 1983, 34.

23. Baldinucci, 1948, 140; Bernini, 1713, 89; for a detailed analysis of these studies see Courtright, in Lavin et al., 1981, 108–19.

24. For a brief summary and recent bibliography, see Borsi, 1980, 315. Bernini's original project, identified by the arms of Innocent X over the portal, is recorded in a painting in the Camera dei Deputati, Rome (Figs. 202, 203), often attributed to Bernini's assistant, Mattia de' Rossi (cf. Borsi et al., 1972, fig. 16).

The palace was left half-finished after 1654, following a rupture between the pope and his niece's husband Niccolo Ludovisi; it was finally completed in the early eighteenth century. Only the rusticated strip to the right of the central block was fully "finished," along with the rusticated window sills (another striking innovation in the design, which Bernini did not repeat for the Louvre); see now Terracina and Vittorini, 1983.

25. Jordan, 1871–1907, I, pt. 3, 603; Gnoli, 1939, 175f.

26. The possibility that this project (for which see further below, p. 178 and n. 84) originated with Bernini's plans for the Palazzo Montecitorio was evidently first suggested by Capasso in 1966; cited by Fagiolo dell'Arco and Fagiolo dell'Arco,

1967, 236 fig. 47, scheda 201; followed by Krautheimer, 1983, 207.

27. Jordan, 1871–1907, I, pt. 3, 603; cf. Nardini, 1666, 349.

28. The base of the column of Antoninus Pius, now in the Vatican, and a portion of the shaft were excavated early in the eighteenth century, toward the end of which the present installation with the obelisk of Augustus was also created (D'Onofrio, 1965, 238ff., 280ff.). Early depictions of the Aurelian column are listed and some reproduced in Caprini *et al.*, 1955, 42; Pietrangeli, 1955, 19ff.

The engraving by Johann Meyer the Younger appears in Sandrart, 1665–79, II, pl. XXII. Reproduced, without reference to Sandrart and dated in the eighteenth century, in Angeli, 1926, frontispiece.

29. Lauro, 1612–41, pl. 101, cited by Del Pesco, *Il Louvre*, 1984, 145ff., and *idem*, "Una fonte," 1984, 423f.

30. "... sopra detto scoglio dalle parte della porta principale invece d'adornamento di doi colonne, vi ha fatto due grandi Ercoli, che fingono guardare il palazzo, alle quali il sig. caval. gli da un segnificato e dice Ercole è il retratto della vertù per mezzo della sua fortezza e fatica, quale risiede su il monte della fatica che è lo scoglio ... e dice chi vuole risiedere in questa regia, bisognia che passi per mezzo della vertù e della fatica. Qual'pensiero e alegoria piacque grandamente a S. M., parendogli che havesse del grande e del sentesioso" (Mirot, 1904, 218n., Mattia de' Rossi, June 26).

31. Millon, 1987, 485ff., has recently discussed the relationship between Bernini's designs for the Louvre and the early reconstructions of the palace of the Caesars on the Palatine. Professor Millon very kindly shared with me the Palatine material he collected.

32. On the history of this view of the Palatine, see Zerner, 1965.

33. "... li Romani antichi con questo insegnauano, che nissuno doueua essere honorato, ò desiderare honori, che non fosse entrato, e lungamente con profitto dimorato nelle virtù ... Da che doureb-bono gli Principi pigliare occasione di fabricare nell'animi loro simili tempij d'Honore, e Virtù [see the dictum by Bernini that serves as the epigraph for this chapter] ... nè giamai volsero accettare il titolo di Massimo, se prima per virtù non lo meritauano ... come ... fecero Traiano, & Antonino, li quali perche appoggiarono le attioni loro alla virtù, le hanno conseruate, & illese contro la violenza del tempo, guerre, & calamità publiche, come si può comprendere dalle due bellissime Colonne che a honor di essi furono fabricate, & hoggi nella bellezza, & integrità antica si conseruano" (pl. 30v; the full Latin text was quoted by Del Pesco, "Una fonte," 1984, 434f. n. 25).

34. Körte, 1935, 22f., pl. 11. Two drawings for the fresco are preserved, one in the Morgan Library, where the buildings are labeled, the other in Berlin (cf. Winner, 1962, 168ff., fig. 14; Heikamp, 1967, 28f., fig. 22b). The Temple of Fame had particular metaphorical significance in artistic circles; it was also used by Van Mander (1973, 381f.).

There was a tradition of temporary festival decorations in Turin that may have been relevant to Bernini's idea: a hilly facade (in reference to the Piemonte) was erected in front of the Palazzo Ducale, topped by a pavilion or temple and, in 1650, an elaborate Herculean allegory (Pollak, 1991, 63, 137f.); for other connections with Turin, see n. 68 and pp. 174f.

35. On Alexander, Helios, the divinely inspired ruler, and the idea of apotheosis in ancient portraiture, see L'Orange, 1982, 34–36.

36. "Le Cavalier a dit ... que la tête du Roi avait de celle d'Alexandre, particulièrement le front et l'air du visage" (Chantelou, 1885, 99, August 15).

37. "... il m'a dit ... qu'il venait de sortir un évêque, qui lui avait dit que son buste ressemblait aux médailles d'Alexandre, et que de lui donner pour piédestal un monde, il lui en ressemblait encore davantage" (Chantelou, 1885, 178, September 25). "Il a ajouté que plusieurs avaient trouvé que le buste avait de ces belles têtes d'Alexandre" (Chantelou, 1885, 187, September 27).

38. "... le buste a beaucoup de l'air d'Alexandre et

tournait de côté comme l'on voit aux médailles d'Alexandre" (ibid, 183, September 26).

39. On the relationship to ancient Alexander portraiture, see Lavin, 1972, 181 n. 71. On the coin of Vespasian reproduced here, see Vermeule, 1986, 11; I am indebted to Dr. Vermeule for kind assistance in the numismatics of Alexander. M. J. Price brought to my attention a coin of Alexander of Pherae in which a three-quarter head of Hecate appears on the obverse (Gardner and Poole, 1883, 47 no. 14, pl. X fig. II). The relationship to Alexander and allegorical portraiture generally was formulated perfectly by Wittkower, 1951 (18): "Bernini rejected the popular type of allegorical portraiture then in favour at the court of Louis XIV which depicted *le Roi Soleil* in the guise of Apollo, of Alexander, or of a Roman Emperor. Bernini's allusion to Alexander was expressed by physical and psychological affinities, not by external attributes." Allegory was confined to the base, which also reinforced the allusion to Alexander; see pp. 163–66.

40. On the work shown in Fig. 214, see Haskell and Penny, 1981, 134–36; on that in Fig. 215, see Helbig, 1963–72, II, 229f. (the head has holes that served to hold metal rays).

41. Haskell and Penny, 1981, 291–96; on Bernini and the Pasquino, see Lavin *et al.*, 1981, 39f.

42. Cf. Lavin, 1972, 180 n. 67; on the treatment of the arms generally, 177ff. Vergara, 1983, 285, has also seen Bernini's reference to this model, perhaps through the intermediary of one of Van Dyck's series of portrait prints, the *Iconography*; in adopting the pose Van Dyck similarly raised the head and glance to suggest some distant and lofty goal or vision.

43. "Il m'a ajouté qu'il s'était étudié à faire, *che non paresse che questo svolazzo fosse sopra un chiodo* . . ." (Chantelou, 1885, 166, September 19).

44. See I. Lavin, 1972, 180 n. 68; on the treatment of the drapery generally, 177ff.

45. Gamberti, 1659, frontispiece. The book (for which see Southorn, 1988, 38f.) is a description, profusely illustrated, of the decorations erected for Francesco's funeral in 1658. The dedication is

an elaborate metaphor on Bernini's portrait, which in the engraving has at the base papal and Constantinian insignia that announce the idea of the ideal Christian ruler. Since, as is noted in the title of the book, Francesco was commander of the French troops in Italy, Bernini may have had special reason to recall the work in connection with the bust of the King.

There is no evidence that the pedestal shown in the engraving was Bernini's conception; however, its expanding shape, apart from formal considerations, would have helped keep spectators at a distance, something we know he considered in designing the *Louis XIV* base (Chantelou, 1885, 150, September 10).

On the notion of the heroic monarch, see De Mattei, 1982–84, II, 21ff. De Mattei cites the following definition by Gamberti, which is interesting in our context not only for the concept itself but also for the sculpture metaphor and the contrast made between crude base and heavenly head: "Oltre il primo nome di Principe, v'ho aggiunto il secondo di Eroe, la cui definizione si può trarre al nostro propositio colà di Luciano: *Heros est qui neque homo est, neque Deus, et simul utrumque est* [Lucian, *Dial.* 3]. È l'Eroe quasi dissi una terza natura, ed una statua di elettro, fabricata con l'oro della Divinità e coll'argento delle più squisite prerogative dell'essere umano: bensì sostenuta in piè da una base di sozzo fango, ma però circondata sul capo con una reale fascia dal Cielo" (Gamberti, 1659, 102).

For more on the theory of prince-hero and the related anti-Machiavellian tradition of political ideology, see pp. 195f.

46. The images of Henry IV were made for triumphal entries: Vivanti, 1967, 188, pl. 22a–b; cf. Bardon, 1974, 65, 141, pl. XXXIV B.

On the ancient prototypes for Bernini's pedestal, see I. Lavin, 1972, 180f.; D. Rosenthal, 1976, cites the depiction of Monarchia Mondana in Cesare Ripa's *Iconologia*, where the ruler is shown seated on the globe. For the emperor enthroned on the globe in antiquity, see MacCormack, 1981, 127–29.

47. *The Sun King*, 1984, 182, no. 3; *Les Gobelins*, 1966,

11, no. 1; *Charles Le Brun*, 1963, 239 no. 98; Montagu, 1962; Fenaille, 1903–23, I, 9–15; Jouin, 1889, 553f.

48. Bernini visited the Gobelin tapestry factory and greatly praised Le Brun's designs on September 6 —"Il a fort loué les dessins et tableaux de M. Le Brun et la fertilité de son invention" (Chantelou, 1885, 140)—four days before he designed the pedestal for the bust (see n. 50 below).

49. Pollitt, 1965, 145.

50. "Je lui ait dit que sa pensée se rapporte encore heureusement à la devise du Roi, dont le corps est un soleil avec le mot: *Nec pluribus impar*" (Chantelou, 1885, 150, September 10); cf. also Del Pesco, *Il Louvre*, 1984, 153 n. 16.

51. See n. 37 above.

52. For all these points, see Wittkower, 1951, 16, 17, 18. The passage in Chantelou concerning the subtle expression of the mouth is worth quoting: "Le Cavalier, continuant de travailler à la bouche, a dit que, pour réussir dans un portrait, il faut prendre un acte et tâcher à le bien représenter; que le plus beau temps qu'on puisse choisir pour la bouche est quand on vient de parler ou qu'on va prendre la parole; qu'il cherche à attraper ce moment" (Chantelou, 1885, 133, September 4).

53. On the French tradition, see M. Martin, 1986; Prinz and Kecks, 1985, 252–61; Scheller, 1985, 52ff. The Louvre projects with equestrian statues mounted on the facade are conveniently reproduced in Del Pesco, *Il Louvre*, 1984, figs. 56, 57, 61.

54. See J. Brown and Elliott, 1980, 111ff.; Torriti, 1984, 50ff. But see also n. 72 below.

55. See p. 175 and n. 73 below.

56. On these gestures, see Lavin, "Duquesnoy's 'Nano di Créqui,'" 1970, pp. 145f. n. 78.

57. The analogies with the Piazza Navona fountain and the Louvre rustication were also observed by Bauer, in Chantelou, 1985, 37f. n. 115. Wittkower (1961, 508ff.) discussed the relationship with the Pegasus-Mount Parnassus theme, which was often conflated with that of Hercules at the Crossroads.

58. Wittkower (1961, 502–5) argues convincingly that the smile and the victory flags were introduced late in the execution of the work, following Louis's victorious campaign in Holland in the spring of 1672.

59. The only records of the original face, two medals by Antonio Travani of about 1680 (cf. Figs. 231, 232), seem to me quite compatible with the face as we have it now (the replaced nose notwithstanding). Nor do I consider contradictory to this idealization Elpidio Benedetti's statement in September 1672 that the face closely resembled that in other portraits of the king that had been sent to Rome (see Wittkower, 1961, 504 n. 21, 525, no. 47). On the youthfulness of the face, see also Berger, *In the Garden*, 1985, 107 n. 11.

I might add that there is no real evidence that the smile itself was found offensive. The specific objection raised by a Frenchman, to which Bernini's reply is quoted in the text, was that the smile was inappropriate to the military bearing of man and horse. Domenico Bernini reports the episode as a misunderstanding of Bernini's intention, based on a conventional view of the king and army commanders (the passage is quoted in full in n. 63 below). There was, incidentally, a venerable equestrian monument with a smiling rider, Cangrande della Scala at Verona (Panofsky, 1964, 84, figs. 385, 387).

60. Cf. *The Sun King*, 191 no. 20; Berger, *In the Garden*, 1985, 10, fig. 7.

61. "Iuvat ora tueri mixta notis belli placidamque gerentia pacem" (*Silvae*, I, 1, 15–16; Statius, 1928, I, 6).

62. The *locus classicus* of the theme is in Hesiod's *Works and Days*, lines 289–91: ". . . between us and Goodness the gods have placed the sweat of our brows: long and steep is the path that leads to her, and it is rough at first; but when a man has reached the top, then she is easy to reach, though before that she was hard" (Hesiod, 1950, 24f.). Bernini's notion of Glory at the apex of the mountain as the reward of virtue depends on a tradition stemming from Petrarch (cf. Wittkower, 1961, 507f.). See also pp. 182–85, 187f.

63. The translation, with some alterations, is from Wittkower, 1961, 503. I quote the whole passage,

which concerns an "ingegnoso cavalier Francese, che assuefatto alla vista del suo Rè in atto Maestoso, e da Condottiere di Eserciti, non lodava, che quì allora coll'armatura pur'indosso, e sopra un Cavallo medesimamente guerriero, si dimostrasse nel volto giulivo, e piacevole, che più disposto pareva a dispensar grazie, che ad atterrir'inimici, e soggiogar Provincie. Poiche spiegògli a lungo la sua intenzione, quale, benche espressa adequatamente ancora nell'Opera, tuttavia non arrivò a comprendere il riguardante. Dissegli dunque, *Non haver'egli figurato il Rè Luigi in atto di commandare a gli Eserciti, cosa, che finalment è propria di ogni Principe, mà haverlo voluto collocare in uno stato, al quale non altri, che esso era potuto giungere, e ciò per mezzo delle sue gloriose operazioni. E come che fingono i Poeti risieder la gloria sopra un'altissimo, ed erto Monte, nella cui sommità rari son quelli, che facilmente vi poggiano, ragion vuole, che quei, che pur felicemente vi arrivano doppo i superati disaggi, giocondamente respirino all'aura di quella soavissma gloria, che per essergli costata disastrosi travagli, gli è tanto più cara, quanto più rincrescevole gli fù lo stento della salita. E perche il Rè Luigi con il lungo corso di tante illustri vittorie haveva già superato l'erto di quel Monte, egli sopra quel Cavallo lo collocava nel colmo di esso, pieno possessore di quella gloria, che a costo di sangue haveva acquistato il suo nome. Onde perche è qualità propria di chi gode la giovialità del volto, & un'avvenente riso della bocca, quindi è, che tale appunto haveva rappresentato quel Monarca. Oltracche, benche questo suo pensiere si potesse ben ravvisare nel Tutto di quel gran Colosso, tuttavia molto più manifesto apparirebbe, quando collocar si dovesse nel luogo destinato. Poiche colà doveasi scolpir in altro Marmo una Rupe proporzionata erta, e scoscese, sopra cui haverebbe in bel modo a posare il Cavallo con quel disegno, ch'ei fatto ne haverebbe"* (Bernini, 1713, 149ff.).

64. Bocchi, 1555, CLXXVIIIf., Symb. LXXXV titled "Felicitas prudentiae et diligentiae ultima est" (cf. Massari, 1983, II, 108, 210). The relevance of Bocchi's emblem is confirmed by the fact that it was imitated in two engravings illustrating an encomium of Louis published in 1682 by Elpidio Benedetti, Colbert's agent in Rome, who was closely acquainted with Bernini's ideas (cf. Wittkower, 1961, 510f., figs. 28, 29).

65. "... un gran sasso d'un sol pezzo, che si dice essere il maggiore, che fino a dì nostri sia stato percosso da scalpello ..." (Baldinucci, 1948, 126); "... figura a Cavallo in Grandezza superiore alla già fatta dell'Imperador Costantino"; "... un Masso smisurato di marmo, superiore in grandezza a quanti giammai ne vidde la Città di Roma" (Bernini, 1713, 146, 148). "Jamais l'Antique n'a mis en oeuvre un bloc de marbre si grand. Le piédestail, le cheval & la figure bien plus haute que nature, sont d'une seule piéce, le toute isolé" (Cureau de la Chambre, [1685], 22); on this publication, see Lavin, 1973, 429.

Domenico Bernini (1713, 107) reports that the Constantine was carved from a block of 30 *carretate*, or 30 x 362.43 cm^3 = 10.87 m^3 (cf. Zupke, 1981, 85; Klapisch-Zuber, 1969, 72f.). The equestrian Louis XIV measures cm 366h x 364l x 150w = 19.98 m^3. These claims evidently discounted the ancient tradition that the much larger Farnese Bull was made *ex uno lapide*.

The feat of carving a life-size freestanding equestrian statue from a single block was extolled in the fourteenth century, with reference to the monument of Bernabò Visconti in Milan (Pope-Hennessy, 1972, 201).

66. Vitruvius, 1931–34, I, 72f. Dézallier d'Argenville, 1787, I, 220–22, refers the Alexander story to Bernini's sculpture, citing Jean Barbier d'Aucour (1641–94). It should be borne in mind that metaphorical mountains generally were then much in vogue in Rome, mountains forming part of the family arms of Fabio Chigi, the reigning pope Alexander VII (1655–67). The story was applied to the pope in a composition by Pietro da Cortona (cf. Noehles, 1970, 16, 36, fig. 27; Körte, 1937, 305f.; Fagiolo, in *Bernini in Vaticano*, 1981, 159f.; see also n. 75 below). Recent contributions on the Dinocrates theme are Oechslin, 1982; Meyer, 1986.

The size of Bernini's sculpture and the reference to Alexander and Mount Athos are the main theme of a poem eulogizing the work written by the great Bolognese art critic and historian Carlo Cesare Malvasia, printed as a broadside in 1685. As far as I know, the text has

never been cited in the literature on the sculpture. I reprint it here, *in extenso*, from a copy in the Princeton University Library:

<div align="center">

PER LA STATUA EQUESTRE

DEL RE CHRISTIANISSIMO

COLOSSO MARMOREO

DEL FIDIA DE NOSTRI TEMPI

IL SIG. CAVALIER BERNINI

ALL ILLUSTRISS. ET ECCELLENTISS. SIG. IL SIG.

MARCHESE DI LOVVOIS.

</div>

Questa di bel Destrier Mole fastosa
 In sostener del RE l'Imago viua,
 E la più del Bernini opra famosa,
 Ch'eterna lode al suo gran nome ascriua.
Con essa mai di gareggiar non osa
 Greco scalpello, e non mai lima Argiua;
 E vinta è quell'idea sì ardimentosa,
 Che far di vn monte vn'Alessandro ardiua.
Pure al degno lauor niega, ò contrasta
 La penuria del marmo il pregio intiero,
 Quasi picciola sia mole si vasta;
Che il Colosso à formar del RE GVERRIERO,
 Maggior di vn Alessandro, oggi non basta
 D'Ato e di Olimpo il doppio giogo altiero.
<div align="center">Humiliss., e Deuotiss. Seruitore
Carlo Cesare Malvasia.</div>

<div align="center">

IN ROMA, Nella Stamperia della Reuerenda Camera Apostolica. M.DC.LXXXV.

CON LICENZA DE'SUPERIORI.

</div>

(The broadside is part of a collection mentioned by Lindgren and Schmidt, 1980, 187.)

67. Lavin, 1977–78, 20ff.; Mockler, 1967, 23f.
68. On his way north Bernini stopped in Florence for three days and in Turin for two. His regal treatment by Ferdinando II of Tuscany and Carlo Emanuele of Savoy is described by Baldinucci, 1948, 117f., and Bernini, 1713, 125. Bernini also stopped in Turin on his way back to Rome (cf. Mirot, 1904, 260 n. 2); a product of this visit was his role in an imaginary dialogue describing the ducal hunting lodge, published by Di Castellamonte, 1674 (see "Madama Reale" prologue); further, Claretta, 1885, 517ff.; Cavallari-Murat, 1984, 347ff.

69. For the facts presented here see Haskell and Penny, 1981, 165–67, with references, and the important results of the recent restoration of the group in *Il Toro*, 1991. The Farnese Bull measures cm 370h x 295l x 293w = 31.98m^3.
70. I am indebted to Signoria Nicoletta Carmiel of Florence, who helped with the recent restoration of the group, for obtaining its dimensions: cm 285h x 200l x 130w = 7.41m^3 (cf. n. 65 above); Avery, 1987, 117f.
71. Avery and Radcliffe, eds., 1978–79, 222, no. 229. On the motto, from Virgil, *Aeneid* IX, 641, see Cheles, 1986, 63; Cieri Via, 1986, 55 n. 18; Tenzer, 1985, 240, 317 n. 124.
72. See most recently, Viale, ed., 1963, II, 25f. Rivalta's horse was itself a substitute for an unexecuted project of 1619 by Pietro Tacca that would have preceded the Philip IV in Madrid as the first modern rearing equestrian monument in bronze (cf. Torriti, 1984, 31ff.; K. J. Watson, in Avery and Radcliffe, eds., 1978–79, 182f.).
73. The relation to the Constantine is documented in an exchange of letters between Colbert and Bernini: "Joint que le bloc de marbre que vous avez demandé a esté dans la veue de faire la figure du Roi de la manière de celle de vostre Constantin, en changeant neantmoins quelque chose dans l'attitude de la figure et du cheval en sorte que l'on ne puisse pas dire que s'en est une Coppie, et que d'ailleurs ce bloc de marbre a l'estendue et les mesures necessaires pour cela..." (December 6, 1669, Paris, Bibliothèque Nationale, MS lat. 2083, 259f., quoted in part by Wittkower, 1961, 521, no. 23); Bernini's response: "Questa statua sarà del tutto diversa a quella di Costantino, perche Costantino stà in atto d'amirare la Croce che gl'apparve, e questa del Rè starà in atto di maestà, e di comando, nè io mai havrei permesso, che la statua del Rè fosse una copia di quella di Costantino" (December 30, Wittkower, 1961, 521, no. 24, cf. p. 501). On the equestrian figures of Constantine-Charlemagne, Seidel, 1976.
74. The medals, by Antonio Travani, were first published by Dworschak, 1934, 34f.

75. The same motto had been used by Stefano della Bella in an allegorical composition of 1661 showing the Chigi mountain emblem (cf. n. 66 above) as the Mountain of Virtue whose tortuous path is recommended by the Wise Men of antiquity and the prudent Hercules: "Per salebrosus Montium anfractus certissimum esse Virtutis, ad Beatitudinem, ac ad Superos iter, fuit commune Sapientiorum Iudicium, prudens Herculis ad posteros documentum" (Donati, 1939; cf. *Bernini in Vaticano*, 1981, 162; Massar, 1971, 61f., no. 69, pl. 25).

According to Cureau de la Chambre (1685, 23), the statue was to have been inscribed with the motto *Per ardua*: "Il doit y avoir un Inscription Latine au bas, qui en deux mots renferme tout ce qu'on peut dire sur un sujet si heroïque. PER ARDUA. Le départ de cette Statue a donné lieu de supposer un Dialogue . . ." This passage was added to the version of the "Eloge" printed in the *Journal des sçavans* in 1681, for which see Wittkower, 1961, 529.

76. "Virtus in astra tendit" (Seneca, *Hercules Oetaeus*, line 1971). On the theme generally, see Panofsky, 1930, 45ff.; Hommel, 1949.

77. This medal is reproduced by Menestrier, 1693, pl. 29, no. CLII, with the following caption: "La Ville de Rome a consacré ce Monument au zele DU ROY TRES CHRESTIEN LOUIS LE GRAND, PLUS GRAND ENCORE PAR SA VERTU QUE PAR LE RANG QU'IL TIENT et la Victoire qui eleve la Couronne Royale au dessus de la Croix que tient la Religion et qui a l'heresie sous ses pieds, assure que PENDANT QUE LE ROY SERA VICTORIEUX, LA RELIGION TRIOMPHERA."

On the French king as *Rex Christianissimus*, see De Pange, 1949. In connection with this epithet, Fumaroli has emphasized the sacerdotal nature of Louis's conception of kingship (see Fumaroli, 1986, 108ff.). The tapestry series of the life of Constantine, begun by Louis XIII and completed by Urban VIII, had drawn a connection between the French king, Constantine, and the pope (Dubon, 1964).

Louis adopted the title Magnus only in 1672 (see Jacquiot, 1967, 190 n. 1).

78. ". . . il lui était venu dans la pensée de faire dans cet espace deux colonnes comme la Trajane et l'Antonine et, entre les deux, un piédestal où serait la statue du Roi à cheval avec le mot de *non plus ultra*, allusion à celle d'Hercule" (Chantelou, 1885, 96, August 13). The project is reflected in the medal of Charles VI of 1717 illustrated in Fig. 235 (Koch, 1975–76, 59; Volk, 1966, 61); here, however, the equestrian group, the pedestal, the columns, and the motto are all returned to their traditional forms and reconverted to the traditional theme of Hapsburg imperialism. For more of the legacy of Bernini's idea, see n. 79 below.

Combinatory thinking as a means of superseding the great monuments of antiquity also underlies Bernini's alternative project for the area between the Louvre and the Tuileries — a double structure for spectacles and stage performances, joining the Colosseum to the Theater of Marcellus (Chantelou, 1885, 96, August 13) — perhaps reflected in a later project reproduced by Del Pesco, *Il Louvre*, 1984, fig. 43; cf. pp. 42, 49 n. 22.

79. A certain precedent is provided by Roman sarcophagi in which the labors of Hercules are placed between columns with spiral fluting (cf. Robert, 1969, part 1, 143ff., pls. XXIVff.) and in works like the Hercules fountain in the Villa Aldobrandini at Frascati, where water descends around the pair of columns in spiral channels (D'Onofrio, 1963, figs. 78, 82, 86, 90; Fagiolo dell'Arco, 1964, 82ff.; R. M. Steinberg, 1965). The columns of the Hapsburg device, often shown entwined by spiraling banners, were identified by Rubens (J. R. Martin, 1972, pl. 37) with the twisted columns in St. Peter's in Rome, supposedly brought from the Temple of Jerusalem by Constantine the Great; see also a painting of Augustus and the Sibyl by Antoine Caron (Yates, 1975, 145, fig. 21). Yet, none of these cases involved Bernini's clear and explicit conflation of the triumphal and Herculean columns.

Perhaps Bernini was himself alluding to the pair of columns erected by Solomon before the Temple of Jerusalem (1 Kings 7:14–22; 2 Chron.

3:17); these were frequently associated with the twisted columns at St. Peter's, an association that had played an important role in Bernini's designs for the crossing of St. Peter's. (Lavin, *Bernini*, 1968, 14ff., 34; the paired columns of Perrault's Louvre facade have been linked to the Temple of Solomon by Corboz, 1984). If so, Bernini would have been the first to extend the association to the imperial spiral columns, an idea that was then taken up by Fischer von Erlach in the St. Charles Church, Vienna, built for Charles VI: the pair of columns flanking the facade is identified in one source as Constancy and Fortitude, in reference to the biblical names of Solomon's columns, Jachin and Boaz, meaning "He shall establish" and "In it is strength" (cf. Fergusson, 1970, 321ff.). Fischer seems also to echo the design and the themes of Giacomo Lauro's reconstruction of the ancient temple of Honor and Virtue in Rome, to be discussed presently.

80. Kircher, 1650, 235f., also in Kircher, 1652–54, II, 1, 206 (cf. Godwin, 1979, 60). The relief had been elaborately interpreted by Girolamo Aleandro in a publication of 1616 (see Allen, 1970, 270–72), from which it was reproduced and discussed in our context by Del Pesco, *Il Louvre*, 1984, 143, fig. 114. On Kircher and Bernini, cf. Preimesberger, 1974, 102ff.; Rivosecchi, 1982, esp. 117–38; Del Pesco, *Il Louvre*, 1984, 138f.

Kircher also wrote a book on the Piazza Minerva obelisk erected by Bernini shortly after his return from Paris (Heckscher, 1947); in certain workshop studies for the monument the obelisk is held up by allegorical figures posed on a rocky base (Brauer and Wittkower, 1931, pls. 176, 177b; cf. also D'Onofrio, 1965, fig. 134 opp. p. 235).

Bernini's preoccupation at this period with the theme of the rocky mountain of virtue is expressed also in a series of drawings of devotional themes, which evidently began during his stay in Paris. The compositions portray penitent saints kneeling and ecstatically worshiping a crucifix that lies prone before them; all portray the event taking place atop a rocky peak. See Brauer and Wittkower, 1931, 151ff.; Blunt, 1972.

81. Gamberti, 1659, 5, pl. opp. p. 190; cf. Berendsen, 1961, 134ff., no. 80, 219ff. The catafalque was designed by Gaspare Vigarani, who later built the Salle des Machines in the Tuileries and whose son, Carlo, was in Paris as theater architect to Louis XIV during Bernini's visit (Chantelou, 1985, 80 n. 139, 81 n. 144). Surmounted by a trumpeting figure of Glory standing on a globe and triumphant over Death, the monument also anticipated Bernini's notion of Glory at the summit of the earth as the reward for virtue (see pp. 170–72).

The projected equestrian monument to Francesco I is the subject of correspondence in June 1659 published by Fraschetti, 1900, 226.

82. On the Hapsburg device, see E. S. Rosenthal, 1971, 1974, and 1985, 81f., 257ff.; and Sider (1989), who stresses the spiritual aspects.

83. See most recently Krautheimer, 1983 and 1985, 53ff.

84. Bernini recalls his project on two occasions recorded in Chantelou's diary: "Il a parlé ensuite de la proposition qu'il avait faite au Pape de transporter la colonne Trajane dans la place où est la colonne Antoniane, et d'y faire deux fontaines que eussent baigné toute la place; qu'elle eût été la plus belle de Rome" (Chantelou, 1885, 40, June 25); "Il a dit qu'il avait proposé au Pape de la transporter dans la place où est l'Antoniane, et là, faire deux grandes fontaines, qui auraient noyé la place en été; que c'eût été la plus magnifique chose de Rome; qu'il répondait de la transporter sans la gâter" (Chantelou, 1885, 249, October 19).

A legacy of Bernini's idea, and an echo of his linking it to France, are evident in the pair of monumental spiral columns that formed part of the temporary decorations erected in the Piazza Navona to celebrate the birth of Louis XIV's successor in 1729 (Kiene, 1991).

85. The ancient tradition, admirably sketched by Frazer, 1966, was revived in the palace architecture of the popes in sixteenth-century Rome, for which see Courtright, 1990, 119ff.

86. See Pastor, 1923–53, XXI, 239ff.; the inscriptions are given in Caprini *et al.*, 1955, 41f.

87. On the catafalque, cf. Berendsen, 1961, 110ff., no. 10, 166ff. The columns are often shown together in the imagery of Sixtus V (D'Onofrio, 1965, fig. 63 opp. p. 149, fig. 89 opp. p. 187; Fagiolo and Madonna, eds., 1985, fig. on p. 199).

 The temple (Lauro, 1612–41, pl. 30) is cited by Del Pesco, *Il Louvre*, 1984, 147f., and *idem*, "Una fonte," 1984, 424f. Lauro's reconstruction had been compared to Bernini's Santa Maria dell'Assunta in Ariccia by Hager, 1975, 122f.; also Marder, "La chiesa," 1984, 268.

88. The force of the ecclesio-political associations evoked by the columns is witnessed by another project from the time of Alexander VII (published by Krautheimer, 1983, 206, and *idem*, 1985, 58f.) that envisaged making the column of Marcus Aurelius the mast of a fountain in the form of a ship—the navicella of St. Peter, the ship of the church. Although related to a specific boat-fountain type (for which see Hibbard and Jaffe, 1964), the project obviously revives a proposal made by Papirio Bartoli early in the seventeenth century to create a choir in the crossing of St. Peter's in the form of a ship whose mast was a bronze version of the column of Trajan, with reliefs of the Passion (Hibbard and Jaffe, 1964, 164; Lavin, *Bernini*, 1968, 43); the spiral column also recalls the Solomonic twisted columns that decorated the Constantinian presbytery at St. Peter's.

89. Marchesi, 1660; the work was published under the pseudonym Pietro Roselli. The importance of Bernini's relationship to his nephew, first emphasized by Lavin (1972), has been greatly expanded by the recent studies of Marchesi's ambitious project for a charitable hospice for the indigents of Rome, for which Bernini's last work, the bust of the Savior, became the emblem; see the essays by B. Contardi, M. Lattanzi, and E. Di Gioia, in *Le immagini*, 1988, 17ff., 272ff. (cf. p. 273 on Marchesi, 1660), 285ff.

90. Menestrier, 1660, opposite p. 54. The print was first related to Bernini's project by K. O. Johnson, 1981, 33f., followed by Petzet, 1984, 443, and Del Pesco, *Il Louvre*, 1984, 150; Johnson drew no implications concerning the interpretation of

the statue, but he clearly understood the Bernini project in the light of current political repercussions of the treaty. A confusing error by Vivanti, 1967, pl. 21e, concerning the print, was corrected by Johnson, 40 n. 12.

91. Menestrier, 1662, 129f.: "Il seroit souvent à souhaiter pour la gloire des Heros qu'ils missent eux mesmes des bornes volontaires à leur desseins avant que le Temps ou la Mort leur en fissent de necessaires . . . c'est ce grand Example, qui doit faire admirer à tous les Peuples la moderation de nostre Monarque qui ayant plus d'ardeur & de courage que n'en eurent tous les Heros de la vieille Grece & de Rome, à sceu retenir ces mouvemens genereux au milieu du succez de ses victoires, & donner volontairement des bornes à sa fortune . . . Ce sera aussi ce Trophée qui le rendra glorieux dans l'histoire de tous les siècles, quand on sçaura que ce ieune conquerant à preferé le repos de ses Peuples aux avantages de sa gloire, & sacrifié ses interests à la tranquillité de ses Sujets."

 The Lyon image, in turn, was evidently modeled in part on Rubens's Arch of the Mint from the *Pompa Introitus Ferdinandi* (J. R. Martin, 1972, pl. 99; and see McGrath, 1974). The motif of a woman chained to two pillars was familiar from zodiacal depictions of the constellation Andromeda (Murdoch, 1984, 252f.).

92. Louis XIIIIe
 Roy de France et de Navarre,
 Après avoir dompté ses ennemis, donné la paix à
 l'Europe,
 A soulagé ses peuples.

 For the entire inscription and its Latin pendant, see Chantelou, 1885, 228, October 12, and, for the ceremony, 240f., October 17; Chantelou, 1985, 290f., 306.

93. Chantelou, 1885, 219, October 10; on Le Brun's paintings see Hartle, 1957, 93f.; Posner, 1959, 240ff.; Hartle, 1970, 393ff., 401ff., and *idem*, 1985, 109. Rosasco, 1991, has shown that the same idea subsequently played an important role at Versailles. For other aspects of the theme of Alexander as the self-conquering hero, see also,

concerning an opera first performed in Venice in 1651, Osthoff, 1960; Straub, 1969, 201–9.

94. The latest contributions concerning this project, in which references to the earlier literature will be found, are by Marder, "The Decision," 1984, 85f.; Laurain-Portemer, in Fagiolo, ed., 1985, 13ff.; and Krautheimer, 1985, 99ff.

95. The significance of the Peace of the Pyrenees may be deeper still. Menestrier felt constrained to publish a whole volume (1679) in which he defended the king's *Nec Pluribus Impar* emblem of 1662 against a claim that it had been used earlier by Philip II. Menestrier was certainly right, but it is no less clear that the device was invented as a response, from Louis's new position of power, to the Hapsburg claim to world dominion. (Although he did not connect it to the treaty, K. O. Johnson, 1981, 40 n. 17, also recognized that Louis's device had Spanish connotations from the beginning.) The Lyon tableau belongs to the same context, and I suspect its rocky mountains may be reflected not only in the base of Bernini's equestrian statue but also in the *scogliera* of the Louvre itself. The Peace of the Pyrenees and its implications were fundamental to Bernini's conception of the Sun King, and linking the globe of the *Nec Pluribus Impar* emblem with the mountain of the *Non Ultra* tableau provided the common ground for the image he created in all three projects for the king.

 In an exemplary study Ostrow, 1991, esp. 109ff., has emphasized the importance both of the rivalry between Spain and France and of the Peace of the Pyrenees in the history of the statue of Philip IV in Santa Maria Maggiore, designed by Bernini just before his trip to Paris.

96. See Berger, *In the Garden*, 1985, 72, 108 n. 25, fig. 102f.

97. "... il s'estimerait heureux de finir sa vie à son service, non pas pour ce qu'il était un roi de France et un grand roi, mais parce qu'il avait connu que son esprit était encore plus relevé que sa condition" (Chantelou, 1885, 201, October 5; translation from Chantelou, 1985, 254, with modifications).

98. See n. 10 above. Fleurs-de-lys crown the cornice of the central oval in the first project (Fig. 191; for a discussion of the crown motif, see Berger, 1966, 173ff., and *idem*, 1969, 29f.); a coat of arms appears above the portal in the third project (Figs. 177, 180); and fleurs-de-lys, monograms, and sunbursts appear in the frieze of the Stockholm version of the third project (Del Pesco, *Il Louvre*, 1984, fig. 40).

99. "Nel prepararsi del opere usava di pensare ... prima all'invenzione e poi rifletteva all'ordinazione delle parti, finalmente a dar loro perfezione di grazia, e tenerezza. Portava in ciò l'esempio dell'oratore, il quale prima inventa, poi ordina, veste e adorna" (Baldinucci, 1948, 145). Bernini's is a simplified and more sharply focused version of the orator-painter analogy drawn by Federico Zuccari: "E si come l'Oratore ... prima inventa, poi dispone, orna, manda à memoria, e finalmente pronuncia ... Così il buon Pastore deve considerare tutte le parti della sua Pittura, l'inventione, la dispositione, e la compositione" (see Zuccari, 1607, part II, p. 9; Heikamp, ed., 1961, 229).

100. The rigor and astrigency of the project designed in Paris seem to have been mitigated by the modifications Bernini introduced after his return to Rome, as recorded in drawings preserved at Stockholm. Changes evident in the east facade (see also n. 98 above) include the following: the natural rustication is confined to the main central block, and the horizontal joins in the stone courses seem more emphatic; the Hercules figures are asymmetrical, they are placed on regular low plinths, and their poses are more open and "welcoming" (cf. Del Pesco, *Il Louvre*, 1984, 44f. n. 7, figs. 40–42).

101. "... *Esser i panneggiamenti del Rè, & i crini del Cavallo, come troppo ripiegati, e trafitti, fuor di quella regola, che hanno a Noi lasciata gli antichi Scultori, liberamente rispose, Questo, che ... gli veniva imputato per difetto, esser il pregio maggiore del suo Scalpello, con cui vinto haveva la difficoltà di render' il Marmo pieghevole come la cera ... E'l non haver ciò fatto gli antichi Artefici esser forse provenuto dal non haver loro dato il cuore di rendere i sassi così ubbidienti alla mano, come se stati fossero di*

pasta" (Bernini, 1713, 149; cf. Baldinucci, 1948, 141).

102. Bernini himself chose the position in the antechamber of the king's new audience hall, on October 13, a week before his departure (Chantelou, 1885, 231f.).

103. The idea of Paris surpassing Rome was expressed by Bernini himself at his first meeting with the king (cf. p. 147 and n. 12 above) and was bruited in a French sonnet extolling Bernini and the king (Chantelou, 1885, 149, September 9).

104. Robert Berger (1966) has persuasively argued that Bernini's first Louvre project, including its characteristic drum-without-dome motif, doffed its hat, as it were, to an ideal château design of 1652 by Antoine Lepautre.

105. The medal (for which see *La Médaille*, 1970, 81, no. 116; Jones, 1982–88, II, 224ff., no. 239) was inserted in the foundation stone along with the inscriptions mentioned above, p. 182 n. 92; it is discussed several times in Chantelou's diary (Chantelou, 1885, 164, 168f., 215, 228f., 240, September 16, 19; October 8, 12, 17).

106. Cureau de la Chambre, 1685, 23 (cf. n. 65 above); Wittkower, 1961, 511 n. 61, 529.

107. Fabricii, 1588; the emblem to be discussed appears on p. 308. On this emblem and its significance for the Quirinal palace, see Courtright, 1990, 128f.

108. De la Rochefoucauld is portrayed on the obverse; his devotion to the papacy was exemplary (see Pastor, 1923–53, XXVIII, 441; Bergin, 1987). The elevation of St. Peter's, which includes Maderno's bell towers, reproduces Mattheus Greuter's 1613 engraving (Hibbard, 1971, pl. 54). The reverse is illustrated without comment in Küthmann *et al.*, 1973, 219f., no. 351. The reverse of the example in the Bibliothèque Nationale, reproduced in Fig. 248, is inscribed т. BERИARD. F. [*sic*], presumably the first medallist of that name, who was active ca. 1622–65 (Forrer, 1904–30, I, 172f., VII, 74). It should be noted that the Rochefoucauld medal repeats the image of St. Peter's on a rock on the medal by Caradosso of 1506 illustrating Bramante's project for the new basilica.

Bernini explicitly recalled the piazza of St. Peter's in his planning for the area between the Louvre and the Tuileries as well as for that in front of the Louvre (Chantelou, 1885, 42, July 1; 52, July 15). B. Boucher (1981) has recently suggested that Bernini's first design for the Louvre reflected early projects by Peruzzi for St. Peter's.

109. "... egli sia stato fra' Primi ... che habbia saputo in modo unire assieme le belle Arti della Scultura, Pittura, & Architettura, che di tutte habbia fatte in se un maraviglioso composto ... con uscir tal volta dalle Regole, senza però giammai violarle" (Bernini, 1713, 32f.; cf. Baldinucci, 1948, 140).

For a discussion of Bernini's "wholistic" views on art generally, see Lavin, *Bernini*, 1980, 6ff.

110. On this project see Josephson, 1928; Wittkower, 1961, 513f.; Hedin, 1983, 211, no. 49; Souchal, 1977–, vol. *G–L*, 47f., no. 47; Weber, 1985, 190ff.; M. Martin, 1986, 54–60.

111. Keller-Dorian, 1920, I, 37ff., no. 30.; Kuraszewski, 1974; Souchal, 1977–, vol. *A–F*, 186f., no. 25. On the personification of "Gloria dei Prencipi" holding an obelisk (Ripa, 1603, 189), see Petzet, 1984, 443.

112. See on this important point Berger, *In the Garden*, 1985, 63. The traditional architectural pedestal the work ultimately received was supplied by Mattia de' Rossi (Menichella, 1985, 23f.).

113. There was a striking and well-known precedent for such an interpretation of the theme in Rome early in the century: Cardinal Scipione Borghese had been compared to Marcus Curtius, and Bernini's father, Pietro, had portrayed the subject by restoring an antique fragment for display at the Villa Borghese (cf. D'Onofrio, 1967, 208–9, 213, 255–58; Haskell and Penny, 1981, 191–93). Though in a different way, Wittkower also saw the appropriateness of the Marcus Curtius theme; see Wittkower, 1961, 514.

114. Strictly speaking this observation applies to Guidi's group as well; incidentally, Guidi himself might be said to have metaphorized his portrait of the king by transforming the contemporary

armor shown in the model into classical costume (cf. Seelig, 1972, 90).

The evident restraints on direct portrayals of the king inside Versailles until about 1680, and much more tenaciously in the garden, are emphasized by Berger, *Versailles,* 1985, 39, 50, 53, 55, and *In the Garden,* 1985, 26, 64f.

115. Again, I am indebted to Berger for this perception (*Versailles,* 1985, 39, 50, 87 nn. 104–5).

116. Cf. Blunt, 1953, 192, 279 n. 35.

117. Cf. Berger, *Versailles,* 1985, 23, 25. My analysis is merely an extension and refinement of Berger's observation that the primary sources of Le Vau's Enveloppe at Versailles were the Italian villa type with terrace and Roman High Renaissance palaces. French indebtedness to Bernini later at the Louvre and at Versailles has also been stressed by Tadgell, 1978, 54–58, 83 n. 121 and 1980, 327, 335.

118. K. O. Johnson, 1981, 33ff. Our attention here being focused in the legacy at Versailles of Bernini's ideas for the Louvre, I will not pursue possible relationships between the planning of the château and other projects in which Bernini had been involved—notably those between the tridentine avenues of approach with twin buildings at the angles and the Piazza del Popolo at Rome (most recently, Castex *et al,* 1980, 7ff., a reference for which I am indebted to Guy Walton). A similar arrangement was proposed in 1669 by François d'Orbais for the approach to the main facade of the Louvre (cf. Chastel and Pérouse de Montclos, 1966, 181, fig. 5 and pl. V).

119. For what follows, see Pühringer-Zwanowetz, 1976. The author of the report to be discussed was probably Lorenzo Magalotti, whose interest in the Louvre is known from letters written to him by the painter Ciro Ferri on September 30, 1665, and February 17, 1666 (Bottari and Ticozzi, 1822–25, II, 47–52).

120. Chantelou, 1885, 154ff., September 13.

121. I am greatly indebted to Simone Hoog of the Musée Nationale du Château de Versailles for photographs and the following information, *in litteris:*

1) l'acte de vandalisme sur le Marcus Curtius s'est passé dans la nuit du 5 au 6 juin 1980.

2) les morceaux du cheval qui avaient été arrachés concernaient: la queue, la crinière, la patte avant droite, l'oreille droite et, pour le cavalier un morceau du cimier et le menton; avec bien sûr quelques épauffrures supplémentaires de moindre importance . . . tout a été 'recollé,' mais il nous manque malheureusement quelques petits éclats de marbre (pour la queue et l'oreille du cheval en particulier).

3) la presse française a été étrangement silencieuse sur ce triste événement. Voici malgré tout trois références: *Les Nouvelles de Versailles,* 11 juin et 3 septembre 1980; *Le Figaro,* 12 août 1980; *Le Monde,* 20 novembre 1980.

Mais il ne s'agit pas d'articles importants, seulement de bulletin d'information très courts. J'ai moi-même évoqué le sujet et les problèmes de restauration qu'il soulève dans un article paru dans *Monuments Historiques,* no. 138, avril–mai 1985.

The restored sculpture is now permanently on display in the Grandes Ecuries.

122. On Bernini, the anti-Machiavellian tradition, and the prince-hero (p. 163), see Lavin, 1991. The anti-Machiavellian tradition, first defined by Meinecke, 1924, has been studied by De Mattei, 1969 and 1979, and the theories of the chief exponents in the sixteenth and seventeenth centuries have been summarized by Bireley, 1990. This development in the secular sphere had a close and surely related corollary in the theological principle of heroic virtue, essential in the process of canonizing saints, first introduced in 1602 and elaborately formulated later in the century (for which see Hofmann, 1933; *Enciclopedia cattolica,* 1948–54, III, *s.v.* "Canonizzazione," cols. 595f., 605f.).

An important and pioneering study by Keller (1971) discusses the major European equestrian monuments of the sixteenth and seventeenth centuries in relation to contemporary political theory, including some of the writers who belong in the anti-Machiavellian camp. In the

present context, however, Keller's work has a critical shortcoming: although his perception of Bernini's intention is sound, Keller excludes Bernini's equestrian Louis XIV as expressing an allegorical conceit rather than a political theory (see pp. 17 and 68ff.). In fact, Bernini's innovation lay precisely in merging these two levels of meaning.

123. The sharpest critique is that of Colbert, reported by Chantelou as the last entry in his diary, November 30, 1665, a few days after Bernini left for Rome (Chantelou, 1885, 264f.). Bauer rightly recalls the Gunpowder Plot in this connection (in Chantelou, 1985, 37, 303).

124. The inversion and moralization of conventional social values implicit in Bernini's attitude in the official, public domain has its counterpart in his creation of the private caricature portrait of exalted and high-born personages (see Chapter 7 and Lavin, 1990).

125. For a complete and thorough survey of these projects, see Daufresne, 1987.

126. The sources concerning this proposal are conveniently gathered in Del Pesco, *Il Louvre*, 1984, 41f., 48 n. 22.

127. Bernini's comedy of two theaters is described by Baldinucci, 1948, 151, and Bernini, 1713, 56.

128. In an interview Pei demonstrated to me (see Fig. 261) how he derived the pyramid from the geometric configuration of Le Nôtre's garden parterre of the Tuileries.

129. The importance of simplicity-opacity-transparency as Pei's way of relating his pyramid to the historic buildings of the Louvre has been observed by S. Lavin, 1988. The transparency of the pyramid was discussed in a fine paper by Stephen L. Rustow, "Transparent Contradictions: Pei's Pyramid at the Louvre," delivered at the 1990 meeting of the Society of Architectural Historians.

130. See Hoog, 1989, 57ff.

131. The displacement of the statue on the *grand axe* of Paris is also noted in a forthcoming paper on the Grand Louvre by Fleckner.

132. ". . . il sommo pregio dell'artefice [*is*] il sapere inventar maniere per servirsi del poco, del cattivo e male adattato al bisogno per far cose belle e far sì che sia utile quel che fu difetto e che, se non fusse, bisognerebbe farlo" (Baldinucci, 1948, 146; cf. Bernini 1713, 32).

7. Picasso's Lithograph(s) "The Bull(s)" and the History of Art in Reverse

The substance of the discussion of Picasso's prints was presented initially in February 1986 at a meeting of the College Art Association of America, in a session which I organized together with Whitney Davis and Jonathan Fineberg. The session was devoted to Art without History and its significance for the mainstream of European, especially Modern, art. This essay is a partner and sequel to a lengthy paper on Bernini's caricatures first published in 1981 (Lavin *et al.*, 1981) and reprinted with additions in a volume published in conjunction with an exhibition on High and Low art at the Museum of Modern Art (Lavin, "High and Low," 1990).

1. There is a substantial bibliography on primitivism, beginning with the classic work of Lovejoy and Boas, 1935; more recent literature on primitivism in art generally will be found in *Encyclopedia*, 1959–87, XI, cols. 704–17, to which should be added Gombrich, 1985, and, for the modern period, Rubin, ed., 1985; Connelly, 1987; Leighten, 1990. Other domains of art-without-history and their relations to sophisticated art have yet to receive a comprehensive treatment. The development of interest in the art of the insane, in particular, has now been studied in an exemplary fashion by MacGregor, 1989.

2. On the Olynthus mosaics, see Salzmann, 1982, 100ff.

3. Cited by M. L. Hadzi in Lehman, 1982, 312.

4. This last is the insightful suggestion of Tronzo, 1986. The idea had been explored with respect to classical literary style by Gombrich, 1966.

5. These works have been the subject of a study by Schmitt (1980) whose fundamental importance for our understanding of medieval art has yet to be fully grasped.

6. For a description and bibliography, see Lavin *et al.*, 1981, no. 99, 336–37. The paper has been cut, and traces of further drawing appear at the upper right. In this case, perhaps, the sheet was not devoted exclusively to the caricature, which Bernini may have drawn for his personal satisfaction and kept for himself. Twenty-five caricatures are mentioned in a 1706 inventory of Bernini's household; Fraschetti, 1900, 247.

7. For a general account of social criticism in post-medieval art, see Shikes, 1969. A good analysis of the Carraccis' *ritrattini carichi,* with the attribution to Annibale of the drawing reproduced as my Figure 272, will be found in Posner, 1971, 65–70, fig. 59 (cf. fig. 60, certainly cut from a larger sheet); but see also Bohlin, 1979, 48, 67 nn. 83–84. So far as can be determined, the Carracci drawings displayed neither the social content nor the distinctive draftsmanship of Bernini's caricatures, nor is it clear that they were autonomous sheets. On the papal satires of the Reformation, see Grisar and Heege, 1921–23; Koepplin and Falk, 1974–76, II, 498–522.

8. For caricature generally, and bibliography, see *Encyclopedia,* 1959–68, III, cols. 734–35. For a useful survey of caricature since the Renaissance, see *Caricature,* 1971. On the development in Italy, the fundamental treatment is that of Juynboll, 1934; important observations will be found in an essay by Kris and Gombrich, 1952. The pages on Bernini's caricatures in Brauer and Wittkower, 1931, 180–84, remain unsurpassed, but see also Boeck, 1949. Harris (1975, 158, and *Selected Drawings,* 1977, p. xviii, nos. 40, 41) has questioned whether the caricatures in the Vatican Library and the Gabinetto Nazionale delle Stampe in Rome, attributed to Bernini by Brauer and Wittkower, are autographs or close copies; the issue, however, does not affect the general argument presented here. Caricature drawings attributed to Bernini other than those noted by Brauer and Wittkower and by Harris (*Selected Drawings,* 1977) will be found in Cooke, 1955; Sotheby, 1963, lot 18; Stampfle and Bean, 1967, 54f.

9. In Bernini's drawings, "si scorge simmetria maravigliosa, maestà grande, e una tal franchezza di tocco, che è propriamente un miracolo; ed io non saprei dire chi mai nel suo tempo gli fusse stato eguale in tal facoltà. Effetto di questa franchezza è stato l'aver egli operato singolarmente in quella sorte di disegno, che noi diciamo caricatura o di colpi caricati, deformando per ischerzo a mal modo l'effigie altrui, senza togliere loro la somiglianza, e la maestà, se talvolta eran principi grandi, come bene spesso accadvea per lo gusto, che avevano tali personaggi di sollazzarsi con lui in si fatto trattenimento, anche intorno a' propri volti, dando poi a vedere i disegni ad altri di non minore affare" (Baldinucci, 1948, 140).

10. "Ne devesi passar sotto silenzio l'havere ei in quel tempo & appresso ancora, singolarmente operato in quella sorte di Disegno, che communemente chiamasi col nome di *Caricatura.* Fù questo un'effetto singolare del suo spirito, poichè in essi veniva a deformare, come per ischerzo, l'altrui effigie in quelle parti però, dove la natura haveva in qualche modo difettato, e senza toglier loro la somiglianza, li rendeva sù le Carte similissimi, e quali in sostanza essi erano, benche se ne scorgesse notabilmente alterata, e caricata una parte; Invenzione rare volte pratticata da altri Artefici, non essendo giuoco da tutti, ricavare il bello dal deforme, e dalla sproporzione la simetria. Ne fece egli dunque parecchi, e per lo più si dilettava di caricare l'effigie de' Principi, e Personaggi grandi, per lo gusto, che essi poi ne ricevevono in rimirarsi que' medesimi, pur d'essi, e non essi, ammirando eglino in un tempo l'Ingegno grande dell'Artefice, e solazzandosi con sì fatto trattenimento" (Bernini, 1713, 28).

11. For the foregoing, see Lavin, "Duquesnoy's 'Nano,'" 1970, 144 n. 75.

12. Cf. Wilde, 1978, 147ff.

13. For portrait drawing generally see Meder, 1978, 335ff.; for drawings by Leoni, see Kruft, 1969.

14. It is interesting that in both cases contemporaries were already aware of the distinctive techniques used in these drawings (Barocchi, ed., 1962–72, I, 118, 121f., and IV, 1898ff.; Baglione, 1935, 321).

15. There was one class of sixteenth-century works,

incidentally, in which the loose sketch might become a sort of presentation drawing, namely the German autograph album (*album amicorum,* or *Stammbuch*); see, for example, Thöne, 1940, 55f., figs. 17–19; *Drawings,* 1964, 23, nos. 33, 35.

16. Bernini employed a comparable technique when he portrayed nature in what might be called a primitive or formless state, as in the sketches for fireworks (Lavin *et al.,* 1981, nos. 56–58, 219–27) or a project for a fountain with a great display of gushing water (Brauer and Wittkower, 1931, pl. 101a; cf. Harris, *Selected Drawings,* 1977, p. xxi, no. 70).

17. Cf. Rupprich, 1956–69, I, 54f. "Item: Know that my picture says it would give a ducat for you to see it; it is good and beautifully coloured. I have earned great praise for it, but little profit. I could well have earned 200 ducats in the time and have refused much work, so that I may come home. I have also silenced all the painters who said I was good at engraving, but that in painting I did not know how to handle colours. Now they all say they have never seen more beautiful colours."

Dürer made the drawing immediately before he wrote this passage, which surrounds the figure. Lange and Fuhse, 1893, 35 n. 1, noted that the sketch must refer to this, rather than the preceding portion of the letter.

18. Panofsky, 1969, 203. On Erasmus's self-mocking sketches, see Heckscher, 1967, 135f. n. 23, and the bibliography cited there.

19. Erasmus speaks of marveling and laughing at the extreme crudity of artists a century or two earlier: "admiraberis et ridebis nimiam artificum rusticitatem." On this point, see Panofsky (1969, 200, 202f.) who also discusses Erasmus's early interest in and practice of painting and drawing.

20. Cf. Clark, 1968, 1:165, no. 126732.

21. Franco Fiorio, 1971, 47f., 100; for a suggestive analysis of the painting, see Almgren, 1971, 71–73.

22. On the eye of painting, see Posner, 1967, 201f.

23. What may be a deliberately crude head appears among the test drawings and scratches on the back of one of Annibale Carracci's engraved

plates; Posner, 1971, 70, fig. 68; Bohlin, 1979, 437.

24. Ancient graffiti are often considered in the literature on comic art (e.g., Champfleury, 1865, 57–65, 186–203), but I am not aware that they have hitherto been treated seriously as specific progenitors of the modern caricature. For ancient graffiti generally, see *Enciclopedia,* 1958–73, 3:995f. For a survey of the figural graffiti at Pompeii, see Cèbe, 1966, 375f.; for graffiti on the Palatine in Rome, see Väänänen, ed., 1966 and 1970.

25. "Il m'a dit qu'à Rome il en avait une [a gallery] dans sa maison, laquelle est presque toute pareille; que c'est là qu'il fait, en se promenant, la plupart de ses compositions; qu'il marquait sur la muraille, avec du charbon, les idées des choses à mesure qu'elles lui venaient dans l'esprit" (Chantelou, 1885, 19, June 6, 1665). The idea recalls the ancient tales of the invention of painting by tracing shadows cast on the wall; cf. Kris and Kurz, 1979, 74 and n. 10.

26. The association between sgraffiti and *grotteschi* is clear from Vasari's description and account of their invention: Vasari, 1966–, vol. 1, Testo, 142–45, Commento, 212, vol. 4, Testo, 517–23; cf. Maclehose and Brown, 1960, 243–45, 298–303. On sgraffiti and *grotteschi,* see Thiem and Thiem, 1964; Dacos, 1969.

27. "E stato Michelagnolo di una tenace e profonda memoria, che nel vedere le cose altrui una sol volta l'ha ritenute si fattamente e servitosene in una maniera che nessuno se n'è mai quasi accorto; né ha mai fatto cosa nessuna delle sue che riscontri l'una con l'altra, perchè si ricordava di tutto quello che aveva fatto. Nella sua gioventù, sendo con gli amici sua pittori, giucorno una cena a chi faceva una figura che non avessi niente di disegno, che fussi goffa, simile a que' fantocci che fanno coloro che non sanno e imbrattano le mura. Qui si valse della memoria; perchè, ricordatosi aver visto in un muro una di queste gofferie, la fece come se l'avessi avuta dinanzi du tutto punto, e superò tutti que' pittori: cosa dificile in uno uomo tanto pieno di disegno, avvezzo a cose scelte, che no potessi uscir netto"

(Barocchi, ed., 1962–72, I, 124; see also IV, 2074f.).

28. Dal Poggetto, 1979, 267, no. 71, and 272, nos. 154, 156. Sketches attributed to Mino da Fiesole, discovered on a wall in his house in Florence, constitute a striking precedent for the Medici chapel drawings; see Sciolla, 1970, 113, with bibliography.

29. Tolnay (1975–80, I, 126) also notes the disjunction between the two parts of the drawing.

30. For this drawing, see Janeck, 1968, 122f.; and Levine, 1987. The figure shown from the back on the wall recurs among other graffiti in a painting attributed to van Laar in Munich; Janeck, 1968, 137f.; see also Kren, 1980, 68. On the Bamboccianti see now Levine and Mai, eds., 1991.

31. Caricatures are mentioned in two sharp and revealing passages in the diary of Bernini's visit kept by Chantelou (who uses the phrase attributed to the Carracci, "charged portraits"). During an audience with the king, ". . . le Cavalier a dit en riant: 'Ces messieurs-ci ont le Roi à leur gré toute la journée et ne veulent pas me le laisser seulement une demi-heure; je suis tenté d'en faire de quelqu'un le portrait chargé.' Personne n'entendait cela; j'ai dit au Roi que c'étaient des portraits que l'on faisait ressembler dans le laid et le ridicule. L'abbé Butti a pris la parole et a dit que le Cavalier était admirable dans ces sortes de portraits, qu'il faudrait en faire voir quelqu'un à Sa Majesté, et comme l'on a parlé de quelqu'un de femme, le Cavalier a dit que *Non bisognava caricar le donne che da notte.*" Subsequently, Butti was himself the victim: ". . . quelqu'un parlant d'un portrait chargé, le Cavalier a dit qu'il avait fait celui de l'abbé Butti, lequel il a cherché pour le faire voir à Sa Majesté, et, ne l'ayant pas trouvé, il a demandé du crayon et du papier et l'a refait en trois coups devant le Roi, qui a pris plaisir à le voir, comme a fait aussi Monsieur et les autres, tant ceux qui étaient entrés que ceux qui étaient à la porte" (Chantelou, 1885, 106, 151).

32. . . . mio sig.re
Da chavaliere vi giuro di non mandarvi più di-

segni perchè avendo voi questi dui ritratti potete dire d'avere tutto quel che può fare quel baldino di bernino, ma perchè dubito che il Vostro corto ingegno non sapia conoscerli per non vi fare arrossire vi dico che quel più lungo è Don Ghiberti e quel più basso è Bona Ventura. Credetemi che a voi e toccato aver la buona Ventura perchè mai mi sono più sodisfatto che in queste due caricature e lo fatte di cuore. Quando verrò costì vedrò se ne tenete conto.

> Roma li 15 Marzo 1652.
> Vero Amico
> G. L. Bern.

Ozzola, 1906, 205; Lavin, "Duquesnoy's 'Nano,'" 1970, 144 n. 75.

The addressee is not named, but Ozzola guessed from the letter itself that it might have been intended for someone called Bonaventura. I have no doubt that the fortunate recipient was the Bolognese painter and Franciscan friar Bonventura Bisi. Bisi was a friend and correspondent of Guercino, who also made a caricature of him, datable 1657–59, with an inscription punning on his last name (see Galleni, 1975; Lavin, 1990, 45 n. 76).

33. The basic catalogue of Picasso's lithographs is that of Mourlot, 1970.

Brief but illuminating comments on the bull series may be found in two relatively rare publications: *Picasso: The Bull,* n.d.; Deuchler, 1974 (an unpaginated, partial catalogue of the collection of Marie-Thérèse Walter, including three intermediate states and two reverse impressions of the bull not listed by Mourlot, of which evidently only single trial proofs were made). Deuchler notes [24 n. 8] that Picasso produced only twenty-seven lithographs from 1919 to 1930 and none thereafter until the series with Mourlot. Indeed, Picasso seems previously to have disliked lithography; see p. 257.

34. Picasso's work at Mourlot's was vividly described by Hélène Parmelin in her introduction (unpaginated) to Mourlot's catalogue, from which the passage given here, quoting the printer Jean Celestin, is taken [p. 3]: "'On lui donnait une

pierre, et deux minutes après, avec le crayon et le pinceau, il partait. Et ça n'arrêtait plus . . . Il nous a épatés au point de vue litho. Vous faites une litho. Si vous avez une correction à faire, la pierre a subi une préparation, ou une dépréparation . . . Bon. On lui tire douze ou quinze épreuves. On lui remet la pierre comme il faut. Lui, il faisait son deuxième état. Sur une pierre comme ça, en principe, quand on l'a dépréparée deux fois, ça abîme un peu la préparation . . . Et lui il grattait, et vas-y donc, et il ajoutait de l'encre, et du crayon! il transformait tout! Après on commence à mal voir. Et puis on abîme. Mais lui, en bien! à chaque fois ça venait très bien. Pourquoi? Mystère . . .' Célestin dit de Picasso que c'est un gars qui est 'au boulot'. Travailleur à ne pas y croire. 'Tous les grands patrons que j'ai connus, c'étaient des travailleurs énormes. Lui, il gratte . . . On partait le soir à 8 heures, le matin à 8 heures et demie il était là. Quelquefois je disais: on pourrait peut-être s'arrêter là . . . Lui, il regardait sa pierre, il allumait sa gauloise, il m'en donnait une et hop! ça partait . . . Et puis chez lui dans la nuit, il faisait une litho sur papier report sur sa cuisinière et le matin ça recommençait.'"

Mourlot himself gave an account in his *Gravés dans ma mémoire*, 1979, 11–37 (quoted in part in n. 48 below); see also the preface by Sabartés to vol. 1 of the first edition of Mourlot's *Picasso lithographe*, 1947–64; Gilot and Lake, 1964, 88ff.; Mourlot, 1973, 104ff. All convey Picasso's passionate involvement with the lithographic process and his revolutionary breaks with the traditional limitations of the medium.

35. The fruits of Picasso's affair with lithography are gathered in Mourlot, 1970, 15–44; important emendations by Baer, 1983, 127–31.

36. Brassaï, 1966, 182 (July 10, 1945); *idem*, 1964, 224: "S'il m'était possible, je la laisserais telle quelle, quitte à recommencer et l'amener à un état plus avancé sur une autre toile. Puis j'agirais de même avec celle-ci . . . Il n'y aurait jamais une toile 'achevée', mais les différents 'états' d'un même tableau qui disparaissent d'habitude au cours du travail . . ."

37. There is no comprehensive study of the development of seriality in modern art, but see generally Coplans, 1968, 7–30, and the introductory chapters of Seiberling's study of the series paintings of Monet, 1981, 1–38; on the latter, see further Tucker, 1989. Deuchler, 1974, also emphasized the novelty of Picasso's lithographic series, contrasting them with Monet's cathedrals, where only the color changes, not the forms, and with Mondrian's trees, where the forms become completely abstract. (Further to this point below, see p. 231.)

38. For Picasso's graphic works generally, see Geiser, 1933–86; Block, 1968.

39. Zervos, 1932–78, XIV, nos. 130, 132, 133, 136; Mourlot, 1970, nos. 21, 27, 28; Deuchler, 1974, nos. 49, 50, 55, 58, 61. A synopsis of the series of lithographic bulls and these parerga will be found in the Appendix, p. 261.

40. Barr, 1939, 13f.; Zervos, 1935, 173: "Auparavant les tableaux s'acheminaient vers leur fin par progression. Chaque jour apportait quelque chose de nouveau. Un tableau était une somme d'additions. Chez moi, un tableau est une somme de destructions. Je fais un tableau, ensuite je le détruis. Mais à la fin du compte rien n'est perdue . . . Il serait très curieux de fixer photographiquement, non pas les étapes d'un tableau, mais ses métamorphoses. On s'appercevrait peut-être par quel chemin un cerveau s'achemine vers la concrétisation de son rêve. Mais ce qui est vraiment très curieux, c'est d'observer que le tableau ne change pas au fond, que la vision initiale reste presque intacte malgré les apparences."

The development of the bull would seem to contradict Picasso's criticism of Matisse's serial drawings: "Matisse fait un dessin, puis il le recopie . . . Il le recopie cinq fois, dix fois, toujours en épurant son trait . . . Il est persuadé que le dernier, le plus dépouillé, est le meilleur, le plus pur, le définitif; or, le plus souvent, c'était le premier . . . En matière de dessin, rien n'est meilleur que le premier jet" (Brassaï, 1964, 71, early October 1943). Picasso's lithographic bull did not start life as a "drawing," however.

41. Interview with Léon Degand, published October

5, 1945 (translation, with slight modifications, from Flam, 1973, 103): "J'ai ma conception dans ma tête, et je veux la réalizer . . . Les photos prises en cours d'exécution du travail me permettent de savoir si la dernière conception est plus conforme que les précédents, si j'ai avancé ou reculé" (Fourcade, 1972, 302). Many photographic sequences are reproduced in Delectorskaya, 1986.

42. Cf. Fourcade, 1972, index, *s.v. étaps.*

43. Matisse, 1943. Cf. letter to Pierre Matisse, February 1945, 165 n. 13; Barr, 1951, 268. See the perceptive observations on Matisse's temporal sequences by P. Schneider (1984, 374–78, 578–80), who also describes in this connection the artist's habit of superimposing drawings on a single sheet. Matisse's method of photographing his works-in-progress, and his *Thèmes et variations* suite, are discussed in a fine essay by Flam (1989), who also notes that Matisse often made pairs (not sequential series) of images, the first reflecting the "shock of recognition of nature," the second a more abstracted interpretation.

44. On this point, with respect to the states of the lithograph after Lucas Cranach's *David and Bathsheba,* see R. Castleman, in Rubin, ed., 1972, 170.

45. The five *Jeanette* heads (1910–13) were shown as a complete series only in 1950; the four *Backs* were never exhibited together in Matisse's lifetime. This point, and the nature of Matisse's sculpture as "a private medium of study," are emphasized by Mezzatesta, 1984, 14.

46. Doesburg, 1925, 18, figs. 5–8; cf. McNamee, 1968; Doig, 1986, 15–17. So far as I know, Picasso's bulls and Doesburg's cows were first mentioned together by Cowart (1981, 64), who further regards Lichtenstein's bull series as a reversal of how-to-draw books, a relationship which, as will be seen, I believe also applies to Picasso's concept.

47. According to Françoise Gilot (Gilot and Lake, 1964, 85) the two nudes represented her and Dora Maar; cf. on this point L. Steinberg (1972, 105ff.). I suspect that the contemporary head of a youth, Mourlot, 1970, no. 8, is a rejuvenated self-portrait.

48. Mourlot, 1970, [4]: "'Un jour, dit Célestin, il commence donc ce fameux taureau. Un taureau superbe. Bien dodu. Moi je trouvais que ça y était. Pas du tout. Deuxième état. Troisième. Toujours dodu. Et ça continue. Mais le taureau n'est plus le même . . . Il se met à diminuer, à diminuer de poids . . .' [Henri] Deschamps [another craftsman who worked for Mourlot] me dira que ce jour-là, Picasso 'enlevait plutôt qu'il ne rajoutait . . . Il découpait son taureau en même temps. Il faisait des découpures dedans. Et chaque fois on tirait une épreuve. Il voyait bien qu'on était un peu perplexe. Il plaisantait. Et il travaillait. Et un autre taureau. Et il en restait de moins en moins. Il riait en me regardant. Il disait: "Regarde, Henri. C'est ça qu'on devrait donner au boucher. La ménagère pourrait dire: je veux ce bout-là, ou celui-là." A la fin, la tête était comme une fourmi.' Et Célestin conclut l'histoire du taureau. 'A la dernière épreuve, il ne restait juste que quelques lignes. Je le regardais travailler. Il enlevait. Il enlevait. Moi je pensais au premier taureau. Et je ne pouvais pas m'empêcher de me dire: ce que je ne comprends pas, c'est qu'il finit par où normalement il aurait dû commencer! . . . Mais lui, il cherchait son taureau. Et pour arriver à son taureau d'une ligne, eh bien! il s'était fait passer par tous ces taureaux-là. Et dans cette ligne-là, quand on la voit, on ne peut pas s'imaginer le travail qu'elle lui a demandé . . . '"

The enchanting history of the bull, as recounted by Mourlot himself, is worth quoting *in extenso* (1979, 26–29): "Mais, en décembre, il y avait eu l'histoire du taureau, là il nous a tous possédés . . .

L'opération a duré quinze jours. Le 5 décembre, un mois après son arrivée rue de Chabrol, Picasso a dessiné au lavis un taureau. Un taureau magnifique, très bien fait, gentil même. Et puis on lui a donné l'épreuve; nous en avons tiré à peine deux ou trois, ce qui fait que ce taureau est extrêmement rare. Une semaine après, il revient et il demande une nouvelle pierre; il reprend son taureau au lavis et à

la plume; il recommence le 18. Troisième état, le taureau est repris au grattage à plat, puis à la plume en accentuant fortement les volumes; le taureau est devenu un animal terrible avec des cornes et des yeux effroyables. Bon, ça n'allait pas, Picasso exécute un quatrième état, le 22 décembre, et un cinquième, le 24; à chaque fois il simplifie le dessin qui devient de plus en plus géométrique avec des aplats noirs.

Sixième et septième états, les 26 et 28 décembre, puis, après le retour de Picasso, quatre autres états, onze en tout, les 5, 10 et 17 janvier. Le taureau est réduit à sa plus simple expression; quelques traits d'une maîtrise exceptionnelle qui symbolisent comme un jeu de signes ce malheureux taureau avec sa petite tête d'épingle et ses cornes ridicules en forme d'antenne. Les ouvriers se désolaient d'avoir vu un taureau aussi magnifique transformé en une espèce de fourmi. L'un d'eux m'a dit:

— Il découpait son taureau, et chaque fois on tirait une épreuve.

Picasso voyait bien que les ouvriers étaient un peu perplexes, c'est ça sans doute qui l'excitait. A un moment il a dit à Deschamps, l'un de nos meilleurs chromistes:

— Regarde, Henri, c'est ça qu'on devrait donner au boucher. La ménagère dirait: 'Moi, je veux ce bout-là. Ou celui-là.'

C'est Célestin qui a trouvé le mot de la fin:

— Picasso, il a fini par là où, normalement, il aurait dû commencer.

C'est vrai, seulement pour arriver à son taureau d'une seule ligne, il a fallu qu'il passe par tous les taureau précédents. Et quand on voit ce onzième taureaux on ne peut s'imaginer le travail qu'il lui a demandé.

Chacun de ces onze états a été tiré à dix-huit épreuves réservées à l'artiste, le onzième et dernier l'a été en outre à cinquante épreuves numérotées et signées.

Ah, Picasso, quel homme! Il nous épatait. Jamais je n'ai vu personne travailler comme lui, mais il est très difficile d'expliquer la technique qu'il suivait. Il avait beaucoup regardé les dessinateurs, les imprimeurs. Il avait un oeil qui

voyait tout. Devant la pierre il n'a pas été étonné comme beaucoup d'artistes qui sont toujours un peu désemparés, comme gelés devant une si belle matière lisse. Il commençait à travailler avec son crayon, ça n'allait pas, il prenait un pinceau qu'il trempait dans l'encre et le voilà qui continuait. A un moment donné il s'arrêtait et il disait au reporter—le reporter est l'homme qui prépare les pierres—il lui disait: 'Eh bien, mon vieux, allez-y! Donnez-moi une épreuve de ça!' On lui donnait une épreuve, ça ne le satisfaisait pas. Il demandait: 'Redonnez-moi la pierre.' On encrait la pierre, on la lui rendait, et à l'aide d'un grattoir ou d'un couteau il grattait dans sa pierre, il rajoutait des taches de noir, et quand il pensait que c'était terminé: 'Allez encore, enlevez-moi ça!' et on recommençait l'opération, mais cela durait plusieurs jours et certaines séries comme *Le Taureau,* il les a travaillées pendant plus d'un mois."

49. On St. Luke as the patron of painters, see p. 46 above. On the bull in the drawing books, see Bolten, 1985, 50ff., 102f., 142f., 152f., 278f.

50. I am indebted to Professor William Jordy for adding this splendid "connection" to my collection.

51. The bull seems first to have been referred to Paleolithic painting in a brief essay by Palau i Fabre (1978), who also perceived the relevance of Picasso's interest in children's art.

52. Sabartés, 1948, 213f. The Spanish original was published later in Sabartés, 1953, 235: "No requerdo por qué causa ni en qué ocasión, aunque eso, en realidad, tiene poca importancia, como si lo hubiera estado masculando en su cerebro durante algún tiempo, cansado de pensar, se decidió a pasarme la idea para quitársela de encima, diciendo:

— Nunca se ha hecho nada mejor que la escultura primitiva. ¿Te has fijado alguna vez en la precisión de las lineas grabadas en las cavernas? . . . Has visto reproducciones. Los bajos relieves asirios aún tienen esa pureza de expresión . . .

—¿Cómo te explicas—pregunto—que haya podido perderse esa maravillosa simplicidad?

— Porque el hombre dejó de ser simple. Quiso ver más allá y perdió la facultad de comprender lo que tiene al alcance de la vista. Cuando uno reflexiona, se detiene. No quiero decir que se pare en el camino, si está andando, sino que toda su maquinaria se atasca y, una vez atacado de ese mal, ya no te curas. Si te abalanzas sobre un precipicio, te despeñas . . . Lo mismo pasa con un reloj: marchará más o menos bien; pero si marcha, no está tan mal como parece. Lo peor comienza al caer en manos del relojero remendón . . . El manoseo le roba la pureza, y ésta no vuelve más. Conserva la misma apariencia exterior, así como subsiste la idea del arte; pero ya sabemos lo que la Escuela ha hecho con ella. Por de pronto, la esencia se ha evaporado, y lo que queda ya, te lo regalo . . ."

53. Malraux, 1974, 17–19: "On parle toujours de l'influence des Nègres sur moi. Comment faire? Tous, nous aimions les fétiches. Van Gogh dit: l'art japonais, on avait tous ça en commun. Nous, c'est les Nègres. Leurs formes n'ont pas eu plus d'influence sur moi que sur Matisse. Ou sur Derain. Mais pour eux, les masques étaient des sculptures comme les autres. Quand Matisse m'a montré sa première tête nègre il m'a parlé d'art égyptien." . . . "Les masques, ils n'étaient pas des sculptures comme les autres. Pas du tout. Ils étaient des choses magiques. Et pourquoi pas les Égyptiens, les Chaldéens? Nous ne nous en étions pas aperçu. Des primitifs, pas des magiques. Les Nègres, ils étaient des intercesseurs, je sais le mot en français depuis ce temps-là. Contre tout; contre des esprits inconnus, menaçants. Je regardais toujours les fétiches. J'ai compris: moi aussi, je suis contre tout. Moi aussi, je pense que tout, c'est inconnu, c'est ennemi! Tout! pas les détails! les femmes, les enfants, les bêtes, le tabac, jouer . . . Mais le tout! J'ai compris à quoi elle servait leur sculpture, aux Nègres. Pourquoi sculpter comme ça, et pas autrement. Ils étaient pas cubistes, tout de même! Puisque le cubisme, il n'existait pas. Sûrement, des types avaient inventé les modèles, et des types les avaient imités, la tradition, non? Mais tous les fétiches, ils servaient à la même chose. Ils étaient des

armes. Pour aider les gens à ne plus être les sujets des esprits, à devenir indépendants. Des outils. Si nous donnons une forme aux esprits, nous devenons indépendants. Les esprits, l'inconscient (on n'en parlait pas encore beaucoup), l'émotion, c'est la même chose. J'ai compris pourquoi j'étais peintre. Tout seul dans ce musée affreux, avec des masques, des poupées peaux-rouges, des mannequins poussiéreux. *Les demoiselles d'Avignon* ont dû arriver ce jour-là mais pas du tout à cause des formes: parce que c'était ma première toile d'exorcisme, oui!" . . . "C'est aussi ça qui m'a séparé de Braque. Il aimait les Nègres, mais, je vous ai dit: Parce qu'ils étaient des bonnes sculptures. Il n'en a jamais eu un peu peur."

54. *London Times,* October 25, 1956; p. 11: "Perhaps more than any other living artist, Pablo Picasso, who celebrates to-day his seventy-fifth birthday, has become a legend. It is reported of him that he was once taken to an exhibition of children's art, and asked his opinion. He swept the gallery with eyes as brown and deep and wise as those of one of his own pet owls, and murmured 'À son âge, moi, je dessinais comme Raphael.' The personal arrogance implied in such a remark would be worthy only of a man who has for half a century been the undisputed dictator of artistic fashion, who has baffled prediction so often and yet so easily retained his influence at every turn that he has been accused—primarily by such as could not stand the pace—of that cardinal sin, a lack of high seriousness. And yet that claim to equality with the prince of draughtsmen while he was yet a child would only be a slight exaggeration of fact. Whatever the final rating of posterity may be on the significance and value of his life's work, that one supreme gift will never be denied him. Picasso is among the greatest draughtsmen to have appeared in the history of European art."

55. *London Times,* October 27, 1956, p. 27: "Since the remark you attribute to Picasso in your leading article to-day was made in my presence, and since it has gained currency in several distorted forms, perhaps you would allow me to put on

record what Picasso actually did say. I had been showing him round an exhibition of children's drawings sent to Paris by the British Council. He looked at them very carefully, and when he had finished he turned to me and said (I will not pretend to remember the French words he used): 'When I was the age of these children I could draw like Raphael: it took me many years to learn how to draw like these children.'

It will be seen that, far from implying 'personal arrogance,' as your leading article suggests, the remark shows rather the humility that is a characteristic of all true genius." Read's letter is referred to by Penrose, 1973, 315f.

56. Brassaï, 1966, 86 (November 17, 1943); *idem*, 1964, 106f.: "Contrairement à la musique, les enfants miracles n'existent pas en peinture . . . Cè qu'on prendrait pour un génie précoce était le *génie de l'enfance* . . . Il disparaît sans trace, l'âge venu. Il se peut que cet enfant devienne un jour un vrai peintre, ou même, un grand peintre. Mais il lui faudra alors tout recommencer à zéro . . . Quant à moi, je n'ai pas eu ce génie . . . Mes tout premiers dessins n'auraient jamais pu figurer dans une exposition de dessins d'enfants . . . La gaucherie enfantine, sa naïveté, en étaient presque absentes . . . J'ai très rapidement dépassé le stade de cette merveilleuse vision . . . A l'âge de ce gosse, je faisais des dessins académiques . . . Leur minutie, leur exactitude m'effraient . . . Mon père était professeur de dessin et c'est probablement lui qui m'a poussé prématurément dans cette direction . . ."

57. Parmelin, *Picasso Says* . . . , 1966, 73; *idem, Picasso dit* . . . , 1966, 86: "'On vous explique qu'il faut laisser la liberté aux enfants. En réalité on leur impose de faire des dessins d'enfants. On leur apprend à en faire. On leur a même appris à faire des dessins d'enfants qui sont abstraits . . .

En réalité, comme d'habitude, sous prétexte de leur laisser la liberté, de ne surtout pas les entraver, on les enferme dans leur genre, avec leurs chaînes.'

'Une chose et curieuse,' ajoute-t-il, 'c'est que moi je n'ai jamais fait de dessins d'enfant. Jamais. Même quand j'étais tout petit. J'avais peut-être

six ans, ou moins. Dans la maison de mon père, il y avait dans le couloir un Hercule avec sa massue. Eh bien! je me suis mis là dans le couloir, et j'ai dessiné l'Hercule. Mais ce n'était pas un dessin d'enfant. C'était un vrai dessin, qui représentait Hercule avec sa massue.'"

58. Picasso's early drawings may be studied in Zervos, 1932–78, vol. 6; Cirlot, 1972; Palau i Fabre, 1981; *Museo Picasso* [1986]. For a particularly stimulating discussion, see Staller, 1986. Recently, John Richardson (1991, 28f., 33, 42, 46f.) has been at pains to discredit Picasso's accounts of his early development, seeing them in the conventional way as self-aggrandizing rather than as expressing Picasso's disenchantment with his academic training; to counter the preserved evidence, Richardson even resorts to the unfounded suggestion (following Palau i Fabre, 1981, 32) that early drawings were destroyed to preserve the legend that the artist never drew like a child! See also n. 68 below.

59. The later drawings and paper cutouts are reproduced in Deuchler, 1973, and in Palau i Fabre, 1978; for the early cutouts, see *Museo Picasso* [1986], 33, with references. Richardson, 1991, 31, notes the analogy between Picasso's early cutouts and those he made later. Matisse also began using cutouts in the 1930's, but, unlike Picasso, never with childlike intent or in a reproductive process (see p. 259 below and Figs. 354, 355); on Matisse's cutouts see Cowart *et al.*, 1977, and Flam, 1989.

60. A catalogue, with a preface by Herbert Read, was printed; see *Peintures*, 1945. (Barbara Put of the Fine Arts Department of the British Council, London, was kind enough to provide me with a copy of this rare publication, for which I am most grateful.) The exhibition was briefly reviewed in *Le Monde*, April 12, 1945, 2. Picasso evidently saw the exhibition again later that summer at Antibes, cf. O'Brian, 1976, 385; also *Musée Picasso*, 1972, unpaginated but cf. p.[1] (catalogue kindly supplied by Danièle Giraudy).

61. *American Landscape*, 1982, I, 192–203. Cole's series has been fully discussed in a dissertation by Parry, 1970; for the nascent artist, see 93ff.

62. Brassaï, 1961. The citations in the text are extracted from the following passages in Brassaï: "Je sors de ma serviette mes derniers graffiti. Il me les arrache":

PICASSO: Le mur est quelque chose de merveilleux, n'est-ce pas? J'ai toujours prêté une grande attention à ce qui s'y passe. Quand j'étais jeune, souvent j'ai même copié les graffiti . . . Et combien de fois ai-je été tenté de m'arrêter devant un beau mur et d'y graver quelque chose . . . Ce qui m'a retenu, c'est que . . .

MOI: . . . vous ne pouviez pas l'emporter . . .

PICASSO, rit: . . . mais oui, qu'il faut le laisser là, l'abandonner à son sort . . . Les graffiti sont à tout le monde et à personne . . . Mais un jour pourquoi n'irions-nous pas nous promener ensemble, moi portant un canif et vous, votre appareil? Je gratterais les murs et vous, vous photographieriez mes graffiti . . .

MOI: Il ne vous est jamais arrivé de graver sur un mur?

PICASSO: Mais si. J'en ai laissé beaucoup sur les murs de la Butte . . . Un jour, à Paris, j'attendais dans une banque. On était en train de la rénover. Alors, entre les échafaudages, sur un pan de mur condamné, j'ai fait un graffiti . . . Les travaux achevés, il avait disparu . . . Quelques années après, à la faveur de je ne sais quel remaniement, mon graffiti est réapparu. On l'a trouvé curieux et on a appris qu'il était de . . . Picasso. Le directeur de la banque a arrêté les travaux, a fait découper ma gravure comme une fresque avec tout le mur autour pour l'incruster dans le mur de son appartement. Je serais heureux si vous pouviez le photographier un jour . . .

(1966, 184f. [July 10, 1945]; 1964, 226f.).

"Comme il me la réclame depuis longtemps, je lui ai apporté la dernière série de mes graffiti."

PICASSO: Ils sont vraiment étonnants, ces graffiti! Quelle invention prodigieuse on y trouve parfois . . . Quand je vois dessiner les gosses dans la rue, sur l'asphalte ou sur le mur, je m'arrête toujours . . . On est surpris de ce qui sort de leurs mains . . . Ils m'apprennent souvent quelque chose . . .

MOI: Croyez-vous qu'il y ait des 'styles' de graffiti différents pour chaque pays? Cette question me préoccupe . . .

PICASSO: J'en suis sûr . . . Les graffiti italiens et espagnols—je les connais bien—ne ressemblent pas aux graffiti parisiens . . . Par exemple, les phallus qu'on voit sur les murs de Rome sont spécifiquement italiens . . . Rome est d'ailleurs très riche en graffiti et vous devriez vous amuser à les recueillir . . .

[The inmate of a prison at Gisors] a pu aussi remplir les murs de sa cellule de graffiti absolument splendides . . . Il faudrait que vous les photographiiez un jour . . . Ce sont des petits chefs-d'oeuvre!

(1966, 202ff. [November 27, 1946]; 1964, 247f.).

"Picasso tombe dans l'album sur le chapitre 'Le langage du mur'. Les grands coups de pinceau qui effacent les inscriptions du mur le surprennent."

PICASSO: Vous avez bien fait d'avoir photographié ça . . . Car cela montre bien la nature et les limites de l'art abstrait . . . Ces coups de pinceau sont très beaux . . . Mais c'est une beauté naturelle . . . Des traits de pinceau qui n'ont aucune signification ne feront jamais un tableau. Moi aussi, je donne des coups de pinceau et parfois on dirait même que c'est de l'abstrait . . . Mais ils signifient toujours quelque chose: un taureau, une arène, la mer, la montagne, la foule . . . Pour arriver à l'abstraction, il faut toujours commencer par une réalité concrète . . .

"Il arrive au chapitre 'Naissance du visage' où j'ai groupé les visages faits de deux ou de trois trous."

PICASSO: De semblables visages, j'en ai fait souvent moi-même. Ceux qui les gravent vont d'emblée aux signes. L'art est le langage des signes.

Quand je prononce 'homme,' j'évoque l'homme; ce mot est devenu le signe de l'homme. Il ne le représente pas comme pourrait le faire la photographie. Deux trous, c'est le signe du visage, suffisant pour l'évoquer sans le représenter . . . Mais n'est-il pas étrange qu'on puisse le faire par des moyens aussi simples? Deux trous, c'est bien abstrait si l'on songe à la complexité de l'homme . . . Ce qui est le plus abstrait est peut-être le comble de la réalité . . .

"Au chapitre 'Masques et visages,' il s'exclame: 'Ceci est un Rouault!', 'Cela, un Klee. . . .'"

"Au chapitre 'Images primitives,' une tête 'aztèque' attire particulièrement son attention, et il s'écrie:

— Ça, c'est aussi riche que la façade d'une cathédrale! . . . Votre livre relie l'art avec les arts primitifs . . . Il montre aussi — et c'est important — que l'art abstrait n'est pas loin des coups de pinceau ou des structures du mur . . . Quoi que l'on pense ou dise, on imite toujours quelque chose à son insu même . . . Et quand on abandonne les modèles nus à tant de francs heure, on fait 'poser' bien d'autres choses . . . Ne trouvez-vous pas? Vous serez peut-être content d'apprendre qu'en ce moment, moi aussi, je fais des graffiti . . . Mais au lieu du mur, ils sont gravés dans le ciment . . . L'invention d'un artiste norvégien. Mes graffiti sont agrandis et incisés à l'aide de ciseaux électriques . . . Destinés à un immeuble à Barcelone, chacun d'eux prendra la hauteur de deux ou trois étages . . ."

(1966, 241f. [May 18, 1960]; 1964, 290f.).

63. Bruck, 1905. The relationship to Dürer was first observed by Spies, ed., 1981, 27ff. (I have chosen slightly different examples; all the relevant sketches are reproduced in *Les demoiselles*, 1988, 1:94, 184, 224.) Spies's contribution was brought to my attention by Brigitte Baer, who made the same observation independently and is preparing a detailed study of the subject. The observation seems to me of fundamental importance since by implication it challenges the reading of the *Demoiselles* as a "degradation" of female form and suggests instead that Picasso was seeking a new canon of beauty. Moreover, we must now take seriously the striking analogies between the faceted forms Picasso adopted in the subsequent phase of Cubism, and the prismatic shapes Dürer often employed in his theoretical studies (compare especially the 1909 heads of Fernande with those in the Dresden sketchbook: Panofsky, 1955, 201ff., fig. 312; also 260ff. on Dürer's theory of proportions). Significantly, Dürer's "cubist" studies also have a sculptural corollary, in the characteristically faceted forms of contemporary wood sculpture in an unfinished state (cf. Huth, 1977, figs. 6, 9).

64. The classic study of the academic system of drawing instruction is van Peteghem, 1868. Notable recent contributions are, for the early period, Gombrich, 1972, 156–72; Rosand, 1970; W. Kemp, 1979; Olszewski, 1981, 2–7; Amornpichetkul, 1984, 108–18; Bolten, 1985.

The academic method in nineteenth-century France was the subject of an invaluable thesis by Harle (1975), unfortunately unpublished, which includes a comprehensive catalogue of instruction manuals preserved in the Bibliothèque Nationale. Important further studies: Boime, 1977; *idem*, 1985; A. M. Wagner, 1986, 29–62; Nesbitt, 1987. Boime and Nesbitt, in particular, view the simplification and abstraction employed in these pedagogical works as germane to the development of Cubism — quite different from Picasso's explicit, ironic, and historical reversal of academic principles.

65. Cf. Burk, 1955, 134ff.

66. The cartoon is published in Chardonneret, 1987, 97, fig. 122.

67. Bargue, 1868–69; *idem*, 1871. On van Gogh's copies after Bargue, see Chetham, 1976, 12f.; Wylie, 1970, 211f; van Crimpen, 1974; Koslow, 1981, 159, 161f.; van der Wolk, 1987, 267–69, 284.

68. Zervos, 1932–78, VI, nos. 10, 13. The number 88 inscribed below Picasso's signature on both sheets refers to his matriculation in his father's drawing class of 1892–93 (Palau i Fabre, 1981,

42). So far as I know, the relation of these drawings to Bargue's plates has not been noted heretofore. Nicholson, 1991, 45, intuits that the profile heads were related to drawing manuals but finds the seated nude, although he also recognizes it as a copy, too assured for its date and suspects it was reworked later; Palau i Fabre, 1981, 518, is also astonished by its precocity but acknowledges the unassailability of the date.

69. As reported by Gilot and Lake, 1964, 86.

70. Though less explicitly, Deuchler perceived this metaphorical aspect of the bull series (1974, [15]).

71. Mourlot, 1970, nos. 10, 11 (December 5, 1945); 24 (December 20, 1945); 25, 26 (January 7, 1946); also no. 29 (January 13, 1946). The technique is described by Gilot and Lake, 1964, 86.

72. Brassaï, 1966, 100 (December 6, 1943); 1964, 123: "Pourquoi croyez-vous que je date tout ce que je fais? C'est qu'il ne suffit pas de connaître les oeuvres d'un artiste. Il faut aussi savoir quand il les faisait, pourquoi, comment, dans quelle circonstance. Sans doute existera-t-il un jour une science, que l'on appellera peut-être 'la science de l'homme,' qui cherchera à pénétrer plus avant l'homme à travers l'homme-créateur . . . Je pense souvent à cette science et je tiens à laisser à la postérité une documentation aussi complète que possible . . . Voici pourquoi je date tout ce que je fais . . ."

In the passage that follows Brassaï recognizes the deliberateness and auto-historicism of Picasso's custom, but not the universality of the motive: "Un jour, quand nous parlions avec Sabartés de cette habitude de Picasso de dater ses moindres oeuvres ou écrits en indiquant non seulement l'année, le mois et le jour, mais parfois aussi l'heure, Sabartés haussa les épaules: 'A quoi ça rime? me dit-il. C'est une pure fantaisie, une manie . . . En quoi cela peut intéresser quelqu'un si Picasso a exécuté tel ou tel dessin à dix heures ou à onze heures du soir?' Mais, d'après ce que vient de me révéler Picasso, la minutie de ses datations n'est ni caprice, ni manie, mais un acte prémédité, réfléchi. Il veut conférer à tous ses faits et gestes une valeur historique dans son histoire d'homme-créateur, les insérer lui-même —avant les autres—dans les grandes annales de sa prodigieuse vie . . ."

Picasso associated prehistoric art with his passion for chronology in a comment concerning his own "ages of stone," i.e., engraved pebbles, the "style" of which changed (Brassaï, 1964, 238 [November 26, 1946]): "Mais on change tout le temps . . . Vous n'avez qu'à regarder le changement de ma signature . . . Ce sont mes différents 'âges de pierre.' Il faudrait publier tout ça dans l'album. J'aime les oeuvres complètes . . . On ne peut vraiment suivre l'acte créateur qu'à travers la série de toutes les variations."

Ackerman, J. S., *The Architecture of Michelangelo*, 2 vols., London, 1961.

————, "The Tuscan/Rustic Order: A Study in the Metaphorical Language of Architecture," *Journal of the Society of Architectural Historians*, XLII, 1983, 15–34.

Acqua, G. A. dell', and M. Cinotti, *Il Caravaggio e le sue grandi opere da San Luigi dei Francesi*, Milan, 1971.

Adhemar, J., *Influences antiques dans l'art du moyen age français, Recherches sur les sources et les thèmes d'inspiration*, London, 1939.

Adorno, P., "Andrea del Verrocchio e la tomba di Cosimo il Vecchio," *Antichità viva*, XXVIII, 1989, 44–48.

The Age of Correggio and the Carracci. Emilian Painting of the Sixteenth and Seventeenth Centuries, exhib. cat., Washington, D.C., 1986.

Alaleona, D., "Su Emilio de' Cavalieri, la *Rappresentatione di Anima et di Corpo* e alcune sue compositioni inedite," *La nuova musica*, X, 1905, 1–43.

Alberici, C., ed., *Leonardo e l'incisione. Stampe derivate da Leonardo e Bramante dal XV al XIX secolo*, Milan, 1984.

Alberti, L. B., *Ten Books on Architecture*, transl. J. Leoni, ed. J. Rickwert, London, 1965.

————, *L'architettura [De re aedificatoria]*, eds. G. Orlandi and P. Portoghesi, 2 vols., Milan, 1966.

Almgren, A., *Die umgekehrte Perspektive und die Fluchtachsenperspektive*, Uppsala, 1971.

Alpers, S., "Realism as a Comic Mode: Low-Life Painting Seen Through Bredero's Eyes," *Simiolus*, VIII, 1975–76, 115–44.

American Landscape and Genre Paintings in the New York Historical Society, 3 vols., Boston, 1982.

Ames-Lewis, F., in *Italian Renaissance Sculpture in the Time of Donatello*, exhib. cat., Detroit, 1985.

Amornpichetkul, C., "Seventeenth-Century Italian Drawing Books: Their Origin and Development," in *Children of Mercury. The Education of Artists in the Sixteenth and Seventeenth Centuries*, exhib. cat., Providence, R.I., 1984, 108–18.

Angeli, D., *Il palazzo di Montecitorio*, Rome, 1926.

Apollonj Ghetti, B. M., A. Ferrua, E. Josi, and E. Kirschbaum, eds., *Esplorazioni sotto la confessione di San Pietro in Vaticano*, Vatican City, 1951.

Aries, P. E., E. Crisiani, and E. Gabba, *Camposanto monumentale di Pisa. I. Le antichità*, Pisa, 1972.

Armailhacq, A. d', *L'Eglise nationale de Saint Louis des Français à Rome*, Rome, 1894.

Armi, A. M., *Petrarch. Sonnets & Songs*, New York, 1946.

Aschengreen, C. P., *Il museo degli argenti a Firenze*, Milan, 1968.

Auerbach, E., *Literary Language and Its Public in Late Latin Antiquity and in the Middle Ages*, New York, 1965.

Avery, C., *Studies in European Sculpture*, London, 1981.

————, *Giambologna. The Complete Sculpture*, Oxford, 1987.

————, and A. Radcliffe, eds., *Giambologna, 1529–1608. Sculptor to the Medici*, exhib. cat., London, 1978.

————, and A. Radcliffe, eds., *Giambologna, 1529–1608. Sculptor to the Medici*, exhib. cat., Edinburgh, 1978–79.

Baglione, G., *Le vite de' pittori scultori et architetti dal pontificato di Gregorio XIII. del 1572. in fino a'tempi di Papa Urbino Ottavo nel 1642*, Rome, 1642; ed. V. Mariani, Rome, 1935.

Baldinucci, F., *Vita del cavaliere Gio. Lorenzo Bernino*, Florence, 1682; ed. S. S. Ludovici, Milan, 1948.

Baldwin, A., "Facing Heads on Greek Coins," *American Journal of Numismatics*, XLIII, 1908–09, 113–31.

Bardon, F., *Le Portrait mythologique à la cour de France sous Henri IV et Louis XIII. Mythologie et politique*, Paris, 1974.

Bargue, C., *Cours de dessin . . . avec le concours de J.-L. Gérome. Première partie, modèles d'après la bosse*, Paris, 1868; *Deuxième partie. Modèles d'après les maîtres de toutes les époques et de toutes les écoles*, Paris, 1869.

————, *Exercices au fusain*, Paris, 1871.

Barocchi, P., *Michelangelo e la sua scuola. I disegni di Casa Buonarroti e degli Uffizi*, Florence, 1962.

————, ed., *Giorgio Vasari. La vita di Michelangelo nelle redazioni del 1550 e del 1568*, 5 vols., Milan and Naples, 1962–72.

————, and R. Ristori, *Il carteggio de Michelangelo*, 5 vols., Florence, 1965–83.

Barolsky, P., *Daniele da Volterra*, Ph.D. diss., Harvard Univ., 1969.

Barr, H., *Picasso. Forty Years of His Art*, New York, 1939.

————, *Matisse. His Art and His Public*, New York, 1951.

Bartoli, P. S., *Leonis X admirandae virtutis imagines*, Rome, n.d. (ca. 1690).

Bassi, P. A. di, *The Labors of Hercules*, transl. W. K. Thompson, Barre, Mass., 1971.

Battaglia, S., *Grande dizionario della lingua italiana*, 14 vols., Turin, 1961–.

Battistella, A., *Il S. Officio e la riforma religiosa in Bologna*, Bologna, 1905.

Battisti, E., *Brunelleschi. The Complete Work*, London, 1981.

Beard, C. R., "Cap-Brooches of the Renaissance," *The Connoisseur*, CIV, 1939, 287–93.

Becherini, G., "La 'Rappresentatione di anima e corpo' di Emilio de' Cavalieri," *La rassegna musicale*, XXI, 1943, 1–7.

————, "La musica nelle 'sacre rappresentationi' fiorentine," *Rivista musicale italiana*, LIII, 1951, 193–241.

Becherucci, L., *Donatello. I pergami di S. Lorenzo*, Florence, 1979.

Beck, J., "Desiderio da Settignano (and Antonio del Pollaiuolo): Problems," *Mitteilungen des Kunsthistorischen Institutes in Florenz*, XXVIII, 1984, 203–24.

————, "Leon Battista Alberti and the 'Night Sky' at San Lorenzo," *Artibus et historiae*, no. 19, 1989, 9–35.

Behr, H.-G., H. Grohmann and B.-O. Hagedorn, *Charakter-Köpfe. Der Fall F. X. Messerschmidt: Wie verrückt darf Kunst sein?* Wernheim and Basel, 1983.

Bellarmine, R., *A Shorte Catechisme*, Augsburg, 1614.

Bellocchi, L., *Le monete di Bologna*, Bologna, 1987.

Bellori, G. P., *Le vite de' pittori, scultori et architetti moderni*, Rome, 1672.

Bennett, B. A., and D. G. Wilkins, *Donatello*, Oxford, 1984.

Benois, N., A. Krakau, and A. Resanoff, *Monographie de la cathédrale d'Orvieto*, Paris, 1877.

Bentini, M. R., "Il progetto decorativo per la casa dell'artista. Indagini e proposte per una lettura dell'immaginario di Lelio Orsi," in J. Bentini, ed., *Lelio Orsi e la cultura del suo tempo. Atti del convegno internazionale di studi. Reggio Emilia-Novellara. 28–29 gennaio 1988*, Bologna, 1990, 123–38.

Berendsen, O., *The Italian Sixteenth and Seventeenth Century Catafalques*, Ph.D. diss., New York Univ., 1961.

Bergemann, J., *Römische Reiterstatuen. Ehrendenkmäler im öffentlichen Bereich*, Mainz, 1990.

Berger, R. W., "Antoine Le Pautre and the Motif of the Drum-without-Dome." *Journal of the Society of Architectural Historians*, XXV, 1966, 165–80.

————, *Antoine Le Pautre. A French Architect of the Era of Louis XIV*, New York, 1969.

————, "Charles Le Brun and the Louvre Colonnade," *The Art Bulletin*, LII, 1970, 394–403.

————, *In the Garden of the Sun King. Studies of the Park of Versailles under Louis XIV*, Washington, D.C., 1985.

————, *Versailles, The Château of Louis XIV*, University Park, Pa., and London, 1985.

————, *The Palace of the Sun King. The Louvre of Louis XIV*, forthcoming.

Bergin, J., *Cardinal de la Rochefoucauld. Leadership and Reform in the French Church*, New Haven, Conn., and London, 1987.

Bernini, D., *Vita del cavalier Gio. Lorenzo Bernino*, Rome, 1713.

Bernini in Vaticano, exhib. cat., Rome, 1981.

Bernstein, A. E., "Esoteric Theology: William of Auvergne on the Fires of Hell and Purgatory," *Speculum*, LVII, 1982, 509–31.

Bertelli, S., "Pier Soderini, 'Vexillifer Perpetuus Reipublicae Florentinae' 1502–1512," in A. Mulho and J. A. Tedeschi, eds., *Renaissance Studies in Honor of Hans Baron*, Florence, 1971, 335–59.

Biagetti, B., "Una nuova ipotesi intorno allo studio e alla cappella de Niccolò V nel Palazzo Vaticano," *Atti della pontificia accademia romana di archeologia. Serie III. Memorie*, III, 1933, 205–14.

Bieber, M., *Die Denkmaler zum Theaterwesen im Altertum*, Berlin and Leipzig, 1920.

Binski, P., "The Cosmati at Windsor and the English Court Style," *The Art Bulletin*, LXII, 1990, 6–34.

Biondi, A., *Sigismondo Fanti. Triompho di Fortuna*, Modena, 1983.

Bireley, R., *The Counter-Reformation Prince. Anti-Machiavellianism or Catholic Statecraft in Early Modern Europe*, Chapel Hill, N.C., and London, 1990.

Bizzari, G., M. Guidi, and A. Lucarelli, eds., *Il Nettuno del Giambologna. Storia e restauro*, Milan, 1989.

Block, G., *Pablo Picasso. Catalogue de l'oeuvre gravé et lithographié, 1904–67*, Bern, 1968.

Bloemaert, F., *Artis Apellae liber*, Utrecht, n.d. (ca. 1650).

Blondel, J. F., *Architecture française*, 3 vols., Paris, 1752–56.

Blunt, A., *Art and Architecture in France, 1500–1700*, Harmondsworth, 1953.

————, "A Drawing of the Penitent St. Jerome by Bernini," *Master Drawings*, X, 1972, 20–22.

Bober, P. P., and R. Rubinstein, *Renaissance Artists and Antique Sculpture. A Handbook of Sources*, London, 1986.

Boccardo, P., *Andrea Doria e le arti. Committenza e mecenatismo a Genova nel Rinascimento*, Rome, 1989.

Bocchi, A. *Symbolicarum quaestionum, de universo genere, quas serio ludebat, libri quinque*, Bologna, 1555.

Boeck, W., "Bernini und die Erfindung der Bildniskarikatur," *Das goldene Tor*, IV, 1949, 249–99.

Bohlin, D. D., *Prints and Related Drawings by the Carracci Family*, Washington, D.C., 1979.

Boime, A., "The Teaching Reforms of 1863 and the Origins of Modernism in France," *The Art Quarterly*, I, 1977, 1–39.

————, "The Teaching of Fine Arts and the Avant-Garde in France during the Second Half of the Nineteenth Century," *Arts Magazine*, LX, 1985, 46–57.

Bolten, F., *Method and Practice. Dutch and Flemish Drawing Books, 1600–1750*, Landau, 1985.

Borghini, R., *Il riposo*, Florence, 1584.

Borsi, F., *Il palazzo de Montecitorio*, Rome, 1967.

————, *Bernini architetto*, Milan, 1980.

————, M. Del Piazzo, E. Sparisci, and E. Vitale, eds., *Montecitorio. Ricerche di storia urbana*, Rome, 1972.

Borsook, E., and J. Offerhaus, *Francesco Sassetti and Girlandaio at Santa Trinita, Florence. History and Legend in a Renaissance Chapel*, Doornspijk, 1981.

Bottari, G. G., and S. Ticozzi, *Raccolta di lettere sulla pittura, scultura ed architettura*, 8 vols., Milan, 1822–25.

Bottineau, Y., "L'Alcázar de Madrid et l'inventaire de 1686. Aspects de la cour d'Espagne au XVII^e siècle," *Bulletin hispanique*, LVIII, 1956, 421–52.

Boucher, B., "Bernini e l'architettura del cinquecento: La lezione di Baldassare Peruzzi e di Sebastiano Serlio," *Bollettino del Centro Internazionale di Studi di Architettura "Andrea Palladio,"* XXIII, 1981, 27–43.

Braham, A., and P. Smith, *François Mansart*, London, 1973.

Brassaï, *Graffiti de Brassaï*, Paris, 1961.

————, *Conversations avec Picasso*, Paris, 1964; transl. F. Price, *Picasso and Company*, New York, 1966.

Brauer, H., and R. Wittkower, *Die Zeichnungen des Gian-lorenzo Bernini*, Berlin, 1931.

Braun, H. A., *Das Domkapitel zu Eichstätt von der Reformationszeit bis zur Säkularisation*, Ph.D. diss., Katholische Universität Eichstätt, 1983.

Braun, J., *Der christliche Altar in seiner geschichtlichen Entwicklung*, 2 vols., Munich, 1924.

Braunfels, W., *Abendländische Stadtbaukunst*, Cologne, 1976.

Bredekamp, H., *Botticelli. Primavera. Florenz als Garten der Venus*, Frankfurt am Main, 1988.

———, "Lorenzino de' Medicis Angriff auf den Konstantinsbogen als 'Schlacht von Cannae,'" *Act of the Twenty-Seventh International Congress of the History of Art*, Strasbourg, 1989.

Brion, M., *Michelangelo*, New York, 1940.

Brown, A. M., "The Humanist Portrait of Cosimo de' Medici, Pater Patriae," *Journal of the Warburg and Courtauld Institutes*, XXIV, 1961, 186–221.

Brown, C. M., "Martin van Heemskerck. The Villa Madama Jupiter and the Gonzaga Correspondence Files," *Gazette des Beaux-Arts*, XCI, 1979, 49–60.

Brown, J., and J. H. Elliott, *A Palace for a King. The Buen Retiro and the Court of Philip IV*, New Haven, Conn., and London, 1980.

———, and R. L. Kagan, "The Duke of Alcalá: His Collection and Its Evolution," *The Art Bulletin*, LXIX, 1987, 231–55.

Bruck, R., *Das Skizzenbuch von Albrecht Dürer*, Strassburg, 1905.

Bruno, R., *Roma. Pinacoteca capitolina*, Bologna, 1978.

Buddensieg, T., "Gregory the Great, The Destroyer of Pagan Idols. The History of a Medieval Legend concerning the Decline of Ancient Art and Literature," *Journal of the Warburg and Courtauld Institutes*, XXVIII, 1965, 44–65.

Burk, J., *William Hogarth. The Analysis of Beauty*, Oxford, 1955.

Burns, H., "San Lorenzo in Florence before the Building of the New Sacristy. An Early Plan," *Mitteilungen des kunsthistorischen Institutes in Florenz*, XXIII, 1979, 145–53.

Buschbell, G., ed., *Concilii tridentini epistularum. Pars secunda. Complectens additamenta ad tomum priorem et epistulas a die 13 martii 1547 ad Concilii suspensionem*

anno 1552 factam conscriptas, Freiburg im Breisgau, 1937.

Butters, H. C., *Governors and Government in Early Sixteenth-Century Florence, 1502–1519*, Oxford, 1985.

Cagnetta, F., "La Vie et l'oeuvre de Gaetano Giulio Zummo," in *La ceroplastica nella scienza e nell'arte. Atti del I congresso internazionale*, Florence, 1977, 498–501.

———, "Gaetano Giulio Zummo (Siracusa 1656–Parigi 1701)," in *Kunst des Barock in der Toskana. Studien zur Kunst unter den letzten Medici*, Munich, 1976, 213–24.

Calderini, A., C. Cecchelli, and G. Chierici, *La basilica di S. Lorenzo Maggiore in Milano*, Milan, 1951.

Calvesi, M., *La realtà del Caravaggio*, Turin, 1990.

Cämmerer, M., *Donatello-Studien*, Munich, 1989.

Campbell, M., "Observations on Ammannati's *Neptune Fountain*: 1565 and 1575," in A. Murrogh, F. Superbi Gioffredi, Piero Morselli, and E. Borsook, eds., *Renaissance Studies in Honor of Craig Hugh Smyth*, 2 vols., Florence, 1985, II, 113–29.

Caprini, C., A. M. Colini, G. Gatti, M. Pallottino, and P. Romanelli, *La colonna di Marco Aurelio*, Rome, 1955.

Caricature and Its Role in Graphic Satire, exhib. cat., Providence, R.I., 1971.

Carl, D., "Il ciborio de Benedetto da Maiano nella cappella maggiore di S. Domenico a Siena: Un contributo al problema dei cibori quattrocenteschi con un excursus per la storia architettonica della chiesa," *Rivista d'arte*, XLII, 1990, 3–74.

———, "Der Hochaltar von Benedetto da Maiano für die Collegiata von San Gimignano," *Mitteilungen des Kunsthistorischen Institutes in Florenz*, XXXV, 1991, 21–60.

Carradori, F., *Istruzione elementare per gli studiosi della scultura (1802)*, ed., G. C. Sciolla, Treviso, 1979.

Cartari, V., *Imagini delli dei de gl'antichi*, Venice, 1647 (first pub. Venice, 1556), reprinted Graz, 1966.

Castex, J., P. Celeste, and P. Panerai, *Lecture d'une ville: Versailles*, Paris, 1980.

Catalogue des objets d'art . . . composant la collection de M. D. Schevitch, Galerie Georges Petit, Paris, 1906.

Catani, B., *La pompa funerale fatta dall'Ill.mo & R.mo S.r Cardinale Montalto nella trasportatione dell'ossa di Papa*

Sisto il Quinto, Rome, 1591.

Cattaneo, E. *Note storiche sul canto ambrosiano,* Milan, 1950.

Caus, S. de, *Les Raisons des forces mouvantes,* Frankfurt am Main, 1615.

Cavalca, D., *Volgarizzamento delle vite de' ss. padri,* 6 vols., Milan, 1830.

Cavallari-Murat, A., "Professionalità di Bernini quale urbanista: Alcuni episodi e una confessione su Mirafiori," in Spagnesi and Fagiolo, eds., 1984, 323–58.

Cèbe, J.-P., *La Caricature et la parodie dans le monde romain antique des origines à Juvénal,* Paris, 1966.

Chacon, A., *Vitae et res gestae pontificum romanorum et S. R. E. cardinalium,* 4 vols., Rome, 1677.

Champfleury, J., *Histoire de la caricature antique,* Paris, 1865.

Chantelou, P. Fréart de, *Journal du voyage du Cavalier Bernin en France,* ed. L. Lalanne, Paris, 1885.

————, *Diary of the Cavaliere Bernini's Visit to France,* ed. A. Blunt, annotated by G. C. Bauer, transl. M. Corbet, Princeton, N.J., 1985.

Chardonneret, M.-C., *La Figure de la république. Le concours de 1848,* Paris, 1987.

Charles Le Brun, 1619–1690. Peintre et Dessinateur, exhib. cat., Versailles, 1963.

Chastel, A., *Marsile Ficin et l'art,* Geneva and Lille, 1954.

————, *Art et humanisme à Florence au temps de Laurent le Magnifique. Etudes sur la Renaissance et l'humanisme platonicien,* Paris, 1961.

————, and J.-M. Pérouse de Montclos, "Etude d'urbanisme et d'architecture. L'aménagement de l'accès oriental du Louvre," *Les Monuments historiques de la France,* XII, 1966, 178–218.

Cheles, L., *The Studiolo of Urbino. An Iconographic Investigation,* University Park, Pa., 1986.

Chetham, C., *The Role of Vincent van Gogh's Copies in the Development of His Art,* New York and London, 1976.

Children of Mercury. The Education of Artists in the Sixteenth and Seventeenth Centuries, exhib. cat., Providence, R.I., 1984.

Chiòrboli, E., *Francesco Petrarca. Le "rime sparse,"* Milan, 1923.

Ciardi, R. P., ed., *Gian Paolo Lomazzo. Scritti sulle arti,* 2 vols., Florence, 1973–74.

Cieri Via, C., "Ipotesi di un percorso funzionale e simbolico nel Palazzo Ducale di Urbino attraverso le immagini," in C. Carboni, G. Cittolini, and P. Floriani, eds., *Federico di Montefeltro. Lo stato le arti la cultura,* 3 vols., Rome, 1986, *Le arti,* 47–64.

Cinotti, M., *Michelangelo Merisi detto il Caravaggio,* Bergamo, 1983.

Circa 1492. Art in the Age of Exploration, exhib. cat., Washington, D.C., 1991.

Cirlot, J.-E., *Picasso. Birth of a Genius,* New York and Washington, D.C., 1972.

Claretta, G., "Relazioni d'insigni artisti e virtuosi in Roma col Duca Carlo Emanuele II di Savoia studate sul carteggio diplomatico," *Archivio della r. società romana di storia patria,* VIII, 1885, 511–54.

Clark, K., with the assistance of C. Pedretti, *The Drawings of Leonardo da Vinci in the Collection of Her Majesty the Queen at Windsor Castle,* 3 vols., London, 1968.

Claussen, P. C., *Magistri doctissimi romani. Die römischen Marmorkünstler des Mittelalters (Corpus Cosmatorum I),* Stuttgart, 1987.

Clearfield, J., "The Tomb of Cosimo de' Medici in San Lorenzo," *The Rutgers Art Review,* II, 1981, 13–30.

Clements, R. J., *Michelangelo's Theory of Art,* New York, 1961.

Coffin, D., *The Villa d'Este at Tivoli,* Princeton, N.J., 1960.

Colie, R. L., *Paradoxia Epidemica. The Renaissance Tradition of Paradox,* Princeton, N.J., 1966.

Condivi, A., *Vita di Michelangiolo,* Florence, 1938.

————, *The Life of Michelangelo,* transl. A. S. Wohl, ed. H. Wohl, Baton Rouge, La., 1976.

Connelly, F., *The Origins and Development of Primitivism in Eighteenth- and Nineteenth-Century European Art and Aesthetics,* Ph.D. diss., Univ. of Pittsburgh, 1987.

Connors, J., *Borromini and the Roman Oratory. Style and Society,* New York, 1980.

Conti, P. Ginori, *La basilica de S. Lorenzo de Firenze e la famiglia Ginori,* Florence, 1940.

Cooke, H. L., "Three Unknown Drawings by G. L. Bernini," *The Burlington Magazine,* XCVII, 1955, 320–23.

Coplans, J., *Serial Imagery,* exhib. cat., Pasadena, Calif., and New York, 1968.

Corboz, A., "Il Louvre come palazzo di Salomone," in Spagnesi and Fagiolo, eds., 1984, 563–98.

Corpus nummorum italicorum, X, part 2, Rome, 1927.

Correale, G., ed., *Identificazione di un Caravaggio. Nuove tecnologie per una rilettura del San Giovanni Battista*, Venice and Vicenza, 1990.

Courtright, N., "The Vatican Tower of the Winds and the Architectural Legacy of the Counter Reformation," in M. A. Lavin, ed., *IL60. Essays Honoring Irving Lavin on his Sixtieth Birthday*, New York, 1990, 117–44.

Cowart, J., *Roy Lichtenstein, 1970–1980*, exhib. cat., New York, 1981.

————, J. D. Flam, D. Fourcadé, and J. H. Neff, *Henri Matisse Paper Cut-outs*, New York, 1977.

Cox-Rearick, J., *The Drawings of Pontormo*, 2 vols., Cambridge, Mass., 1964.

————, *Dynasty and Destiny in Medici Art. Pontormo, Leo X, and the Two Cosimos*, Princeton, N.J., 1984.

Crum, R. J., "'Cosmos, the World of Cosimo': The Iconography of the Uffizi Façade," *The Art Bulletin*, LXXI, 1989, 237–53.

Cureau de la Chambre, P., "Elogue du cavalier Bernin," printed with Cureau's *Préface pour servire à l'histoire de la vie et des ouvrages du cavalier Bernin* [Paris, 1685].

Curiosità di una reggia. Vicende della guardaroba di Palazzo Pitti, exhib. cat., Florence, 1979.

Cutler, A., *The Aristocratic Psalters in Byzantium*, Paris, 1984.

Dacos, N., *La Découverte de la Domus Aureus et la formation des grotesques à la Renaissance*, London and Leiden, 1969.

————, *Le logge di Raffaello: Maestro e bottega di fronte all'antico*, Rome, 1977.

Dal Poggetto, P., *I disegni murali di Michelangiolo e della sua scuola nella Sagrestia Nuova di San Lorenzo*, Florence, 1979.

Daufresne, J.-C., *Louvre & Tuileries. Architectures de Papier*, Paris, 1987.

Davis, C. T., "Topographical and Historical Propaganda in Early Florentine Chronicles and in Villani," *Medioevo e Rinascimento*, II, 1988, 33–51.

De' Cavalieri, E., *Rappresentatione di anima, et di corpo*, Rome, 1600; facsimile ed., Farnsborough, 1967.

Deér, J., *The Dynastic Porphyry Tomb of the Norman Period in Sicily*, Cambridge, Mass., 1959.

Delbrueck, R., *Antike Porphyrwerke*, Berlin and Leipzig, 1932.

Delectorskaya, L., *. . . l'apparente facilité . . . Henri Matisse. Peintures de 1935–1939*, n.p., 1986.

Della Porta, G., *De humana physiognomia*, Vico Equense, 1586.

Della Torre, A., *Storia dell'accademia platonica di Firenze*, Florence, 1902.

Del Migliore, F. L., *Firenze città nobilissima*, Florence, 1684.

Del Pesco, D., "Gli 'antichi dèi' nell'architettura di Bernini," in Spagnesi and Fagiolo, eds., 1984, 525–62.

————, *Il Louvre di Bernini nella Francia di Luigi XIV*, Naples, 1984.

————, "Una fonte per gli architetti del barocco romano: L'antiquae urbis splendor di Giacomo Lauro," in *Studi di storia dell'arte in memoria di Mario Rotili*, Naples, 1984, 413–36.

Delumeau, J., *Le Péché et la peur. La culpabilisation en Occident (XIIIe–XVIIIe siècles)*, Paris, 1983.

Demarco, N., "Caravaggio's *Calling of St. Matthew*," *Iris. Notes on the History of Art*, I, 1982, 5–7.

De Mattei, R., *Dal premachiavellismo all'antimachiavellismo*, Florence, 1969.

————, *Il problema della "ragion di stato" nell'età della controriforma*, Milan, 1979.

————, *Il pensiero politico italiano nell'età della controriforma*, 2 vols., Milan, 1982–84.

Les Demoiselles d'Avignon, exhib. cat., 2 vols., Paris, 1988.

De Pange, J., *Le roi très chrétien*, Paris, 1949.

Deuchler, F., *Une collection Picasso*, Geneva, 1973.

————, *Picasso. Thèmes et variations, 1945–46. Une Collection Picasso II*, Geneva, 1974.

Dézallier d'Argenville, A. N., *Vies des fameux architectes et sculpteurs depuis la renaissance des arts*, 2 vols., Paris, 1787.

Di Castellamonte, A., *Venaria reale*, Turin, 1674.

Di Dario Guida, A., *Arte in Calabria. Ritrovamenti-restauri-recuperi (1971–1975)*, Naples, 1978.

Dietterlin, W., *Architectura*, Nuremberg, 1598.

Dionysius Carthusianus, *Cordiale quattuor novissimorum*, Gouda, 1492.

Dizionario biografico degli italiani, Rome, 1960–.

Doesburg, T. van, *Grundbegriffe der neuen gestaltenden*

Kunst, Frankfurt am Main, 1925.

Doig, A., *Theo van Doesburg. Painting into Architecture. Theory into Practice*, Cambridge, 1986.

Donatello e la sagrestia vecchia di San Lorenzo, exhib. cat., Florence, 1986.

Donati, L., "Stefano della Bella," *Maso Finiguerra*, IV, 1939, 161–63.

D'Onofrio, C., *La villa Aldobrandini di Frascati*, Rome, 1963.

————, *Gli obelischi di Roma*, Rome, 1965.

————, *Roma vista da Roma*, Rome, 1967.

Le Dossier d'un tableau. "Saint Luc peignant la Vierge" de Martin van Heemskerck. Rennes, 1974.

Dotson, E., "An Augustinian Interpretation of Michelangelo's Sistine Ceiling," *The Art Bulletin*, LXI, 1979, 223–56, 405–29.

Drawings of the 15th and 16th Centuries from the Wallraf-Richartz-Museum in Cologne, exhib. cat., Berlin, 1964.

Dubon, D., *Tapestries from the Samuel H. Kress Collection at the Philadelphia Museum of Art. The History of Constantine the Great Designed by Peter Paul Rubens and Pietro da Cortona*, Aylesbury, 1964.

Dunkelman, M. L., "A New Look at Donatello's Saint Peter's Tabernacle," *Gazette des Beaux-Arts*, CXVIII, 1991, 1–15.

Dupérac, E., *I vestigi dell'antichità di Roma*, Rome, 1621.

Dworschak, F., "Der Medailleur Gianlorenzo Bernini. Ein Beitrag zur Geschichte der italienischen Barock-medaille," *Jahrbuch der preuszischen Kunstsammlungen*, XXV, 1934.

Echols, E. C., transl., *Herodian of Antioch's History of the Roman Empire*, Berkeley, Calif., 1961.

Emiliani, A., "Uno sguardo sovrano," in *Il Nettuno*, 1989, 27–36.

Enciclopedia cattolica, 13 vols., Vatican City, 1948–54.

Enciclopedia dell'arte antica, classica e orientale, 9 vols., Rome, 1958–73.

Enciclopedia dello spettacolo, 11 vols., Rome, 1975.

Encyclopedia of World Art, 15 vols., London, 1959–87.

Erasmus of Rotterdam, *Opera Omnia*, 10 vols., Leiden, 1703–06.

Esch, A., and D. Esch, "Die Grabplatte Martins V und andrere Importstücke in den römischen Zollregistern der Frührenaissance," *Römisches Jahrbuch für Kunstgeschichte*, XVII, 1978, 211–17.

Ettlinger, L., "Exemplum Doloris. Reflections on the Laocoön Group," in Meiss, ed., 1961, 121–26.

Fabretti, A., "Il teatro anatomico dell'Archiginnasio tra forma simbolica e architettura di servizio," in Roversi, ed., 1987, I, 201–18.

Fabricii, P., *Delle allusioni, imprese, et emblemi . . . sopra la vita, opere, et attioni di Gregorio XIII . . . nei quali, sotto l'allegoria del Drago, Arme del detto Pontefice, si descrive anco la vera forma d'un principe Christiano . . .*, Rome, 1588.

Fagiolo, M., ed., *Natura e artificio. L'ordine rustico, le fontane, gli automi nella cultura del Manierismo europeo*, Rome, 1979.

————, ed., *Bernini e l'unità delle arti visive*, Rome, 1985.

————, and M. L. Madonna, "La Roma di Pio IV: La 'civitas pia,' la 'salus medica,' la 'custoda angelica,'" *Arte illustrata*, V, 1972, 383–402.

————, and M. L. Madonna, eds., *Roma 1300–1875. La città degli anni santi. Atlante*, Rome, 1985.

Fagiolo dell'Arco, M., "Villa Aldobrandini tusculana," *Quaderni dell'istituto di storia dell'architettura*, fascs. 62–66, 1964.

————, and M. Fagiolo dell'Arco, *Bernini. Una introduzione al gran teatro del barocco*, Rome, 1967.

Fairclough, H. R., *Virgil*, 2 vols., Cambridge and London, 1950.

Fanti, S., *Triompho di Fortuna*, Venice, 1527.

Fantuzzi, G., *Notizie degli scrittori bolognesi*, 9 vols., Bologna, 1781–94.

Fasoli, G., "Per il IV centenario della costruzione dell'Archiginnasio," *L'Archiginnasio. Bollettino della Biblioteca Comunale di Bologna*, LVII, 1962, 1–19 (reprinted in *idem, Scritti di storia medievale*, Bologna, 1974, 623–42).

————, "Inaugurazione di una nuova sede per una vecchia scuola," in Roversi, ed., 1987, I, 271–84.

Fenaille, M., *Etat general des tapisseries de la manufacture des Gobelins depuis son origine jusqu'à nos jours, 1600–1900*, 6 vols., Paris, 1903–23.

Fergusson, F. D., "St. Charles' Church, Vienna: The Iconography of Its Architecture," *Journal of the Society of Architectural Historians*, XXIX, 1970, 318–26.

Fernández Alonso, J., *S. Maria di Monserrato*, Rome, 1968.

ffolliott, S., *Civic Sculpture in the Renaissance. Montorsoli's*

Fountains at Messina, Ann Arbor, Mich., 1984.

Fialetti, O., *Il vero modo et ordine per dissegnare tutte le parti et membra del corpo umano*, Venice, 1608.

Ficino, M., *Opera omnia*, 2 vols., Basel, 1576.

Filipczak, Z. Z., *Picturing Art in Antwerp*, Princeton, N.J., 1987.

Filippo Brunelleschi. La sua opera e il suo tempo, 2 vols., Florence, 1980.

Fillitz, H., "Studien zu Nicolaus von Verdun," *Arte medievale*, II, 1984, 79–91.

Finarte. Mobili, arredi e tappetti antichi. Asta 565, auction cat., Rome, 1986.

Fiore, K. H., "Il tema 'Labor' nella creazione artistica del Rinascimento," forthcoming in the papers of a colloquium on the artist's self-image, held at the Bibliotheca Hertziana, Rome, 1989.

Firenze e la Toscana dei Medici nell'Europa del Cinquecento. La corte il mare i mercanti. La rinascita della scienza. Editoria e società. Astrologia, magia e alchimia, Florence, 1980.

Flam, J. D., *Matisse on Art*, London, 1973.

————, "Matisse's Subjects: Themes and Variations," unpublished MS, 1989.

Fleckner, U., "*Le Grand Louvre*. Museale Präsentation als Historische Reflexion," forthcoming in T. Grütter and J. Rüsen, *Geschichtskultur*.

Fokker, T. H., "Due pitture di 'genere' fiamminghe nella reggia di Napoli—I," *Bollettino d'arte*, VIII, 1928–29, 122–33.

Forrer, L., *Biographical Dictionary of Medallists*, 8 vols., London, 1904–30.

Forti, G., I. Lapi Ballerini, B. Monsignori Fossi, and P. Ranfagni, "Un planetario del XV secolo," *Astronomia*, IX, no. 62, 1987, 5–14.

Fortuna, A., *The Church of San Lorenzo in Florence and the Medicean Chapels*, Florence, 1954.

Fourcadé, D., *Henri Matisse. Ecrits et propos sur l'art*, Paris, 1972.

Franco Fiorio, M. T., *Giovan Francesco Caroto*, Verona, 1971.

Franza, G., *Il catechismo a Roma e l'Arciconfraternita della Dottrina Cristiana*, Alba, 1958.

Fraschetti, S., *Il Bernini. La sua vita, la sua opera, il suo tempo*, Milan, 1900.

Fraser, D., H. Hibbard, and M. J. Lewine, eds., *Essays in the History of Art Presented to Rudolf Wittkower*, London, 1967.

Fraser, P. M., *Ptolemaic Alexandria*, 2 vols., Oxford, 1972.

Frazer, A., "The Iconography of the Emperor Maxentius' Buildings in Via Appia," *The Art Bulletin*, XLVIII, 1966, 384–92.

Frey, C., ed., *Il codice magliabechiano*, Berlin, 1892.

————, *Il libro di Antonio Billi*, Berlin, 1892.

Friedlaender, W., *Caravaggio Studies*, Princeton, N.J., 1955.

Friedländer, M. J., *Early Netherlandish Painting*, 14 vols., Leiden, 1967–74.

Frommel, C. L., *Baldassare Peruzzi als Maler und Zeichner*, Munich and Vienna, 1967–68.

————, "'Capella Julia': Die Grabkapelle Papst Julius' II in Neu-St. Peter," *Zeitschrift für Kunstgeschichte*, XL, 1977, 26–62.

Fumaroli, M., *L'Age de l'éloquence. Rhétorique et "res literaria" de la Renaissance au seuil de l'époque classique*, Geneva, 1980.

————, "Sacerdoce et office civil: La Monarchie selon Louis XIV," in E. Le Roi Ladurie, ed., *Les monarchies*, Paris, 1986, 104–14.

Fumi, L., *Il santuario del SS. Corporale nel duomo di Orvieto*, Rome, 1896.

Galleni, R., "Bonaventura Bisi e il Guercino," *Paragone*, XXVI, no. 307, 1975, 80–82.

Gamberti, D., *L'idea di un prencipe et eroe christiano in Francesco I. d'Este di Modona, e reggio duca VIII. Generalissimo dell'arme reali di Francia in Italia*, etc., Modena, 1659.

Gardner, J., "The Stefaneschi Altarpiece: A Reconsideration," *Journal of the Warburg and Courtauld Institutes*, XXXVII, 1974, 57–103.

Gardner, P., and E. S. Poole, *A Catalogue of Greek Coins in the British Museum. Thessaly to Aetolia*, London, 1883.

Garrard, M. D., "Jacopo Sansovino's *Madonna* In Sant'Agostino: An Antique Source Rediscovered," *Journal of the Warburg and Courtauld Institutes*, XXXVIII, 1975, 333–38.

Garzelli, A., "Nuovi documenti figurativi per la ricostruzione degli apparati di arredo monumentale di Donatello," in *Università di Pavia. Istituto di storia dell'arte. La scultura decorativa del primo rinascimento. Atti del I convegno internazionale di studi*, Pavia, 1983, 55–66.

Gaston, R., "Liturgy and Patronage in San Lorenzo, Florence, 1350–1650," in Kent *et al.*, eds., 1987, 121–33.

Gaye, G., *Carteggio inedito d'artisti dei secoli XIV, XV, XVI*, 3 vols., Florence, 1839–40.

Geiser, B., *Picasso. Peintre-graveur*, 4 vols., Bern, 1933–86.

Gibbons, F., *Dosso and Battista Dossi. Court Painters at Ferrara*, Princeton, N.J., 1968.

Gilbert, C., "Fra Angelico's Fresco Cycles in Rome: Their Number and Dates," *Zeitschrift für Kunstgeschichte*, XXXVIII, 1975, 245–65.

————, transl., and R. N. Linscott, ed., *Complete Poems and Selected Letters of Michelangelo*, New York, 1963.

Gilbert, F., *Macchiavelli and Guicciardini. Politics and History in Sixteenth-Century Florence*, Princeton, N.J., 1965.

Gilot, F., and C. Lake, *Life with Picasso*, London, 1964.

Ginori Conti, P., *La basilica di S. Lorenzo di Firenze e la famiglia Ginori*, Florence, 1940.

Ginzberg, L., *The Legends of the the Jews*, 7 vols., Philadelphia, 1938.

Girardi, E. N., *Michelangiolo Buonarroti. Rime*, Bari, 1960.

Gnoli, G., *Topografia e toponomastica di Roma medievale e moderna*, Rome, 1939.

Les Gobelins. Trois siècles de tapisserie, exhib. cat., Paris, 1966.

Godwin, J., *Athanasius Kircher. A Renaissance Man and the Quest for Lost Knowledge*, London, 1979.

Gombrich, E. H., "The Debate on Primitivism in Ancient Rhetoric," *Journal of the Warburg and Courtauld Institutes*, XXIX, 1966, 24–38.

————, *Art and Illusion*, Princeton, N.J., 1972.

————, *Il gusto dei primitivi. Le radici della rebellione*, Naples, 1985.

Gómez-Moreno, M., *Catálogo monumental de España. Provincia de Salamanca*, 2 vols., Valencia, 1967.

Gonzáles-Palacios, A., *Il tempio del gusto. Le arti decorative in Italia fra classicismo e barocco. Roma e il regno delle due Sicilie*, 2 vols., Milan, 1984.

Gordon, D. J., "Gianotti, Michelangelo, and the Cult of Brutus," in D. J. Gordon, ed., *Fritz Saxl, 1890–1948. A Volume of Memorial Essays from His Friends in England*, London, 1957, 281–96.

Gorse, G. L., "The Villa of Andrea Doria in Genoa: Architecture, Gardens, and Suburban Setting," *Journal of the Society of Architectural Historians*, XLIV, 1985, 18–36.

Gould, C., *Bernini in France. An Episode in Seventeenth-Century History*, Princeton, N.J., 1982.

Gramaccini, N., *Alfonso Lombardi*, Frankfurt am Main, 1980.

Gramberg, W., *Giovanni Bologna. Eine Untersuchung über die Werke seiner Wanderjahre (bis 1567)*, Berlin, 1936.

Green, L., *Chronicle into History. An Essay on the Interpretation of History in Florentine Fourteenth-Century Chronicles*, Cambridge, 1972.

Greenhalgh, M., *Donatello and His Sources*, London, 1982.

Greenstein, J. M., "Alberti on Historia: A Renaissance View of the Structure of Significance in Narrative Painting," *Viator*, XXI, 1990, 273–99.

Grisar, H., and F. Heege, *Luthers Kampfbilder*, 4 vols., Freiburg im Breisgau, 1921–23.

Grosshans, R., *Maerten van Heemskerck. Die Gemälde*, Berlin, 1980.

Gutkind, C. S., *Cosimo de Medici. Pater Patriae, 1389–1464*, Oxford, 1938.

Hager, H., *Die Anfänge des italienischen Altarbildes. Untersuchungen zur Entstehungsgeschichte des toskanischen Hochaltarretabels*, Munich, 1962.

————, "Puntualizzazioni su disegni scenici teatrali e architettura scenografica del periodo barocco a Roma," *Bollettino del Centro Internazionale di Studi di Architettura "Andrea Palladio,"* XVII, 1975, 119–29.

Hahnloser, H. R., ed., *La pala d'Oro*, Florence, 1965.

Haines, M., *The "Sacrestia della Messe" of the Florentine Cathedral*, Florence, 1983.

Haitovsky, D., "Sources of the *David and Goliath* in the Sistine Chapel: Continuity and Variation in the Meaning of Images," *Source*, VII, 1988, 1–8.

Hamilton, M. J., *Neptune: Allegory and Politics in Sixteenth Century Florence*, Master's thesis, Univ. of Pennsylvania, 1976.

Hankins, J., "Cosimo de' Medici and the 'Platonic Academy,'" *Journal of the Warburg and Courtauld Institutes*, LIII, 1990, 144–62.

————, "The Myth of the Platonic Academy," *Renaissance Quarterly*, XLIV, 1991, 429–75.

Harlé, D., "Les Cours de dessin gravés et lithographiés du XIXème siècle conservés au Cabinet des Estampes de la Bibliothèque Nationale. Essai critique et catalogue," unpublished thesis, Ecole du Louvre, 1975.

Harris, A. S., "Angelo de' Rossi, Bernini, and the Art

of Caricature," *Master Drawings*, XIII, 1975, 158–60.

————, *Andrea Sacchi*, Princeton, N.J., 1977.

————, *Selected Drawings of Gian Lorenzo Bernini*, New York, 1977.

Harrison, J. C., Jr., *The Paintings of Maerten van Heemskerck—a Catalogue Raisonné*, Ph.D. diss., Univ. of Virginia, 1987.

Hartle, R. W., "Le Brun's *Histoire d'Alexandre* and Racine's *Alexandre le Grand*," *Romanic Review*, XLVIII, 1957, 90–103.

————, "The Image of Alexander the Great in Seventeenth-Century France," in B. Laourdas and C. Macaronas, eds., *Ancient Macedonia. I*, Thessaloniki, 1970, 387–406.

————, "The Image of Alexander the Great in Seventeenth-Century France, II: Royal Parallels," in *Ancient Macedonia. II*. Thessaloniki, 1977, 517–30.

————, "Louis XIV and the Mirror of Antiquity," in *The Sun King. Louis XIV and the New World*, exhib. cat., New Orleans, La., 1985, 107–17.

Hartwig, O., *Quellen und Forschungen zur ältesten Geschichte der Stadt Florenze*, Marburg, 1875.

Haskell, F., and N. Penny, *Taste and the Antique. The Lure of Classical Sculpture, 1500–1900*, New Haven, Conn., and London, 1981.

Hass, A., "Caravaggio's *Calling of St. Matthew* Reconsidered," *Journal of the Warburg and Courtauld Institutes*, LI, 1988, 245–50.

Head, B. V., *Historia Numorum. A Manual of Greek Numismatics*, Oxford, 1911.

Heckscher, W., "Bernini's Elephant and Obelisk," *The Art Bulletin*, XXIX, 1947, 155–82.

————, "Reflections on Seeing Holbein's Portrait of Erasmus at Longford Castle," in Fraser *et al.*, eds., 1967, 128–48.

Hedin, T., *The Sculpture of Gaspard and Balthazard Marsy. Art and Patronage in the Early Reign of Louis XIV*, Columbia, Mo., 1983.

Heezen-Stoll, B. A., "Een vanitasstilleven van Jacques de Gheyn II vit 1621: Afspiegeling van neostoïsche denkbeelden," *Oud-Holland*, XCIII, 1979, 217–50.

Heikamp, D., ed., *Scritti d'arte di Federico Zuccaro*, Florence, 1961.

————, "Federico Zuccari a Firenze (1575–1579)," *Paragone*, XVIII, no. 207, 1967, 3–34.

Helbig, W., *Führer durch die öffentlichen Sammlungen klassischer Altertümer in Rom*, 4 vols., Tübingen, 1963–72.

Heninger, S. K., Jr., *The Cosmographical Glass. Renaissance Diagrams of the Universe*, San Marino, Calif., 1977.

Herz, A., "Cardinal Cesare Baronio's Restoration of Ss. Nereo e Achilleo and S. Cesareo de Appia," *The Art Bulletin*, LXX, 1988, 590–620.

Herzner, V., "Donatello in Siena," *Mitteilungen des kunsthistorischen Institutes in Florenz*, XV, 1971, 161–86.

————, "Die Kanzeln Donatellos in San Lorenzo," *Münchner Jahrbuch der bildenden Kunst*, XXIII, 1972, 101–64.

————, "David Florentinus I. Zum Marmordavid Donatellos im Bargello," *Jahrbuch der Berliner Museen*, XX, 1978, 43–115.

Hesiod, *The Homeric Hymns and Homerica*, ed. H. G. Evelyn-White, London and New York, 1950.

Hess, J., *Kunstgeschichtliche Studien zu Renaissance und Barock*, Rome, 1967.

Heydenreich, L. H., *Die Sakralbau Studien Leonardo da Vinci's*, Munich, 1971.

————, and W. Lotz, *Architecture in Italy, 1400 to 1600*, Harmondsworth, 1974.

Hibbard, H., *Carlo Maderno*, London, 1971.

————, *Caravaggio*, New York, 1983.

————, and I. Jaffe, "Bernini's Barcaccia," *The Burlington Magazine*, CVI, 1964, 159–70.

Hill, G. F., *Catalogue of the Greek Coins of Palestine (Galilee, Samaria, and Judaea)*, London, 1914.

Hill, J. W., "Oratory Music in Florence, I: *Recitar Cantando*, 1583–1655," *Acta Musicologica*, LI, 1979, 109–36.

Hinds, A. B., transl., and W. Gaunt, ed., *Giorgio Vasari. The Lives of the Painters, Sculptors, and Architects*, 4 vols., London and New York, 1963.

Hirst, M., "From the Mouth of the Oracle," *Times Literary Supplement*, March 17, 1977.

Hofmann, R., *Die heroische Tugend. Geschichte und Inhalt eines theologischen Begriffes*, Munich, 1933.

Hogarth, W., *The Analysis of Beauty*, London, 1753.

Holderbaum, J., "A Bronze by Giovanni Bologna and a Painting by Bronzino," *The Burlington Magazine*, XCVIII, 1956, 439–45.

————, *The Sculptor Giovanni Bologna*, New York and London, 1983.

Hollstein, F. W., *German Engravings, Etchings, and Woodcuts, ca. 1400–1700*, Amsterdam, 1954–.

Hommel, H., "Per aspera ad astra," *Würzburger Jahrbücher für die Altertumswissenschaft*, IV, 1949, 157–65.

Hoog, S., *Le Bernin. Louis XIV. Une statue "déplacée"*, Paris, 1989.

Houlet, J., *Les Combats des vertues et des vices*, Paris, 1969.

The Hours of the Divine Office in English and Latin, 3 vols., Collegeville, Minn., 1964.

Hugedé, N., *La Métaphore du miroir dan les Epîtres de Saint Paul aux Corinthiens*, Neuchâtel and Paris, 1957.

Huth, H., *Künstler und Werkstatt der Spätgothik*, Darmstadt, 1977.

Hyman, I., "Towards Rescuing the Lost Reputation of Antonio di Manetto Ciaccheri," in S. Bertelli and G. Ramakus, eds., *Essays Presented to Myron P. Gilmore*, 2 vols., Florence, 1978, II, 261–79.

"Il se rendit en Italie." Etudes offertes à André Chastel, Rome, 1987.

Le immagini del SS.mo Salvatore. Fabbriche e sculture per l'Ospizio Apostolico dei Poveri Invalidi, exhib. cat., Rome, 1988.

Isermeyer, C. A, "Das Michelangelo-Jahr und die Forschungen zu Michelangelo als Maler und Bildhauer von 1959 bis 1965," *Zeitschrift für Kunstgeschichte*, XXVIII, 1965, 307–62.

Isidore of Seville, *De natura rerum*, Augsburg, 1474.

Italienische Zeichnungen des 16. Jahrhunderts, exhib. cat., Linz, 1991.

Jacopone da Todi, *Landi, trattato e detti*, ed. F. Ageno, Florence, 1953.

Jacquiot, J., "Les portraits de Louis XIV gravés sur les médailles des séries metallique uniformes," *Bulletin de la société nationale des antiquaires de France*, 1967, 185–201.

Janeck, A., *Untersuchung über den Holländischen Maler Pieter van Laer, genannt Bamboccio*, Ph.D. diss., Universität Würzburg, 1968.

Janson, H. W., *The Sculpture of Donatello*, Princeton, N.J., 1957.

————, "La Signification politique du David en bronze de Donatello," *Revue de l'art*, XXXIX, 1978, 33–38.

The Jewish Encyclopedia, 12 vols., New York, n.d.

Johnson, C., "Cosimo de' Medici e la sua 'Storia Metallica' nelle medaglie de Pietro Paolo Galeotti," *Medaglia*, no. 14, 1976, 15–46.

Johnson, K. O., "Il n'y a plus de Pyrénées: The Iconography of the First Versailles of Louis XIV," *Gazette des Beaux-Arts*, XCVII, 1981, 29–40.

Jones, M., *A Catalogue of the French Medals in the British Museum*, 2 vols., London, 1982–88.

Jordan, H., *Topographie der Stadt Rom im Altertum*, 3 vols., Berlin, 1871–1907.

Josephson, R., "Le Monument du triomphe pour le Louvre. Un projet de Charles Le Brun retrouvé," *La revue de l'art ancien et moderne*, LIII, 1928, 21–34.

Jouin, H., *Charles le Brun et les arts sous Louis XIV*, Paris, 1889.

Judson, J. R., *Dirck Barendsz, 1534–1592*, Amsterdam, 1970.

Juynboll, W. R., *Het komische genre in de Italiaansche schilderkunst gedurende de zeventiende en de achttiende eeuw: Bijdrage tot de geschiedenis van de caricatur*, Leyden, 1934.

Kallendorf, C., *In Praise of Aeneas. Virgil and Epideictic Rhetoric in the Early Italian Renaissance*, Hanover and London, 1989.

Kantorowicz, E., "Oriens Augusti-Lever du Roi," *Dumbarton Oaks Papers*, XVII, 1963, 117–77.

Katzenellenbogen, A., *Allegories of the Virtues and Vices in Medieval Art. From Early Christian Times to the Thirteenth Century*, New York, 1964.

Kauffmann, H., *Donatello. Eine Einführung in sein Bilden und Denken*, Berlin, 1936.

Keller, U., *Reitermonumente absolutischer Fürsten. Staatstheoretische Voraussetzungen und politische Funktionen*, Munich and Zurich, 1971.

Keller-Dorian, G., *Antoine Coysevox (1640–1720)*, 2 vols., Paris, 1920.

Kemp, M., *Leonardo da Vinci. The Marvelous Works of Nature and Man*, London, 1981.

Kemp, W., "Disegno. Beiträge zur Geschichte des Begriffs zwischen 1547 und 1607," *Marburger Jahrbuch für Kunstwissenschaft*, XIX, 1974, 219–40.

————, ". . . einen wahrhaft bildenden Zeichenunterricht überall einzu führen." *Zeichen und Zeichenunterricht der Laien 1500–1870. Ein Handbuch*, Frankfurt am Main, 1979.

Kempers, B., and S. de Blaauw, "Jacopo Stefaneschi, Patron and Liturgist. A New Hypothesis Regarding the Date, Iconography, Authorship, and Function of the Altarpiece for Old Saint Peter's," *Mededelingen van het Nederlands Instituut te Rome*, XLVII, 1987, 83–113.

Kent, F. W., P. Simons, and J. C. Eade, eds., *Patronage, Art, and Society in Renaissance Italy*, Canberra and Oxford, 1987.

Kiene, M., "'L'Image du Dieu vivant.' Zum 'Aktionsbild' und zur Ikonographie des Festes am 30. November 1729 auf der Piazza Navona in Rom," *Zeitschrift für Kunstgeschichte*, LVIII, 1991, 220–48.

Kier, H., *Der mittelalterliche Schmuckfussboden*, Düsseldorf, 1970.

King, C., "National Gallery 3902 and the Theme of Luke the Evangelist as Artist and Physician," *Zeitschrift für Kunstgeschichte*, XLVIII, 1985, 249–55.

Kircher, A., *Obeliscus pamphilius*, Rome, 1650.

————, *Oedipus aegyptiacus*, 3 vols., Rome, 1652–54.

Kirkendale, W., "Emilio de' Cavalieri, a Roman Gentleman at the Florentine Court," *Quadrivium*, XII, 1971, 9–21.

Kitzinger, E., "The Threshold of the Holy Shrine: Observations on Floor Mosaics at Antioch and Bethlehem," in P. Granfield and J. A. Jungmann, eds., *Kyriakon. Festschrift Johannes Quasten*, 2 vols., Münster, 1970, II, 639–47.

Klapisch-Zuber, C., *Les Maîtres du marbre. Carrare, 1300–1600*, Paris, 1969.

Klibansky, R., "Plato's Parmenides in the Middle Ages and Renaissance," *Mediaeval and Renaissance Studies*, I, 1943, 281–370; reprinted in *idem, The Continuity of the Platonic Tradition . . .* , Milwood, N.Y., 1982.

Kliemann, J., "Vertumnus und Pomona. Zum Program von Pontormos Fresko in Poggio a Caiano," *Mitteilungen des kunsthistorisches Institutes in Florenz*, XVI, 1972, 293–328.

Koch, E., "Das barocke Reitermonument in Österreich," *Mitteilungen der österreichischen Galerie*, XIX–XX, 1975–76, 32–80.

Koepplin, D., and T. Falk, *Lukas Cranach: Gemälde Zeichnungen Druckgraphik*, 2 vols., Stuttgart, 1974–76.

Körte, W., *Der Palazzo Zuccari in Rom. Sein Freskenschmuck und seine Geschichte*, Leipzig, 1935.

————, "Deinokrates und die barocke Phantasie," *Die Antike*, XII, 1937, 289–312.

Koslow, S., "Two Sources for Vincent van Gogh's 'Portrait of Armand Roulin': A Character Likeness and a Portrait Schema," *Arts Magazine*, LVI, 1981, 156–63.

Krautheimer, R., "Fra Angelico and—perhaps—Alberti," in I. Lavin and J. Plummer, eds., *Studies in Late Medieval and Renaissance Painting in Honor of Millard Meiss*, New York, 1977, 290–301.

————, S. Corbett, and A. K. Frazer, *Corpus basilicarum christianarum Romae*, vol. V, Rome, 1980.

————, "Alexander VII and Piazza Colonna," *Römisches Jahrbuch für Kunstgeschichte*, XX, 1983, 195–208.

————, *The Rome of Alexander VII, 1655–1667*, Princeton, N.J., 1985.

Kren, T., "Chi non vuol Baccho: Roeland van Laer's Burlesque Painting about Dutch Artists in Rome," *Simiolus*, XI, 1980, 63–80.

Kretschmer, H., "Zu Caravaggios Berufung des Matthäus in der Cappella Contarelli," *Pantheon*, XLVI, 1988, 63–66.

Kris, E., and E. H. Gombrich, "The Principles of Caricature," in E. Kris, *Psychoanalytic Explorations in Art*, 189–203, New York, 1952.

————, and O. Kurz, *Legend, Myth, and Magic in the Image of the Artist. A Historical Experiment*, New Haven, Conn., and London, 1979.

Kristeller, P. O., *The Philosophy of Marsilio Ficino*, New York, 1943.

————, *Renaissance Thought. II. Papers on Humanism and the Arts*, New York, 1965.

Kruft, H.-W., "Ein Album mit Porträtzeichnungen Ottavio Leonis," *Storia dell'Arte*, no. 4, 1969, 447–58.

Kuraszewski, G., "La Cheminée du salon de la guerre au château de Versailles. Sa création et ses transformations successives," *Bulletin de la société de l'histoire de l'art français*, 1974, 63–69.

Kurz, O., "A Group of Florentine Drawings for an Altar," *Journal of the Warburg and Courtauld Institutes*, XVIII, 1955, 35–53.

Küthmann, H., B. Overbeck, D. Steinhilber, and I. Weber, *Bauten Roms auf Münzen und Medaillen*,

Munich, 1973.

Ladendorf, H., *Antikenstudium und Antikenkopie, Abhandlungen der sächsischen Akademie der Wissenschafen zu Leipzig. Philologisch-historische Klasse,* XLVI, pt. 2. Berlin, 1953.

Lainez, J., *Disputationes tridentinae,* 2 vols., Regensburg, 1886.

Landi, F., *Le Temps revient. Il fregio di Poggio a Caiano,* Florence, 1986.

Lane, B. G., "Bosch's Tabletop of the Seven Deadly Sins and the *Coridale Quattuor Novissimorum,*" in W. W. Clark, ed., *Tribute to Lotte Brand Philip, Art Historian and Detective,* New York, 1985, 89–94.

Lange, K., and F. Fuhse, *Dürers schriftlicher Nachlass,* Halle, 1893.

Langedijk, K., *The Portraits of the Medici: 15th–18th Centuries,* 3 vols., Florence, 1981–87.

Lapi Ballerini, I. "L'emisfero celeste della Sagrestia Vecchia: Rendiconti da un giornale di restauro," in *Donatello,* 1986, 75–85.

————, "Gli emisferi celesti della Sagrestia Vecchia e della Cappella Pazzi," *Rinascimento,* XXVIII, 1988, 321–55.

Larousse Ménager, Paris, 1926.

Larsson, L. O., *Von allen Seiten gleich schön,* Stockholm, 1977.

Lates, A. von, *Stoics and Libertines. Philosophical Themes in the Art of Poussin, Caravaggio, and their Contemporaries,* Ph.D. diss., Columbia Univ., 1989.

Lauer, P., *Le Palais de Latran,* Paris, 1911.

Laurain-Portemer, M., "Fortuna e sfortuna di Bernini nella Francia di Mazzarino," in M. Fagiolo, ed., *Bernini e l'unità delle arte visive,* Rome, 1985, 1–17.

Lauro, G., *Antiquae urbis splendor,* Rome, 1612–41.

Lavin, I., "The Sources of Donatello's Pulpits in San Lorenzo. Revival and Freedom of Choice in the Early Renaissance," *The Art Bulletin,* XLI, 1959, 19–38.

————, "Bozzetti and Modelli. Notes on Sculptural Procedure from the Early Renaissance through Bernini," in *Stil und Überlieferung in der Kunst des Abendlandes. Akten des 21. internationalen Kongresses für Kunstgeschichte in Bonn, 1964,* Berlin, 1967, III, 93–104.

————, *Bernini and the Crossing of St. Peter's,* New York, 1968.

————, "Five Youthful Sculptures by Gianlorenzo Bernini and a Revised Chronology of his Early Works," *The Art Bulletin,* L, 1968, 223–48.

————, "On the Sources and Meaning of the Renaissance Portrait Bust," *The Art Quarterly,* XXXIII, 1970, 207–26.

————, with the collaboration of M. A. Lavin, "Duquesnoy's 'Nano di Créqui' and Two Busts by Francesco Mochi," *The Art Bulletin,* LII, 1970, 132–49.

————, "Bernini's Death," *The Art Bulletin,* LIV, 1972, 159–86.

————, "Afterthoughts on 'Bernini's Death,'" *The Art Bulletin,* LV, 1973, 429–36.

————, "Divine Inspiration in Caravaggio's Two St. Matthews," *The Art Bulletin,* LVI, 1974, 59–81.

————, "Addenda to 'Divine Inspiration,'" *The Art Bulletin,* LVI, 1974, 590–91.

————, "On Illusion and Allusion in Italian Sixteenth-Century Portrait Busts," *Proceedings of the American Philosophical Society,* CXIX, 1975, 353–62.

————, "The Sculptor's 'Last Will and Testament,'" *Allen Memorial Art Museum Bulletin,* XXXV, 1977–78, 4–39.

————, *Bernini and the Unity of the Visual Arts,* New York and London, 1980.

————, "A Further Note on the Ancestry of Caravaggio's First *Saint Matthew,*" *The Art Bulletin,* LXII, 1980, 113–14.

————, and P. Gordon, L. Klinger, S. Ostrow, S. Cather, N. Courtright, and I. Dreyer, *Drawings by Gianlorenzo Bernini from the Museum der Bildenden Künste. Leipzig, German Democratic Republic,* exhib. cat., Princeton, N.J., 1981.

————, "Bernini's Cosmic Eagle," in I. Lavin, ed., *Gianlorenzo Bernini. New Aspects of His Art and Thought. A Commemorative Volume,* University Park, Pa., and London, 1985.

————, "Le Bernin et son image du Roi-Soleil," in *"Il se rendit en Italie,"* 1987, 441–78.

————, "David's Sling and Michelangelo's Bow," in *L'Art et les révolutions. Conférences plénières. XXVII^e congrès international d'histoire de l'art,* Strasbourg, 1990, 107–46.

————, "High and Low before Their Time: Bernini

and the Art of Social Satire," in K. Varnadoe and A. Gupnik, eds., *Modern Art and Popular Culture: Readings in High and Low*, New York, 1990, 18–50.

———, "Bernini's Image of the Ideal Christian Monarch," paper presented at a colloquium, "Les Jésuites et la civilisation du baroque (1540–1640)," held at Chantilly, June, 1991.

Lavin, M. A., *Piero della Francesca. "The Flagellation,"* London, 1972.

———, "Piero della Francesca's Fresco of Sigismondo Malatesta before St. Sigismund," *The Art Bulletin*, LVII, 1974, 345–74.

———, "St. Francis Reads a Psalm: A Two-Sided Processional Panel," *Record of the Art Museum. Princeton University*, XLIV, 1985, 32–35.

Lavin, S., "Viewpoint by Sylvia Lavin," *Interiors*, CXLVIII, 1988, 23–27.

Leeuwenberg, J., *Beeldhouwkunst in het Rijksmuseum*, Amsterdam, 1973.

Lehman, P. W., and D. Spittle, *Samothrace. The Temenos*, Princeton, N.J., 1982.

Leighten, P., "The White Peril and *L'Art nègre*: Picasso, Primitivism, and Anticolonialism," *The Art Bulletin*, LXXII, 1990, 609–30.

Leite de Vasconcellos, J., *Signum salomonis. Estudo de etnologia comparativa*, Lisbon, 1918 (*O archeologo portuguệs*, XXIII).

Leithe-Jasper, M., "Eine Medaille auf Papst Pius IV. von Guglielmo della Porta?" *Mitteilungen des Kunsthistorisches Institutes in Florenz*, XVI, 1972, 329–35.

Levie, S., *Der Maler Daniele da Volterra, 1509–1566*, Ph.D. diss., Universität Basel, 1962.

Levine, D., "Pieter van Laer's *Artist's Tavern*. An Ironic Commentary on Art," in *Holländische Genremalerei im 17. Jahrhundert. Symposium Berlin 1984* (Jahrbuch Preussischer Kulturbesitz, Sonderband 4), Berlin, 1987, 169–91.

———, and E. Mai, eds., *I Bamboccianti. Nederländische Malerrebellen im Rom des Barock*, exhib. cat., Milan, 1991.

Levine, S., "The Location of Michelangelo's *David*: The Meeting of January 25, 1504," *The Art Bulletin*, LVI, 1974, 31–49.

Liebenwein, W., *Studiolo. Die Entstehung eines Raumtyps und seine Entwicklung bis um 1600*, Berlin, 1977.

Lightbown, R. W., "Gaetano Guilio Zumbo—I: The

Florentine Period," *The Burlington Magazine*, CVI, 1964, 486–96.

———, *Donatello and Michelozzo. An Artistic Partnership and Its Patrons in the Early Renaissance*, 2 vols., London, 1980.

Lindgren, L. E., and C. B. Schmidt, "A Collection of 137 Broadsides concerning Theatre in Late Seventeenth-Century Italy: An Annotated Catalogue," *Harvard Library Bulletin*, XXVIII, 1980, 185–229.

L'Orange, H. P., *Apotheosis in Ancient Portraiture*, New Rochelle, N.Y., 1982.

Lord, C., "Raphael, Marcantonio Raimondi, and Virgil," *Source Notes in the History of Art*, III, 1984, 23–33.

Lovejoy, A. O., and G. Boas, *Primitivism and Related Ideas in Antiquity*, Baltimore, Md., 1935.

Luporini, E., *Brunelleschi. Forma e ragione*, Milan, 1964.

MacCormack, S. G., *Art and Ceremony in Late Antiquity*, Berkeley and Los Angeles, 1981.

McGrath, E., "Ruben's *Arch of the Mint*," *Journal of the Warburg and Courtauld Institutes*, XXXVII, 1974, 191–217.

MacGregor, J. M., *The Discovery of the Art of the Insane*, Princeton, N.J., 1989.

McKillop, S. R., "Dante and *lumen Christi*: A Proposal for the Meaning of the Tomb of Cosimo the Elder," in F. Ames-Lewis, ed., *Cosimo "il Vecchio" de' Medici, 1389–1464*, Oxford, forthcoming.

Maclehose, L. S., and G. B. Brown, *Vasari on Technique*, New York, 1960.

McNamee, D., "Van Doesburg's Cow: A Crucial Translation," *The Structurist*, no. 8, 1968, 12–20.

Mahon, D., "Addenda to Caravaggio," *The Burlington Magazine*, XCIV, 1952, 3–23.

Mai, W. W. K., *"Le Portrait du roi." Staatsporträt und Kunsttheorie in der Epoche Ludwigs XIV. Zur Gestaltikonographie des spätbarocken Herrscherporträts in Frankreich*, Bonn, 1975.

Malaguzzi Valeri, F., *La zecca di Bologna*, Milan, 1901.

Malke, L., "Zur Ikonographie der 'Vier letzten Dinge' vom ausgehenden Mittelalter bis zum Rokoko," *Zeitschrift des Deutschen Vereins für Kunstwissenschaft*, XXX, 1976, 44–66.

Malraux, A., *La Tête d'obsidienne*, Paris, 1974.

Malvasia, G. C., *Per la statua squestre del re christianis-*

simo . . . , Rome, 1685.

Manetti, A., *The Life of Brunelleschi*, ed. H. Saalman, transl. C. Enggass, University Park, Pa., and London, 1970.

Manni, A., *Essercitii spirituali . . . Dove si mostra un modo facile per fare fruttuosamente oratione à Dio, et di pensare le cose, che principalmente appartengono alla salute, di acquistare il vero dolore de' peccati, e di fare una felice morte. Con tre essercitii per diventare devoto della Beatissima Vergine Maria Madre di Dio*, Brescia, 1609.

_____, *Essercitii spirituali nei quali si mostra un modo facile di far fruttuosamente oratione à Dio, di pensar le cose che principalmente appartengono alla salute, d'acquistar'il vero dolore de' peccati, e di fare una felice morte . . . Parte Prima. Con tre altri essercitii per diventar devoto della B. Verg. Maria Madre di Dio. Agguntovi in quest quarta impressione un'ragionamento sopra la grandezza, e verità della Fede Cristiana; e qual sia la fede viva, e la fede morta. Con gl'essercitii formati, dove s'impara la dottrina della salute, & il modo i'impetrar da Dio questo glorioso lume*, Rome, 1613.

_____, *Essercitii spirituali per la mattina, e sera all'Oratione . . . Et un modo di meditar le cinque Piaghe del N. S. Giesu Christo, con dimandargli gratie d'infinito valore*, Rome, 1620.

_____, *Raccolta di due Esercizii, uno sopra l'eternità della felicità del Cielo, e l'altro sopra l'eternità delle pene dell'Inferno*, Rome, 1625.

_____, *Raccolta di due essercitii, uno sopra l'Eternità della felicità del cielo, e l'altro sopra l'eternità delle pene dell'Inferno. Ed una rappresentatione nella quale sotto diverse imagini si mostra al particolare il fine calamitoso del peccatore, & il fine honorato, e glorioso dell'Huomo giusto*, Rome, 1637.

Marcel, R., *Marsile Ficin. Commentaire sur le Banquet de Platon*, Paris, 1956.

Marchesi, F. [Pietro Roselli], *De antiqua gallias inter, atque hispanias in divinis, et humanis rebus communione. Authore Petro Rosello, sacerdote gallo*, Lyon, 1660.

Marder, T., "La chiesa del Bernini ad Ariccia," in Spagnesi and Fagiolo, eds., 1984, 255–77.

_____, "The Decision to Build the Spanish Steps: From Project to Monument," in H. Hager and S. S. Munshower, eds., *Projects and Monuments in the Period of the Roman Baroque*, State College, Pa., 1984, 81–99.

Marini, M., *Io Michelangelo da Caravaggio*, Rome, 1974.

_____, *Caravaggio. Michelangelo Merisi da Caravaggio "pictor praestantissimus,"* Rome, 1989.

Marlier, G., *Erasme et la peinture flamande de son temps*, Damme, 1954.

_____, *La Renaissance flamande. Pierre Coeck d'Alost*, Brussels, 1966.

Martin, J. R., *The Decorations for the Pompa Introitus Ferdinandi*, Brussels, 1972.

Martin, M., *Les Monuments équestres de Louis XIV. Une grande entreprise de propagande monarchique*, Paris, 1986.

Masi, M., *Boethian Number Theory. A Translation of the "De Institutione Arithmetica,"* Amsterdam, 1983.

Massar, P. D., *Stefano della Bella*, New York, 1971.

Massari, S., *Giulio Bonasone*, 2 vols., Rome, 1983.

Matisse, H., *Dessins. Thèmes et variations*, Paris, 1943.

Mauquoy-Hendrickx, M., *Les Estampes des Wierix*, 3 vols., Brussels, 1978–83.

La Médaille au temps de Louis XIV, exhib. cat., Paris, 1970.

Meder, J., *The Mastery of Drawing*. Translated and revised by W. Ames, New York, 1978.

Meinecke, F., *Die Idee der Staatsräson in der neueren Geschichte*, Munich and Berlin, 1924 (English edition: *Machiavellism. The Doctrine of Raison d'Etat and Its Place in Modern History*, Boulder, Colo., 1984).

Meiss, M., ed., *De Artibus Opuscula XL. Essays in Honor of Erwin Panofsky*, New York, 1961.

Mellinkoff, R., "Judas's Red Hair and the Jews," *Journal of Jewish Art*, IX, 1982, 31–46.

Mende, M., *Das alte Nürnberger Rathaus*, I, Nuremberg, 1979.

Mendelsohn, L., *Paragoni. Benedetton Varchi's "Due Lezzioni" and Cinquecento Art Theory*, Ann Arbor, Mich., 1982.

Menestrier, C. F., *Reioüissances de la paix*, Lyon, 1660.

_____, *L'Art des emblèmes*, Lyon, 1662.

_____, *La Devise du roy justifiée*, Paris, 1679.

_____, Histoire du règne de Louis le Grand par les médailles . . . , Paris, 1693.

Menichella, A., *Matthia de'Rossi discepolo prediletto del Bernini*, Rome, 1985.

Merrill, D. O., "The 'Vanitas' of Jacques de Gheyn," *Yale University Art Gallery Bulletin*, XXV, 1960, 7–29.

Metken, S., ed., *Die letzte Reise. Sterben, Tod und Trauer-*

sitten in Oberbayern, exhib. cat., Munich, 1984.

Meyer, H., "Der Berg Athos als Alexander. Zu den realen Grundlagen der Vision des Deinokrates," *Rivista di archeologia,* X, 1986, 22–30.

Mezzatesta, M. P., "Marcus Aurelius, Fray Antonio de Guevara, and the Ideal of the Perfect Prince in the Sixteenth Century," *The Art Bulletin,* LXVI, 1984, 620–32.

————, *Henri Matisse. Sculpture/Painter,* exhib. cat., Fort Worth, Tex., 1984.

Miller, N., "Piazza Nettuno, Bologna: A Paean to Pius IV," *Architectura,* VII, 1977, 14–39.

————, *Renaissance Bologna. A Study in Architectural Form and Content,* New York, 1989.

Millon, H., "Bernini–Guarini: Paris–Turin: Louvre–Carignano," in *"Il se rendit en Italie,"* 1987, 497–500.

Mirot, L., "Le Bernin en France. Les travaux du Louvre et les statues de Louis XIV," *Mémoires de la société de l'histoire de Paris et de l'Ile-de-France,* XXXI, 1904, 161–288.

Mockler, V. B., *Colossal Sculpture of the Cinquecento from Michelangelo to Giovanni Bologna,* Ph.D. diss., Columbia Univ., 1967.

Monducci, E., and M. Pirondini, eds., *Lelio Orsi,* Milan, 1987.

Mongitore, A., *Memorie dei pittori, scultori, architetti, artefici in cera siciliani,* ed. E. Natoli, Milan, 1977.

Montagu, J., "The Tapestries of Maincy and the Origin of the Gobelins," *Apollo,* LXXVI, 1962, 530–35.

Montfaucon, B. de, *L'Antiquité expliquée,* 5 vols., Paris, 1719.

Montini, R. U., *Le tombe dei papi,* Rome, 1957.

Morelli, A., "Musica a Roma negli anni santi dal 1600 al 1700," in M. Fagiolo and M. L. Madonna, eds., *Roma sancta. La città delle basiliche,* Rome, 1985, 190–200.

Morolli, G., "'A quegli idei selvestri': Interpretazione naturalistica, primato e dissoluzione dell'ordine architettonico nella teoria cinquecentesca sull'ordine rustica," in Fagiolo, ed., 1979, 55–97.

Moroni, G., *Dizionario di erudizione storico-artistico da S. Pietro sino ai nostri giorni,* 103 vols., 1840–61.

Morrogh, A., "Vasari and Coloured Stones," in G. C. Garfagnini, ed., *Giorgio Vasari tra decorazione ambientale e storiografia artistica.* Florence, 1985, 309–20.

Morselli, P., "A Project by Michelangelo for the Ambo(s) of Santa Maria del Fiore, Florence," *Journal of the Society of Architectural Historians,* XL, 1981, 122–28.

Mostra didattica di Carlo Sellitto primo caravaggesco napoletano, exhib. cat., Naples, 1977.

Mourlot, F., *Picasso lithographe,* 4 vols., Monte Carlo, 1947–64.

————, *Picasso lithographe,* Paris, 1970; transl. J. Didry, *Picasso Lithographs,* Boston, 1970.

————, *Souvenirs and portraits d'artistes,* Paris, 1973.

————, *Gravés dans ma mémoire,* Paris, 1979.

Moxey, K. P. F., "The Criticism of Avarice in Sixteenth-Century Netherlandish Painting," in G. Görel-Björkman, ed., *Netherlandish Mannerism,* Uddevalle, 1985, 21–34.

Müller-Meiningen, J., *Die Moriskentänzer und andere Arbeiten des Erasmus Grasser für das Alte Rathaus in München,* Munich and Zurich, 1984.

Murdoch, J. E., *Album of Science. Antiquity and the Middle Ages,* New York, 1984.

Musée Picasso. Château d'Antibes. Juillet-Novembre 1972. Peinture d'enfants, exhib. cat.

Museo Picasso. Catalogo de pintura y dibujo, Barcelona, [1986].

Muthmann, F., *Statuenstützen und dekoratives Beiwerk an griechischen und römischen Bildwerken,* Heidelberg, 1951.

Nardini, F., *Roma antica,* Rome, 1966.

Nesbitt, M., "The Language of Industry," paper presented at the Davis Center Seminar, Princeton University, 1987.

Il Nettuno del Giambologna. Storia e restauro, Milan, 1989.

Nicholson, B., *Hendrick Terbrugghen,* London, 1958.

Noehles, K., *La chiesa dei Ss. Luca e Martina nell'opera di Pietro da Cortona,* Rome, 1970.

Nussbaum, O., *Der Standort des Liturgen am christlichen Altar vor dem Jahr 1000. Eine archäologische und liturgiegeschichtliche Untersuchung,* Bonn, 1965.

Nyberg, D. E., "A Study of Proportions in Brunelleschi's Architecture," Master's thesis, Institute of Fine Arts, New York Univ., 1953.

O'Brian, P., *Picasso. Pablo Ruiz Picasso,* New York, 1976.

Oechslin, W., "Dinocrates and the Myth of the

Megalomaniacal Institution of Architecture,"
Daidalos, no. 4, 1982, 7–26.

Olivato, L., "Filippo Brunelleschi e Mauro Codussi,"
in *Filippo Brunelleschi*, Florence, 1980, II,
799–807.

Olszewski, E. J., *The Draftsman's Eye. Late Italian Renaissance Schools and Styles*, Bloomington, Ind., 1981.

O'Malley, J. W., *Giles of Viterbo on Church and Reform. A Study in Renaissance Thought*, Leiden, 1968.

Orlandi, P. A., *Abecedario pittorico dei professori più illustri in pittura, scultura, e architettura*, Florence, 1788.

Osthoff, W., "Antonio Cestis 'Alessandro vincitor di se
stesso,'" *Studien zur Musikwissenschaft*, XXIV, 1960,
13–43.

Ostrow, S. F., "Gianlorenzo Bernini, Girolamo Lucenti,
and the Statue of Philip IV in S. Maria Maggiore: Patronage and Politics in Seicento Rome,"
The Art Bulletin, LXXIII, 1991, 89–118.

Ozzola, L., "Tre lettere inedite riguardanti il Bernini,"
L'Arte, IX, 1906, 205.

Paatz, W., and E. Paatz, *Die Kirchen von Florenz*, 7 vols.,
Frankfurt am Main, 1952–55.

Palau i Fabre, J., *Child and Caveman: Elements of Picasso's
Creativity*, New York, 1978.

—————, *Picasso. The Early Years, 1881–1907*, New York,
1981.

Palisca, C. V., "Musical Asides in the Diplomatic
Correspondence of Emilio de' Cavalieri," *The
Musical Quarterly*, XLIX, 1963, 339–55.

Le Pamphlet. Provisoire illustré, no. 57, October 19–22,
1848, IV.

Panofsky, E., *Hercules am Scheidewege*, Leipzig, 1930.

—————, *The Life and Art of Albrecht Dürer*, Princeton,
N.J., 1955.

—————, *Tomb Sculpture*, New York, 1964.

—————, "Erasmus and the Visual Arts," *Journal of the
Warburg and Courtauld Institutes*, XXXII, 1969,
200–227.

Panvinio, O., *De ludis circensibus*, Padua, 1642.

Parks, N. R., "The Placement of Michelangelo's *David*:
A Review of the Documents," *The Art Bulletin*,
LVII, 1975, 560–70.

Parmelin, H., *Picasso dit . . .*, Paris, 1966; transl.
C. Trollope, *Picasso Says . . .*, London, 1966.

Parronchi, A., "Sulla collocazione originaria del
tabernacolo di Desiderio da Settignano,"

Cronache di archeologia e di storia dell'arte, IV, 1965,
130–40.

—————, *Donatello e il potere*, Florence and Bologna,
1980.

—————, "Un tabernacolo brunelleschiano," in *Filippo
Brunelleschi*, Florence, 1980, I, 239–55.

—————, "Il 'ghugante' di Agostino di Duccio," *Prospettiva*, nos. 53–56, 1989–90, 227–35.

Parry, E. C., III, *Thomas Cole's "The Course of Empire."
A Study in Serial Imagery*, Ph.D. diss., Yale University, 1970.

Passavant, G., *Verrocchio. Sculptures, Paintings and Drawings*,
London, 1969.

Passional Christi und Antichristi, 1521, ed. D. G. Kawerau,
Berlin, 1885.

Pastor, L. von, *The History of the Popes from the Close of the
Middle Ages*, ed. R. F. Kerr, 40 vols., London,
1923–53.

Pedretti, C., *The Literary Works of Leonardo da Vinci
. . . Commentary*, 2 vols., Berkeley and Los
Angeles, 1977.

—————, "L'organizzazione simbolica dello spazio
nelle cartelle dell'accademia vinciana," in
M. Dalai Emiliani, ed., *La prospettiva rinascimentale.
Codificazioni e trasgressioni*, 2 vols., Florence, 1980,
I, 261–66.

—————, *Leonardo architect*, New York, 1981.

La Peinture dans la peinture, exhib. cat., Dijon, 1983.

*Peintures d'enfants anglais. Exposition organisée par le British
Council. 28 Avenue des Champs Elysées*, preface by
H. Read, London and Beccles, 1945.

Penrose, R., *Picasso. His Life and Work*, New York, 1973.

Perlove, S., "Guercino's *Esther Before Ahasuerus* and Cardinal Malagotti, Bishop of Ferrara," *Artibus et
historiae*, no. 19, 1989, 133–48.

Perrault, C., *Mémoires de ma vie par Charles Perrault. Voyage
à Bordeaux (1669) par Claude Perrault*, ed.
P. Bonnefon, Paris, 1909.

Petzet, M., "Der Obelisk des Sonnenkönigs. Ein
Projekt Claude Perraults von 1666" *Zeitschrift für
Kunstgeschichte*, XLVI, 1984, 439–64.

Pevsner, N., *Academies of Art Past and Present*, New York,
1973.

Pfeiffer, H., *Zur Ikonographie van Raffaels Disputa*, Rome,
1975.

Picasso. The Bull. National Gallery of Art, fascimile edition,

introduction by Andrew Robinson [Washington, D.C., n.d.].

Pietrangeli, C., *Commune di Roma. Mostre topografiche di Rome. Piazza Colonna*, Rome. 1955.

Plato, *The Republic*, ed. and transl. P. Shorey, 2 vols., Cambridge, Mass., and London, 1956.

Poirer, M. G., *Studies on the Concepts of "Disegno," "Invenzione," and "Colore" in Sixteenth and Seventeenth Century Italian Art and Theory*, Ph.D. diss., New York Univ., 1976.

Pollak, M. D., *Turin, 1564–1690. Urban Design, Military Culture, and the Creation of the Absolutist Capital*, Chicago and London, 1991.

Pollitt, J. J., *The Art of Greece, 1400–31 B.C. Sources and Documents*, Englewood Cliffs, N.J., 1965.

Pope-Hennessy, J., *Catalogue of Italian Sculpture in the Victoria and Albert Museum*, 3 vols., London, 1964.

————, *Italian Renaissance Sculpture*, London and New York, 1971.

————, *Italian Gothic Sculpture*, London and New York, 1972.

————, *Luca della Robbia*, Ithaca, N.Y., 1980.

Portheim, F., "Beiträge zu den Werken Michelangelo's," *Repertorium für Kunstwissenschaft*, XII, 1889, 140–58.

Posner, D., "Charles Lebrun's Triumphs of Alexander," *The Art Bulletin*, XLI, 1959, 237–48.

————, "The Picture of Painting in Poussin's *Self-Portrait*," in Fraser *et al.*, eds., 1967, 200–203.

————, *Annibale Carracci: A Study in the Reform of Italian Painting around 1590*, London, 1971.

Prater, A., "Wo is Matthäus? Beobachtungen zu Caravaggios Anfängen als Monumentalmaler in der Contarelli-Kapelle," *Pantheon*, XLIII, 1985, 70–74.

Preimesberger, R., "Obeliscus Pamphilius. Beiträge zu Vorgeschichte und Ikonographie des Vierströmerbrunnens auf Piazza Navona," *Müncher Jahrbuch der bildenden Kunst*, XXV, 1974, 77–162.

————, "Eine grimassierende Selbstdarstellung Berninis," in I. Lavin, ed., *World Art. Themes of Unity in Diversity. Acts of the XXVIth International Congress of the History of Art*, Washington, D.C., 3 vols., University Park, Pa., 1989, II, 415–24.

Prinz, W., and R. G. Kecks, *Das französische Schloss der Renaissance*, Berlin, 1985.

Prizer, W. F., "The Lauda and Popular Religion in Italy at the Beginning of the Counter Reformation," unpublished MS, 1987.

Prosperi, A., "Intorno ad un catechismo figurato del tardo '500," *Quaderni di Palazzo del Te*, I, 1985, 45–53.

Prota-Giurleo, U., *Pittori napoletani del seicento*, Naples, 1953.

Pühringer-Zwanowetz, L., "Ein Entwurf Berninis für Versailles," *Wiener Jahrbuch für Kunstgeschichte*, XXIX, 1976, 101–19.

Puyvelde, L. van, "Nouvelles oeuvres de Jean van Hemessen," *Revue belge d'archéologie et d'histoire de l'art*, XX, 1951, 57–71.

————, "Un portrait de marchand par Quentin Metsys et les percepteurs d'impôts par Marin van Reymerswale," *Revue belge d'archéologie et d'histoire de l'art*, XXVI, 1957, 5–23.

Pyke, E. J., *A Biographical Dictionary of Wax Modelers*, Oxford, 1973.

Quatremère de Quincy, A. C., *Encyclopédie méthodique. Architecture*, 3 vols., Paris 1788–1825.

Quednau, R., *Die Sala di Costantino im vatikanischen Palast. Zur Dekoration der beiden Medici-Päpste Leo X. und Clemens VII.*, Hildesheim and New York, 1979.

Rackham, H., *Cicero. De natura deorum. Academica*, London and New York, 1933.

————, *Pliny. Natural History*, 10 vols., London and Cambridge, Mass., 1945.

Read, T. C., *A Critical Study and Performance Edition of Emilio de' Cavalieri's Rappresentatione di Anima e di Corpo*, Ph.D. diss., Univ. of Southern California, 1969.

Regoli, S., *In primum Aeneidos Virgilii librum ex Aristotelis De arte poetica & rhetorica praeceptis explicationes*, Bologna, 1563.

————, *Oratio habita in Academia Bononiensi III Non. Novemb. MDLXIII*, Bologna, 1563.

Rhode Island School of Design. Museum Notes, LXXII, 1985, 30f.

Ribalta y la escuela valenciana, exhib. cat., Madrid, 1987.

Richa, G., *Notizie istoriche delle chiese florentine*, 10 vols., Florence, 1754–62.

Richardson, J., with M. McCully, *A Life of Picasso. Volume I, 1881–1906*, New York, 1991.

Richter, J. P., ed., *The Literary Works of Leonardo da Vinci.*

Compiled and Edited from the Original Manuscripts, 2nd ed., 2 vols., London, 1939.

Ripa, C., *Iconologia*, Rome, 1603.

Ristori, R., "L'Aretino, il David di Michelangelo e la 'modestia fiorentina,'" *Rinascimento*, XXVI, 1986, 77–97.

Rivosecchi, V., *Esotismo in Roma barocca. Studi sul padre Kircher*, Rome, 1982.

Robert, C., *Die antiken sarkophag-reliefs. III. Einzelmythen*, Rome, 1969.

Robinson, D. M., "The Villa of Good Fortune at Olynthus," *American Journal of Archaeology*, XXXVIII, 1934, 501–10.

Roethlisberger, M., "A propos d'un tableau du cercle Reymerswaele et Hemessen," *Bulletin du Musée national de Varsovie*, VII, 1966, 65–67.

Rolfe, J. C., *Suetonius*, 2 vols., Cambridge, Mass., and London, 1950.

Roover, R. de, *Money, Banking, and Credit in Mediaeval Bruges*, Cambridge, Mass., 1948.

Rosand, D., "The Crisis of the Venetian Renaissance Tradition," *L'arte*, X, 1970, 5–53.

Rosasco, B., "*Bains d'Apollon, Bains de Diane:* Masculine and Feminine in the Gardens of Versailles," *Gazettes des Beaux-Arts*, CXVII, 1991, 1–26.

Rosenthal, D., "A Source for Bernini's Louis XIV Monument," *Gazette des Beaux-Arts*, LXXXVIII, 1976, 231–34.

Rosenthal, E. S., "*Plus ultra, non plus ultra,* and the Columnar Device of Emperor Charles V," *Journal of the Warburg and Courtauld Institutes*, XXIV, 1971, 204–28.

————, "*Plus Oultre:* The *Idea Imperial* of Charles V in his Columnar Device on the Alhambra," in R. Enggass and M. Stokstad, eds., *Hortus Imaginum. Essays in Western Art*, Lawrence, Kans., 1974, 85–93.

————, *The Palace of Charles V in Granada*, Princeton, N.J., 1985.

Rospigliosi, G., *Il S. Alessio*, Rome, 1634.

Rossi, S., *Dalle botteghe alle accademie. Realtà sociale e teorie artistiche a Firenze dal XIV al XVI secolo*, Milan, 1980.

Roth, E., *Die Rustika der italienischen Renaissance und ihre Vorgeschichte*, Ph.D. diss., Friedrich-Alexander Universität Erlangen, Vienna, 1917.

Rotondò, A., "Per la storia dell'eresia a Bologna nel secolo XVI," *Rinascimento. Rivista dell'Istituto Nazionale di Studi sul Rinascimento*, 2nd ser., II, Florence, 1962, 107–60.

Röttgen, H., *Il Caravaggio. Ricerche e interpretazioni*, Rome, 1974.

Roversi, G., ed., *L'Archiginnasio. Il palazzo, l'università, la biblioteca*, 2 vols., Bologna, 1987.

Royal Commission on Historical Monuments (England). An Inventory of the Historical Monuments of London. Vol. I, Westminster Abbey, London, 1924.

Rubin, W., *Picasso in the Collection of the Museum of Modern Art*, New York, 1972.

————, ed., *"Primitivism" in 20th Century Art. Affinity of the Tribal and the Modern*, 2 vols., New York, 1985.

Rubenstein, N., "The Beginnings of Political Thought in Florence," *Journal of the Warburg and Courtauld Institutes*, V, 1942, 198–227.

Rupprich, H., *Dürer: Schriftlicher Nachlass*, 3 vols., Berlin, 1956–69.

Ruschi, P., "La Sagrestia Vecchia di San Lorenzo: Per un disegno delle vicende costruttive," in *Donatello*, 1986, 15–23.

Sabartés, J., *Picasso. An Intimate Portrait*, New York, 1948.

————, *Picasso. Retratos y recuerdos*, Madrid, 1953.

Saffrey, H. D., "ΑΓΕΩΜΕΤΡΗΤΟΣ ΜΗΔΕΙΣ ΕΙΣΙΤΩ. Une inscription légendaire," *Revue des études grecques*, LXXXI, 1968, 66–87.

Salomone, S., "Il 'capriccio regolato.' L'interpretazione della natura nella architettura di Federico Zuccari," in Fagiolo, ed., 1979, 129–36.

Salvadori, A., *Guerra di bellezza*, Florence, 1616.

Salzmann, D., *Untersuchungen zu den antiken Kieselmosaiken*, Berlin, 1982.

Sammlung des Freiherrn Adalbert von Lanna. Prag. Rudolph Lepke's Kunst-Auctions-Haus, Berlin, 1911.

Sandrart, J. von, *L'accademia todesca della architettura, scultura & pittura: oder Teutsche Academie der edlen Bau-Bild und Malereykünste*, Nuremberg and Frankfurt am Main, 2 vols., 1675–79.

————, *Academie der Bau-, Bild- und Mahlerey-Künste von 1675*, ed. A. R. Peltzer, Munich, 1925.

Sax, J., *Die Bischöfe und Reichsfürsten von Eichstadt, 745–1806*, 2 vols., Landshut, 1884–85.

Saxl, F., "Veritas Filia Temporis," in R. Klibansky and

H. J. Paton, eds., *Philosophy and History. Essays Presented to Ernst Cassirer,* Oxford, 1936, 197–222.

Scarchilli, R., "Note sul metodo progettuale del Brunelleschi. Il complesso laurenziano: la chiesa (prima parte)," *Controspazio,* IX, 1977, no. 1, 43–47.

Schaefer, J. O., "Saint Luke as Painter: From Saint to Artisan to Artist," in X. Barral i Altet, ed., *Artistes, artisans et production artistique au moyen âge,* Paris, 3 vols., 1986–90, I, 413–17.

Scheller, R. W., "Gallia Cisalpina: Louis XII and Italy, 1499–1508," *Simiolus,* XV, 1985, 5–60.

Schiavo, A., "Il viaggio del Bernini in Francia nei documenti dell 'Archivio Segreto Vaticano," *Bollettino del Centro di Studi per la Storia dell'Architettura,* X, 1956, 23–80.

Het Schildersatelier in de Nederlanden, 1500–1800, Nijmegen, 1964.

Schlegel, U., *Die italienische Bildwerke des 17. und 18. Jahrhunderts in Stein, Holz, Ton, Wachs und Bronze mit Ausnahme der Plaketten und Medaillen,* Berlin, 1978.

Schmidt, D. H. W., *David der Goliathsieger. Stadtheroe und Verfassungsbild der Republik Florenz im Zeitalter der Renaissance,* Ph.D. diss., Freie Universität Berlin, 1960.

Schmitt, M., "'Random' Reliefs and 'Primitive' Friezes: Reused Sources of Romanesque Sculpture?" *Viator,* XI, 1980, 123–45.

Schneider, L., "Leon Battista Alberti: Some Biographical Implications of the Winged Eye," *The Art Bulletin,* LXXII, 1990, 261–70.

Schneider, P., *Matisse,* New York, 1984.

Schwartz, J., *Irony and Ideology in Rabelais. Structures of Subversion,* Cambridge, 1990.

Sciolla, G. C., *La scultura di Mino da Fiesole,* Turin, 1970.

Scott, J. B., *Images of Nepotism. The Painted Ceilings of Palazzo Barberini,* Princeton, N.J., 1991.

Scribner, C., III, "*In Alia Effigie:* Caravaggio's London Supper at Emmaus," *The Art Bulletin,* LIX, 1977, 375–82.

La Sculpture. Méthode et vocabulaire (Ministère de la culture et de la communication. Inventaire général des monuments et des richesses artistiques de la France. Principes d'analyse scientifique), Paris, 1978.

Sears, E., *The Ages of Man. Medieval Interpretations of the Life Cycle,* Princeton, N.J., 1986.

Seelig, L., "Zu Domenico Guidi's Gruppe 'Die Geschichte zeichnet die Taten Ludwigs XIV auf,'" *Jahrbuch der Hamburger Kunstsammlungen,* XVII, 1972, 81–104.

Seiberling, G., *Monet's Series,* New York and London, 1981.

Seidel, L., "Constantine 'and' Charlemagne," *Gesta,* XIV, 1976, 237–39.

Le XVI^e siècle européen. Peintures et dessins dans les collections publiques françaises, Paris, 1966.

Serlio, S., *Regole generali di architettura,* Venice, 1562.

Seymour, C., Jr., *The Sculpture of Verrocchio,* Greenwich, Conn., 1971.

————, *Michelangelo's David. A Search for Identity,* Pittsburgh, Pa., 1974.

Sheard, W. S., "Verrocchio's Medici Tomb and the Language of Materials, with a Postscript on his Legacy in Venice," forthcoming in the acts of a symposium on late quattrocento sculpture held at Provo, Utah, 1988.

Shikes, R. E., *The Indignant Eye: The Artist as Social Critic in Prints and Drawings from the Fifteenth Century to Picasso,* Boston, 1969.

Sider, S., "Transcendent Symbols for the Hapsburgs: *Plus Ultra* and the Columns of Hercules," forthcoming in the journal *Emblematica.*

Sieveking, H., ed., *Das Gebetbuch Kaiser Maximilians. Der Münchner Teil mit den Randzeichnungen von Albrecht Dürer und Lucas Cranach d. Ae.,* Munich, 1987.

Silver, L., *The Paintings of Quinten Massys with Catalogue Raisonné,* Montclair, N.J., 1984.

Simolachri, historie, e figure de la morte, Lyon, 1549.

Simons, P., "Patronage in the Tornaquinci Chapel, Santa Maria Novella, Florence," in Kent *et al.,* eds., 1987, 221–50.

Sinding-Larsen, S., "A Tale of Two Cities. Florentine and Roman Visual Context for Fifteenth-Century Palaces," *Acta ad archaeologicam et artium historiam pertinentia,* VI, 1975, 163–212.

Smith, W., "Definitions of *Statua,*" *The Art Bulletin,* L, 1968, 263–67.

Smither, H. E., *A History of the Oratorio,* 3 vols., Chapel Hill, N.C., 1977–87.

Snyder, J., *Northern Renaissance Art. Painting, Sculpture, the Graphic Arts from 1350 to 1575,* Englewood Cliffs, N.J., and New York, 1985.

Soprani, R., *Vite de' pittori, scoltori, et architetti genovesi*, Genoa, 1674; ed. C. G. Ratti, 2 vols., Genoa, 1768.

Sorbelli, A., *Le marche tipografiche bolognesi nel secolo XVI*, Milan, 1923.

Sotheby and Company. Catalogue of Old Master Drawings, May 21, 1963.

Souchal, F., *French Sculptors of the 17th and 18th Centuries*, 1977–.

Southorn, J., *Power and Display in the Seventeenth Century. The Arts and Their Patrons in Modena and Ferrara*, Cambridge, 1988.

Spagnesi, G., and M. Fagiolo, eds., *Gian Lorenzo Bernini architetto e l'architettura europea del sei-settecento*, Rome, 1984.

Spargo, J. W., *Virgil the Necromancer. Studies in Virgilian Legends*, Cambridge, Mass., 1934.

Sperling, C., "Verrocchio's Medici Tombs," forthcoming in the acts of a symposium on late quattrocento sculpture held at Provo, Utah, 1988.

Spies, W., ed., *Pablo Picasso. Eine Ausstellung zum hundertsten Geburtstag. Werke aus der Sammlung Marina Picasso*, exhib. cat., Munich, 1981.

Staller, N., "Early Picasso and the Origins of Cubism," *Arts Magazine*, LXI, 1986, 80–91.

Stampfle, F., and J. Bean, *Drawings from New York Collections. II. The Seventeenth Century*, New York, 1967.

Statius, *Silvae*, ed. J. H. Mozley, 2 vols., London and New York, 1928.

Steinberg, L., *Other Criteria. Confrontations with Twentieth-Century Art*, New York, 1972.

Steinberg, R. M., "The Iconography of the Teatro dell'Acqua at the Villa Aldobrandini," *The Art Bulletin*, XLVII, 1965, 453–63.

Stephens, J. N., *The Fall of the Florentine Republic, 1512–1530*, Oxford, 1983.

Stilleben in Europa, exhib. cat., Münster and Baden-Baden, 1979.

Straub, E., *Repraesentatio Maiestatis oder churbayerische Freudenfeste. Die höfische Feste in der Münchner Residenz vom 16. bis zum Ende des 18. Jahrhunderts*, Munich, 1969.

Strauss, W. L., ed., *The Book of Hours of the Emperor Maximilian the First decorated by Albrecht Dürer, Hans Baldung Grien, Hans Burgkmair the Elder, Jörg Breu,* *Albrecht Altdorfer, and other Artists. Printed in 1513 by Johannes Schoensperger at Augsburg*, New York, 1974.

————, *The Illustrated Bartsch, 3 . . . Hendrik Goltzius*, New York, 1980.

Suckale-Redlefsen, G., *Die Bilderzyklen zum Davidleben. Von den Anfängen bis zum Ende des 11. Jahrhunderts*, Ph.D. diss., Universität Müchen, 1972.

Summers, J. D., "David's Scowl," in W. S. Sheard and J. Paoletti, eds., *Collaboration in Italian Renaissance Art*, New Haven, Conn., and London, 1978, 113–20.

————, *The Sculpture of Vincenzo Danti: A Study in the Influence of Michelangelo and the Ideals of the Maniera*, New York and London, 1979.

————, *Michelangelo and the Language of Art*, Princeton, N.J., 1981.

The Sun King. Louis XIV and the New World, exhib. cat., New Orleans, La., 1984.

Symonds, J. A., *The Life of Michelangelo Buonarroti*, 2 vols., London, 1893.

Tadgell, C., *Ange-Jacques Gabriel*, London, 1978.

————, "Claude Perrault, François Le Vau and the Louvre Colonnade," *The Burlington Magazine*, CXXII, 1980, 326–35.

Talbot, C. W., ed., *Dürer in America. His Graphic Work*, New York and London, 1971.

Tenzer, V. G., *The Iconography of the Studiolo of Federico da Montefeltro in Urbino*, Ph.D., diss., Brown Univ., 1985.

Terracina, S., and A. Vittorini, "Il problema dell'attribuzione delle 'rocce' berniniane nel palazzo di Montecitorio," *Ricerche di storia dell'arte*, XX, 1983, 125–33.

Tervarent, G. de, *Attributs et symboles dans l'art profane, 1450–1600. Dictionnaire d'un langage perdu*, 2 vols., Geneva, 1958–59.

Thiem, G., and C. Thiem, *Toskanische Fassaden-Dekoration*, Munich, 1964.

Thiersch, H., *Pharos. Antike Islam und Occident. Ein Betrag zur Architekturgeschichte*, Leipzig and Berlin, 1909.

Thöne, F., "Caspar Freisingers Zeichnungen," *Zeitschrift des deutschen Vereins für Kunstwissenschaft*, VII, 1940, 39–63.

Tolnay, C. de, *Michelangelo*, 5 vols., Princeton, N.J., 1943–60.

————, *The Art and Thought of Michelangelo*, New York,

1964.

———, "La Venere con due amorini già a Pitti ora in Casa Buonarroti," *Commentari*, XVII, 1966, 324–32.

———, *Corpus dei disegni di Michelangelo*, 4 vols., Novara, 1975–80.

Il Toro Farnese. La "montagna di marmo" tra Roma e Napoli, Naples, 1991.

Torriti, P., *Pietro Tacca da Carrara*, Genoa, 1984.

Toschi, P., *Le origini del teatro italiano*, Turin, 1955.

Tōyama, K., "La cantoria di Luca della Robbia—una prova di interpretazione," *"Bijutsushi": Bulletin of the Japan Art History Society*, XXXIX, 1990, 14–28; Italian summary, 2.

Trapp, J. B., "The Owl's Ivy and the Poet's Bays. An Enquiry into Poetic Garlands," *Journal of the Warburg and Courtauld Institutes*, XXI, 1958, 227–55.

Treffers, B., "Dogma, esegesi e pittura: Caravaggio nella cappella Contarelli in San Luigi dei Francesi," *Storia dell'arte*, no. 67, 1989, 241–55.

Trinchieri Camiz, F., "Death and Rebirth in Caravaggio's *Martyrdom of St. Matthew*," *Artibus et historiae*, no. 22, 1990, 89–105.

Tronzo, W., "The Prestige of Saint Peter's: Observations on the Function of Monumental Narrative Cycles in Italy," *Studies in the History of Art*, XVI, 1985, 93–112.

———, *The Via Latina Catacomb. Imitation and Discontinuity in Fourth-Century Roman Painting*, University Park, Pa., and London, 1986.

Tucker, P. H., *Monet in the 90's*, exhib. cat., New Haven, Conn., and London, 1989.

Turrini, M., "'Riformare il mondo a vera vita christiana': Le scuole di catechismo nell'Italia del cinquecento," *Annali dell'Istituto storico-germanico in Trento*, VIII, 1982, 407–89.

Tuttle, R. J., "Per l'iconografia della fontana del Nettuno," *Il Carrobbio. Rivista di studi bolognesi*, III, 1977, 437–45.

———, "La Fontana del Nettuno," in G. Roversi, ed., *La Piazza Maggiore di Bologna*, 1984, 143–67.

———, "*Bononia Resurgens*: A Medallic History by Pier Donato Cesi," *Studies in the History of Art*, XXI, 1987, 215–46.

———, "Il palazzo dell'Archiginnasio in una relazione inedita di Pier Donato Cesi al cardinale Carlo Borromeo," in Roversi, ed., 1987, I, 66–85.

Väänänen, V., ed., *Graffiti del Palatino. I. Paedagogium*. Helsinki, 1966; *II. Domus Tiberiana*, Helsinki, 1970.

Valeriano, P., *Hieroglyphica*, Lyon, 1602.

Van Crimpen, J., "Drawings by Vincent, Not Included in De la Faille," *Vincent*, III, 1974, 2–5.

Van der Wolk, J., *The Seven Sketchbooks of Vincent Van Gogh*, New York, 1987.

Van de Velde, C., *Frans Floris (1519/20–1570). Leven en Werken*, Brussels, 1975.

Van Mander, K., *Den grondt der edel vry schilder-const*, ed. H. Miedema, 2 vols., Utrecht, 1973.

Van Os, H., *Sienese Altarpieces, 1215–1460*, 2 vols., Groningen, 1988–90.

Van Peteghem, L. J., *Histoire de l'enseignement du dessin*, Brussels, 1868.

Vasari, G., *Le vite de' più eccellenti pittori scultori ed architettori*, ed., G. Milanesi, 9 vols., Florence, 1906.

———, *Le vite de' più eccellenti pittori scultori e architettori nelle redazioni del 1550 e 1568*, R. Bettarini and P. Barrocchi, eds., Florence, 1966–.

Veca, A., *Vanitas, Il simbolismo del tempo*, Bergamo, 1981.

Veldman, I. M., *Maarten van Heemskerck and Dutch Humanism in the Sixteenth Century*, Amsterdam, 1977.

Vergara, L., "Steenwyck, De Momper, and Snellinx: Three Painters' Portraits by Van Dyck," in *Essays in Northern European Art Presented to Egbert Haverkamp-Begemann on His Sixtieth Birthday*, Doornspijk, 1983, 283–86.

Vermeule, C., *Alexander the Great Conquers Rome*, Cambridge, Mass., 1986.

Verspohl, F.-J., "Michelangelo und Machiavelli. Der David auf der Piazza della Signoria in Florenz," *Städel-Jahrbuch*, VIII, 1981, 204–46.

Vetter, E. M., and C. Brockhaus, "Das Verhältnis von Text und Bild in Dürers Randzeichnungen zum Gebetbuch Kaiser Maximilians," *Anzeiger des Germanischen Nationalmuseums*, 1971–72, 70–121.

Vezzosi, A., ed., *Il concerto di statue*, Florence, 1986.

Viale, V., ed., *Città di Torino. Mostra del barocco piemontese. Palazzo Madama—Palazzo Reale—Palazzina di Stupinigi*, 3 vols., Turin, 1963.

Vigenère, B. de, *Les Images ou tableaux de platte peinture des deux Philostrates sophistes grecs et des statues de Calli-*

strate, Paris, 1578.

Villani, G., *Cronica*, 8 vols., Florence, 1823.

Villarosa, Marchese di, *Memorie degli scrittoti filippini o siano della Congregazione dell'Oratorio di S. Filippo Neri*, Naples, 1837.

Vitruvius, *On Architecture*, ed. F. Granger, 2 vols., London and New York, 1931–34.

Vivanti, C., "Henry IV, the Gallic Hercules," *Journal of the Warburg and Courtauld Institutes*, XXX, 1967, 176–97.

Vlam, G. A. H., "The Calling of Saint Matthew in Sixteenth-Century Flemish Painting," *The Art Bulletin*, LIX, 1977, 561–70.

Volk, P., "Darstellungen Ludwig XIV. auf steigendem Pferd," *Wallraf-Richartz-Jahrbuch*, XXVIII, 1966, 61–90.

Voragine, Jacobus de, *The Golden Legend*, New York, 1969.

Wagner, A. M., *Jean-Baptiste Carpeaux. Sculptor of the Second Empire*, New Haven, Conn., and London, 1986.

Wagner, H., *Michelangelo da Caravaggio*, Bern, 1958.

Wallen, B., *Jan van Hemessen. An Antwerp Painter between Reform and Counter-Reform*, Ann Arbor, Mich., 1983.

Walther, H., *Das Streitgedicht in der lateinischen Literatur des Mittelalters*, Munich, 1920.

Walton, G., "The Lucretia Panel in the Isabella Stuart Gardner Museum in Boston," in W. Cahn, M. Franciscono, F. Richardson, and D. Wiebenson, eds., *Essays in Honor of Walter Friedlaender*, Locust Valley, N.Y., 1965, 177–86.

Wander, S. H., "The Westminster Abbey Sanctuary Pavement," *Traditio*, XXXIV, 1978, 137–56.

Warnke, M., "Die erste Seite aus den 'Viten' Giorgio Vasaris. Der politische Gehalt seiner Renaissancevorstellung," *Kritische Berichte*, V, 1977, 5–28.

Weber, G. *Brunnen und Wasserkünste in Frankreich im Zeitalter von Louis XIV*, Worms, 1985.

Weil-Garris, K., "On Pedestals: Michelangelo's *David*, Bandinelli's *Hercules and Cacus*, and the Sculpture of the Piazza della Signoria," *Römisches Jahrbuch für Kunstgeschichte*, XX, 1983, 377–415.

_____, "Cosmological Patterns in Raphael's Chigi Chapel in S. Maria del Popolo," in *Raffaello a Roma*, Rome, 1986, 127–56.

Welter, H., *L'Exemplum dans la littérature religieuse et didactique du Moyen-Âge*, Paris, 1927.

Wilde, J., *Michelangelo*, Oxford, 1978.

Wiles, B. H., *The Fountains of the Florentine Sculptors and Their Followers from Donatello to Bernini*, Cambridge, Mass., 1933.

Willaert, A., *Cinque Messe*, Venice, 1536.

Wilmart, A., "Un grand débat de l'âme et du corps en vers élégiaques," *Studi medievali*, XII, 1939, 192–207.

Winner, M., *Die Quellen der Pictura-Allegorien in gemalten Bildergalerien des 17. Jahrhunderts zu Antwerpen*, Ph.D. diss., Universität Köln, 1957.

_____, "Gemalte Kunsttheorie. Zu Gustav Courbets 'Allégorie réelle' und der Tradition," *Jahrbuch der Berliner Museen*, IV, 1962, 152–85.

_____, "Pontormo's Fresko in Poggio a Caiano," *Zeitschrift für Kunstgeschichte*, XXXV, 1972, 153–97.

Wittkower, R., *Bernini's Bust of Louis XIV*, London, 1951.

_____, "The Vicissitudes of a Dynastic Monument. Bernini's Equestrian Statue of Louis XIV," in Meiss, ed., 1961, 497–531; reprinted in Wittkower's *Studies in the Italian Baroque*, London, 1975, 83–102.

_____, *Gian Lorenzo Bernini. The Sculptor of the Roman Baroque*, London, 1981.

Wylie, A. S., "An Investigation of the Vocabulary of Line in Vincent van Gogh's Expression of Shape," *Oud Holland*, LXXXV, 1970, 210–35.

Yates, F. A., *Astraea. The Imperial Theme in the Sixteenth Century*, London and Boston, 1975.

Young, G. F., *The Medici*, 2 vols., New York, 1923.

Zangheri, L., *Pratolino il giardino delle meraviglie*, Florence, 1979.

_____, "Salomon de Caus e la fortuna di Pratolino nell'Europa del primo seicento," in A. Vezzosi, ed., *La fonte delle fonti. Iconologia degli artifizi dacqua*, Florence, 1985, 35–47.

Zappella, G., *Le marche dei tipografi e degli editori italiani del Cinquecento. Repertorio di figure, simboli e soggetti e dei relativi motti*, 2 vols., Milan, 1986.

Zerner, H., "Observations on Dupérac and the *Disegni de le ruine di Roma e come anticamente erono*," *The Art Bulletin*, XLII, 1965, 507–12.

Zervos, C., *Pablo Picasso. Catalogue des peintures et dessins*, 33 vols., Paris, 1932–78.

_____, "Conversation avec Picasso," *Cahiers d'Art*, X, 1935, 173–78.

Zimmer, G., *Römische Berufsdarstellungen*, Berlin, 1982 (Archäologische Forschungen, vol. 12).

Zischka, U., *Zur sakralen und profanen Anwendung des Knotenmotives als magisches Mittel, Symbol oder Dekor.* *Eine vergleichend-volkskundliche Untersuchung*, Munich, 1977.

Zuccari, F., *L'idea de' pittori, scultori, et architettori*, Turin, 1607.

Zupke, R. W., *Italian Weights and Measures from the Middle Ages to the Nineteenth Century*, Philadelphia, 1981.

Armi, A. M., 269n.4

Ars moriendi/The Art of Dying, 102f, 124, 284

Art

 "art without history"/high-low, 203–22, 253–60, 302n.1

 life history of work of, 224, 231, 257–59

 restoration as, 63

 See also Artist; Art theory; Historicism; Popular
 (unsophisticated) culture

Art forms. *See* Architecture; Drawing; Lithography;
 Painting; Sculpture

Artist

 creative process as conceived by Michelangelo,
 33–43, 50

 as David, 33, 43, 50, 272n.48

 guilds and academies, 46, 243, 271f

 as Hercules, 34–36

 Luke as, 43–46, 243, 271f, Figs.52,53

Art theory

 Bambocciani on, 220

 on Neptune, 78f

 Paragone, 43f, 48–50

 See also Historicism

Askew, P., 272n.48

Astrological symbolism

 of Andromeda (zodiacal depictions), 298n.91

 Fanti's book of astrological games, 40–43, 46,
 271n.30, Fig.51

 Florence, S. Lorenzo, Old Sacristy, 20f, 267n.52

 Michelangelo and, 43, 46, 271n.30, Fig.51

Astronomy, 23, 268n.59, 298n.91

Athens

 National Archeological Museum,
 front of an altar from Epidaurus, Fig.267
 side of an altar from Epidaurus, Fig.268

 Plato's Academy, entrance motto, 22

Atlas, 185

Atton, Domenico, 98

Augustine, St., 157–60

 Confessions, 23

Augustus

 Golden Age of, 52, 57

 laurel imagery, 52, 273n.54

 Lorenzo de' Medici and, 52

 obelisk of, 291n.28

 palace on Palatine hill, 143

 and Sibyl (Caron painting), 296n.79

villa *Ad Gallinas*, 273n.54

 Virgil's Neptune and, 75

Autograph album, German, 303f

Avarice

 and Liberality, 123

 Matthew's, 92, 97, 280f

Azzolini, Giovanni Bernardino, 114f, 285nn.10,13

 Four Last Things, wax depictions, 114, 129,
 Figs.157–76

Babies, laughing/crying, 115, 285n.13, Figs.145,146

Baer, B., 306n.35, 312n.63

Baldinucci, Filippo, 125, 210–12, 288n.7, 295n.68,
 302n.127

Bamberg, Staatsliche Bibliothek, Boethius, diagram
 illustrating nature of odd and even numbers, Fig.26

I Bamboccianti, 220

Bandinelli, Baccio, 25, 274n.69

Baptism, Caravaggio's *Martyrdom of St. Matthew* and, 282n.28

Barberini, 141, 288n.7

Barbier d'Aucour, Jean, 294n.66

Bargue, Charles (publisher), 257

 seated nude, lithograph, 313n.68, Figs.348,352

 studies after a sculpture by Pilon, Fig.350

Barocchi, P., 269n.2

Baronio, Cardinal Cesare, 26, 268n.72

Bartoli, Papirio, 298n.88

Basel, Universitäts-Bibliothek, Erasmus of Rotterdam,
 manuscript page, 215f, Fig.277

Basilicas

 and artistic unity, 1, 15

 Florence, S. Lorenzo, symbolic, 15

 Rome, early Christian, 1, 5, 6, 15, 26

Bassano, Museo Civico, Bernini, study for the eques-
 trian monument of Louis XIV, Fig.226

Bassi, Pietro Andrea di, *Le fatiche d'Ercole*, 270n.14

Baths of Caracalla, 172

Baur, Johannes, Rome, Galleria Borghese, view of the
 Villa Borghese, 191, Fig.199

Beard pulling, Jews and, 281f

Beast

 of Apocalypse, 68

 Beauty and the, 101, 203, 221f, Fig.114

Beata, 124

 Bernini's *Anima Beata*, 101, 109, 118f, 124, 125,
 284n.2, Fig.112, Pl.VIII

Bernini, works (*continued*)

 Stockholm, Nationalmuseum, second project for
 the Louvre, 144, 288n.10, 299nn.98,100,
 Fig.192

 Versailles,
 bust of Louis XIV, 139, 161–69, 186, 189–91,
 195, 292n.45, Figs.178,181, Pl.X
 design for château (presumed), 195
 equestrian statue of Louis XIV, 166–87,
 189–91, 195, 296n.75, 301n.122, Figs.179,
 182, Pl.XI
 defaced, 195, Fig.257
 measurements, 294n.65
 restored, 199, Fig.262
 smile on, 170, 293nn.58,59

Bernini, Pietro, 300n.113

Bestiality
 bull as symbol of, 231
 See also Beast

Bible
 Caravaggio's paintings and, 85, 92, 93, 97, 98, 99
 Gospel narratives, 92, 93, 97, 98, 99, 188, 280n.6,
 283n.37
 Paul's letters, 85, 99, 272n.42, 280n.6
 See also Christology; Old Testament

Bireley, R., 301n.122

Bisi, Bonaventura, 305n.32

Bisticci, Vespasiano da, 1

Blacks, African sculpture, 245

Bloemaert, Abraham, ox of St. Luke as symbol of
 painting, Fig.329

Blume, P., 267n.52

Boccaccio, 34

Bocchi, Achille, "Felicitas prudentiae et diligentiae est,"
 172, 294n.64, Fig.228

Boethius, *De institutione arithmetica*, 18, 266n.45, Fig.26

Boime, A., 312n.64

Bologna, 63–64
 Bolognino d'oro, *Bononia Docet* with rampant lion
 holding vexillum, St. Peter, 63, Fig. 75
 coinage, 63f, Figs.75,76
 emblem, 63f
 Fontana Vecchia, 65
 Giambologna in, 275n.8
 Grossone, *Bononia Mater Studiorum* with rampant lion
 holding vexillum, St. Petronius, 63, Fig.76

 heresies, 64
 intellectual center, 63, 64, 75, 78, 278n.31
 inventions, 63
 mottos, 63f
 politics, 63, 65, 68–71
 religion, 64–71
 republic, 63
 S. Petronio, 65, 66, Fig.77
 Michelangelo, Julius II statue, 71, 276n.16
 urban renewal, 66
 Via Emilia and Via Flaminia, 63
—collections,
 Biblioteca Comunale del Archiginnasio, Gnudi,
 "Ichnoscenografia" of Bologna, Fig.77
 Museo Civico,
 Giambologna,
 Mercury, 72, 275n.8, Fig.83
 Neptune, 79f, Fig.94
—palaces, 66, Fig.77
 Palazzo Comunale, 65, 66
 Ceroli, "Casa di Nettuno," Figs.73,74
 Lombardi, Hercules statue, 68–71, Figs.80,81
 Palazzo dell'Archiginnasio, 65
—public sites,
 Piazza del Nettuno,
 Giambologna, Neptune fountain, 63–83,
 274–79, Figs.87–90, Pl.III
 Piazza Maggiore, 65, 79, Fig.67
—university, Archiginnasio, 63, 65, 68, 78, 278f,
 Fig.77
 Giambologna,
 Mercury (planned), 72f, 76, 79, 83
 statue of Pius IV (planned), 65–68, 71, 75,
 80, 81, 83, 275f, Fig.79

Bologna, Giovanni. *See* Giambologna

Bonaventura, 221, 305n.32

Borghese, Cardinal Scipione, 300n.113

Borghini, Raffaele, 274n.64

Borromeo, St. Carlo, 65

Borsi, F., 289n.17

Boston, Gardner Museum, Botticelli, *Death of Lucrezia*,
 273n.49

Botinete, Fernando, 101, 125

Botticelli, Sandro
 Boston, Gardner Museum, *Death of Lucrezia*, 273n.49
 Primavera, 273n.56

Ostrow, S. F., 299n.95
Ovid, *Metamorphoses*, 143
Ox, of St. Luke, 243, 272n.42, Fig.329
Ozzola, L., 305n.32

Pacification, Neptune and, 75, 78, 80–83
Padua, Donatello's altar, 13, 263n.2
Paganism
 Alciati scholar of, 65
 Bernini and, 102, 109
 Christianity and, 2–5, 22f, 45–48, 71–76, 81, 180,
 208, 272n.42
 See also Antiquity; Hercules; Jupiter
Painting
 invention of, 304n.25
 mural, 216
 orator analogy with, 299n.99
 ox of St. Luke as symbol of, Fig.329
 vs. sculpture, 36, 48–50, 270n.18
Palaces
 ancient circus connected with, 178–80, 297n.85,
 Figs.208–10
 sun images in, 143–61
 urban palace and extramural villa fusion, 191–95,
 301n.117
 See also Bologna; Florence; Milan; Rome
Palau i Fabre, J., 308n.51, 313n.68
Paleolithic art, 243, 308n.51, 313n.72, Fig.331
Panofsky, E., 215
Panvinio, Onofrio, Palatine palace and Circus Maxi-
 mus, 157, Fig.208
Paradox, 85, 92
Paradoxical inversion, 115
Paragone (comparison of the arts), 43f, 48–50
 interpretatio christiana, 44
Parigi, Giulio, *Mount Parnassus*, Fig.196
Paris
 Bernini's trip to, 172, 178, 182, 189, 195, 220,
 297n.81
 ceremonial urbanism, 199
 children's exhibition, 247
 grand axe, 199, 302n.131
 liberation of, 222
 Picasso in, 222
 Rome surpassed by, 187, 300n.103
 —estate of the artist,

Picasso,
 profile heads after Bargue, 257, Fig.351
 seated nude after Bargue, drawing, 257, Fig.353
—libraries,
 Bibliothèque de l'Institut de France, Leonardo,
 drawing of ground plan of centralized church,
 Fig.23
 Bibliothèque Nationale,
 David the Psalmist, Fig.39
 de' Rossi, project for a monument containing
 Bernini's equestrian Louis XIV, 185,
 Fig.244
 François Le Vau, project for the Louvre, 144,
 157, Fig.190
 projects for the Louvre (1624–1829), 197,
 Fig.258
—museums,
 Louvre, 170, 189, 191, 197, 301nn.118,119
 Bernini, first project for the Louvre, drawing,
 144, 299n.98, 300nn.104,108, Fig.191
 Bernini's projects for (all), 139, 144–61, 177,
 182–91, 195f, 197, 288nn.9,10, 291n.31,
 299nn.95,98,100, 300nn.104,108,
 Figs.177,180,191,192
 Bernini's theaters proposal, 197
 Jupiter herm, 46, Fig.57
 Le Brun,
 Amour and *Désespoir*, 109, Figs.133–34
 Palace of the Sun, drawing, 143, Fig.188
 portière of Mars, 166, Fig.222
 Louis Le Vau, project for the Louvre, 143f,
 Fig.189
 Michelangelo, studies for the bronze and
 marble Davids, 29–33, 48, 51–53, 58,
 Fig.37, Pl.II
 Mithras Killing the Bull, 38
 Pei, entrance to, 197–99, 302n.129,
 Figs.259–61
 Perrault's project for, 169, 297n.79
 projects for building (1624–1829), 197,
 Fig.258
 projects for equestrian statues, 169, 293n.53
 Musée Picasso, Picasso, bull, December 24,
 1945, 224, Fig.321
 Schevitch Coll. (formerly), Purgatory, Heaven,
 Hell, wax reliefs, 129, Figs.166–68

Compositor: **T:H** Typecast, Inc.

Text: 12.5/14 Centaur

Display: Centaur

Text Printer: Malloy Lithographing

Binder: Malloy Lithographing